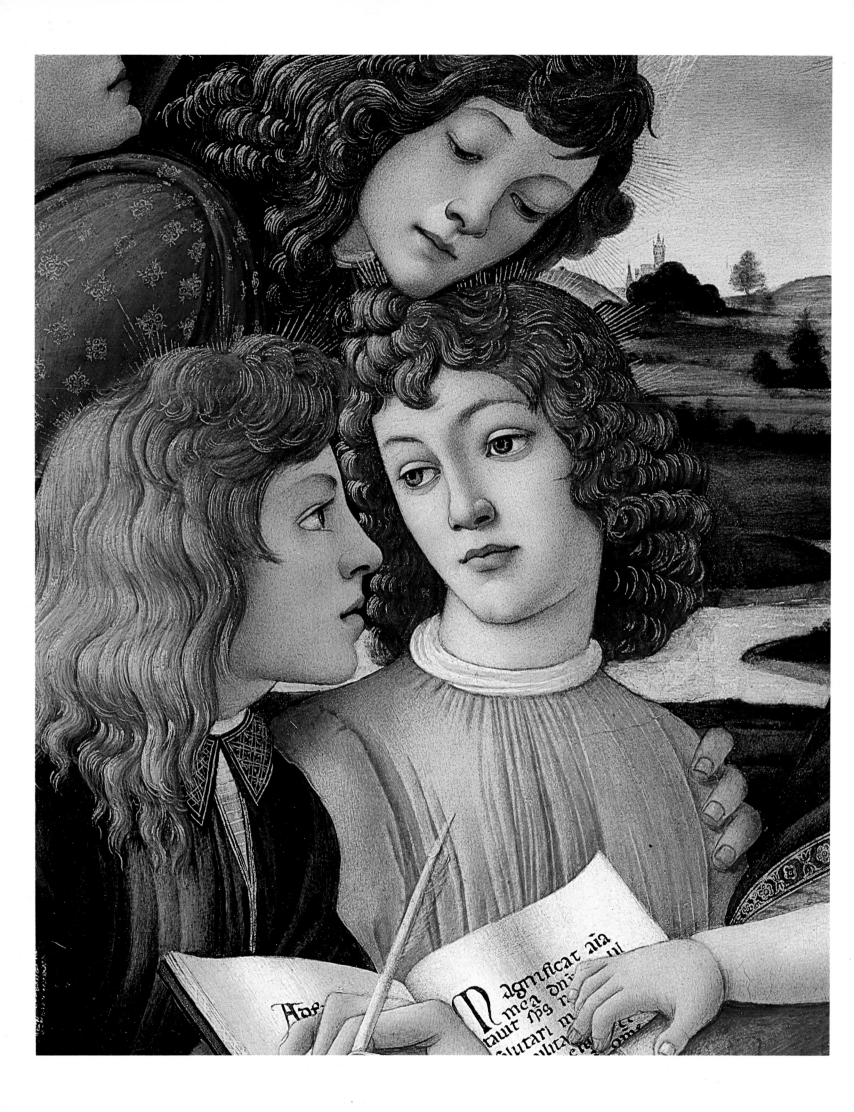

Mina Gregori

PAINTINGS IN THE UFFIZI & PITTI GALLERIES

Introductions by

Antonio Paolucci
and
Marco Chiarini

A Bulfinch Press Book

Little, Brown and Company
Boston • New York • Toronto • London

Translated by Caroline Hufton Murphy and
Henry Dietrich Fernandez
Translation editing by Paola Sergi Mignone
Copyedited by Dorothy Straight

First English-language Edition

Editorial Director: Guido Ceriotti
Editors: Beatrice Simonutti and Rodolfo Illich
Editorial Secretary: Daniela Peressini
Design: Gilberto Brun
Consultant for photography and text:
Enrico Mazzoli

ISBN 0-8212-2084-5
Library of Congress Catalog Card Number 94-72364

Bulfinch Press is an imprint and trademark of
Little, Brown and Company (Inc.)

Published simultaneously in Canada by Little,
Brown & Company (Canada) Limited

PRINTED IN ITALY

Contents

Acknowledgments

I would like to express my gratitude to the Soprintendenza per i Beni Artistici e Storici di Firenze and to the Superintendent Antonio Paolucci; to Annamaria Petrioli Tofani, Director of the Uffizi Gallery; to Marco Chiarini, Director of the Palatine Gallery; and to Caterina Caneva and Serena Padovani. Their unfailing courtesy in making this complex project easier was invaluable. I would also like to thank Maria Sframeli, Silvia Meloni, Giovanna Giusta, and Maddalena De Luca for their prompt response to each of our requests. I am also grateful to Maria Rosa Pelliconi and to Roberto Zanieri at the administrative offices of the Soprintendenza, whose helpful attention made the inevitable bureaucratic obstacles more bearable.

I would also like to stress the commitment of the photographers who participated in this editorial project, and to give special thanks to Paolo Tosi for his friendly and important collaboration, without which this book would not exist.

Many others have helped with this work, in many ways. It is impossible to list them here, but each of them deserves the grateful thanks of the publishing house for the contribution made to the completion of this extraordinary work. Finally, I would like to offer my personal thanks to Guido Ceriotti for the commitment, the passion, and the knowledge he has lavished on this long and exhausting editorial project.

Antonio Stella
President
Magnus Edizioni

Foreword

The painting collections in the state museums of Florence are unequaled for their quality, historical significance, and for the sheer number of works; never before have they been presented in a publication of such splendid technical quality.

The Uffizi, the Palatine Gallery, the Accademia, and the other national collections—to which the Contini Bonacossi donation and the works recovered by Rodolfo Siviero have recently been added—constitute the greatest museum complex in the world. It is a complex unified by its history, closely tied at first to the Medici family, who were originally patrons and benefactors but who later, as their political power waned, came to be characterized as collectors and preservers of heritage. These museums bear witness to the Florentine supremacy in the arts that was established by Cosimo I with the invaluable assistance of Vincenzo Borghini and of Giorgio Vasari.

When in 1631 the duchy of Urbino was ceded to the Papal States, the art collections and the possessions of Urbino were assigned to Vittoria della Rovere, wife of Ferdinando II of Florence, thus enriching the Medici galleries with important paintings including numerous masterpieces by Titian and Raphael; this gesture was proof of the general respect for the Medici as patrons of the arts. That the treasure of the Medici dynasty was linked intimately to Florence and to its history— unique in the arts—was quite clear to the last of the Medici, the Electress Palatine Anna Maria Ludovica, when, in 1737, she left the treasure to the city of Florence as its inalienable possession in what is called the "family pact."

In the 1600s the Uffizi Gallery, admired and described by visitors in part because of its "Wunderkammer" objects and, later, for its classical sculpture, was laid out with a magnificence inspired by ancient Roman galleries. As part of this broader vision Cardinal Leopoldo (aided probably by Cardinal Giovan Carlo) acquired Venetian paintings to expand the range of the collections that had always been prevalently—but never exclusively—Tuscan. This move antici- pated the concept of organization by "schools" that was to be the organizing principle of eighteenth- century attempts to reorder the gallery along entirely new lines.

Cardinal Leopoldo kept up a steady relationship with Venice, at that time the most important European center for art, and with other Italian cities from which he received reports about paintings, drawings, self-portraits, and miniature portraits (he created unique collections of the latter two genres). Cosimo III, on the other hand, looked to the rest of Europe: in the late seventeenth century, paintings by Rembrandt and Hercules Seghers arrived from Holland, together with works by Dutch and Flemish petits-maîtres. Ferdinand III of Lorraine also felt the need to round out the collection, and he directed the acquisition of numerous important Bolognese works.

The complexity and extraordinary variety of the Florentine galleries is born of this centuries-old historicist tradition, which anticipated modern reorganization principles. The suppression of the monasteries allowed most of the earlier paintings to enter the collection, making the collection even further complete.

Here too, respectful of this tradition, we have decided to present the works by school. Together with chronological progression, this is the only way to organize the anthology presented here by an array of specialists.

Thus the reader can trace the various phases and great moments of Florentine painting, including lesser known works of the seventeenth and eighteenth centuries; can appreciate the presence of masterpieces from other, perhaps unknown, schools; and can examine details different from the standard ones consecrated by tradition.

Mina Gregori

The Florentine Museum System

From the Palazzo Vecchio to the Forte Belvedere, through the Uffizi, the Vasari Corridor, the Pitti Palace, and the Boboli Gardens, Florence is honeycombed with a series of public art collections that is unparalleled in Europe for its size and for the variety and value of its holdings. If the principal feature of the "Florence Museum" is the combination of the monumental Palazzo Vecchio and the Forte Belvedere, from this trunk the secondary parts branch out like the boughs of a great tree: the Accademia, San Marco and the Bargello, and, outside the city walls, the villas of Petraia and Castello, of Poggio Imperiale, and the Villa di Poggio a Caiano, which contribute to the grand complex of Florentine galleries.

This complex is certainly the most difficult proving ground for museum curators in Italy today; the requirements of mass public exhibition require that the criteria of display be reinvented from the ground up.

How can one explain the exceptional nature—in quality and quantity—of Florence's public historical and art-historical collections? Why did it become a city of museums? What caused such a large and visible phenomenon to happen here and not elsewhere? These are crucial questions that demand historically solid answers. One of the root causes is certainly the happy circumstance that granted the city an unparalleled artistic flowering for almost three centuries, from the end of the thirteenth through the entire sixteenth century. Giorgio Vasari suggested that the air of Florence was responsible for the superiority of Florentine talent, an air that "liberates great talent" and nurtures boundless pride, fierce competition, and tough individualism. Vasari's psycho-naturalistic theory is provocative and yet unacceptable to us, his heirs, saturated as we are with historicism and relativism; and yet Vasari is necessarily the starting point for any exploration of the unique nature of the Florentine museum panorama. Indeed, the long tradition of collection and conservation of Florentine art would not have existed without Vasari's proud and lucid historiographic framework, based as it is on the concept of Florentine supremacy in the figurative arts. The masterpieces and the masters celebrated in the *Lives* began immediately to be appreciated, collected, and protected, creating the nuclei for future museums. And very soon the Accademia delle Arti del Disegno, founded by Vasari, began to function as a regional Soprintendenza for the protection and appreciation of early Tuscan art. This shows how the authority of Vasari's writings contributed to the swift formation of a solid spirit of protection in the city and in the Duchy of Tuscany, and how this awareness encouraged the growth of a cultural climate favorable to museums. In other words, there is a precise correspondence between the publication of Vasari's *Lives* (the second edition of which came out in 1568) and the birth of the Uffizi (1582), Europe's first museum. So the city that witnessed the birth of modern art history, with Vasari's monumental work, was also able to provide efficient protection and a stable setting for art masterpieces (at that time property of the crown) by "inventing" the modern museum. Museum culture—or the critical conservation of works and knowledge—thus blossomed first in Florence, the first city to offer modern civilization the tools and the methods of art-historical science.

There is also another historical reason for the phenomenon of the Florentine museums, and that is the enlightened policy of the ruling dynasties, the Medici and then the Lorraines. Some Italian dynasties are remembered for the tragic dissipation of extraordinary museum-quality treasures. For example, the Este family of Modena will never be forgiven for having sold the family masterpieces—now the pride of the Gemäldegalerie in Dresden—to Prince Elector August III of Saxony; and the Gonzagas of Mantua carry the shame of ceding perhaps the best collection of paintings in Europe—including works by Mantegna, Giambellino, Correggio, Rubens, Titian, and Caravaggio—to the English crown. By contrast, the world will be eternally grateful to the Medici of Florence, not only for the quality and intelligent selection of their holdings (one could say, with Dumas, that "they did more for the glory of the world than any king or prince or emperor") but, above all, for the enlightened Covenant of 1737. With this document Anna Maria Ludovica, the last survivor of the dynasty that ended with her life, tied the entire family treasure to the State and to its site in Florence, in perpetuity, the greatest and most valuable portion of which is preserved today in the state museums of Florence. Thanks to the wisdom and foresight of this cultivated princess, Florence is still home to Botticelli's *Venus* and Raphael's *Madonna of the Goldfinch*, to Michelangelo's *Doni Tondo* and Lorenzo the Magnificent's vases and the Arezzo *Chimera*, and to the Titians and Piero della Francescas and numerous other masterpieces on display in the city museums.

It is interesting to read the third paragraph of the Covenant (better known as the Family Pact), signed on October 31, 1737, by Francesco Stefano of Lorraine and the Electress Palatine Anna Maria Luisa, widow of Johann Wilhelm of Saxony, Grand Lord of the Empire and Prince Elector of the Rhine:

"Her Most Serene Highness cedes, gives and transfers to the undersigned H.R.H. for himself and for the successive Grand Dukes all of the furniture, possessions, and treasures of the Succession of the Most Serene Grand Duke, her brother, such as Galleries, Paintings, Statues, Libraries, Jewels and other precious things, also including the sacred relics, which H.R.H. undertakes to preserve under the express condition that such is for the ornamentation of the State, for public use, and to attract the curiosity of Foreigners, and will not be removed nor transported away from the Capital and the State of the Grand Duchy."

Only a few lines long, the dynastic agreement had decisive consequences for the history, the culture, and even the economy of Florence. Rarely has a political decision been more provident or more promising. While another Italian sovereign, Duke Francesco III of Modena, allowed the best of his family's painting collection to move abroad in 1745, the political powers in Florence solemnly undertook to ensure that the most important works, perhaps, in the history of all Europe would remain at the site of their creation and first collection; and furthermore that they would become a rich heritage for future generations.

The "city of museums" developed from the Family Pact of 1737 and from the culture demonstrated by that extraordinary document. The immense artistic heritage of the Medici and the Lorraines—frozen first by a political edict and then enriched by acquisitions—was gradually settled into the beautifully varied system that we know today, a series of exhibition spaces that have become world-famous.

The transfer of Classical and Renaissance sculpture out of the Uffizi to other sites gave birth to the Archeological Museum and the Bargello, which then attracted additional works. The valuable collection of scientific instruments and related objects from the Grand Ducal collections was likewise separated out and housed in the building that is now the Museum of the History of Science. Pietro Leopoldo's Enlightenment theories led to the grouping together of earlier paintings in the Accademia, paintings that served as models for students' works; later, this museum—the most popular one in Florence, after the Uffizi—welcomed Michelangelo's *David*, moved here from the Piazza della Signoria in 1873 together with the *Prigioni*. Many convents were suppressed in the patriotic and anti-clerical movements of the nineteenth century, and their refectories were turned into museums.

In the San Marco a monographic museum was created to showcase the work of Fra Angelico. Florence, the international capital of antiques and collecting, became a prime spot for conspicuous donations of art; and so a number of fascinating and unique public collections were created, each linked to the name of a famous collector or dealer or art historian. Among these are the Bardini, Horne, Stibbert, and Davanzati Museums, the collections named for Salvatore Romano, Contini Bonacossi, and Alberto della Regione, and the Berenson and Longhi Foundations.

The Medici were succeeded by the Lorraines and the Savoie in the Pitti Palace, but thanks to the providential agreement of 1737 none of the historic collection was lost, and, in fact, the harmonious accretion of decorative styles only increases the beauty of the whole. There is no other dynastic center in all Italy that has preserved its treasure intact through four centuries; the original furniture and the fixtures, the silver and the paintings, as well as the dishes, fabrics, carriages and horse trappings of the Pitti are all on display. It's no surprise that the Pitti houses six different museums: the Palatine Gallery, where you can see the Raphael paintings—still hung on silk-covered walls—that so delighted Stendhal and the Marquis de Sade; the Silver Museum, with the best examples of great European craftsmanship; as well as the Costume Museum, the Museum of Carriages, and the Gallery of Modern Art. Last but not least is the garden, the Boboli, with its fountains and its white statues in green labyrinths of laurel and ilex; it is the archetypal garden, just as the Uffizi is the archetype of all museums and just as Michelangelo's library in San Lorenzo is the archetype of all libraries.

Taken all together, the museums of Florence are one of the wonders of the world, for the spiritual values that they embody as much as for the works they contain. I believe, however, that the wonder of wonders is that the Florentine museums are anticipated, documented and, in a sense, replicated even beyond their physical sites. You leave the Uffizi or the Bargello only to find, outside, the same artistic personalities that you studied and admired indoors: outside in the niches of Orsanmichele or under the Loggia dell'Orcagna, in the church of Santa Maria del Fiore or in the courtyard of San Lorenzo, in the Santo Spirito chapels or in front of the Baptistery of San Giovanni. When we enter the Accademia or the Palazzo Pitti our eyes and our hearts are already accustomed to the colors, the images, and the feelings that the city offers. In Florence the museum breaks its bounds, occupying streets and squares, reproducing its forms and its charm in a sculpted architrave, in the image of a saint overlooking the intersection of two streets, in a carved marble column, in the Della Robbia panel standing guard over an ancient palace.

This is why Florence stands as an irreplaceable reference point of culture and art history for the entire world; this, and not just for the extraordinary variety and wealth of its public collections.

Antonio Paolucci

From Palace to Museum: The History of the Florentine Galleries

The instinct to collect works of art, whether antique or contemporary, seems to have been an essential factor in the life of the Medici family. It was an impulse that spanned a period of three hundred years, from the fifteenth to the eighteenth century, historical vicissitudes notwithstanding. This instinct for collecting brought to Florence incomparable artistic treasures that even today continue to attract both visitors and scholars. Naturally, not everything in the Florentine galleries can boast a Medici provenance. The artistic vocation began when the city became a significant urban center, in the thirteenth century, at the glorious moment of the Republic; when Florence later became important in a wider European context, it was not only as an economic power but also as a hub of humanistic culture. The great altarpieces and crosses by Cimabue, Duccio, and Giotto that today are displayed at the Uffizi and the Accademia once graced the city's principal churches, where they disseminated a pictorial word that was to become the foundation of the entire Renaissance. If the Medici were not themselves solely responsible for what is now known as the Renaissance, they were surely among its greatest patrons: the tradition of patronage that began with Cosimo the Elder provides us with our foremost examples of the enlightened "prince" who loved to surround himself with exceptional objets d'art reminiscent of classical antiquity.

The famous *studiolo* ("little studio") or "treasury" of Piero de' Medici, in the palace built by Michelozzo on the Via Larga (and later owned by his son Lorenzo, called the Magnificent), would become the symbol par excellence of the refined collector. It further symbolized the universal culture of his intellectual world, insofar as the varied works and objects that the collection comprised—which included antique gems, ceramics, illuminated manuscripts, contemporary small bronzes that imitated pieces from antiquity, and paintings that developed the new Renaissance language—were all tangible signs of the activity that would one day be defined as "collecting." Among the treasures kept in the palace on the Via Larga—presently known as the Palazzo Medici-Riccardi—were paintings by Paolo Uccello (today divided among the Uffizi, the Louvre, and the National Gallery in London), bronzes by Pollaiolo, Bertoldo, and Verrocchio (now in the Bargello), and manuscripts decorated with miniature paintings (now at the Laurentian Library), while the villas housed paintings by Botticelli (in Castello) and works by Northern painters such as Rogier van der Weyden (as in the *Deposition* from the villa at Careggi, now in the Uffizi). At the same time, the diffusion of Flemish Renaissance painting throughout Florence was exemplified by the great Portinari triptych by Hugo van der Goes, which was once in Sant'Egidio and is now in the Uffizi collection. Other aspects of the Florentine taste for the Northern Renaissance are documented by such works as the triptych by Nicolas

Froment (also now in the Uffizi), once owned by Cosimo the Elder.

The myth of the Florentine "collection," dissipated with the death of Lorenzo, was revived with the restoration of the Medici, which was affirmed by Duke Cosimo I and the collateral branch of the Giovanni di Bicci family. The affirmation of the Medici power manifested itself in Florence's mercantile activity and in the continual embellishment of the city with works of art that exalted the reigning dynasty. Cosimo himself was not an outstanding collector, yet it was through him that such famous works as the *Chimera of Arezzo* and the *Portrait of Pietro Aretino* by Titian came to Florence. More importantly, Cosimo was responsible for assigning Vasari—codifier of the glories of Italian art in his famous *Lives of the Artists* and systematic collector of drawings by fourteenth- and fifteenth-century artists in his *libri*, or books, today dispersed among numerous collections—the task of celebrating Florentine art from Cimabue to Michelangelo.

It was Vasari who designed for his patron the great building of the Uffizi, which, as its name (the Italian word for "offices") indicates, once served primarily as the seat of the ducal administration. However, on the prince's orders, the top floor housed a "gallery" containing all the different works of art of various provenances that had been accumulating in the Guardaroba. This location was sanctioned by Francis I with his building of the Tribune designed by Buontalenti: the space became the site for the heart of the collection and has ever since played a central role in the museographic conception of the Uffizi, serving as a sort of *Schatzkammer* representing the high point of the princely collections, as well as a mediating entity between the humanistic *studiolo* and the modern gallery. It was here that the collection's most precious objects were accumulated, and the paintings that are considered to represent Medici taste best were exhibited, beginning with the *Doni Tondo* by Michelangelo, which came into the collection through Ferdinand I, in 1594.

The Uffizi was nonetheless still—and would remain for a long time—the "Gallery of Statues," the museum where the Medici began systematically to gather together those antiquities that would win the collection its greatest fame for centuries to come. The paintings, instead, were selected for their quality of execution, and eventually exhibited in the Tribune.

The Medici family's collection was further augmented as a result of marriages contracted with the great reigning families of Europe. When, for example, Ferdinand I married Christine of Lorraine, the favorite niece of Catherine de' Medici, herself the wife of Henry II of France, the Medici treasure trove was enriched with objects and paintings of French provenance. Similar riches were accumulated when, in 1600, Maria, daughter of Francis I, married Henry IV of Navarre, who had just become king of France; it was through these relationships that the first paintings

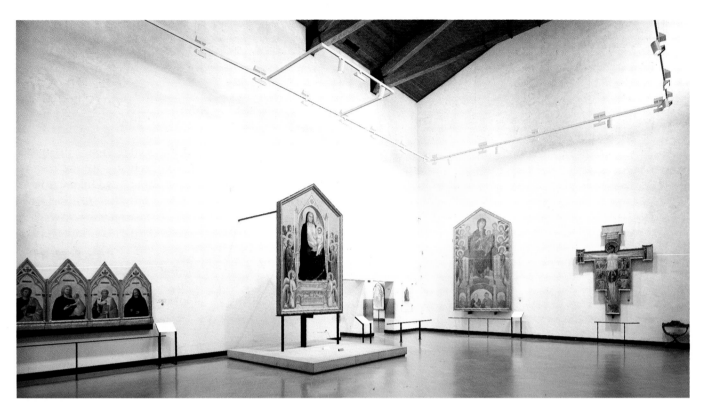

The Thirteenth-Century and Giotto Room in the Uffizi as it appears in the current installation. Housed in the former Medici Theatre (the imposing wooden ceiling remains from its previous incarnation), the room was last renovated in 1956 by Michelucci, Scarpa, and Gardella.

from the "other side of the mountain" reached Florence, among the best examples of which were French portraits by Clouet and Frans Pourbus the Younger.

It was Cosimo II de' Medici, however, who enabled the Medici collection to take on a European scope and opened it up to different artistic directions. Notwithstanding the brevity of his reign (1608–1621), the son and successor of Ferdinand I greatly increased the family's patronage as he enlarged its collection of art. His marriage to Maria Maddalena of Austria contributed to and enriched the Northern segment of the grand-ducal collection, by now housed in the Uffizi and the Pitti, when the bride brought with her works by artists from Albrecht Dürer to Jan Brueghel the Elder. For his part, Cosimo, perhaps under the influence of the theories of Galileo Galilei, became more and more attracted to paintings that expressed the naturalistic realism practiced by Caravaggio and his followers, exemplified by the master's *Medusa,* which had been sent to Florence as a gift for Cosimo's father. He was likewise fascinated by the variegated views of city life that were reproduced before his eyes by Jacques Callot, the great engraver from Lorraine who was in his employ, and by the painter Filippo Napoletano, who produced scenes similar to those by Callot and was famous as well for his adherence to the ideas of Galileo and those of the papal scientist and chief physician Johannes Faber. The grand duke had Napoletano paint "portraits" of his purebred horses and commissioned him to decorate his chamber with a series of pictures; the artist also provided his patron with works on *paesina* stone for the decoration of the "loggia of the palace," today the Gallery of Statues.

The grand duke's interest in pictorial realism not only drove him to seek out works by celebrated portraitists such as Hans Holbein the Younger (now in the Uffizi) but also inspired him to collect paintings by followers of Caravaggio including Artemisia Gentileschi (active in Florence between 1614 and 1621) and Battistello Caracciolo (recorded as being at the Medici court in 1617), who painted the grand duchess's portrait (now lost); by Bartolomeo Manfredi and Gerrit van Honthorst (known as Gherardo delle Notti); and by the German Adam Elsheimer, whose famous movable altarpiece, the *Exaltation of the Cross,* hung in the grand duke's bedroom for some time before being dismantled and dispersed (it has now been reassembled in the Frankfurt Museum).

It is not without significance that on the advice of Filippo Napoletano, Justus Sustermans (or Suttermans) of Antwerp became the Medici court painter in 1619 and remained so until his death in 1690. Sustermans was a pupil of Pourbus and thereafter was influenced by Rubens, Van Dyck, and Velázquez. The Villa del Poggio Imperiale, built by Cosimo II for his wife, Maria Maddalena, was richly decorated with examples of the "new painting" born in Rome, which paid particular attention to the representation of landscape, as seen in the work of Ludovico Cigoli in collaboration with "Adrian the Fleming" and in that of the Fleming Paul Brill, of Cornelis van Poelenburgh (both admirers of Elsheimer), and of Filippo Napoletano. Nor were the great painters of the past and present neglected: in Cosimo II's collection there was the so-called *La Velata,* a masterpiece of portraiture from the end of Raphael's career (now in the Pitti), while Maria Maddalena acquired Cigoli's *Calling of*

Peter, painted for the Duomo at Livorno (also in the Pitti).

The grand duke's taste for collecting was shared by his brother Carlo, a cardinal, whose inventory in the Buontalenti Casino di San Marco reflected Cosimo II's passion for paintings *da stanza,* or in private rooms. (It should be noted that this tendency had its origins in Florence, in the *studiolo* of Francis I in the Palazzo Vecchio.) Cardinal Carlo was interested, as well, in other large-scale works, such as those by Fra Bartolomeo (now in the Pitti and the Accademia), and he eventually became the most enthusiastic collector of them in the family. He also collected works by other Florentine painters of the sixteenth century, including the artists of the "Reformation," from Santi di Tito to Cristofano Allori, from Jacopo da Empoli to Cesare Dandini, Francesco Curradi, and the Sienese Manetti and Rustici. All of these artists produced huge canvases on biblical and mythological subjects, paintings that are today exhibited in the Pitti and in the Medici villas.

A direct knowledge of the Roman artistic ambience also led the cardinal to add "modern" paintings to his collection, and among these are to be found an important early work by the greatest landscape artist of the century, Claude Lorrain (in the Uffizi), and later works by Paul Brill and Filippo Napoletano (in the Pitti). The collection put together by Don Lorenzo de' Medici (another brother of the grand duke) in the Villa della Petraia was more of an example of Florentine painting from the first half of the seventeenth century, which thus came to be further represented in the family's collections.

Of Cosimo II's four sons, Leopoldo, who was made a cardinal in 1666, was the most enlightened and cultivated, with "universal" interests that ranged from physics to music and even painting; in the Pitti Palace he built up, as we shall see, a collection that was to make him famous. His brother, Grand Duke Ferdinand II, inherited the collection formed by their father but not the latter's interest in it; he did, however, exhibit enthusiasm for the Roman baroque as the artistic style that best represented the mores of court life.

Thus in 1638, Pietro da Cortona, one of the creators of the Roman baroque, began to decorate the winter grand-ducal apartments, beginning with the "stove room." The ceiling decorations that Cortona produced in five rooms, called "the planets" (two of them actually by his pupil Ciro Ferri), paid homage to Galileo's discoveries and opened up a new world of images and forms in contemporary Florentine culture, as manifested by the last surviving mannerist works in Lorenzo the Magnificent's Sala dei Fasti, on the ground floor of the palace (by Giovanni da San Giovanni, Furini, and Cecco Bravo). It was Ferdinand II, as well, who brought the extroverted talents of Salvator Rosa to court, even though Rosa's real patron was Cardinal Giancarlo, brother of the grand duke.

Significant additions were made to the collection with Ferdinand's marriage to his cousin Vittoria della Rovere, the last heir to the riches of her Urbino family. The young bride brought her family's artistic treasures with her to Florence, including Piero della Francesca's *Montefeltro*

Diptych (in the Uffizi), some of Titian's major paintings (the *Venus of Urbino* and the della Rovere portraits in the Uffizi; the *Man with Gray Eyes,* the *Tommaso Mosti* portrait, the *Mary Magdalen,* and *"La Bella"* in the Pitti), and works by Barocci, Bronzino, and others—taken together, an incredibly important legacy for the local culture. The reception of Roman developments was also fundamental for Ferdinand's brothers Giancarlo and Mattias. Between them they contributed to the already vast family patrimony with a rich collection of works that revealed their interest in artistic activity outside the contemporary Florentine cultural milieu. They acquired works by the Dutchmen Willem van Aelst and Otto Marseus van Schrieck—both painters of the still-lifes, animals, and insects that satisfied the Medici's new "taste for nature"—and by the Neapolitan Salvator Rosa, who arrived in Florence in 1639 and remained for ten years, introducing into Tuscany a "wind-swept" and preromantic aspect of painting that is especially visible in his landscapes.

If Cardinal Giancarlo's collection demonstrated a considerable interest in the work of his contemporaries, however, he also remained faithful to Medici tradition in his taste for the efforts of older painters, such as the *Madonna of the Goldfinch* by Raphael or Parmigianino's *Turkish Slave* (taken to Parma in this century). His acquisition of the roundels by Francesco Albani and the only securely attributable work by Nicolas Poussin (*The Adoration of the Shepherds,* now in the National Gallery in London) likewise documents his adherence to the classicizing tendencies of Roman painting in the 1640s. Mattias, who owned a *St. Francis* by Ribera (now in the Pitti), was a dedicated patron of the painter of battle scenes Jacques Courtois, called Il Borgognone (an appropriate choice, given Mattias's position as the grand duke's general), and also sponsored Livio Mehus, a painter from Cortona of Dutch origin who is today almost forgotten but who had as a second patron Mattias's great-nephew the grand prince Ferdinand.

As has already been mentioned, one of the most vital figures in seventeenth-century collecting was the fourth brother, Leopoldo. He appears to have inherited from his father a passion for art as well as a lively interest in the sciences (he was the founder and onetime director of the Accademia del Cimento), and the collection he accumulated in the apartments on the second floor of the Pitti Palace, comprising paintings, drawings, prints, and books, today forms the nucleus of the Florentine galleries' holdings.

Leopoldo's most important cultural achievement came about as a result of his passion for Venetian painting of the sixteenth century, which brought to the Pitti paintings by Giorgione, Titian, Paolo Veronese, Tintoretto, Palma Vecchio, Paris Bordone, Jacopo Bassano, Schiavone, and Moroni—today part of the most important works of this school in the Florentine galleries—along with works by Bolognese artists of the sixteenth and seventeenth centuries, from Dosso Dossi to Francesco Albani, from Annibale Carracci to Guido Reni (whose *Christian Charity* and *Cleopatra* are both part of the Pitti collection).

With his brothers Ferdinand and Giancarlo, Leopoldo

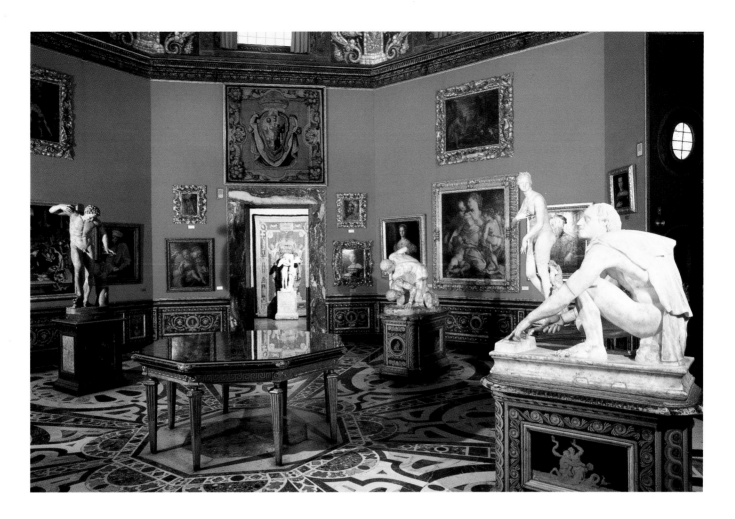

The Tribune in the Uffizi. Built by Bernardo Buontalenti at the behest of Francesco I de' Medici, it was designed to accommodate the Gallery's masterpieces; today it is a showplace of Florentine Mannerism, with masterpieces by Bronzino, Pontormo, and Vasari.

also developed an interest in the *petits-maîtres* of the Dutch school, including the above-mentioned Aelst and Marseus (Leopoldo probably collected the latter's works, of which he owned the greatest number, for their scientific content). His interests also extended to Dutch painters of nature such as Cornelis van Poelenburgh (already collected extensively by his parents). Above all, Leopoldo bought works by the so-called *bamboccianti*, a group of artists dedicated to the representation of the everyday life of Romans, led by the painter Pieter van Laer, nicknamed "Bamboccio" for his physical deformity. It is thanks to their patron that Florence possesses the best examples of the painter's work. Because of Leopoldo's interest in the realistic style of Roman artists, he was presented with the *Sleeping Cupid,* one of Caravaggio's last works (now in the Pitti).

In the Medici apartments on the third floor of the Pitti Palace, a roomful of artists' self-portraits formed the basis of an extremely important collection that today contains more than a thousand examples, including works by Rembrandt and Rubens acquired by Leopoldo himself. Leopoldo also began, quite ahead of his time, to collect *bozzetti,* or preparatory works and sketches, annexing them to his collection of drawings and prints, curated by the art historian Filippo Baldinucci. Leopoldo's *bozzetti* served as both example and stimulus for similar collections put together by his nephew Cosimo and his great-

nephew Ferdinand. Leopoldo further seems to have conveyed his passion for the artists of the Low Countries to Cosimo III, son of Ferdinand II and nephew of the cardinal, who added to his uncle's collection works by the celebrated naval painter Willem van de Velde the Elder and probably the self-portrait by Rembrandt. On his father's death, in 1670, Cosimo became grand duke, and inherited his collection, which was augmented by those of Leopoldo (upon his death in 1675), Cardinal Carlo, and Mattias. Giancarlo's collection, apart from a few works kept for their importance, was sold to pay off debts.

Cosimo III was a significant collector of Northern paintings, especially ones by contemporary artists, and acquisitions made during his journeys across northeastern Europe, before his succession to the grand-ducal throne, were fundamental to the expansion of the family's collection of Northern and Flemish paintings. He also acquired works by German artists such as Johann Carl Loth and Daniel Seiter when they happened to be in Florence.

The collection of Dutch and Flemish paintings in the Uffizi and Pitti galleries ranges over a variety of periods and derives from the Medici passion for collecting small-scale works by the "fine painters" of Leiden, the Hague, and Antwerp. A favorite artist was Frans van Mieris the Elder, whose work the grand duke continued to seek out even after he stopped traveling, and from whom he commissioned three self-portraits (two in miniature). Medici

tastes seem, however, to have precluded the representation in Florentine collections of those artists considered to be masters of the "Golden Age" in the Netherlands, from Rembrandt to Frans Hals, from Jan Steen to Van Goyen and Ruisdael (though two paintings by Ruisdael came to Florence at a later date). The collections nonetheless comprise a broad selection of the genres considered typical of seventeenth-century Dutch art, including city views, landscapes, intimate scenes, allegorical and biblical pictures, genre scenes (for which Cosimo had a decided preference), and still-lifes. Other examples were added later from the great collection of Johan Wilhelm von der Pfalz, the palatine elector of Dusseldorf, who sent Cosimo and his son Ferdinand several Dutch and Flemish works after his marriage to Anna Maria Luisa de' Medici. Rubens, Van Dyck, and Jordaens, for their part, do appear in the Florentine collections; from the middle of the seventeenth century their works were often given as gifts to the grand duke or to Cardinal Leopoldo, who acquired the *Four Philosophers* and the *Three Graces* by Rubens and the *Portrait of Cardinal Guido Bentivoglio,* Van Dyck's Italian masterpiece (all now in the Pitti). However, Cosimo III likewise did not pass up the opportunity to obtain two great canvases for an iconographic project begun but never completed by Rubens, a pictorial cycle depicting the life of Henry IV of France, commissioned by Maria de' Medici for the Luxembourg Palace in Paris (today in the Uffizi).

Cosimo also encouraged the patronage of small bronze sculptures and the development of decorative arts in the court workshops, under the expert supervision of highly skilled cabinetmakers, mostly foreigners, chosen for their specializations. Concerned about the direction that Florentine art was taking, he founded an academy in Rome under the direction of Ciro Ferri, a pupil of Pietro da Cortona, to instruct some of the most promising young Florentine artists; here were trained Anton Domenico Gabbiani, Giovan Battista Foggini, and others whose works may be found in the Medici collections.

Their interest in historical figures and European dynasties led the Medici to collect portraits of monarchs, princes, generals, and famous men and women of their own day, which were housed in a gallery that remains today an important but little-known component of the Florentine patrimony. Likenesses of the Stuarts and of noblewomen and generals of the court of Charles II of England (painted by Peter Lely) were thus brought to Florence, as were other pictures of admirals, generals, and leaders of troops that still hang in the galleries. Then, too, Cosimo continued to augment the collection of self-portraits begun by his uncle Leopoldo, adding works by the most famous contemporary European painters even as he kept an eye on the artists of the past and on the most promising young Florentines.

The favorite artists of the Low Countries are almost exhaustively represented in the collections. The grand duke kept his most highly prized paintings and sculpture in the Tribune, and delighted in the increasing fame of the collection displayed at the Uffizi; at the same time, other works were scattered throughout the various family palaces—beginning with the Pitti—and villas spread over the grand duchy's territories, which served as storehouses for the immense family collection. Cosimo sought to reorganize these holdings in the most rational fashion possible. For example, after the death of Leopoldo, the self-portraits, drawings, and prints were sent to the Uffizi, where they could be exhibited more publicly. The Venetian paintings, with those from Bologna, Flanders, and the Netherlands, were temporarily placed on various floors of the Pitti Palace, where they began to fill the piano nobile apartment that later became the residence of the princely heir Ferdinand.

In the salon of Leopoldo's apartments, on the third floor, another temporary collection was dedicated to the works of Sustermans, in homage to his memory. The villas, meanwhile, housed a series of paintings created as a testament to the fruit and vegetable production of Tuscany and to the diversity of animals raised in the provinces. All of these, taken together, were organized in an exemplary manner. Cosimo's involvement in the reordering of the family collection lasted much longer than he himself had anticipated. His son Ferdinand, who was to succeed him, died before Cosimo, who thus inherited the rich collection accumulated in the apartments of the Pitti Palace and in the villas at Pratolino and Poggio a Caiano.

Ferdinand de' Medici, the grand prince of Tuscany, was the son of Cosimo III and Marguerite-Louise of Orléans, the princess royal of France and niece of Louis XIV. Ferdinand seems to have exalted the rights of patronage and his inherited collection in a burst of tireless activity in which art played a prominent role. A talented musician, Ferdinand was also an enthusiastic patron of music and of such composers as Handel, Scarlatti, and Albinoni, and maintained an apartment filled with the most exquisite musical instruments; but above all he continued to augment the art collection, so that by the time of his death it numbered some thousand works. His taste, like his ancestors' and his father's, ran to Venetian and Genoese painting, to *bozzetti* by artists of the seventeenth and eighteenth centuries, and to works from foreign schools including the Dutch and Flemish. However, Ferdinand had a special veneration for the great masters of the past, by whom he sought to obtain large-scale works; he was particularly eager to obtain further examples of the altarpieces by famous painters that characterized the family collection. (This zeal was not shared by his father, who after his son's death returned several works that had come from churches.) Among his acquisitions were the two *Assumption*s and the *Gambassi Altarpiece* by Andrea del Sarto, today still in the Pitti. From del Sarto (the *Madonna of the Harpies*) to Fra Bartolomeo, from Parmigianino to Rosso Fiorentino and Cigoli, from Francesco Bassano to Rutilio Manetti to Riminaldi, artists of the sixteenth and seventeenth centuries are today represented by altarpieces in the holdings of the Pitti Palace, housed in the prince's apartments. His mania for collecting illustrious examples of painting also compelled Ferdinand to look to nearby schools such as the Bolognese (exemplified by Guercino and Lanfranco) and the Roman (Maratta), and even to make an effort to obtain works that his ancestors

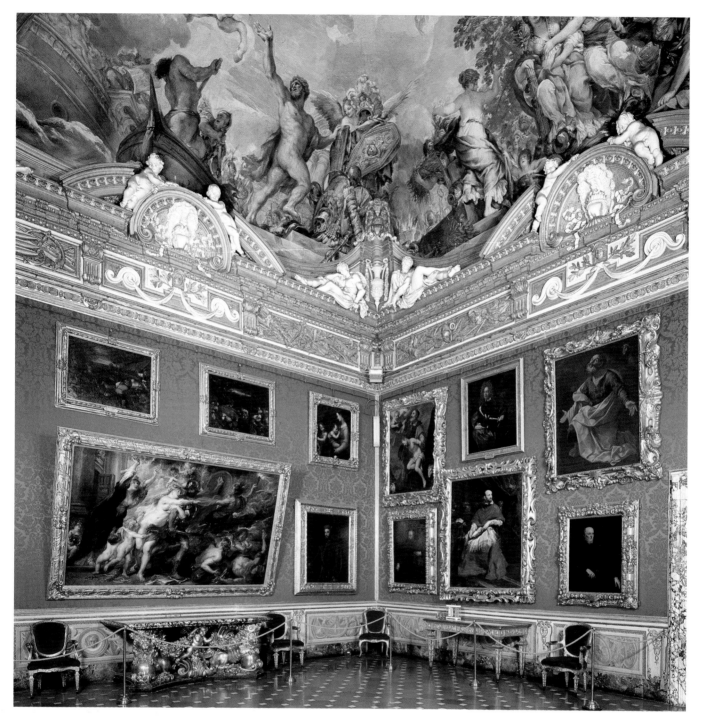

The Hall of Mars in the Palazzo Pitti. The rooms housing the Palatine Gallery testify to the pomp and magnificence created by the Medici and the Lorraines, who orchestrated the artworks and their exhibition space.

could not get (such as Parmigianino's *Madonna of the Long Neck*). This policy was also justified by the prince on the grounds that he was rescuing paintings that had been found in a state of disrepair.

Ferdinand's program of collecting was organized along very similar lines to that of his father. In the vast rooms of his apartment in the Pitti were hung altarpieces and other works by the most important sixteenth- and seventeenth-century Italian and European artists (among these were the *Resurrection of Christ* and the *Consequences of War* by Rubens and the *Rabbi* by Rembrandt). On the mezzanine floors was a collection of *bozzetti* and works by minor artists. In the villa at Poggio a Caiano he assembled a collection of small-scale works (transferred to the Uffizi in

1778), among which were the small Dutch and Flemish paintings given to the family by the aforementioned palatine elector (including the splendid portrait of *Helena Fourment*, Rubens's first wife, painted by the great master of Antwerp) and genre paintings such as the still-lifes painted for him by Cristoforo Munari and Margherita Caffi. At Pratolino were kept the great decorative canvases by Gabbiani with portraits of Ferdinand's musicians and by Onofri of the terrain in which he loved to hunt—an organic design into which was inserted his activity of "talent scout," which the prince developed to the maximum in his admiration for the "tactile" painting that was becoming popular all over eighteenth-century Europe. Ferdinand had developed, as had his uncle Leopoldo

before him, a passion for Venetian painting, of which he sought to obtain—though not always with so much success in his choices—examples of the highest quality. He began with Titian (though his *Portrait of Alvise Cornaro*, always considered to be Titian's masterpiece, has since been revealed to be merely a . . . Tintoretto!), Paolo Veronese, and Giorgione; the work of the last of these—the *Singing Lesson* (the *Three Ages of Man*), in the Pitti—came to the collection as an "unknown work by a fine Lombard hand" and has only in this century been recognized as being by Giorgione.

The fame of this prince rests not only in his collection itself but also in his ability to select paintings representing the new artistic trends throughout Italy, in particular the schools of Venice, Genoa, and Bologna. His generous patronage caused artists to court his favor, but in the end Ferdinand's choice was always entirely his own. In the first years of the eighteenth century, when Florentine painting was keeping up with the times, but without any especially dynamic practitioners, Ferdinand saw in the work of Giuseppe Maria Crespi, Sebastiano and Marco Ricci, and Alessandro Magnasco the beginnings of what would be the style of the new century. Without Ferdinand's intuitive capabilities, Florence would not today enjoy the achievements of these artists, which signified a determinant development in Italian and European painting of the eighteenth century. Likewise, Ferdinand's pursuit of the eighteenth-century Genoese school (through such artists as Giovanni Benedetto Castiglione, Valerio Castello, and Giovanni Battista Langetti) and the corresponding Venetian school (typified by Federico Cervelli and Johann Carl Loth) enabled him to open up new cultural areas. In the end, however, it is the attention he paid to Crespi, and to the two Ricci (Ferdinand was particularly enthusiastic about the "modern" landscapes of Marco), as well as to Peruzzini, Magnasco, and Crescenzio Onofri, that most clearly indicates just how greatly Florence benefited from his aesthetic intuition.

On his son's death, in 1713, Cosimo III inherited this magnificent collection. In its eventual reordering, enriched by other paintings from the collection of Cardinal Leopoldo, it was to form the first nucleus of what, a century later, would be the Palatine Gallery. Other works were sent over to the Uffizi and to the various villas in the first major reorganization of the Medici collection. That this immense artistic patrimony, of science and of culture, ultimately passed intact to the city of Florence was thanks to the enlightened accord of the last of the Medici, Anna Maria Luisa, widow of the palatine elector of Dusseldorf, and the successors to the grand duchy of Tuscany, the Hapsburg-Lorraines. In this way the city could continue to center the richness of its collections on the treasures accumulated by the Florentine family over three centuries of government. After more than twenty years of regency, the state of Tuscany in 1765 welcomed its first Austrian grand duke, Pietro Leopoldo, cadet son of the Empress Maria Teresa and Francesco di Lorena. An able reformer, he reordered the Florentine collection in a complex design within the reestablishment of the state. Helping him in this task was Luigi Lanzi, the first Italian art historian, and their combined effort aimed to rationalize the organization of the Medici collection along didactic lines.

In this new scheme, the Uffizi lost its role as the Gallery of Statues (emphasizing its archaeological holdings) but assumed the aspect of a gallery of paintings ordered in accordance with historical criteria, divided by schools or trends, anticipating all the nineteenth-century organizations of this type. While the Pitti collection and those of the villas became exalted reservoirs for all that was left over, the Uffizi came to be representative of the "Gallery of the Prince," the public place where one might see the grand-ducal treasures.

The Accademia has an important place in the history of Italian painting, having been conceived as a teaching institution for students of the fine arts. The endeavor began with the acquisition of some of the oldest types of paintings, those characterized as "primitive," which were obtained from monasteries and convents after the Napoleonic suppression. These constituted the first examples of the "pictorial history" that Lanzi had written in his corollary to the museographic reordering.

The Leopoldian approach to the Florentine collections was for a long time the standard by which other European collections were judged, so that, for instance, Zoffany, writing in 1778, could describe the Tribune to Queen Caroline of England as the highest paradigm of a princely collection. Consumed as he was with his reorganization, Pietro Leopoldo did not have time to make acquisitions of his own to augment the Medici picture collection; it was left to his successors Ferdinand III and Leopoldo II to sift through the pictures of increasing significance that were now being offered to Florence. The direct relationship between the courts of Tuscany and Vienna meant that advantageous exchanges could be arranged with the Viennese Belvedere collection for examples of the Italian baroque. Seventeenth-century Roman, Florentine, and Bolognese paintings—including works by Pietro da Cortona, Salvator Rosa, Giuseppe Maria Crespi, and Francesco Furini—were thus sent to Vienna, while Florence in turn received exceptional material from the German school (by Dürer and Cranach), the Venetian school (by Bellini, Titian, and Veronese), and the seventeenth-century Flemish school (by De Crayer, Seghers, and Rubens and his circle).

Further important acquisitions were made by the last two grand dukes from Lorraine for the private grand-ducal gallery, which opened its doors to the public in 1834. From the end of the eighteenth century to after the Restoration (1815), the collection added works by Raphael (*Madonna of the Grand Duke* and the portraits of Agnolo and Maddalena Doni), landscapes by Salvator Rosa, Gaspard Dughet, and Jacob van Ruisdael (one for the Pitti and one for the Uffizi), two masterpieces by the Dutch Rachel Ruysch (Pitti), and marine paintings by Ludolf Backhuysen, Hendrick Dubbels, and other minor Flemish and Dutch artists. One particularly significant addition to the Dutch segment of the collection was the great landscape painting by Hercules Seghers, which came to the Uffizi by way of a bequest in 1834.

The Hall of Venus is perhaps the most lavish of the rooms decorated by Pietro da Cortona, who was responsible for the four great stucco medallions as well as for the ceiling.

It is interesting to note that Ferdinand III had evidently recognized the weakness of the French section of the collection, which consisted almost entirely of dynastic portraits from the Medici inheritance. He thus sought to integrate with these portraits works by Nicolas Poussin, Charles Le Brun, Philippe de Champaigne, Louis Le Nain, Laurent de la Hyre, Simon Vouet, François Mignard, François Boucher, Antoine Watteau, and other painters of high caliber. Unfortunately, he met with less than satisfactory results, as many of the attributions turned out to be wrong, and the works themselves were of only secondary importance. Ferdinand next pursued, along with the Lorraines, a policy of obtaining important panels from convents and churches to complete the collections in the gallery of the Accademia, with particular emphasis on works by sixteenth-century Florentine painters. Today these latter examples are still admired in the Uffizi, the Pitti, and the Accademia.

With the unification of Italy, the enlarging of the collection became less systematic and more reliant on generous donations (as with Caravaggio's *Sacrifice of Isaac*, in the Uffizi, and the precious group of Franco-Flemish paintings and Sienese works given to the Bargello from the Carrand donation); on the rediscovery of works in the depository and in the villas (such as Caravaggio's *Bacchus* and works by Crespi in the Uffizi); and on the exercising of the right of preemption (works by Chardin and Van Wittel). Certain Dutch and Spanish paintings (most recently a painting by El Greco and two by Goya, in the Uffizi) were acquired by this means, while two quite sig-

nificant works, the *Turkish Slave* by Parmigianino and the *Mute* by Raphael were commandeered from the galleries in Parma and in Urbino, respectively.

Florence saw an increase in its artistic patrimony when a series of portraits of the French royal family of Louis XV were sent from Parma to the Pitti Palace (where they are now to be found in their original location in the Sala Verde). Unhappy though this episode may have been for Parma, it was nonetheless an event of historical importance, as the Savoy wished to install the paintings in the Florentine royal palace after the unification of Italy.

After World War I the Florentine galleries were once again reorganized, with the Uffizi being given the lion's share, as it was turned into a national gallery (Rome, at the time, did not have one). Works that had been held at the Pitti (in the gallery and the royal apartments), in the Accademia, and even in Siena (at the Altdorfer) began to flow into the Uffizi, with the consequent loss of the Lorrainean design, which had attempted to give each gallery a precise historical role. At the same time, the Gallery of Modern Art was created at the Pitti as a compromise location between the commune's and the state's plans for Macchiaioli's works and those works that had been casually acquired by the Savoy. At the Pitti proper were exhibited the Florentine paintings of the seventeenth century that the Medici had originally kept at their villas, now on public view in the wing that Vittorio Emanuale III ceded to state domain.

This new order came in response to the same historico-critical reasoning that lay behind the 1922 exhibition "Italian Painting in the Seventeenth and Eighteenth Centuries" in the royal apartments of the Pitti Palace. If this event determined the direction of study and the appreciation of art from those centuries, it nonetheless contributed to the dissolution of the traditional historical presentation of the Florentine galleries. This philosophical position was also prompted by a new museology that continued in the recent rearrangement of the Uffizi galleries on art-historical lines rather than according to a scheme based on the history of the collections themselves. This tendency, a result of the birth of the great national galleries in our own century, is irreversible, but it seems also to be the logical outcome of the ideas of Pietro Leopoldo and Luigi Lanzi. Most important and decisive for the complete scope of the collection since World War II have been the acquisition of paintings by Lotto and Foppa and the recovery of works stolen during the war (by Masaccio, Masolino, Veronese, Tintoretto, and Giovanbattista Tiepolo). In 1969 the Contini Bonacossi donation, provisionally housed in the small Meridiana Palace, brought to the collections a nucleus of paintings of the finest quality by such artists as Cimabue, Sassetta, Andrea del Castagno, Bramantino, Zenale, Savoldo, Cima da Conegliano, Tintoretto, Veronese, Jacopo Bassano, Velázquez, Zurburán, and Goya; among other things, this has allowed gaps to be filled in the Florentine galleries, which thus command great prominence among the great museum institutions.

Marco Chiarini

The technical essays and the painting commentaries were written by:

Angela Acordon: 578–583
Roberta Bartoli: 99–101; 128–133; 146; 147; 152–154
Sandro Bellesi: 528–530; 533; 541; 559; 567–571
Daniele Benati: 456–458; 460–476; 478–484; 486
Annamaria Bernacchioni: 68; 69; 71–78; 80–84; 86; 91–93
Elena Capretti: 222–244; 246–248; 250–253; 255–260; 262; 264–268; 271–277
Cecilia Filippini: 70; 79; 87–90; 117; 137–145; 148–151
Francesco Frangi: 378–396; 572–577
Elena Fumagalli: 477; 505; 507; 514; 535; 561–565; 609–618; 623–626
Irene Graziani: 308–311; 313–324
Mauro Lucco: 164–187; 325–333; 335–344; 346–359; 361–377
Marilena Mosco: 538; 545; 558; 560; 566; 620–622
Gianni Papi: 435–450; 452–455
Nicoletta Pons: 94–98; 102–109; 112–116; 122; 125; 126
Marta Privitera: 201–221; 245; 261; 278–307; 431–434
Riccardo Spinelli: 487–504; 506; 508–513; 515–527; 531; 532; 534; 536; 537; 539; 540; 542–544; 546–557
Angelo Tartuferi: 1–67
Lisa Venturini: 85; 110; 111; 118–121; 123; 124; 127; 134–136; 155–163
Jeanne van Waadenoijen: 188–197; 199; 200; 397–407; 409–423; 425–430
Tiziana Zennaro: 584–601; 603–608

Tuscan Painting in the Thirteenth Century

The thirteenth century remains one of the most enigmatic periods in Italian painting, and one of the least studied by scholars. The problems facing art historians today are compounded by the extremely small number of works that have survived, and by the fact that those few paintings that do exist have often been repainted or subjected to antiquated methods of "restoration."

Current interpretation of this period has finally dispensed with the belief that these works of art were primarily the result of a strong Byzantine influence, as past scholars had a priori claimed. Evidence now suggests that in the thirteenth century, in this singularly well developed area of the Italian peninsula, there must have been a rich and multifaceted artistic culture that anticipated the extraordinary flowering of the following century.

In Tuscany, the principal critical literature of this tradition assigns an essential role to the pictorial tradition of Lucca, represented primarily by the work of Berlinghiero and his three sons, Bonaventura, Marco, and Barone. More recently, however, scholars have come to place greater emphasis on the role played for most of the thirteenth century by the city of Pisa, a principal center of creativity and innovation. This artistic impetus was nonetheless also influenced by the Byzantine tradition, especially with regard to its Middle Eastern foundations. The Pisan cultural matrix was widely disseminated and contributed, through successive waves of influence, to the establishment of local artistic languages within each region.

The Crucifixion Number 432 in the Uffizi is the highest example of the Pisan artistic culture of the last quarter of the twelfth century. Pisan ideas derived primarily through Giunta Capitini, called Pisano, who formed the basis for the stylistic developments of two protagonists of Florentine painting in the first half of the thirteenth century: the Master of the Crucifixion Number 434 in the Uffizi and the Master of St. Francis Bardi. Such developments nonetheless took place within a context that was itself influenced by the Luccan painting tradition. This Luccan influence is evident in the magnificent *Stigmata of St. Francis* in the Uffizi, a work that is surely by the same hand as the great altarpiece of the Bardi chapel in the church of Santa Croce in Florence. The artistic language of the Crucifixion Number 434 is, by comparison, characterized by a minor formal elegance and incisiveness. This is true as well of the author of *St. Catherine of Alexandria and Eight Stories from Her Life* in the museum at Pisa, datable presumably to the decade between 1235 and 1245.

Typical characteristics of thirteenth-century Pisan culture can also be seen in the altarpiece with *The Benediction of Christ with the Virgin and SS. Peter, John the Evangelist, and Paul*, signed and dated 1271 by the Florentine Meliore, who is mentioned in 1260 as being among those who had to fight at Montaperti against the Sienese. This work is typologically notable for being one of the earliest known examples using a rectangular frame with a pointed, or cuspid, central part.

The flourishing Sienese culture of the thirteenth century is represented in Florentine museums by two paintings by its greatest exponents: Guido da Siena and Duccio di Buoninsegna. The first of these, though the more typical example of the local tradition, was influenced by the neo-Hellenistic culture of the Giuntesque masters through the interpretation of the so-called Master of the Madonna of SS. Cosmas and Damian, as well as that of the Florentine Coppo di Marcovaldo. The second, Duccio, is considered to be one of the founding fathers of the Italian Gothic. The recent restoration (1988–1990) of Duccio's splendid *Maestà* allows us to fully appreciate the painting's extraordinary beauty and quality, while in art historical terms it clearly shows itself to be the most extensive and liberal interpretation of the Cimabuesque language up to that time. On the subject of Cimabue, it has been reaffirmed that his own powerful *Maestà* in the Uffizi, painted for the Vallombrosani monks in Santa Trinita in Florence, is datable to about 1280. This work has recently been restored and will undoubtedly contribute to further elucidation of the primary role played by its creator in the development of Italian painting in the thirteenth century.

The introduction of Cimabuesque culture into the milieu of Florentine painting in the last quarter of the century was of no less relevance. A precise and determinate reflection of Cimabue's influence can be seen in the work of the delightful unidentified painter who is usually referred to as the Master of the Magdalen, after a painting by him in the Florentine Accademia. The métier of the Master of the Magdalen also produced the work of the Master of San Gaggio, whose name is taken from a painting (today also in the Accademia) originally owned by the Florentine convent of San Gaggio. In all likelihood he was the Florentine painter Grifo di Tancredi. In the middle period of his career, this artist was much influenced by Cimabue, while the final phase of his artistic activity may be characterized as one of the earliest and most attentive interpretations of the work of the young Giotto.

Angelo Tartuferi

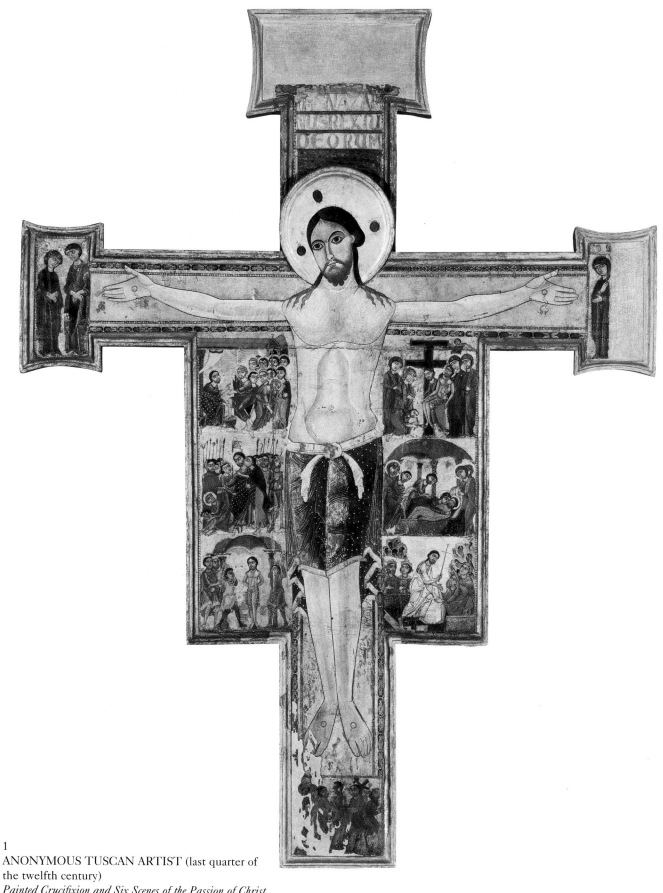

1
ANONYMOUS TUSCAN ARTIST (last quarter of
the twelfth century)
Painted Crucifixion and Six Scenes of the Passion of Christ
Tempera on panel, 109¹⁄₁₆ × 90¹⁵⁄₁₆ in.
(277 × 231 cm)
Inscription: IHS NAZARE / NUS REX IU / DEORUM
Uffizi, Gallery; inv. 1890: no. 432

This painting, of unknown provenance, is recorded as having been
in the Uffizi since 1886. The author of the painting was probably a
local artist whose style was formed in the Pisan pictorial climate of
the last quarter of the twelfth century.

20

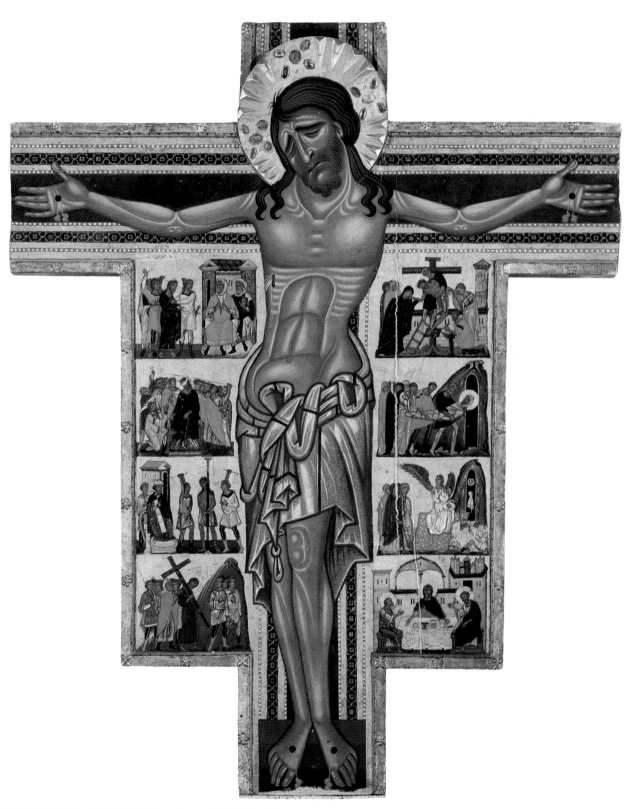

2

MASTER OF THE CRUCIFIXION No. 434 IN THE UFFIZI
Painted Crucifixion and Eight Stories of the Passion of Christ
Tempera on panel, 98⁷⁄₁₆ × 78¾ in. (250 × 200 cm)
Uffizi, Gallery; inv. 1890: no. 434

Catalogued in the Uffizi collection for the first time in 1888, this work is of unknown provenance. It is speculated that its author was a Florentine painter who was active around 1230–1250 and influenced by the Luccan artist Berlinghiero.

21

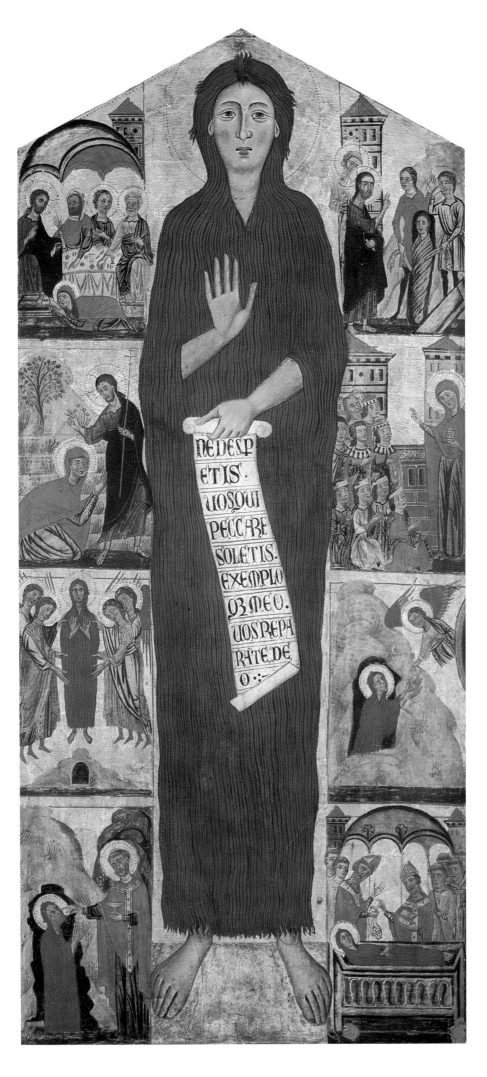

The inscription in the scroll reads:

NEDESP
ETIS.
UOSQUI
PECCARE
SOLETIS.
EXEMPLO
Q3 MEO.
UOS REPA
RATE DE
O .:.

22

3

MASTER OF THE MAGDALEN
*St. Mary Magdalen and Eight Stories from
Her Life*
Tempera on panel, 64⁹⁄₁₆ × 29¹⁵⁄₁₆ in. (164
× 76 cm)
Inscription: NE DESPERETIS VOS QUI
PECCARE SOLETIS EXEMPLOQUE MEO
VOS REPARATE DEO
Accademia, Gallery; inv. 1890: no. 8466
This painting, which was transferred to
the Accademia from the convent of the
Santissima Annunziata in 1810, forms the
basis for the critical conventional naming
of one of the most important figures in
thirteenth-century Florentine painting,
active between 1265 and 1290. The *Mag-
dalen* can be located within the artist's
most mature phase, around the middle of
the 1280s.

4

MASTER OF ST. FRANCIS BARDI
The Stigmata of St. Francis
Tempera on panel, 31⅞ × 20¹⁄₁₆ in. (81 × 51 cm)
Inscription: S FRANCISC[US]
Uffizi, Gallery; inv. 1890: no. 8574

Given to the Accademia by the merchant Ugo Baldi in 1863 and transferred to the Uffizi in 1948, this panel, painted at the end of the thirteenth century, is undoubtedly by the same hand as the altarpiece comprising twenty stories in the Bardi chapel in Santa Croce in Florence.

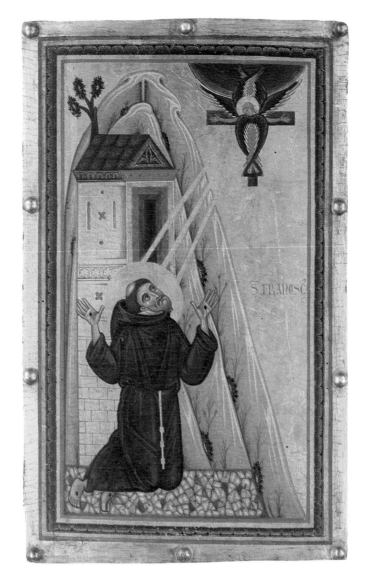

5

MELIORE
The Benediction of Christ with the Virgin and SS. Peter, John the Evangelist, and Paul
Tempera on panel, 33⁷⁄₁₆ × 82¹¹⁄₁₆ in. (85 × 210 cm)
Signed and dated: AD MCC MELIOR ME FECIT LXXI
Uffizi, Gallery; inv. 1890: no. 9153

This altarpiece was removed from Florence and taken to Parma in 1792 by the Marchese Tacoli Canacci; it was returned to Florence's Accademia from the gallery at Parma in 1928 and given to the Uffizi twenty years later. The six cherubs at the spandrels of the arches were added in the fifteenth century. This is a key work in the reconstruction of the career of Meliore, one of the major artistic personalities of the third quarter of the thirteenth century in Florence.

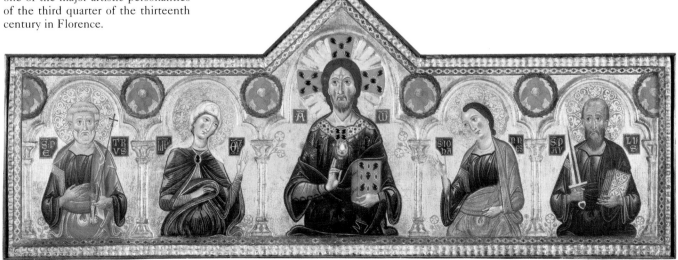

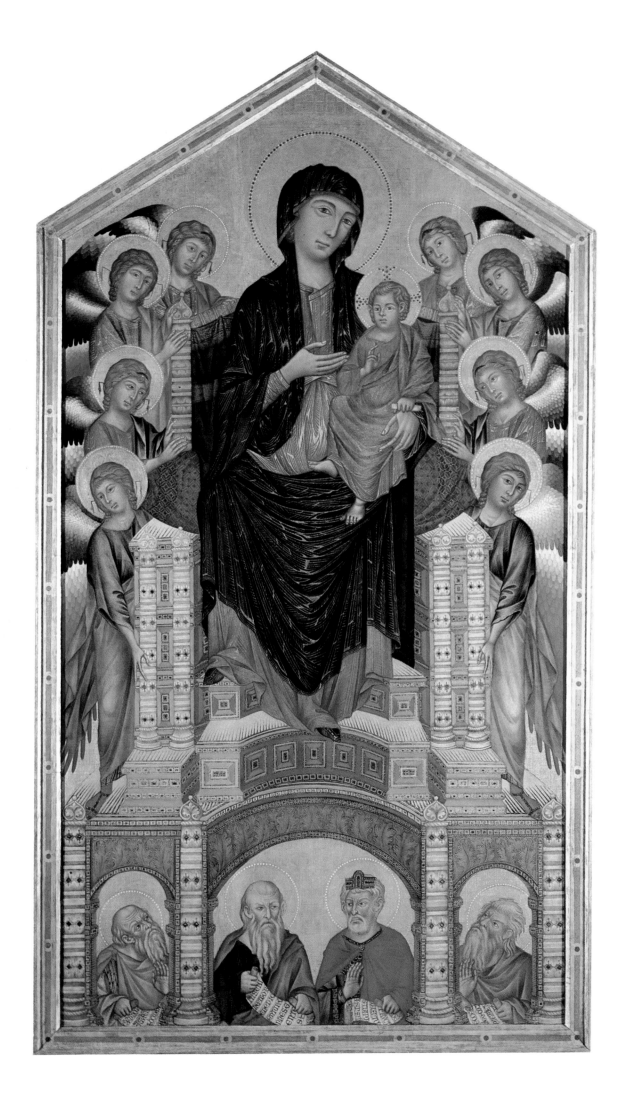

24

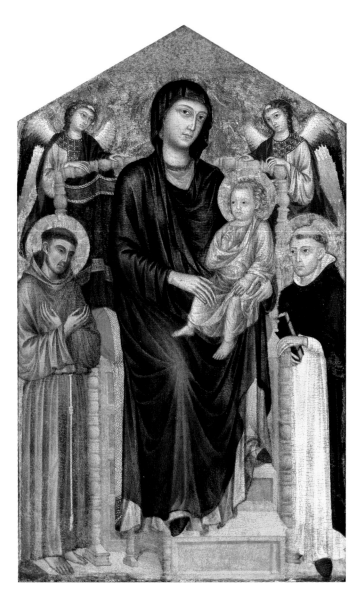

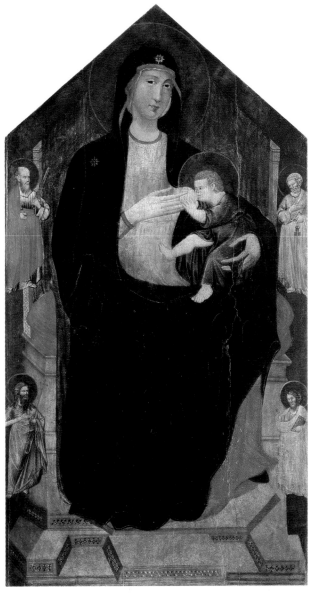

7
CIMABUE
Madonna and Child Enthroned with Two Angels and SS. Francis and Dominic
Tempera on panel, 52⅜ × 32⁵⁄₁₆ in. (133 × 82 cm)
Pitti, Meridiana (provisional location); inv. Contini Bonacossi: no. 32

This panel was formerly in the Hutton collection in London and then passed into the Contini Bonacossi collection. Generally recognized as being by Cimabue, it may be an example of his later style, perhaps influenced in some measure by the work of the young Giotto.

8
MASTER OF SAN GAGGIO
Madonna and Child Enthroned with SS. Paul, Peter, John the Baptist, and John the Evangelist
Tempera on panel, 78¾ × 44⅛ in. (200 × 112 cm)
Accademia, Gallery; inv. 1890: no. 6115

This panel came to the Accademia in 1867 from the monastery of San Gaggio in Florence and probably dates from the last years of the thirteenth century. It has given a name to one of the most interesting figures of late-thirteenth-century Florence, who may perhaps be identified as the painter Grifo di Tancredi.

Opposite: 6
CIMABUE
Madonna and Child Enthroned with Eight Angels and Four Prophets (Maestà)
Tempera on panel, 151⁹⁄₁₆ × 87¹³⁄₁₆ in. (385 × 223 cm)
Inscription: CREAVIT DOMINUS NOVUM SUPER TERRAM FOEMINA CIRCUMDAVIT VIRO; IN SEMINE TUO BENEDICENTUR OMNES GENTES; DE FRUCTU VENTRIS TUI PONAM SUPER SEDEM TUAM; ECCE VIRGO CONCIPIET ET PARIET
Uffizi, Gallery; inv. 1890: no. 8343

Commissioned by the Vallombrosani monks for the church of Santa Trinita in Florence, this major work by Cimabue has always been recognized as having stylistic affinities with the frescoes in the major church of St. Francis in Assisi; it is datable to around 1280.

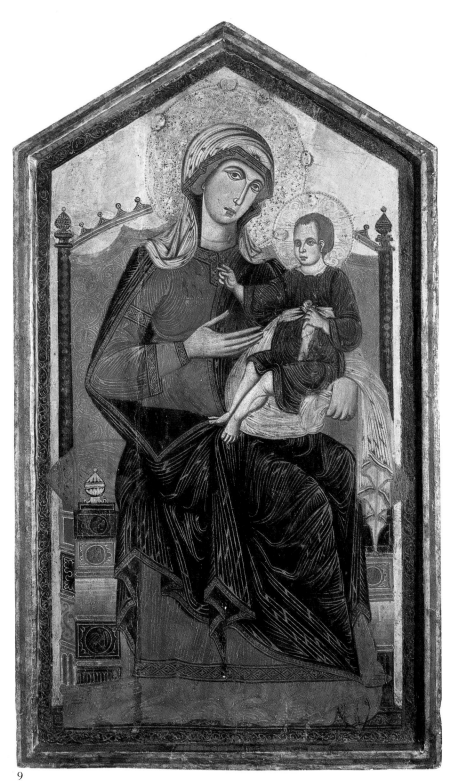

9
GUIDO DA SIENA
Madonna and Child Enthroned
Tempera on panel, 49³⁄₁₆ × 28¾ in. (125 × 73 cm)
Accademia, Gallery; inv. 1890: no. 435
This work was acquired in 1889 from the Murray collection and transferred from the Uffizi to the Accademia in 1919. Of high quality, it is attributed to Guido, a major figure in Sienese painting in the second half of the thirteenth century, before the arrival of Duccio.

Opposite: 10
DUCCIO DI BUONINSEGNA
Madonna and Child Enthroned with Six Angels (Maestà)
Tempera on panel, 177³⁄₁₆ × 114³⁄₁₆ in. (450 × 290 cm)
Uffizi, Gallery; deposited in the church of Santa Maria Novella
Commissioned from Duccio on April 15, 1285, by the Company of the Laudesi of Santa Maria Novella in Florence, this painting, known as the *Rucellai Madonna*, is one of the masterpieces of Italian Gothic art.

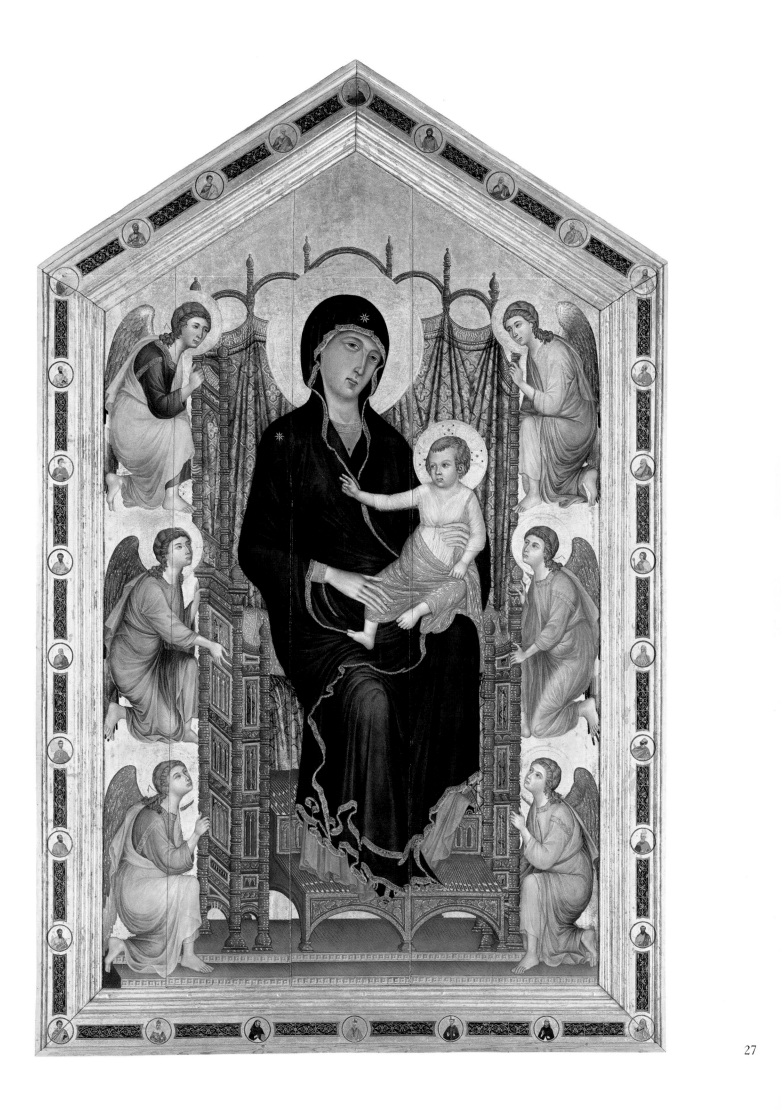

27

Italian Painting in the Fourteenth Century

Florence in the First Half of the Fourteenth Century

The extraordinary articulateness and continual capacity for innovation that characterize Florentine painting in the first part of the fourteenth century can also be interpreted in the light of certain fundamental premises, laid down during the last quarter of the thirteenth century under the decisive, catalyzing influence of the nascent Giottesque culture. Significantly, Giotto's artistic generation included a number of painters whose talents developed along typical thirteenth-century lines, though they continued to be active into the fourteenth century. It will be sufficient to cite a few of the most important of them here, namely, the Master of San Gaggio, the Master of St. Cecilia, Lippo di Benivieni, and Pacino di Bonaguida. Some exquisite fragments of a *Maestà* attributed to Giotto, the most important artist of this group, have been rediscovered in recent years and are now reassembled in the oratory of San Omobono at Borgo San Lorenzo. This work must be understood within the context of the frescoes of the *Story of Isaac,* in the higher registers of the major church of S. Francis in Assisi. This is further confirmation (if there can be any need for such) of the promise of Giotto's essential reform of traditional Western figurative representation.

The most recent studies have suggested that the period of greatest cultural growth in Tuscany occurred in the first quarter of the fourteenth century. The research conducted by generations of scholars is exemplified by the seminal works of Osvald Sirén, Bernard Berenson, and Roberto Longhi, and by Richard Offner's *Corpus of Florentine Painting,* extraordinary for its scientific and systematic rigor. Additional mention must be made of more recent studies by Luciano Bellosi and Miklós Boskovits, who have also helped to establish the Florentine fourteenth century as one of the best-known periods in the history of Italian painting. All of these scholars represent the artistic culture of Florence in the first part of the fourteenth century as being at once articulate and vital, an appraisal that is verifiable throughout the career of each individual artist. This assessment is an integral part of the critical characterization proposed, in turn, by every great scholarly argument of its day. Richard Offner, for example, identifies a "miniaturist tendency," while Roberto Longhi posits a "Giottesque revolt," a term coined to describe the milieu within which some artists were less than respectful toward the new Giottesque language.

The author of the Uffizi's *St. Cecilia Enthroned and Eight Stories from Her Life* may, for a number of reasons, be said to be exploring an alternative to the Giottesque styles, while his *Maestà* in the Florentine church of Santa Margherita in Montici is an example of a strict Giottesque approach, almost to the point of being a blind imitation. For a more inventive interpretation of Giotto, one may turn instead to the works of Taddeo Gaddi, who in capturing the artistic authority of the master's idiom can be viewed as the official heir to Giotto. The works by Gaddi that correspond most elegantly to this role include the small panels of the *Story of the Lives of Christ and St. Francis* in the Accademia, which at one time were installed in the reliquary chamber of the church of Santa Croce in Florence.

In the oldest surviving polyptych from the altar of the chapel in the right transept of San Andrea (recently auctioned at a sale in London), in contrast, one finds yet another exemplar of the so-called Giottesque revolt. Above all, this work exhibits Sienese characteristics that were well known at that time in Florence through the important and intense activity of Ugolino di Neri.

Returning to Giotto, the patriarch of fourteenth-century Italian painting, we may note that the style of the somber polyptych from the Badia (now in the Uffizi collection) dates to around 1300. Belonging to the same phase of Giotto's career seems to be the very beautiful *Crucifixion* in the Tempio Malatestiano in Rimini. The famous *Maestà* painted for the church of Ognissanti in Florence is likely to have been executed later than the artist's creation of the frescoes in the Scrovegni chapel in Padua, in 1303–1305.

Among the best of the interpreters and popularizers (in the best sense of the term) of Giottesque culture in the Florentine ambience was Bernardo Daddi. Daddi positioned himself most faithfully in the Giottesque tradition and set the highest standards for both the narrative and the chromatic aspects of figurative painting. Daddi further exercised a notable influence on his contemporaries among Florentine painters, as well as on many whose artistic temperament was substantially different from his own, including Jacopo del Casentino and the Master of the Dominican Images. The talents of Puccio di Simone were likewise developed in Daddi's workshop in Florence. Within the formative Giottesque landscape tradition, Daddi was able to incorporate the new stylistic tendencies of the Orcagnesque school, resulting in a most effective, interesting, and pleasing figurative synthesis that combined plasticity with chromatic vivacity.

Angelo Tartuferi

Opposite: 11
GIOTTO
Madonna and Child Enthroned among Angels and Saints
Tempera on panel, 127^{15}/₁₆ × 80^{5}/₁₆ in. (325 × 204 cm)
Uffizi, Gallery; inv. 1890: no. 8344
The stylistic similarities between this work, which was painted by Giotto for the Umiliati brothers of the Ognissanti church in Florence, and the frescoes in the Scrovegni chapel in Padua suggest a date within the first decade of the fourteenth century.

28

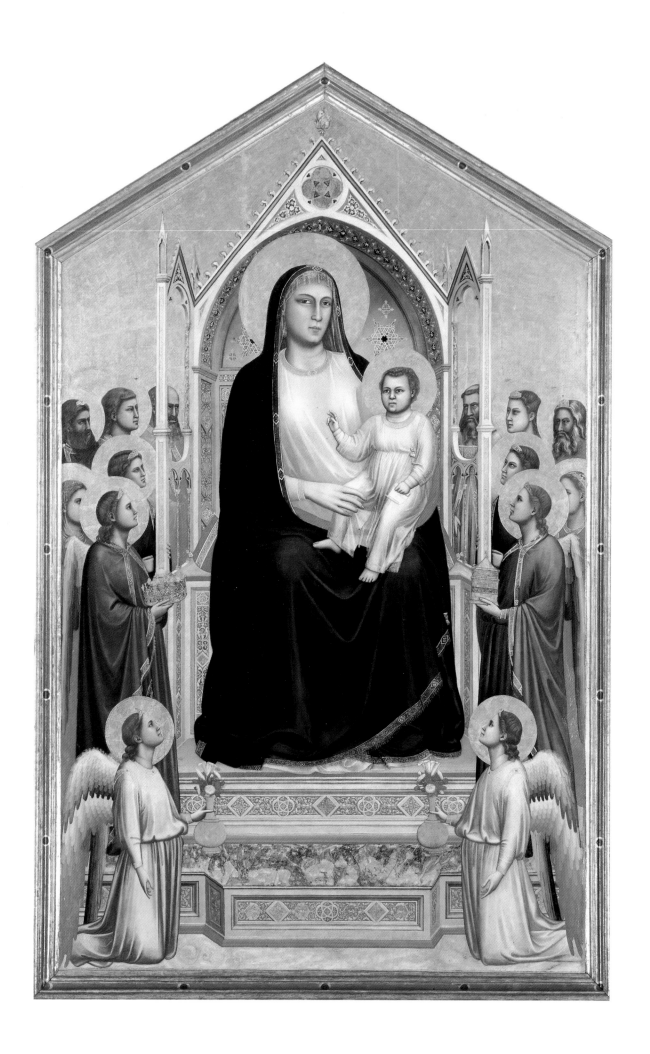

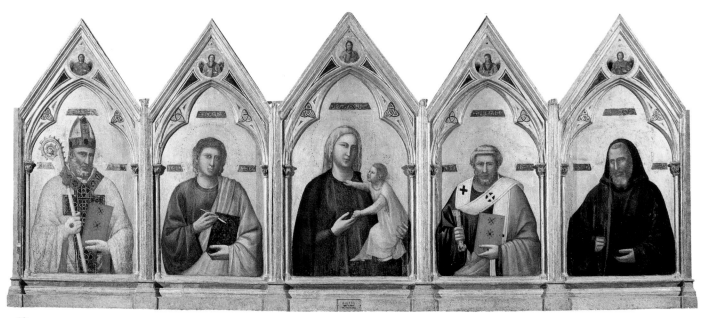

12
GIOTTO
Madonna and Child with SS. Nicholas, John the Evangelist, Peter, and Benedict
(Badia Polyptych)
Tempera on panel, 35¹³⁄₁₆ × 133⁷⁄₈ in. (91 × 340 cm)
Uffizi, Gallery; s.n. inv.

This work was painted for the church of the Badia in Florence and is signed by the master.
The painting's archaic timbre dates to around 1300; stylistically it is very close to the
Crucifixion in the Tempio Malatestiano in Rimini.

13
MASTER OF ST. CECILIA
St. Cecilia Enthroned and Eight Stories from Her Life
Tempera on panel, 33⁷⁄₁₆ × 71¼ in. (85 × 181 cm)
Uffizi, Gallery; inv. 1890: no. 449

This work was painted immediately after 1304 for the Florentine
church of Santa Cecilia.

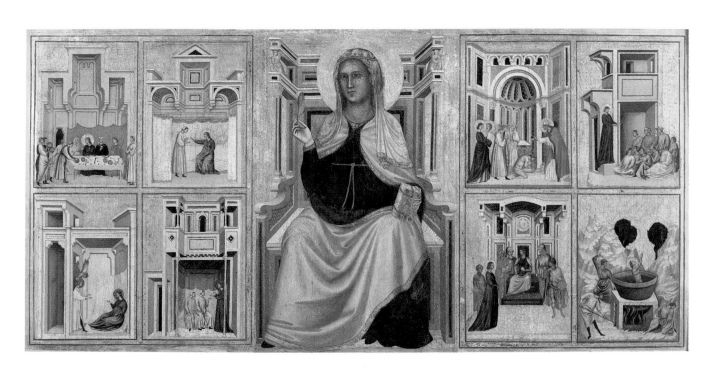

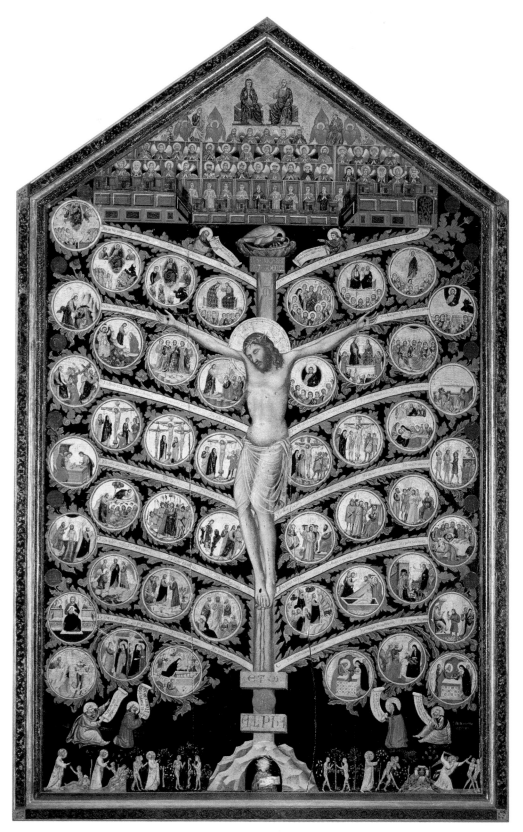

Overleaf: 15 and 16
MASTER OF THE CODICE
OF SAN GIORGIO
Noli Me Tangere
Tempera on panel, 16⁹⁄₁₆ × 11⁷⁄₁₆
in. (42 × 29 cm)
Bargello, Museum; inv. Carrand:
no. 2017
Coronation of the Virgin
Tempera on panel, 16⁹⁄₁₆ × 11⁷⁄₁₆
in. (42 × 29 cm)
Bargello, Museum; inv. Carrand:
no. 2018
These panels were once in the col-
lection of the antiquarian Luigi
Carrand and were donated to the
Commune di Firenze in 1888 for
the Bargello Museum. The two
small pictures date to around 1330,
when they were probably pro-
duced as part of a single series
along with two other paintings that
are now in the Cloisters Collection
of the Metropolitan Museum of Art
in New York.

14
PACINO DI BONAGUIDA
The Tree of Life
Tempera on panel, 97⁵⁄₈ × 59⁷⁄₁₆ in. (248 × 151 cm)
Accademia, Gallery; inv. 1890: no. 8459
Painted for the Florentine convent of Clarisse di Monticelli, out-
side the Porta Romana, this is a characteristic example of the
painter's miniaturist tendency, dating from around the first decade
of the fourteenth century.

Overleaf: 17
BERNARDO DADDI
*Madonna and Child with SS. Mat-
thew and Nicholas of Bari*
Tempera on panel, 56¹¹⁄₁₆ × 76³⁄₈
in. (144 × 194 cm)
Signed and dated: ANO-DNI-
MCCCXXVIII FR. NICHOLAUS-DE-
MAZINGHIS-DE-CANPI-ME-FIERI-
FECIT-PRO-RIMADIO-ANIME-
MATRIS-ET-FRATRUM-BERNARDUS
DE FLORENTIA ME PINXIT
Uffizi, Gallery; inv. 1890: no. 3073
The provenance of this painting is
the Florentine monastery of Ognis-
santi. Although it is the earliest
dated work by Daddi, it is likely to
belong to the first period of his ma-
turity as a painter, corresponding to
the creation of the frescoes in the
Pulci-Berardi chapel in Santa
Croce in Florence.

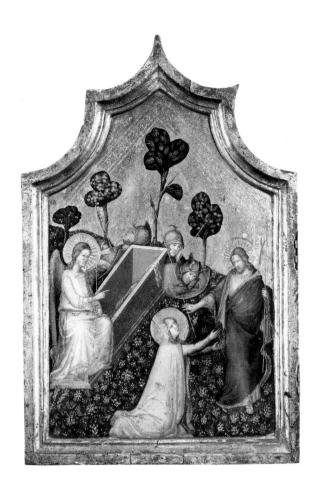

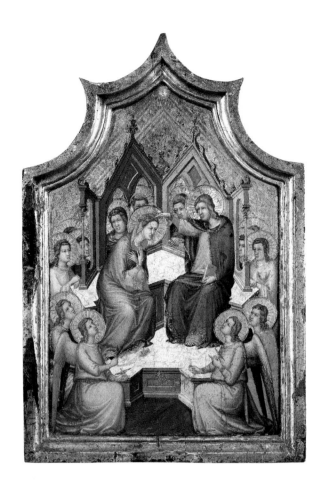

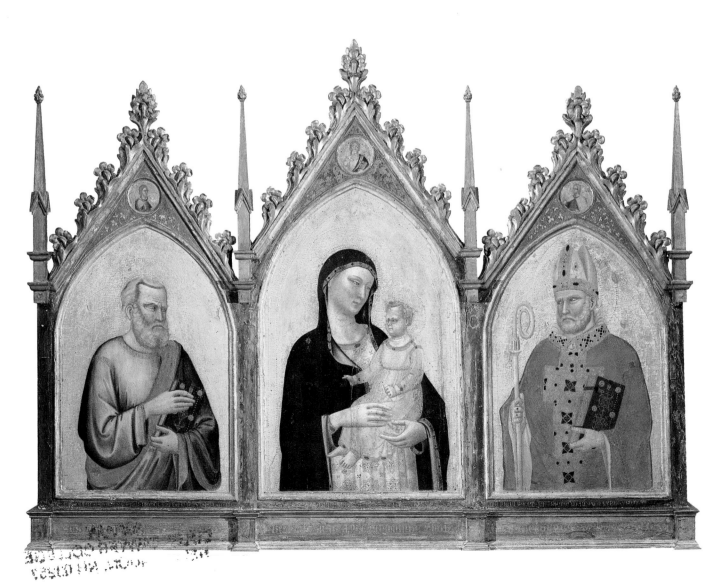

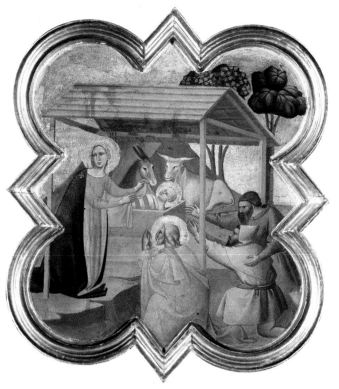
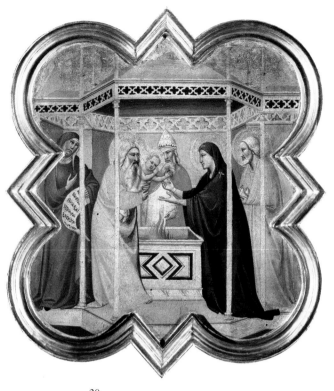

18 and 19 *(above)*
TADDEO GADDI
The Adoration of the Shepherds
Tempera on panel, 18⅞ × 16¹⁵⁄₁₆ in. (48 × 43 cm)
Accademia, Gallery; inv. 1890: no. 8583
The Presentation at the Temple
Tempera on panel, 18⅞ × 17⅛ in. (48 × 43.5 cm.)
Accademia, Gallery; inv. 1890; no. 8585

These panels belong to a series comprising two half-lunettes and twelve panels with scenes from the life of Christ and ten panels with scenes from the life of St. Francis, all of which decorated the reliquary cupboard in the sacristy of Santa Croce in Florence. The series can be dated to Gaddi's first period of maturity as a painter, somewhat later than the Baroncelli chapel frescoes (c. 1327–1330) in Santa Croce in Florence.

20
BERNARDO DADDI
Madonna and Child Enthroned with Angels and SS. Zenobius, Pancras, John the Evangelist, John the Baptist, Miniato, and Reparata
(predella) *Seven Stories from the Life of the Virgin*
Tempera on panel, 64¹⁵⁄₁₆ × 33⅜ in. (165 × 85 cm) (central element); 50 × 16⁹⁄₁₆ in. (127 × 42 cm) (wings); 12³⁄₁₆ × 6¹¹⁄₁₆ in. (31 × 17 cm) (apostles and prophets, in the cusps); 7¹⁵⁄₁₆ in. (20 cm) in diameter (roundels); 19¹¹⁄₁₆ × 11¹³⁄₁₆ in. (50 × 30 cm) (each panel of the predella)
Uffizi, Gallery; inv. 1890: nos. 8345, 6127–6128

This great polyptych, adorned with cusps and four roundels, was perhaps the most elaborate work ever to come out of Daddi's workshop. It was painted for the church of San Pancrazio in Florence, presumably toward the end of the 1340s.

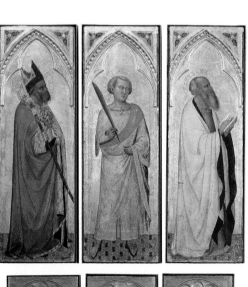
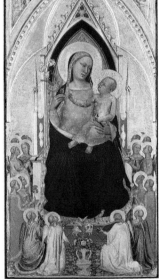

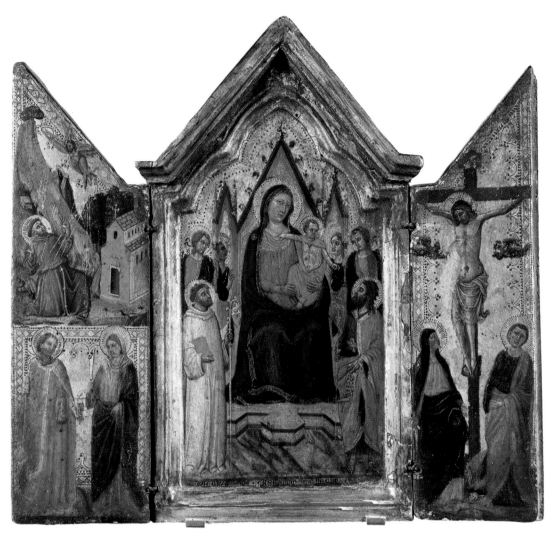

21 (above)
JACOPO DEL CASENTINO
Madonna and Child Enthroned with SS. Bernard and John the Baptist and Four Angels
The Stigmata of St. Francis and Two Saints
The Crucifixion
Tempera on panel, 15⁷⁄₁₆ × 16⁵⁄₈ in. (39.2 × 42.2 cm)
Signed: IACOBUS.DE.CASENTINO.ME FECIT
Uffizi, Gallery; inv. 1890: no. 9258

This panel, formerly in the Cagnola collection in Milan, was given to the Uffizi in 1947. It is the only surviving signed work by the artist and can be dated to the end of the 1320s.

22
MASTER OF THE DOMINICAN IMAGES
Madonna and Child with SS. Benedict, Lucy, Margaret, and Zenobius
Tempera on panel, 25³⁄₈ × 76 in. (64 × 193 cm)
Accademia, Gallery; inv. 1890: no. 4633

Of unknown provenance, this double-sided altarpiece (on the verso is a *Coronation of the Virgin with Saints*) was mentioned for the first time in an inventory of 1881; it has been exhibited in the Accademia since 1909. Datable to the second half of the 1330s, it is remarkable for its distinctive coloring, characterized by crisp and luminous tones.

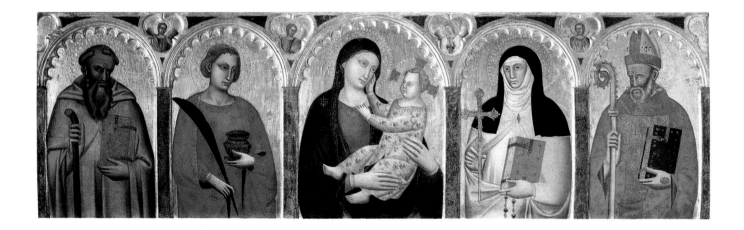

Florence in the Second Half of the Fourteenth Century

Florentine painting of the second part of the fourteenth century has always been considered from the most ordered and individual points of view, both culturally and qualitatively. It is now necessary to reassess substantially the accepted critical notion that artistic production declined after the first half of the fourteenth century. The intrinsic invalidity of this presumption should in fact be quite evident to anyone who troubles to investigate further; it is particularly apparent in light of the work of the young painter Nardo di Cione, whose extremely fine *Crucifixion* in the Uffizi in no way allows for any suggestion of a diminution of quality in Florentine painting in the years following 1350.

Similarly, it now seems rather difficult to comprehend the earlier critical dismissal of such an able painter as Andrea Orcagna. In his polyptych from the church of the Santissima Annunziata (now in the Accademia), Orcagna lays claim to a rightful place in the lineage of the Florentine masters belonging to that intimate Giottesque tradition. If the grave solemnity of Orcagna's figures supports this contradictory reevaluation, the indisputably elevated and profound skills of Maso di Banco argue for a reappraisal of his work. Likewise, the plasticity of the reliefs and the colors attest to his worth as an artist when compared to those featured in the workshop pictures of his contemporary Taddeo Gaddi.

The contrast between the cultural merit of these works and the harsh critical response to them in the past appears unsubstantial before a painting such as *Lamentation of Christ* in the Uffizi, which hung at one time in the Florentine church of San Remigio. This painting, which was deemed "incomparable" by Carlo Volpe, together with the same artist's fresco—a *Madonna and Saints* of the highest quality, originally in the tabernacle of the Canto della Cuculia on the Piazza Santo Spirito in Florence, and datable to 1356—offers concrete evidence of the activity of the still-obscure Giottino, otherwise known as Giotto di Maestro Stefano. Documents place him in Rome in 1369, along with Giovanni da Milano and Agnolo Gaddi, to execute work in the papal apartments. Thanks to the scholarly efforts of Carlo Volpe, we can also include in this painter's very brief catalog of works two fresco fragments with *Heads of Saints* that were detached in the eighteenth century from the church of San Pancrazio in Florence and today are in the museum of the Ospedale degli Innocenti. Giottino's extraordinary artistic sensibility has too often been interpreted only in the light of the Lombard presence of Giovanni da Milano; however, Giottino himself seems directly to have taken up the Giottesque style as typified by the Assisi *Stories of the Infancy of Christ*, located in the right transept of the lower church of St. Francis, and by the work in the adjacent chapel of the Magdalen, developed particularly in the Umbrian environment by Puccio Capanna. Giottino was also influenced by Maso di Banco and by Nardo di Cione's exaltation of pictorial tenderness.

The ability of the second rank of artists active in Florence in this period manifested itself in the high and mostly unexceptional technical standards of such painters as Jacopo di Cione, Niccolò di Tommaso, Andrea Bonaiuti, Matteo di Pacino, and Giovanni del Biondo. All of the artists in this last group upheld the quality of Florentine painting until the last quarter of the century, and this moment in the history of Italian painting saw, as well, the affirmation of a neo-Giottesque style propagated primarily by artists of the first rank, among them Spinello Aretino, who was always flanked by a group of like-minded contemporaries, from Niccolò Gerini to Cenni di Francesco. Paralleling these neo-Giottesque tendencies was the development of a late Gothic style on the initiative of the young Agnolo Gaddi, the last descendant of an ancient and illustrious dynasty of painters who had been among the first to introduce a new language of Florentine pictorial culture.

Angelo Tartuferi

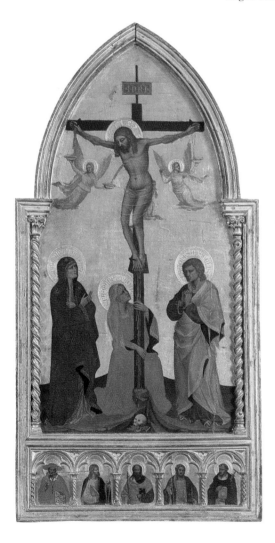

23
NARDO DI CIONE
Crucifixion Scene with Mourners
(in the predella panel) *SS. Jerome, James the Lesser, Paul, James the Greater, and Peter Martyr*
Tempera on panel, 57⅛ × 27¹⁵⁄₁₆ in. (145 × 71 cm)
Inscription: NO SE CAGITET XIANUM QUI P(MORI) SE NO INVENIET PRE(PARATUM)
Uffizi, Gallery: inv. 1890: no. 3515

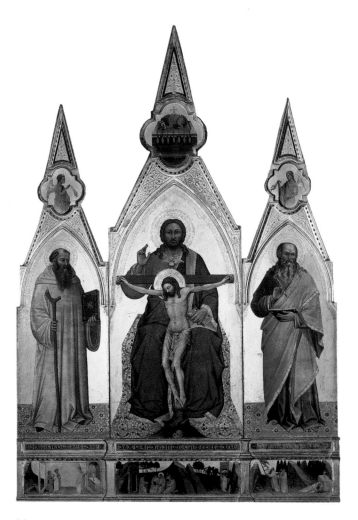

24
NARDO DI CIONE
The Trinity and SS. Romuald and John the Evangelist
(predella) *Three Stories from the Life of St. Romuald*
Panel, 119⅛ × 83⁷⁄₁₆ in. (300 × 212 cm)
Accademia, Gallery; inv. 1890: no. 8464
Painted under the patronage of Giovanni Ghiberti for the chapel of St. John the Evangelist in the chapter house of the Florentine convent of Santa Maria degli Angeli, this panel bears the date 1365.

Opposite: 26
ANDREA ORCAGNA (and MASTER OF THE ASH-MOLEAN PREDELLA)
St. Matthew and Four Stories from His Life
Tempera on panel, 114⁹⁄₁₆ × 104⅜ in. (291 × 265 cm)
Inscription: QUOMODO.SANTUS. MATHEUS.DECESSIT.DE. CHELONEO.ET.SECUTUS. EST.CHRISTUM; QUOMODO. MISERUT.SUP.EUM.SANCTUS. MATHEUS.DRACONES.QUOMODO. SANCTUS.MATHEUS. RESUCITAVIT. UNUM.MORTUUM; QUOMODO. SANCTUS.MATHEUS.FUIT. ACCISIS./SANTUS.MATHEUS. APOSTOLUS.ET.EVANGELYSTA
Uffizi, Gallery; inv. 1890: no. 3163
The council of the Arte del Cambio commissioned this work from Orcagna for a pier in the church of Orsanmichele in Florence. Scholars have also detected the hand of the so-called Master of the Ashmolean Predella.

25
ANDREA ORCAGNA
Madonna and Child Enthroned with Two Angels and SS. Andrew, Nicholas, John the Baptist and James
Tempera on panel, 50 × 22¼ in. (127 × 56.5 cm) (central part); 40¹⁵⁄₁₆ × 14⁹⁄₁₆ in. (104 × 37 cm) (wings)
Accademia, Gallery; inv. 1890: no. 3469
In all probability, these panels were painted for the altar of the Palagio chapel in the Santissima Annunziata in Florence.

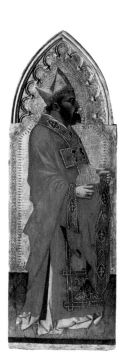

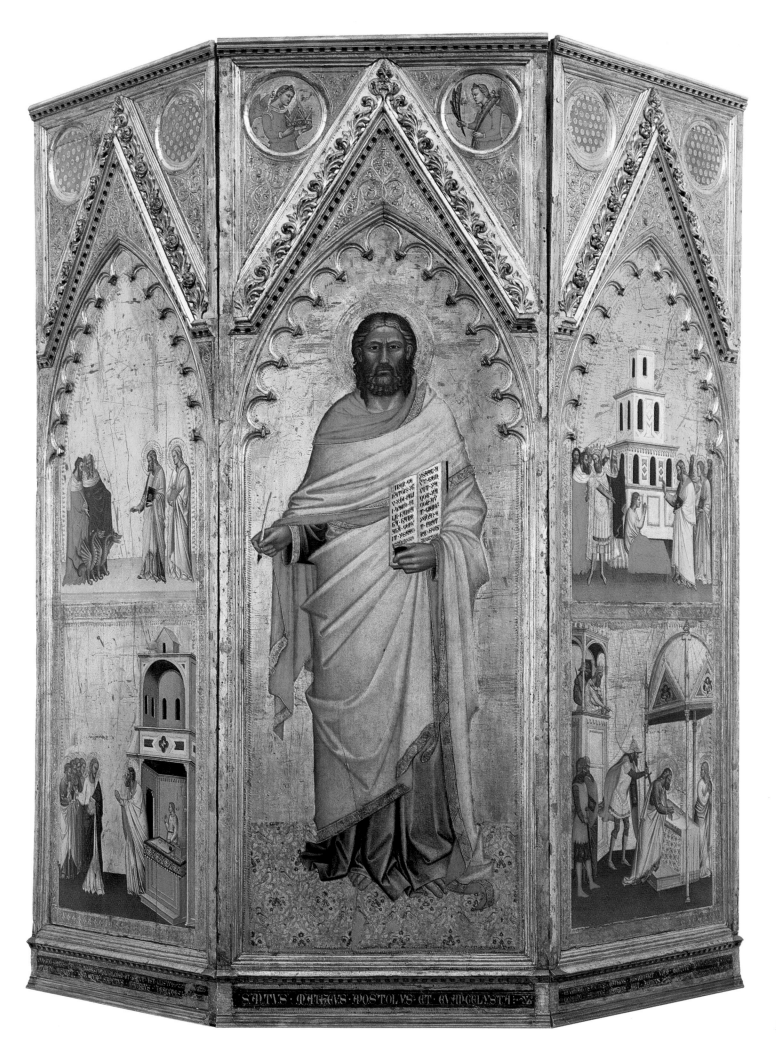

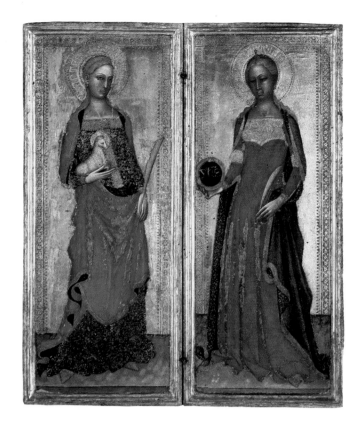

27
ANDREA BONAIUTI
St. Agnes and *St. Domitilla* (diptych)
Tempera on panel, 25¹⁵⁄₁₆ × 11¹⁄₁₆ in. (66 × 28 cm) (each panel)
Accademia, Gallery; inv. 1890: no. 3145
This diptych was acquired by the galleries on July 19, 1900, from the hospital of Santa Maria Nuova in Florence. It is influenced by the art of Giovanni da Milano and was probably executed around 1360–1365. It belongs to a period preceding the famous frescoes in the Cappelone of Santa Maria Novella.

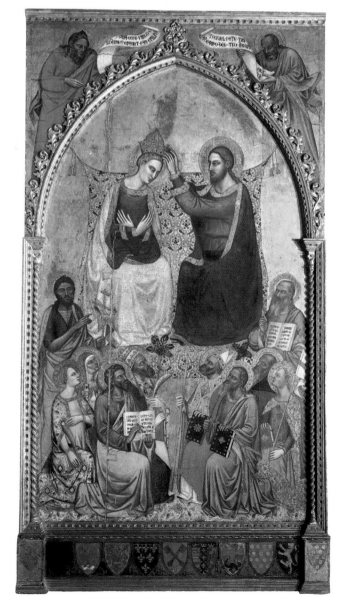

Opposite: 29
GIOTTINO
The Lamentation of Christ
Tempera on panel, 76⅜ × 52¾ in. (195 × 134 cm)
Uffizi, Gallery; inv. 1890: no. 454

Vasari noted the presence of this panel in the church of San Remigio in Florence. One of the greatest examples of Florentine painting of the second half of the fourteenth century, it is datable to around 1360 and reflects the stylistic influence of both Nardo di Cione and Giovanni da Milano.

28
JACOPO DI CIONE
The Coronation of the Virgin with Prophets and Saints
Tempera on panel, 137¹³⁄₁₆ × 74¹³⁄₁₆ in. (350 × 190 cm)
Accademia, Gallery; inv. 1890: no. 456
This painting comes from the office of the Florentine mint, whose coats of arms are represented on its lower edge.

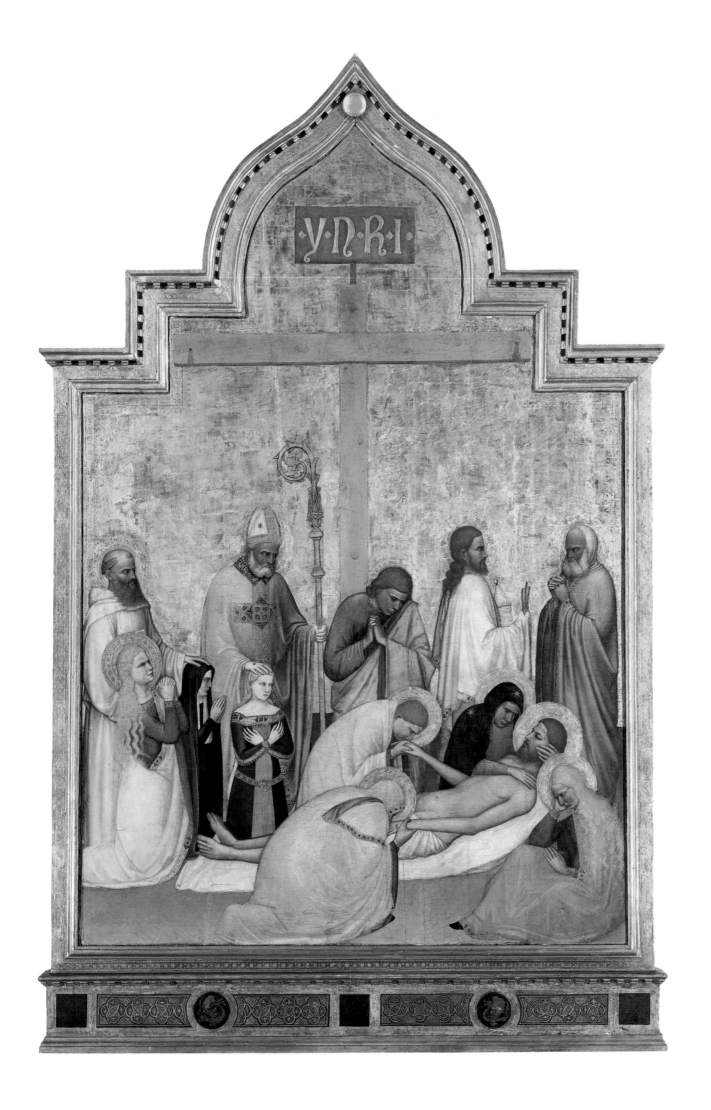

39

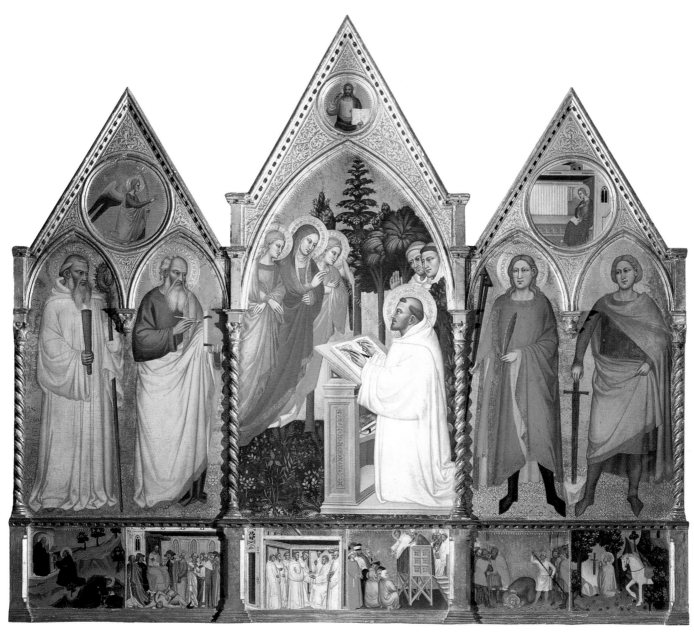

30

MATTEO DI PACINO

St. Bernard's Vision of the Virgin with SS. Benedict, John the Evangelist, Quintinus, and Galgano; (cusps) *The Blessed Redeemer and the Annunciation* (predella) *Stories of the Saints Depicted in the Principal Register of the Triptych*

Tempera on panel, 68¹⁵⁄₁₆ × 78¾ in. (175 × 200 cm)

Inscription: REGINA CELI MATER CRUCIFIXI DIC MATER DOMINI SI IN JERUSALEM ERAS QUANDO CAPTUS FUIT FILIUS TUUS CUI ILLA RESPONDIT; J(E)RU(SALE)M ERAM Q(UA)N(DO) HOC AUDIVI

Accademia, Gallery; inv. 1890: no. 8463

This work came to the Accademia from the Florentine Badia, to which it was taken from the Benedictine convent at Campora. A pleasing interpretation of the Orcagnesque language, it is characterized particularly by a certain chromatic harmony.

Opposite: 31

GIOVANNI DEL BIONDO

St. John the Baptist and Ten Stories from His Life

(below the central panel) *Christ in Limbo*

Tempera on panel, 108¼ × 70⅞ in. (275 × 180 cm)

Pitti, Meridiana (temporary location); inv. Contini Bonacossi: no. 27

This panel, originally from the Ginori chapel in San Lorenzo in Florence, was probably painted during the artist's youth, around 1360–1365.

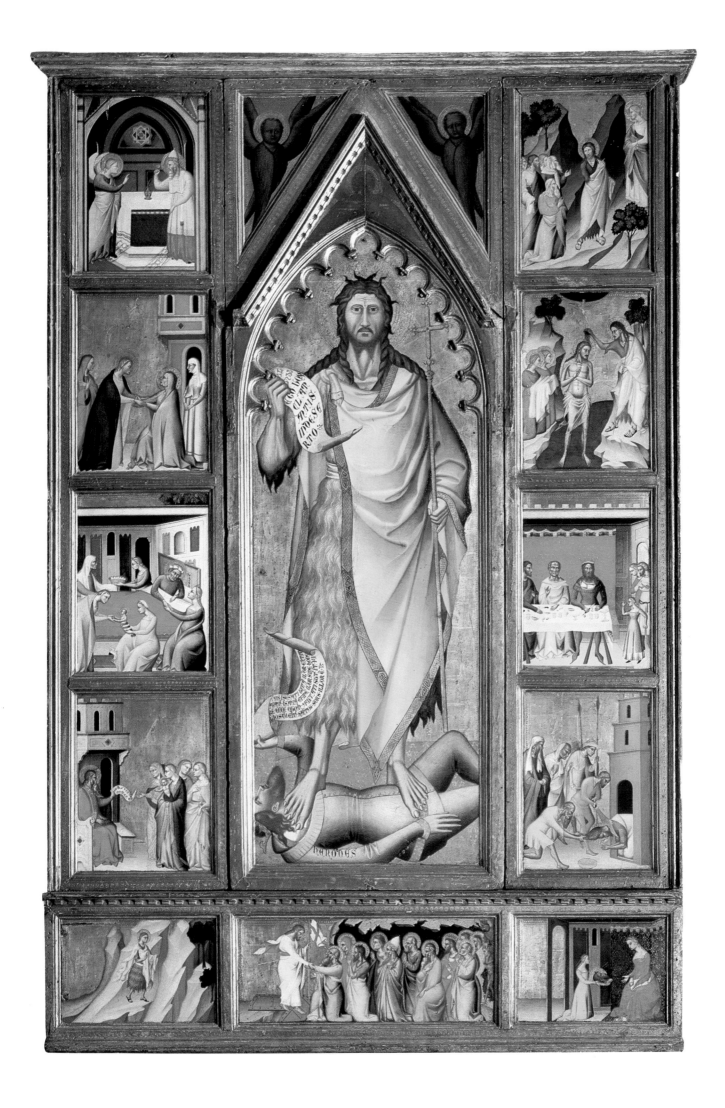

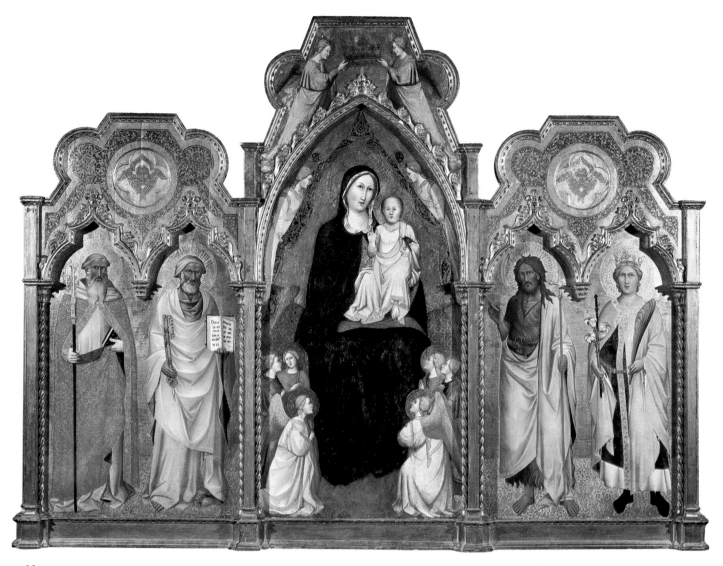

32

AGNOLO GADDI

Madonna and Child with Angels and SS. Benedict and Peter; John the Baptist and Miniato

Tempera on panel, 87⁷⁄₁₆ × 114³⁄₁₆ in. (222 × 290 cm)

Pitti, Meridiana (temporary location); inv. Contini Bonacossi: no. 29

The two wings of this work were probably painted c. 1375 for San Miniato in Florence. Today the lateral panels are joined to a later *Madonna* by Agnolo Gaddi.

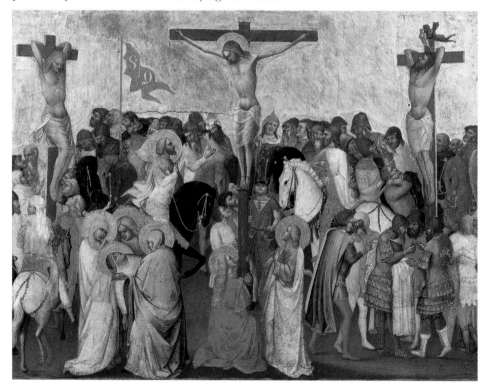

33

AGNOLO GADDI

The Crucifixion

Tempera on panel, 23¼ × 30⁵⁄₁₆ in. (59 × 77 cm)

Uffizi, Gallery; inv. 1890: no. 464

This work was acquired for the Uffizi in 1860. The central element of a polyptych predella, it bears some similarity to the altarpiece painted by Gaddi in 1393–1396 for the church of San Miniato al Monte.

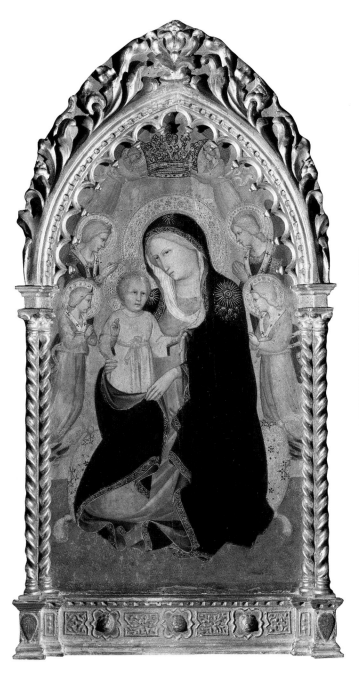

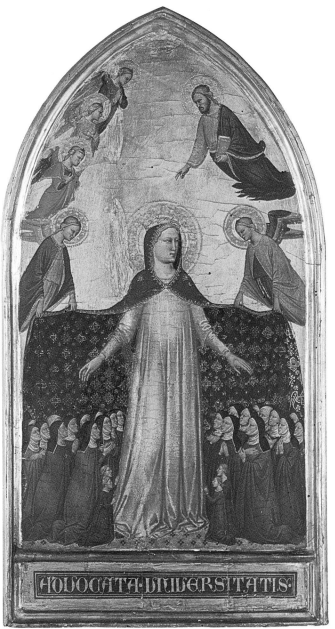

34
AGNOLO GADDI
Madonna of Humility with Six Angels
Tempera on panel, 46⁷⁄₁₆ × 22¹³⁄₁₆ in. (118 × 58 cm)
Accademia, Gallery; inv. 1890: no. 461
Originally installed in the Florentine convent of Santa Verdiana, this panel is typical of Gaddi's mature style.

35
MASTER OF THE MISERICORDIA
Madonna of the Misericordia
(above) *The Benediction of Christ with Five Angels*
Tempera on panel, 24¹³⁄₁₆ × 13³⁄₈ in. (63 × 34 cm)
Inscription: ADVOCATA.UNIVERSITATIS
Accademia, Gallery; inv. 1890: no. 8562
From the convent of the Augustinian nuns of Santa Maria a Candeli, this work was moved to the Accademia after 1850. Datable to around 1375, the panel gives its name to an especially interesting figure in Florentine painting.

43

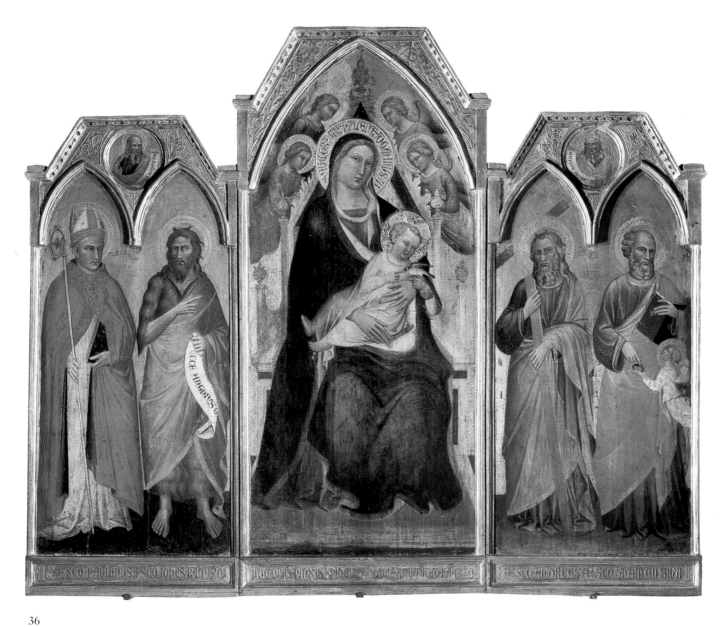

36

SPINELLO ARETINO

Madonna and Child Enthroned with SS. Paulinus, John the Baptist, Andrew, and Matthew
(in the roundels above the side cusps) *The Prophets Jeremiah and Moses*

Tempera on panel, 63 × 98⅜ in. (160 × 250 cm)

Signed and dated: HOC.OPUS PINXIT.SPINELLUS.LUCE DE ARITIO.IN.A.1391

Accademia, Gallery; inv. 1890: no. 8461

This triptych from the church of Sant'Andrea in Lucca, signed and dated 1391, is characteris-
tic of the fully mature work of Spinello.

44

Pisa and Siena

Pisa's extraordinarily rich and vital thirteenth-century culture allowed Pisan painting in the fourteenth century to make special use of artists imported from Florence and Siena, among them Simone Martini, Bonamico Buffalmacco, Taddeo Gaddi, and Stefano. The city nonetheless also succeeded in expressing its own autonomous style with native artists of the first rank, including Francesco Traini. The mixture of tastes and the tangential contacts with Sienese culture are both expressed in the activity of the so-called Master of San Torpè, who was active at the end of the thirteenth century. His work exhibits traits that can be connected to the style of Memmo di Filippuccio.

The presence in Pisa, at the end of the second decade of the fourteenth century, of Simone Martini—with Giotto, the greatest painter of the century in Italy—was decisive in launching the local artistic culture. Simone led the way, as well, for other artists of the highest caliber, who came together from Florence for the decoration of Pisa's monumental Camposanto.

The Sienese school of painting, which developed toward the end of the thirteenth century and into the first years of the fourteenth, has generally, and quite simply, been identified by critics with Gothic culture. But this latter phenomenon, like every other complex historical development, is recognized in Italy as having been an extraordinary and varied articulation of themes and styles. Within the artistic ambience of Siena, for example, there evolved a particularly harmonious coexistence and interrelationship between different formal tendencies. The most noble art of Duccio di Buoninsegna, still largely indebted to the "Greek style," managed to retain, unaltered, a great deal of its fascination and its illuminating strength even in the work of that master's most immediate successors. Among these latter artists was Ugolino di Neri, who held a position of eminence as is documented by the very beautiful triptych from the Contini Bonacossi collection.

Simone Martini, at once the greatest representative of Sienese Gothic culture and the founder of the local artistic tradition, was the only artist of any rank who can be said to contend with Giotto for the role of absolute leadership of fourteenth-century Italian painting. Of all of Simone's works, the gilded and dazzling *Annunciation* in the Uffizi, painted for the altar of Sant'Ansano in the Duomo in Siena, is perhaps the most intentionally demonstrative of his artistic style; it bears its own distinctive stamp even when compared with the work of local artists from the following century.

The brothers Pietro and Ambrogio Lorenzetti secured a significant historical position through their sophisticated dialectic and privileged rapport with Giottesque Florentine culture. This intellectual exchange was expressed by Pietro in his *Maestà*, executed for San Francesco in Pistoia, and in his series of *Stories of the Blessed Humility* in the Uffizi. These works exhibit a matchless synthesis of plasticity and Giottesque space with a traditional Sienese linear and chromatic sense. Ambrogio Lorenzetti's work, instead, approached spatial experiments in a very particular fashion, culminating in the Uffizi's *Presentation in the Temple*, painted in 1342 for the altar of San Crescenzio in the Duomo in Siena.

The influence of the Lorenzettis can also be seen in the paintings and miniatures of Niccolò di Ser Sozzo, while Niccolò di Buonaccorso, in his *Presentation of the Virgin*, followed Simone Martini's model in developing a poetry that had a decisively late-Gothic sensibility.

Angelo Tartuferi

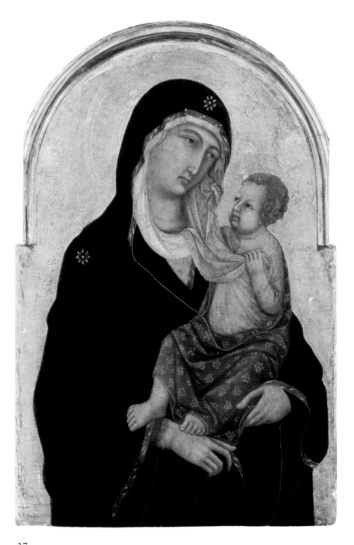

37
ANONYMOUS SIENESE ARTIST (first quarter of 14th C.)
Madonna and Child
Tempera on panel, 32¹¹⁄₁₆ × 21¼ in. (83 × 54 cm)
Pitti, Meridiana (temporary location); inv. Contini Bonacossi: no. 26
This panel was formerly in the Boninsegni collection in Siena and the Tadini-Boninsegni collection in Pisa. Variously attributed to the circle or followers of Duccio, it suggests the hand of an artist close to Niccolò di Segna.

45

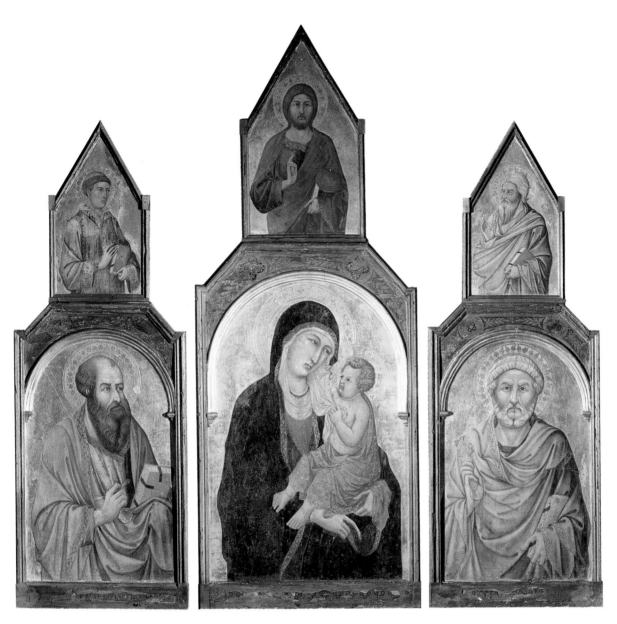

38

UGOLINO DI NERI
Madonna and Child with SS. Peter and Paul
(in the cusps) *The Eternal Benediction and SS. Stephen and John the Evangelist*
Tempera on panel, 58¼ × 59⅞ in. (148 × 152 cm)
Pitti, Meridiana (temporary location); inv. Contini Bonacossi: no. 4

This work was commissioned by the Pannilini family and originally held by the church of San Pietro in Villore in San Giovanni d'Asso (Siena).

39 and 40

BERNARDO FALCONI (so-called)
St. Benedict Giving Over His Rule to St. Romuald and His Monks
Tempera on panel, 17⁵⁄₁₆ × 30⁵⁄₁₆ in. (44 × 77 cm)
Inscription: INCIPIT REGULA BE(A)TI BENEDIC(TI)
Accademia, Gallery; inv. 1890: no. 3340
The Dream of St. Romuald
Tempera on panel, 17⁵⁄₁₆ × 30⁵⁄₁₆ in. (44 × 77 cm)
Accademia, Gallery; inv. 1890: no. 3339

These two panels originally belonged to a polyptych in the church of San Michele in Borgo di Pisa; after 1857 they passed into the Toscanelli collection in Pisa. In 1905 they were acquired by the Florentine galleries and exhibited in the Uffizi, and in 1954 they were transferred to the Accademia.

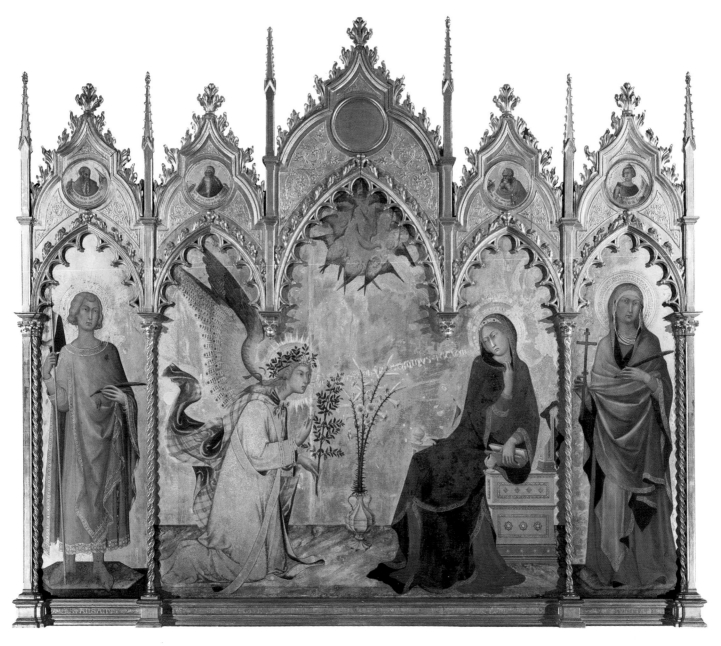

41

SIMONE MARTINI (and LIPPO MEMMI)
The Annunciation with SS. Ansanus and Margaret and *Four Prophets*
Tempera on panel, 72⁷⁄₁₆ × 44 ⅞ in. (184 × 114 cm) (central part);
41⁵⁄₁₆ × 18 ⅞ in. (105 × 48 cm) (wings)
Signed and dated: SYMON MARTINI ET LIPPUS MEMMI DE SENIS
ME PINCXERUNT ANNO DOMINI MCCCXXXIII
Uffizi, Gallery; inv. 1890: nos. 451–453

Painted for the altar of Sant'Ansano in the Duomo in Siena, this
large panel was moved to the church of Sant'Ansano in Castelvec-
chio at the end of the sixteenth century. In 1799, by order of Grand
Duke Pietro Leopoldo, it was brought to Florence in exchange for
two works by Luca Giordano and immediately exhibited in the
Uffizi. According to the most recent hypotheses, the participation
of Lippo Memmi must be limited solely to the figure of St. Marga-
ret, to the right of the central scene.

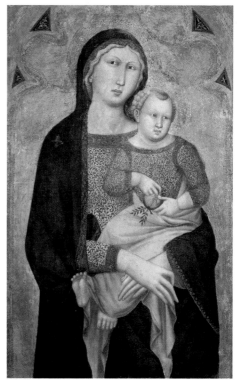

42

NICCOLÒ DI SER SOZZO
Madonna and Child
Tempera on panel, 33½ × 21¹¹⁄₁₆ in. (85 × 55 cm)
Uffizi, Gallery; inv. 1890: no. 8439

The provenance of this work is the church of Sant'Antonio in Bosco
(Poggibonsi), from which it was stolen in 1919. When it was recov-
ered not long afterward, in Paris, it was sent to the Uffizi galleries.

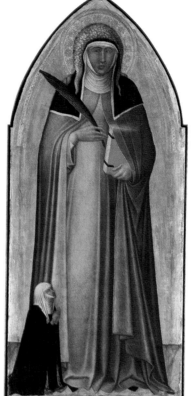

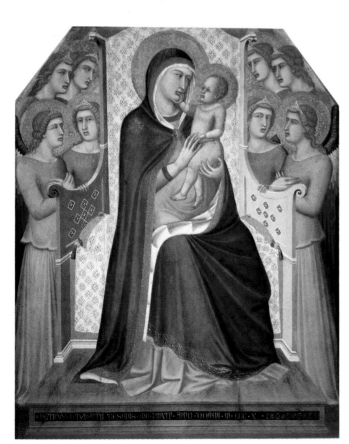

43

PIETRO LORENZETTI

The Blessed Humility and Eleven Stories from Her Life

Tempera on Panel, 50⅜ × 22½ in. (128 × 57.2 cm) (central element); 17¾ × 12⅝ in. (45 × 32 cm) (each smaller panel)

Uffizi, Gallery; inv. 1890: n. 8347

In addition to the eleven narrative panels shown here, two further pictorial episodes of the saint's life are to be found in Berlin. Intended for the church of San Giovanni Evangelista, the polyptych was painted for the order of the Women of Faenza, who transferred it in 1534 to the Florentine convent of San Salvi. In 1919 it was moved once more, to the Uffizi. It is thought to date from the artist's maturity.

44

PIETRO LORENZETTI

Madonna and Child Enthroned with Eight Angels

Tempera on panel, 57 × 48 in. (145 × 122 cm)

Signed and dated: PETRUS.LAURENTII.DE.SENIS.ME
PINXIT.ANNO.DOMINI.M.CCC.XL

Uffizi, Gallery; inv. 1890: no. 445

The provenance of this painting is the Company of St. Bartholomew, which was joined to the church of St. Francis in Pistoia. The authenticity of the inscribed date, 1340, has often been questioned, but the panel does appear to be compatible with the known style of the artist at that time.

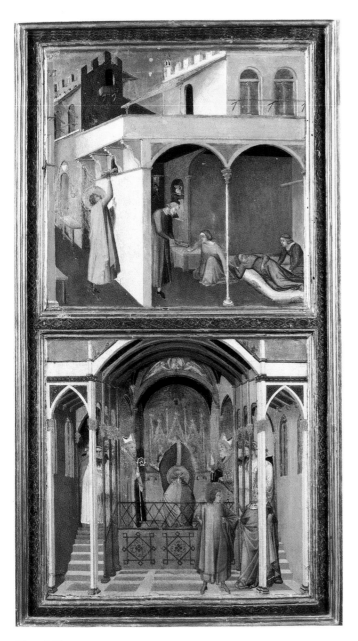

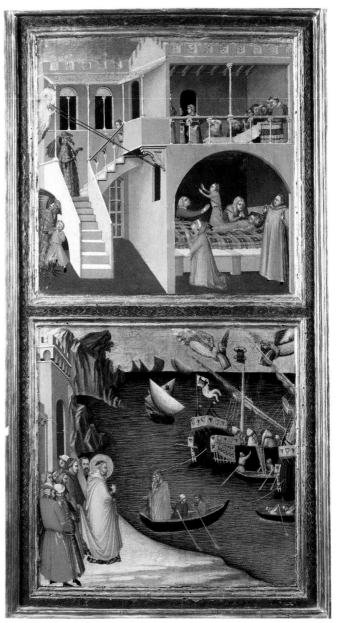

45 and 46
AMBROGIO LORENZETTI
St. Nicholas Offers Three Girls Their Dowry and *St. Nicholas Is Elected Bishop of Mira*
Tempera on panel, 37¹³⁄₁₆ × 20⅞ in. (96 × 53 cm)
Uffizi, Gallery; inv. 1890: no. 8348
St. Nicholas Revives a Boy and *St. Nicholas Saves Mira from Famine*
Tempera on panel, 37¹³⁄₁₆ × 20⅞ in. (96 × 53 cm)
Uffizi, Gallery; inv. 1890: no. 8349
These paintings, which were originally held by the church of San Procolo in Florence, probably belonged to a series of images center-ing on St. Nicholas. They were brought to the Accademia in 1810 and transferred to the Uffizi in 1819. Scholars have assigned them to the documented period of Ambrogio's stay in Florence (1327–1332); this dating seems quite plausible in light of the work's affinity with the altarpiece of the Blessed Agostino Novello by Simone Martini (Sant'Agostino, Siena).

Overleaf: 47
AMBROGIO LORENZETTI
The Presentation in the Temple
Tempera on panel, 101³⁄₁₆ × 66 ³⁄₁₆ in. (257 × 168 cm)
Signed and dated: AMBROSIUS.LAURENTII.DESENIS.
FECIT.HOC OPUS.ANNO.DOMINI.M.CCC.XLII
Uffizi, Gallery; inv. 1890: no. 8346
Painted for the altar of San Crescenzio in the Duomo in Siena, this panel once had wings, now lost, depicting St. Crescenzio and St. Michael, Archangel. In 1822 the panel was taken to Florence by order of Grand Duke Ferdinand III. The work shows Ambrogio at the height of his experimentation into illusionistic spatial effects.

49

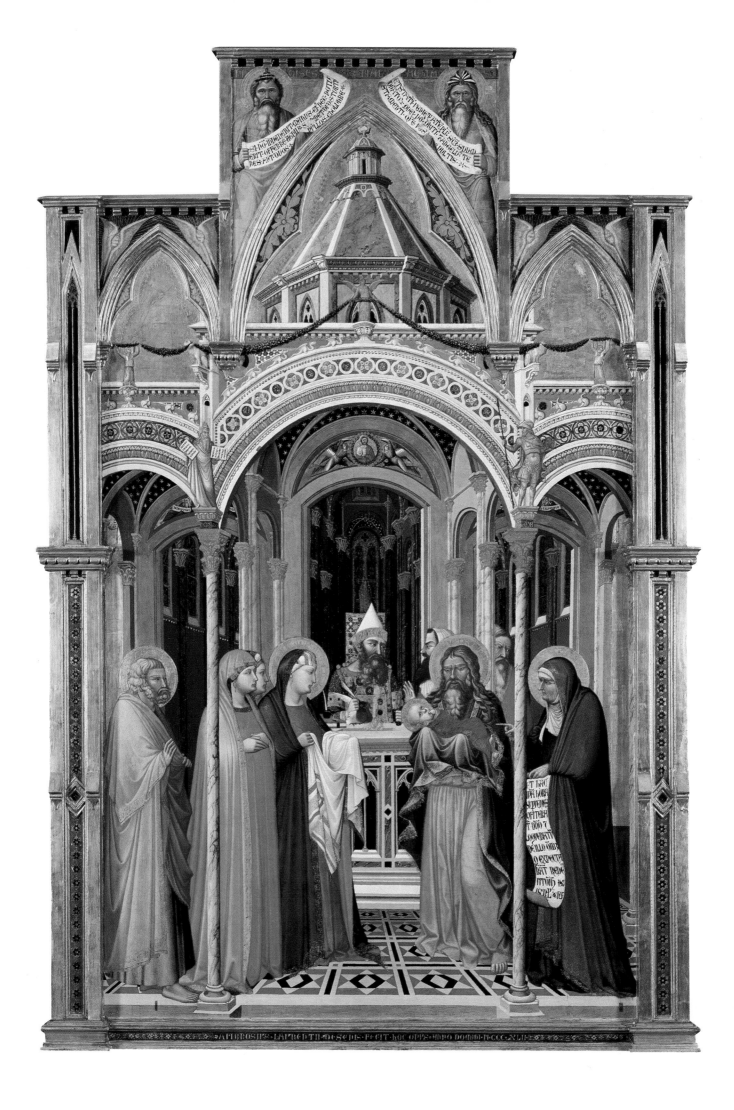

Northern Italy

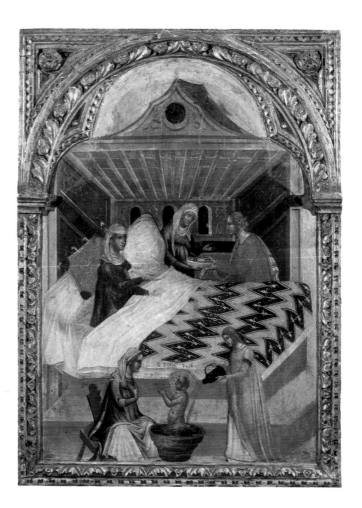

Although the collection of northern Italian paintings of the fourteenth century in the Florentine galleries is slight in number, the works are nonetheless of the highest order both in quality and historical significance. The two *Stories from the Life of St. Nicholas* from the Contini Bonacossi collection may once have been part of the polyptych executed by Paolo Veneziano in 1346 for the chapel of San Nicola in the Palazzo Ducale in Venice; they illustrate the great originality and unmistakable cultural expansiveness that characterize the activity of the greatest Venetian painter of the fourteenth century. In this one pair of panels can be found a chromatic preciosity combined with pictorial freedom, rhythmic and refined elegance of Byzantine origin, and elements inspired by Giottesque influences.

Through the research conducted in recent years on Lombard painting of the fourteenth century, a singularly rich artistic culture has surfaced, one that is remarkable particularly for its thematic expressiveness. For examples of this, one has only to recall the dazzling and phantasmagoric pictorial cycles that decorate the Sala di Giustizia in the Rocca di Angera (now considered to date from the end of the thirteenth century) and the basilica of Sant'Abbondio in Como, as well as the "Giottesque" abbeys of Viboldone and Chiaravalle.

The artistic style of the Lombard Giovanni da Milano, one of the greatest Italian painters of the fourteenth century, was formed in the crucible of Florentine cultural tradition. He very quickly incorporated the principal stylistic developments of Florence and Tuscany, which were themselves directly dependent on the late activity of Giotto. Scholars have often acknowledged the influence exercised by this Lombard painter on Florentine culture in the latter half of the century, but he was in turn influenced by Florence, even in those naturalistic aspects that he generally expressed in a singularly Lombard register. The extraordinary *Pietà of Christ and His Mourners* in the Accademia demonstrates Giovanni's indebtedness to Stefano (called the "ape of nature" by his contemporaries) and, certainly, to Giottino, the author of the very beautiful *Lamentation of Christ* in the Uffizi, which was at one time housed in San Remigio in Florence.

Angelo Tartuferi

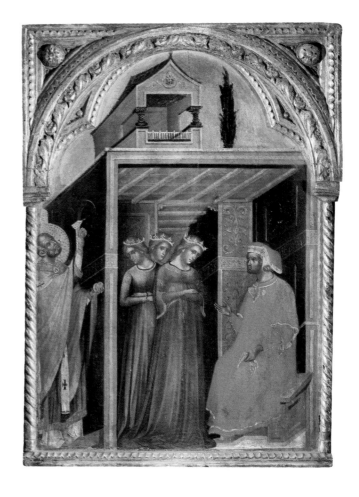

48 and 49
PAOLO VENEZIANO
The Birth of St. Nicholas
Tempera on panel, 29⁵⁄₁₆ × 21 ⁷⁄₁₆ in. (74.5 × 54.5 cm)
Inscription: s. NICO(LA)US
Pitti, Meridiana (temporary location); inv. Contini Bonacossi: no. 6
Alms of St. Nicholas
Tempera on panel, 28¾ × 20⅞ in. (73 × 53 cm)
Pitti, Meridiana (temporary location); inv. Contini Bonacossi: no. 7

These two panels may once have been part of a series executed by Veneziano in 1346 for the chapel of San Nicola in the Palazzo Ducale in Venice.

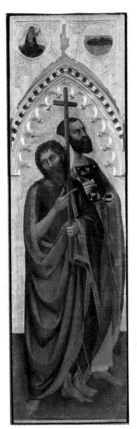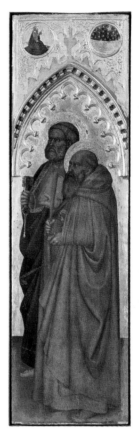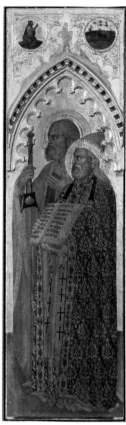

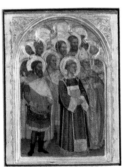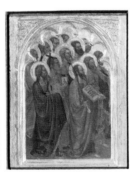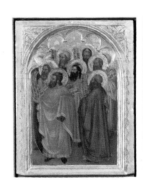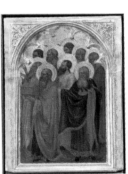

50

GIOVANNI DA MILANO

The Ognissanti Polyptych: SS. Catherine and Lucy, Stephen and Laurence, John the Baptist and
Luke, Peter and Benedict, James the Greater and Gregory
Tempera on panel, 51¹⁵⁄₁₆ × 15⅜ in. (132 × 39 cm) (each panel)
(predella panels) *Chorus of the Virgins, Chorus of the Martyrs, Chorus of the Apostles, Chorus*
of the Patriarchs, Chorus of Prophets
Tempera on panel, 19⁵⁄₁₆ × 15⅜ in. (49.1 × 39 cm) (each panel)
Uffizi, Gallery; inv. 1890: no. 459

These five panels and predella panels belong to a polyptych painted for the main altar in
the Ognissanti church in Florence. On several occasions the polyptych was moved inside
the convent, and some parts of it were lost.

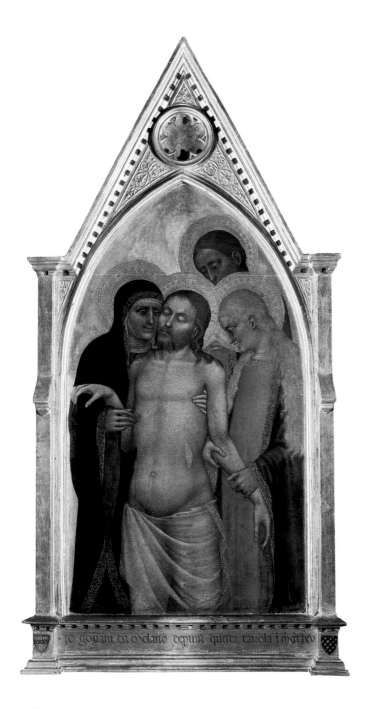

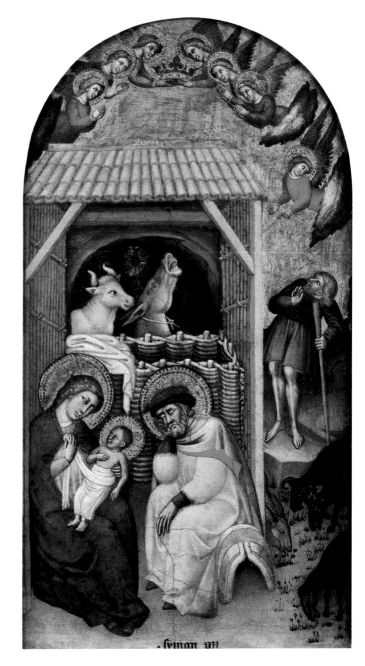

51

GIOVANNI DA MILANO

Pietà of Christ and His Mourners

Tempera on panel, 48 1/16 × 22 7/8 in. (122 × 58 cm)

Signed and dated: JO GOVANI DA MELANO DEPINSI QUESTA

TAVOLA I MCCCLXV

Accademia, Gallery; inv. 1890: no. 8467

This panel came to the Accademia from the Florentine convent of San Girolamo sulla Costa during the Napoleonic suppression of 1808–1810. Perhaps the masterpiece of this Lombard painter, it is, as well, one of the greatest examples of fourteenth-century Italian art.

52

SIMONE DEI CROCIFISSI

Nativity

Tempera on panel, 18 1/2 × 9 7/8 in. (47 × 25 cm)

Signed: SYMON PIN..

Uffizi, Gallery; inv. 1890: no. 3475

Donated to the Accademia in 1863 by the merchant Ugo Baldi, this work was given to the Uffizi in 1905. It appears to belong to the artist's mature period and probably dates from the decade between 1370 and 1380.

The Late or International Gothic Style

Within the Florentine cultural context, Gherardo Starnina took a leading role in the movement away from the artistic language of the late fourteenth century, still strongly influenced by neo-Giottesque formal tendencies, and toward the International Gothic aesthetic. Returning from Spain at the beginning of the fifteenth century, the artist introduced a manner of painting that was characterized by sharp contours and brilliant contrasts of color and light. These attributes can be seen in a group of panel paintings that scholars have in the past given to the so-called Master of the Bambino Vispo. Aside from Starnina, the principal promoter of International Gothic culture in Florence was Lorenzo Monaco, who seems to have allied himself early on with local artistic traditions even as he kept up with the latest developments in sculpture, particularly as exemplified by the work of Lorenzo Ghiberti. The Uffizi's *Adoration of the Magi,* painted for the church of Sant'Egidio in Florence in 1422, can be seen as the culmination of Lorenzo's formal research; it is characterized by a dreamlike and unreal atmosphere created by the manipulation of spatial planes and by the profiles of the personages, which are elongated in an exaggerated manner.

Following on the work of these two major protagonists in Florentine art in the first two decades of the century, a later group of artists of the highest quality explored a brightly colored landscape variegated by the infinite expressive possibilities of late Gothic painting. The refined Master of the Straus Madonna, whose early sensibilities were influenced by the neo-Giottesque inclinations at the end of the fourteenth century, came to be one of the principal proponents of the new language, developing an expressive style gleaned in the workshop of Agnolo Gaddi. For his part, Rossello di Jacopo Franchi exhibited a faithful adherence to Lorenzo Monaco's vision and also notably reflected the work of Starnina.

With the arrival of Gentile da Fabriano, Florentine artistic culture became an authentic locus of International Gothic activity. Gentile's style is splendidly illustrated by his *Adoration of the Magi,* painted in 1423 for the chapel of Palla di Onofrio Strozzi, in the sacristy of Santa Trinita in Florence. The influence of Gentile's sophisticated visual rhythms, accented by conspicuous stylistic references to Ghiberti, is evident in the paintings of Giovanni Toscani, also known as the Master of the Griggs Crucifixion.

In the third decade of the century, the artistic scene in Florence was fragmented as a result of its particular cultural and stylistic traditions. The revolutionary impact of Masaccio's new style of painting, which ultimately signaled the decline of the International Gothic, was nonetheless felt by many artists. Thus one sees, for example, Giovanni dal Ponte maintaining a difficult synthesis of two stylistic languages even as Andrea di Giusto remains tenaciously attached to late Gothic culture well into the 1440s. To some extent, at least, these different approaches were finally reconciled by Renaissance elements derived from the work of Fra Angelico.

Angelo Tartuferi

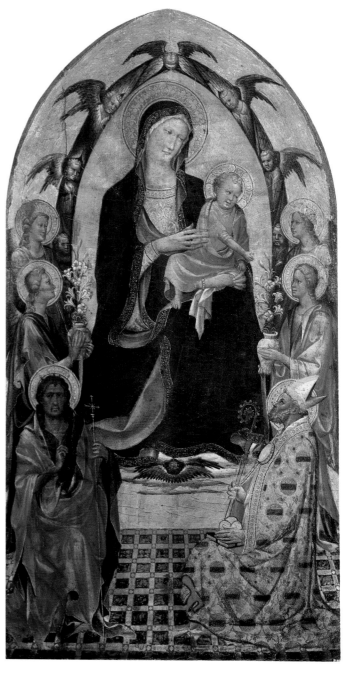

53

GHERARDO STARNINA

Madonna and Child with SS. John the Baptist and Nicholas and Four Angels

Tempera on panel, 37¹³⁄₁₆ × 20¹⁄₁₆ in. (96 × 51 cm)

Accademia, Gallery; inv. 1890: no. 441

The original provenance of this painting is unknown. Characteristic of the mature activity of Starnina within the International Gothic climate, it can be dated around the first decade of the fifteenth century.

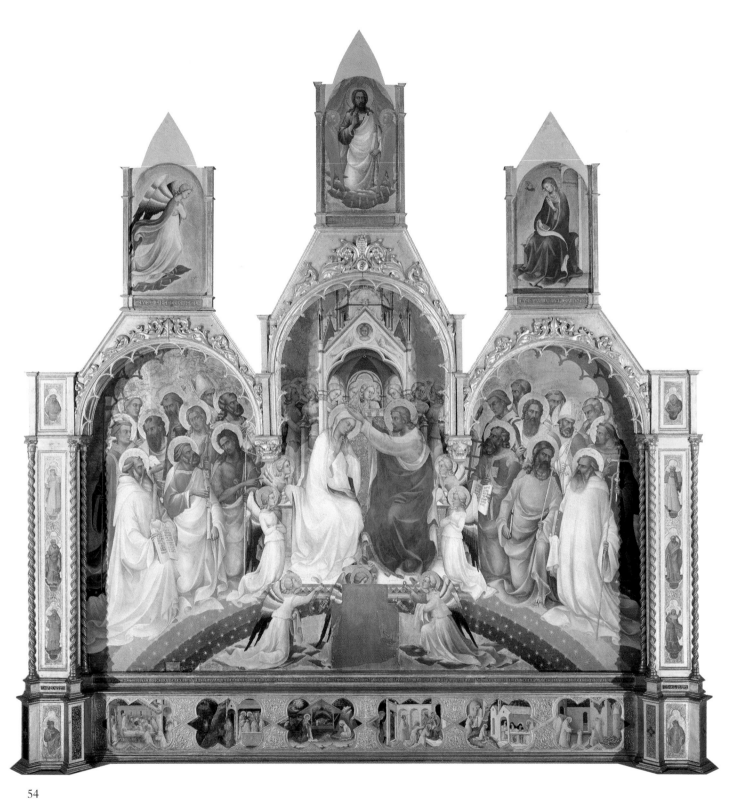

54

LORENZO MONACO

The Coronation of the Virgin with Saints and Angels
(in the cusps) *The Annunciation* and *The Blessing Redeemer*

Tempera on panel, 177³⁄₁₆ × 138¹⁵⁄₁₆ in. (450 × 350 cm)

Signed and dated: FEBBRAIO 1413 [1414 according to the Floren-
tine calendar]

Uffizi, Gallery; inv. 1890: no. 885

This work came originally from the church of the Angioli convent
in Florence.

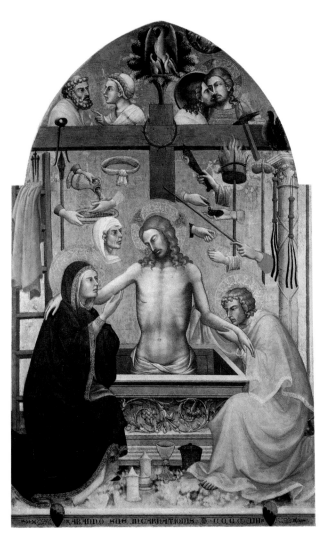

55

LORENZO MONACO
Pietà of Christ with Mourners and the Symbols of the Passion
Tempera on panel, 105⅛ × 66¹⁵⁄₁₆ in. (267 × 170 cm)
Dated: AB ANNO SUE INCARNATIONIS M.CCCC.IIII
Accademia, Gallery; inv. 1890: no. 467

This panel is a work of great elegance. It dates from the same time as Monaco's triptych in the Pinacoteca of the Collegiata in Empoli; together, the two compositions testify to a turning point in the artist's Gothic sensibility.

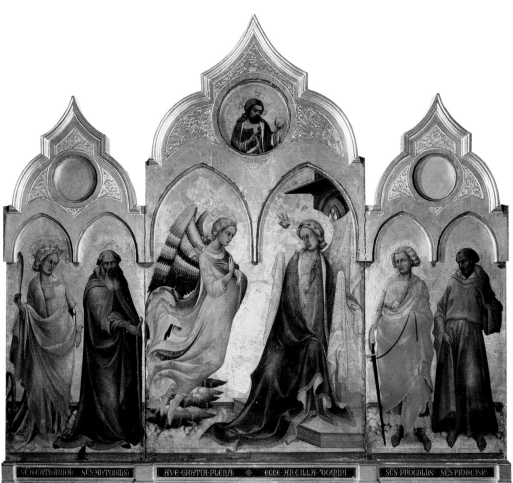

56

LORENZO MONACO
The Annunciation with SS. Catherine, Antony Abbot, Proculus, and Francis (in the central cusp) *Christ Blessing*
Tempera on panel, 82¹¹⁄₁₆ × 90³⁄₁₆ in. (210 × 229 cm)
Accademia, Gallery; inv. 1890: no. 8458

Although acquired from the Florentine Badia, this panel was originally painted for the church of San Procolo in around 1415. One of the two prophets that formerly graced the roundels on the wings could be found at one time in the collection of Artaud de Montor in Paris.

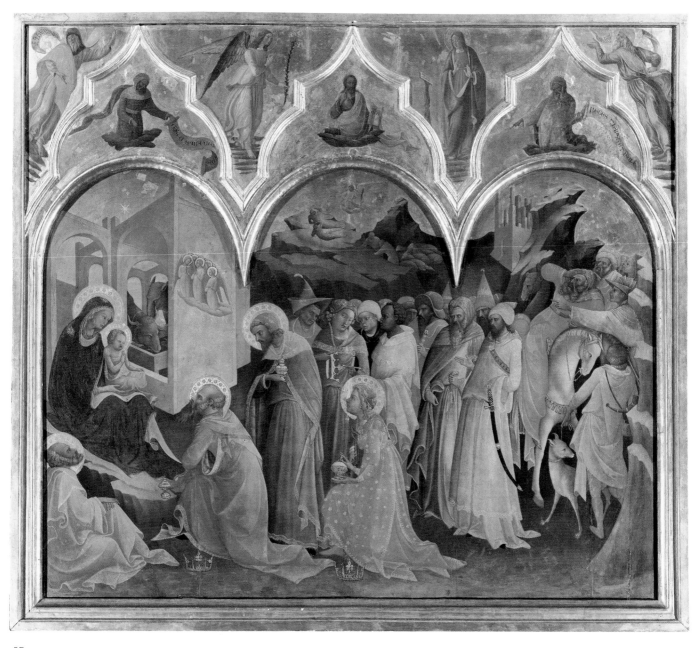

57
LORENZO MONACO
The Adoration of the Magi
Tempera on panel, 45⁵⁄₁₆ × 66 ¹⁵⁄₁₆ in. (115 × 170 cm)
Uffizi, Gallery; inv. 1890: no. 466

This work has been identified as the altarpiece that was painted, according to documentation, in 1421–1422 for the church of Sant'Egidio in Florence. It was repainted in the second half of the fifteenth century by Cosimo Rosselli, who added the Annunciation and two prophets above to the three original cusps, decorated with the Eternal Blessing and two other prophets.

58
LORENZO MONACO
Scene from the Life of St. Onuphrius
Tempera on panel, 10¼ × 23⅝ in. (26 × 60 cm)
Accademia, Gallery; inv. 1890: no. 466

This is one of three panels that originally comprised the predella for an altarpiece commissioned by Palla Strozzi for the sacristy of Santa Trinita in Florence. The work was unfinished at the artist's death.

59 and 60
MASTER OF THE STRAUS MADONNA
St. Catherine of Alexandria
Tempera on panel, 22¹⁄₁₆ × 9¹⁄₁₆ in. (56 × 23 cm)
Accademia, Gallery; inv. 1890: no. 476
St. Francis
Tempera on panel, 22¹⁄₁₆ × 9¹⁄₁₆ in. (56 × 23 cm)
Accademia, Gallery; inv. 1890: no. 477

These two exquisite panels from the Convent of San Jacopo De'Barbetti in Florence are datable to around 1410; they were originally part of a small polyptych.

61
GIOVANNI DAL PONTE
The Coronation of the Virgin with Four Angel Musicians, and SS. Francis and John the Baptist, Ivo and Dominic
(above the cusps) *The Angel of the Annunciation, Christ in Limbo, and the Virgin Annunciate*
Tempera on panel, 76³⁄₈ × 81⁷⁄₈ in. (194 × 208 cm)
Accademia, Gallery; inv. 1890: no. 458

This panel came from Monte di Pietà in Florence. Characteristic of the artist's mature phase, its style can be seen as a very personal synthesis of late Gothic painting and the new Renaissance expression.

58

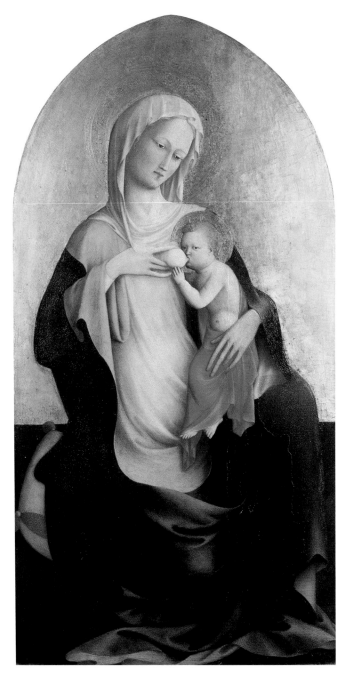

62

GIOVANNI TOSCANI

The Incredulity of St. Thomas

Tempera on panel, 84¹¹⁄₁₆ × 42¹⁵⁄₁₆ in. (215 × 109 cm) (without frame)

Inscription: TOCCATE IL VERO COM'IO E CREDETE NELLA SOMMA GIUSTIZIA IN TRE PERSONE CHE SEMPRE EXALTA OGNUN CHE FA RAGIONE

Accademia, Gallery; inv. 1890: no. 457

This panel was originally in the Tribunale della Mercanzia; in the eighteenth century it could be found in the Camera di Commercio. Previously attributed to the Master of the Griggs Crucifixion.

63

MASOLINO DA PANICALE

Madonna of Humility

Tempera on panel, 43½ × 24 ⁷⁄₁₆ in. (110.5 × 62 cm)

Uffizi, Gallery; inv. 1890: no. 9922

In the 1930s this panel was in private collections in London, from which it passed into the Contini Bonacossi collection in Florence. It was confiscated during World War II by General Göring, and recovered by the state only in 1954. One of the earliest known works by this artist, it dates from around 1415–1420 and shows some stylistic similarity to the work of Starnina.

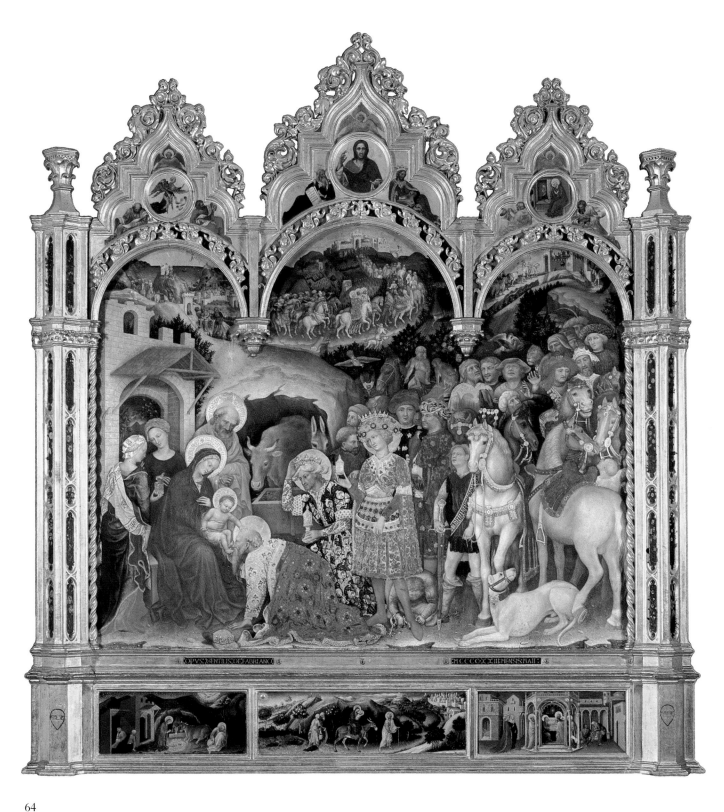

64

GENTILE DA FABRIANO
The Adoration of the Magi
(in the cusps) *The Judgment of Christ, the Annunciation, Prophets, and Cherubim*
(in the predella) *The Nativity, the Flight into Egypt, and the Presentation in the Temple*
Tempera on panel, 68⅛ × 86⅝ in. (173 × 220 cm)
Signed and dated: OPUS GENTILIS DE FABRIANO MCCCCXXIII MENSIS MAIJ
Uffizi, Gallery; inv. 1890: no. 8364

Painted for the Strozzi chapel in the church of Santa Trinita in Florence, this famous
work was brought to the Accademia in 1810 and transferred to the Uffizi in 1919. It is
among the most representative examples of International Gothic culture as it flour-
ished in Italy. The predella panel depicting *The Presentation in the Temple* is a
nineteenth-century copy of the original, which today is in the Louvre.

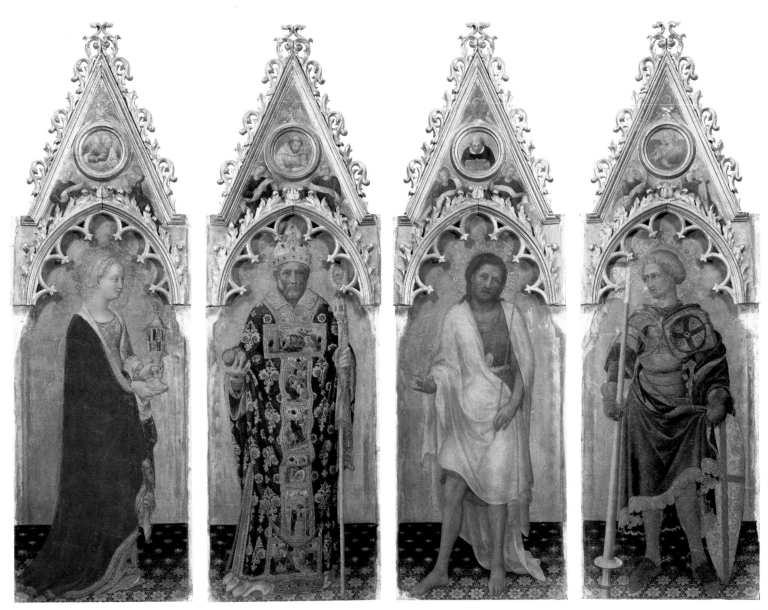

65

GENTILE DA FABRIANO

SS. Mary Magdalen, Nicholas, John the Baptist, and George

Tempera on panel, 37 × 22⁷⁄₁₆ in. (94 × 57 cm) (each panel)

Uffizi, Gallery; inv. 1890: no. 887

Part of a series painted for the altar of the Quaratesi chapel in San Niccolò Oltrarno in Florence. The central element of the polyptych, depicting the Madonna and Child, may now be found at Hampton Court; the predella, *Stories of the Life of St. Nicholas,* is divided between the Vatican Pinacoteca and the National Gallery in Washington, D.C. According to Vasari, the work was originally signed and dated 1425.

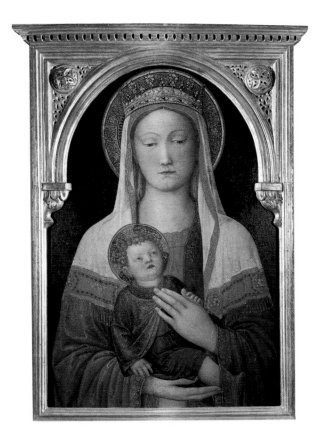

66

JACOPO BELLINI
Madonna and Child
Tempera on panel, 27³⁄₁₆ × 19⁵⁄₁₆ in. (110.5 × 62 cm)
Uffizi, Gallery; inv. 1890: no. 3344
This painting was once in the monastery of San Micheletto in Lucca and was acquired by the Uffizi in 1906 through an antiquarian from that city. It is characteristic of the later style of the painter and can be dated to around 1450.

67

ANDREA DI GIUSTO
Madonna della Cintola
Tempera on panel, 72¹³⁄₁₆ × 86⁵⁄₈ in. (185 × 220 cm)
Accademia, Gallery; inv. 1890: no. 3236
This panel was acquired from the church of Santa Margherita in Cortona.

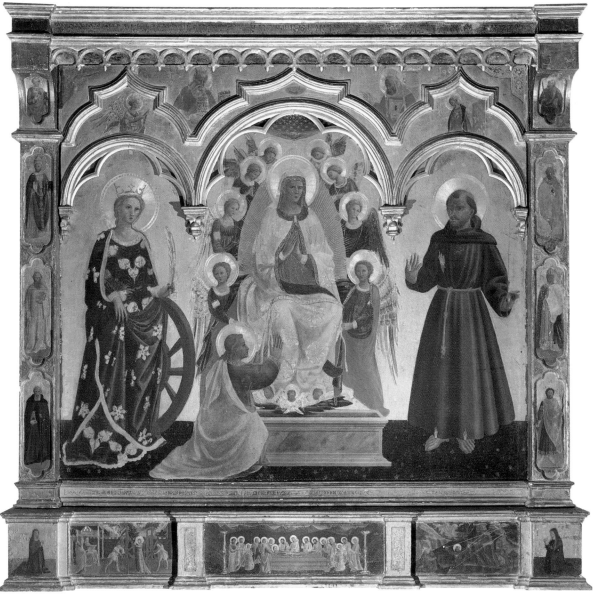

Italian Painting in the Fifteenth Century

Florence in the First Half of the Fifteenth Century

In the panorama of "Renaissance" painting in the first part of the fifteenth century in Florence, an important part was played by Paolo Uccello (1397–1478). A highly cultured artist, Uccello was inscribed in the Company of St. Luke in 1414 and in the Arte dei Medici e Speziali on October 15 of the following year. His artistic sensibilities were nurtured in the late Florentine Gothic era (he was among Ghiberti's collaborators on the north door of the Baptistry), inspiring his knowledge of and passionate interest in perspective in its diverse theories and applications. While working for the most distinguished patrons and institutions (including the cathedral in Florence, the Medici family, and the ducal court at Urbino), Uccello was responsible for substantial developments in this Florentine ambience, though if various anecdotes recounted by Vasari can be believed, some of the paintings he produced must have been quite incomprehensible to his contemporaries. These were largely the result of his learned intellectualism, which led his Aretine biographer to characterize him as a "sophisticated and subtle genius."

However, according to the considerations that attend historical reality, as Vasari tells it, it was the slightly younger Masaccio (born in 1401) who was the first in Florence to translate into purely pictorial terms the new ideas that Filippo Brunelleschi and Donatello expressed in architecture and sculpture in the first and second decades of the century. What was more, he achieved this by "always following when he could the traces left by Filippo and Donato, even though the art was different": thus, Vasari expressed his understanding of Masaccio's essential character and of his attitude toward color effects ("the works he painted had a cohesion and an incisive quality of line"), an appraisal reaffirmed by the recent restoration of the Brancacci chapel.

It is not to be forgotten that Brunelleschi was the first to experiment in this direction, with two "perspectival panels" mentioned in sources and dating most probably around 1420. These panels were intended to illustrate how painting might represent proportionately the measurable depth of spaces.

Masaccio was trained entirely in Florence, between 1417 and 1421, probably in one of the most important workshops of the day, that of Bicci di Lorenzo. This grounding explains the solid technical skills that reinforce his innovative inclination in the *Virgin Enthroned with Saints*, dated April 23, 1422, commissioned by the Florentine Castellani family for the church of San Giovenale in Cascia but perhaps destined for—or at any rate retained for a little while at—San Lorenzo in Florence. This work was the young artist's first important commission as an autonomous "master" of the Arte dei Medici e Speziali (according to the contract of January 7, 1422). His collaboration with his elder, Masolino, which ended only with Masaccio's premature death, probably did not begin until 1424, when Masolino returned to Florence from Empoli after frescoing the Augustinian church, in which there is no trace of Masaccio's style. Thus the *St. Anne Metterza* from the church of Sant'Ambrogio in Florence (now in the Uffizi); the Brancacci chapel frescoes in the Florentine church of Santa Maria del Carmine; the dismantled polyptych in Santa Maria Maggiore in Rome; and perhaps also the frescoes in the Branda Castiglioni chapel in San Clemente, likewise in Rome—all of these represent the joint efforts of Masaccio and Masolino, the latter two in the papal city, where Masaccio died in June 1428.

The resonance of Masaccio's brief activity was such that Florentine painting was influenced by it for several generations. Masaccio was recognized by the most important artistic figures of his time as a patriarch and new founder, as Giotto had been in his day. Vasari, in his life of Masaccio, cites a lengthy series of artists who went to study his frescoes in the Carmine, beginning with Fra Angelico, a few years older than Masaccio himself (and already a recognized master by the second decade of the century), and continuing through Perino del Vaga and Toto del Nunziata, who were active well into the sixteenth century.

In fact, however, the influence of Masaccio's painting style declined after 1430. This change in taste was due largely to the work of Fra Filippo Lippi, a Carmelite monk who was in the Florentine monastery when Masaccio was creating his frescoes. Lippi himself was attentive, in the years preceding the middle of the century, to the continuous increase in depth of the perspectivally luministic planes of the "flattened" style of Donatello and of the Dominican Fra Angelico.

Fra Angelico himself is considered to have been the founder of the devotional current within the humanistic cultural stream that runs through all of fifteenth-century Florentine art. His work, which expressed the most profound instances of religiosity of its time, was much influenced by the Florentine lay confraternities and by the "Tertiary," movements organized by the large mendicant orders. Fra Angelico's painting, which succeeded didactically through his great technical knowledge and his richly cultivated expressiveness, was always underscored by a deeply felt theological doctrine and a fertile Christian spirituality. At the same time, Fra Angelico's work sought a serenely equilibrated religious interpretation and, as such, humanistic element of the evangelical message. When required by the destination or situation of the work, it evoked a noble liturgical sense of ceremony—for example, in the *Linaioli Tabernacle* of 1433, or in the slightly

earlier *Coronation of the Virgin*—that permitted a relationship of benign confidence with the worshipping spectator.

The power of his art greatly impressed Fra Angelico's contemporaries, both artists and patrons. He was the preferred painter of Cosimo de' Medici, and his style was copied by a number of pupil-collaborators, including Zanobi Strozzi, Domenico di Michelino, and, above all, Benozzo Gozzoli, though each of these was known for his own individual technique. Other masters, of very different training, looked to him as a pleasant mediator of a particular way of painting, one whose work was decorative and devotional yet nonetheless "modern" in its artistic expression. Indebted to him were minor artists such as Mariotto di Cristofano and Andrea di Giusto, but also the greatest artists of his and the successive generation, such as Domenico Veneziano and the aforementioned Fra Filippo and Pesellino, Piero della Francesca and Alesso Baldovinetti, and even, in some ways, Luca della Robbia.

Domenico Veneziano, in particular, evolved his own elegantly ornate style out of the lessons taught everyone by Fra Angelico's development of perspectival luminosity. Veneziano's sumptuous and sophisticated style, defined by a completely "modern" concept of design, rendered intelligible plastic forms and spatial systems of every element. This was probably a reflection of the refined and cultivated tastes of the time, which still had religious implications relating to the Medicean court, led by the "pater patriae" Cosimo but dominated as well by the presence of Piero il Gottoso and his wife Lucrezia Tornabuoni. That Veneziano in fact turned to Piero de' Medici can be seen in a letter written from Perugia in 1438, in which the artist requests protection and work, offering his talents "to make marvelous things seen." He accomplished precisely that in the roundel of the *Adoration of the Magi* (now in the Berlin Museum), in which he also painted the portraits of his patron, prominently visible by the side of the young Magus.

In the *Madonna and Child Enthroned with Saints* in the Uffizi, Veneziano's only surviving altarpiece, his stupendous combination of rigorous perspectival construction, luminous color, and extraordinary experimentation in design extend to physiognomic anatomy and to the representation of natural and artificial decorative elements. These details exemplify the artistic tastes of Florence toward the end of the first half of the fifteenth century, when it had been prematurely robbed of the presence of Masaccio, recently of Brunelleschi, and later of Donatello. This refined culture, with its sophisticated elegance, produced such typical fruits as decorated coffers and the beautiful *spalliere*, or bench-backs, painted with mythological and allegorical subjects, of which sources and documents so often speak and which have come to us in great quantity.

To this list of artists should also be added, for a brief period of time, the name of Andrea del Castagno, who in the previous years was seen as the heir to Masaccio's solemn and severe plasticity, best captured in Castagno's frescoes of 1477 for the nuns' refectory at Sant'Apollonia. Castagno's decorations of 1449–1450 in the Villa Carducci in Legnaia, with a series of *Illustrious Men and Women* (now at the Uffizi and at San Piero a Scheraggio), display an elaborate pictorial formation of illusionistic architecture. This work can clearly be seen and was certainly intended, in both its subject matter and its destination, as a move toward an expression of aristocratic decorative valor, a quality that is likewise present in Castagno's paintings of sacred subjects of the same years, represented in particular by the *Assumption* for San Miniato fra le Torri (in the Berlin Museum) and the *Crucifix* for the Confraternity of San Lorenzino in Piano (now in the Santissima Annunziata in Florence). We might place in the same canon the more eclectic Giovanni di Francesco, as well as Masaccio's younger brother Giovanni di Ser Giovanni, called Lo Scheggia, who was above all a pleasing decorator of coffers and home furniture for the most elevated of Florentine households.

Soon after this time, in about 1453, Donatello returned to Florence from Padua and immediately reentered the Medici world, accepting the constant fidelity expressed by Cosimo—who, in Vasari's words, "continuously gave him work"—and coming to undermine the complete trust in the beauty and harmony of the elegant compositions of Domenico Veneziano and Andrea del Castagno. The former's fresco in Santa Croce, depicting *SS. Francis and John the Baptist*, and the latter's *Vision of the Trinity to SS. Jerome, Paula and Eustochium* in the Santissima Annunziata—works that conclude the artistic activity of these two painters prior to their respective deaths in 1461 and 1457—exhibit the transposition of Donatello's later sculptural ideas to the medium of painting. These ideas are expressed in Donatello's *Judith* and in his *Magdalen* and *St. John the Baptist* in the Duomo in Siena, all of them severe images of a mournful and heroic humanity.

Anna Padoa Rizzo

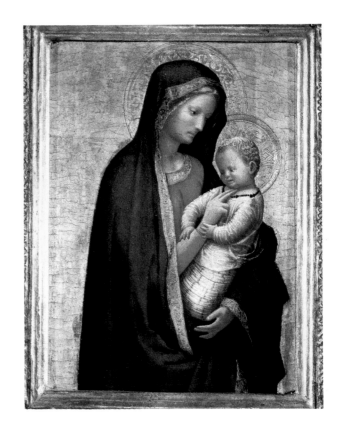

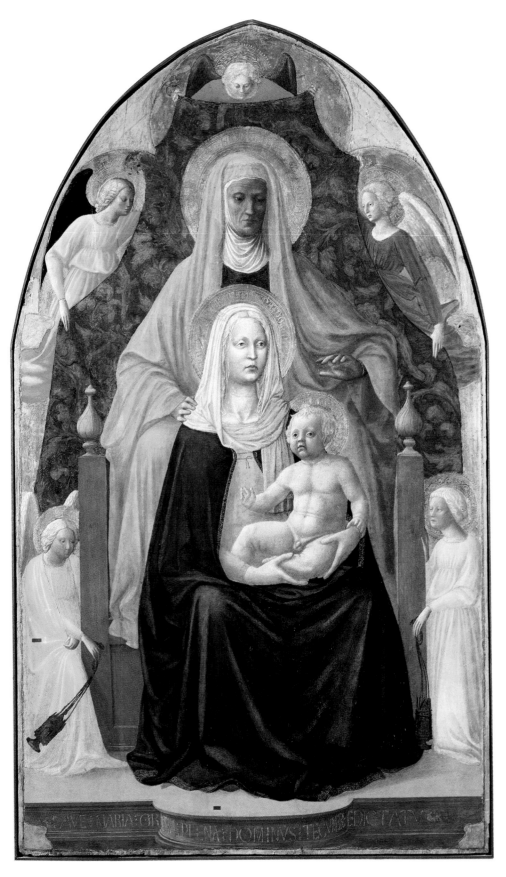

Opposite: 68
MASACCIO
Madonna and Child
Tempera on panel, 9⅝ × 7⅞ in. (24.5 × 18 cm)
Uffizi, Gallery; inv. 1890: no. 9929
This work was likely executed a little after 1426, a date suggested by the cardinal's coat of arms figured on the back. The insignia belonged to Antonio Casini, probably either the patron or the recipient of the painting, who was raised to the status of cardinal on May 26 of that year.

69
MASOLINO and MASACCIO
St. Anne Metterza
Tempera on panel, 68⅞ × 40⁹⁄₁₆ in. (175 × 103 cm)
Inscription: AVE MARIA/S.ANNA È DI NOSTRA DONNA FASTI(GIO)
Uffizi, Gallery; inv. 1890: no. 8386
Datable to around 1424, shortly before Masolino's departure for Hungary, this panel is recorded by Vasari as being in the church of Sant'Ambrogio. According to Roberto Longhi, Masaccio painted the Virgin and Child and the angel at the top right, and Masolino the remainder.

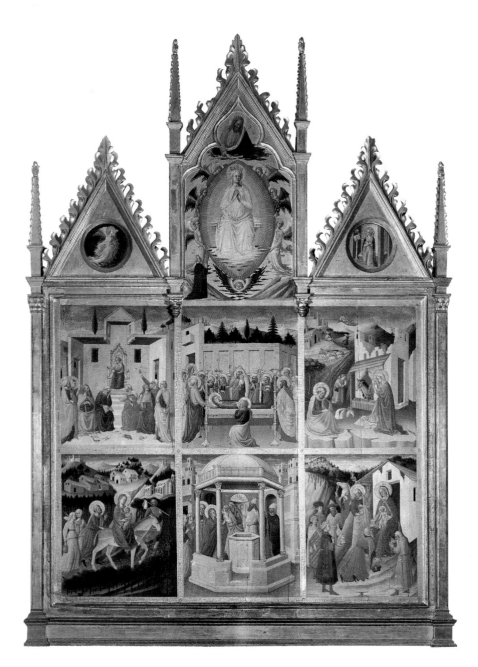

70

MARIOTTO DI CRISTOFANO
Stories from the Lives of Christ and the Virgin
Tempera on panel, 88⁹⁄₁₆ × 68⁷⁄₈ in. (225 × 175 cm)
Accademia, Gallery; inv. 1890: no. 8508
This altarpiece came to the Accademia from the church of Sant'Andrea in Doccia, near Florence, in 1856. Datable to around 1440, it is considered a sensitive reinterpretation of the work of Fra Angelico and of Bicci di Lorenzo, who was probably Mariotto's master.

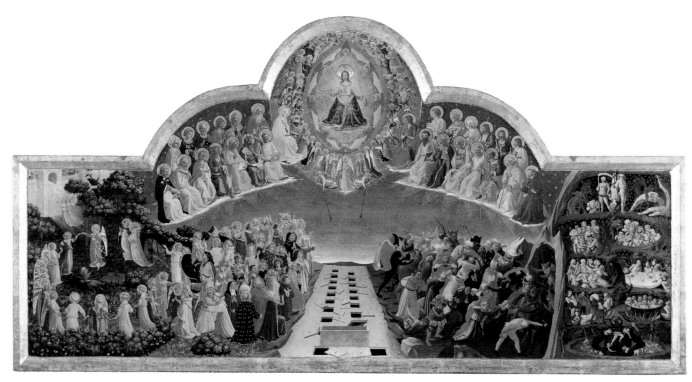

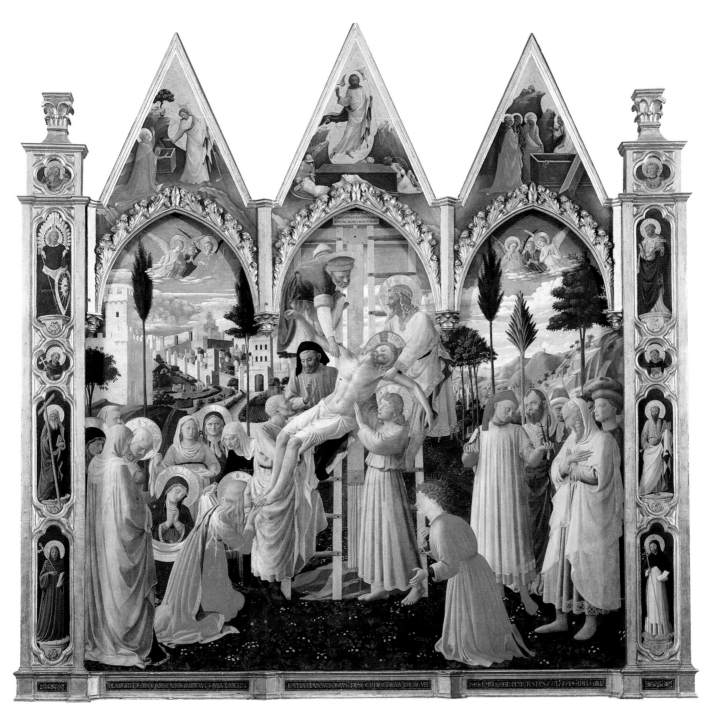

Opposite: 71
FRA ANGELICO
Universal Judgment
Tempera on panel, 41⅜ × 82¹¹⁄₁₆ in. (105 × 210 cm)
San Marco, Museum; inv. 1890: no. 8505
This painting came from the Camaldolensian church of Santa Maria degli Angeli, where it once decorated the upper part of the holy seat for the sung Mass. It dates from sometime after 1431, when the agreement for the construction of the oratory for which it was destined was stipulated.

72
FRA ANGELICO
The Deposition
Tempera on panel, 68⅞ × 72¹³⁄₁₆ in. (175 × 185 cm)
San Marco, Museum; inv. 1890: no. 8509
Originally commissioned from Lorenzo Monaco by Palla Strozzi for the sacristy of Santa Trinita, this painting was left unfinished on Lorenzo's death in 1425, with only the predella and the cusps complete. The work was then turned over to Fra Angelico, who finished it around 1432.

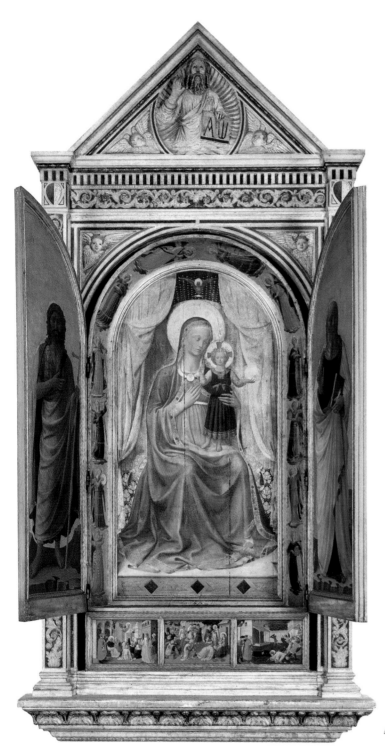

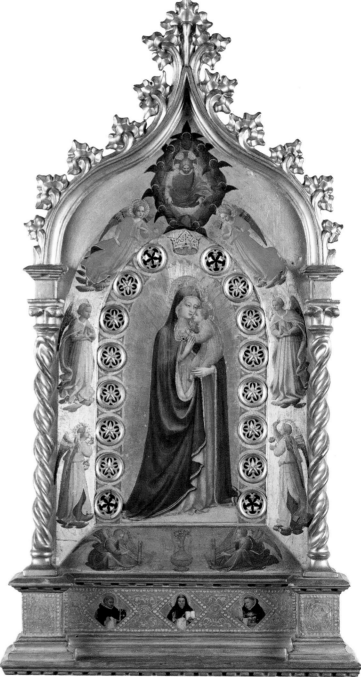

73

FRA ANGELICO
The Linaioli Tabernacle
Tempera on panel, 219¹¹⁄₁₆ × 97¼ in. (558 × 247 cm) (entire work); 114³⁄₁₆ × 69¹¹⁄₁₆ in. (290 × 177 cm) (central part); 18⅛ × 69¹¹⁄₁₆ in. (46 × 177 cm) (predella)
San Marco, Museum; inv. 1890: no. 879

This work was commissioned from Fra Angelico in 1433 for the Florentine Arte dei Linaioli, or linen-weavers' guild, for the fee of 190 gold florins. The wooden frame was made by Jacopo di Pero, called Papero, and the marble decoration was produced by pupils of Lorenzo Ghiberti after one of their master's designs.

74

FRA ANGELICO
Madonna of the Star
Tempera on panel, 33¹⁄₁₆ × 20¹⁄₁₆ in. (84 × 51 cm)
San Marco, Museum; inv. San Marco e Cenacoli: no. 274

This reliquary-tabernacle and three others were commissioned from Fra Angelico by Fra Giovanni Masi for the church of Santa Maria Novella. The latest possible date for the panel is thus 1434, the year of Masi's death.

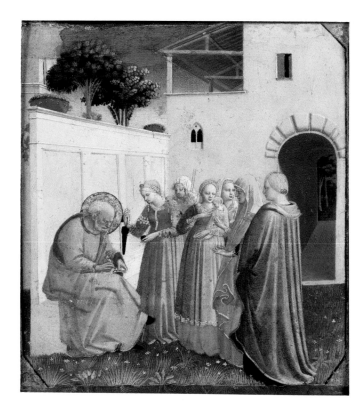

75
FRA ANGELICO
The Naming of the Baptist
Tempera on panel, 10¼ × 9⁷⁄₁₆ in. (26 × 24 cm)
San Marco, Museum; inv. 1890: no. 1499
While it was believed that this section of the predella, which dates from before 1435, was once part of the *Coronation of the Virgin* painted for Santa Maria Nuova, it in fact seems to have more in common with another fragment of identical dimensions, *St. James the Greater Liberating Ermogene*, now in the Kimbell Museum in Fort Worth, Texas.

76
LO SCHEGGIA
The "Adimari" Cassone
Tempera on panel, 34⁷⁄₈ × 119⁵⁄₁₆ in. (88.5 × 303 cm)
Inscription: O PICCINA/ODI VERAM/VENATIS AMORIS
Accademia, Gallery; inv. 1890: no. 8457
Once thought to have been the front of a chest celebrating the marriage of Lisa Ricasoli and Boccaccio Adimari, which took place on June 22, 1420, in reality, it dates from around 1440–1445.

77
LO SCHEGGIA
A Game of Civettino
Tempera on panel, 23¼ in. (59 cm) in diameter
Palazzo Davanzati; inv. 1890: no. 488
This work, perhaps originally part of a decoration for a coffer or a bench-back, was likely turned into a tondo at the end of the eighteenth century. The costumes worn by the spectators suggest a composition date around the middle of the fifteenth century.

Overleaf: 78
PAOLO UCCELLO
The Battle of San Romano
Tempera on panel, 71¹¹⁄₁₆ × 127³⁄₁₆ in. (182 × 323 cm)
Signed: PAULI UGIELI OPUS
Uffizi, Gallery; inv. 1890: no. 479
This famous panel has two companion pieces by Uccello, one in the collection of the National Gallery in London and the other in the Louvre, in Paris. It was probably produced sometime after 1432 (the year the Battle of San Romano took place), for the old Florentine home of Cosimo de' Medici, and transferred soon after to the new family palace on the Via Larga.

79
DOMENICO VENEZIANO
Madonna and Child Enthroned with SS. Francis, John the Baptist, Zenobius, and Lucy
Tempera on panel, 82⁵⁄₁₆ × 85¹⁄₁₆ in. (209 × 216 cm)
Signed: OPUS DOMINICI DE VENETIIS HO MATER DEI MISERERE MEI . . . DATUM EST
Uffizi, Gallery; inv. 1890: no. 884
Painted for the Florentine church of Santa Lucia dei Magnoli between 1445 and 1450, this
altarpiece combines scientific rigor in its perspectival planning with a sweetness of coloring
enlivened by the brightness of daylight.

80
FILIPPO LIPPI
The Coronation of the Virgin
Tempera on panel, 78¾ × 113 in.
(200 × 287 cm)
Inscription: IS PERFECIT OPUS
Uffizi, Gallery; inv. 1890: no. 8352

This painting was executed for the
high altar of the church of
Sant'Ambrogio in Florence; its pa-
tron was Canon Francesco Ma-
ringhi. Begun in the middle of
1441, it was finished in 1447 and
paid for by the canon's nephew
Domenico Maringhi, whose por-
trait appears to the right of the fig-
ure of John the Baptist.

81
FILIPPO LIPPI
*Madonna and Child with Stories of
the Life of St. Anne*
Tempera on panel, 53⅛ in. (135
cm) in diameter
Pitti, Palatine Gallery; inv. 1912:
no. 343

This tondo, commissioned by the
Florentine Leonardo Bartolini, was
not yet finished when Lippi began
the frescoes in the choir of the ca-
thedral at Prato in 1452. The back-
ground depicts the birth of the
Virgin and the meeting between
Joachim and Anne.

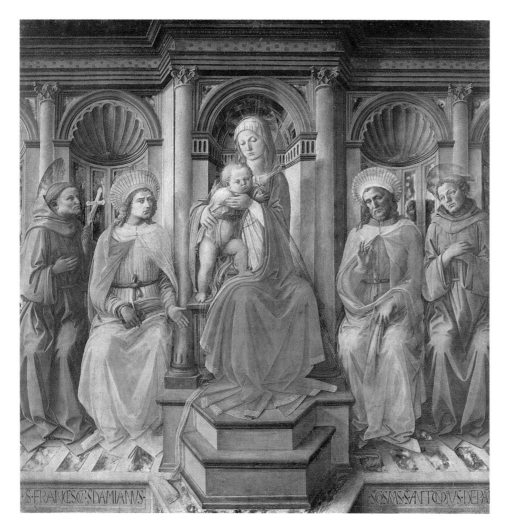

82

FILIPPO LIPPI
Madonna Enthroned with Four Saints
Tempera on panel, 77³⁄₁₆ × 77³⁄₁₆ in.
(196 × 196 cm)
Inscription: S.FRANCISCUS.
S.DAMIANUS.S.COSMUS.S.ANTONIUS.
DE PADU(VA)
Uffizi, Gallery; inv. 1890: no. 8354
Commissioned by the Medici between 1442 and 1450 for the altar of the Noviziato chapel in Santa Croce, this panel was paired with a predella by Pesellino, since separated from the painting and now in several parts, at the Uffizi and the Louvre.

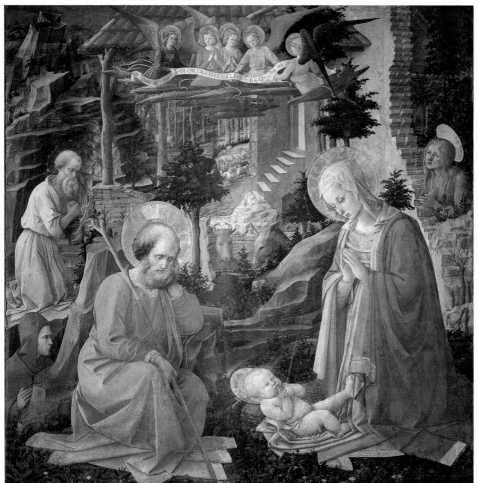

83

FILIPPO LIPPI
The Adoration with SS. Joseph, Jerome, Mary Magdalen, and Ilarion
Tempera on panel, 53¹⁵⁄₁₆ × 52¾ in.
(137 × 134 cm)
Inscription: GLORIA.INECELSIS.
DEO/S.ILARIONE
Uffizi, Gallery; inv. 1890: no. 8350
Believed to have been painted around 1453 for the Florentine convent of Annalena. The figure of St. Ilarion is supposed to be a portrait of the hermit Ruberto Malatesta, brother of Annalena, founder of the convent. The composition includes some pervasive Gothic elements, in the surreal and fantastic landscape and in the flowering bank upon which the holy group is seated.

84

FILIPPO LIPPI
Madonna and Child with Angels
Tempera on panel, 37⅜ × 24⅜ in. (95 × 62 cm)
Uffizi, Gallery; inv. 1890: no. 1598

On the basis of its style, this is thought to be a later work by Lippi, dating from between 1457 and 1465. It has been suggested that it was a gift from Lippi to Giovanni de' Medici and that the Madonna and Child are modeled on Lucrezia Buti and the little Filippino.

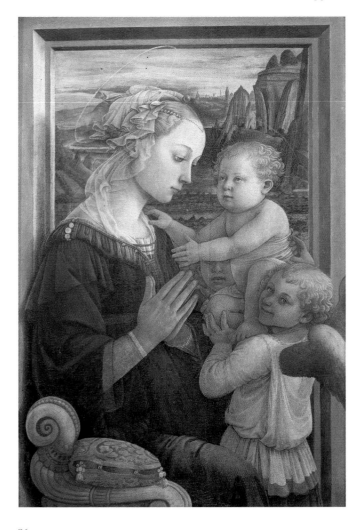

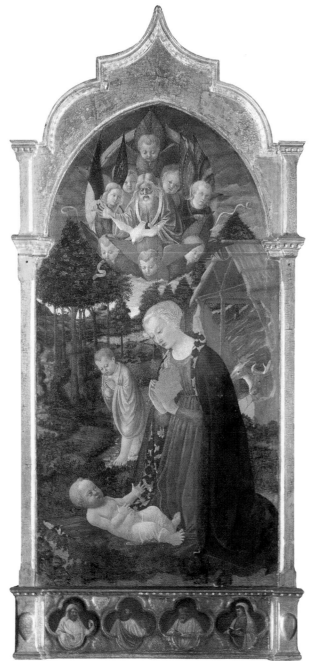

86

PESELLINO
Stories of Saints
Tempera on panel, 12⅝ × 56⁹⁄₁₆ in.
(32 × 144 cm)
Uffizi, Gallery; inv. 1890: no. 8355

Believed to have been executed around 1445 as a predella for Lippi's painting for the Medici for the Noviziato chapel in Santa Croce. The two narrative scenes on the left are now owned by the Louvre.

85

MASTER OF THE CASTELLO NATIVITY
Adoration of the Child
Tempera on panel, 83⁷⁄₁₆ × 37 in. (212 × 94 cm)
Inscription: ISAIC(A)
Accademia, Gallery; inv. depository: no. 171

The two shields on the sides of this predella (now illegible) once displayed the Medici and Tornabuoni coats of arms, which suggests that the work may have been commissioned by Piero il Gottoso and his wife, Lucrezia. It dates from around 1460 and came from the Medici villa at Castello.

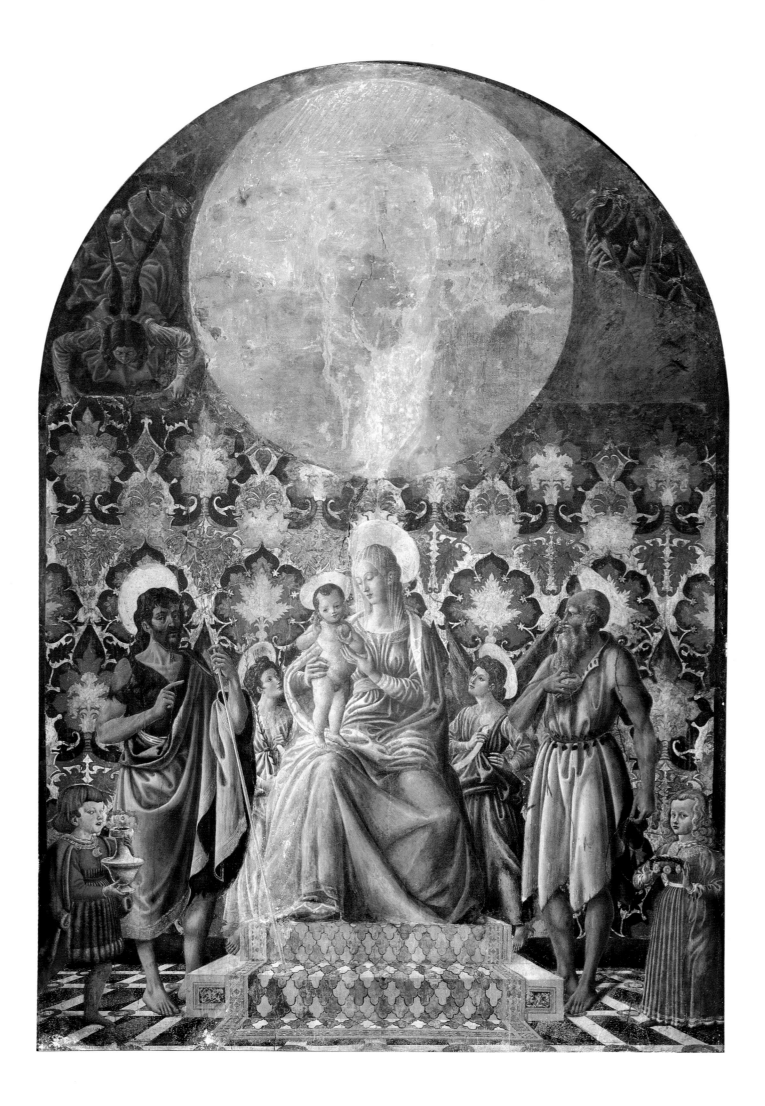

88, 89 and 90
ANDREA DEL CASTAGNO
The Cumaean Sibyl
Fresco transferred to canvas, 98⁷⁄₁₆ × 60⁵⁄₈ in. (250 × 154 cm)
Inscription: CVMA(NA) QUE PROPHETAVIT ADVENTVM (CHRISTI)
Uffizi, Gallery (church of San Piero a Scheraggio); inv. San Marco
e Cenacoli 1915: no. 170
Farinata degli Uberti
Fresco transferred to canvas, 98⁷⁄₁₆ × 60⁵⁄₈ in. (250 × 154 cm)
Inscription: DOMINVS FARINATA DE VBERTIS SUE PATRIE
LIBERATOR
Uffizi, Gallery (church of San Piero a Scheraggio); inv. San Marco
e Cenacoli 1915: no. 172
Pippo Spano
Fresco transferred to canvas, 98⁷⁄₁₆ × 60⁵⁄₈ in. (250 × 154 cm)
Inscription: DOMINVS PHILIPPVS HISPANVS DE SCHOLARIS
RELATOR VICTORIE THEVCRO(RVM)
Uffizi, Gallery (church of San Piero a Scheraggio); inv. San Marco
e Cenacoli 1915: no. 173
Executed around 1450 for the loggia of the Villa Carducci at Le-
gnaia, these frescoes were once part of a cycle of nine paintings
depicting three leaders of troops, three women, and three scholars.

Opposite: 87
ANDREA DEL CASTAGNO
*Madonna and Child with Angels, SS. John the Baptist and Jerome, and
Two Youths from the Pazzi Household*
Detached fresco, 114³⁄₁₆ × 83⁷⁄₁₆ in. (290 × 212 cm)
Pitti, Meridiana (temporary placement); inv. Contini Bonacossi:
no. 2
This fresco surmounted the altar of the chapel in the Trebbio
Castle. It has been given a date of around 1443 based on the ages of
the twins Niccolò and Oretta Pazzi, who were born in 1437 and are
portrayed here.

Florence in the Second Half of the Fifteenth Century

Florentine painting at the opening of the second half of the fifteenth century is characterized, as are the other arts, by the expansion of a courtly, cultivated, and refined taste, one that was in addition extremely varied. This era, whose finest moments came between the end of the 1460s and the beginning of the 1470s, had as its protagonists Filippo Lippi, Benozzo Gozzoli, and Alesso Baldovinetti, three artists dear to the Medici, who, in their generosity, endowed them with commissions and granted them protection. Shortly after the middle of the century, the first two were entrusted with the pictorial decoration of the private chapel in the Medici family's new palace on the Via Larga. For the altarpiece Lippi executed a *Nativity* (today in Berlin) rich in its symbolism of the Virgin adoring the Child, a schema that became almost exclusive to Florence around 1420 as word spread of the mystic "visions" of Bridget of Sweden. Gozzoli, for his part, was working in the chapel as of July 1459. His depiction of the procession of the Magi and their followers unfolds in a sumptuous parade, one that clearly resembles a real cortege. It was certainly inspired by parades organized for the Feast of the Epiphany by the Confraternity of the Magi, which was resident at San Marco and protected by the Medici. The beauty of the damasked or embroidered materials, of the furnishings and ornamentation, were all lovingly reproduced by Gozzoli, who had a deep appreciation for masterly workmanship and a great understanding of the refined tastes for which it was intended. Gozzoli was always interested in the meticulous process of artistic manufacture; he availed himself of the quality of the material employed, and of his painter's technical ability, and because of this he was a renowned master "in muro." He created a decoration that was not only phantasmagoric but serenely well balanced and perfectly integrated into Michelozzo's splendid architectural surroundings.

As for Baldovinetti, the Medici family commissioned from him, at around the same time, a painting for the altar of their private chapel in the Villa Cafaggiolo (now in the Uffizi). It is an elegant masterpiece that displays a luministic and chromatic equilibrium, humanistically uniting a naturalism of proportion with the representation of abstract, detached things "existing" in images, lucid as fragile crystal.

It was not, we believe, chance or, even worse, a lack of esteem in his hometown that took Filippo Lippi first to Prato for a lengthy stay, from 1452 to 1465, for the fresco decoration of the major chapel in the Duomo (a collaborative effort by Lippi, his alter ego Fra Diamante, and other minor workshop assistants) and then to Spoleto, in 1467–1469, for the frescoing of the apse of the cathedral there, completed, after Lippi's death, by Fra Diamante with the young Filippino and the collaboration of Pier Matteo d'Amelia. Benozzo Gozzoli, after finishing the Magi chapel and some other important works doubtless obtained through the favor and protection of the Medici, went first to San Gimignano (in 1464–1467) and then to Pisa (in 1468–1494) to fresco the north wall of the Camposanto and to execute other pictorial commissions. In this atmosphere of calculated Medicean "politicized culture," Benozzo Gozzoli was able to contribute to the confirmation of a Florentine hegemony that would dominate not only the artistic field but also the political one, over subject territories (particularly those that had the most autonomous tendencies) and even other states—such as those of the papacy—with whom Florence maintained a relationship that varied from the more-or-less friendly to the downright hostile).

The frescoes by Lippi at Prato and those by Gozzoli in the Magi chapel and in the choir of San Agostino in San Gimignano (executed in 1464–1465), along with the pictorial decorations by Baldovinetti and the Pollaiolo brothers in the chapel of the Cardinal of Portugal in San Miniato al Monte (1464–1466), testify to the heights that painting achieved in expressing the monumental and ornamental tendencies of those years. This direction was taken particularly in response to the taste of Piero il Gottoso, but also to that of Giovanni de' Medici and of other great Florentine families associated with the Medici.

The 1470s were dominated by the personality of Lorenzo the Magnificent, who became, in practice, patron of the city after the death of his father, Piero, in 1469. Within his complex personality there coexisted diverse elements determined both by his family background (evident in his deep involvement in many important lay confraternities and also in the "flagellant" orders such as those of San Domenico, called "del Bechella," into which he was initiated at the end of 1467—certainly not only so as to be better able to control their activity) and by his profoundly humanistic culture. He granted protection to Verrocchio and his flourishing workshop and to the competing, if not rival, one of the Pollaiolo brothers as Lorenzo was also interested, even through his paternal inheritance, in what were considered to be the "minor" arts. His predilection for these workshops of goldsmithry as well as sculpture and painting, all characterized by a very high level of quality, is quite understandable.

The workshop of Verrocchio, around 1470, was perhaps the liveliest, the most exciting, and the most modern center of artistic activity in the entire city. Working alongside the master was Lorenzo di Credi, Verrocchio's principal disciple and collaborator, who inherited the workshop on his mentor's death (1488). Also in Verrocchio's shop was Leonardo da Vinci, who developed, with the most sublime success, a style of cultivated naturalism, wedded to a willingness to experiment with technique and a desire to probe the psychology of holy and historical figures. But even more innovative were Leonardo's fascinating research into spatial concepts of movement and his ideas concerning the pictorial surrender to a concept according to which atmosphere can be described as a "medium" through which forms of greater plasticity may evolve.

The masterpieces of Leonardo's Florentine phase, along with those of small dimensions, are of incalculable value in the search for a new pictorial language. These include *Ginevra de' Benci* (in the National Gallery of Art in Washington, D.C.), the *Virgin of Garofano* (at the

Alte Pinakothek in Munich), the *Benois Madonna* (at the Hermitage in St. Petersburg), the *Annunciation* for San Bartolomeo at Monteoliveto, and the unfinished *Adoration of the Magi* for the monastery of San Donato a Scopeto, at the Uffizi. These last two pictures were executed at significant moments in Leonardo's career, one at the beginning and one at the end of his formative period in Florence; they are perfectly illustrative of the contribution made by the genius of Leonardo to the artistic culture of the city.

Through Verrocchio's workshop there also passed, as collaborators or as "friends," for varying periods of time, such artists as the young Perugino, who contemporary sources and documents suggest was trained in Florence. For his part, Sandro Botticelli appears on the basis of his artistic style to have come to Verrocchio quite early in his career, after being apprenticed to Filippo Lippi, a little after 1475. Out of the lessons that Botticelli learned from Fra Filippo, and from his relationship with Verrocchio's workshop, in around 1470, came one of the Uffizi's most beautiful paintings, the recently restored *Madonna and Child Enthroned with SS. Mary Magdalen, Catherine of Alexandria, John the Baptist, Francis, and Cosmas and Damian.* Perhaps one can see in this, Botticelli's first altarpiece, in the presence of Saints Cosmas and Damian, the suggestion of a relationship with the Medici. It is a work of great importance, as well, for our understanding of the artistic development of the very young Filippino Lippi, who was documented as working with Botticelli in 1472, at the age of fifteen, but who may have been at his side for a year or two before that, following the death of his father's collaborator Fra Diamante, as related by Vasari.

Francesco Botticini was a painter of more modest stature, but one who was nonetheless extremely talented and much celebrated in his lifetime. Botticini would have entered Verrocchio's workshop as a collaborator. His works from around 1470 and a little after are of the highest quality ever produced by him; they exhibit Botticini's interest in the fully developed plasticity of Verrocchio's style. Botticini's precisely defined contours, fabrics, and ornamentation are reproduced as illusionistically as possible, much as a goldsmith or "tinsel maker" would work. It is enough simply to think of Botticini's *Tobias and the Three Archangels,* in the Uffizi, or the *Crucifixion and Saints,* of 1475, now destroyed, that was once in Berlin, or the sumptuous and monumental *Tabernacle of St. Sebastian* in the Museo della Collegiata in Empoli, painted at about the same time.

Lorenzo de' Medici must have appreciated the unrestrained and refined elegance of Antonio Pollaiolo, an elegance that was sustained by an inexhaustible inventiveness, a harmonious sense of design, and a superb technical ability that could be seen in goldsmithing and sculpture as well as in painting. For the Medici family, Antonio executed three large *Labors of Hercules,* now lost, two of which are recorded in small surviving replicas in the Uffizi. Other extremely important civic works by Pollaiolo, such as his embroidered tapestry of St. John (now in the Museo dell'Opera del Duomo in Florence), could not have come into being without the explicit consent of the Medici family. The dynamic linearism that Antonio Pollaiolo experimented with, a product of Donatello's influence combined with the "prehensile" design of Maso Finiguerra, is wholly evident in the luminous plasticity of his forms. This quality emanates from the fresh liberality of his environment, which can be glimpsed in his narrative scenes but is apparent, as well, in his drawings and signed portraits, where the "place" is never entirely defined.

If, then, it was this aspect of naturalism, with its suggestion of the antique, that Lorenzo admired in the work of Antonio, he must have been somewhat put off by the more rigid and severe taste of Piero Pollaiolo as manifested in such personal masterpieces as the *Annunciation,* in the Berlin museums, and the *Coronation* of 1483, in the church of Sant'Agostino in San Gimignano.

From another perspective, the workshop of Ghirlandaio should be understood within the context of the political implications of Lorenzo's personal taste. Domenico Ghirlandaio was assisted in his shop by his brothers David and Benedetto and his brother-in-law Bastiano Mainardi; additionally, the studio was full of collaborators and assistants at various levels, among them the young Granacci and Michelangelo Buonarroti himself.

Domenico, with his comprehensive grasp of technical skills, consciously upheld the highest standards of the Florentine pictorial tradition. His predilections for fresco (in which he excelled), for great centralized, perspectival plans, and for simple monumentality and a "positive" narrative method that was both clear and detailed—all of these represented the incarnation of Florentine art in its need for rationality and dignity as it was perceived from the time of Giotto onward.

A passionate interest in Northern art, already present in Florentine painting since the time of Fra Angelico and Filippo Lippi, turned to the monumentality and plasticity of Hugo van der Goes, exemplified by his masterly *Adoration of the Shepherds* executed for the Portinari family and placed on the high altar of the church of Sant'Egidio on May 28, 1483. At the same time Hans Memling's pious intimacy and sweet sentimentality must have influenced Filippino Lippi and certainly his pupil Raffaellino del Garbo.

In the late 1470s and the 1480s, the pictorial climate of Florence was dominated, above all, by the amazing personality of Sandro Botticelli. This "most excellent painter on panel and wall," as he was described around 1490 by an envoy of the duke of Milan, was ranked in first place on the same writer's list of the best Florentine artists of the time, with particular regard to their ability in fresco. In fact, Botticelli was, along with Ghirlandaio (and Cosimo Rosselli, who was added, later, it seems), affiliated with the Umbrian masters who were then decorating the walls of the Sistine Chapel in Rome (1481–1482), as once again Florentine art was used as a means to establish political relations.

While characteristic of the humanistic cultural climate of the day, those works by Botticelli that were destined for the Medici family and other prominent Florentine patrons close to them testify to the narrowness of the distinction between art and politics during the Laurentian

period. This notion is clearly visible in three famous mythological-allegorical paintings in the Uffizi: the *Pallas*, the *Birth of Venus*, and the *Primavera*, executed for Lorenzo di Pierfrancesco de' Medici, cousin of Lorenzo the Magnificent. The same may be said of the *Adoration of the Magi*, also in the Uffizi, painted sometime before 1478 for the chapel of Gaspare di Zanobi del Lama in Santa Maria Novella.

The complex and fascinating art of Filippino Lippi, the son of Fra Filippo and a pupil of Botticelli, held great appeal for the majority of patrons of his day. Lorenzo put his faith in the young artist Lippi, and perhaps even had a particular preference for him, as it was Lippi who was chosen to decorate the villa at Spedaletto, near Volterra, and then that at Poggio a Caiano, the patron's favorite retreats.

Alongside these outstanding figures were a group of artists of lesser talents who nonetheless worked quickly and capably, with workshops that catered to the tastes and demands of both private and public clienteles, which were differentiated through culture and census. Such artists as Neri di Bicci, Jacopo del Sellaio, Domenico di Michelino, Domenico di Zanobi, Bernardo di Stefano Rosselli, and Bartolomeo di Giovanni—along with many others whose identities and careers are still being reconstructed—were dedicated to decoration "of the highest degree," which was applied to such items as caskets, coffers, birth and matrimonial salvers, and bench-back panels. These artists have left ample traces of their professional lives; even if much of their artistic output has been lost, enough remains to serve as testament to the high regard in which art, and particularly painting, was held in Florentine Renaissance society.

The crisis that pervaded this society in the last decades of the fifteenth century—not only a political crisis but above all a spiritual one—had important consequences for art. Savonarola's fierce voice was a catalyst in this context, one whose importance has perhaps not even yet been fully interpreted. There are certainly profound differences in style and sentiment between Botticelli's masterpieces of the 1470s and 1480s and his later works, such as *The Calumny* or the Fogg *Crucifixion* and other panels of the same period. In the allegorical subjects, as in the religious themes, there lacks that feeling of harmony and humanism, a sense of man in the world, which yields to an atmosphere of laceration, of insubstantiality and pain. In the "religious" works, the pictorial material is leaner, more severe, with eloquent gesticulations that more often than not express what seem to be human emotions behind tragic masks, alluding to a revealed attraction as if in a calculated desire to imitate the "sacred representations" of that period. And indeed, Savonarola's preaching encouraged a kind of devotional theater that had great recourse to gestures, eloquent tones, and crude supplications, all evident in sacred images of this time.

Then, too, there was an even deeper rapport between contemporary "theater" and art, an overlap that included complex scenographic ephemera, in the form of designs constructed by artists for festivals, parades, and visits by important personages. To this festive tradition belong the frescoes produced by Filippino Lippi for the chapel of Filippo Strozzi in Santa Maria Novella, finished in 1502. These works may be read as preludes to the marvelous hallucinatory fantasies of the first Florentine mannerists, painted in the third decade of the sixteenth century.

Among the artists who remained impressed by Savonarola's predictions was Benozzo Gozzoli, who was moreover committed to the reformed Dominican order, in particular at the convent of San Marco, through his master Fra Angelico. In his most extreme works, notably those executed in Pistoia for Bishop Pandolfini (*The Deposition from the Cross*, in the Museo Horne in Florence, and *The Raising of Lazarus*, of 1497, in the National Gallery in Washington, D.C.), this elderly master shows a profound adherence to the grave spirituality and emotion that pervaded Savonarola's impassioned sermons, which were collectively, and without residue, fashioned into a social "Christian humanism." His intentions were reiterated by Vasari, who insisted that Gozzoli was not only one of the most learned of the great professional painters but also one of the most moral. This righteous voice, humanistic in its tone and authentic in its religiosity (even before Savonarola) in Renaissance Florence, resonated in the pulpits of the Dominican "preacher brethren" who came together in the first half of the fifteenth century through the devoted and contemplative imagery of Fra Angelico, founder of the "Christian way" in Florentine art. Following Angelico's example, artistic humanism allied itself with the various theoretical movements, known as the "Christian humanism," first of Dominici, then of St. Antoninus the Bishop, of Nesi and of Benivieni, right up to Savonarola. The origins of this austere religiosity, which found its most direct expression in the many lay confraternities of Florence, can be traced back to Peter of Verona, known as St. Peter Martyr, the Dominican who lived in Florence in the thirteenth century. In many instances, the art that typifies this tendency may be associated with confraternity purchases, traditional acts of devotion. Among those commissioned to produce such works was Cosimo Rosselli, the best-known member of a family of Florentine artists; he was active in the fields of architecture, painting, the making of miniatures, and engraving.

Rosselli was the author of a great number of paintings in fresco and on panel, most of them of very large size, a testament to the high regard in which his monumental art was held by patrons. He worked mostly for the confraternities and may have produced his *Adoration of the Magi* in the Uffizi (c. 1470) for the great brotherhood of the same name whose seat was in San Marco and was protected by the Medici.

Rosselli's other artistic activity in the 1490s was destined for important families in Savonarolian Florence, such as the Salviati, for whom Cosimo interpreted sacred subjects with a profound theological doctrine and a rigorous severity. His complex workshop served as training ground for such important artists as Piero, called "di Cosimo" because of his lengthy apprenticeship and his master's affection for him (recorded by Vasari); Andrea "di Cosimo" Feltrini, a specialist in decoration and "grotesques"; Fra Bartolomeo, heir to Rosselli's moral rigor;

and probably the brothers Donnino and Agnolo di Domenico "del Mazziere," artists of elevated traditional tastes who produced the group of paintings once assigned to the Master of Santo Spirito and who were, according to Vasari, great friends with Rosselli. All of these were artists of the highest level, each in his own way a significant protagonist in the passage from one century to another in the history of Florentine painting.

Anna Padoa Rizzo

91
DOMENICO DI MICHELINO
Tobias and the Three Archangels
Tempera on panel, 66¹⁵⁄₁₆ × 66 ¹⁵⁄₁₆ in. (170 × 170 cm)
Accademia, Gallery; inv. 1890: no. 8624
The merchant Michele di Corso delle Colombe commissioned this work between 1468 and 1475 for the altar of the chapel of Santa Felicita in Florence to invoke the protection of the three archangels over Corso's young son, depicted in the figure of Tobias.

92
ALESSO BALDOVINETTI
Madonna and Child with Saints
Tempera on panel, 69⁵⁄₁₆ × 65⅜ in. (176 × 166 cm)
Uffizi, Gallery; inv. 1890: no. 487
This work, which once decorated the chapel of the villa of Cafaggiolo, was probably executed around 1454 to celebrate the birth of Giuliano, brother of Lorenzo the Magnificent. It depicts the figures of Saints Cosmas and Damian, the protectors of the Medici family.

81

93
ALESSO BALDOVINETTI
The Annunciation
Tempera on panel, 65¾ × 53¹⁵⁄₁₆ in. (167 × 137 cm)
Uffizi, Gallery; inv. 1890: no. 483
Painted around 1457 for the church of the Salvestrini fathers of San Giorgio sulla Costa,
this panel, with its limpid coloring and clear perspectival approach, represents a compre-
hensive assimilation of the ideas of Domenico Veneziano and Fra Angelico.

94 and 95
ANTONIO POLLAIOLO
Hercules and Antaeus
Oil on panel, 6⁵⁄₁₆ × 3⁹⁄₁₆ in. (16 × 9 cm)
Uffizi, Gallery; inv. 1890: no. 1478
Hercules and the Hydra
Oil on panel, 6¹¹⁄₁₆ × 4¾ in. (17 × 12 cm)
Uffizi, Gallery; inv. 1890: no. 8268
These small panels reproduce the subjects of two of the three lost works comprising the *Labors of Hercules*, painted in collaboration by the brothers Pollaiolo in 1460 for the Palazzo Medici on the Via Larga. The Uffizi studies are by Antonio and likely date from around 1470.

96
ANTONIO AND PIERO
POLLAIOLO
SS. Vincent, James, and Eustace
Tempera on panel, 67¾ × 70⁷⁄₁₆ in. (172 × 179 cm)
Uffizi, Gallery; inv. 1890: no. 1617
This painting once decorated the altar of the chapel of the cardinal of Portugal in San Miniato al Monte. It is thought to have been a collaboration between the two brothers—as is indicated in a payment dated 1466—with Piero doing most of the actual painting, following Antonio's design.

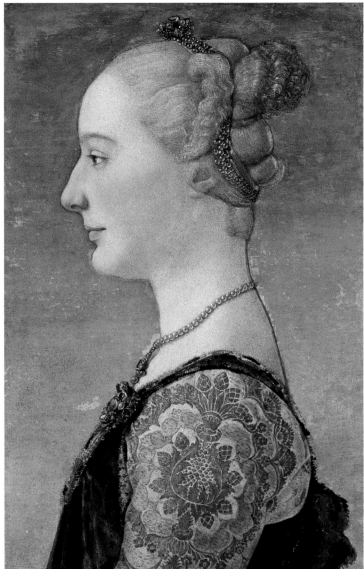

97
PIERO POLLAIOLO
Portrait of Galeazzo Maria Sforza
Tempera on panel, 25⅝ × 16⁹⁄₁₆ in. (65 × 42 cm)
Uffizi, Gallery; inv. 1890: no. 1492
This painting is mentioned in the 1492 inventory of the Palazzo
Medici on the Via Larga, where it hung in Lorenzo's chamber. It is
listed therein as the work of Piero Pollaiolo, an attribution accepted
by scholars. This portrait was probably executed on the occasion of
Galeazzo Sforza's visit to Florence in 1471.

98
PIERO POLLAIOLO
Portrait of a Woman
Tempera on panel, 21⅝ × 13⅜ in. (55 × 34 cm)
Uffizi, Gallery; inv. 1890: no. 1491
This picture can be attributed to the hand of Piero Pollaiolo
through contemporary sources that emphasized his noteworthy ca-
pabilities in portraiture. It dates from around 1480.

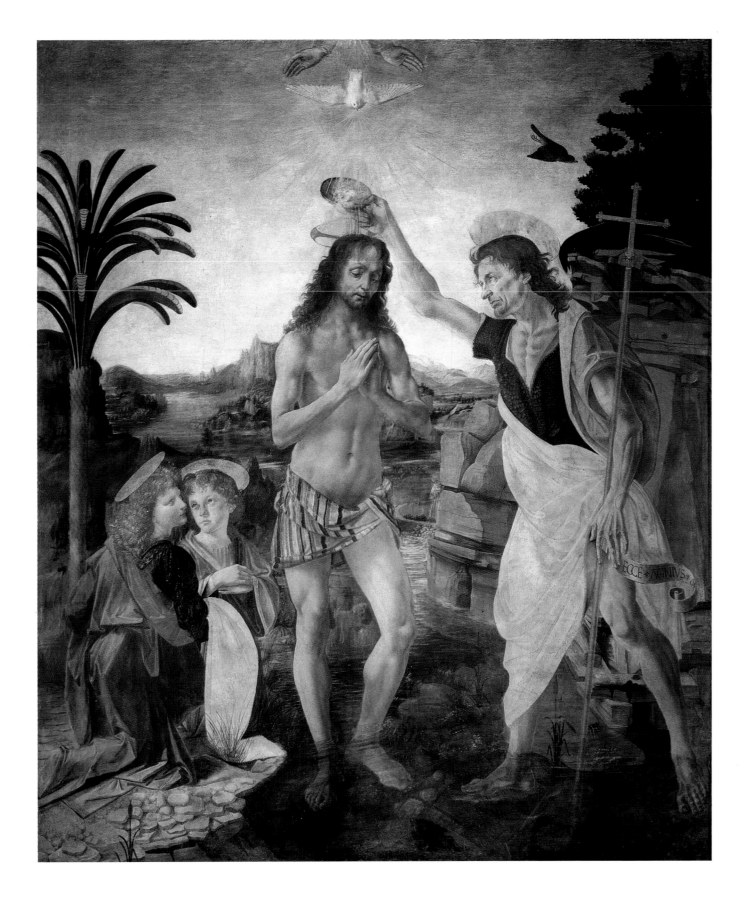

99
ANDREA DEL VERROCCHIO and WORKSHOP
The Baptism of Christ
Oil and tempera on panel, 69¹¹/₁₆ × 59⁷/₁₆ in. (177 × 151 cm)
Uffizi, Gallery; inv. 1890: no. 8358

In this painting, commissioned from Verrocchio (the author of the figure of the Baptist and the landscape on the right) by the monks of San Salvi, one can also detect the hand of Leonardo (in the angel on the left, in the left background, and in the repainting of Christ), that of a third, unknown painter (the upper part, with God the Father), and perhaps even that of Botticelli. The commission was probably completed around 1478–1480.

100
LEONARDO DA VINCI
The Annunciation
Oil and tempera on panel, 38⁹⁄₁₆ × 85⁷⁄₁₆ in. (98 × 217 cm)
Uffizi, gallery; inv. 1890: no. 1618
This work, from the church of San Bartolomeo at Monteoliveto, is
known to have been painted during the artist's youth (around 1470).
The carved design of the Virgin's lectern is derived from that of the
Medici tomb by Verrocchio in the old sacristy in San Lorenzo.

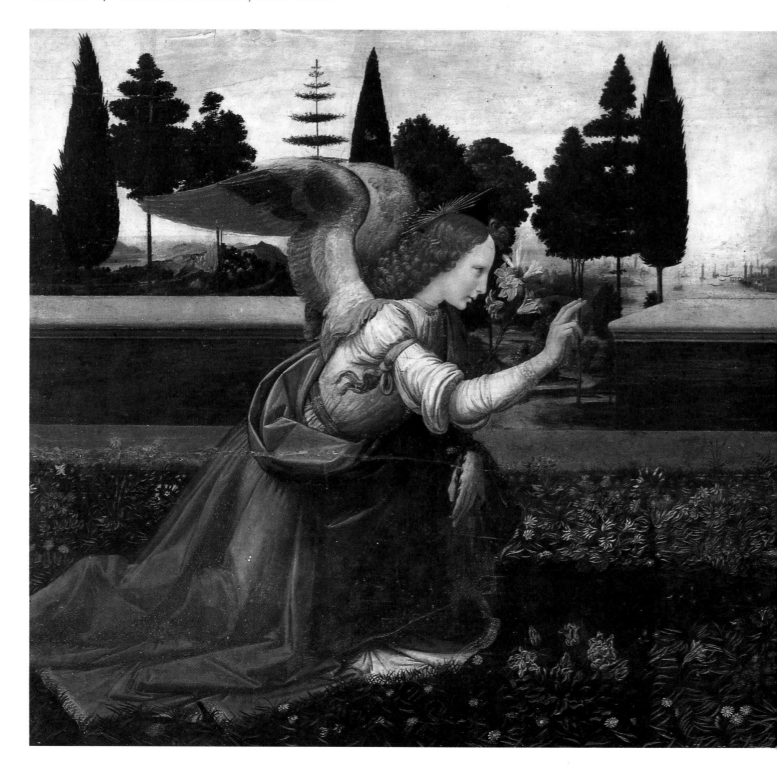

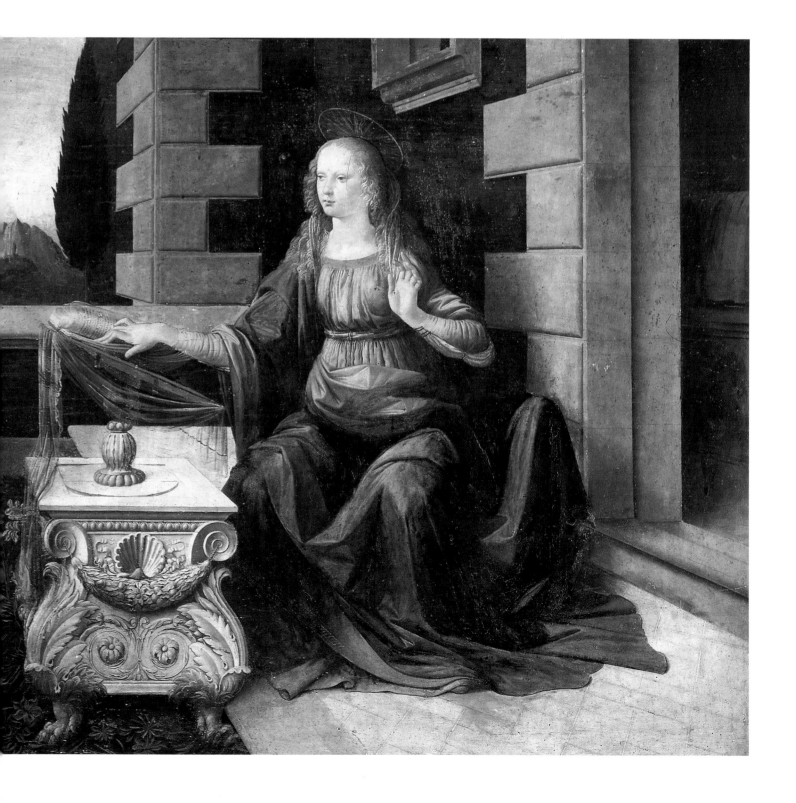

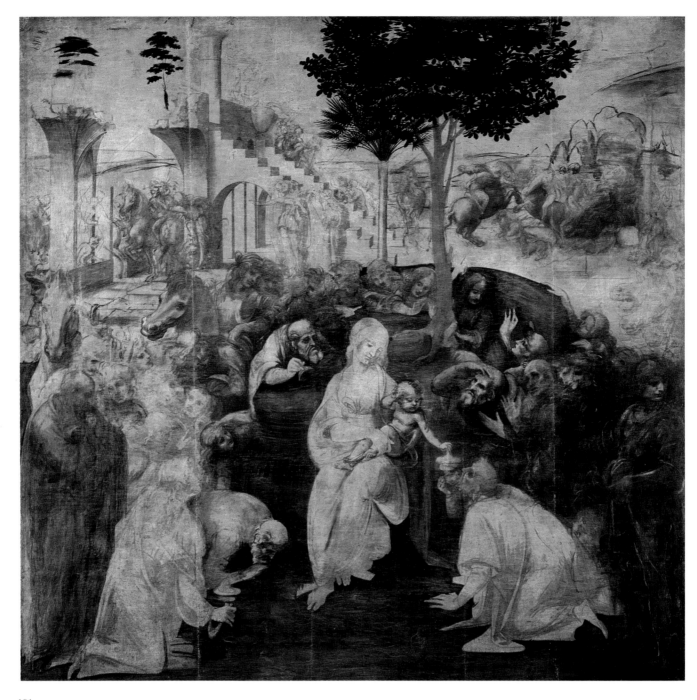

101
LEONARDO DA VINCI
The Adoration of the Magi
Tempera, oil, varnish, and white lead on panel, 95¹¹⁄₁₆ × 96⅞ in. (243 × 246 cm)
Uffizi, Gallery; inv. 1890: no. 1594

Commissioned by the brothers of San Donato a Scopeto in March 1480, this work was left
unfinished by Leonardo when he departed for Milan in 1481–1482. It is a sublime example of
the artist's research on the effects of light.

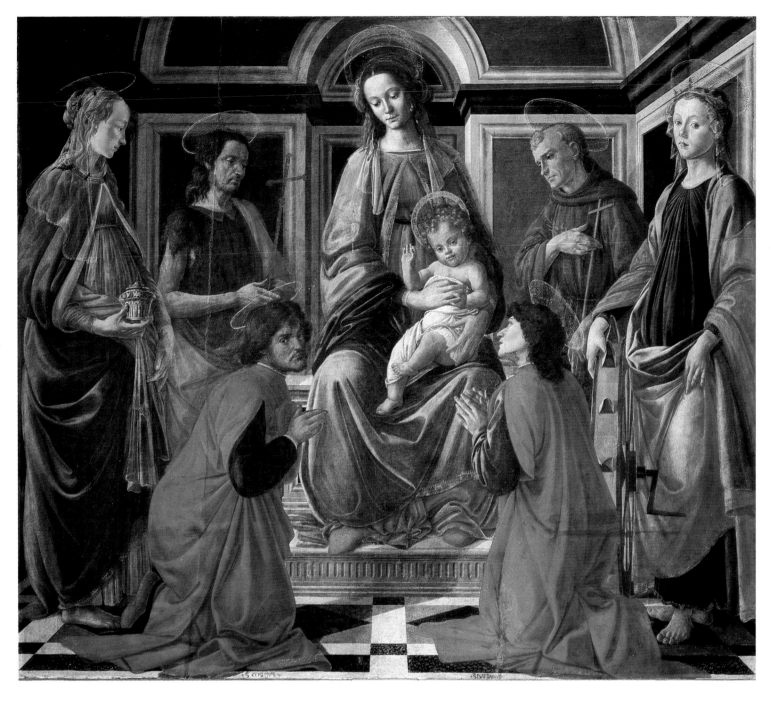

102

SANDRO BOTTICELLI

The Madonna and Child Enthroned, with SS. Mary Magdalen, Catherine of Alexandria, John
the Baptist, Francis, and Cosmas and Damian

Tempera on panel, 66¹⁵⁄₁₆ × 76 ³⁄₈ in. (170 × 194 cm)

Uffizi, Gallery; inv. 1890: no. 8657

Dating from around 1470, this painting is among the oldest of the altarpieces produced by
Botticelli. The nineteenth-century location of the painting in the church of Sant'Ambro-
gio does not seem to have been its original site; rather, the presence of Cosmas and
Damian suggests a connection with the Medici family, whom the two saints were sup-
posed to protect.

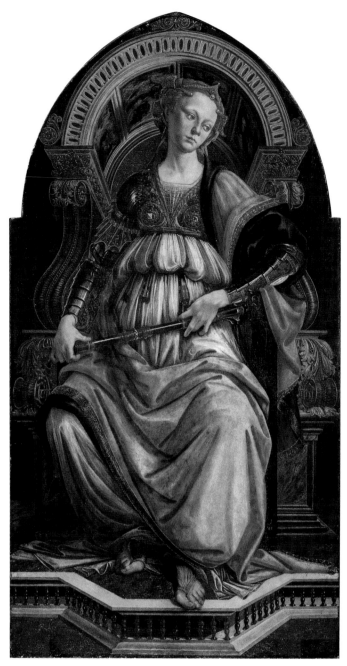

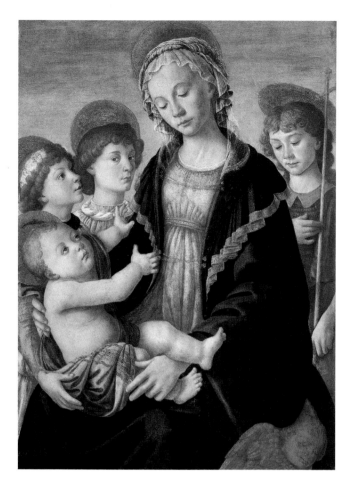

104

SANDRO BOTTICELLI

Madonna and Child, with the Young St. John and Two Angels

Tempera on panel, 33⁷⁄₁₆ × 24⁷⁄₁₆ in. (85 × 62 cm)

Accademia, Gallery; inv. 1890: no. 3166

The attribution of this panel to Botticelli is almost uncontested, despite its dreadful condition and the fact that it was entirely repainted at some point. Its style dates it to the early years of the painter's career, around 1470, when the influence of his master Fra Filippo Lippi mingled with Verrocchiesque motives.

103

SANDRO BOTTICELLI

Fortitude

Tempera on panel, 65¾ × 34¼ in. (167 × 87 cm)

Uffizi, gallery; inv. 1890: no. 1606

This work belongs to the cycle of seven *Virtues* commissioned in 1469 by the Arte di Mercanzia from Piero Pollaiolo. In 1470 the commission for *Fortitude* was given, for reasons unknown, to Botticelli; it constitutes the first known work by him to be dated and documented.

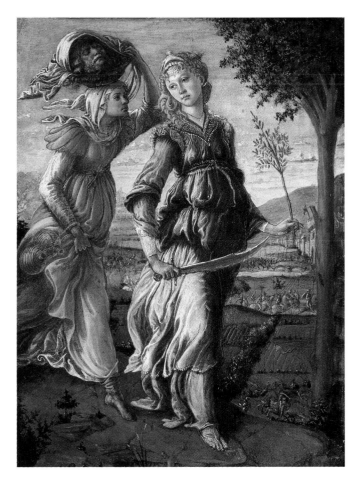

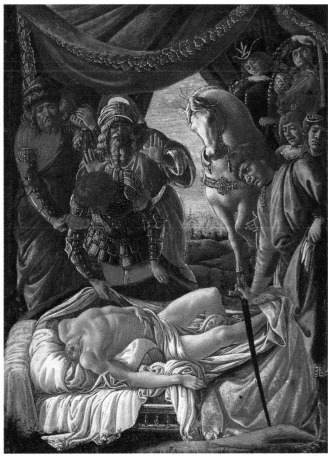

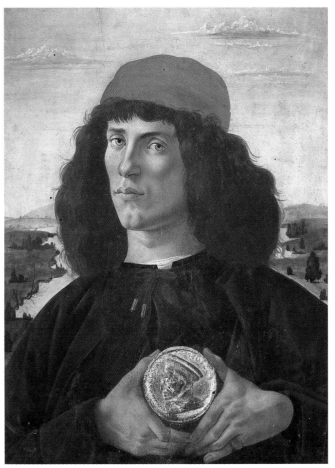

105 and 106
SANDRO BOTTICELLI
Judith Returns from the Enemy Camp at Bethulia
Tempera on panel, 12³⁄₁₆ × 9⁷⁄₁₆ in. (31 × 24 cm)
Uffizi, Gallery; inv. 1890: no. 1484
The Discovery of Holofernes' Corpse
Tempera on panel, 12³⁄₁₆ × 9¹³⁄₁₆ in. (31 × 25 cm)
Uffizi, Gallery; inv. 1890: no. 1487

In the sixteenth century, Borghini listed these two little paintings as works by Botticelli in the collection of Bianca Cappello, the wife of Francis I. The panels have stylistic references to the artist's early career and likely date from around 1472.

107
SANDRO BOTTICELLI
Portrait of a Young Man with a Medallion
Tempera on panel, 22⁵⁄₈ × 17⁵⁄₁₆ in. (57.5 × 44 cm)
Inscription: MAGNUS COSMUS/MEDICES PPP
Uffizi, Gallery; inv. 1890: no. 1488

The identification of the young man holding the medal engraved with the likeness of Cosimo il Vecchio is still problematic. The medal's inscription alludes to the title "Pater Patriae," conferred upon Cosimo in 1465; the panel itself dates from around 1475.

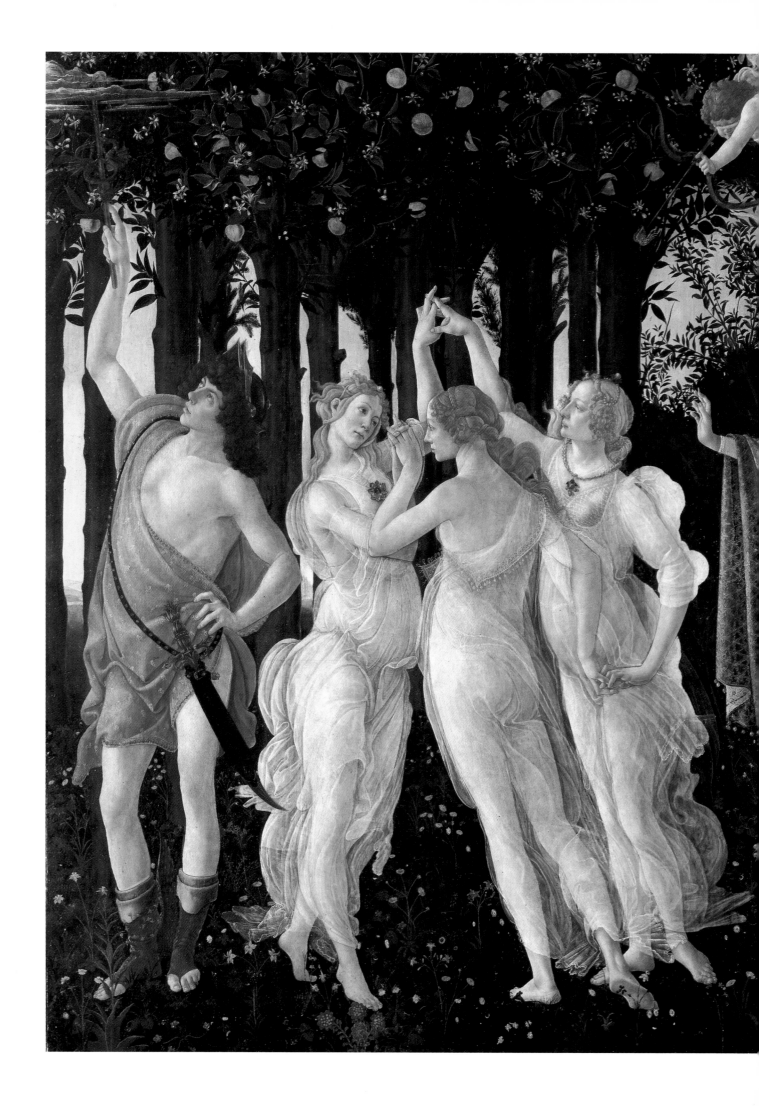

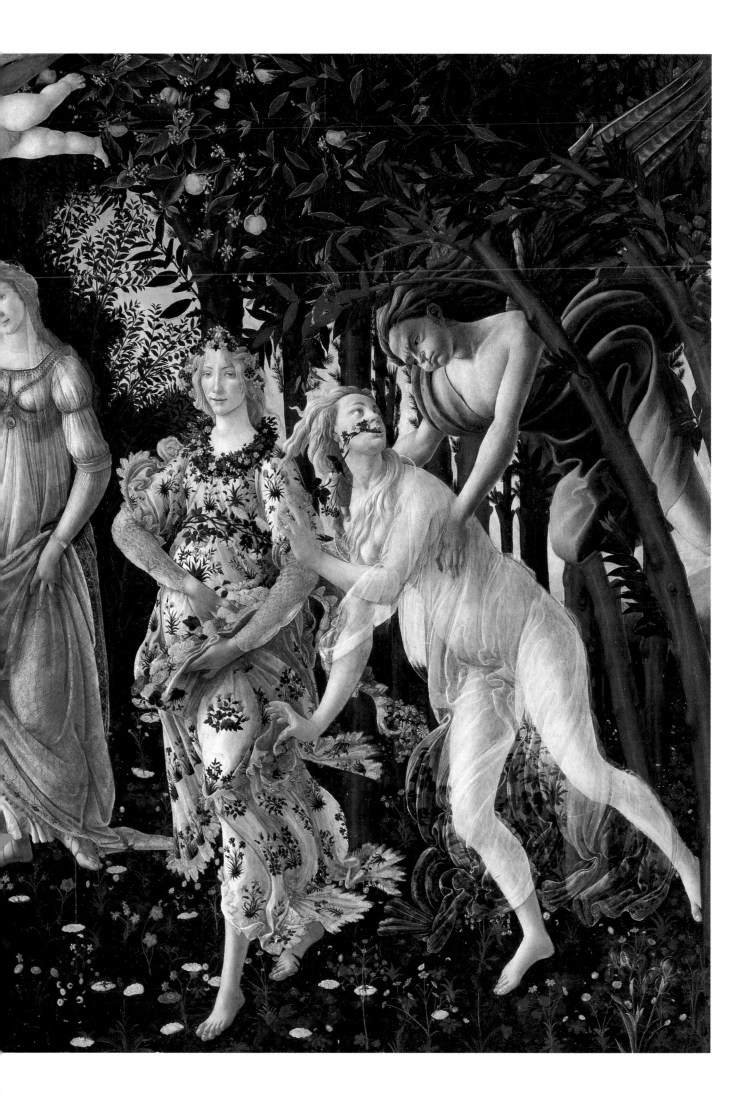

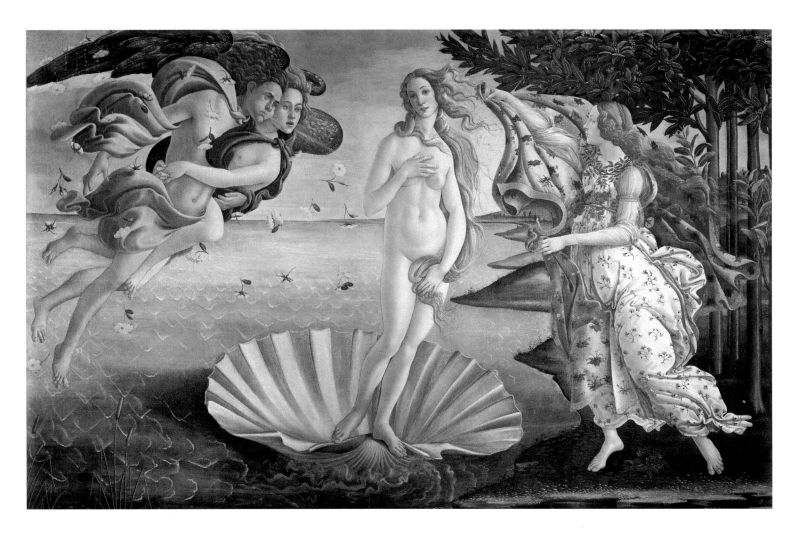

109
SANDRO BOTTICELLI
The Birth of Venus
Tempera on panel, 67¹⁵⁄₁₆ × 109⅝ in. (172.5 × 278.5 cm)
Uffizi, Gallery; inv. 1890: no. 878
This well-known work was recorded by Vasari as being in the Villa
Medici in Castello (once owned by Lorenzo Pierfrancesco de' Me-
dici), but it is not certain that that was its original location. Painted
around 1484, it corresponds very closely to the description of the
Birth of Venus given by Poliziano in his *Giostra*.

Preceding pages: 108
SANDRO BOTTICELLI
Primavera
Tempera on panel, 79¹⁵⁄₁₆ × 123⅝ in. (203 × 314 cm)
Uffizi, Gallery; inv. 1890: no. 3860
Scholars are by now almost unanimous in their agreement that this
is the famous "painting on wood[. . .] upon which nine figures of
women and men are painted," recorded in the inventory of 1498 in
the palace of Lorenzo di Pierfrancesco de' Medici. It dates from
around 1480.

110

SANDRO BOTTICELLI
Madonna and Child with Angels
("Madonna of the Magnificat")
Tempera on panel, 46⁷⁄₁₆ in. (118 cm) in diameter
Uffizi, Gallery; inv. 1890: no. 1609
This roundel takes its informed name from the beginning of the inscription legible in the open book. Variously dated between 1481 and 1485, the work is rich in intellectual implications, possessing a quality that serves to create an illusion of superficial convexity.

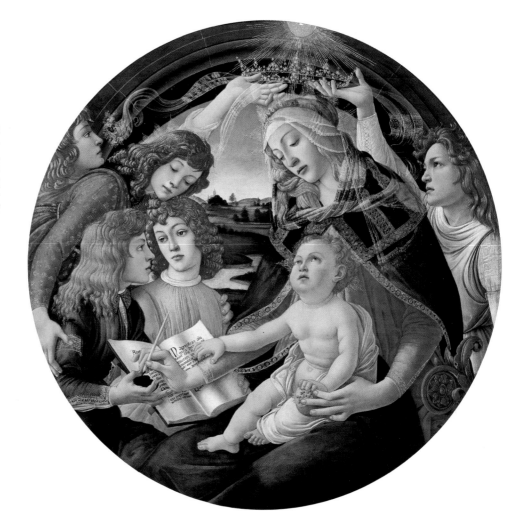

111

SANDRO BOTTICELLI
Madonna and Child with Angels
("Madonna of the Pomegranate")
Tempera on panel, 56½ in. (143.5 cm) in diameter
Uffizi, Gallery; inv. 1890: no. 1607
This roundel was executed in 1487 for the Sala dell'Udienza dei Massai di Camera in the Palazzo Vecchio. The frame, which is original, is decorated with gilded lilies, the symbol of Florence, carved on a blue background, to signify the public destination of the painting. It takes its title from the pomegranate, which alludes to the Passion of Christ.

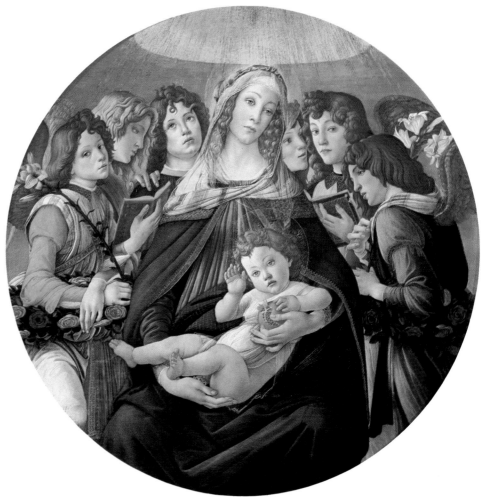

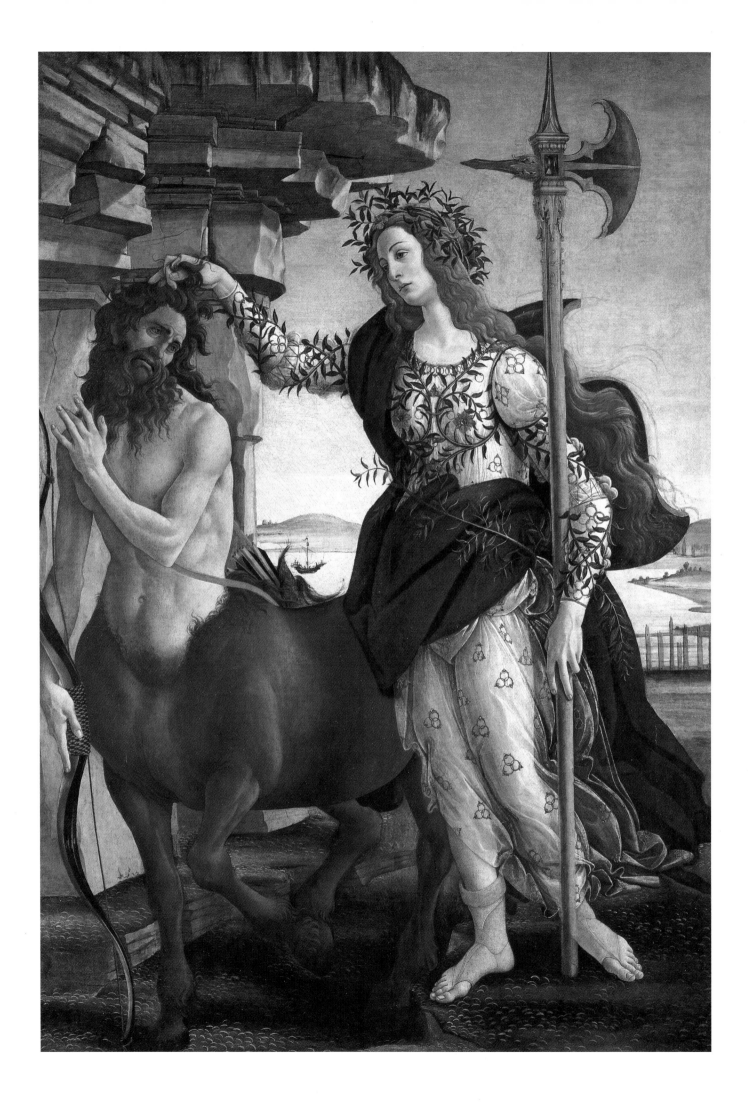

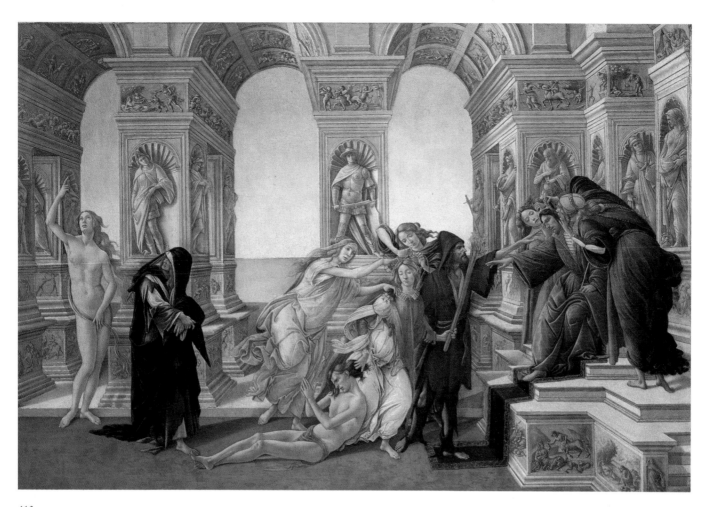

113
SANDRO BOTTICELLI
The Calumny
Tempera on panel, 24⅜ × 35¹³⁄₁₆ in. (62 × 91 cm)
Uffizi, Gallery; inv. 1890: no. 1496

This work, which dates from around 1495, reproduces the subject of a painting by the Greek artist Apelles, a description of which, given by Lucian, corresponds perfectly to Botticelli's composition. It is doubtless significant that Botticelli was considered to be the Apelles of his day.

Opposite: 112
SANDRO BOTTICELLI
Pallas and the Centaur
Tempera on canvas, 81½ × 58¼ in. (207 × 148 cm)
Uffizi, Gallery; inv. depository: no. 29

This painting appears in the 1498 inventory of the Via Larga palace of Lorenzo Pierfrancesco de' Medici, cousin of Lorenzo the Magnificent. The painting, which dates from around 1482, may be seen as a moral allegory for the victory of Reason over Instinct.

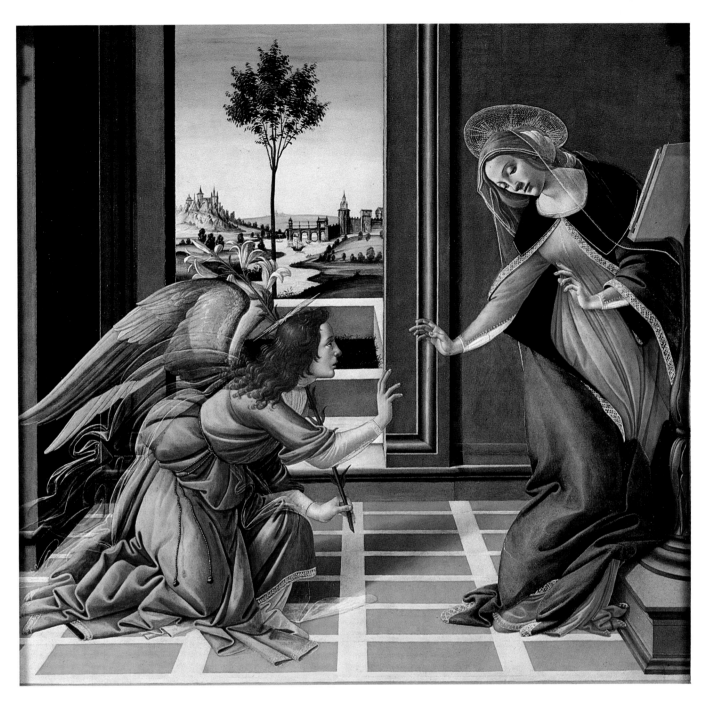

114
SANDRO BOTTICELLI
The Annunciation
Tempera on panel, 59 × 61⁷⁄₁₆ in. (150 × 156 cm)
Uffizi, Gallery; inv. 1890: no. 1608
This was once the altarpiece for the chapel of the Annunciate in the church of Cestello, today Santa Maria Maddalena de'Pazzi in Borgo Pinti. It was paid for by Benedetto di Ser Francesco Guardi in March of 1489.

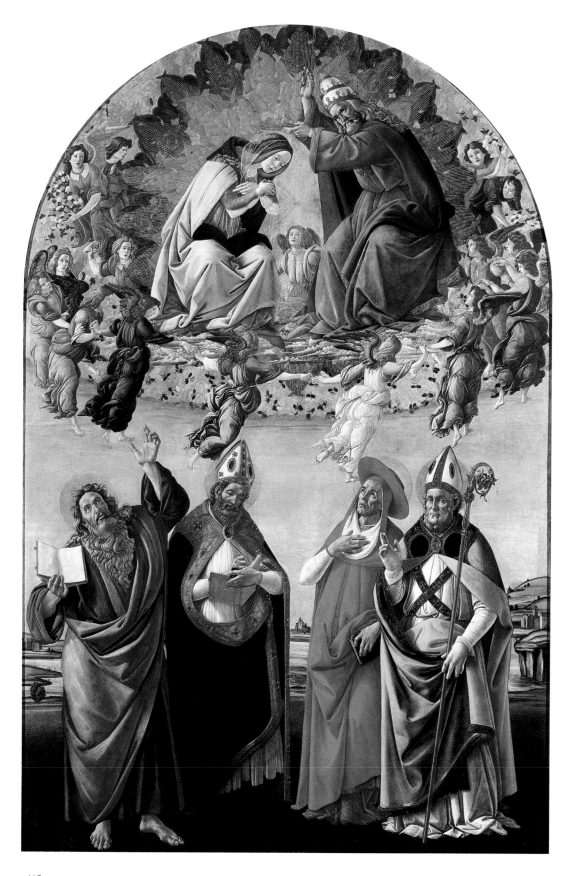

115

SANDRO BOTTICELLI

The Coronation of the Virgin with SS. Eligius, John the Evangelist, Augustine, and Jerome

Tempera on panel, 148¹³⁄₁₆ × 101⁹⁄₁₆ in. (378 × 258 cm)

Uffizi, Gallery; inv. 1890: no. 8362

This panel was executed by Botticelli in around 1490 for the altar of the Arte della Seta, or silk merchants' guild, dedicated to St. Eligius, in the church of San Marco. The predella (not shown) depicts episodes in the lives of the saints represented in the main panel, with the Annunciation in the center.

116
SANDRO BOTTICELLI
St. Augustine in His Study
Tempera on panel, 16⅛ × 10⅝ in. (41 × 27 cm)
Uffizi, Gallery; inv. 1890: no. 1473

Vasari reported that this small painting was owned by Bernardo Vecchietti; the habit of the saint probably indicates that Botticelli produced it for an Augustinian hermit. It dates from around 1494.

117
COSIMO ROSSELLI
St. Barbara between SS. John the Baptist and Matthew
Tempera on panel, 84⅝ × 86³⁄₁₆ in. (215 × 219 cm)
Accademia, Gallery; inv. 1890: no. 8635

Completed by Rosselli in 1468 with the help of collaborators, this panel is iconographically innovative with respect to the saint in the center. It was produced for the altar of the chapel of the Company of St. Barbara, belonging to the "German nation," in the church of the Santissima Annunziata, where it remained until the restructuring of 1740.

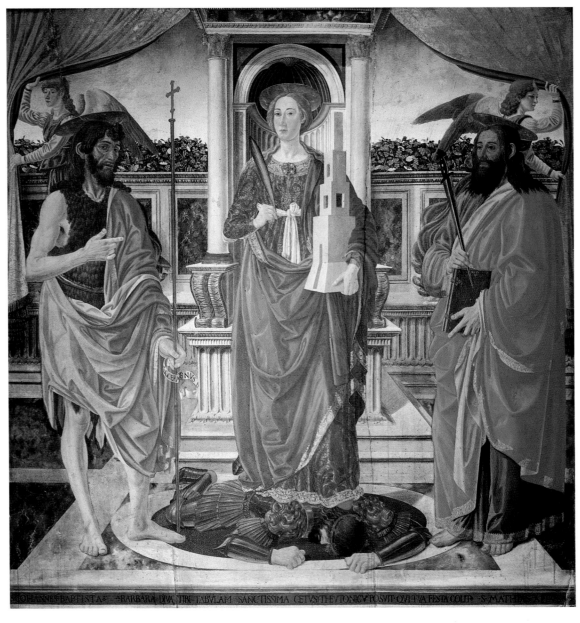

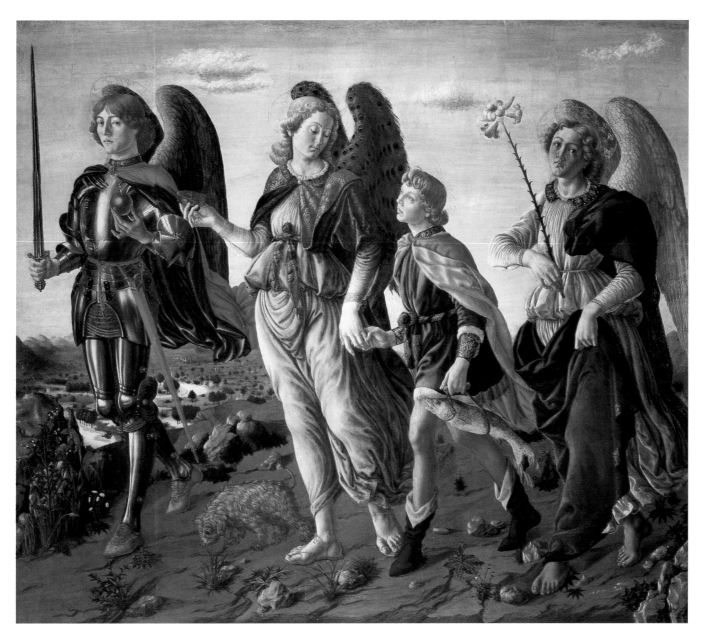

118
FRANCESCO BOTTICINI
Tobias and the Three Archangels
Tempera on panel, 53⅛ × 60⅝ in. (135 × 154 cm)
Uffizi, Gallery; inv. 1890: no. 8359

Painted in around 1470, this panel originally decorated the altar of the Company of the
Archangel Raphael, known as the "Raffa," in the Florentine church of Santo Spirito.
Francesco Botticini was in fact a member of this confraternity, which met in the Augustin-
ian church.

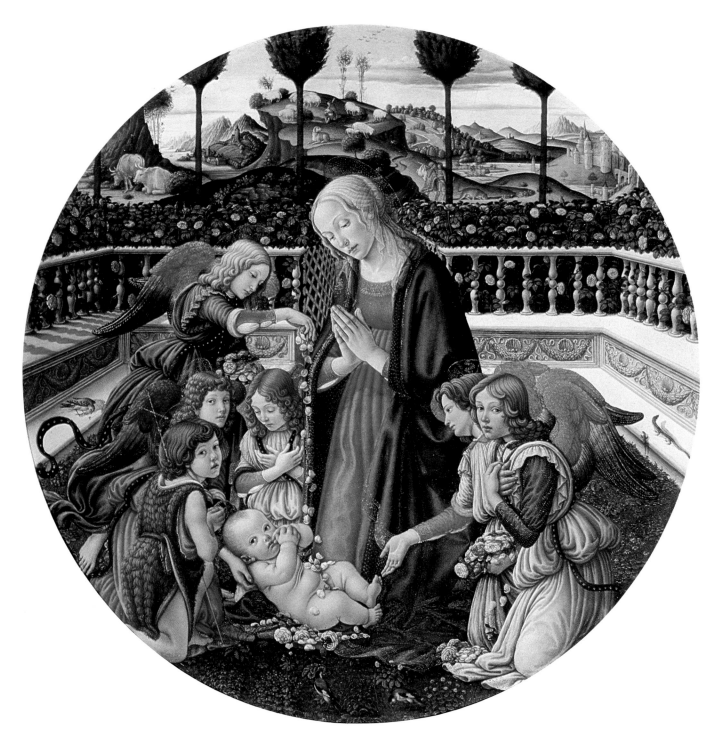

119
FRANCESCO BOTTICINI
The Adoration of the Child
Tempera on panel, 48⁷⁄₁₆ in. (123 cm) in diameter
Pitti, Palatine Gallery; inv. 1912: no. 347
This roundel, which exemplifies the descriptive and analytical qualities of Botticini's work, shows Flemish influences and can be dated to about 1485. It served as the prototype for many later Botticiniesque paintings on the same subject.

120 and 121
FRANCESCO BOTTICINI
St. Augustine
Tempera on panel, 67⁵⁄₁₆ × 20¹⁄₁₆ in. (171 × 51 cm)
Accademia, Gallery; inv. 1890: no. 8625
St. Monica
Tempera on panel, 67⁵⁄₁₆ × 20¹⁄₁₆ in. (171 × 51 cm)
Accademia, Gallery; inv. 1890: no. 8626

The provenance of these two paintings is unknown, but their subject matter indicates that they were executed for an Augustinian monastery. They likely date from between 1470 and 1475.

122
JACOPO DEL SELLAIO
The Banquet of Ahasuerus
Tempera on panel, 17¹¹⁄₁₆ × 24¹³⁄₁₆ in. (45 × 63 cm)
Uffizi, Depository; inv. 1890: no. 491

This small panel and its four companion pieces, now at the Uffizi (*The Driving Away of Queen Vashti* and *The Triumph of Mordechai*), in Budapest, and at the Louvre, originally belonged to a "lettucio" (a kind of coffer) datable to around 1490.

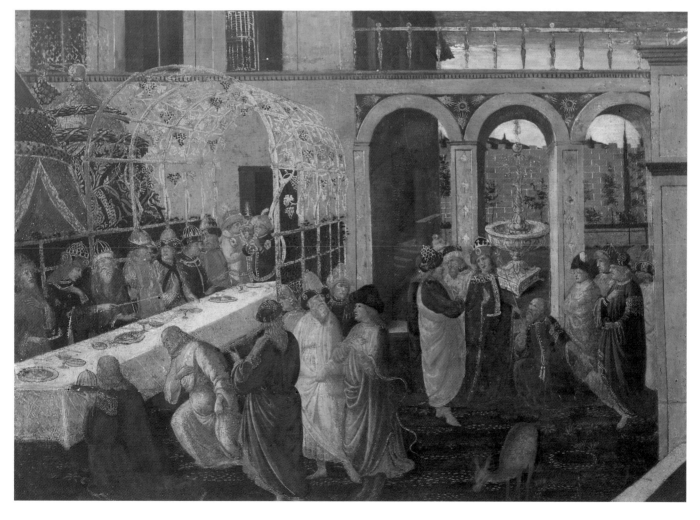

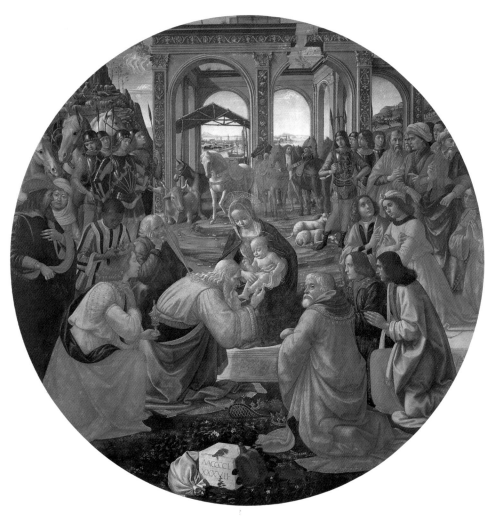

123
DOMENICO GHIRLANDAIO
The Adoration of the Magi
Oil on panel, 67¹¹⁄₁₆ in. (172 cm) in diameter
Dated: MCCCCLXXXVII
Uffizi, Gallery; inv. 1890: no. 1619

This is almost certainly the "roundel with the story of the Magi, done with great diligence," that Vasari recorded as being in the house of Giovanni Tornabuoni. Ghirlandaio produced the frescoes in the choir of Santa Maria Novella during the same period for the same patron.

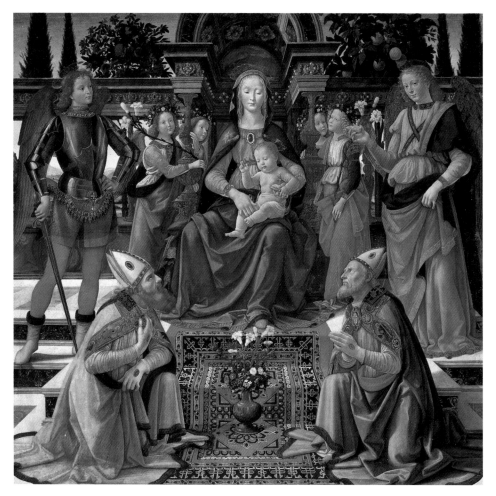

124
DOMENICO GHIRLANDAIO
Madonna and Child Enthroned with Four Angels, the Archangels Michael and Raphael, and SS. Giusto and Zenobius
("Altarpiece of San Giusto alle Mura")
Oil and tempera on panel, 75³⁄₁₆ × 78¾ in. (191 × 200 cm)
Uffizi, Gallery: inv. 1890: no. 881

This altarpiece, from the Jesuit church of San Giusto alle Mura, is considered to be one of this artist's masterpieces, dating from between 1480 and 1485. Today its five sections are divided among the Metropolitan Museum in New York, the Detroit Institute of Arts, and the National Gallery in London.

125 and 126
BARTOLOMEO DI GIOVANNI
St. Placid's Rescue
Tempera on panel, 12⁹⁄₁₆ × 11¹³⁄₁₆ in. (32 × 30 cm)
Uffizi, Gallery; inv. 1890: no. 3154
The Miracle of the Glass of Poisoned Wine
Tempera on panel, 12⅝ × 12⅜ in. (32 × 31.5 cm)
Uffizi, Gallery; inv. 1890: no. 1502
Part of a predella with two other sections of unknown location depicting *Saint Benedict Exorcising a Demon from a Monk* and *The Miracle of the Small Flask.* These panels date from around 1490.

127
DOMENICO and
DAVID GHIRLAN-
DAIO and
BARTOLOMEO DI
GIOVANNI
*Madonna and Child En-
throned with Two Angels,
SS. Dionysius the
Aereopagite and Dominic,
Pope Clement, and St.
Thomas Aquinas*
Oil and tempera on
panel, 66⅛ × 77⁹⁄₁₆ in.
(168 × 197 cm)
Inscription: S.DIONYSIUS
ARIOPAGITA—AVE
GRATIA PLENA—
S.THOMAS AQUINAS
Uffizi, Gallery; inv. 1890:
no. 8388
Painted in around 1485,
the panel could be found
in the church of Sant'Am-
brogio in Florence at the
beginning of the nine-
teenth century. The pre-
della is by Bartolomeo di
Giovanni, an occasional
collaborator of Ghirlan-
daio's.

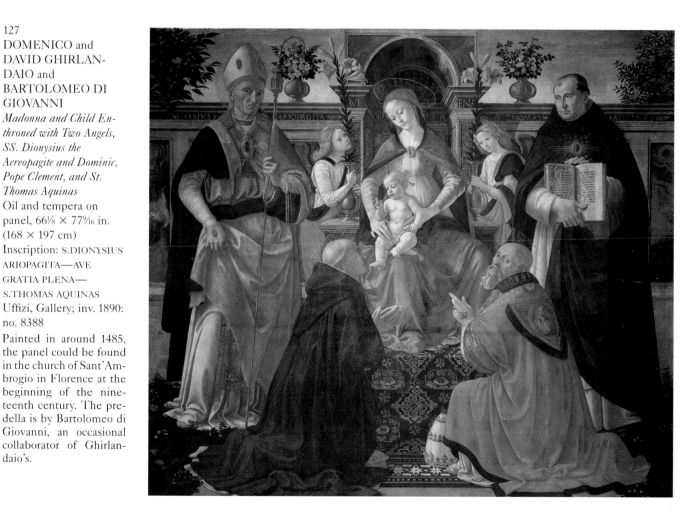

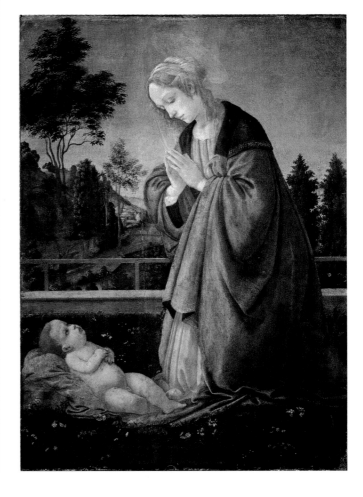

128 and 129
FILIPPINO LIPPI
St. John the Baptist
Tempera on panel, 51^{15}/$_{16}$ × 21^{5}/$_{8}$ in. (132
× 55 cm)
Accademia, Gallery; inv. 1890: no. 8651
Mary Magdalen
Tempera on panel, 51^{15}/$_{16}$ × 21^{5}/$_{8}$ in. (132
× 55 cm)
Accademia, Gallery; inv. 1890: no. 8653
Acquired from the Valori chapel in San Pro-
colo in Florence, these two panels were
originally the wings of a Crucifixion scene
with the Madonna and St. Francis (for-
merly in Berlin, but destroyed in 1945).
They were painted in around 1500.

130
FILIPPINO LIPPI
The Adoration of the Child
Tempera on panel, 37^{13}/$_{16}$ × 27^{15}/$_{16}$ in. (96 × 71 cm)
Uffizi, Gallery; inv. 1890: no. 3246
This painting can be dated to the period just after 1480; it combines
the elongated anatomy and physiognomy of Botticelli's figures with
the chiaroscuro effects characteristic of Leonardo.

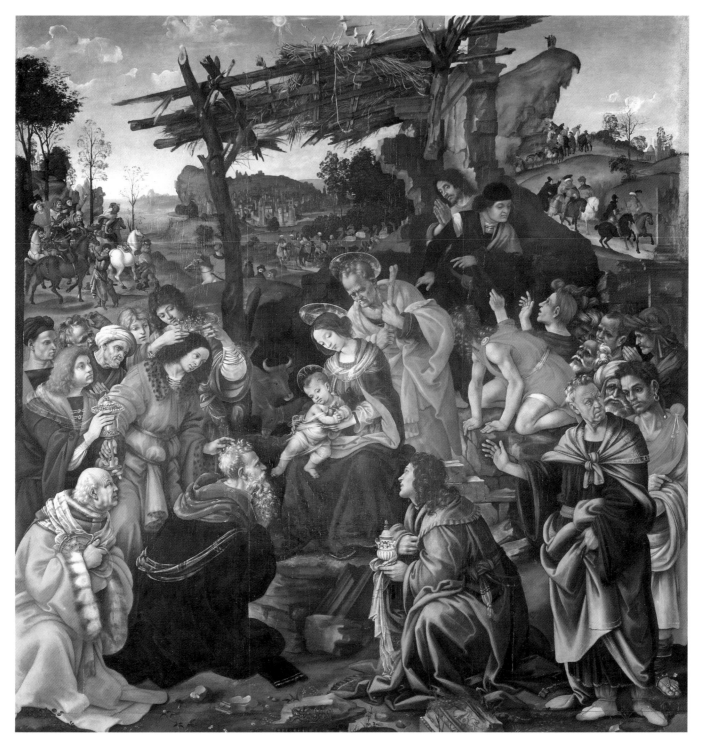

131

FILIPPINO LIPPI

The Adoration of the Magi

Tempera on panel, 101$\frac{9}{16}$ × 95$\frac{11}{16}$ in. (258 × 243 cm)

Uffizi, Gallery; inv. 1890: no. 1566

This panel, signed and dated March 29, 1496, on the back, was commissioned by the monks of San Donato a Scopeto as a substitution for a painting on an identical subject, left unfinished by Leonardo. In the seventeenth century it belonged to Cardinal Carlo de' Medici.

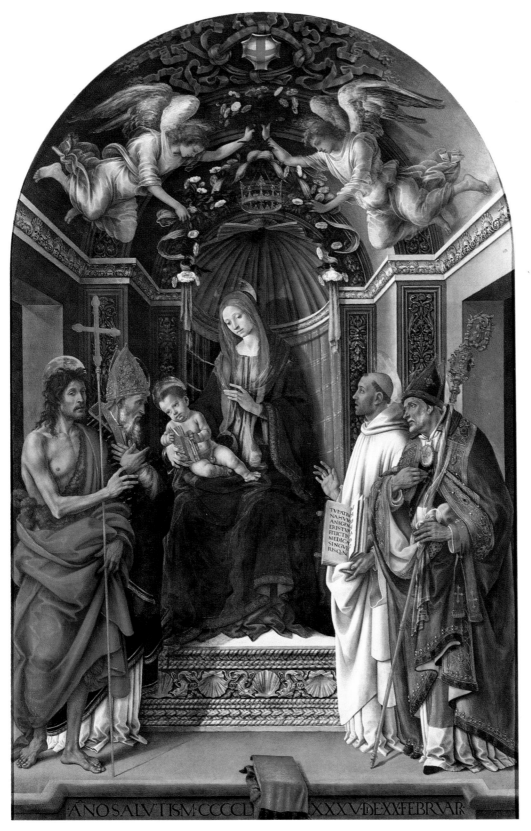

132
FILIPPINO LIPPI
Madonna and Child Enthroned with SS. John the Baptist, Victor, Bernard, and Zenobius ("Altarpiece of the Otto di Pratica")
Tempera on panel, 139¾ × 100 ⅜ in. (355 × 255 cm)
Dated: ANO SALUTIS MCCCCLXXXV DIE XX FEBRUARI
Uffizi, Gallery; inv. 1890: no. 1568

Sources unanimously record the presence of this painting in the Sala degli Otto di Pratica in the Palazzo della Signoria. It was completed in 1486, since the date in the inscription follows the traditional Florentine year which ends the following March 25.

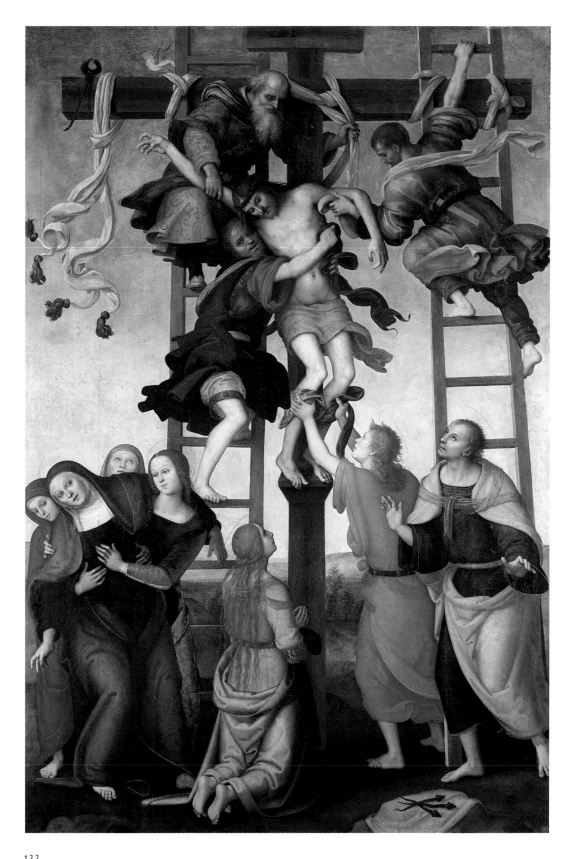

133

FILIPPINO LIPPI and PIETRO PERUGINO
The Deposition from the Cross
Tempera on panel, 131⅛ × 85¹³⁄₁₆ in. (333 × 218 cm)
Accademia, Gallery; inv. 1890: no. 8370

Fra Zaccaria commissioned this work from Filippino in 1503 for the
Santissima Annunziata. Lippi began the painting but was able to
complete only the figures in the upper part before his death in 1504.
It was then handed over to Perugino, who finished it in the years
immediately following.

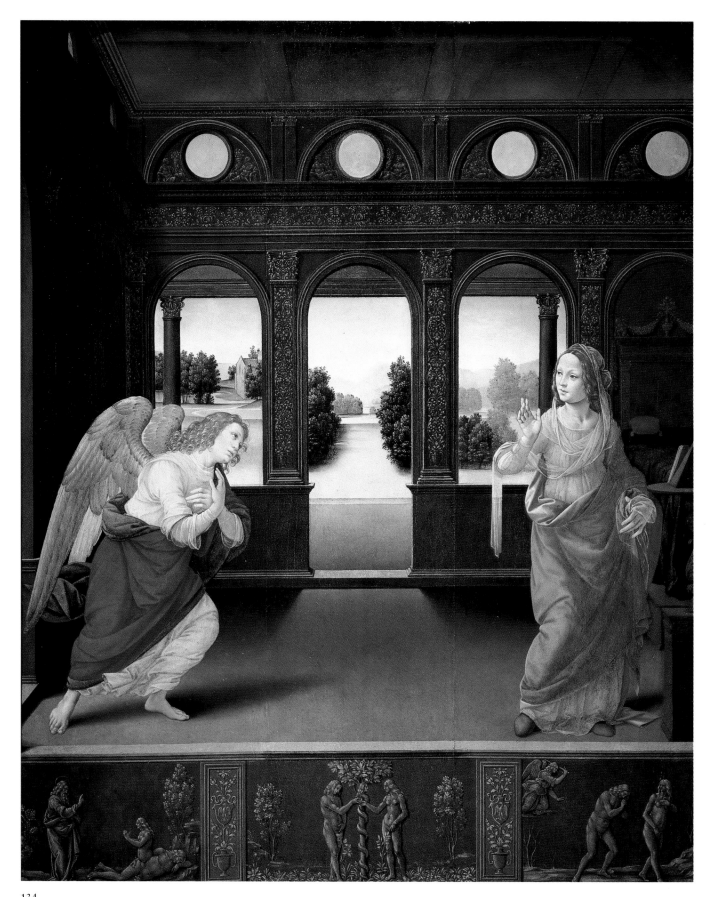

134
LORENZO DI CREDI
The Annunciation
Oil on panel, 34⅝ × 27¹⁵⁄₁₆ in. (88 × 71 cm)
Uffizi, Gallery; inv. 1890: no. 1597

Dating from between 1480 and 1485, this is one of the finest surviving works by Lorenzo di Credi, remarkable both for its lucid spatial disposition and for its figures, rich in Leonardesque suggestion.

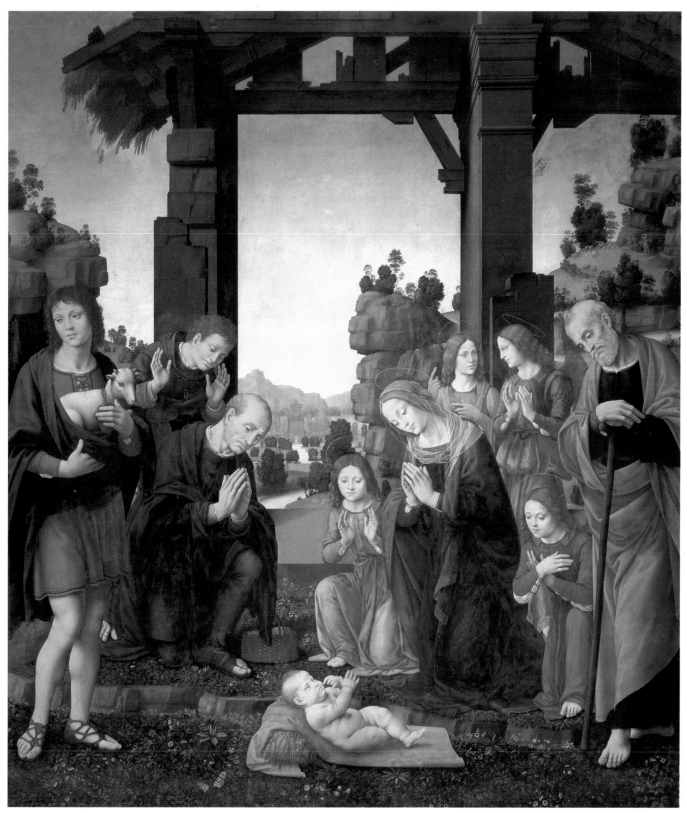

135
LORENZO DI CREDI
The Adoration of the Shepherds
Oil on panel, 88³/₁₆ × 77³/₁₆ in. (224 × 196 cm)
Uffizi, Gallery; inv. 1890: no. 8399

This panel was produced in around 1500 for the Florentine church of Santa Chiara. Its patron has been identified as the merchant Jacopo Bongianni, a follower of Savonarola.

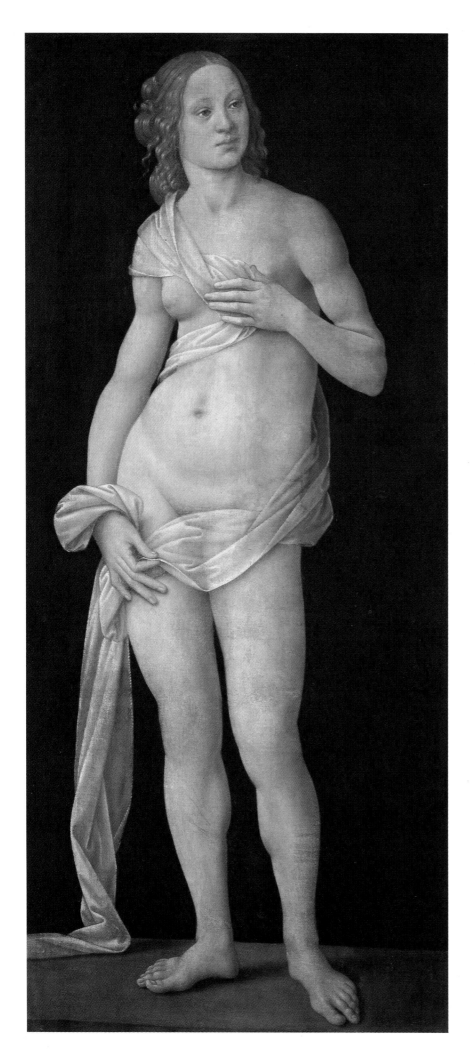

136
LORENZO DI CREDI
Venus
Oil on panel, 59⁷⁄₁₆ × 27³⁄₁₆ in. (151 × 69 cm)
Uffizi, Gallery; inv. 1890: no. 3094
This painting was found in 1869 in the Medici villa at Cafaggiolo (apparently its original location) and entered the Uffizi collection in 1893. It dates from around 1490.

Opposite: 137
RAFFAELLINO DEL GARBO
The Resurrection
Oil on panel, 68¹¹⁄₁₆ × 73⁷⁄₁₆ in. (174.5 × 186.5 cm)
Accademia, Gallery; inv. 1890: no. 8363
Executed in 1510 at the behest of the Capponi family for the altar of the Chapel of Paradise in the church of San Bartolomeo in Monteoliveto, this panel was considered by Vasari to be Raffaellino's masterpiece, remarkable for its modernity, for its composition, and for the fine quality of the figures' heads.

Opposite: 138
PIERO DI COSIMO
Andromeda Freed by Perseus
Oil on panel, 27⁹⁄₁₆ × 48⁷⁄₁₆ in. (70 × 123 cm)
Uffizi, Gallery; inv. 1890: no. 1536
This is the panel painted for Filippo Strozzi that was described by Vasari as including a "bizarre sea creature." It appears to have been painted in around 1515 and its subject suggests that it may refer to the return of the Medici to Florence in 1512. It was exhibited in the Tribune beginning in 1589, for almost two centuries.

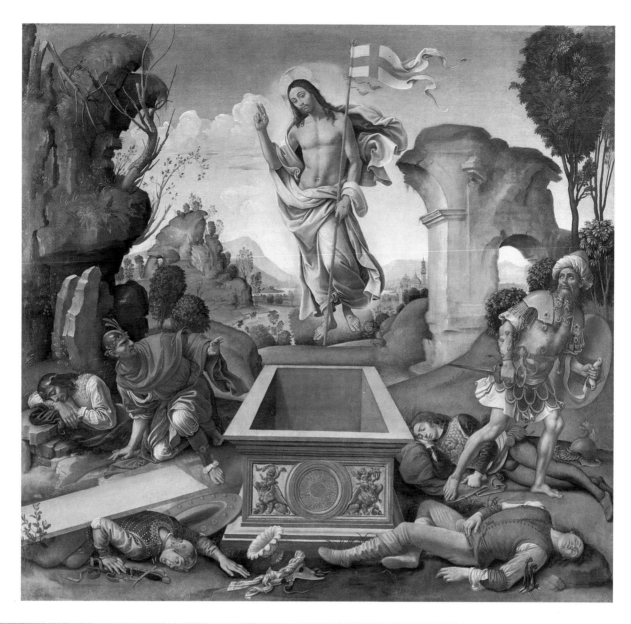

139

PIERO DI COSIMO

The Immaculate Conception and Six Saints

Oil on panel, 81⅛ × 67¹¹⁄₁₆ in. (206 × 172 cm)

Uffizi, Gallery; inv. 1890: no. 506

Notable for its rendition of intense light emerging from the Holy Spirit in the form of a dove, this panel was painted at the beginning of the sixteenth century for the Tedaldi chapel in the church of the Santissima Annunziata. Requested in 1670 by Cardinal Leopoldo de' Medici for his collection, it came to the Uffizi in 1804.

Siena in the Fifteenth Century

Most scholars would agree that during the fifteenth century, Sienese painting remained tied to the great local Gothic traditions: the city's art was, in a sense, the vessel for its great civic history. However, it is also true that after the third decade of the fourteenth century, its many contacts with Florentine humanistic art, as well as with certain non-Florentine artists who had both a conception of and an impetus toward aesthetic innovation (such as Gentile da Fabriano and Domenico Veneziano), helped to establish for Siena a new cultural identity that, if it was not as assertive as that of Florence, was by no means superficial.

The cultural exchange that took place between Siena and Florence at the beginning of the 1300s continued, for the most part, throughout the first half of that century. At the very beginning of the following century, a novel opportunity was created in the competition of 1401 for the design of the north door of the Baptistry in Florence, a contest in which both Florentines and Sienese were invited to participate. By the 1420s the Florentine artists Ghiberti and Donatello were collaborating on the baptismal font in the Duomo at Siena, an exemplar of the new Renaissance culture. Among the Sienese painters, it was Sassetta who in that same decade showed the greatest interest in the work of Masolino and Ghiberti, of Masaccio and Angelico. Sassetta's altarpiece of the so-called Madonna of the Snow (1430–1432), executed for the Sienese Duomo, with its extraordinary predella (unfortunately no longer complete), fully demonstrates its author's ability to unite old and new ideas in a perfect equilibrium of rhythm, color, and space, all within an enclosing frame. Others who shared Sassetta's vision included the Master of the Osservanza and the very able Pietro di Giovanni Ambrosi, as well as Giovanni di Paolo (who was perhaps a bit detached in his perception), Domenico di Bartolo, and, on a decidedly more modest level, Sano di Pietro. Taken together, all of these comprise the first generation of Sienese Renaissance painters.

Later, the benefits of the Florentine-Sienese partnership on the Sienese baptismal font—combined with an awareness of the art of Filippo Lippi and Domenico Veneziano, and exposure to the activity (and the presence) of Donatello in Siena after his return from Padua—would be manifest in the work of Vecchietta. This promise is fulfilled most particularly in his important painting of 1457 (now in the Uffizi) for Giacomo d'Andreuccio and in that of 1461–1462 for the Duomo at Pienza. This latter example reveals the influence of Leon Battista Alberti's theories on classicism, perspective, and light, along with the ideas of Rossellino, the builder of Pienza, in its beautiful modern woodwork (or, for the artists and patrons of the fifteenth century, its *all'antica* spirit).

To this list of major figures we might append, with some reservations, such names as Matteo di Giovanni, Neroccio di Landi, and Francesco di Giorgio Martini. Sienese art was deeply influenced by Donatello's work and by the style of Benozzo Gozzoli (active in Val d'Elsa between 1463 and 1467), as well as by the traditional and ornate painting tradition of Neri di Bicci, who likewise "exported" his paintings to Sienese territories. Also in play were ideas suggested by the works of Pollaiolo and Filippino Lippi and the Florentine and Po Valley miniaturists, who were involved in the decoration of the choirs of the Duomo. A different view of these artists, however, shows them to be not altogether immune to a nostalgic yet poetic reflection of the Gothic style. Francesco di Giorgio, for instance, adopted (as in the *Annunciation* of c. 1470–1475 in the Siena Pinacoteca) a fragile, crystalline quality in his paintings, an approach to design that was exemplified in Florence, a little after the middle of the century, by the work of Baldovinetti. Indeed, recent studies have made it clear that constant collaboration left the workshop largely to its own devices in carrying out the pictorial ideas and projects of the master.

Sienese painting of the fifteenth century thus developed a distinctive style, one that was consciously retrospective but at the same time not resistant to innovation. It generally made use, even in large altarpieces, of gold grounds to show off sharp and elegant outlines, and of precious chiselling to play off the complex perspectives and sophisticated architecture of the Renaissance, incorporating a refined, epigraphic style with beautifully humanistic letters.

Anna Padoa Rizzo

140
SASSETTA
Madonna and Child Enthroned with Four Angels and SS. John the Baptist, Peter, Francis, and Paul (detail of the predella)
Pitti, Meridiana (temporary location);
inv. Contini Bonacossi: no. 1

141

SASSETTA

Madonna and Child Enthroned with Four Angels and SS. John the Baptist, Peter, Francis,
and Paul

Tempera on panel, 94⁷⁄₁₆ × 100¹³⁄₁₆ in. (240 × 256 cm)

Signed: STEFANUS DA SENIS . . . PINXIT

Pitti, Meridiana (temporary location); inv. Contini Bonacossi: no. 1

This panel was executed between 1430 and 1432 for the altar of San Bonifazio in the Duomo
in Siena. The predella, which was largely repainted in the nineteenth century, narrates the
story of the founding of Santa Maria Maggiore in Rome after the amazing snowstorm of
August 5, 356.

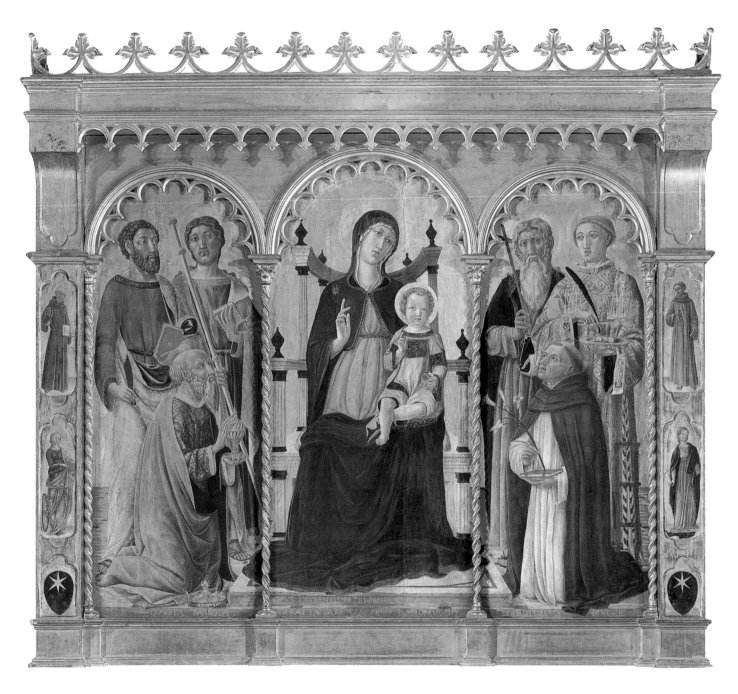

142

VECCHIETTA

Madonna and Child Enthroned with SS. Bartholomew, James, Eligius, Andrew, Lawrence,
and Dominic

Tempera on panel, 61⅜ × 90⁹⁄₁₆ in. (156 × 230 cm)

Signed and dated: OPUS LAURENTII PETRI SENESIS MCCCCLVII

Inscription: QUESTA TAVOLA HA FATTA FARE GIACOMO DANDREUCCIO SETAIUOLO P(ER)
SUA DIVOZIONE

Uffizi, Gallery; inv. 1890: no. 474

Produced in 1457 for the silk merchant Giacomo d'Andreuccio, this painting entered the
grand-ducal collection in 1798 from the villa at Monteselvoli.

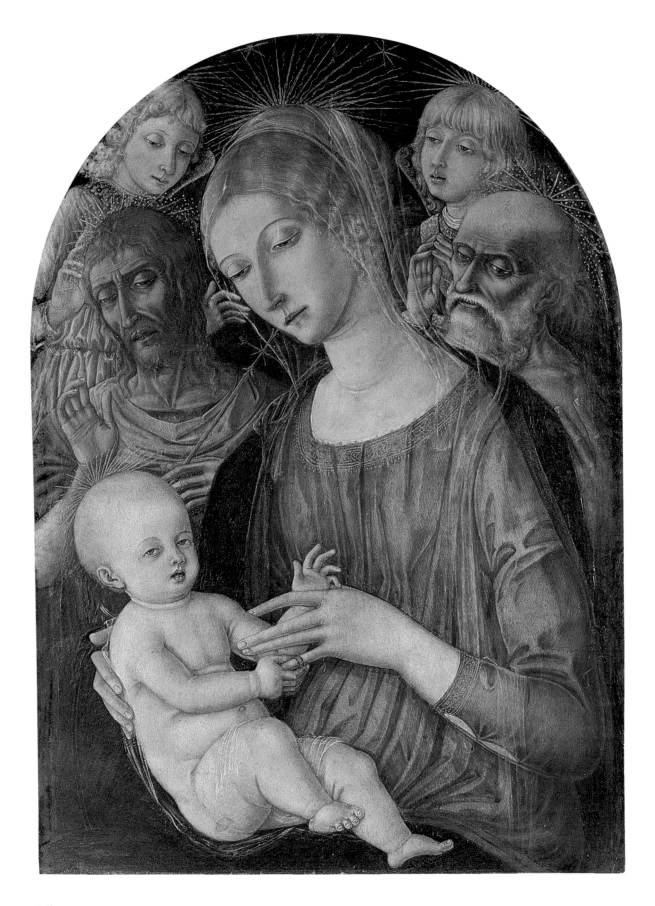

143
MATTEO DI GIOVANNI
Madonna and Child with Angels and Saints
Tempera on cambered panel, 25³⁄₁₆ × 18⁷⁄₈ in. (64 × 48 cm)
Uffizi, Gallery; inv. 1890: no. 3949

This work came to the Uffizi in 1915 from the Oratory of Selve in Siena. A
typical example of Sienese painting in the middle of the fifteenth century,
it illustrates the linearism and exhausted elegance of the late Gothic in its
vivid coloring and lack of volumetric depth.

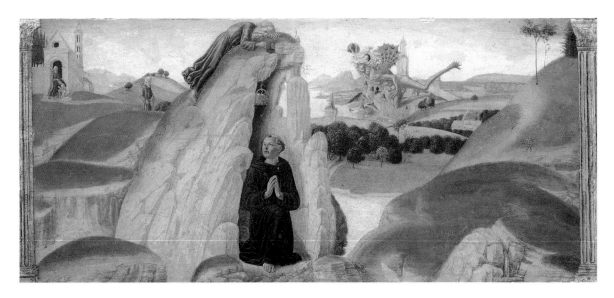

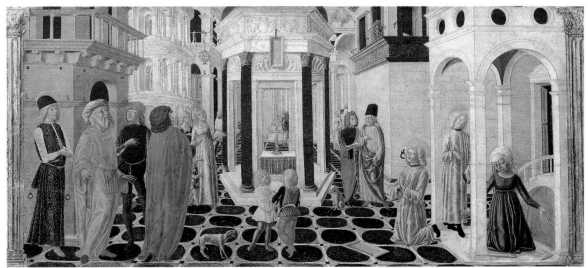

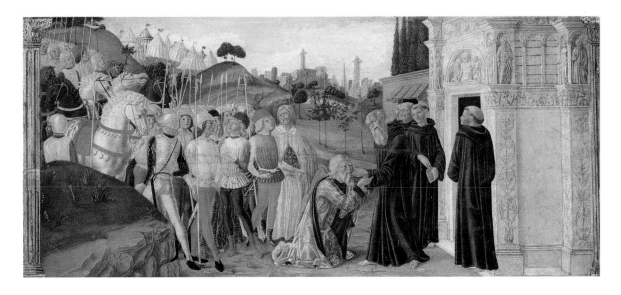

144

NEROCCIO DI BARTOLOMEO LANDI and
FRANCESCO DI GIORGIO MARTINI
Three Stories from the Life of St. Benedict
Tempera on panel, 11$\frac{3}{16}$ × 76 in. (28 × 193 cm)
Uffizi, Gallery; inv. 1890: no. 1602

These three scenes probably constituted the predella for the altarpiece
of the *Coronation of the Virgin* that Francesco di Giorgio painted for the
monastery of Monteoliveto. He completed the commission sometime
between 1473 and 1475, when he was working with Neroccio.

Central Italy

Within the Florentine artistic culture at the end of the 1430s, Piero della Francesca's professional and spiritual development reached its maturity. Piero's Florentine sojourn of 1439–1440, during which he collaborated with Domenico Veneziano on the fresco decorations of the choir of Sant'Egidio (now unfortunately lost), proved to be an important experience for the painter, to which his own work in Borgo San Sepolcro attests. Throughout his long career Piero would elaborate on this project with continual embellishments, which included the suggestion of a luminous articulation of perspective, a cultivated naturalism, and an especially precious and exalted attention to the direction of falling light, which he learned from Florentine painting in general and from Domenico Veneziano in particular. It now seems beyond question that the horses in the cortege of the queen of Sheba, in the well-known frescoes by Piero in the choir of San Francesco in Arezzo (painted after 1452), took their cue—in both color and pose—from Veneziano's *Adoration of the Magi* in Berlin.

Piero's subsequent activity at the court of Federico da Montefeltro in Urbino, along with his lifelong residence in central Italy around Borgo San Sepolcro, the Marches, and Rome, largely determined the artistic climate in those parts of the peninsula. His work influenced the style of numerous well-known artists who would mediate the passage into the next century, among them Signorelli, Perugino, and Girolamo Genga. Also making their mark, however, were others from the preceding generation, perhaps less famous but no less interesting for all that, such as Melozzo da Forlí, Antoniazzo Romano, and to some extent Giovanni Boccati and Girolamo di Giovanni from Camerino, as well as the Umbrian Bartolomeo Caporali. Caporali, like his peer Antoniazzo Romano, based his serene and pious style of painting on the slightly archaic idiom of the Umbrian and Roman works of Fra Angelico, and more especially on Benozzo Gozzoli's art. The icons by Gozzoli in Rome (particularly the *Virgin and Child Blessing* in Santa Maria Sopra Minerva, and the fresco fragments in SS. Domenico and Sisto) and in Umbria (for instance the *Head of Christ* in the treasury of the basilica in Assisi and the altarpiece of 1456 for the Sapienza Nuova in Perugia) are characterized by their dignity but also by their exalted sense of the liturgical ceremony, rendered splendidly on golden backgrounds. These works clearly inspired the Umbrian painters who were active in the 1440s; this kind of emulation is apparent, for example, in Antoniazzo Romano's painting of the nursing Virgin in the Museo in Rieti, signed and dated 1464.

Other very important roles in Italy's artistic panorama were played by Luca Signorelli of Cortona and by Pietro Vannucci of Città della Pieve, known as Perugino. The styles of these two artists formed the foundation for the "modern culture" of the young Raphael. Raphael was educated in his native Urbino, which was then dominated by the cultural influence of Piero della Francesca and that of the Florentines from Luca della Robbia to Paolo Uccello and Giuliano da Maiano, as well as the master carvers who were working on the wooden decorations of the Palazzo Ducale from the Florentines' designs.

Perugino himself actually had something of a Florentine education when he worked, in around 1470, in Verrocchio's workshop, alongside Leonardo, Lorenzo di Credi, Botticini, and perhaps even Botticelli and Ghirlandaio. In any case, he was considered by Vasari to be the inventor of a pictorial style that modern critics have termed a kind of classicism *ante litteram*, characterized by a "sweetness of unified color" that was so attractive that the "people who saw his work marveled at this new and vivid beauty and declared that absolutely no one could ever achieve anything better." Perugino can be said to have stimulated Florentine and Tuscan artistic culture in the last decade of the century, running a workshop and working intensively in the Medici city in addition to his primary activity in Perugia. His Florentine work, which was destined for the most important and most visited churches and convents in the city, as well as for the Medici family, proposed an ideal of serene rhythmic equilibrium, of architecture and open spaces in which the figures are in proportion, with empathy and harmony between them, and an ambience filled, as it were, with peaceful contemplation and with the simple surrender to the Christian devotional embodied in the viewing of the painting. According to a recent interpretation, the sweet atmosphere evoked in Perugino's pictures coincides with the esoteric humanistic culture of the Neoplatonic circles of the Laurentian epoque.

Signorelli, too, was sympathetic to these ideals and to the cultural climate of Florence and Tuscany at this time. His work was sustained, however, during moments of more controlled creativity, by a robust plasticity coupled with a severe physicality. He played quite an important historical role in the artistic development of central Italy during this period, influencing both Raphael, as has already been mentioned, and Michelangelo. Signorelli's art superimposes an assertive plasticity over the classical monumentality of Ghirlandaio; his figures' lean and polished limbs have an almost sculptural quality that recalls the appearance of painted wooden statues dressed in clothes, almost like posed mannequins or workshop "models." Always, however, they are heroic, symbolic images, and characters of a grave moral significance.

Anna Padoa Rizzo

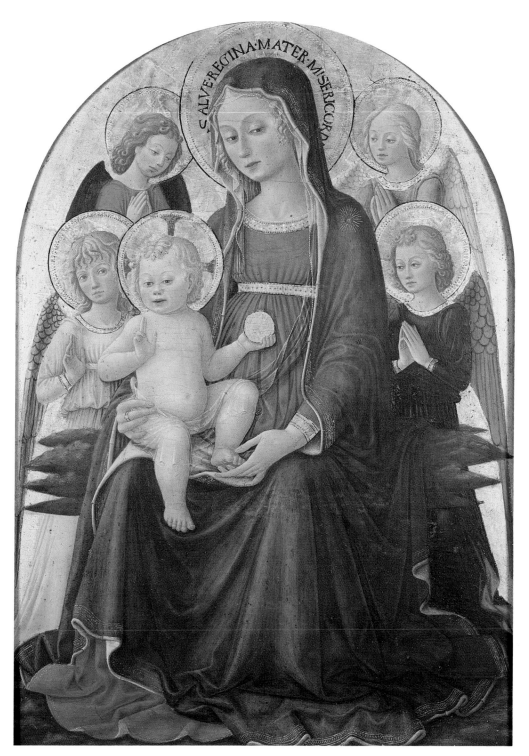

145
BARTOLOMEO CAPORALI
Madonna and Child with Angels
Tempera on panel, 31⅛ × 21⅝ in. (79 × 55 cm)
San Marco, Museum; inv. 1890: no. 3250
This painting was acquired from the antiques market in 1904. It is a testament
to the persistence, in the area around Umbria, of echoes of the work of Fra
Angelico, a tendency that is particularly evident in the positioning of the Virgin
on a golden background. The faces recall the style of Benozzo Gozzoli.

Following pages: 146 and 147
PIERO DELLA FRANCESCA
Portrait of Battista Sforza
(verso) *The Triumph of Battista Sforza*
tempera on panel, 18½ × 13 in. (47 × 33 cm)
Inscription: QUE MODUM REBUS TENUIT
SECUNDIS / CONIUGIS MAGNI DECORATA
RERUM / LAUDE GESTARUM VOLITAT PER
ORA / CUNCTA VIRORUM
Uffizi, Gallery; inv. 1890: no. 3342
Portrait of Federico da Montefeltro
(verso) *The Triumph of Federico da Montefeltro*
Tempera on panel, 18½ × 13 in. (47 × 33 cm)
Inscription: CLARUS INSIGNI VEHITUR
TRIUMPHO / QUEM PAREM SUMMIS DUCIBUS
PERENNIS / FAMA VIRTUTUM CELEBRAT
DECENTER / SCEPTRA TENENTEM
Uffizi, Gallery; inv. 1890: no. 1615

These pendant paintings, datable to around
1465, joined the Florentine collections in 1631
as part of the della Rovere inheritance. Piero's
psychological investigation exalts the noble
character of the duke and duchess, painted in
courtly profile against a vaguely Flemish back-
ground rich in details from real life.

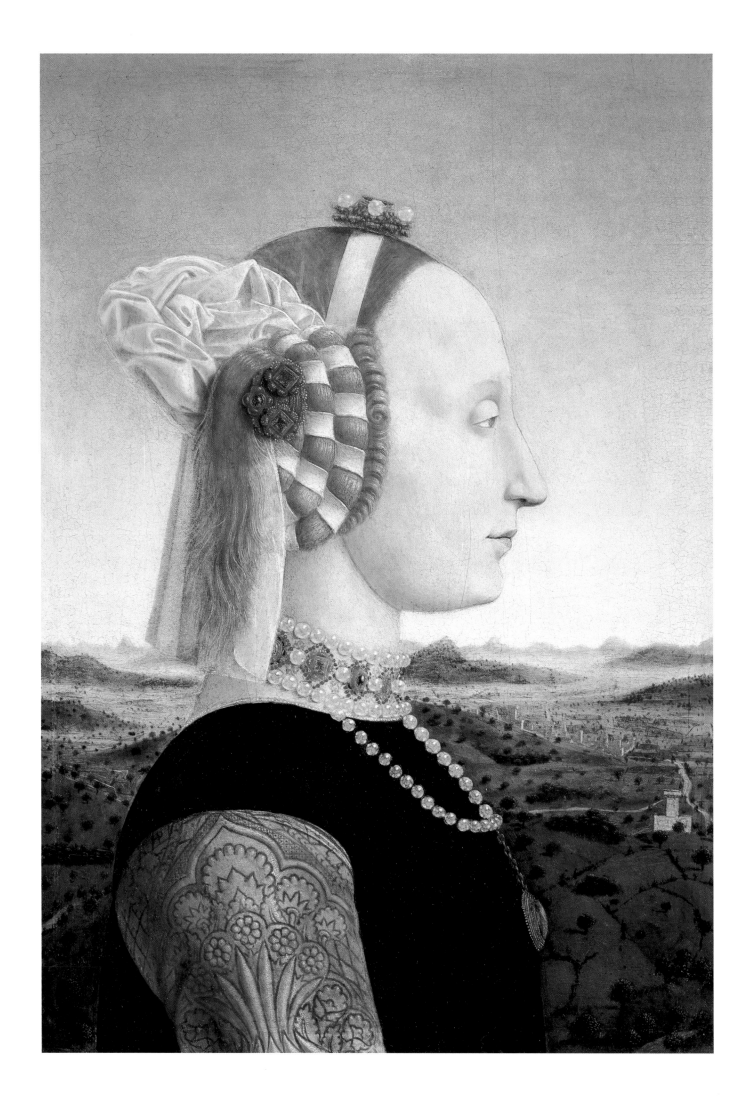

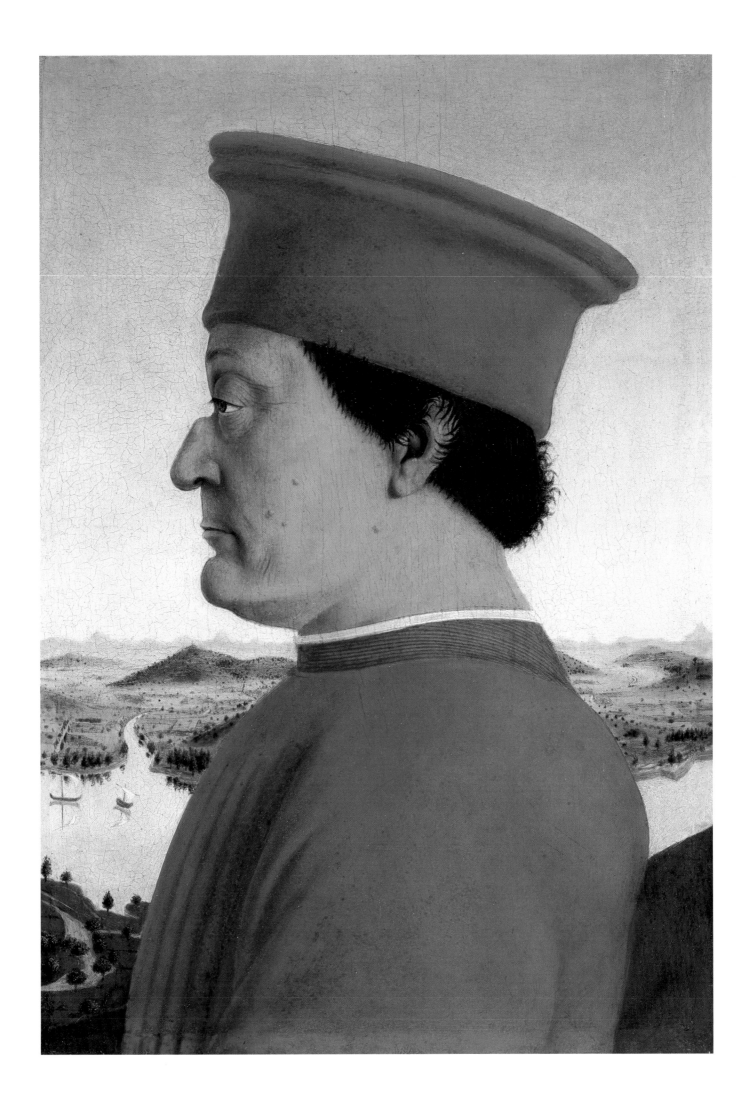

123

QVE MODVM REBVS TENVIT SECVNDIS ·
CONIVGIS MAGNI DECORATA RERVM ·
· LAVDE GESTARVM VOLITAT PER ORA ·
CVNCTA VIRORVM ·

CLARVS INSIGNI VEHITVR TRIVMPHO ·
QVEM PAREM SVMMIS DVCIBVS PERHENNIS ·
FAMA VIRTVTVM CELEBRAT DECENTER ·
SCEPTRA TENENTEM ↝

148
LUCA SIGNORELLI
The Holy Family
Oil on panel, 48¹³⁄₁₆ in. (124 cm) in diameter
Uffizi, Gallery; inv. 1890: no. 1605

To judge from the pre-Michelangelesque monumentality of the figures disposed harmoniously around the circular format, this roundel may have been executed in about 1490. It may have been painted, as Vasari suggested, for the Sala delle Udienze in the Palace of the Captains of the Guelf party in Florence.

149
LUCA SIGNORELLI
Allegory of Fecundity and Abundance
Oil on panel, 22¹³⁄₁₆ × 41⁹⁄₁₆ in. (58 × 105.5 cm)
Uffizi, Gallery; inv. 1890: no. 3107

Among the very few profane subjects attributable to Signorelli, this painting joined the Uffizi collection in 1894. It can probably be dated to around 1500, through analogies with the monochromes in the frescoes at Orvieto.

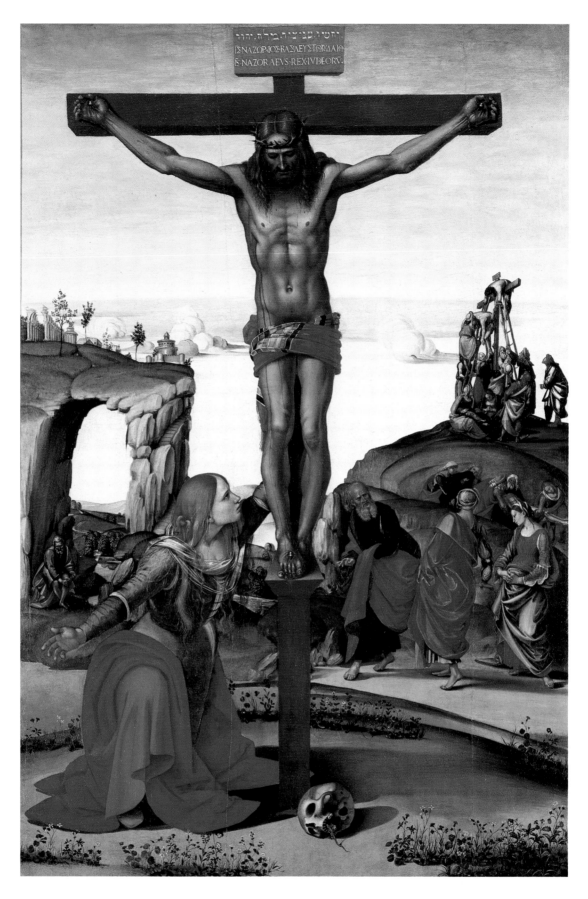

150
LUCA SIGNORELLI
The Crucifixion with St. Mary Magdalen
Oil on canvas, 97¼ × 64¹⁵⁄₁₆ in. (247 × 165 cm)
Uffizi, Gallery; inv. 1890: no. 8368
This painting, which came from the Annalena convent, is one of
Signorelli's mature works, dating from the end of the fifteenth or the
beginning of the sixteenth century. On the back is a design by the
same painter for a *St. Jerome.*

151

LUCA SIGNORELLI

Madonna and Child with Prophets

Oil on panel, 66¹⁵⁄₁₆ × 46¼ in. (170 × 117.5 cm)

Inscription: ECCE AGNUS DEI

Uffizi, Gallery; inv. 1890: no. 502

According to Vasari, this panel was executed for Lorenzo the Magnificent, along with the *Education of Pan* (once in Berlin, but now destroyed). It remained in the Medici villa of Castello until July 16, 1779, when it was transferred to the Uffizi.

152 and 153
MELOZZO DA FORLÍ
The Angel of the Annunciation
Tempera on panel, 45¹¹⁄₁₆ ×
23⅝ in. (116 × 60 cm)
Uffizi, Depository: inv. 1890:
no. 3341
The Virgin Annunciate
Tempera on panel, 45¹¹⁄₁₆ ×
23⅝ in. (116 × 60 cm)
Uffizi, Depository; inv. 1890:
no. 3343

These two panels have been cut down along the top; originally they probably decorated an organ. Conceived as monochromes, they were painted toward the end of the fifteenth century. On the back of each is the figure of a saint, cropped above the shoulders by the panel's trimmed edge.

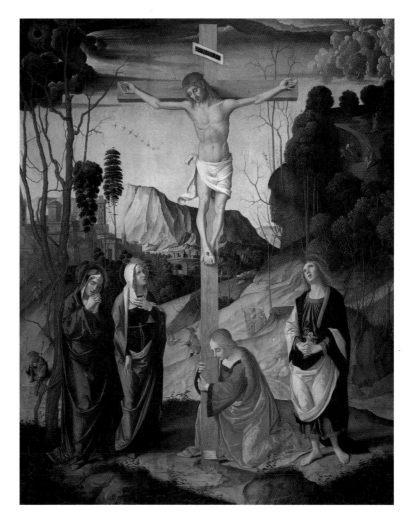

154
MARCO PALMEZZANO
The Crucifixion
Tempera on panel, 44¹⁄₁₆ × 35⁷⁄₁₆ in. (112 × 90 cm)
Inscription: MARCUS PALMI / ZANUS FOROLIVIE / SIS
FATIEBAT
Uffizi, Gallery; inv. 1890: no. 1418

In the seventeenth century this painting could be found in the sacristy of the church of Monteoliveto in Florence. Executed around 1510, it draws in style both on Bellini's work and on the formal simplification of Francia.

129

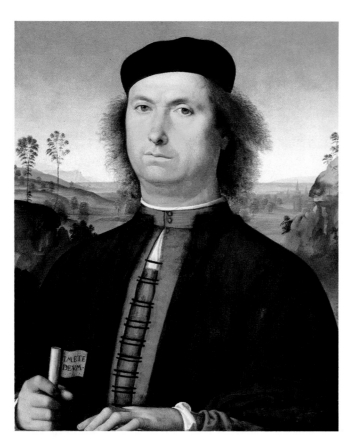

155
PERUGINO
Portrait of Francesco delle Opere
Oil on panel, 20½ × 17⁵⁄₁₆ in. (52 × 44 cm)
Inscription: TIMETE DEUM
Uffizi, Gallery; inv. 1890: no. 1700

On the reverse side of this picture are inscribed its date of execution (July 1494), the name of the painter, and the identity of the sitter.

156
PERUGINO
Madonna and Child Enthroned with SS. John the Baptist and Sebastian
Oil on panel, 70¹⁄₁₆ × 64⁵⁄₁₆ in. (178 × 164 cm)
Signed and dated: PETRUS PERUSINUS PINXIT MCCCCLXXXXIII
Uffizi, Gallery; inv. 1890: no. 1435

This altarpiece was painted for the chapel of Cornelia di Giovanni Martini da Venezia, constructed in 1488 in San Domenico in Fiesole. Signed and dated 1493 on a scroll at the base of the throne, it was lauded by Vasari for its "most praiseworthy" depiction of St. Sebastian.

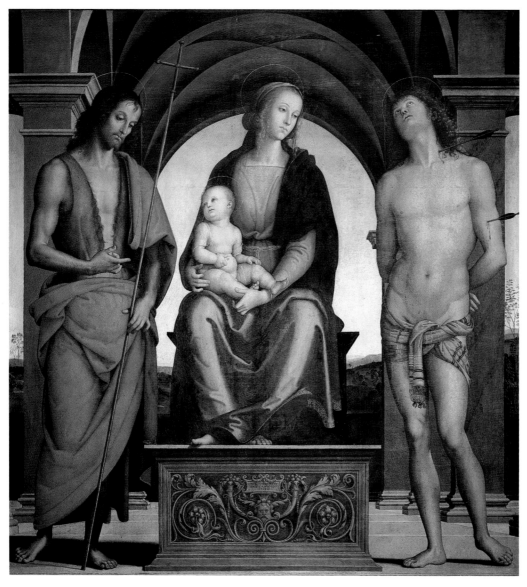

PERUGINO

Mary Magdalen

Oil on panel, 18½ × 13⅜ in. (47 × 34 cm)

Inscription: S. MARIA MADALENA

Pitti, Palatine Gallery; inv. 1912: no. 42

Correctly attributed to Perugino in the Medici inventory of the villa at Poggio Imperiale of late 1641, this painting dates from around the last years of the fifteenth century.

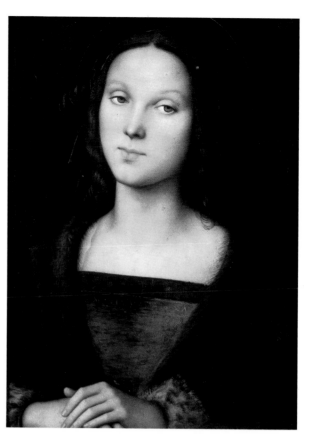

158

PERUGINO

Pietà

Oil on panel, 66⅛ × 69⁵⁄₁₆ in. (168 × 176 cm)

Uffizi, Gallery; inv. 1890: no. 8365

This work, which was admired by Vasari, was commissioned for one of the side altars in the church of the Gesuati monks, San Giusto alle Mura, where it originally hung beside the *Agony in the Garden* (today in the Uffizi). It dates from around 1493–1494.

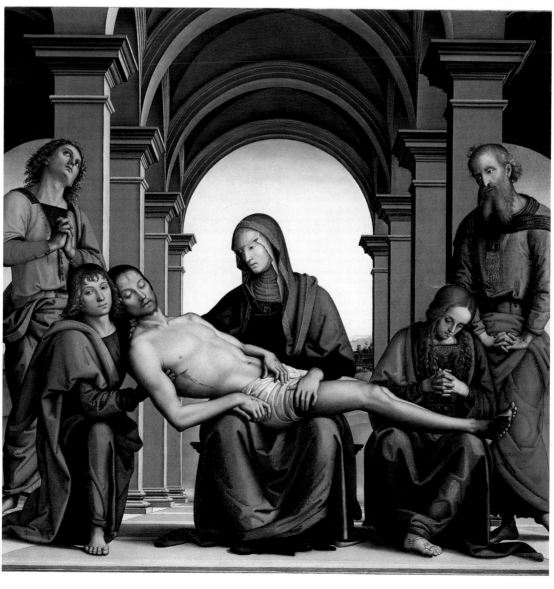

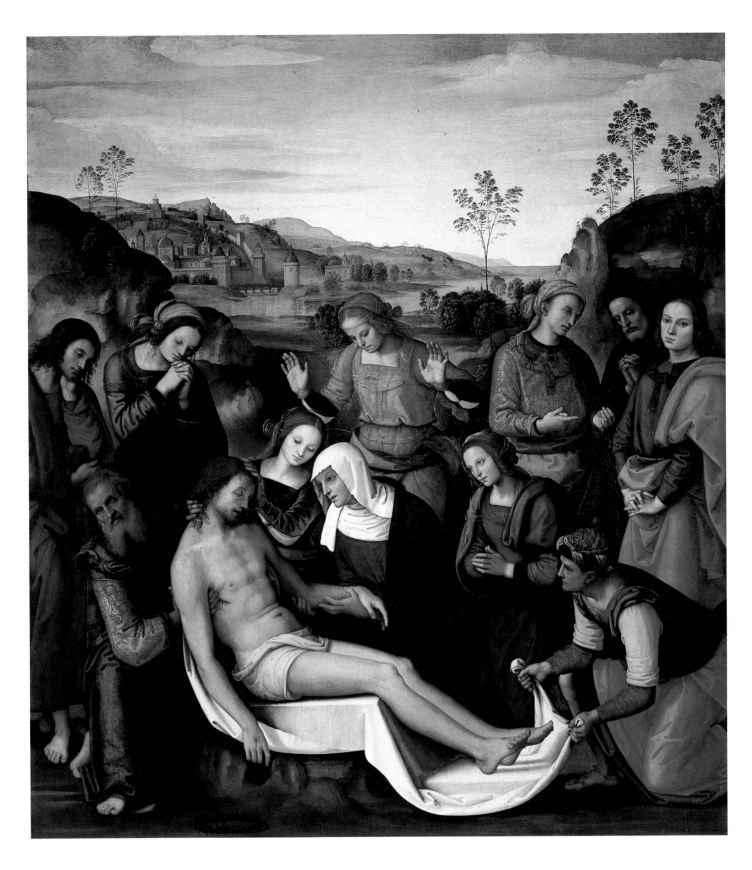

159

PERUGINO

The Lamentation over the Dead Christ

Oil on panel, 84¼ × 76¾ in. (214 × 195 cm)

Signed and dated: PETRUS PERUSINUS PINXIT A.D. MCCCCLXXXXV

Pitti, Palatine Gallery; inv. 1912: no. 164

This masterpiece by Perugino was installed behind the second altar on the right-hand side in the church of Santa Chiara in Florence. Signed and dated 1495, it was particularly admired by Vasari for its admirable representation of the mourners' emotions and for the "landscape that has been rendered so beautifully."

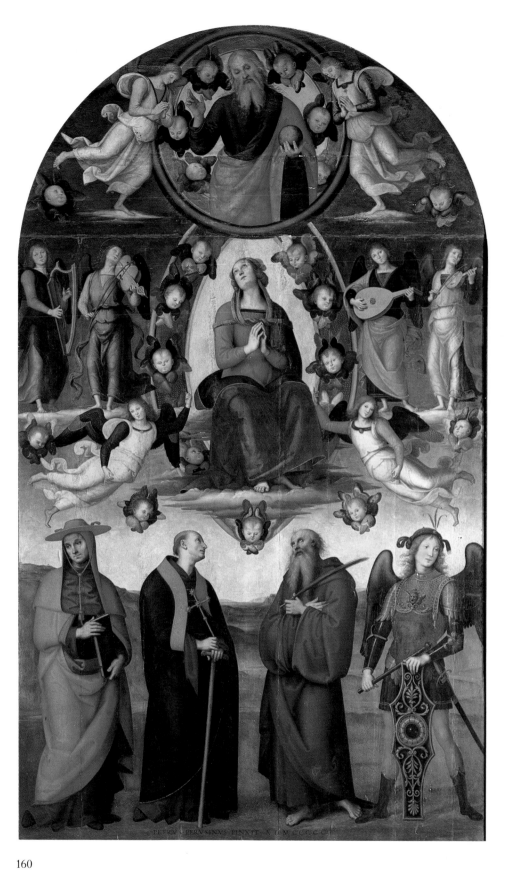

160
PERUGINO
The Assumption of the Virgin with Saints
Oil on panel, 163⅜ × 96⅞ in. (415 × 246 cm)
Signed and dated: PETRUS PERUSINUS PINXIT AD MCCCCC
Accademia, Gallery; inv. 1890: no. 8366

This large altarpiece was commissioned from Perugino for the
church of the abbey of Vallombrosa in 1498; it was placed on the
altar on July 18, 1500. The four saints at the Virgin's feet (John
Gualbert, Bernardo degli Uberti, Benedict, and Michael) are affili-
ated with the Vallombrosian order of monks.

161 and 162
PERUGINO
*Portrait of Don Biagio
Milanesi*
Oil on panel, 11¼ × 10⁷⁄₁₆ in.
(28.5 × 26.5 cm)
Uffizi, Gallery; inv. 1890:
no. 8375
*Portrait of Baldassare
Vallombrosano*
Oil on panel, 10¼ × 10⅝ in.
(26 × 27 cm)
Uffizi, Gallery; inv. 1890:
no. 8376

These two small panels were
once part of the predella of
*The Assumption of the Virgin
with Saints*, Perugino's altar-
piece of 1500 for the abbey
of Vallombrosa (now in the
Accademia, see p. 133).

163
GIROLAMO GENGA
*The Martyrdom of
St. Sebastian*
Tempera on panel, 39⅜ ×
32¹¹⁄₁₆ in. (100 × 83 cm)
Uffizi, Gallery; inv. 1890:
no. 1535

This painting, which came
to the Uffizi in 1798, is dat-
able to the first years of the
sixteenth century, during the
period when Genga was dis-
tancing himself from the
work of his master, Sig-
norelli, and allying himself
quite decisively with Peru-
gino's style.

Venice, Emilia, and Lombardy

The extraordinary change in the visual system of representation that is associated with the term *Renaissance* took hold in Padua before anywhere else in the Veneto. This is mainly due to the city's cultural tradition, the optical and perspectival studies shaped by the presence of its ancient and prestigious university. In particular, these ideas were constantly reaffirmed in relation to the ideas of the classical and Roman world, which had been given a voice by the most eminent "antiquarians" of the era. Thus we find in Padua, at the end of the fourteenth century, the native-born Giovanni Dondi dell'Orologio, who produced a written description of the ancient buildings of Rome. In 1443 Ciriaco d'Ancona passed through the city, and in 1452 Giovanni Marcanova taught there.

Obviously these men did not belong to the pictorial profession, but it is important to mention them as examples of the different ways in which that profession was then being considered. The image of the medieval artisan who waited for commissions in his workshop is no longer fundamental to our understanding of this historical period. By the middle of the fifteenth century, the Paduan artist, though not yet able to abandon his work practices, had intellectuals as his companions; and from them he received a new and revolutionary instrument of representation, a science of perspective that was based on mathematical principles of proportion and was no longer exclusively empirical. The artist had dialogues and discussions with intellectuals, and he imitated them, from their alphabet on. He now began to read and write and study in Latin, the language of the learned; through a new interest in his immediate environment, the artist began to understand the importance of travel and to open his mind to a greater range of ideas.

It was the institution of this new intellectual dimension and the possibilities of the new didacticism that made the presence in Padua of Francesco Squarcione, the master of Andrea Mantegna, so important. If the above-mentioned were the elements of fusion in the crucible, then the catalyst came from Tuscany in the person of Donatello, who arrived in Padua at the end of 1443 and stayed for ten years. The extraordinary impressions of the Florentine sculptor are most keenly expressed in his equestrian statue of Gattamelata, the first great bronze monument of this type since antiquity. Therefore, Donatello was seen as a man capable of reviving the antique, one who could confront and give life to a concept that had lain dormant for more than a thousand years. As a consequence of this, he was commissioned to create the high altar in the church of the Santo (finished in haste for the feast of Sant'Antonio in 1450), where he placed an arrangement of figures under a stone loggia of new, measured, and architectonic proportions.

Indeed, Donatello's stay in Padua, around the middle of the century, begins to seem a kind of watershed, an event that served to turn an old world into a newly "antique" one. There was a consequent outgrowth of Floren-tine sculpture, as well as a new Paduan painting (with its revelation of a rational world constructed in a new, rational way, coherent in its parts and in the rapport between parts and whole) whose greatest champion was Andrea Mantegna. This latter artist was to display an extraordinary influence outside the confines of the city, particularly in the direction of Ferrara (to which, at an extremely young age, he traveled in 1449 on the invitation of Lionello d'Este), then Verona (which in 1459 welcomed the astonishing triptych of San Zeno, a grandiose and gigantic refiguring in painting of the sculptural altar of the Santo), and finally Mantua, where he took up definitive residence in 1460.

If Venice was not touched in precisely the same way as Padua by these developments, it was nonetheless not immune to innovation. In 1450 the Muranese Antonio Vivarini, brother of Bartolomeo, abandoned his work on the walls of the Gothic chapel of the Ovetari family, in the church of the Eremitani in Padua, after the death of his colleague, the older and more versatile figure in fresco technique, Giovanni d'Alemagna. (This chapel also contained some extraordinary frescoes by Mantegna, which were almost entirely destroyed during the course of World War II.) Another talented Venetian, Jacopo Bellini, well represented in the gallery by a beautiful *Madonna and Child*, cultivated a dream of creating a powerful workshop that would produce works through prudent politics and artistic alliances. In 1453 Jacopo's eldest daughter, Nicolosia, was married to that genial new Paduan, Mantegna; but if the father-in-law entertained any thoughts of retaining Andrea, a magnificent soloist, as a mere choral singer, he was doomed to failure. Not a great deal of time passed before Mantegna accepted a position as court painter at Mantua, where he was able to exploit his situation and be the sole owner of his art. But the family tie which bound him to his young brother-in-law, Giovanni Bellini, was destined to produce, up to around 1475, works of the greatest poetic invention.

The Uffizi has a triptych by Mantegna, each panel a different size and all retained *ab antiquo*. Included is *The Adoration of the Magi, The Circumcision*, and *The Ascension*. Executed in Mantua in the early 1460s, they are all perfect specimens of his art, displaying an extraordinary suppleness of execution and emotion, an attention to the most minuscule and distanced detail, and the application of a rigorous perspective that manages to be both unusual and adventurous (as, for example, in the rocks curving in the background of the *Adoration of the Magi*). They are laid out with superhuman exactitude and rendered with a sense of rational adherence to the rudiments of vision. The "variety" recommended by his friend Leon Battista Alberti is evident in Mantegna's fascination with the rare and exotic, here typified by the black king and those in his entourage, the costumes and unusual headdresses, and even the presence of a dromedary. Mantegna's paint has been applied in such a way as to stretch an abstract ray of light over the objects and so escape the fragmentation of Gothic taste; the result has the emotional impact of a true dawn, with light radiating from a tangential horizon and imbuing the lower part of the painting with passing ten-

drils of luminescence. The *Circumcision*, for its part, presents the viewer with the calculated and surprising choice of a quintet of scenes that form not a coherent architectural unit, but rather a single structural element—a marble column—with its intended contrast between figures that seem to fuse together into an immutable eternity between the expression of fear on the face of the baby Jesus and the abandoned hold of the other baby, in red, who, having nibbled at his *bussolà*, now sucks his thumb. Finally, the *Ascension* serves as excellent proof of Mantegna's ability: it shows the figure of the apostle, at the right of the panel, in an uninterrupted walking pose, with one foot raised slightly off the ground, a detail that was to please painters up to Carpaccio and Titian.

Mantegna's attention to the living quality of stone and to the beauty of this resilient material, as well as to all aspects of construction, is manifest in the small and late *Madonna of the Caves*, with its fantastic landscape of basaltic rocks near a cultivated countryside. The artist likewise introduces novel stylistic flourishes into his portraiture as in the *Portrait of Carlo de' Medici*, painted in the three-quarter Flemish mode. But here, Mantegna's renunciation of the parapet typical of such works annuls any distance felt between the observer and the portrait, conferring upon it a modernity that would not be surpassed for a very long time; a portrait of the "social rank" thus abandons the heraldic aspect and the made-up characteristics of the profile portrait.

It has been said that the family relationship between Mantegna and Giovanni Bellini was destined to bear fruit and indeed, the two men evidently shared a common and continuous ideal that may be seen in the *Portrait of a Man*, signed by Giovanni, which, almost forty years later, seems to repeat Andrea's image of Carlo de' Medici. However, the differences between these artists outnumber the similarities. Bellini's painting seems to have been consciously based on Flemish prototypes (many of them were even then in Venetian collections), with a nod to the mediating influence of Antonello da Messina, who was in Venice from the end of 1474 to 1476. Bellini was responsible for reestablishing the presence of the parapet in front of the sitter, but what mattered more was that by raising the figure slightly in front of the plane of vision, he was able to ensure a sort of circulation of air that created a natural ambience against the cloud-filled sky. This conception contrasts greatly with the dark shadows and artificial light effects employed by Mantegna in, for example, the Medici portrait. Those who are searching for man in a friendly universe will find him most consistently in the work of Giovanni Bellini. In Mantegna's art there are compositional depths and fantastic scenes built out of a strenuously calculated perspective. The landscapes of the mature Bellini, removed from the tutelage of his brother-in-law, are marked by a new intuition (moved, perhaps, by a knowledge of Flemish painting more than by a demonstrable contact with Piero della Francesca) and an equivalence between the receding of the picture plane in depth and the modulation of intensity of luminous color that might well exist outside the norm. This latter quality has, as well, a

more empirical perspective function that results in a greater naturalism and an extraordinary increase in emotional expressiveness—something more than ideas. Whereas Mantegna's works, constructed in the throes of a romantic archaeological and geological passion, describe something hard and splintering and seem at once indifferent, Bellini's paintings are a loving observation of the stuff of human life, scenes of familiar experience that are credible in their affectionate recording of vines, elms, hornbeams, and poplars (all typical trees of the Veneto) and in their understanding of the animals who inhabit that world. No longer the naked and untamed product of tectonic cataclysms, these lands are reclothed in light, grassy pelts, modulated and remolded by the sacredness of work. Space itself, it seems, now accepts the presence of humanity, in such distant places as it might be found, as a component of its essential being. Every ideological distance between man and nature leans toward a level of equal dignity; and because almost all of Bellini's subjects are otherworldy figures (such as God, the Virgin, and various saints) appearing in human form, even on their surroundings is conferred a somewhat divine worth.

This last effort is particularly evident in the so-called *Sacred Allegory*, where each area of the composition of the spaces—the divine quadrelled terrace above the lake, and the almost primeval human world where hermits meet with centaurs, where shepherds repose and muleteers go to work—interpenetrate and merge in an extraordinary visual unity, in the calm and solemn silence, at the gates of the universe, of a ring of mountains. Similar considerations can be seen in the slightly earlier *St. Jerome in the Desert*. These cultural tendencies are different, and the Mantegna reform, which is actuated by a softening of line and volume, aims at diverse constituent orders of natural species, scrutinized with a clear and incisive eye, in the fashion of the Flemish painters, from the lizard to the fossilized shells, from the stones to the thin grass, from the fig tree to the ivy to the squirrel to the pheasant.

This scenic poetics is similarly, yet uniquely, revisited in the work of Cima da Conegliano, who, if not a direct pupil of Bellini's, was nonetheless strongly influenced by him in painting a work of the same subject as that mentioned above; here all of the magic of the light, the muted beauty of the colors, the glint on the far-off waters, and the shadows cast by the leafy branches are retained. Perhaps painted after 1510, the work also contains Giorgionesque elements reminiscent of works such as the *Tempest* in Venice.

Giovanni Bellini was also a gifted interpreter of narrative painting, an aspect of his work that must today be reconstructed from the imagination, since this production has been completely lost. Giovanni took to narrative painting especially in the 1490s, during which period he was commissioned to paint a series of scenes from the history of Venice for the city's Palazzo Ducale, unfortunately lost in the great fire of 1577. Of these kinds of works we can see only a pale reflection in the Florentine galleries, in the form of a fragment, perhaps of a *Crucifixion*, by Vittore Carpaccio. However, we can also observe, in the "grisaille" of Bellini's *Lamentation over the Dead*

Christ, the artist's profound acuity in choosing the moment of greatest emotional significance in the series of deeds and gestures associated with the Deposition.

Bellini's construct of movement from color and light, without recourse to rhetorical gestures, greatly influenced certain painters from Verona, including Francesco Morone. Morone, despite the diverse local figurative traditions and his ties to a certain Lombard naturalism, no doubt looked to Venice for inspiration in his extremely lyrical works.

Of all the different ways in which the original lessons of Mantegna came to be codified and transformed, it was in Ferrara that through a furious and irrational abstract chromaticism, with an almost tormented line, artistic fruits were born of a brilliant intellectual sophistication. This is particularly evident in Cosmè Tura's *St. Dominic,* with the emaciated and tortured hollow face, the hands almost impeded by an internal mechanical rigidity, a wooden puppetlike quality, and clothes that shroud the saint's form with a metallic sharpness. These models were recast and transplanted to Bologna by two other great Ferrarese artists, Francesco Del Cossa and Ercole de' Roberti, who were succeeded by the very different Lorenzo Costa. As court artist of the Bentivoglio family, Costa produced, around 1506, work characterized by a kind of ideal and artificial elegance. Another adherent, Francesco Francia, showed himself to be receptive to ideas from Tuscan classical sculpture, to the formal approach of Ghirlandaio, and to Bellini's glazed light. The evolution of the two courtly artists, Costa and Francia, stimulated the more sophisticated fantasy of Amico Aspertini's genius. On returning to Bologna after completing a series of frescoes in Lucca, he began to base his paintings on his drawings of subjects from antiquity, to mix, in works such as his *Adoration of the Shepherds,* citatory emphasis with brilliant decoration, creating new gestures and attitudes not seen before in painting. This effect was achieved by means that have often been considered bizarre, if not downright deviant, invoked as a sort of conscious defense— suggestive of sentiment—of a sharp and pungent taste for a "protoclassicism" that was already out of fashion.

For contrast one can refer to that other figurative civilization, in Lombardy, notwithstanding the old reference to the Parmesan painter Alessandro Araldi, in the so-called *Portrait of Barbara Pallavicino.* He apparently took as his models the great heraldic profile portraits, such as those by the Master of the Sforza Altarpiece, used in his painting for Sant'Ambrogio ad Nemus (today in Brera).

The gallery does not have many Lombardian paintings, and none was acquired by the Medici—evidence that there was little taste for them. Among the small number of paintings from this geographical area, however, is a diminutive painting by Vincenzo Foppa that takes its cue from Flemish models, transmitting through an atmosphere of grayness an extraordinarily luminous poetic strength. Two panels from a polyptych by Bernardo Zenale, now detached from their original frame and losing part of their perspectival efficacy, leave one to guess at the effect of their former painterly ambience. When placed together with a *Madonna and Saints* in the Lawrence Museum in

Kansas, these panels appear to make up a series that would seem to lay to rest any consideration of collaboration between Zenale and Bernadino Butinone; so different it is from a work in Treviglio, begun around 1485 in collaboration with his partner, and completed in the early 1490s.

Mauro Lucco

164
ANDREA MANTEGNA
Portrait of Carlo de' Medici
Tempera on panel, 16 × 11⅞₆ in. (40.6 × 29.5 cm)
Uffizi, Gallery; inv. 1890: no. 8540
The identification of the portrait's subject is based on its similarity to a medallion depicting the monument erected to Carlo de' Medici in the Duomo in Prato. This suggests that the painting was executed in 1467, during Mantegna's visit to Florence.

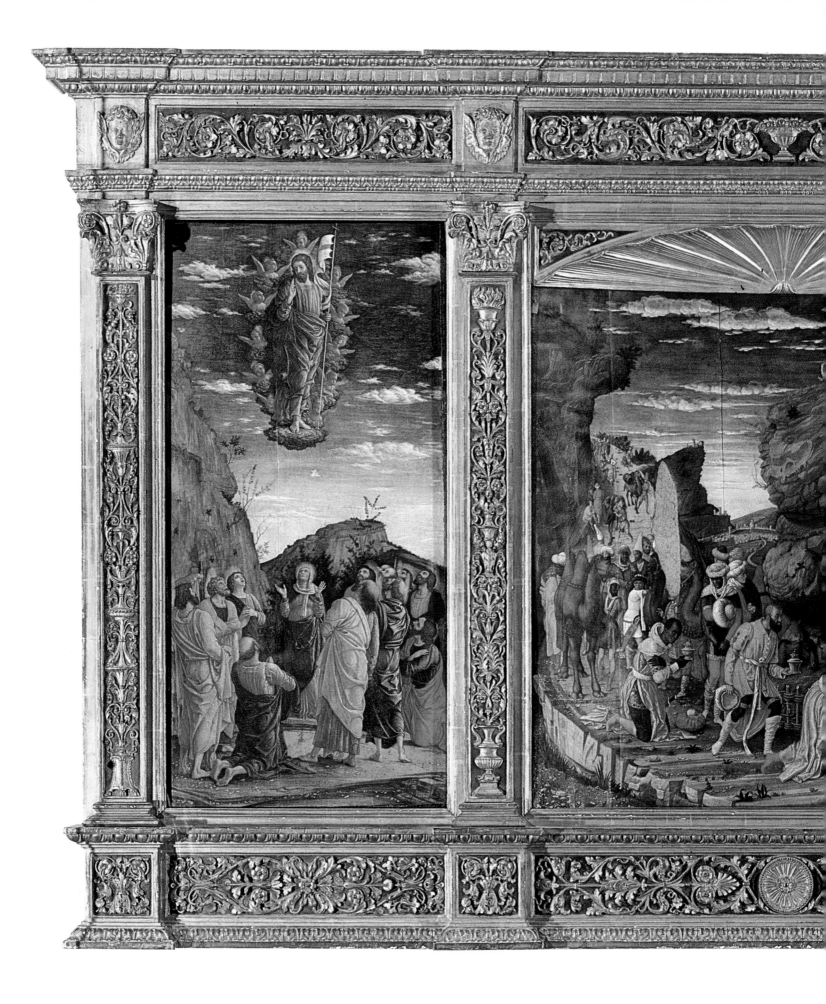

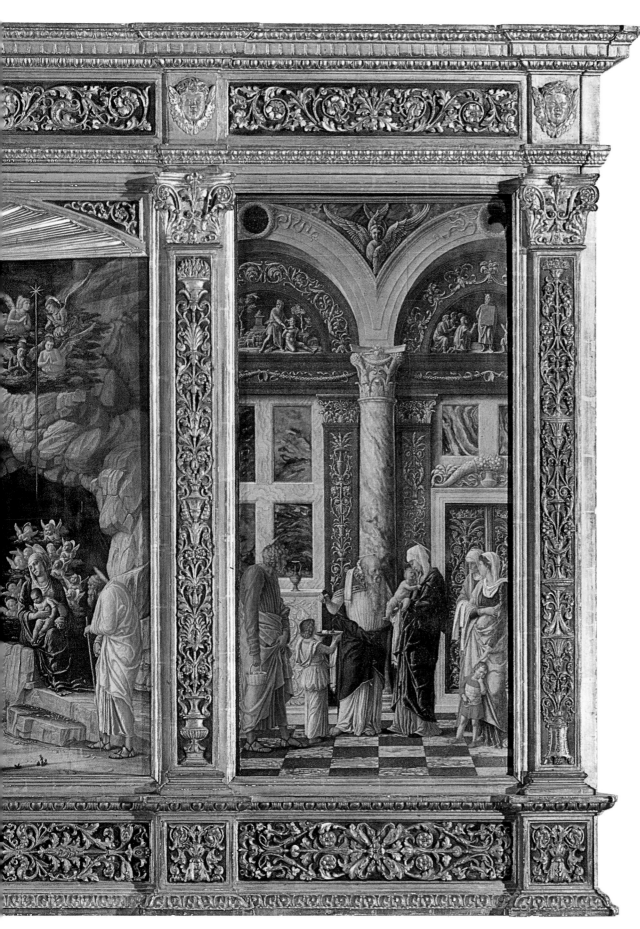

165
ANDREA MANTEGNA
Triptych
Tempera on panel, 33⅞ ×
63⁵⁄₁₆ in. (86 × 161.5 cm)
The Ascension 33⅞ × 21¼ in.
(86 × 54 cm);
The Adoration of the Magi 30⁵⁄₁₆
× 29½ in. (77 × 75 cm);
The Circumcision 33⅞ × 16¹⁵⁄₁₆
in. (86 × 43 cm)
Uffizi, Gallery; inv. 1890: no.
910

By 1587 this triptych was al-
ready in the possession of Don
Antonio de' Medici, in the gal-
lery of the Casino di San Marco;
it came to the Florentine gallery
in 1632. It may be one of the
paintings that Mantegna did for
the little chapel of the Castello
di Goito, which he began in Oc-
tober 1463 and mentioned in a
letter dated April 26, 1464. The
cycle probably depicted events
in the life of Christ.

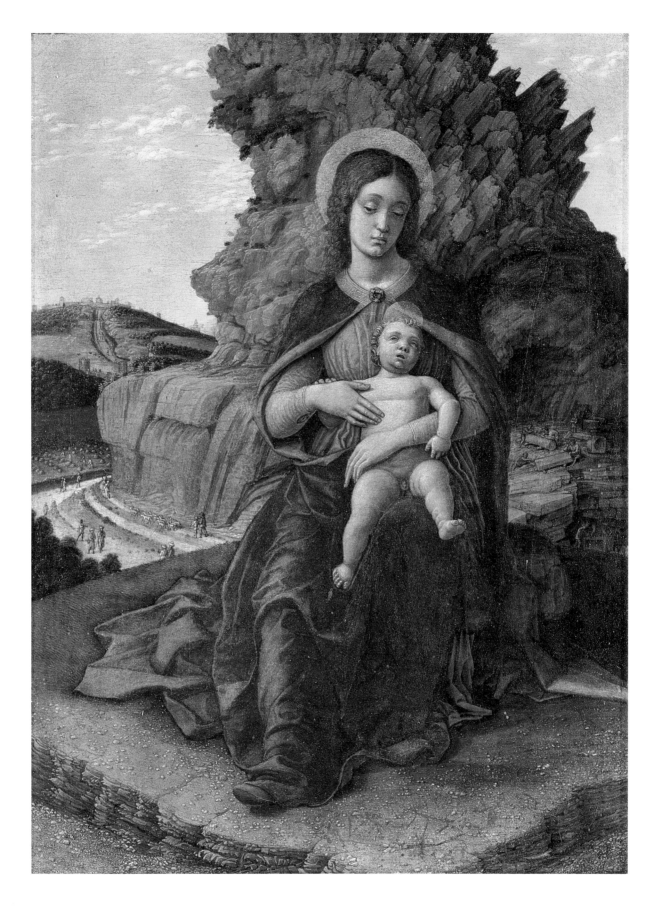

166
ANDREA MANTEGNA
Madonna and Child ("Madonna of the Caves")
Tempera on panel, 11⁷⁄₁₆ × 8⁷⁄₁₆ in. (29 × 21.5 cm)
Uffizi, Gallery; inv. 1890: no. 1348

This work was recorded by Vasari as property of Prince (then Grand
Duke) Francesco de' Medici in 1568; it is first mentioned in the
gallery inventory in 1704. Vasari dated the work to Mantegna's visit
to Rome in 1489–1490.

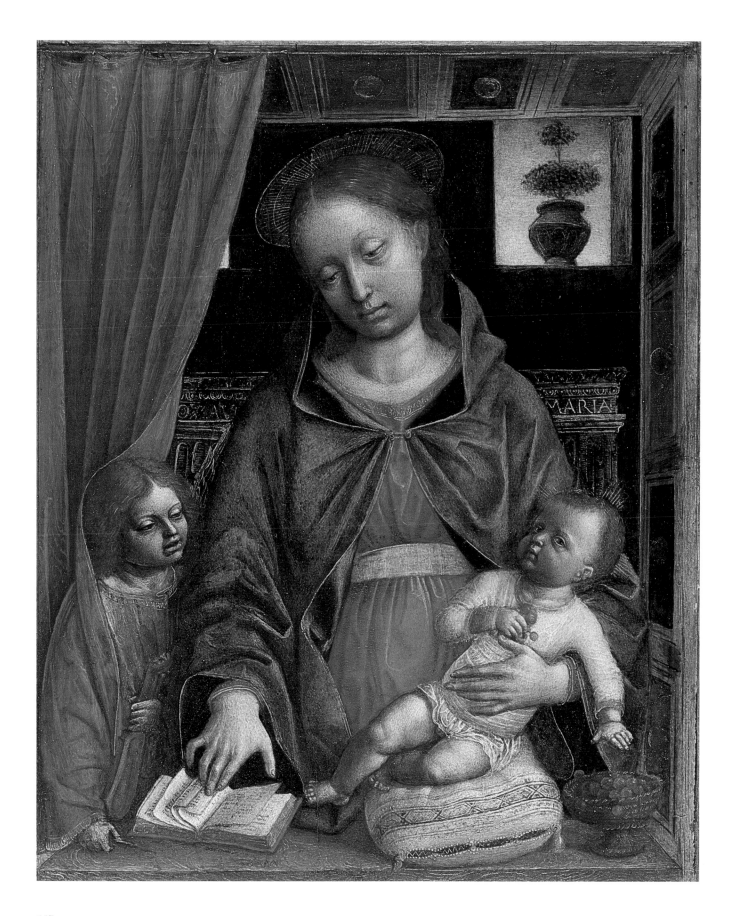

167
VINCENZO FOPPA
Madonna and Child with an Angel
Tempera on panel, 16⅛ × 12¹³⁄₁₆ in. (41 × 32.5 cm)
Uffizi, Gallery; inv. 1890: no. 9492

Included in the Genoulhiac Frizzoni collection of Milan in around 1930, this panel subsequently entered the Contini Bonacossi collection and came to the Uffizi in 1975. It was completed around 1480 and is one of the greatest surviving examples of Lombard painting, capturing the dark atmosphere while deriving its inspiration from a Flemish prototype.

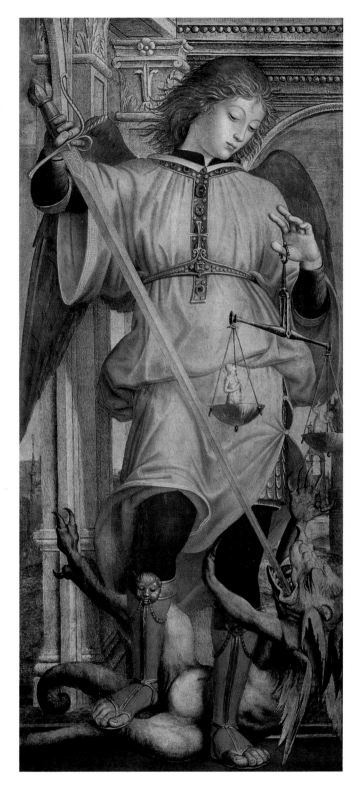

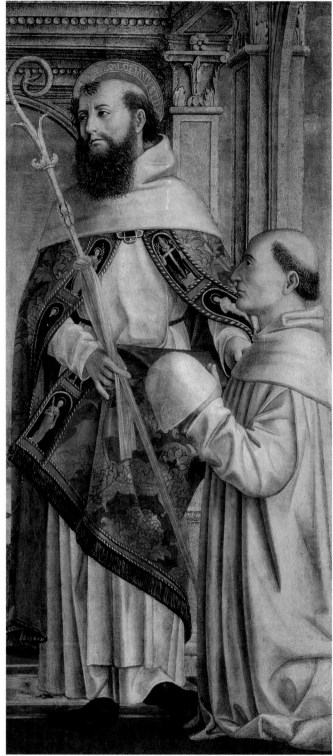

168 and 169
BERNARDO ZENALE
The Archangel Michael
Oil on panel, 45¼ × 20¹/₁₆ in. (115 × 51 cm)
Pitti, Meridiana (temporary location); inv. Contini Bonacossi:
no. 9
St. Bernard and a Cistercian Monk
Oil on panel, 45¼ × 20¹/₁₆ in. (115 × 51 cm)
Pitti, Meridiana (temporary location); inv. Contini Bonacossi:
no. 10
The two panels once belonged to the Frizzoni Salis collection in
Bergamo. They are parts of a triptych, whose central part is the
Madonna and Saints in the Museum of Lawrence (Kansas).

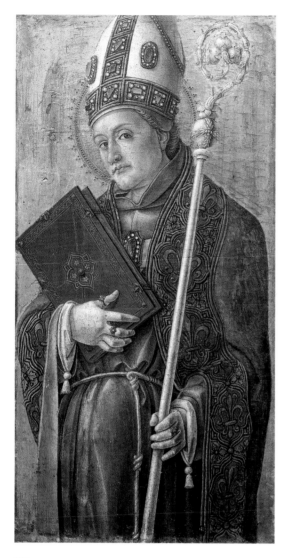

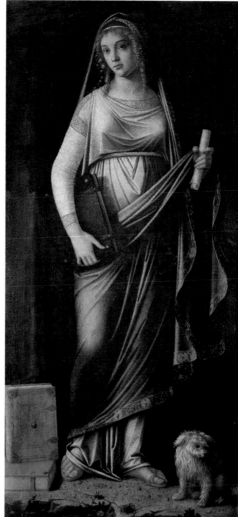

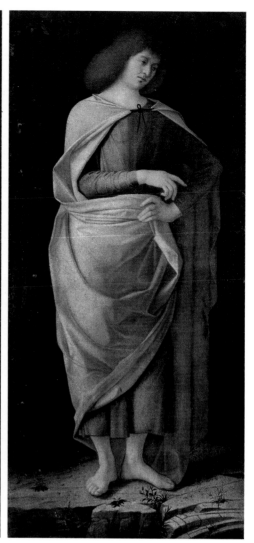

170
BARTOLOMEO VIVARINI
St. Louis of Toulouse
Tempera on panel, 26¾ × 14³⁄₁₆ in. (68 × 36 cm)
Uffizi, Gallery; inv. 1890: no. 3346
Acquired by the gallery in 1906, this panel is believed to have been the side panel of an unknown polyptych and has probably been cut off at the top and bottom. Its style and decoration are quite close to those of the *Dead Christ* in the Museo di Capua; it is possible that the two panels are part of the same series. It dates from around 1465.

171 and 172
BENEDETTO DIANA (?)
Sibyl
Oil on canvas, 73¼ × 34¼ in. (186 × 87 cm)
Uffizi, Gallery; inv. 1890: no. 9938
Prophet
Oil on canvas, 73¼ × 34¼ in. (186 × 87 cm)
Uffizi, Gallery; inv. 1890: no. 9939
These two works were in the Baruffi house in Rovigo in 1871 and then entered the Contini Bonacossi collection; they were recovered by Siviero in Germany in 1953. The iconography is not entirely clear. Variously attributed over the years, the paintings are currently given to a "northern Italian painter at the beginning of the sixteenth century"; in actuality, they date from the first eighty years of the fifteenth century and show many stylistic similarities to the youthful work of Benedetto Diana.

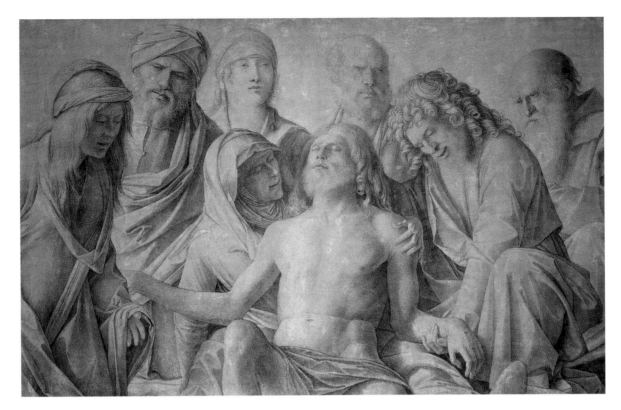

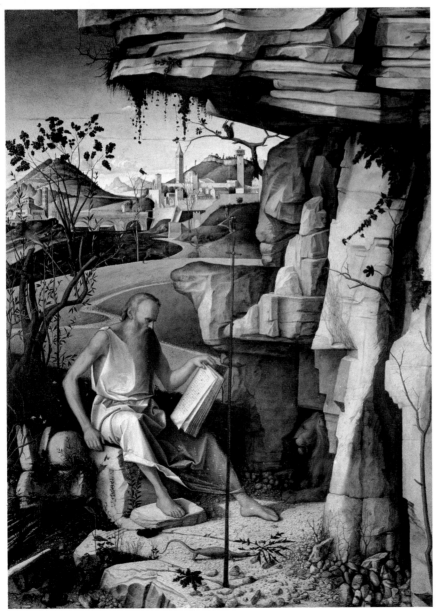

173
GIOVANNI BELLINI
Lamentation over the Dead Christ
Panel, 29⅛ × 46⁷⁄₁₆ in. (74 × 118 cm)
Uffizi, Gallery; inv. 1890: no. 943

This painting was given to Grand Duke Ferdinand III of Tuscany by Alvise Mocenigo in 1798; before that it was in the Aldobrandini collection in Rome. It has been suggested that it may be an exemplar, or a model used in the workshop for making copies. It dates from the first eighty years of the fifteenth century.

174
GIOVANNI BELLINI
St. Jerome in the Desert
Panel, 45¼ × 44½ in. (151 × 113 cm)
Pitti, Meridiana (temporary location): inv.
Contini Bonacossi: no. 25

This work, once the property of the Papafava family of Padua, could well be the "St. Hieronymus in the Desert" recorded by Sansovino in the church of Santa Maria dei Miracoli in Venice in 1581. Datable to around 1480, it may have been commissioned for the new building that was at that time under construction, or may have been donated afterward.

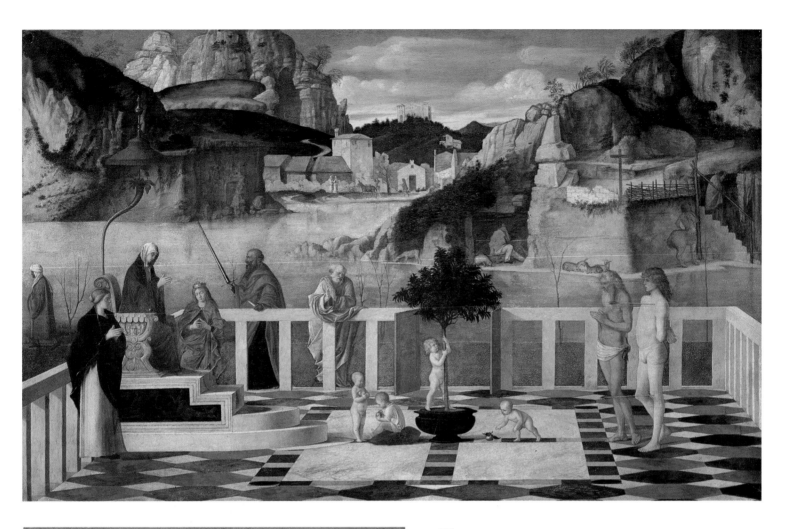

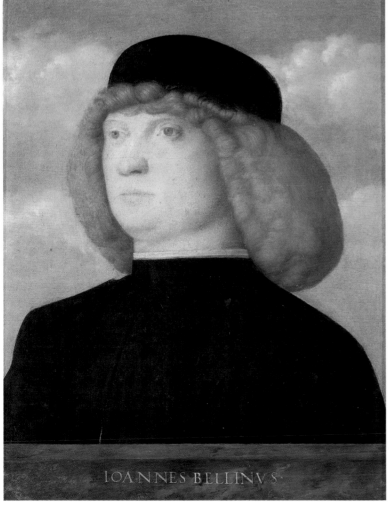

175
GIOVANNI BELLINI
Sacred Allegory
Oil on panel, 28¾ × 46⅞ in. (73 × 119 cm)
Uffizi, Gallery; inv. 1890: no. 903

This painting came to the gallery in 1793 as the result of an exchange with the Imperial Austrian Collection propitiated by Luigi Lanzi. Despite the many interpretations that have been put forward, the subject matter remains mysterious. Its lucid charm links it to the small Barbarigo altarpiece of Murano, datable around 1488–1490.

176
GIOVANNI BELLINI
Portrait of a Man
Oil on panel, 12³⁄₁₆ × 10¼ in. (31 × 26 cm)
Signed: IOANNES BELLINVS
Uffizi, Gallery; inv. 1890: no. 1863

This panel is first mentioned in a 1753 gallery inventory, where it was labeled as a self-portrait of Giovanni Bellini, a hypothesis without any basis. It was later attributed to Rondinelli and then restored to Bellini. The dating of the work is a matter of some controversy, but it was likely painted in the earliest years of the sixteenth century.

177
VITTORE CARPACCIO
Warriors and Orientals
Oil on canvas, 26¾ × 16⁹⁄₁₆ in. (68 × 42 cm)
Uffizi, Gallery; inv. 1890: no. 901

This painting was once in the Biancardi-Pini collection in Florence; it came to the Florentine galleries in 1883. It is thought to be a fragment of a much larger composition, which may have been, to judge from the long beam in the foreground, the inscription "SPQR" on the banner, and the presence of the Oriental figures, a *Crucifixion* or a *Raising of the Cross*. It dates from sometime in the 1490s.

178
CIMA DA CONEGLIANO
Madonna and Child
Tempera on panel, 26 × 22⁷⁄₁₆ in. (66 × 57 cm)
Uffizi, Gallery; inv. 1890: no. 902

Dating from the earliest years of the 1490s, this panel was acquired by the Accademia di Belle Arti in 1818 and came to the Uffizi in 1882. The artist's most striking innovation, the portrayal of the baby grasping his mother's thumb, was copied, perhaps by Anton Maria da Carpi, in the painting that now hangs in the Museo Civico in Padua.

179
CIMA DA CONEGLIANO
St. Jerome in the Desert
Panel, 13 × 10⅞ in. (33 × 27.5 cm)
Pitti, Meridiana (temporary location); inv. Contini Bonacossi: no. 19

Recorded in the Giovannelli collection in Venice in 1884, this work is judged to be one of Cima's late masterpieces, painted after 1510.

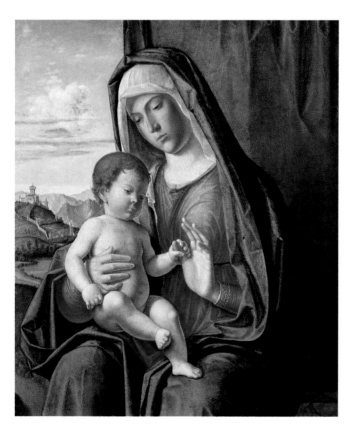

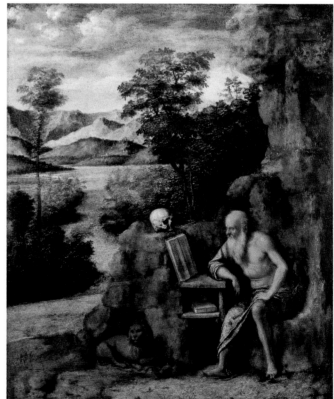

180
COSMÈ TURA
St. Dominic
Tempera on panel, 20⅛ × 12¼ in. (51 × 32 cm)
Uffizi, Gallery; inv. 1890: no. 3273
From the collection of Roberto Canonici in Ferrara, this work
entered the gallery in 1905. Evidently one part of a polyptych, the
painting has been cut off at its base and repainted along its edges in
the same way as the *St. James* in Caen and the *St. Anthony of Padua* in
the Louvre. Their similar treatment suggests that all three panels
were once a single polyptych, recorded in the church of San Gia-
como in Argenta as late as the eighteenth century.

181 and 182
FRANCESCO MORONE
The Angel of the Annunciation
Oil on canvas, 81⅞ × 37 in. (208 × 94
cm)
Pitti, Meridiana (temporary location);
inv. Contini Bonacossi: no. 12
The Virgin Annunciate
Oil on canvas, 81⅞ × 37 in. (208 × 94
cm)
Pitti, Meridiana (temporary location);
inv. Contini Bonacossi: no. 11
These canvases, which originally would
have covered the front of an organ,
could be found in the Monga collection
in Verona in the nineteenth century.
They date from the earliest period of
the artist's activity, around 1496–1498.

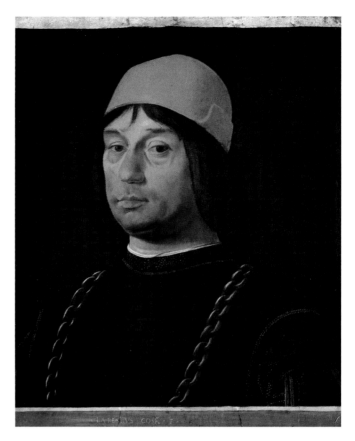

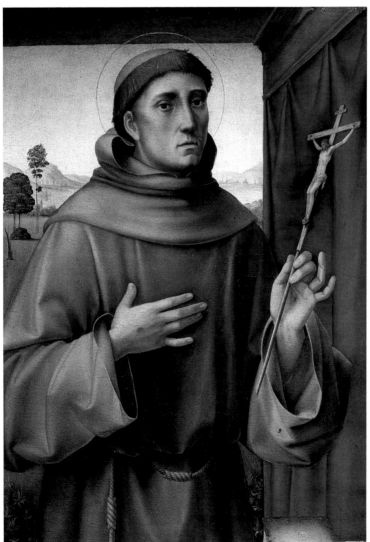

183
FRANCESCO FRANCIA
Portrait of Evangelista Scappi
Tempera on panel, 21⅝ × 17⁵⁄₁₆ in. (55 × 44 cm)
Uffizi, Gallery; inv. 1890: no. 1444
Once in the Pitti, this portrait came to the gallery before 1773. The name of the sitter is taken from the letter he holds in his hand. The panel is datable to around 1506.

184
LORENZO COSTA
Portrait of Giovanni II Bentivoglio
Tempera on panel, 21⅝ × 19⁵⁄₁₆ in. (55 × 49 cm)
Signed: LAURENTIUS COSTA F
Uffizi, Gallery; inv. 1890: no. 8384
This panel was at one time in the Isolani collection in Bologna; it entered the Pitti before 1897 and was in the Uffizi by 1919. Depicting the Signore of Bologna, one of Costa's major patrons, it is executed in the Antonellian-Flemish style, and dates from around the early 1490s.

185
FRANCESCO FRANCIA
St. Francis
Tempera on panel, 25⁹⁄₁₆ × 17⁵⁄₁₆ in. (65 × 44 cm)
Pitti, Meridiana (temporary location); inv. Contini Bonacossi: no. 30
This panel was once in the d'Este collection, then in that of Gustavo Frizzoni. A splendid example of this artist's early Tuscan-Venetian painting style, it dates from around 1490.

186

ALESSANDRO ARALDI (attributed to)
Portrait of Barbara Pallavicino
Oil on panel, 18⁵⁄₁₆ × 13¾ in. (46.5 × 35 cm)
Uffizi, Gallery; inv. 1890: no. 8383

This portrait was transferred to the Uffizi from the Pitti in 1919. It
was attributed to Araldi dal Ricci, with the sitter identified as
Barbara Pallavicino. In fact, the subject seems more reminiscent of
portraits of Beatrice d'Este, and the style closer to that favored by
Milanese artists in Leonardo's circle.

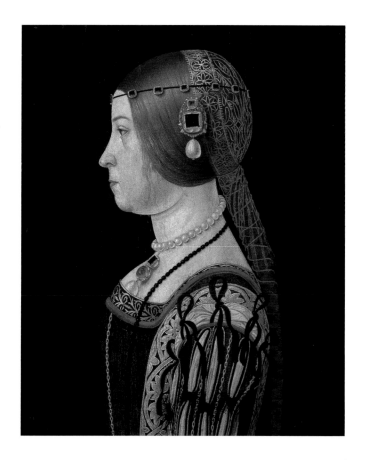

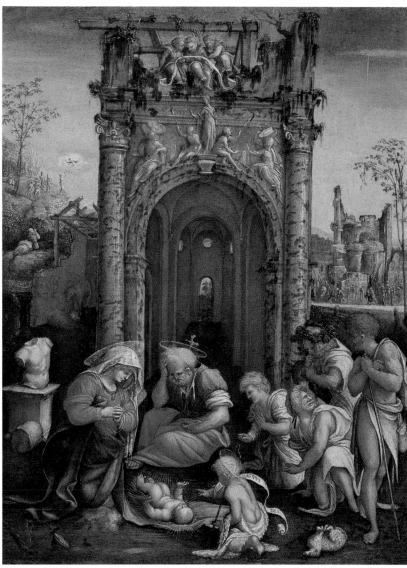

187

AMICO ASPERTINI
The Adoration of the Shepherds
Oil on panel, 17½ × 13⅜ in. (44.5 × 34 cm)
Uffizi, Gallery; inv. 1890: no. 3803

Bernard Berenson gave this panel to the gallery.
It was painted in and is datable to roughly the
second decade of the sixteenth century—not, as
has been more recently suggested, the end of
the 1530s. It is a fine example of Aspertini's
singular style of interpretation of the classical in
accordance with his "grotesque ideal."

149

The Fifteenth Century in Flanders and Germany

The extraordinary success enjoyed by Flemish painting in the fifteenth century depended first of all on the prodigious talents of its most important proponents, beginning with Jan van Eyck. Van Eyck's discovery of the possibilities of painting with oil on panel (or "coloring with oil," in Vasari's words) allowed artists in the North to bring to their work a new and brilliant vivacity, a great variety of tones, and consequently, a richness of color never before seen in European painting.

The great appreciation for Flemish painting in Italy was no less evident in those sectors of society that were directly interested in the subject of art. Writing in 1456, fifteen years after the death of Jan van Eyck, Bartolomeo Facio, the Genoese secretary of King Alfonso at the Neapolitan court, claimed that of the four most important painters, two were Italians—Pisanello and Gentile da Fabriano—and two were Flemings, Jan van Eyck and Rogier van der Weyden. Among the latter two, Jan van Eyck was judged to be the greatest painter of the century. Potential patrons and buyers, sovereigns and gentlemen from the ruling classes were all anxious to acquire Flemish art. Personages such as Facio, meanwhile, admired it because it was so different from Italian painting and because it was based on classical-intellectual ideas. Italian artists themselves demonstrated a specific interest in Flemish painting, as they wished to learn (as Vasari said in the middle of the sixteenth century) the "secret" of painting in oil. In spite of the large number of Flemish paintings to be found on the Italian peninsula, it took Italian painters a very long time to replicate the technique.

The arrival in Italy of a notable quantity of Flemish paintings was facilitated and stimulated by the commercial rapport between the two countries and by the consequent presence in Flanders of bankers and patrons, who acquired paintings either for themselves—whether for their own houses or for family chapels in the churches to which they belonged—or to take back to great gentlemen on the peninsula. A great many Italian courts in the fifteenth century possessed Flemish paintings. In general these works were, like other paintings of similar size, transported by sea, with obvious risks. In 1473, for example, Angelo Tani sent a triptych of the *Last Judgment* by Hans Memling from Bruges to Florence, where it was destined for the altar of a Florentine church. However, the ship, which belonged to the rich Florentine merchant Tommaso Portinari, was captured with its cargo by a pirate from the Hanseatic League, and instead of going to Pisa, the ship's port of destination, the cargo was transported to Danzig, where the triptych can still be found.

Things went a little better a decade later, when one of the most famous Flemish paintings arrived in Florence. This was the *Portinari Triptych* by Hugo van der Goes, commissioned by the aforementioned Tommaso Portinari for the high altar of the church of Sant'Egidio, where it was to complement the frescoes in the Portinari chapel (unfortunately now almost entirely destroyed), dedicated to the life of Mary and executed by Domenico Veneziano and Andrea del Castagno. The magnificent triptych (now in the Uffizi) was brought to Florence from Pisa by boat and was then carried by sixteen men to the Arcispedale of Santa Maria Nuova. From the moment of its arrival in Florence, in 1483, it was a subject of great interest and lively curiosity among the artists active in Florence. Sandro Botticelli, Filippino Lippi, Piero di Cosimo, Domenico Ghirlandaio, and others were particularly fascinated with the work, and had concepts and ideas that were closely associated with it.

The *Portinari Triptych* was not the only important Flemish work to make an impression on Florentine painting in the fifteenth century, though it is certainly the most often cited. If there are today no actual works by van Eyck in Florence, the composition of the small panel depicting *St. Jerome in His Study*—attributed to the great master and his pupil Petrus Christus and presently in the Detroit Institute of Arts—nonetheless served as Ghirlandaio's model for his frescoes on the same subject in the church of the Ognissanti. An inscription on the Detroit painting links it to Cardinal Niccolò Albergati, who died in Florence in 1443; that the painting subsequently passed to the Medici is known from correspondence referring to a "St. Jerome in his study, with a small cupboard of books in perspective and a lion at his feet, the work of the Master Giovanni of Bruges, colored in oil," found toward the end of the fifteenth century in Lorenzo the Magnificent's writing desk in the Palazzo Medici on the Via Larga. While this and other Flemish works that once belonged to Lorenzo—such as the *Head of a French Woman* painted by Petrus Christus—are no longer in Florence, the Uffizi does have the *Entombment* by Rogier van der Weyden, Jan van Eyck's successor as the master of Flemish painting. This panel was probably in the chapel of the Villa Medici at Careggi shortly after being completed. Facio writes of van der Weyden's staying in Italy in the Holy Year of 1450; it may well have been during this period that he produced the aforementioned painting, which would perhaps suggest some sort of reciprocal influence between Flemish and Italian painters. Rogier in fact derived his composition from a small panel from the predella of the altarpiece painted in around 1440 by Fra Angelico for the high altar of the Florentine church of San Marco (now in Berlin); common to both paintings are the rock with its rectangular entrance to the tomb and the position of Christ before it, held up by his extended arms.

Jan van Eyck, Petrus Christus, Rogier van der Weyden, and Hugo van der Goes were not the only fifteenth-century Flemish painters whose works were brought to Florence. Hans Memling, a Bruges painter and pupil of van der Weyden, enjoyed a fruitful relationship with the Portinari, producing a panel with scenes of the Passion for Tommaso as well as portraits of Tommaso Portinari and his wife, Maria Maddalena Baroncelli (the latter work passed on to Duke Cosimo de' Medici, according to Vasari, writing in 1550, and then was transferred from Florence to the Galleria Sabauda in Turin). In 1487 Memling executed a small triptych, probably for Benedetto di Tommaso dei Portinari, who is depicted on one side panel, with his holy

protector, St. Benedict, on the other (both panels are still in Florence). The central element was a *Madonna*, now in Berlin (Gemäldegalerie); behind the three half-figures, a unifying landscape gives the triptych spatial depth.

Various inventories indicate a Medici interest in Flemish painting, one that was not limited solely to oil paintings or to religious subject matter: the family also possessed quite a large number of canvases painted in tempera—known as "Flemish cloths"—and some very costly tapestries on profane themes, which anticipated the genre paintings of Pieter Aersten, Joachim de Bueckelaer, and Caravaggio.

Late fifteenth-century inventories and other sources cite numerous Flemish works that either were produced in Florence or arrived there shortly after their creation. Of these, whatever remained in Florence, or still exists, is only a small part. Some of the most significant works are still in Florentine collections; together with other Flemish works that came to Italy in the fifteenth century, these testify to the existence of an international market for Flemish painting during the period in which Flemish and Florentine artists were regarded as the most eminent practitioners of figurative art in Europe.

Bert W. Meijer

188
ANONYMOUS PARISIAN ARTIST
The Adoration of the Magi and *The Crucifixion*
Panel, 21¼ × 14 in. (54 × 36 cm) (each panel)
Bargello, Museum: inv. 1889: no. 2038C

These two paintings from the Carrand collection were given to the Commune of Florence for the Bargello Museum in 1888. Together forming a portable diptych, the panels are today considered to be of French origin with German influences, and are datable to around 1360.

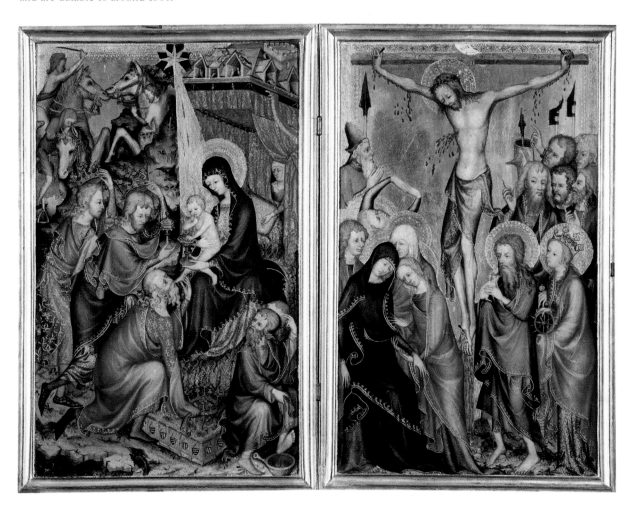

189
ANONYMOUS GERMAN ARTIST
Madonna and Child with Saints and Angels and *The Crucifixion*
Panel, 35⅞₆ × 11⅞₆ in. (90 × 29 cm) (each panel)
Bargello, Museum; inv. 1889: no. 2025C
Acquired by the Bargello through the Carrand donation of 1888, this diptych is now thought to be by a German master from the Rhenish region. It dates from around 1400.

Opposite: 190
ROGIER VAN DER WEYDEN
The Entombment
Oil on panel, 43⁵⁄₁₆ × 37 ¹³⁄₁₆ in. (110 × 96 cm)
Uffizi, Gallery; inv. 1890: no. 1114
The work joined the grand-ducal collection in 1666 from the estate of Cardinal Carlo de' Medici, where it was catalogued as a Dürer. The landscape was copied by an anonymous Florentine painter in the circle of Lorenzo di Credi in around 1500, which supports the hypothesis that this is the painting mentioned at Careggi in an inventory of 1492 for Lorenzo the Magnificent.

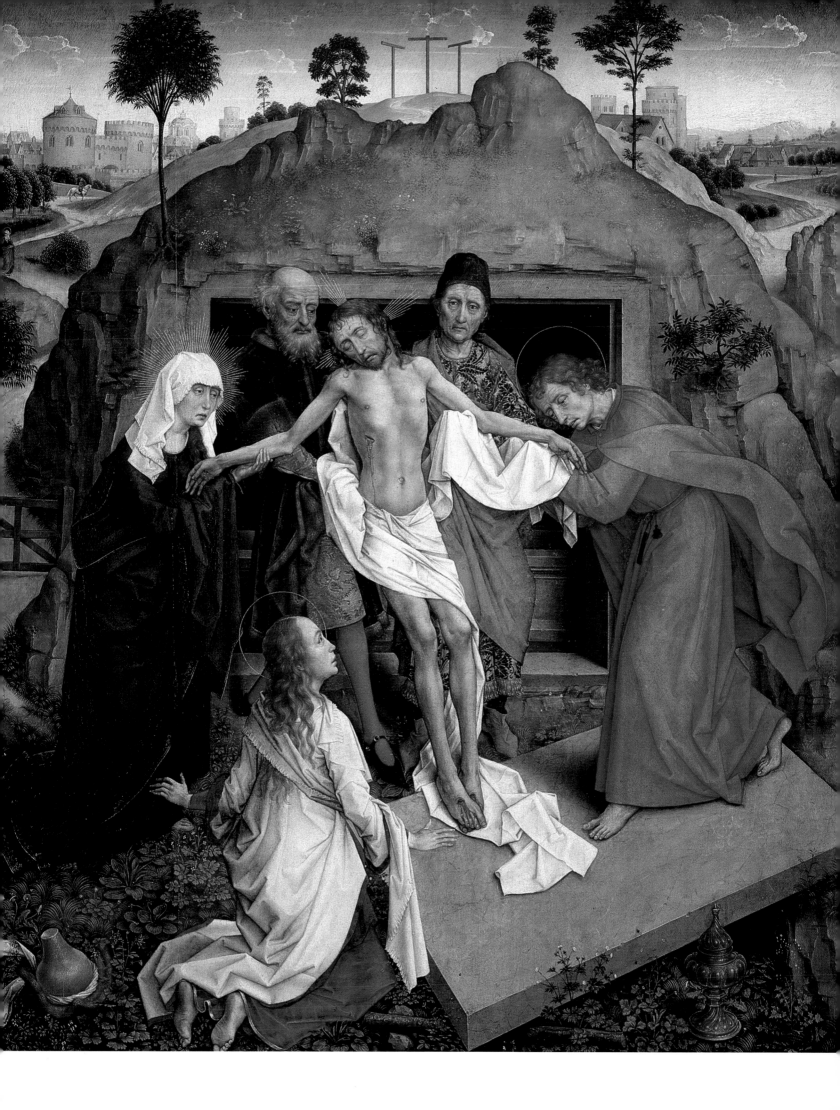

191

HUGO VAN DER GOES

The Portinari Triptych
Oil on panel, 99⅝ × 230¹¹⁄₁₆ in. (253 × 586 cm)
The Adoration of the Shepherds (central panel) 98 × 119¹¹⁄₁₆ in. (249 × 304 cm)
Tommaso Portinari with His Children and SS. Thomas and Anthony Abbot; Maria Bonciani with
Her Daughter Margherita and SS. Margaret and Mary Magdalen (verso of side panels)
99⅝ × 55½ in. (253 × 141 cm) (each panel)
Uffizi, Gallery; inv. 1890: nos. 3191, 3192, 3193

This great triptych, painted in Bruges in around 1475, originally stood on the high altar of
the church of Sant'Egidio dell'Arcispedale of Santa Maria Nuova, patronized by the Por-
tinari family. The side wings carry portraits of Tommaso Portinari, his wife, Maria Mad-
dalena Baroncelli, and the first three of their ten children, with their respective holy
protectors, SS. Anthony Abbot, Thomas, Margaret, and Mary Magdalen. The verso *Annunci-*
ation is in monochrome.

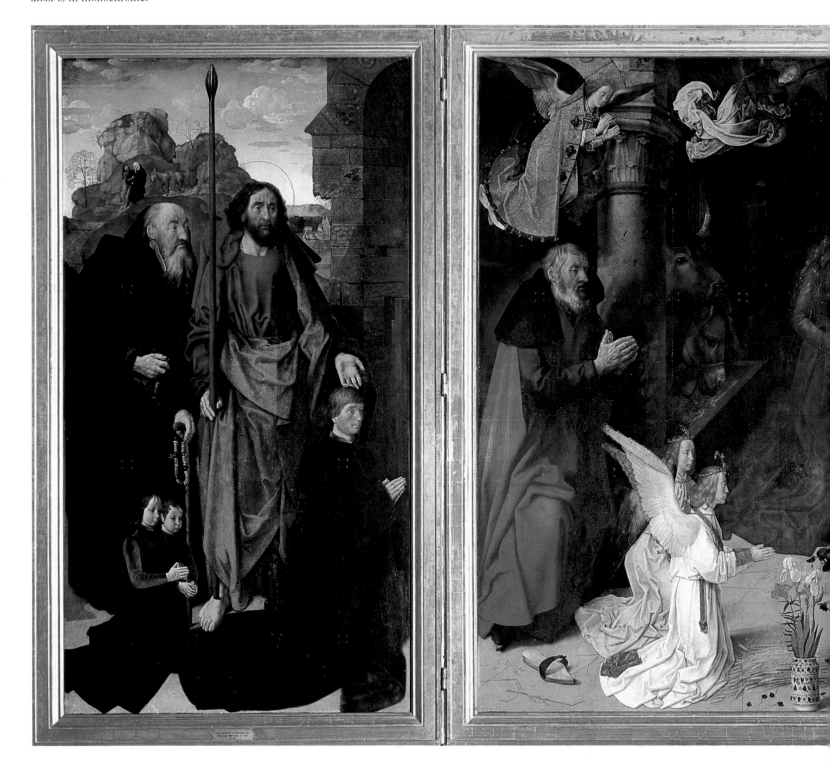

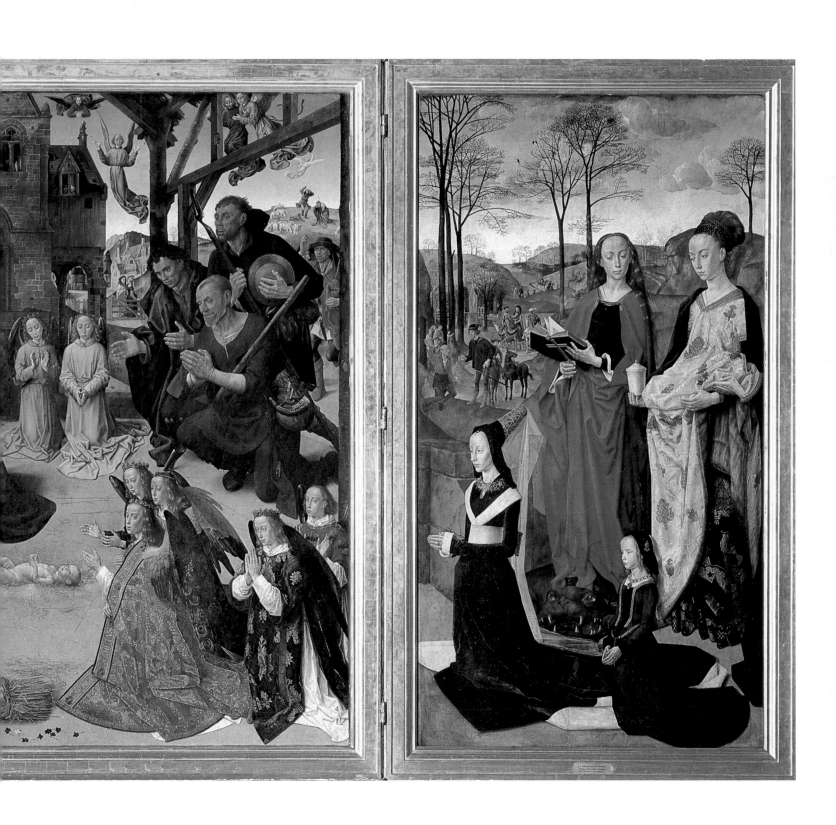

192 and 193
MASTER OF THE BARONCELLI PORTRAITS
Portrait of Pierantonio Bandini Baroncelli
Oil on panel, 22¹⁄₁₆ × 12³⁄₁₆ in. (56 × 31 cm)
Uffizi, Gallery; inv. 1890: no. 1036
Portrait of Maria Bonciani
Oil on panel, 22¹⁄₁₆ × 12¹⁄₁₆ in. (56 × 31 cm)
Uffizi, Gallery; inv. 1890: no. 8405

These paintings were probably the side panels for a triptych whose central element is now lost. The coat of arms depicted on the window in the male portrait is that of the Baroncelli; the works may well have been executed on the occasion of the marriage of Pierantonio Baroncelli to Maria Bonciani, in 1489. The pictures on the reverse of the panels are in monochrome.

Opposite: 195
HANS MEMLING
Madonna and Child with Two Angels
Oil on panel, 22⁷⁄₁₆ × 16⁹⁄₁₆ in. (57 × 42 cm)
Uffizi, Gallery; inv. 1890: no. 1024
This panel was sold to the Lorraine family in the eighteenth century from the estate of the painter Ignatius Hugford.

194
HANS MEMLING
Portrait of a Man in a Landscape
Oil on panel, 22⁷⁄₁₆ × 16⁹⁄₁₆ in. (38 × 27 cm)
Uffizi, Gallery; inv. 1890: no. 1102
Acquired by Abbot Celotti in 1836 as a work by Antonello, this panel can be dated within the last twenty-five years of the fifteenth century.

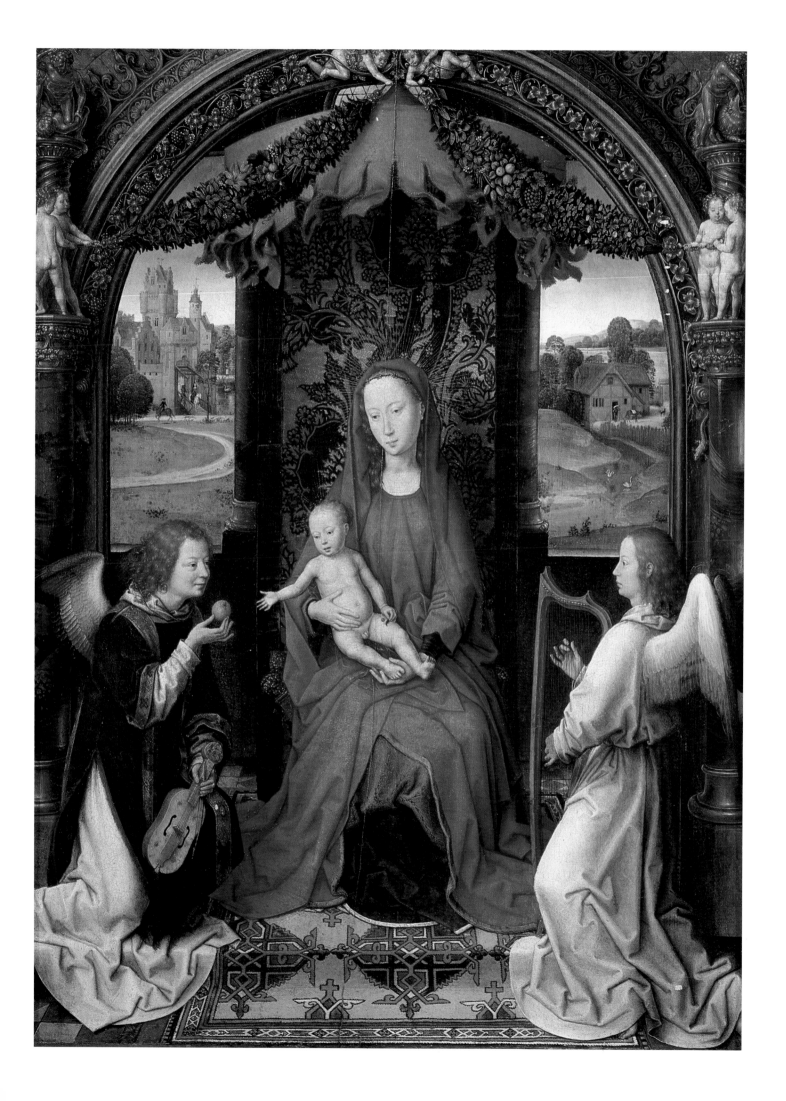

196 and 197
HANS MEMLING
Portrait of Benedetto di Tommaso Portinari
Oil on panel, 17¹¹⁄₁₆ × 13⅜ in. (45 × 34 cm)
Dated: 1487
Uffizi, Gallery; inv. 1890: no. 1090
St. Benedict
Oil on panel, 17¹⁵⁄₁₆ × 13⁹⁄₁₆ in. (45.5 × 34.5 cm)
Inscription: SANCTUS BENEDICTUS
Uffizi, Gallery; inv. 1890: no. 1100

These two panels were transferred to the Uffizi in 1825 from the hospital of Santa Maria Nuova. They are presumed to be the wings for a triptych painted for the Portinari family, whose central panel, a *Madonna and Child*, can be found in the Gemäldegalerie in Berlin. On the verso of the portrait of Benedetto Portinari, who was resident in Bruges for many years, is the trunk of an oak tree inscribed with the motto DE BONUS IN MELIUS.

198
HANS MEMLING
Portrait of a Man
Oil and resins on panel, 13¾ × 10¼ in. (35 × 26 cm)
Uffizi, Gallery; inv. 1890: no. 9970

Once in the Corsini Gallery in Florence, this late work by Memling was sold to Hitler in 1941 on Mussolini's orders. It was recovered in 1948.

199

NICOLAS FROMENT

Polyptych

Oil on panel, 68⅞ × 78¾ in. (175 × 200 cm)

The Raising of Lazarus 68⅞ × 52¾ in. (175 × 134 cm) (central panel)

Martha Appealing to Christ (left wing) and *Portrait of Francesco Coppini* (verso) 68⅞ × 26 in. (175 × 66 cm)

Mary Magdalen Putting Ointment on Christ's Feet (right wing) and *Madonna and Child* (verso) 68⅞ × 26 in. (175 × 66 cm)

Signed and dated on the outside of the wings: NICOLAUS FROMENTI ABSOLVIT HOC OPUS XVKl. JUNII MCCCCLXI

Uffizi, Gallery; inv. 1890: no. 1065

On the reverse side of one of the wings of this polyptych is a portrait of Francesco Coppini with two family members. Bishop of Terni and papal legate to Pius II in England and Flanders between 1459 and 1462, Coppini later gave the work to Cosimo de' Medici the Elder, who in turn donated it to the convent of the Minori Osservanti di Bosco ai Frati in Mugello.

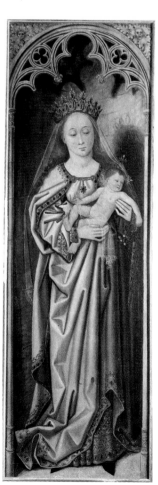

159

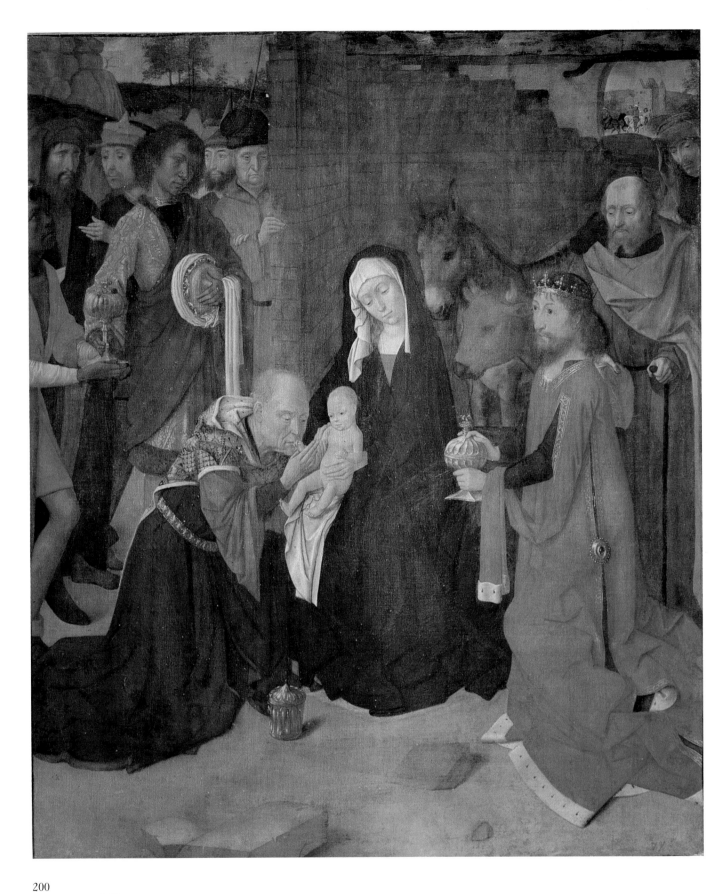

200
GERARD DAVID
The Adoration of the Magi
Tempera on panel, 37⅜ × 31½ in. (95 × 80 cm)
Uffizi, Gallery; inv. 1890: no. 1029

Of unknown provenance, this painting was catalogued in the 1825
inventory of the Accademia as the work of an anonymous Fleming;
in fact, it is an early David.

Italy in the Sixteenth Century

Michelangelo, Raphael, and Their Pupils

The first decade of the sixteenth century, during which time Michelangelo and Raphael were both working in Florence (and before their respective activity in Rome at the papal court had caused a real, and malevolently amplified, rivalry between them), was a moment of exceptional importance for Florentine and Italian art. By 1508, to be precise, the decisive cards had already been played.

The situation in the city was critical. The previous decade had witnessed the occurrence of extremely traumatic events, with the death of Lorenzo the Magnificent in 1492; the entrance into Florence of Charles VIII of France and the fall of the Medici in 1494; and Savonarola's furious sermons, followed by his death in 1498. All of these things colored the life of the republic at the beginning of the new century, despite the apparent accord reached under the gonfalonier Piero Soderini in 1502. Emblematic of the precarious nature of the political balance were the great public artistic commissions for the reception room of the Gran Consiglio, which were intended to celebrate liberty and the republican spirit but remained unfinished due to external events: the *Battle of Anghiari* and the *Battle of Cascina* given between 1503 and 1504 to Leonardo and Michelangelo, respectively, and the *Signoria Altarpiece,* assigned in 1510 to Fra Bartolomeo (which, it has been recently demonstrated, reflects Savonarolian ideals of religion and the Florentine nation). The political ambitions of these commissions were a failure, but on the level of artistic style they were most exalted and would continue to exercise an influence throughout the century.

The last decade of the fifteenth century had also seen something of an artistic crisis. A great many of the masters most admired by the humanistic, bourgeois Laurentian world had died, including Ghirlandaio in 1494, Gozzoli in 1497, and Antonio Pollaiolo in 1498. At the same time, Botticelli was battling with mysterious complexities, upsetting his once harmonious style of painting. Leonardo had been in Milan since 1482 and worked in various locations in Lombardy, even as Lorenzo the Magnificent and his followers kept an eye on him. In 1496, Savonarola's "Bonfire of the Vanities" incited such artists as Lorenzo di Credi and Fra Bartolomeo to burn their own studies of nudes and other profane subject matter. Signorelli, who had worked for Lorenzo the Magnificent, was still active in Tuscany, but outside Florentine circles. Working alongside nonnative artists such as Perugino (who had been sponsored by Lorenzo and in 1493 had opened up a house and a workshop in Florence) were Florentine artists such as Filippino Lippi and Piero di Cosimo, who openly confronted the decorous principles of the fifteenth-century artistic equilibrium, executing rich and newly fertile works of art that were both bizarre and disquieting.

In the last decade of the century, Michelangelo began to work. Born in 1475, he had, much to his father's dismay, precociously applied himself to art. In 1488 he entered Ghirlandaio's workshop along with Francesco Granacci, who was to become a faithful friend. His participation in the frescoing of figures in Santa Maria Novella remains a matter of speculation, but his dissatisfaction with his training at the Ghirlandaio workshop is suggested by the fact that, despite a three-year contract, he left after only one year. What he did acquire there, other than the rudiments learned from his master, was a lifelong love of drawing practice, as well as an attention to the truth that produced highly unexpected effects and a knowledge of Northern art that was not marginal to his culture. Although very few of the drawings from Michelangelo's apprenticeship have survived, Vasari and Condivi attest to his portraits from "nature," of boys on the scaffolding, and his copying and imitating of Schongauer's engravings of the *Temptation of St. Anthony;* they even recall his going to the market to look at the fish with their "strangely colored scales," in order to render as realistically as possible Anthony's diabolical temptations. An interest in the truth, which he inherited from Ghirlandaio but which he applied in a more direct manner, allowed Michelangelo to discover elements of magic and a Leonardesque science. Leonardo would suggest more things in more innovations to Michelangelo in the years to come, as Michelangelo became a painter, a sculptor, and, above all, a designer.

Michelangelo understood very quickly that for him sculpture was to be the "lantern of painting," and that his first vocation was as a sculptor. He entered the school of Bertoldo and perhaps also that of Benedetto da Maiano, and he frequented the so-called Garden of San Marco, where he could study antique statues and reliefs as well as medallions, gliptychs, and goldsmithing. Michelangelo also joined the Laurentian circle of humanists, men of letters, and philosophers. His journeys to Venice and Bologna in 1494 and his stay in Rome from 1496 to 1501 expanded his cultural knowledge in more than a figurative sense, especially through the impact of the antique. He made drawings after Giotto and Masaccio and drew sculptural inspiration from the work of Donatello and Jacopo della Quercia, Nicola Pisano and Maitani, which shows just how highly—far more than any of his contemporaries—he regarded the innovators of the thirteenth and fourteenth centuries. This was a "course of study" that went beyond copying and aimed for an understanding of fundamental artistic values—volume, bodily structure, figurative space, and the gestures prompted by emotions, whether the peaceful emotions, whether the peaceful stillness of the *Pietà* of 1498 in St. Peter's, or the dynamic struggle of the *Centaurs,* which some sources say was done for Lorenzo the Magnificent but may in fact have been a later project.

All of Michelangelo's certain works before the end of 1504 are sculptures and drawings. There are a few arguable paintings that would seem to have been conceived by him but have no signature, among them the *Deposition* in the National Gallery in London and the group by the

so-called Master of the Manchester Madonna. In March 1504 the great marble *David* was placed in front of the Palazzo della Signoria, an emblem of republican liberty and a towering formal example of Michelangelo's skills. He also began to work on colossal tasks that were never completed, such as the series of the twelve apostles for the Duomo, the contract for which Michelangelo signed in 1503. He got only as far as a rough hewing of the figure of St. Matthew, however. Then, too, there is the forty-year-long "tragedy of the tomb" of Julius II, who, from 1505, had called Michelangelo to Rome for the project. At the beginning of the year the artist may have finished the cartoon for the *Battle of Cascina,* if in February a payment was recorded for the "painting" of the work, which saw him in competition with the older and more famous Leonardo. In 1506, the latter interrupted his work on the same project in order to return to Milan. Michelangelo, meanwhile, was still working by November, when Soderini wrote that he had "begun a history . . . that shall be greatly admired." But neither Michelangelo's historical work nor Leonardo's was ever completed, though their respective cartoons were admired, copied, broken up, and collected like reliquaries, only to be destroyed little more than a decade later. They would be for all their century the "school of the world," in Cellini's words.

Raphael was among the first to see them, copy them, and understand them. Michelangelo's cartoon, of which all that remains is copies, engravings, and a few original drawings (though one alone serves to explain the whole), was the antithesis of Leonardo's style and introduced an unfamiliar language. It was full of "nudes . . . and peculiar attitudes. . . . There were many figures outlined and grouped in various ways, sketched with charcoal, designed with outlines and *sfumato* and in relief, using white lead," according to Vasari. They experimented, above all, with the various passions of the mind. That Raphael may have seen the cartoon around 1505 is suggested by a drawing in the Vatican Library in which two important figures are copied; in any event, the echo was heard for a long time in the Stanza della Segnatura and in the *Massacre of the Innocents,* engraved and popularized in Rome by Marcantonio Raimondi.

Raphael Sanzio came to Rome in the autumn of 1504 with a letter of recommendation from Giovanna Feltria to the gonfalonier Soderini and, perhaps, the hope of obtaining public commissions, a dream that would never be realized. At twenty, he already had a great deal of pictorial and refined cultural experience from the school of his father, Santi, and from Perugino. Raphael had learned about perspective from the example of Signorelli and, even more, that of Piero della Francesca; he had learned about architecture, antiquities, and Flemish art at the court of Urbino; and he had acquired a restrained and erudite classicism from the Bolognese. In 1504 he had produced the *Marriage of the Virgin* (now at Brera), a work of spatial clarity and color, for Città di Castello, witness to his first and purest attempts. It was perhaps in the previous year that he supplied the sophisticated drawings for the Libreria Piccolomini in the Duomo in Siena, at the request of the older Pinturicchio. He may have been in Florence occasionally at the end of the fifteenth century or in the first two or three years of the sixteenth, since his master Perugino had a workshop there. Raphael must have felt the need to absorb the noble traditions and the most recent works by Ghirlandaio, Lorenzo di Credi, Leonardo, and the new star, Michelangelo; still, he did not lose contact with Umbria and the Marches, given that the various cities, together with Venice and Rome, were likely sites for commission work, as exemplified by the contract he signed with Berto di Giovanni for the monks of Monteluce in 1505. Leonardo was Raphael's constant point of reference; references to Leonardo's drawings and portraits of women, his Madonnas, and his *Adoration of the Magi, Leda,* and *Battle of Anghiari* appear constantly in the younger painter's work from these years, and in his Roman works, too. In Florence, Raphael, already a great admirer of antique sculpture, looked in depth at the modern work of Donatello, Luca della Robbia, Pollaiolo, Verrocchio, and Michelangelo; in his drawings he copied several times the colossal *David,* selecting it for its great and vivid tension. He drew the *Taddei Tondo* and then the *Pitti* and the unfinished *St. Matthew* for the Duomo, storing up these ideas for the Borghese *Deposition* and for its predella. The Child in the *Belle Jardinière* of 1507 certainly recalls Michelangelo's severe marble *Madonna,* which Raphael must have seen before it was sent to Bruges in 1506; the latter statue itself has echoes of Donatello's work, along with Michelangelo's meditations on the sentiments and contrasting movements of Leonardo's *St. Anne Metterza.* These newest Leonardesque themes, founded on an ancient tradition, were expressed in the cartoon now in the National Gallery and in the one, now lost, that was in the Santissima Annunziata in 1501, as well as in a number of drawings that had great significance for Florentine art. Raphael surely studied these carefully.

Michelangelo used it as the antithetic touchstone in his *Doni Tondo,* the only picture he ever completed in his homeland. Incorporated into the clear surface of the round painting, itself almost a concave mirror, are three divine and athletic protagonists, united by the bright light and the crossing of their glances, yet differentiated by the chasms of the contours between them and the changes in the vivid color. The nudes in the background, about whom there has been so much iconographic speculation, are based on the physiognomic grammar that Michelangelo introduced in his studies for the *Battle of Cascina* and further developed in the Sistine ceiling frescoes. The debate over the painting's chronology also involves Raphael, and it is not negligible. It has been thought that Agnolo Doni commissioned the work in honor of his wife, Maddalena Strozzi, whose family coat of arms is incorporated into the beautiful frame. This would mean that the painting was executed either in January 1504, the date of the wedding, or else in September 1507, when the couple's eldest child, Maria, was born. (But would such an expensive work of art have been ordered at that time to celebrate the birth of a girl?) Alternatively, it may have been painted even later. Raphael must have seen it, in the house of the married Doni, either before or after he produced his famous portraits of them, in around 1506 (ac-

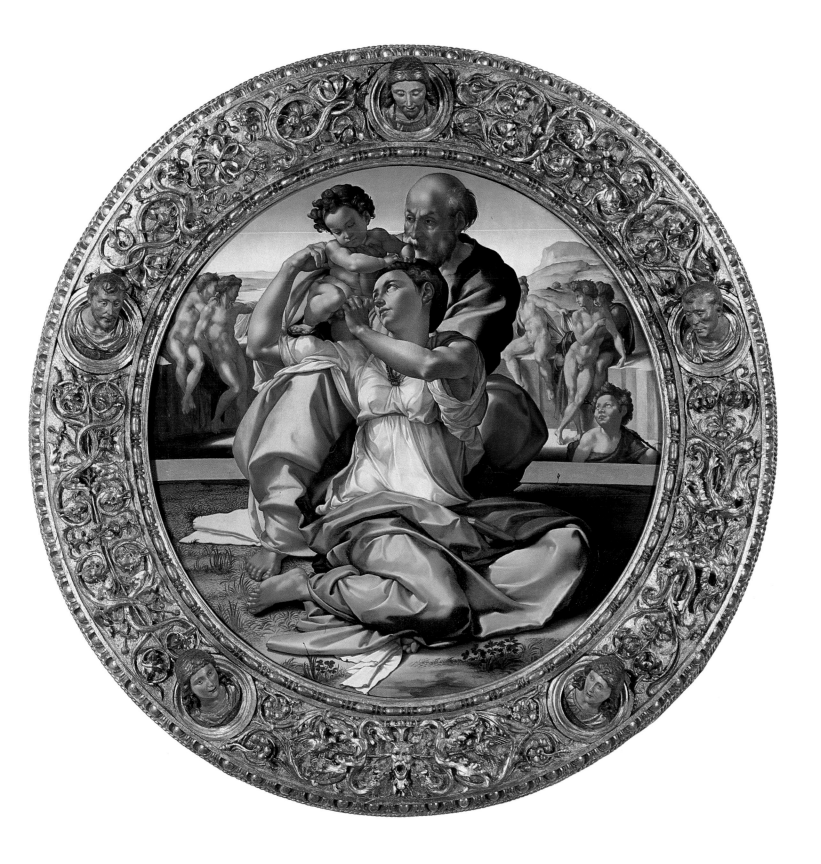

201
MICHELANGELO
The Holy Family with the Young St. John the Baptist ("Doni Tondo")
Oil on panel, 47¼ in. (120 cm) in diameter (without the frame)
Uffizi, Gallery; inv. 1890: no. 1456

It has generally been assumed that this panel was painted in 1504
for the marriage of Agnolo Doni to Maddalena Strozzi, whose coat
of arms is carved in the frame. One more recent hypothesis, how-
ever, holds that the tondo may have been commissioned by Agnolo
to celebrate the birth of his firstborn daughter in 1507.

cording to some, 1505), but that does not resolve the question of the tondo's date. That Raphael was inspired by the *Doni Tondo* is unequivocally evident in his pictures from around 1506–1507: the *Esterhazy Madonna,* the *St. Catherine* in the National Gallery in London, and, despite every argument to the contrary, the Borghese *Deposition,* dated 1507, painted for Atalanta Baglioni in Perugia but based on a cartoon that, according to Vasari, was completed in Florence. Echoes of the tondo are carried through into Raphael's Roman work, from the designs for the ceiling of the Segnatura to the *Madonna di Foligno,* of around 1512, with its overbearing reminders of the Sistine ceiling.

As mentioned above, Raphael did not receive any public commissions while he was in Florence. Rather, he produced pictures, predominantly portraits and Madonnas, for the private rooms of the nobility and the bourgeoisie, who often became his friends and arranged for him to see prestigious works of art in private homes and in the workshops of other artists, even items jealously guarded by Michelangelo himself. The Doni and the Taddei were patrons of both artists who, not infrequently, had the chance to meet, for example in the workshop of Baccio d'Agnolo, where, as Vasari testified, "among many citizens the best and foremost artists would meet . . . to have . . . wonderful discussions and important arguments. The first among these was the still very young Raphael; and then Andrea Sansovino, Filippino, Maiano, Cronaca, Antonio and Giuliano Sangalli, Granaccio, and sometimes, but not so often, Michelangelo." According to Vasari, Raphael also allied himself with Fra Bartolomeo, "who pleased him greatly, and whose use of color he sought to imitate; in return, he taught the good father the ways of perspective." Raphael's eye for Fra Bartolomeo's use of color would have seen plenty in the solemn *Justice* in Santa Maria Nuova, in the frescoes of San Severo, and in the *Disputation,* as well as in the natural *sfumato* of his drawings of draping. For his part, Fra Bartolomeo was among the first in Florence to appropriate Raphael's select sweet cadences and to incorporate into his own work the kind of extraordinary fusion between figures and architecture displayed in Raphael's *Madonna of the Baldachino.* This is the only one of Raphael's works that was commissioned for a Florentine church (by the Dei, for their chapel in Santo Spirito, in 1506), but it remained unfinished, and was never placed in the church.

In 1508, both Michelangelo and Raphael left Florence for Rome. Fra Bartolomeo, meanwhile, went to Venice, and Leonardo never returned to the city after 1506. The new artistic center of Italy was quite definitely the papal capital, in the Vatican building sites opened up by Julius II. Here, in the new fervor of archaeological discovery and amid the most diverse cultural influences, with artists from the Veneto, Lombardy, and Emilia all descending on Rome, the confrontation between Raphael and Michelangelo exploded, and found both audience and fellow players. Michelangelo still remembered the rift in 1542, when he wrote in a rancorous letter, "All the discord that was born between Pope Julius and me was caused by the envy of Bramante and Raphael of Urbino . . . and Raphael

had good reason, because everything he ever learned about art, he learned from me." This was only a partial truth; in fact, Michelangelo himself had learned something from Raphael's art, as may be seen in the facile line of the drawings for Cavalieri, in the more realistic flesh-tones of certain nudes in the *Last Judgment* (only recently uncovered) and, later, in the elements of the Pauline chapel that recall the Vatican tapestries or the Sala of Constantine. But certainly these things only marginally reflect on Florence.

Raphael never returned to that city, though work by him or by members of his workshop did sporadically arrive there; indeed, Raphaelesque painting is quite well represented in the Florentine galleries. (Only the works of Giulio Romano were the result of later acquisitions.) The most credible of Raphael's students came from Florence; among these were the "fiduciary" Giovan Francesco Penni, who had little to do with his hometown; the still-mysterious Maturino, who worked with Polidoro da Caravaggio on facade decorations; and Perino del Vaga, who moved back to his native city in 1522. He left behind few works, but those few had great impact, as for example the monochrome *spalliera* with *Crossing of the Red Sea,* a genre by then little practiced in Tuscany. Indeed, it was said to contain the "most beautiful figural attitudes." A cartoon by him, now lost, for a never-executed fresco of the *Martyrdom of the Ten Thousand,* was described as being rich in "various attitudes," with "very ornate and bizarre dress" in the style of the ancients; Vasari maintained that this drawing was responsible for bringing the "Roman style" to Florence.

As for Michelangelo, his feelings for Florence continued to fluctuate between bad and good (his relatives and friends lived there) until the end of his very long life. After 1534, however, he never returned to the city again. He left behind projects and memorable works of architecture and sculpture, which made their mark in the pictorial field as well. A sculptural painting, executed according to Michelangelo's precepts, is also the only late panel produced for his homeland by his devoted disciple Daniele da Volterra. Through such homages and the fame of his Roman work and through the admiration of patrons, artists, and scholars, Michelangelo—exalted when still alive, thanks to his biographers Condivi and Vasari—lived on in Florence throughout the century. He was the "genius loci," and all the city is still marked by his myth; yet his only secure contribution to painting remains the tondo produced for the Doni family.

Anna Forlani Tempesti

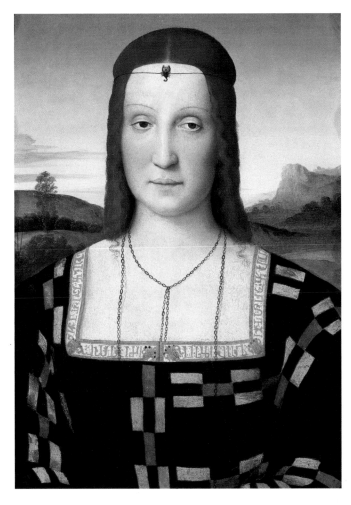

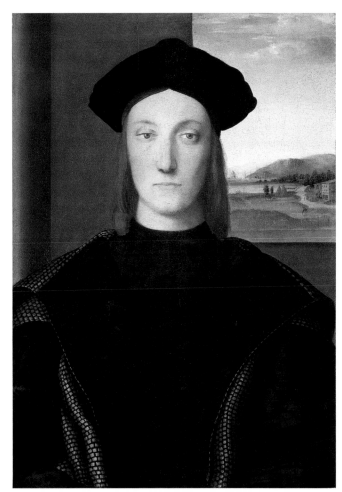

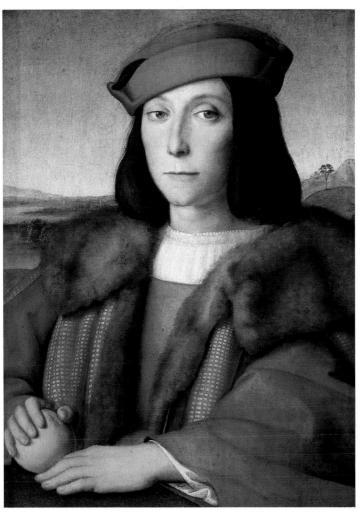

202
RAPHAEL
Portrait of Elisabetta Gonzaga
Oil on panel, 20¹³⁄₁₆ × 14¹¹⁄₁₆ in. (52.9 × 37.3 cm)
Uffizi, Gallery; inv. 1890: no. 1441

An old inscription on the reverse of this painting indicates that the lady portrayed hereon is Elisabetta Gonzaga, the wife of Guidubaldo da Montefeltro, duke of Urbino and an early patron of Raphael. Painted sometime between 1502 and 1508, the portrait was brought to Florence from Urbino in 1631 by Vittoria della Rovere.

203
RAPHAEL
Portrait of Guidubaldo da Montefeltro
Oil on panel, 27¾ × 19⅝ in. (70.5 × 49.9 cm)
Uffizi, Gallery; inv. 1890: no. 8538

Guidubaldo, duke of Urbino, was the son of Federico da Montefeltro. This portrait came to Florence in 1631 with other works belonging to Vittoria della Rovere.

204
RAPHAEL
Portrait of Francesco Maria della Rovere
Oil on panel, 18¹⁄₁₆ × 13⅞ in. (47.4 × 35.3 cm)
Uffizi, Gallery; inv. 1890: no. 8760

Francesco Maria was the son of Giovanni della Rovere and Giuliana Feltria, sister of Guidubaldo da Montefeltro. He was adopted by his uncle and, in 1504, made heir to the duchy of Urbino, which occasion this portrait may have been executed to mark.

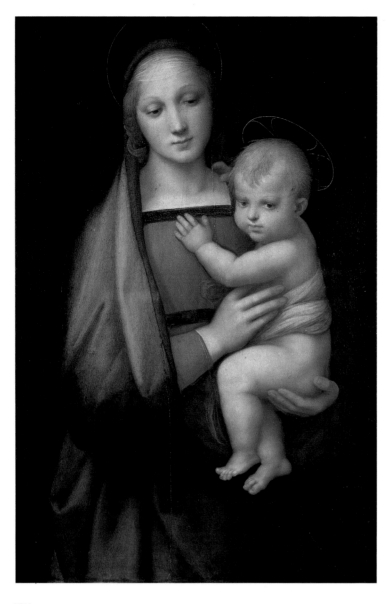

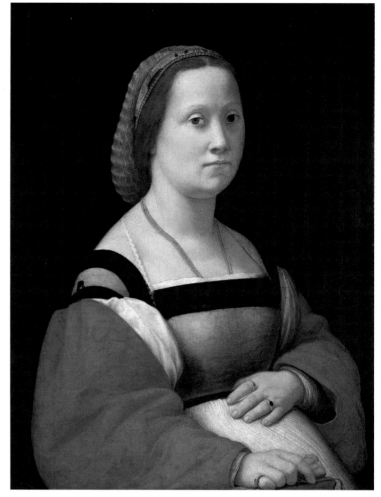

206

RAPHAEL

Portrait of a Woman ("La Gravida")

Oil on panel, 26 × 20¾ in. (66 × 52.7 cm)

Pitti, Palatine Gallery; inv. 1912: no. 229

This painting dates from the same period as the Doni portraits (see page 168). While all contain traces of Leonardo's style, Raphael's work has a greater sense of plasticity.

205

RAPHAEL

Madonna del Granduca

Oil on panel, 33¼ × 22 in. (84.4 × 55.9 cm)

Pitti, Palatine Gallery; inv. 1912: no. 178

The provenance and patrons of this work, which was intended for private devotion, are unknown; Ferdinand III of Lorraine acquired it in 1800 through a Florentine merchant. It was likely produced around 1506. Recent study has revealed a window and landscape hidden by the dark background.

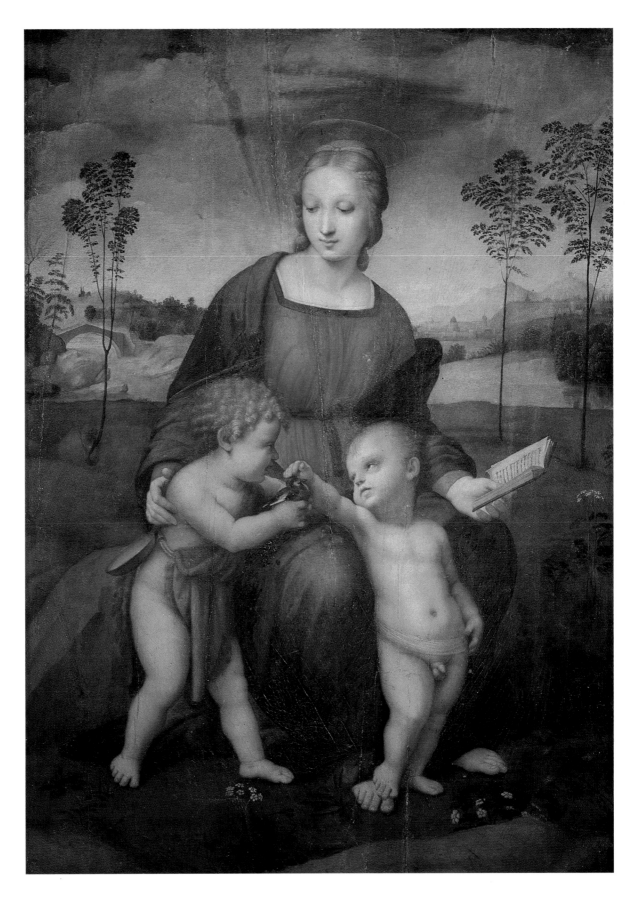

207
RAPHAEL
Madonna of the Goldfinch
Oil on panel, 42⅛ × 30⅜ in. (107 × 77.2 cm)
Uffizi, Gallery; inv. 1890: no. 1447
This panel was commissioned by the merchant Lorenzo Nasi to celebrate his
wedding to Sandra Canigiani at the beginning of 1506. Following the collapse
of the Nasi house, the painting was much damaged and had to be restored by
Nasi's son, Giovambattista. By 1646 it was already property of the Medici.

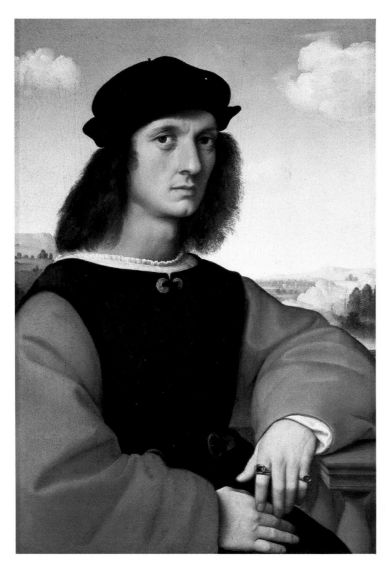 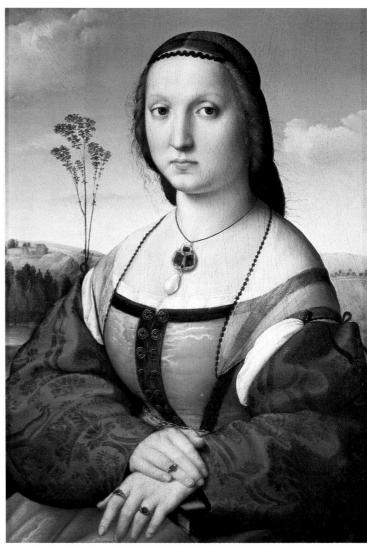

208 and 209
RAPHAEL
Portrait of Agnolo Doni
Oil on panel, 25⅝ × 18 in. (65 × 45.7 cm)
Pitti, Palatine Gallery; inv. 1912: no. 61
Portrait of Maddalena Strozzi Doni
Oil on panel, 25⅝ × 18¹⁄₁₆ in. (65 × 45.8 cm)
Pitti, Palatine Gallery; inv. 1912: no. 59

Agnolo Doni, who belonged to a wealthy family of merchants, married Maddalena Strozzi in 1504; their portraits by Raphael, recorded by Vasari, date from around 1506. On the reverse are two scenes in monochrome that have recently been attributed to the Master of Serumido: the *Flood* backing the portrait of Agnolo and *Deucalion and Pyrrha* behind that of Maddalena, the latter alluding to fertility. The portraits were acquired in 1826 by Leopold II of Lorraine from the Doni estate.

Opposite: 210
RAPHAEL
Madonna of the Baldachino
Oil on panel, 109¹³⁄₁₆ × 85⁷⁄₁₆ in. (279 × 217 cm)
Pitti, Palatine Gallery; inv. 1912: no. 165
Raphael began this painting in 1507 for the Dei chapel in Santo Spirito but left it incomplete on his departure for Rome the following year. It is a very important model for the development of this type of composition. After being in various locations, the panel was acquired by the Grand Prince Ferdinand de' Medici at the end of the seventeenth century.

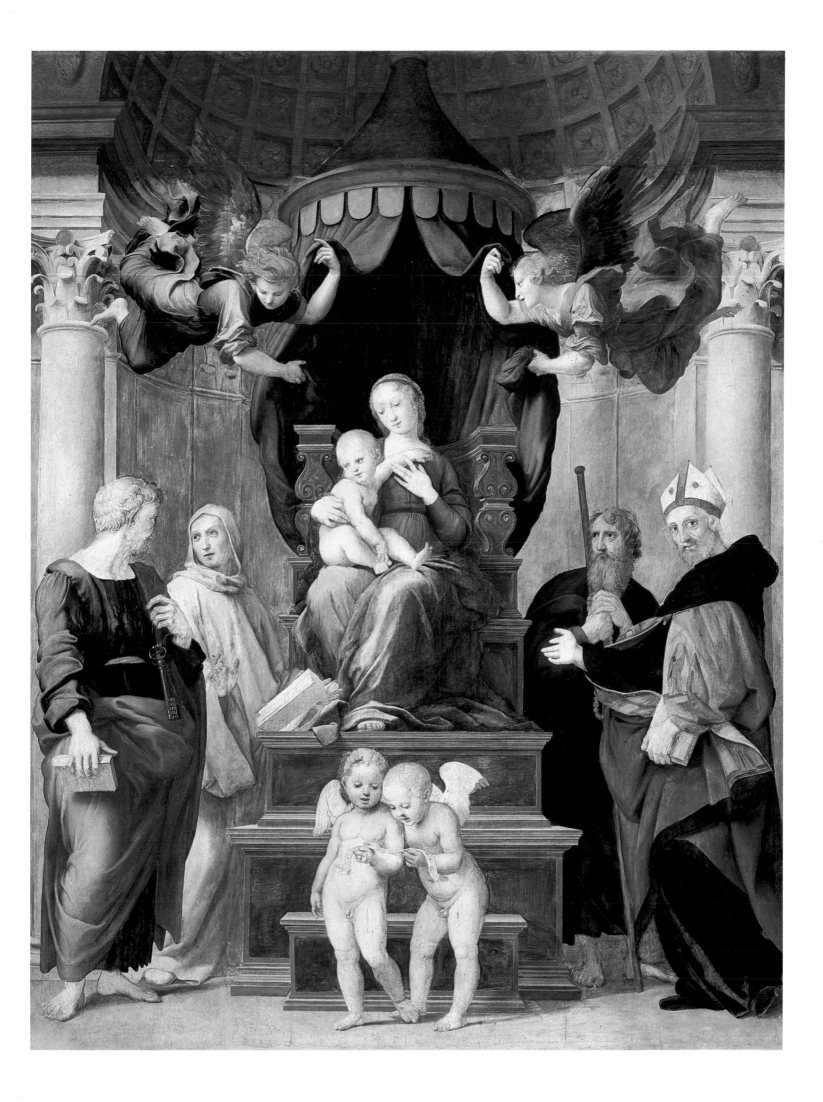

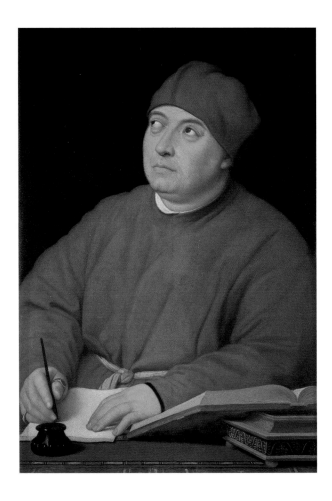

211
RAPHAEL
Portrait of Tommaso Inghirami ("Fedra Inghirami")
Oil on panel, 35¼ × 24½ in. (89.5 × 62.3 cm)
Pitti, Palatine Gallery; inv. 1912: no. 171
Tommaso Inghirami was made prefect of the Vatican Library in 1510, and it was perhaps on that occasion that he commissioned this portrait. It was first cited among the property of Cardinal Leopoldo, with its artist and subject both explicitly identified, in 1663.

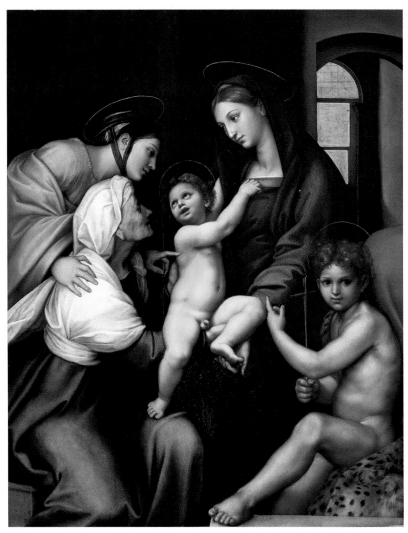

212
RAPHAEL
Madonna of the Cloth
Oil on panel, 63 × 50 in. (160 × 127 cm)
Pitti, Palatine Gallery; inv. 1912: no. 94
On this work one can today make out the Raphaelesque insignia that was used frequently throughout the life of the master's workshop. Commissioned in around 1514 by Bindo Altoviti, a Florentine banker who was opposed to the Medici and lived in Rome, the panel came into the Medici collection in 1554 with the confiscation of its patron's Florentine goods.

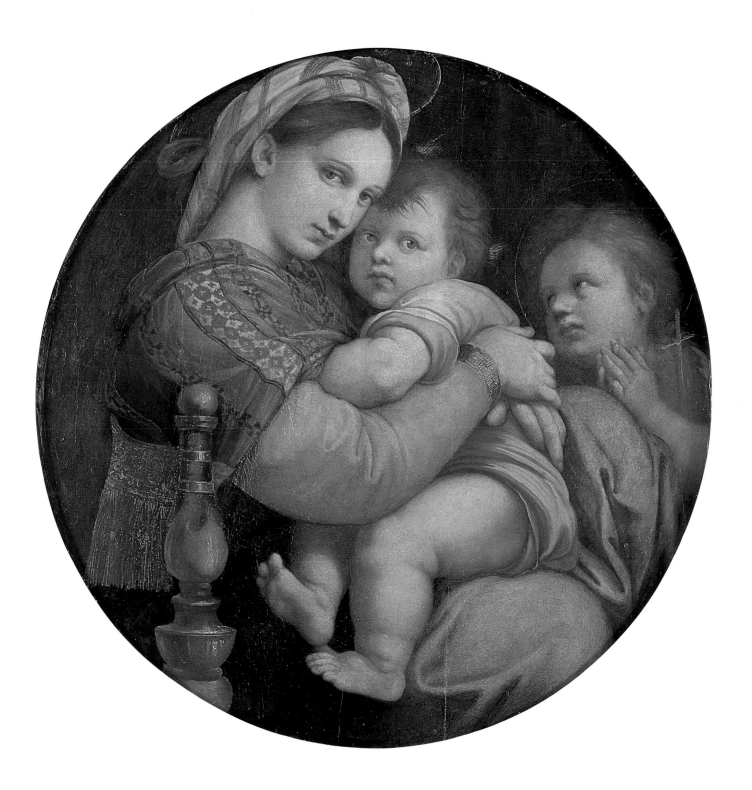

213
RAPHAEL
Madonna of the Chair
Oil on panel, 27¹⁵⁄₁₆ in. (71 cm) in diameter
Pitti, Palatine Gallery; inv. 1912: no. 151

It is not known who commissioned this tondo, which can be dated
to around 1513; nor is it known precisely when it came into the
Medici collection, though a painting whose description corresponds
to this composition is recorded in the inventory of the Tribune of
the Uffizi in 1589.

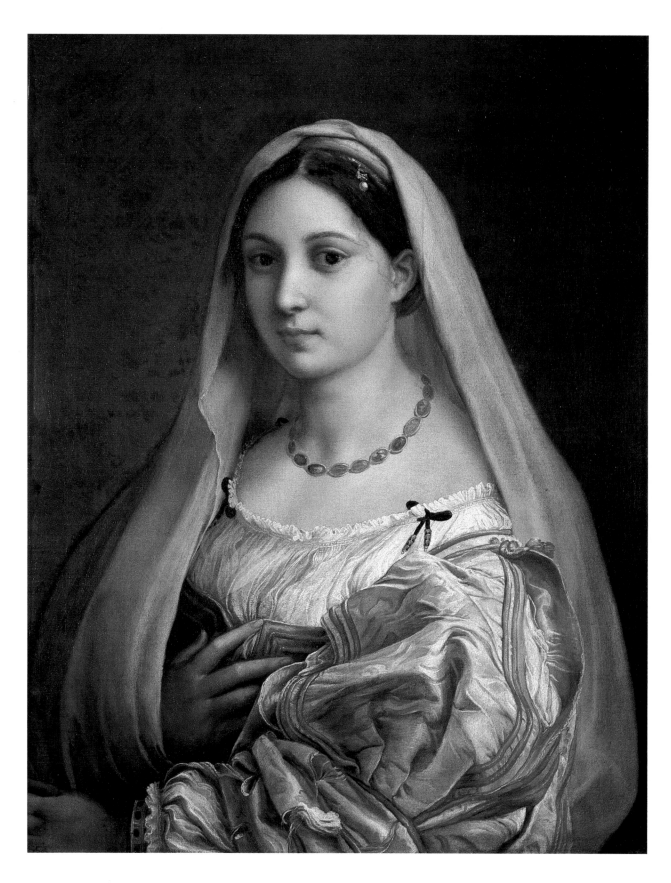

214

RAPHAEL
Portrait of a Woman ("La Velata")
Oil on canvas, 32⁵⁄₁₆ × 23¹³⁄₁₆ in. (82 × 60.5 cm)
Pitti, Palatine Gallery; inv. 1912: no. 245
Vasari's deduction that this is Margherita Luti, or "La Fornarina," a common girl loved by Raphael, cannot be verified. The painting is presumed to date from between 1512 and 1516. Vasari saw it in the house of the Florentine Matteo Botti, whose heirs sold it to Cosimo II de' Medici in 1622.

Opposite: 215
RAPHAEL
Portrait of Leo X with Cardinals Giulio de' Medici and Luigi de' Rossi
Oil on panel, 61¹⁄₈ × 46¹³⁄₁₆ in. (155.2 × 118.9 cm)
Uffizi, Gallery; inv, 1912: no. 40

Leo X, born Giovanni de' Medici, second son of Lorenzo the Magnificent, is pictured here with Giulio de' Medici, the future Clement VII, on his left. The other cleric, Luigi de' Rossi, was a relative on his mother's side. The portrait dates from between 1517 and 1518, when it was sent from Rome to Florence for Lorenzo de' Medici, duke of Urbino and nephew of Leo X.

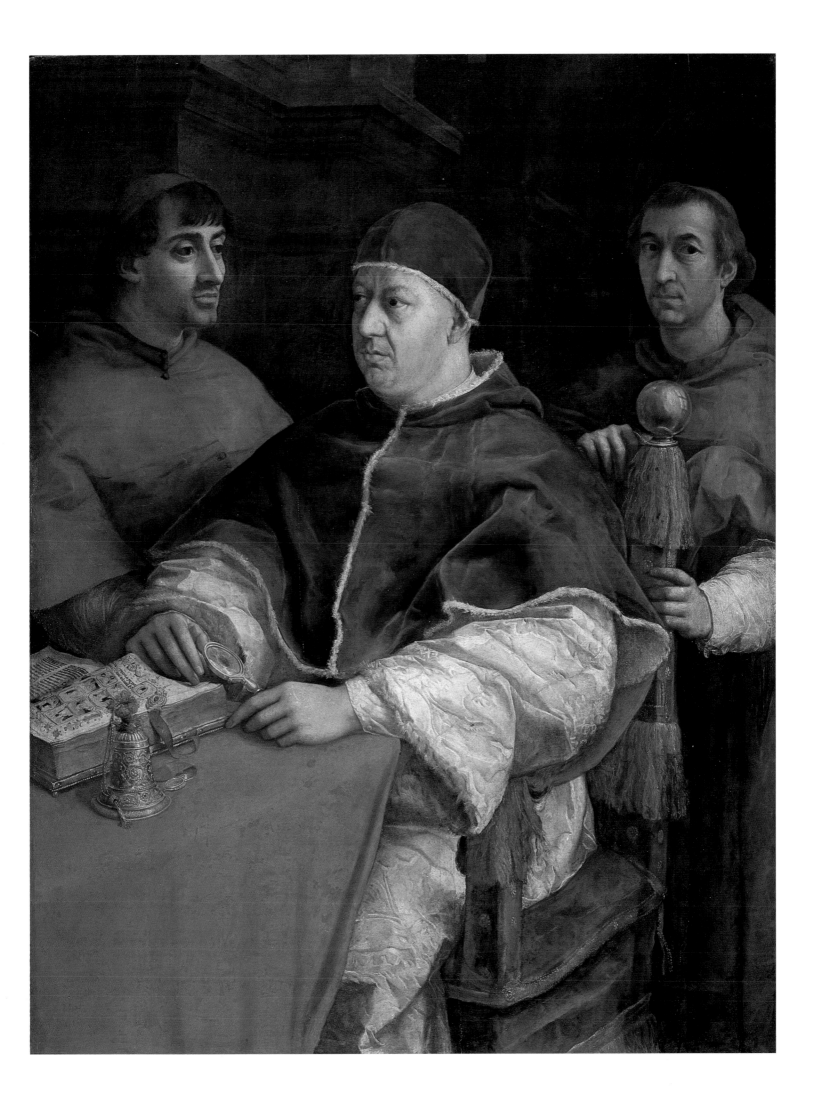

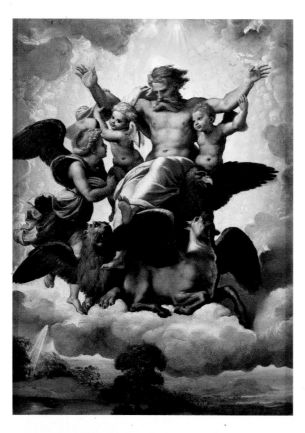

216
RAPHAEL
Ezekiel's Vision
Oil on panel, 15⅞ × 11⅝ in. (40.7 × 29.5 cm)
Pitti, Palatine Gallery; inv. 1912: no. 174
God the Father (based on an antique representation of Jove) is here depicted appearing to Ezekiel with the symbols of the Evangelists. The painting was commissioned by a member of the Ercolani family of Bologna, perhaps Vincenzo, and is datable to 1518. It was acquired by Francesco I de' Medici and already exhibited in the Tribune by 1589.

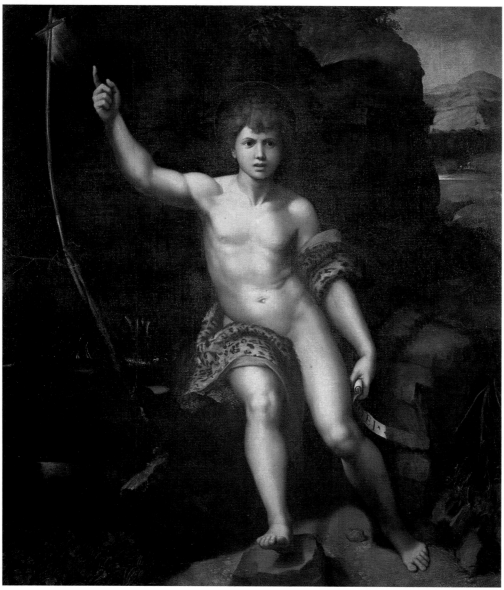

217
RAPHAEL
St. John the Baptist
Oil on canvas, 64³⁄₁₆ × 57⅞ in. (163 × 147 cm)
Uffizi, Gallery; inv. 1890: no. 1446

This picture was executed for Pompeo Colonna, probably in 1517, the year in which he was made a cardinal by Leo X; the subject may have been chosen in homage to the pope, Giovanni de' Medici. Formerly attributed to Giulio Romano, the work has only lately been given to Raphael. It has been documented in the Tribune since 1589.

218
GIULIO ROMANO
Madonna and Child
Oil on panel, 41⅝₆ × 30⅝₆ in. (105 × 77 cm)
Uffizi, Gallery; inv. 1890: no. 2147
This painting, which was recently restored to the Giulio corpus,
dates from around 1520–1522. It has been in the Uffizi since the
late eighteenth century, when it was transferred from the Imperial
Academy in Vienna.

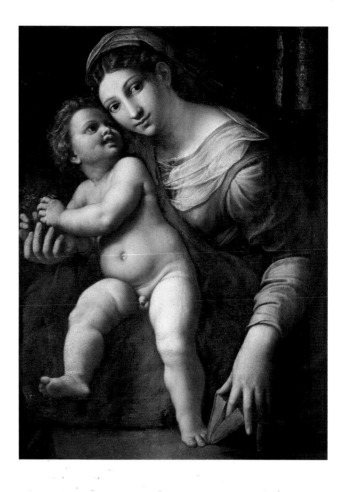

219
DANIELE DA VOLTERRA
Massacre of the Innocents
Oil on panel, 20⅛₆ × 16⅝₆ in.
(51 × 42 cm)
Uffizi, Gallery; inv. 1890: no.
1429
This painting, conceived for
the church of San Pietro in
Volterra and paid for in 1557,
is based on Michele Alberti's
fresco cartoons for the della
Rovere chapel in the Church
of Trinità dei Monti in Rome.
In 1782 the panel was given
to Grand Duke Pietro Leo-
poldo de' Medici, who dis-
played it in the Uffizi.

220 and 221
PERINO DEL VAGA
The Justice of Seleucus
Detached fresco reapplied to canvas, 58¼ × 77⁹⁄₁₆ in. (148 × 197 cm)
Uffizi, Gallery; inv. 1890: no. 5380
Tarquin the Bold Founds the Temple of Jove on the Campidoglio
Detached fresco reapplied to canvas, 52 × 59⅛ in. (132 × 150 cm)
Uffizi, Gallery; inv. 1890: no. 5907

Probably executed between 1519 and 1525 for Melchiorre Baldassini, a judge, these frescoes were part of the decoration, according to Vasari, for a room in Baldassini's house in Rome. They were detached in 1830 and came to the Florentine galleries in 1880.

Tuscany from 1494 to 1530

Between Piero de' Medici's fall from power in 1494 and the definitive restoration of the Medici after 1530, Florence was the artistic, if not the political, capital of Tuscany; its status as political capital would be revived after the middle of the century, when Cosimo de' Medici was given the title of grand duke. Between the former two dates, the republican dream was born and died. It was helped along by Savonarola's preaching and finally realized by the gonfalonier Piero Soderini in 1502; having withstood the return of the Medici in 1512, it ended with the conquest of the city by the imperial troops.

Official artistic commissions from the republican government tended to exalt civic victories and the Christian ideals of the Savonarolian matrix. Emblematic of this tendency was *Universal Justice*, by Bartolomeo (Baccio) della Porta, later known as Fra Bartolomeo. Commissioned in 1499 by Gerozzo Dini for his chapel in the cemetery of Santa Maria Nuova, the painting was completed in 1501 by Baccio's companion, Mariotto Albertinelli, after the former had entered the Dominican order. The elegant sureness of design, the ample volume built up with intense color and *sfumato* (recaptured, at least in part, by a recent restoration), and the feeling of space in this sadly ruined painting are components of a new pictorial vocabulary, elaborated by the two painters, but more especially by Baccio. He and Mariotto were trained together in the Ghirlandaiesque workshop of Cosimo Rosselli. Baccio exceeded the limits of his first master and went on to be an intelligent interpreter of Leonardo's example, even as he studied the great many Flemish works that had come to Florence in the previous century. There was a grandeur and an unedited naturalness to his painting, as seen in the two wings of a tabernacle executed for Piero del Pugliese. An intense spirituality is also apparent in the work, as is a certain poetic acuity, with shadows being suggested through color and sweetly undulating contours. A rapport developed between luminous spatial planes characterizes the artist's *Vision of St. Bernard*, his frescoes with busts of male and female Dominican saints, and the lunette of his *Christ on the Road to Emmaus* in San Marco.

Between 1509 and 1512, Fra Bartolomeo reestablished a formal partnership with his friend Albertinelli. Through his contact with Raphael, who was in Florence between 1504 and 1508, and after a brief sojourn in Venice in 1508, Bartolomeo in those years produced altarpieces that are distinctive for their relationship between dense shadow and intense, brilliant color—the result, in part, of an awareness of the work of Giovanni Bellini. These works became increasingly monumental, often taking as their theme the Holy Family, a subject with which Raphael, too, was occupied during that period, particularly in the *Madonna of the Baldachino*. The great *Mystic Marriage of St. Catherine*, of 1512, represents the pinnacle of Fra Bartolomeo's and Mariotto's development of new pictorial ideas in its combination of traditional schema with an innovative solution that would soon become canonical. It is a grand classicism evoked by an airy spatial ambience, constructed out of figures made of simple masses and soft contours, mediated by a knowing use of chiaroscuro and a sense of stability that defines the "group" in accordance with a symmetrical response.

This phase of Fra Bartolomeo's work was the culmination of the ideas of many of his contemporaries, not only in Florence but throughout Tuscany. This is perhaps less true of the techniques he explored after his journey of 1513–1514 to Rome, where he drew upon the new suggestions of Michelangelo and Raphael for his *St. Mark,* his *Pitti Redeemer,* and his pictures of the prophets Isaiah and Job (both now in the Accademia). By this point Bartolomeo's art was no longer on the cutting edge, though this work serves as an exalted conclusion to his achievements.

Among the painters influenced by Fra Bartolomeo— influenced, that is, to such an extent that we may even style them the "school of San Marco"—the most noteworthy was his workshop partner, Mariotto Albertinelli, whose *Visitation* of 1503 is so close to Fra Bartolomeo's grandiose classicism as to suggest that the composition was in fact from Bartolomeo's own idea. Albertinelli's spectacular *Annunciation* for the Company of San Zanobi, for its part, is built around an extremely complex scenic machine in which the figures achieve monumentality through a bold foreshortening and are situated in the delicate penumbra of the prevalent architecture; his *Trinity,* meanwhile, is intensified and dramatized by chiaroscuro. The course of Albertinelli's career ran parallel to, but independent from, the oeuvre of his greater partner; it was distinguished primarily (when he was not leaning on Bartolomeo) by a substantial adherence to fifteenth-century tradition.

The monastic simplicity and the elegant language of Antonio del Ceraiolo and Sogliani's work were closer to the ideals of the devout San Marco school. It is important to mention in this context, too, both Giuliano Bugiardini — who as Albertinelli's partner for some while after 1503 had access to and made use of Bartolomeo's drawings — and Ridolfo Ghirlandaio. These two painters were decisively influenced first by Raphael and then by Andrea del Sarto, but there is some justification for including them under the banner of the "school of San Marco," a general term for a precise mode of Tuscan painting found not only in Florence but also in Pistoia, in Lucca, in Siena, in Pisa, and in Volterra, where the stylistic ideals and direction of Fra Bartolomeo still held sway.

At the beginning of the second decade of the sixteenth century, another personality was introduced to the local Florentine scene, one who took up some of Fra Bartolomeo's ideas and infused them with a new strength; this was Andrea del Sarto. Del Sarto's character is described with a great deal of liveliness and enthusiasm by Vasari, in part because he had once been that artist's pupil; beyond the biographical encomiums, however, lay an exceptional figure who was fixed in conventional systems of painting that, though unassailable, were yet somewhat cautious and unadventurous, with a pictorial formula

that originated in a kind of academic and reductive artistic interpretation of his painting. Apart from these historiographic schemes (which certainly have their worth), del Sarto, along with Michelangelo and Raphael, is credited with the creation of the pictorial language of Florentine mannerism; he is seen, too, as the leader of the "school of the Santissima Annunziata," to which Pontormo and Rosso Fiorentino belonged. By the 1520s, when the "manner" had spread throughout central Italy, Andrea del Sarto was considered to be the reviver of the sophisticated, solemn, and peaceful classicism envisioned by the generation of Tuscan "reformers" at the end of the century.

In Andrea's early works, the fine Leonardesque style that he had inherited from Fra Bartolomeo burst into an intense and unrestrained expressiveness coupled with a poetic evocation of the daily reality of places and objects (as, for example, in the *Noli Me Tangere*). A journey to Rome in 1511, not actually documented but reasonably hypothesized by recent scholars, suggests that del Sarto came into direct contact with the new ideas of Raphael and Michelangelo, just then coming into being. This trip seems to have been the necessary catalyst to release the stylistic energy evident in the "votive cloister" of the Santissima Annunziata, from the elegant and peaceful narrative cycle of the life of San Filippo Benizzi (1509–1510) to the intriguing complexity of the *Journey of the Magi* (1511) and the *Birth of the Virgin* (1513–1514), which gives evidence of the Florentine version of the stately classicism of the Vatican rooms.

Andrea del Sarto's pictorial language—based not only on an elaboration of the new and sensational Roman style but also on careful study of the Northern engravings (by Lucas van Leyden and, in particular, by Dürer) that were then circulating around Florence—is a point of reference for the small group of artists led by del Sarto. These artists—Andrea di Cosimo Feltrini, Franciabigio, Pontormo, and Rosso Fiorentino—all collaborated with him on the decoration of the above-mentioned votive cloister of the Santissima Annunziata, painting stories from the life of the Virgin, the fundamental artistic text of the first kind of mannerism produced by the avant-garde that would later be known as the "school of the Santissima Annunziata." After Andrea's *Journey of the Magi* and *Birth of the Virgin,* in chronological and physical order, came Franciabigio's fresco of the *Marriage of the Virgin* (1513), Rosso's *Assumption of Mary* (1513–1514), and Pontormo's *Visitation* (1514–1516).

The inherited tradition of fresco cycles, having reached its culmination at the end of the fifteenth century in the vast production of Ghirlandaio's workshop, was never quite abolished but was, rather, absorbed into and transferred by the various stylistic solutions of different artistic personalities, with del Sarto's art as the common denominator. His painting provided the best response to the communal questioning of the worth of Renaissance rationalism: his palette was charged with an accessible and changing abstraction; his lines were nervous, sinuous, and broken; his research focused not on beauty understood as perfect proportion, but rather on "grace." In 1515 Andrea was hired, along with Granacci, Bachiacca, and Pontormo,

to paint panels with the life story of Joseph the Hebrew for the bridal chamber of Pierfrancesco Borgherini and Margherita Acciaioli, designed by the architect Baccio d'Agnolo. The whole extraordinary complex—which Margherita later defended passionately from the acquisitive desires of the king of France, but which was nonetheless dismantled at the end of the sixteenth century—raised contemporary Florentine artistic achievement to a new level. The older Granacci adapted quite ably to Andrea del Sarto's innovative style and to the influences it was modeled upon—that is, the ideas of his friend Michelangelo and the language of Albertinelli and Fra Bartolomeo. Bachiacca, while aware of this new style, remained faithful to his Peruginesque training and clothed the figures in his panel in vivacious color. Del Sarto himself, meanwhile, and especially Pontormo, transformed their narratives into disquieting and allusive chronicles set against a sort of dreamy classicism, rich and marvelous in their humanity.

The same group of artists also sought to transform the typology of the altarpiece during this period. Fra Bartolomeo's *Redeemer* of 1516, for example, is a monumental piece of sacred architecture arrayed with figures solemnly disposed in a triumphal affirmation of faith; the structure of del Sarto's contemporaneous *Madonna of the Harpies*, in contrast, dissolves into a harmonious correspondence of rhythms and into shadows that lend a delicate naturalness to the figures' clothing and faces, with their expressions alternately intense and ambiguous. The *Debate over the Trinity,* of 1517, is infused with and dramatized by a depth of feeling that partakes of the atmosphere of crisis experienced by the Christian world. Pontormo and Rosso Fiorentino took the debate even further, to the point of breaking with tradition: Pontormo's *Pucci Altarpiece* (still in the Florentine church of San Michele Visdomini) and Rosso's altarpiece in Santa Maria Nuova, both painted in 1518, employ schemes devised by Fra Bartolomeo and Andrea del Sarto but subvert those schemes entirely by giving the elongated bodies an elaborated and studied expressiveness, and charging the faded and changing colors with an emotional tension. These artists' message is one of profound dissatisfaction with the values of the preceding generations.

In the last ten years of his life, del Sarto closely followed Michelangelo's experiments in the New Sacristy in San Lorenzo. Andrea's last works serve as essential reference points for Tuscan art of this period; these include such masterpieces as the *Pietà of Luco,* the Panciatichi and Passerini Assumptions, the Gambassi and Sarzana altarpieces, the spectacular *Last Supper* in the refectory of the Vallombrosian convent of San Salvi, the dismantled *Vallombrosiana Altarpiece,* and the intense late portraits (for example, his *Lady with a Book of Petrarch*). All of these display a peaceful equilibrium of rhythm and palette, a penetrating and intimate poetic content, and significant parallels with the work being done just at this time by Correggio.

Besides Michelangelo, who had returned to Florence to work on the Medici tombs, the major figures in the city's artistic scene were now Pontormo and Rosso Fiorentino.

With them the vocabulary of "mannerism" became a stylistic reality, a disturbing and fascinating expression of their furious research and their individual dramas, but at the same time a reflection of the violent tensions that were then raging across Europe, and Italy in particular. (These tensions culminated in the field of religion with the break of the Protestant reform in 1517, and in the political arena with the Sack of Rome in 1527 and the conquest of Florence in 1530.) Early echoes of Leonardo, Piero di Cosimo, Fra Bartolomeo, and Albertinelli, along with references to the first developments of del Sarto, can be clearly seen in the youthful work of both painters up to around 1518; after that those influences were left behind, if not completely forgotten, in favor of ideas suggested by Leonardo's and especially Michelangelo's cartoons, as well as personal reinterpretations of Dürer's engravings.

From his cycle of the *Passion of Christ*, frescoed in the large cloister of the Certosa del Galluzzo between 1523 and 1527, Pontormo passed through extraordinary stages such as his *Supper at Emmaus* and his *Birth of the Baptist* before reaching a decorative zenith in his 1527 Capponi chapel in Santa Felicita, and his Carmignano *Visitation* of 1528, where the weighty certitudes of the Renaissance are replaced with an equally weighty but irrational vision of stupendous force and modernity.

Rosso Fiorentino was just as much an outsider and a rebel as Pontormo, or perhaps even more so. It was probably because he could convert conventional sources into decidedly unconventional ones that Florentine artistic society, while recognizing his greatness, saw to it that most of his commissions came from outside the city, in minor centers such as Volterra, after 1520. His *Deposition* of 1521, in the Pinacoteca in Volterra, makes use of Florentine traditions but treats them with a kind of bizarre geniality. In looking at the work of Michelangelo and at Dürer's prints, Rosso Fiorentino arrived at an innovative and revolutionary proposition.

The model with the three ladders is particularly complex. He borrowed this from other artists' works, such as the composition of the *Deposition* begun by Filippino Lippi and finished by Perugino (now in the Accademia in Florence) and numerous derivations from the wax *bozzetto* of Jacopo Sansovino (in the Victoria and Albert Museum, London) by Perugino, Bachiacca, and Andrea del Sarto. In Fiorentino's hands these became ravaged and animated by broken or caved-in or blockaded bodies, mannequins weighed down by nervous brushstrokes, thick and short, upon which bombardments of light change and distort even simple forms. The expressive violence of the Volterra *Deposition* is somewhat subdued in the remaining fragments of Rosso's *Musical Angels* in the *Dei Altarpiece* of 1522, where he softened the psychologically tense expressions and provided accents of calm patience and suggestive sweetness. This holy group is orchestrated, beyond the inevitable and not far removed echoes of Raphael's *Madonna of the Baldachino* and Fra Bartolomeo's altarpieces, around the anxious rhythms of the stretched and lively bodies and the same preciousness of changing surface colors.

Rosso's subsequent journey to Rome, in 1524–1527,

made a different sort of impression on his painting. His *Moses Defending the Daughters of Jethro* is the result of direct study, not only of work by Michelangelo and by Raphael's school in the Vatican, but also of antique statues and reliefs, and the Laocöon group in particular. Perhaps, ironically, Rosso produced an exaggerated articulation of athletic bodies (actually the same body, seen in various positions) that serves only to fill up the space, to cancel out the depth, and to block sculptural gestures and any symmetrical response evoked by the movement. The Sack of Rome caused many artists to abandon the city; in his wanderings Rosso ventured to Arezzo and San Sepolcro, to Perugia and Città di Castello, often leaving behind masterpieces of a tragic and metallic grandness and a refined elegance, until in 1530 he arrived at last at the court of Francis I, where he concluded his career with the decoration of Fontainebleau.

The other great artistic personality of this time in Tuscany was Domenico Beccafumi, who was trained in Siena. The influence of the Florentine Leonardo, Fra Bartolomeo, and Albertinelli, along with that of Andrea del Sarto, was just then superimposing itself over the local Sienese culture which had been dominated since the beginning of the century by a group of "foreigners"— Signorelli, Pinturicchio, and Perugino—and by such masters of the younger generation as Genga and Sodoma. Beccafumi concentrated nearly all of his activity in Siena (only later did he produce some altarpieces for the Duomo in Pisa) and developed in a direction parallel to that of Pontormo and Rosso. He was equally and profoundly impressed by Raphael, by Michelangelo, and by Northern prints. His "manner" consisted of an almost abstract coloring and a sublime and delicate *sfumato* that created consistent volume and spatial relationships; his increasing experimentation never abated in any of his more extreme works, and it would influence all of Sienese painting for the first half of the century and beyond. The Florentine collections attest to this influence in Pacchia's *Madonna and Child with the Young St. John* and in the tondo by Andrea del Brescianino, one of the most interesting of the Sienese masters, who in 1525 produced an elegant if somewhat archaic interpretation of prototypes by Fra Bartolomeo, Andrea del Sarto, and Beccafumi.

The provenance of paintings, which is indicated, wherever possible, in the short catalogue notes, shows that the last decades of the sixteenth century and the first decades of the seventeenth were devoted largely to the collection of works of art from the period in question. In the older Medici collections—such as that of the Casino of San Marco, registered in the inventory of 1588—are listed, among others, the tondo by Beccafumi, Franciabigio's *Calumny of Apelles*, and *Moses Defending the Daughters of Jethro* by Rosso Fiorentino. Among Francesco I's acquisitions for the Uffizi Tribune, the most prestigious part of the gallery, were panels depicting the *Story of Joseph* by Andrea del Sarto and by Granacci, paid to the Borgherini heir in 1584.

Besides donations to and acquisitions for the Tribune and the splendid private collections of various members of the grand duke's family—patrimonies that would revert

on their death to the grand duke himself—the galleries' holdings were enriched by a practice initiated at the end of the sixteenth century by the grand duke and his family. Through this arrangement, made with a number of orders, churches received copies and generous donations in exchange for altarpieces by Fra Bartolomeo and Andrea del Sarto—works that Bocchi, in his *Beauties of the City of Florence* of 1591, had celebrated as masterpieces. Cardinal Ferdinand thus removed Andrea's late *Annunciation* from the Santissima Annunziata in 1580 and substituted a copy by Alessandro Allori, while in about 1619 Cardinal Carlo obtained the *Pietà* by Fra Bartolomeo from the church of San Jacopo tra' Fossi. Christine of Lorraine, for her part, took del Sarto's *Debate over the Trinity,* and Maria Maddalena of Austria followed suit by acquiring the same artist's *Annunciation;* the two works were replaced with copies by Ottavio Vannini. In 1639 Ferdinand II acquired the monumental *Assumption* by Cortona, and Cosimo II's eldest son, Grand Prince Ferdinand, added to his magnificent collection, over the protests of both religious figures and citizens, some of the most important altarpieces of the sixteenth century, including the *Madonna of the Baldachino* by Raphael (from the Duomo in Pescia), the *Dei Altarpiece* by Rosso (from Santo Spirito), and the *Mystic Marriage of St. Catherine* and *St. Mark* by Fra Bartolomeo (from the church of San Marco).

These great paintings, created expressly to be installed into the architectural framework of the altar, were often modified to fit into magnificent gilded frames that lent an elegant symmetry to the arrangement of the pictures on the walls. One particularly blatant example is the alterpiece by Rosso Fiorentino that was added to on all sides in order to accommodate a very beautiful late baroque frame in the grand prince's Pitti apartments; but without a doubt the most extreme instance of such intervention can be seen in the *Pietà* by Fra Bartolomeo, whose recent restoration has recovered its intended appearance, even if it remains only a fragment of its original self.

Other criteria, too, guided the collecting of the Medici, who so loved and appreciated painting from the early part of the sixteenth century that they gathered together these masterpieces in the galleries of the Uffizi and the Pitti Palace. Here, as in many other cases, they transformed altarpieces into extraordinary paintings for a room.

Serena Padovani

222
FRA BARTOLOMEO
Nativity
Oil on panel, 7¹¹⁄₁₆ × 3⁹⁄₁₆ in. (19.5 × 9 cm)
Uffizi, Gallery; inv. 1890: no. 1477
Commissioned by Piero del Pugliese, along with a second wing, which represents the Circumcision; in 1589 it was recorded as being in the Palazzo Vecchio

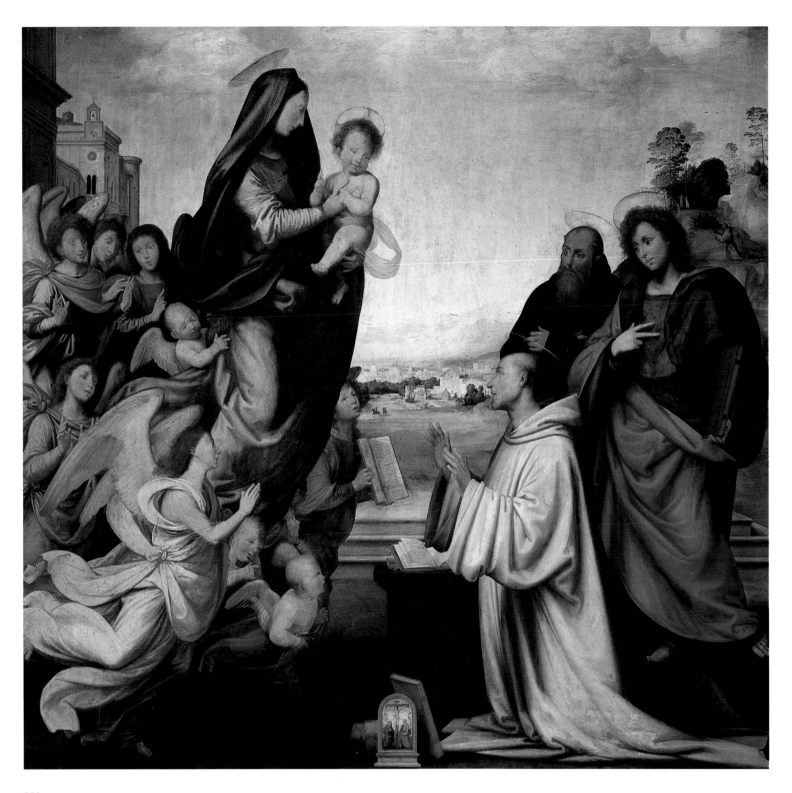

223
FRA BARTOLOMEO
The Vision of St. Bernard
Oil on panel, 84^{11}/$_{16}$ × 90^{15}/$_{16}$ in. (215 × 231 cm)
Uffizi, Gallery; inv. 1890: no. 8455

Bernardo del Bianco commissioned this altarpiece in 1504 for his family chapel in the
Florentine Badia. Due to a controversy over the price, the work was not delivered until
1507.

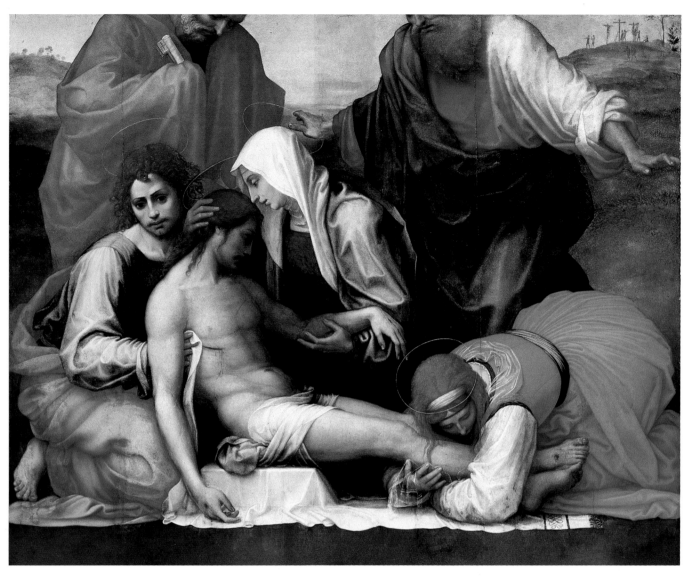

224

FRA BARTOLOMEO

Pietà with SS. Peter and Paul

Oil on panel, 62³⁄₁₆ × 78⅜ in. (158 × 199 cm)

Pitti, Palatine Gallery; inv. 1912: no. 64

Fra Bartolomeo painted this panel in 1511–1512 for the church of San Gallo, perhaps for the high altar. After the convent was destroyed, in 1529, it was transferred to the church of San Jacopo tra' Fossi, from which Cardinal Carlo de' Medici acquired it in 1619 for his collection at the Casino di San Marco. In 1667 the painting was sent to the Pitti Palace. A 1980s restoration revealed a landscape in the background and two figures of saints, which had been cut at face-level in the seventeenth century.

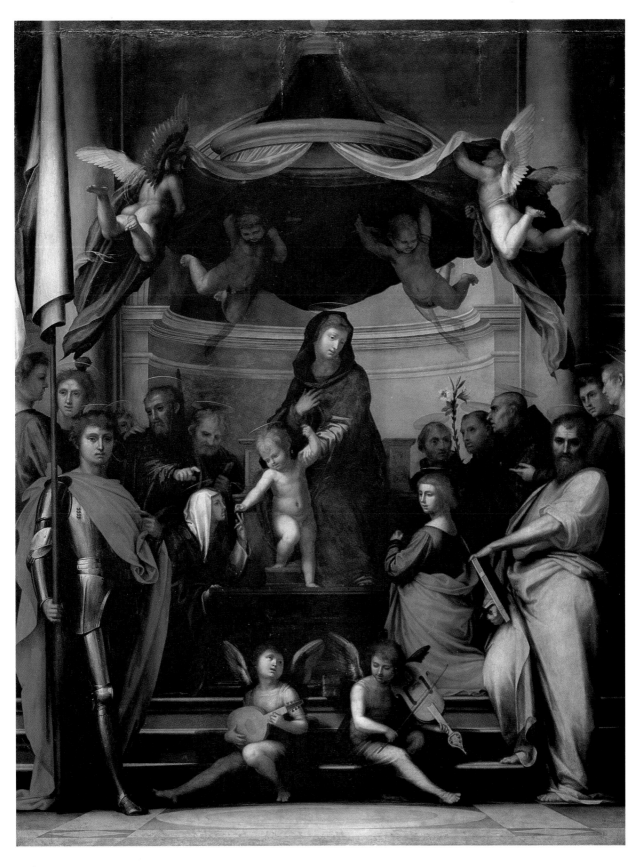

225

FRA BARTOLOMEO

The Mystic Marriage of St. Catherine

Oil on panel, 138³⁄₁₆ × 105⅛ in. (351 × 267 cm)

Dated: MDXII

Inscription: ORATE PRO PICTORE

Accademia, Gallery; inv. 1890: no. 8397

Dated 1512, this altarpiece was executed for the chapel of Santa Caterina in the church of San Marco. In 1690 Grand Prince Ferdinand claimed it for his apartments in the Pitti Palace, leaving in its place a copy by Anton Domenico Gabbiani.

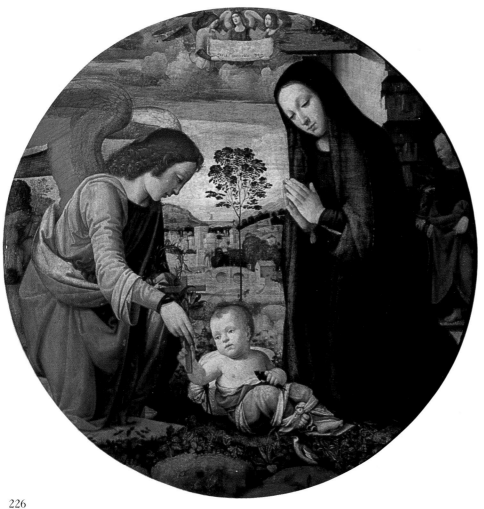

226
MARIOTTO ALBERTINELLI
The Adoration of the Child with an Angel
Oil on panel, 33⅞ in. (86 cm) in diameter
Pitti, Palatine Gallery; inv. 1912: no. 365
Because this tondo is stylistically close to the *Visitation* in the Uffizi
(opposite), it is thought to date from around 1503.

227
MARIOTTO ALBERTINELLI
The Nativity
Oil on panel, 9¹⁄₁₆ × 19¹¹⁄₁₆ in. (23 × 50 cm)
Uffizi, Gallery; inv. 1890: no. 1586
This is the central predella panel for Albertinelli's *Visitation* (oppo-
site).

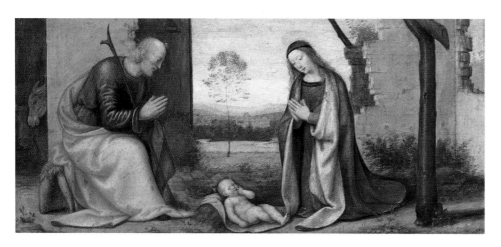

Opposite: 228
MARIOTTO ALBERTINELLI
The Visitation
Oil on panel, 91⁵⁄₁₆ × 57½ in. (232
× 146 cm)
Dated: MDIII
Uffizi, Gallery; inv. 1890: no. 1587
This altarpiece, dated 1503, was
commissioned for the church of the
Congregation of San Martino, from
1517 called the church of the Visita-
tion or of St. Elizabeth.

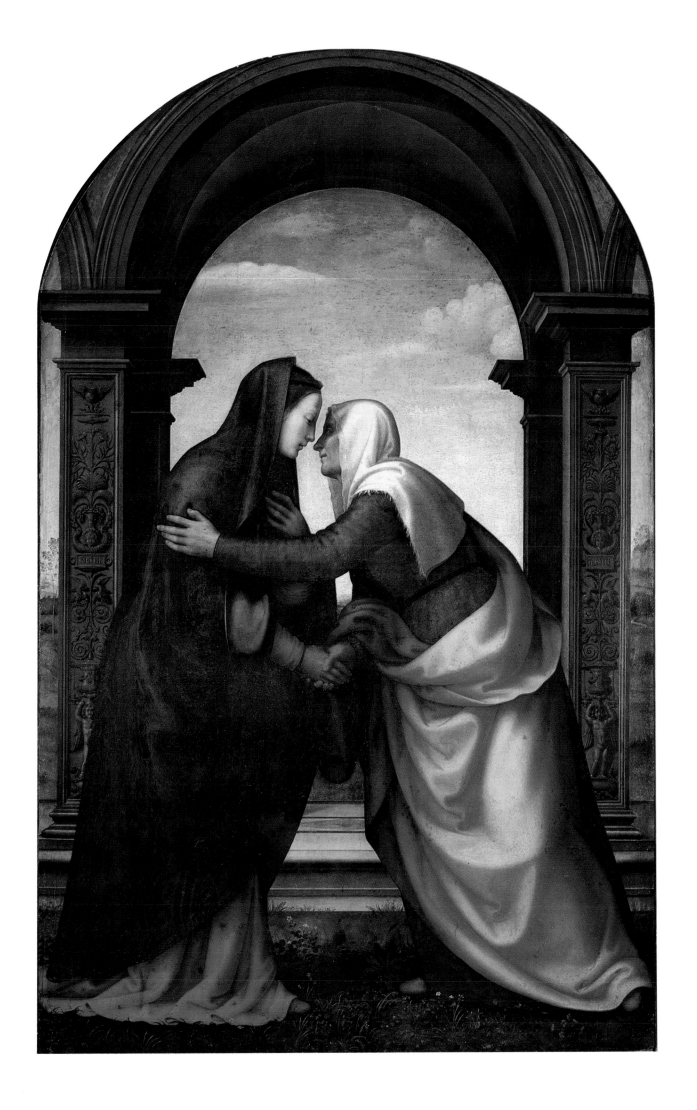

185

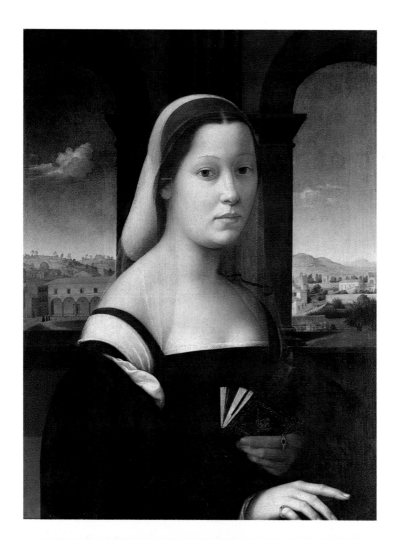

229

GIULIANO BUGIARDINI
Portrait of a Woman ("The Nun")
Oil on panel, 25⁹⁄₁₆ × 18⅞ in. (65 × 48 cm)
Uffizi, Gallery; inv. 1890: no. 8380

Inspired by Leonardo's portraits and Raphael's Florentine ones, this work has been given a date of around 1510 based on the woman's habit, once erroneously thought to be that of a nun. The sitter, who remains unidentified, must have been linked in some way with the hospital of San Paolo, which is visible in the background. The painting was acquired in 1819, with an attribution to Leonardo, by Ferdinand III of Lorraine.

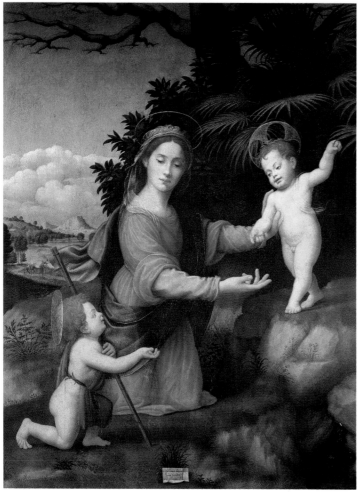

230

GIULIANO BUGIARDINI
Madonna and Child with the Young St. John the Baptist
("Madonna of the Palm")
Oil on panel, 4⁷⁄₁₆ × 35¹³⁄₁₆ in. (118 × 91 cm)
Signed and dated: JULIANUS FLORENTINUS FACIEBAT MDXX
Accademia, Gallery; inv. 1890: no. 3121

This work dates from the beginning of the 1520s and is closely related to Raphael's Roman painting; its provenance is the Mansi collection in Lucca. The palm refers to an episode from the Flight into Egypt mentioned in the Apocryphal gospel.

231
RIDOLFO GHIRLANDAIO
Portrait of a Lady
Oil on canvas, 24 × 19½ in. (61 × 47 cm)
Dated: MDVIIII
Pitti, Palatine Gallery; inv. 1912: no. 224

This composition, dated 1509, was inspired by Raphael's Florentine portraits, such as "La Gravida" (see page 166). The painting came to the Medici collection as part of the dowry of Vittoria della Rovere, the duchess of Urbino.

232 and 233
RIDOLFO GHIRLANDAIO
St. Zenobius Raising a Boy from the Dead
Oil on panel, 79½ × 68½ in. (202 × 174 cm)
Cenacolo di San Salvi; inv. 1890: no. 1584
Conveyance of the Body of St. Zenobius
Panel, 79⅞ × 68½ in. (203 × 174 cm)
Cenacolo di San Salvi; inv. 1890: no. 1589

Both of these scenes are set in Florence; one takes place in the piazza of San Pier Maggiore, and the other between the Duomo and the Baptistry. Painted in 1516–1517, they became the side panels for the *Annunciation* completed in 1510 by Albertinelli for the altar of the Company of San Zanobi in the Duomo.

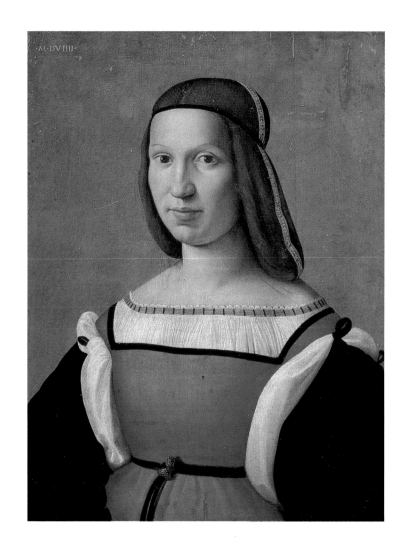

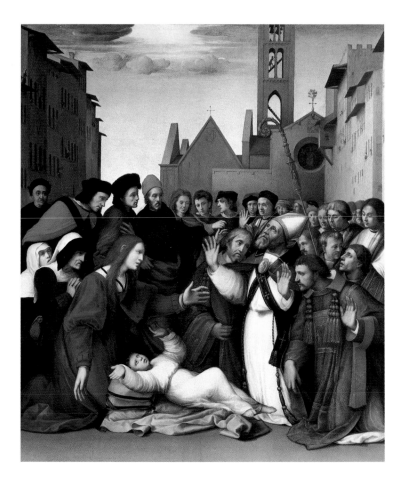

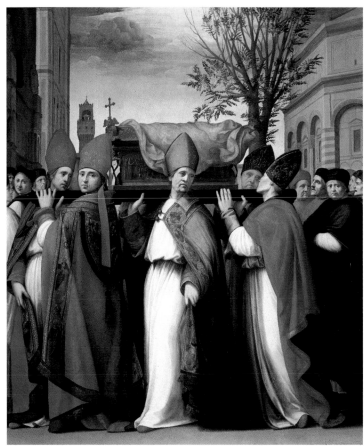

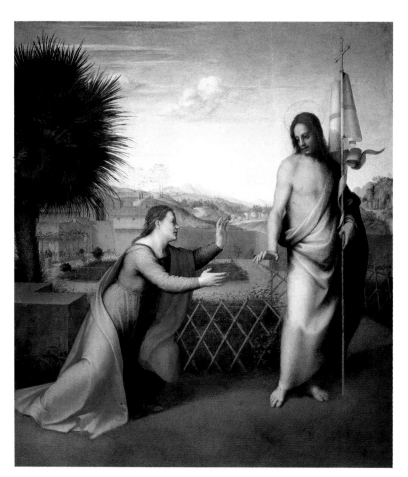

234
ANDREA DEL SARTO
Noli Me Tangere
Panel, 69⁵⁄₁₆ × 61 in. (176 × 155 cm)
Cenacolo di San Salvi; inv. 1890: no. 516
This altarpiece was executed in around 1509–1510 for the church of the Augustinian convent outside Porta San Gallo, perhaps as a commission for the Morelli family. After the Augustinian complex was destroyed during the siege in 1529, the painting was transferred to San Jacopo tra' Fossi, where it remained until the suppression of the church in 1849.

Opposite: 236 and 237
ANDREA DEL SARTO
A *Story from the Life of Joseph the Hebrew*
Panel, 38⁹⁄₁₆ × 53⅛ in. (98 × 135 cm)
Signed and initialed: ANDREA DEL SARTO FACIEBAT, with the artist's monogram (two intertwined *A*'s)
A *Story from the Life of Joseph the Hebrew*
Oil on panel, 38⁹⁄₁₆ × 53⅛ in. (98 × 135 cm)
Initialed with artist's monogram (two intertwined *A*'s)
Pitti, Palatine Gallery; inv. 1912: no. 88

These two panels, together with thirteen others executed by Granacci, Pontormo, and Bachiacca, made up the cycle of *Stories from the Life of Joseph the Hebrew* that decorated the bridal chamber of Pierfrancesco Borgherini and Margherita Acciaioli, who were married in 1515. The series was dismantled in 1584 on the orders of Francesco I de' Medici, who acquired the pair of panels by Andrea and another two by Granacci.

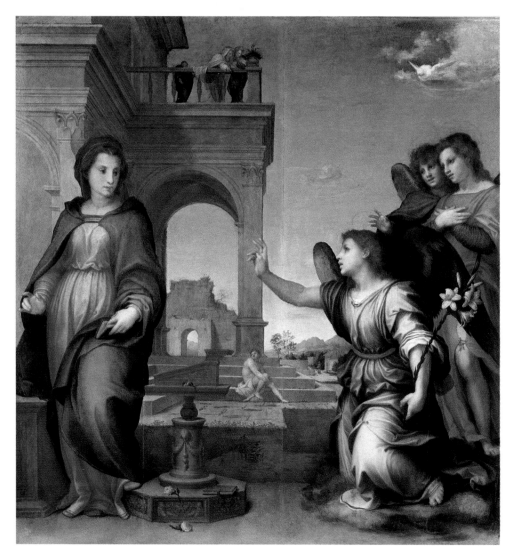

235
ANDREA DEL SARTO
The Annunciation
Oil on panel, 72¹³⁄₁₆ × 68¹¹⁄₁₆ in. (185 × 174.5 cm)
Signed: ANDREA DEL SARTO TA PINTA / QUI COME NEL COR TI PORTA / ET NON QUAL SEI MARIA / PER ISPAR / GER TUA GLORIA ET NON SUO NOME
Pitti, Palatine Gallery; inv. 1912: no. 124

Andrea completed this painting in around 1512 for Taddeo Da Castiglione's chapel in the convent outside Porta San Gallo. After the siege of 1529, the altarpiece was transferred to San Jacopo tra' Fossi, along with the *Noli Me Tangere* and the *Debate over the Trinity.* In 1627 Maria Maddalena of Austria, widow of Cosimo II de' Medici, requested the painting for her chapel in the Pitti Palace.

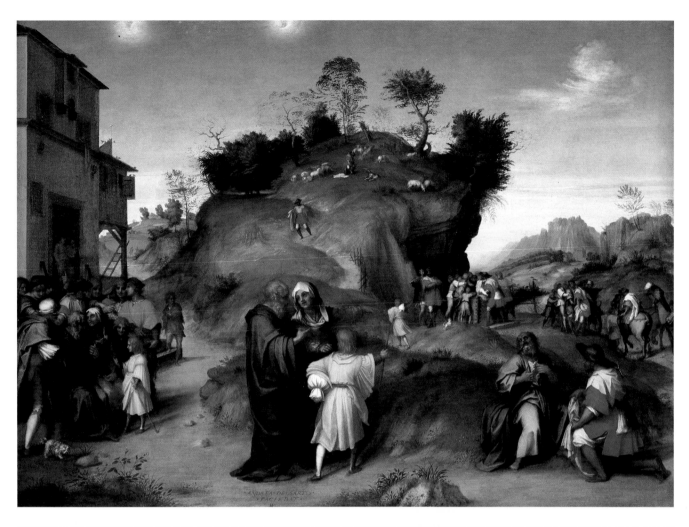

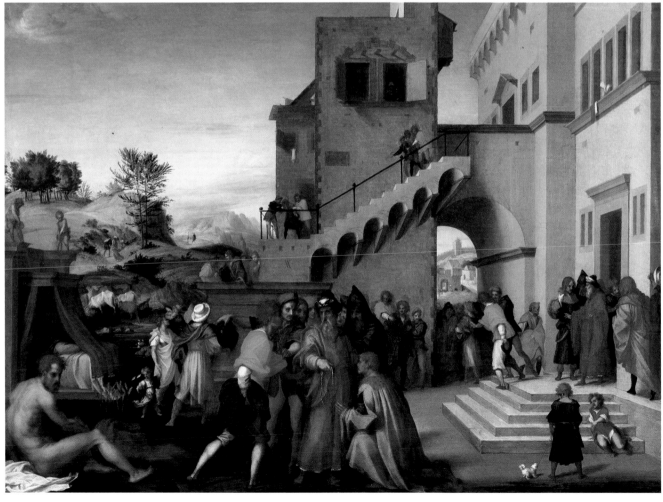

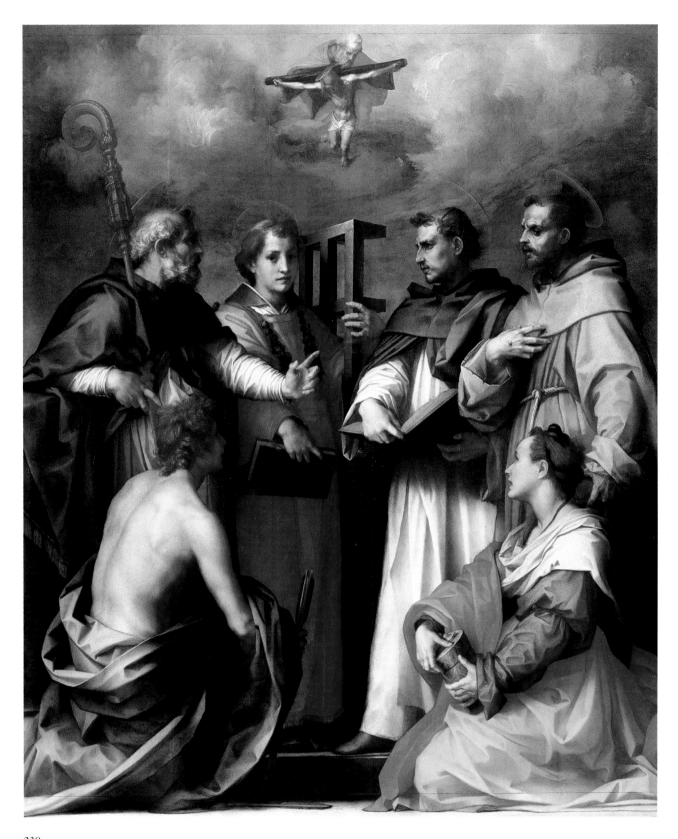

238
ANDREA DEL SARTO
The Debate over the Trinity
Oil on panel, 91⁵⁄₁₆ × 76 in. (232 × 193 cm)
Signed: AND. SAR. FLO. FAB.
Pitti, Palatine Gallery; inv. 1912: no. 172

This panel was painted in around 1517 for the Peri chapel in the Augustinian church of San Gallo. After the building was destroyed, in 1529–30, the painting was taken to San Jacopo tra' Fossi, where it remained until shortly before 1627, when Christine of Lorraine, widow of Ferdinand I, had it transferred to the Pitti Palace.

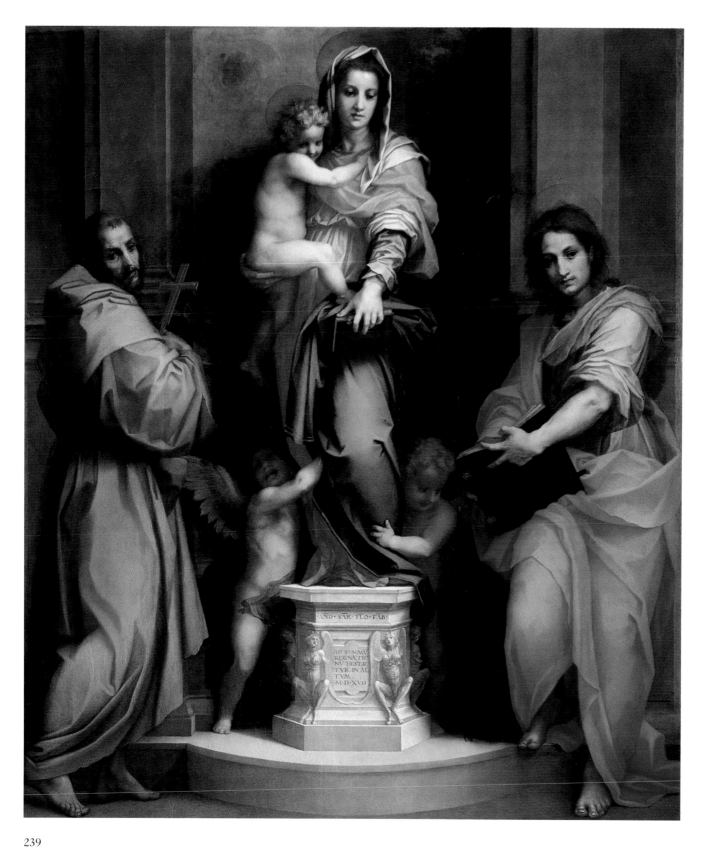

239

ANDREA DEL SARTO

Madonna and Child with SS. Francis and John the Baptist ("Madonna of the Harpies")

Oil on panel, 81½ × 70¹⁄₁₆ in. (207 × 178 cm)

Signed and dated: AND. SAR. FLO. FAB. / AD SUMMU / REG(I)NA TRO / NU DEFER / TUR
IN AL / TUM / MDXVII

Uffizi, Gallery; inv. 1890: no. 1577

Commissioned by the sisters of the Florentine convent of San Francesco de' Macci in
1515, this work was placed on the church's high altar after its completion in 1517. In 1704 it
was requested for the collection of Grand Prince Ferdinand de' Medici, who replaced it
with a copy by Francesco Petrucci.

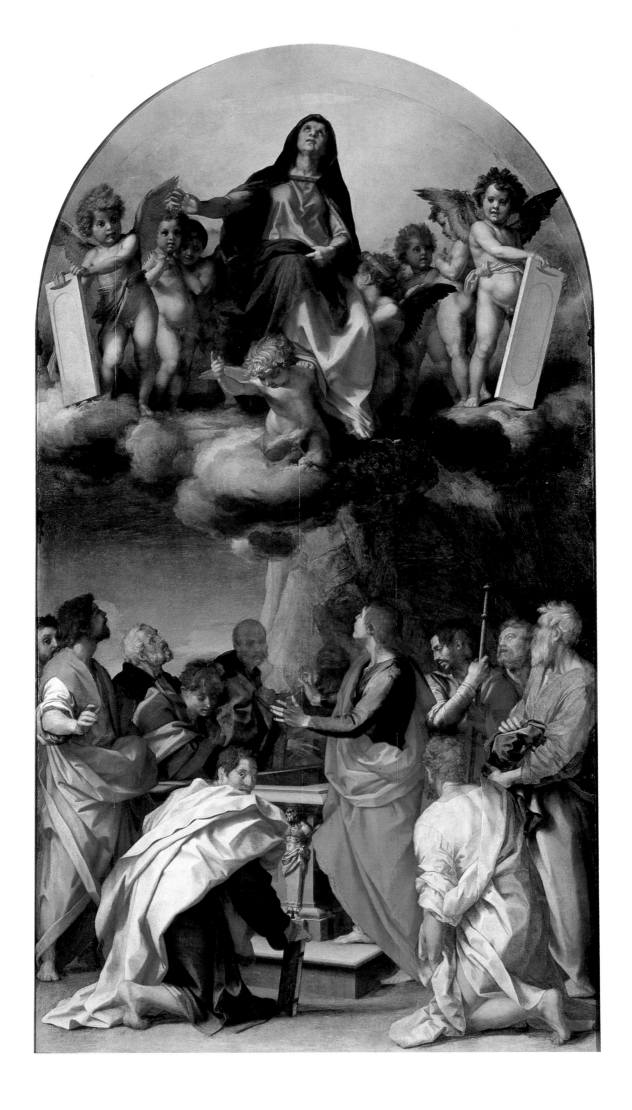

241
ANDREA DEL SARTO
The Young St. John
Panel, 37 × 26¾ in. (94 × 68 cm)
Pitti, Palatine Gallery; inv. 1912: no. 272

This painting was commissioned by Giovan Maria Benintendi, perhaps as a finishing touch for the antechamber decorations done for him by Franciabigio, Bachiacca, and Pontormo, which date from around 1523. Del Sarto's panel was given by Benintendi to Cosimo I de' Medici on December 30, 1553.

Opposite: 240
ANDREA DEL SARTO
Assumption of the Virgin with Saints
("Panciatichi Assumption")
Panel, 142½ × 82⁵⁄₁₆ in. (362 × 209 cm)
Pitti, Palatine Gallery; inv. 1912: no. 191

Bartolomeo Panciatichi commissioned this work from del Sarto, probably in around 1518, for the altar of the Madonna of the Rosary in the church of Nôtre-Dame du Confort in Lyons. Due to the dreadful condition of the support, however, the painting remained in Florence and was acquired, still incomplete, by Panciatichi's son, Bartolomeo the Younger. In 1602 the altarpiece came to the Medici collection, at the request of Archduchess Maria Maddalena of Austria, wife of Cosimo II.

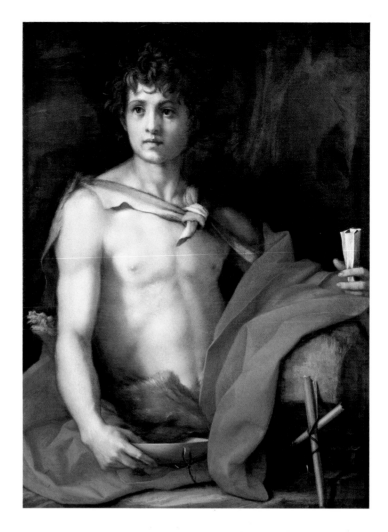

242
ANDREA DEL SARTO
SS. Michael the Archangel and John Gualbert (left panel)
SS. John the Baptist and Bernardo degli Uberti (right panel)
Panel, 72⁷⁄₁₆ × 33⅞ in. (184 × 86 cm) (each panel)
Dated: ANN. DOM. / MDXX / VIII
Uffizi, Gallery; inv. 1890: no. 8395

These two panels belonged to a series that made up the so-called *Vallombrosiana Altarpiece*, painted in 1528. The panels framed a sacred image of the Virgin in the church of Romitorio delle Celle in Vallombrosa, where they remained until 1810.

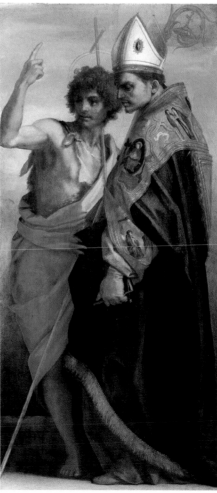

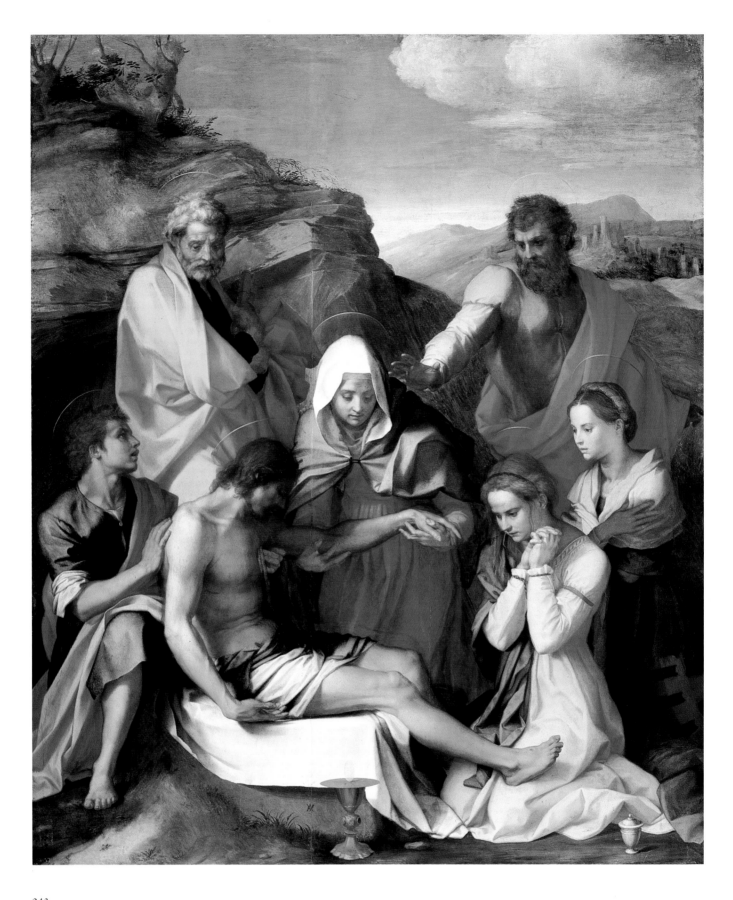

243
ANDREA DEL SARTO
Pietà with Saints ("Pietà of Luco")
Panel, 93⅞ × 78⅛ in. (238.5 × 198.5 cm)
Signed with the artist's monogram (two intertwined *A*'s)
Pitti, Palatine Gallery; inv. 1912: no. 58

After moving to Luco di Mugello in 1523 to escape the plague that had broken out in Florence,
Andrea executed this altarpiece for the high altar of the church of the town convent dedicated to
St. Peter. In 1782 the work was acquired by Grand Duke Pietro Leopoldo of Lorraine, who
exhibited it in the Tribune in the Uffizi and left a copy by Santi Pacini in its place.

244

ANDREA DEL SARTO

Madonna and Child with SS. Elizabeth and the Young John ("The Medici Holy Family")

Panel, 55⅛ × 40¹⁵⁄₁₆ in. (140 × 104 cm)

Pitti, Palatine Gallery; inv. 1912: no. 81

This painting was executed by Andrea toward the end of his life for Ottaviano de' Medici, his enthusiastic collector and patron. It was added to the grandducal collection sometime after 1589.

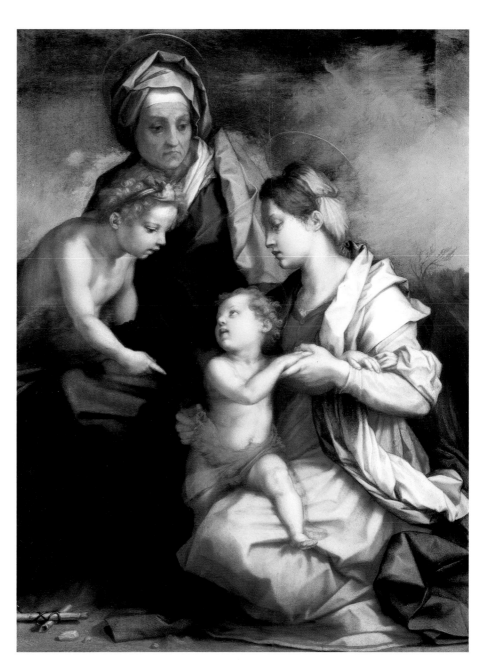

245

ANDREA DEL SARTO

The Annunciation

Oil on panel, 37¹³⁄₁₆ × 74⁷⁄₁₆ in. (96 × 189 cm)

Pitti, Palatine Gallery; inv. 1912: no. 163

Intended to hang over del Sarto's 1528 altarpiece of the *Madonna and Saints* for the church of San Francesco in Sarzana, this lunette instead remained in Florence, where in 1534 it was installed in the Scala chapel in the Santissima Annunziata. Fifty years later, Ferdinand de' Medici acquired it and sent it to the family villa in Rome; it was probably there that its crescent shape was elaborated into a rectangle. By 1723 the panel was back in Florence, in the Pitti Palace.

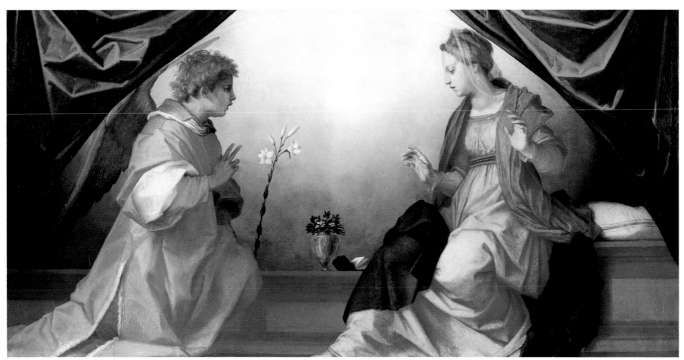

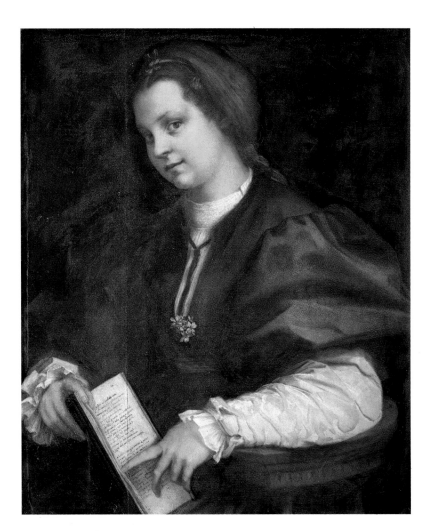

246
ANDREA DEL SARTO
Portrait of a Girl ("Lady with a Book of Petrarch")
Panel, 33¹⁄₁₆ × 27³⁄₁₆ in. (84 × 69 cm)
Uffizi, Gallery; inv. 1890: no. 783

The young subject of this portrait is holding a copy of
Petrarch's *Songs*, opened to the sonnets "Go Warm
Breath to the Cold Heart" (CLIII) and "The Stars,
the Sky and the Elements are Proof" (CLIV). The
painting, which dates from around 1528, was first
exhibited in the Tribune in 1589.

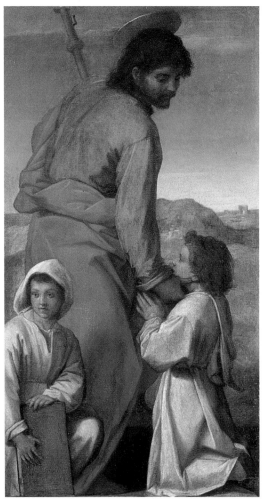

247
ANDREA DEL SARTO
St. James
Oil on canvas, 61³⁄₁₆ × 33¹¹⁄₁₆ in. (155.5 × 85.6 cm)
Uffizi, Gallery; inv. 1890: no. 1583

This work is a processional standard painted in around 1528 for the
Company of San Jacopo, called del Nicchio. After the confraternity
was suppressed, the canvas was transferred first to the Accademia
(in 1784) and then (in 1795) to the Uffizi.

196

248
FRANCIABIGIO
Portrait of a Young Man
Oil on panel, 22¹³⁄₁₆ × 17¹¹⁄₁₆ in. (58 × 45 cm)
Dated and signed: A.S. MDXIIII, with the artist's monogram (the
letters *F, R,* and *C* intertwined)
Uffizi, Gallery; inv. 1890: no. 8381

Dated 1514, this portrait recalls the Florentine compositions of
Raphael and Ridolfo Ghirlandaio. The formula of the parapet was
new to Florence and recalls Venetian examples of preceding years
by Lotto and Sebastiano del Piombo. The painting's provenance is
unknown.

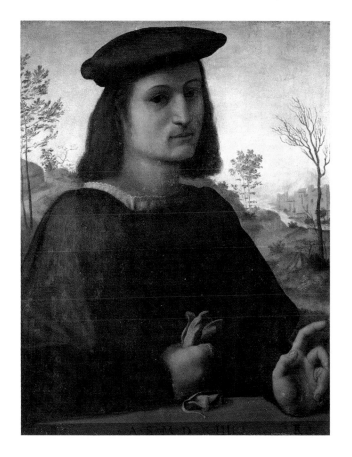

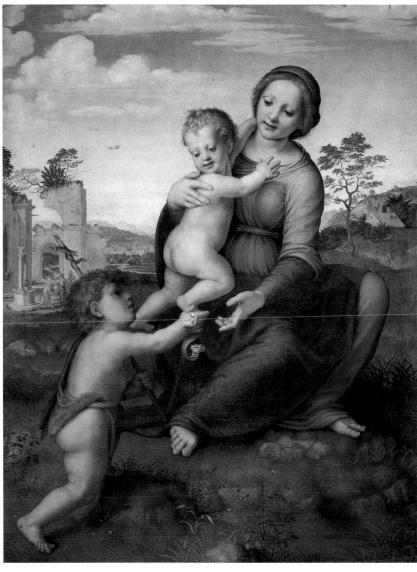

249
FRANCIABIGIO
Madonna and Child with the Young St. John
("Madonna of the Well")
Panel, 41¾ × 31⅞ in. (106 × 81 cm)
Uffizi, Gallery (Tribune); inv. 1890: no. 1445

This work may be identified as the one said by
Vasari to have been executed for a chapel in San
Pier Maggiore, later identified as that of the
Albizi family.

197

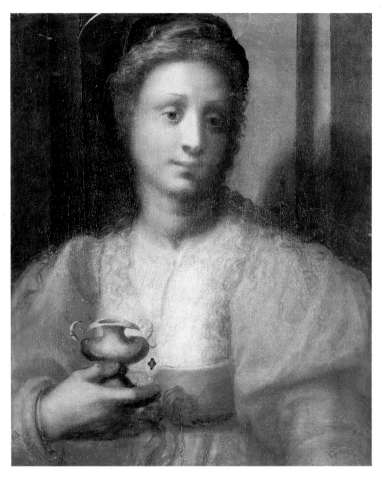

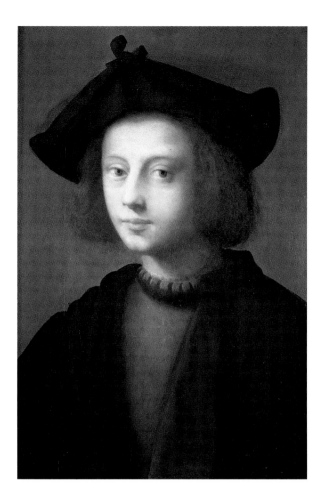

250
DOMENICO PULIGO
Portrait of a Woman Dressed as Mary Magdalen
Oil on panel, 24³⁄₁₆ × 20³⁄₁₆ in. (61.5 × 51.2 cm)
Pitti, Appartamenti Reali; inv. Ogg. d'Arte 1911: no. 770
This portrait dates from around 1525 and is related stylistically to the altarpiece of Santa Maria Maddalena de' Pazzi.

252 and 253
FRANCESCO GRANACCI
The Martyrdom of St. Apollonia
Oil on panel, 15¾ × 23¼ in. (40 × 59 cm)
Accademia, Gallery; inv. 1890: no. 8692
A Female Saint in Front of a Judge
Oil on panel, 15⅜ × 21¹¹⁄₁₆ in. (39 × 55 cm)
Accademia, Gallery; inv. 1890: no. 8694
These panels were two of eight that made up the predella of the altarpiece painted by Granacci for the high altar of the church of Sant'Apollonia.

251
DOMENICO PULIGO
Portrait of Piero Carnesecchi
Oil on panel, 23⁷⁄₁₆ × 15⁹⁄₁₆ in. (59.5 × 39.5 cm)
Uffizi, Gallery; inv. 1890: no. 1489
Vasari refers to this portrait in his painting of Carnesecchi's face in the frescoes decorating the Palazzo Vecchio room of Clement VII. Puligo probably painted it in 1527, when Carnesecchi, the Apostolic nuncio in Rome, returned to Florence. The work was in the Tribune between 1704 and 1769.

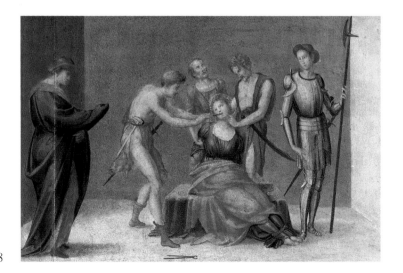

254
FRANCESCO GRANACCI
Madonna della Cintola
Panel, 118⅛ × 71¼ in. (300 × 181 cm)
Accademia, Gallery; inv. 1890: no. 1596
This work came from the church of San Pier
Maggiore in Florence.

255
FRANCESCO GRANACCI
Joseph Presents His Father and Brothers to Pharaoh
Oil on panel, 37⅜ × 88³⁄₁₆ in. (95 × 224 cm)
Uffizi, Gallery; inv. 1890: no. 2152
Granacci produced this panel along with the *Trinity*
now in Berlin (in the Staatliche Museen) and the
Uffizi's *Joseph Being Led to Prison,* for Pierfrancesco
Borgherini's bridal chamber, on the occasion of his
marriage in 1515. In 1584 the Granacci panels were
sold by Niccolò Borgherini to Francesco I de' Med-
ici, who displayed them in the Tribune.

256
BACHIACCA
The Baptism of St. Acacius and Company
St. Acacius Combats the Rebels with the Help of the Angels
The Martyrdom of St. Acacius and Company
Oil on panel, 14¾ × 100¹³⁄₁₆ in. (37.5 × 256 cm) (overall)
Uffizi, Gallery; inv. 1890: no. 877

This panel was the predella for Sogliani's *Altarpiece of the Martyrs*, completed in 1521 for the
church of San Salvatore dei Camaldoli and later transferred to San Lorenzo by Cosimo I.

257
BACHIACCA
The Deposition from the Cross
Oil on panel, 36⅝ × 27¹⁵⁄₁₆ in. (93 × 71 cm)
Uffizi, Gallery; inv. 1890: no. 511

Datable to 1520, the composition refers to a wax model by Jacopo Sansovino, which was copied a number of times in Florence. In 1628 the painting, which had been up to that time in the convent of Santa Maria degli Angeli, was transferred to Santa Maria Maddalena de' Pazzi, from which the Uffizi acquired it in 1867.

258
BACHIACCA
Mary Magdalen
Oil on panel, 20¹⁄₁₆ × 16⁹⁄₁₆ in. (51 × 42 cm)
Pitti, Palatine Gallery; inv. 1912: no. 102

It has been suggested that this painting, which is datable to around 1530, depicts Pentesilea, the Roman courtesan with whom Bachiacca had a relationship.

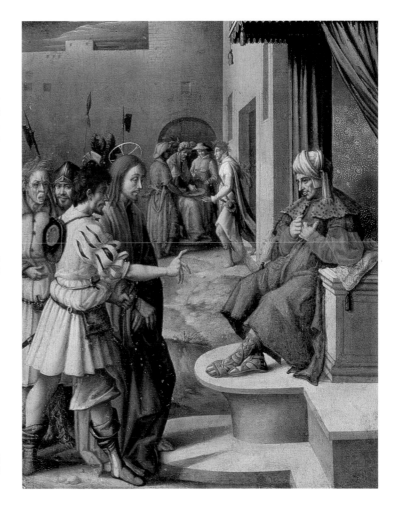

259
BACHIACCA
Christ before Caiaphas
Oil on panel, 19⅞ × 16⅛ in. (50.5 × 41 cm)
Uffizi, Gallery; inv. 1890: no. 8407

This work, which dates from around 1535–1540, is based on an engraving of the same subject by Dürer. The shouting figure at Christ's shoulder refers to a drawing by Buonarroti of the so-called *Damned Soul*.

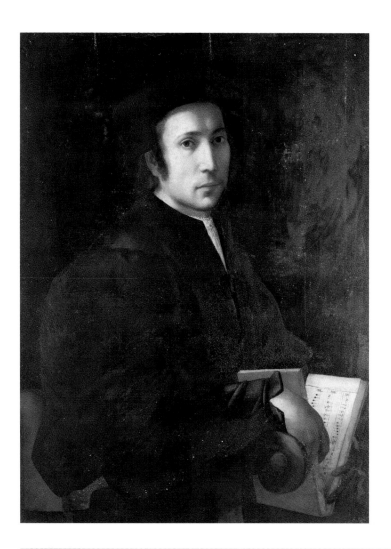

260
PONTORMO
Portrait of a Musician
Oil on panel, 34⅝ × 26⅜ in. (88 × 67 cm)
Uffizi, Gallery; inv. 1890: no. 743
This panel, which came from the collection of Cardinal Leopoldo de' Medici, seems to have been executed a little later than the 1518 *Pucci Altarpiece* in San Michele Visdomini. It is doubtful that the musician represented is Francesco dell'Ajolle, as indicated in old inventories.

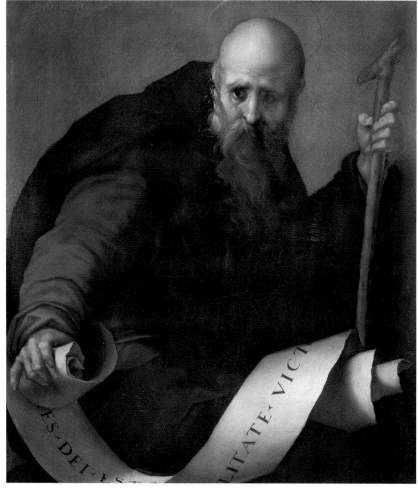

261
PONTORMO
St. Anthony Abbot
Oil on canvas, 30¹¹⁄₁₆ × 26 in. (78 × 66 cm)
Uffizi, Gallery; inv. 1890: no. 8379
This picture, whose provenance is unknown, is datable to the end of the second decade of the sixteenth century, based on its stylistic affinity with Pontormo's altarpiece in the church of San Michele Visdomini.

262
PONTORMO
The Fall of Adam and Eve
Oil on panel, 16¹⁵⁄₁₆ × 12³⁄₁₆ in. (43 × 31 cm)
Uffizi, Gallery; inv. 1890: no. 1517
The dating of this small painting is controversial. It can perhaps be placed around 1520, near the time of the execution of the frescoes at Poggio a Caiano. By 1632 the painting was in Don Antonio de' Medici's collection, already attributed to Pontormo.

263
PONTORMO
Madonna and Child with the Young St. John
Oil on panel, 35 × 29⅛ in. (89 × 74 cm)
Uffizi, Gallery; inv. 1890: no. 4347
Sometimes referred to as *Charity*, this panel was recognized by Gamba as being the work of Pontormo.

Opposite: 264
PONTORMO
The Supper at Emmaus
Oil on canvas, 90⁹⁄₁₆ × 68⅛ in. (230 × 173 cm)
Dated: MDXXV
Uffizi, Gallery; inv. 1890: no. 8740

Pontormo received payment for this altarpiece in 1525; he executed it for the monks at the Certosa del Galluzzo after he had finished frescoing the cloister.

265
PONTORMO
Martyrdom of St. Maurice and the Theban Legions
Oil on panel, 25⁹⁄₁₆ × 28¾ in. (65 × 73 cm)
Pitti, Palatine Gallery; inv. 1912: no. 182

Produced for the nuns of the Spedale degli Innocenti in around 1529–1530, this panel recalls the recent and dramatic siege of Florence by the imperial troops.

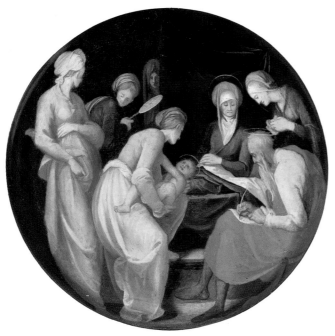

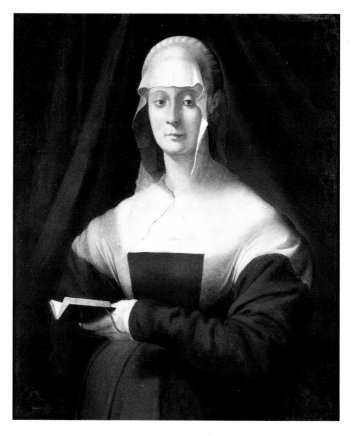

266
PONTORMO
The Birth of the Baptist (birth salver)
Oil on panel, 21¼ in. (54 cm) in diameter
Uffizi, Gallery; inv. 1890: no. 1532

On the reverse of this salver are depicted the arms of the Della Casa and Tornaquinci families. Probably commissioned on the occasion of the birth of the first son of Girolamo Della Casa and Lisabetta Tornaquinci, in 1526, the work has been in the Uffizi at least since 1704.

267
PONTORMO
Portrait of Maria Salviati
Oil on panel, 34¼ × 27¹⁵⁄₁₆ in. (87 × 71 cm)
Uffizi, Gallery; inv. 1890: no. 3565

The sitter in this portrait has been identified as the mother of Cosimo I de' Medici, whom, Vasari claimed, Pontormo painted sometime after 1537, the year in which Cosimo assumed control of the city. It was acquired for the Uffizi in 1911 from the Ciaccheri Bellanti family in Siena.

268
PONTORMO
The Adoration of the Magi
Oil on panel, 33⁷⁄₁₆ × 74¹³⁄₁₆ in. (85 × 190 cm)
Pitti, Palatine Gallery; inv. 1912: no. 379

It is probable that this is the painting Pontormo produced for Giovan Maria Benintendi's antechamber in around 1523, a project that Bachiacca and Franciabigio also participated in. The last figure on the left may be a self-portrait of the artist.

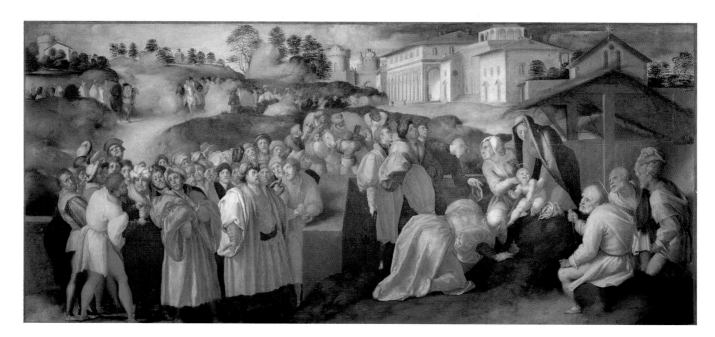

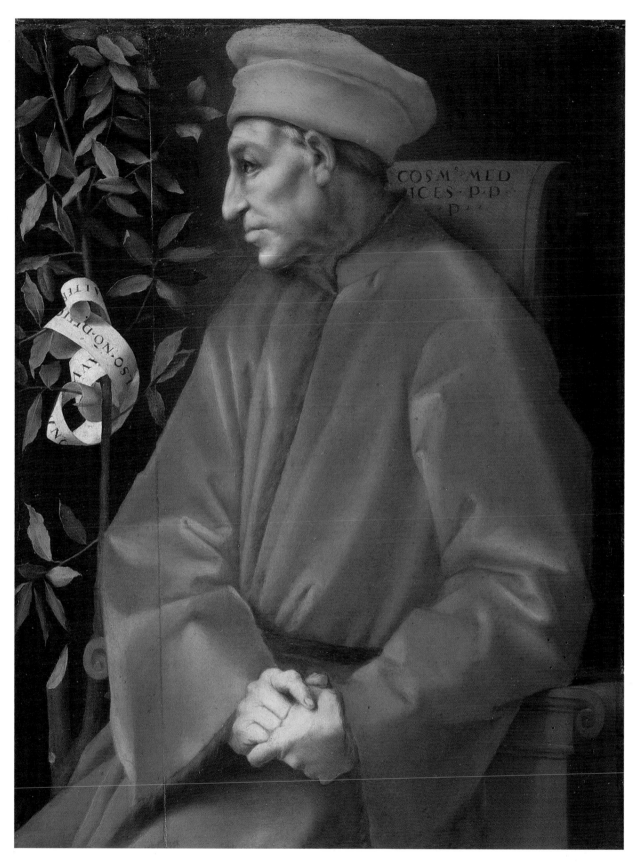

269
PONTORMO
Portrait of Cosimo il Vecchio
Oil on panel, 34¼ × 25⁹⁄₁₆ in. (87 × 65 cm)
Uffizi, Gallery; inv. 1890: no. 3574
This likeness was commissioned from the artist in 1519 by Goro
Gheri of Pistoia, secretary to Lorenzo de' Medici, duke of Urbino.

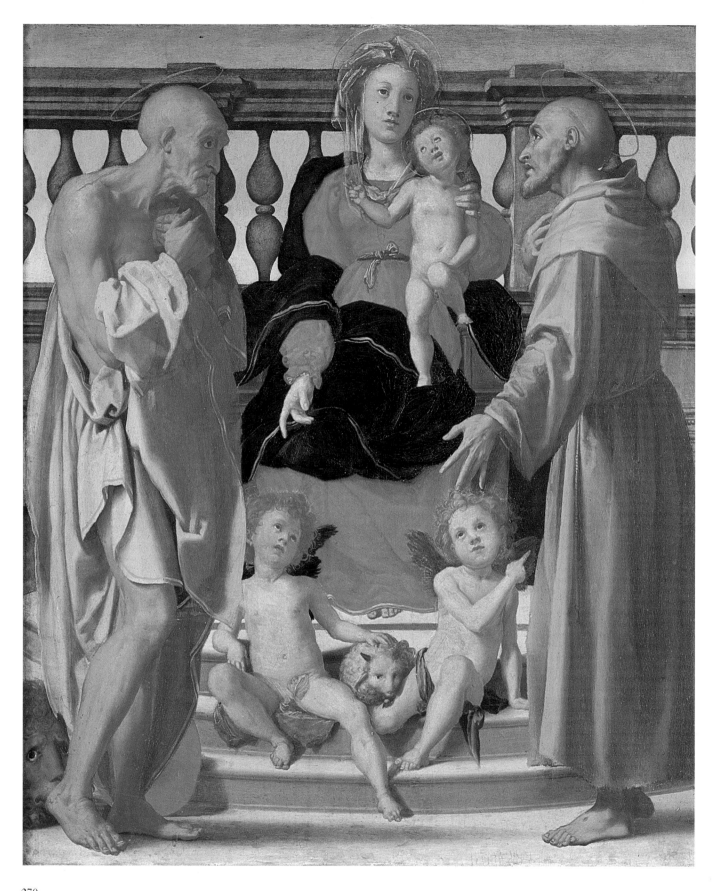

270
PONTORMO
Madonna and Child with SS. Jerome and Francis and Two Angels
Oil on panel, 28¾ × 24 in. (73 × 61 cm)
Uffizi, Gallery; inv. 1890: no. 1538
Scholars have suggested that Pontormo may have collaborated with the young
Bronzino on this painting, which reprises the scheme of a similar composition by Rosso
Fiorentino (to whom it was in fact once attributed). It came to the gallery from the
bequest of Cardinal Carlo de' Medici.

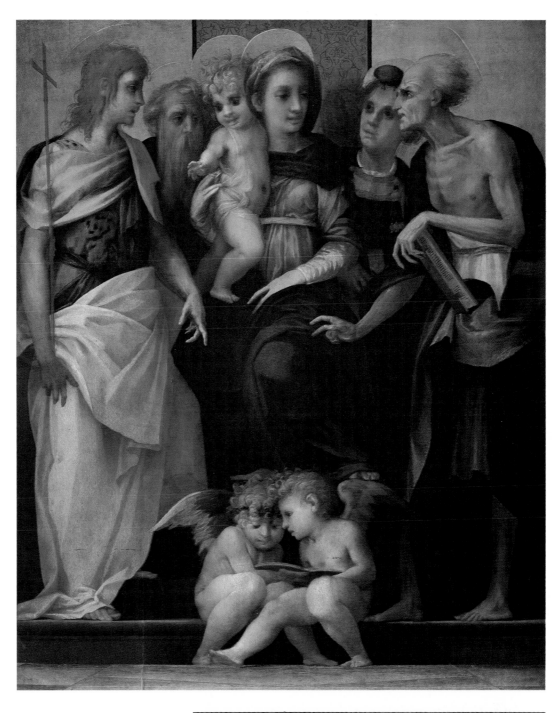

271

ROSSO FIORENTINO
Madonna Enthroned with SS. John the Baptist, Anthony Abbot,
Stephen, and Benedict ("Altarpiece of Santa Maria Nuova")
Panel, 67¹¹⁄₁₆ × 55½ in. (172 × 141 cm)
Uffizi, Gallery; inv. 1890: no. 3190

This altarpiece was commissioned in 1518 by Leonardo Buonafede,
director of Santa Maria Nuova, for the church of Ognissanti. The
work did not please Buonafede and so remained at Santa Maria
Nuova.

272

ROSSO FIORENTINO
Angel Musician
Panel, 15⅜ × 18½ in. (39 × 47 cm)
Uffizi, Gallery; inv. 1890: no. 1505

This panel is a fragment of an altarpiece in which the angel ap-
peared at the feet of the saints surrounding the Virgin, as in contem-
porary examples by Raphael and Fra Bartolomeo. Executed in
around 1521–1524, its dark background was added sometime in the
seventeenth century.

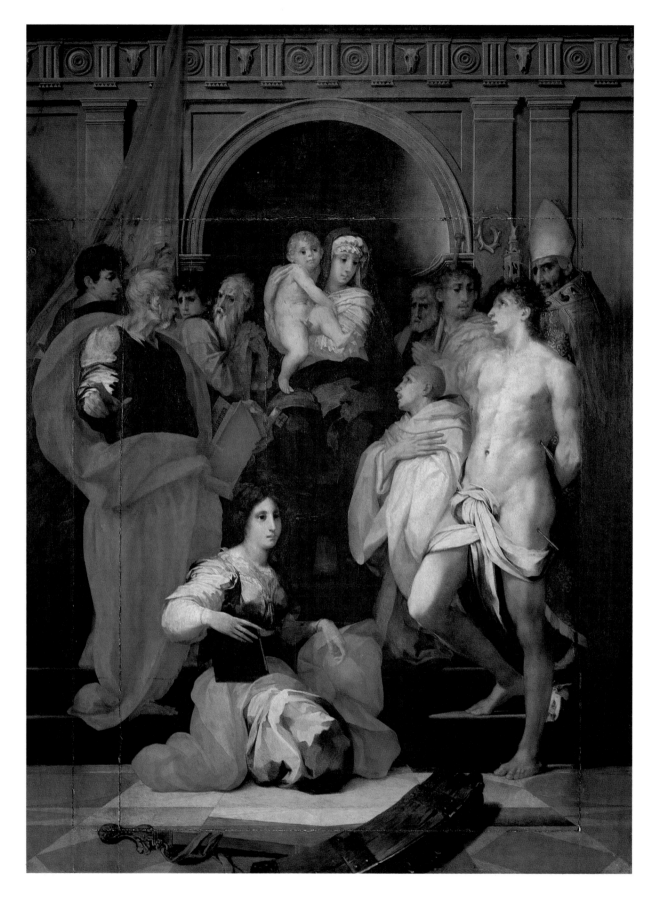

273
ROSSO FIORENTINO
Madonna Enthroned with Ten Saints ("Dei Altarpiece")
Panel, 137¹³⁄₁₆ × 102 in. (350 × 259 cm)
(originally 98⁷⁄₁₆ × 82¹¹⁄₁₆ in. [250 × 210 cm])
Signed and dated: RUBEUS FAC. MDXXII
Pitti, Palatine Gallery; inv. 1912: no. 237
Signed and dated 1522, this altarpiece was commissioned by the Dei family for Santo
Spirito. Grand Prince Ferdinand had it transferred to the Pitti Palace in 1691.

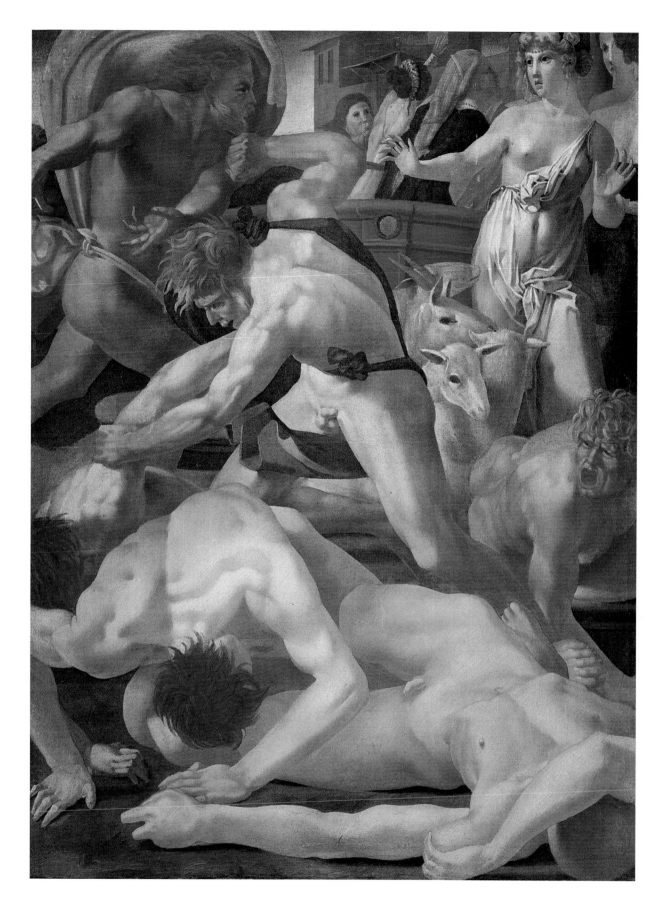

274
ROSSO FIORENTINO
Moses Defending the Daughters of Jethro
Oil on canvas, 63 × 46¹⁄₁₆ in. (160 × 117 cm)
Uffizi, Gallery; inv. 1890: no. 2151

This is thought to be the "story of Moses" that Vasari said Rosso painted for Giovanni Bandini. Painted late in the artist's Florentine period or early in his Roman phase, it came to the Medici collection in 1632 as part of Don Antonio de' Medici's legacy.

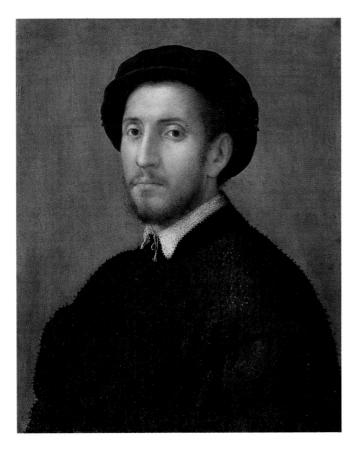

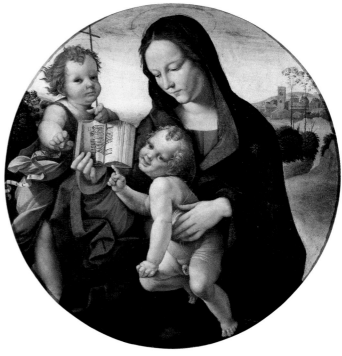

275

PIERFRANCESCO FOSCHI
Portrait of a Man
Oil on panel, 25⅝ × 19¹¹⁄₁₆ in.
(65 × 50 cm)
Uffizi, Gallery; inv. 1890: no.
1483

This painting has very close ties
to some of Pontormo's works,
such as the Uffizi's *Portrait of a
Musician*. Based on its affinities
with Foschi's Santo Spirito al-
tarpiece, it can be dated to
around the 1530s.

276

GIROLAMO DEL PACCHIA
Madonna and Child with the Young St. John
Panel, 35¹⁄₁₆ in. (89 cm) in diameter
Accademia, Gallery; inv. 1890: no. 3441

This tondo, which is close in style to the *Coronation* in Santo Spirito
in Siena, dates from around 1515.

277

BECCAFUMI
*The Holy Family with the Young St.
John*
Oil on panel, 32¾ in. (84 cm) in
diameter
Uffizi, Gallery; inv. 1890: no. 780

This painting usually has been
dated to around 1514–1515 or far-
ther toward the end of that decade.
In 1624 it was cited for the first time
in an inventory of the Medici
Guardaroba.

Florence from 1530 to 1600

In 1555 the decoration of the new quarters of the Palazzo Ducale (now called the Palazzo Vecchio), under the direction of Vasari and on the orders of Cosimo I, gave many young Florentine painters an opportunity either to collaborate on or to watch the progress of the project, and to see the important fresco cycles there. Not many years earlier, Bronzino had finished work on the chapel of Eleonora of Toledo (1540–1543), and Salviati had completed the Sala delle Udienze (1543–1545).

By the time he received the commission for Eleonora of Toledo's chapel, Bronzino was already the house portraitist for the Medici and for some of the most important other families of Florence. An active participant in the city's intellectual ambience, he was sought out for his ability to represent the social and cultural status of his patrons in highly glazed paintings that were splendid in their chromatic accord, realistic in their recording of significant details such as fabrics and precious stones, and attentive in their choice of attributes to be depicted, all combined in a clear and idealistic design. The *Stories of Moses*, frescoed in Eleonora's chapel, united to these characteristics an exemplary study of human figures, taken from what were by then canonized sources: Michelangelo and ancient statues. The figures of the saints in the vaults set an example for those young painters who had an interest in nature, including Mirabello Cavalori, Girolamo Macchietti, and Santi di Tito, but Bronzino's real artistic heir was Alessandro Allori, who maintained his master's workshop, with the highest standards, from 1572 until the early years of the seventeenth century.

If Bronzino's frescoes constituted a model for how the human figure should be understood, Salviati's cycle, of which Vasari wrote in the second edition of his *Lives* (1568), was admirable for the richness of its inventiveness: "[the] narrative is quite beautiful, richly endowed with figures, towns, elements from antiquity, beautiful vessels of different sorts finished in gold and silver." Salviati remained in Florence until 1548, and during that time his fusion of elements from Roman painting with aspects of Emilian mannerism gave young artists an alternative to the style of Vasari, one that was less indulgent to the elegance of form and color.

Until his death in 1574, Vasari was the major artistic influence on young Florentine painters of the day. He was the favorite artist of Cosimo I, who found him to be the perfect interpreter of his own conception of art, and well able to celebrate the Medici power. A fast and efficient organizer, Vasari was put in charge of the major artistic projects in the city—often as both architect and painter, as with the Palazzo Vecchio and the renovation of the churches of Santa Croce and Santa Maria Novella (from 1565).

In the Palazzo Vecchio it is often difficult to distinguish the different hands of the painters who were hired to do the decoration. Vasari delegated the major part of the actual painting to others, though the ideas—the drawings and cartoons—were his own, and he occasionally intervened to maintain a uniformity of style. Among his collaborators were Doceno, Giovanni Stradano, Marco da Faenza, Jacopo Zucchi, Giambattista Naldini, and Michele Tosini.

Today Tosini is almost forgotten, despite the important role he played in Florentine painting in the middle of the sixteenth century. In a letter of 1565, written by Vincenzo Borghini, director of the Spedale degli Innocenti, to Cosimo I, we read that Tosini's workshop was as important as the better-known shops of Bronzino and Vasari. This high regard on the part of Tosini's contemporaries corresponds precisely with the reason for his subsequent anonymity: his works, many of which are often confused with those of his pupils, consist largely of religious paintings constructed around traditional plans, simple compositions that would meet the needs of convents, confraternities, and parishes whose aesthetic tastes were somewhat conservative.

This rather archaic artistic production takes on a particular importance in light of the debate over the cult of images initiated by the Protestants. The principal argument on the part of the Catholics—that the function of painting was didactic and educational—was codified in a decree by the Council of Trent (1563), which, if it was not accompanied by a proposal for the reform of artistic methods, did add a critical reflection on contemporary painting: it became clear to certain segments of the Church that many aspects of art (today defined as "manneristic") could inspire false ideas and impure thoughts in the minds of the faithful. The debate on images and the Tridentine decree did not impose solutions, nor did they provoke sudden changes in artistic taste, but they did have an impact on the crisis of "mannerism." In this context, the paintings of Michele Tosini satisfied patrons who did not approve of the current mode of painting, even as they served as a reference point for artists who wanted to find an alternative language to Vasari's, one that was perhaps nearer to the tastes of the Church.

During the 1560s a number of painters of the generation that succeeded Vasari and Bronzino demonstrated their wish to dispense with the examples of their masters and to look for new models; these were the young artists described by Vincenzo Borghini in the letter of 1565 as "valiant and proud," clever and independent, who were not influenced by just one workshop or one master. The most famous were Maso da San Friano, Mirabello Cavalori, Girolamo Macchietti, and Santi di Tito. They all looked to artists of the first decades of the sixteenth century, but each chose a different model (from Pontormo—whose works were seen as bizarre and obsolete in those years—to Rosso, Andrea del Sarto, Sogliani, and Fra Bartolomeo) and different methods—without, however, renouncing certain aspects of mannerism. For Macchietti it was the Emilian example of Parmigianino that was important: he discarded the more affected elements of Parmigianino's style and revived his naturalistic composition and lighting effects in a new context. More significant to Santi di Tito were the Florentine precedents of Ghirlandaio and Sogliani and the Roman work

of Taddeo Zuccari. It is difficult to establish whether or not these artists, in the early years of their training, were actively interested in the problems concerning sacred images. It would be simplistic to claim that there was an anti-Vasari aspect to their work, or to see in their rediscovery of the painting style of the early sixteenth century—which was, after all, a matter of taste—nothing more or less than a desire for the reform of holy painting; but for certain individuals, biographical details nonetheless suggest that this may have been the case. Santi di Tito, for example, is known to have been a member of the congregation of St. Thomas Aquinas, which was inspired by the Counter-Reformation spirituality of St. Philip Neri. His paintings, though lacking in any true virtuosity, adhere to the biblical text, and are significant for the development of seventeenth-century Florentine painting in their rich observation of nature; they may be regarded as a tentative reform of "mannerism" and from the 1570s, they offered a genuine alternative to that style of painting.

In around 1570, the last important collective "mannerist" project was conceived in Florence; this was the decoration of Francesco de' Medici's *studiolo* ("little studio") or, in sixteenth-century terms, the *stanzino* ("little room"). In this small chamber with no natural light, according to the tradition of the *studiolo,* the cupboards, the walls, and the ceiling were entirely covered with paintings. These works were all somehow related to Francesco's cabinets of "marvels" and in keeping with the theme of the relationship between art and nature, following a plan devised by Vincenzo Borghini and based on mnemonic criteria. The paintings were produced mainly by artists of the current generation, with the exception of the older Carlo Portelli and Vasari, who once again directed the work. The greater part of the work was done by Francesco Morandini da Poppi, to whom Vasari assigned not only two oil paintings (almost all of them were painted in that medium) but also the frescoing of the vaults, since he considered Morandini to be the most faithful interpreter of Vasari's own style. The "valiant and proud" also distinguished themselves in the *studiolo,* Maso, Macchietti, and Cavalori all producing elegantly simple compositions. Particularly successful was Cavalori's synthesis of artistic elements taken from the work of Andrea del Sarto and Pontormo, as well as from contemporary Venetian painting. Santi di Tito's naturalism, based on the exercise of drawing from life and filtered through models from the early 1500s, had already achieved a quality that would be rediscovered by Florentine painting at the end of the century. Also worthy of mention are the refined nocturnal oval by Alessandro Allori, clearly influenced by Venetian developments; the miniaturistic depiction of an alchemist's workshop by the Fleming Giovanni Stradano, who had been in Florence since 1545; and the almost anamorphic and wholly manneristic landscape painted by the young Zucchi just before his departure for Rome, where he was to become the favorite artist of Ferdinand de' Medici (who was at the time a cardinal), one of the most accomplished interpreters of the international tendencies of late mannerism.

In the first half of the 1570s there was a change in the artistic environment. Between 1572 and 1574, Bronzino, Vasari, and Cosimo de' Medici all died. Francesco I favored Alessandro Allori and other painters who knew how to satisfy his refined taste, his demand for an elegant line, and his liking for representations of the human figure, for the layering of smooth color and the realistic description of materials, of objects, of interiors. Francesco hired Allori to decorate the eastern corridor of the Uffizi, where the assembled paintings and sculptures constituted a true and proper museum, the first nucleus of the present collection. In 1584 Francesco authorized work to begin on the room that was destined to house his own collection, the Tribune. Ferdinand, grand duke since 1587, continued to add to the collection of antiquities and precious objects in the upper rooms of the Uffizi, concluded the systematic reorganization of the Tribune, and arranged for the transfer in the west corridor of the workshops where distillates and precious objects were produced. (These latter had already been located in Francesco I's Casino of San Marco.)

Francesco's decision in 1575 to summon a "foreign" painter, Federico Zuccari, to complete the decoration of the cupola of Santa Maria del Fiore, which had been left unfinished on Vasari's death, demonstrated just how out-of-date Cosimo's taste had become. The new possibilities implicit in Zuccari's quick and impressionistic manner of painting, quite different from customary Florentine methods, were understood only by the youngest painters who, in the course of a few decades, would decree a new artistic movement in Florence.

The 1570s also brought changes to the Florentine church. In 1574 the Provincial Synod of the Bishops officially recommended that "unusual" paintings or works "painted in an unusual manner," containing undignified, profane, or offensive elements, be banned from sacred and public places and replaced with works that were respectful of traditional iconography and capable of inspiring devotion. This suggestion, which met with no immediate reaction, would ultimately help to propel Florentine painting in a largely narrative and naturalistic direction. However, more than by the directives of the bishops, the change in taste delineated during the 1570s and 1580s was determined by the artistic preferences of Francesco I. The few works in Florence in the 1570s by Santi di Tito and Girolamo Macchietti (who seems to have been searching in this period for solutions charged with an intense mysticism) demonstrate that there was as yet no general interest in a "Counter-Reformation" art.

The middle of the 1580s saw the beginning of a new collective project, the decoration of the large cloister at Santa Maria Novella. This effort signaled not only the entrance onto the scene of a new generation of artists— among them Poccetti, who was more and more often engaged in decorative undertakings of vast proportions; Passignano, who had helped Zuccari on the scaffolding of the cupola in Santa Maria del Fiore; and Cigoli and Pagani, pupils of Santi di Tito—but also the definitive defeat, within the context of sacred painting, of the most

typical aspects of mannerism. It marked, too, the introductory levels of narrative register that recalled the work of Andrea del Sarto and the more recent example of Santi di Tito. Some of the "painters of the *studiolo*" continued to work up until the first years of the seventeenth century; with the beginning of their pupils' activity, a new, modern course was charted for Florentine painting.

Marta Privitera

278
GIORGIO VASARI
The Immaculate Conception
Oil on panel, 22¹³/₁₆ × 15¾ in. (58 × 40 cm)
Uffizi, Gallery; inv. 1890: no. 1524
This small-scale replica of a larger *Immaculate Conception* was executed in 1541 for Bindo Altoviti. The full-size work, commissioned by the same patron for his chapel in the church of Santi Apostoli, is iconographically innovative.

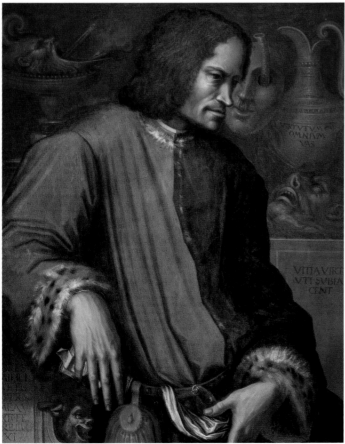

279
GIORGIO VASARI
Portrait of Alessandro de' Medici
Oil on panel, 61¹³⁄₁₆ × 44⅞ in. (157 × 114 cm)
Uffizi, Depository; inv. 1890: no. 1563
Commissioned, together with the portrait of Lorenzo, by Ottaviano de' Medici in 1534, this panel was inspired by Michelangelo's statue of Giuliano di Nemours.

280
GIORGIO VASARI
The Temptation of St. Jerome
Oil on panel, 66⁹⁄₁₆ × 48⁷⁄₁₆ in. (169 × 123 cm)
Pitti, Palatine Gallery; inv. 1912: no. 393
The patron of this panel is unknown. In 1541 Ottaviano de' Medici commissioned a work of the same subject from Vasari, who later reproduced it for Tommaso Cambi (1545) and the bishop of Pavia, de' Rossi (1547); there exist, in addition, three replicas with slight variations. The version owned by the Medici is documented from 1649.

281
GIORGIO VASARI
Portrait of Lorenzo the Magnificent
Oil on panel, 35⁷⁄₁₆ × 28⅜ in. (90 × 72 cm)
Uffizi, Gallery; inv. 1890: no. 1578
Commissioned in 1534 by Ottaviano de' Medici, this painting was hung as a pendant to Pontormo's portrait of Cosimo the Elder.

282
FRANCESCO SALVIATI
The Adoration of the Shepherds
Oil on panel, 33⁷⁄₁₆ × 42½ in. (85 × 108 cm)
Uffizi, Gallery; inv. 1912: no. 114

Attributed to Salviati at the beginning of our own century and dated to the early 1540s, this picture was first listed among the holdings of the Pitti Palace, where it was thought to be the work of Jacopo Bassano.

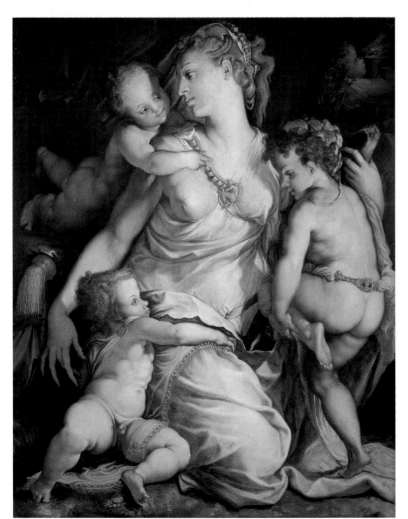

283
FRANCESCO SALVIATI
Portrait of a Gentleman with a Letter
Oil on panel, 39⅜ × 30⁵⁄₁₆ in. (100 × 77 cm)
Uffizi, Depository; inv. 1890: no. 1581
The attribution of this portrait to Salviati is prompted by an inscription in old handwriting on the back. It was perhaps painted toward the beginning of Salviati's stay in Florence, after 1543.

284
FRANCESCO SALVIATI
The Deposition
Oil on panel, 30⁵⁄₁₆ × 20⅞ in. (77 × 53 cm)
Pitti, Palatine Gallery; inv. 1912: no. 115
Probably executed during one of Salviati's last visits to Florence, this work came to the gallery in 1743 from the chapel of the Palazzo Ricasoli. Vasari mentions a *Pietà* painted on a silver cloth for Jacopo Salviati.

285
FRANCESCO SALVIATI
Charity
Oil on panel, 61⁷⁄₁₆ × 48¹⁄₁₆ in. (156 × 122 cm)
Uffizi, Gallery; inv. 1890: no. 2157
This painting dates from Salviati's sojourn in Florence during 1548. Vasari describes a *Charity* painted for Ridolfo Landi and an *Our Lady* (identified by Borghini as another *Charity*) done for Cristofano Ranieri and later exhibited in the Ufficio della Decima.

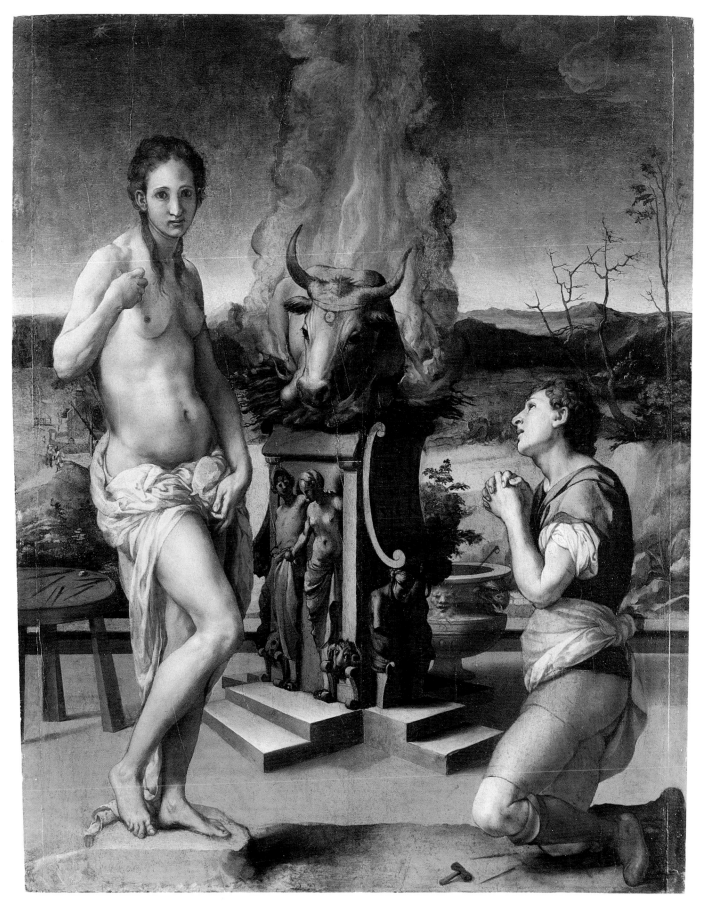

286

BRONZINO

Pygmalion and Galatea

Oil on panel, 31⅞ × 25³⁄₁₆ in. (81 × 64 cm)

Uffizi, Gallery; inv. 1890: no. 9933

Bronzino painted this cover for Francesco Guardi's portrait, which was executed by Pontormo between 1529 and 1530. The subject is derived from Ovid's *Metamorphoses*.

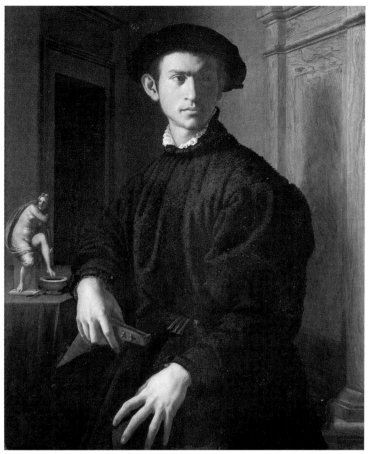

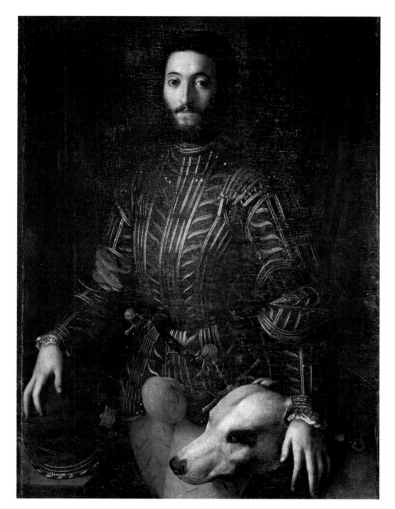

287
BRONZINO
Portrait of a Young Man with a Lute
Oil on panel, 380⁹⁄₁₆ × 32½ in. (98 × 82.5 cm)
Uffizi, Gallery; inv. 1890: no. 1575

The painting, executed during Bronzino's stay in the Marches
(1530–1532) or in the years following, is the only work by the artist
for which a preparatory drawing has survived (Chatsworth).

288
BRONZINO
Portrait of Guidubaldo della Rovere
Oil on panel, 44⁷⁄₁₆ × 33 ⅞ in. (114 × 86 cm)
Pitti, Palatine Gallery; inv. 1912: no. 149

Executed in Urbino between 1531 and 1532, this was Bronzino's first
important portrait.

Opposite: 289
BRONZINO
The Holy Family
Oil on panel, 46¹⁄₁₆ × 35¼ in. (117 × 89.5 cm)
Signed: BRONZO FIORE(N)T
Uffizi, Gallery; inv. 1890: no. 8377

This panel was painted, probably in the mid-1530s, for Bartolomeo
Panciatichi (Vasari). The Panciatichi coat of arms can be seen on the
fluttering banner atop the tower in the background.

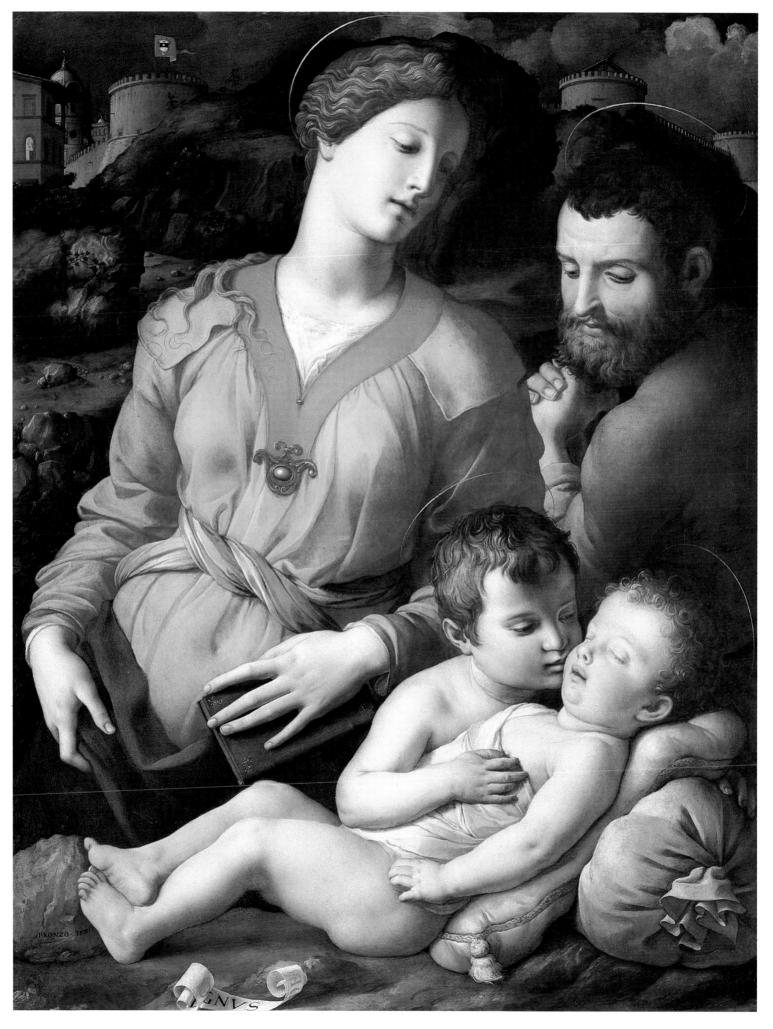

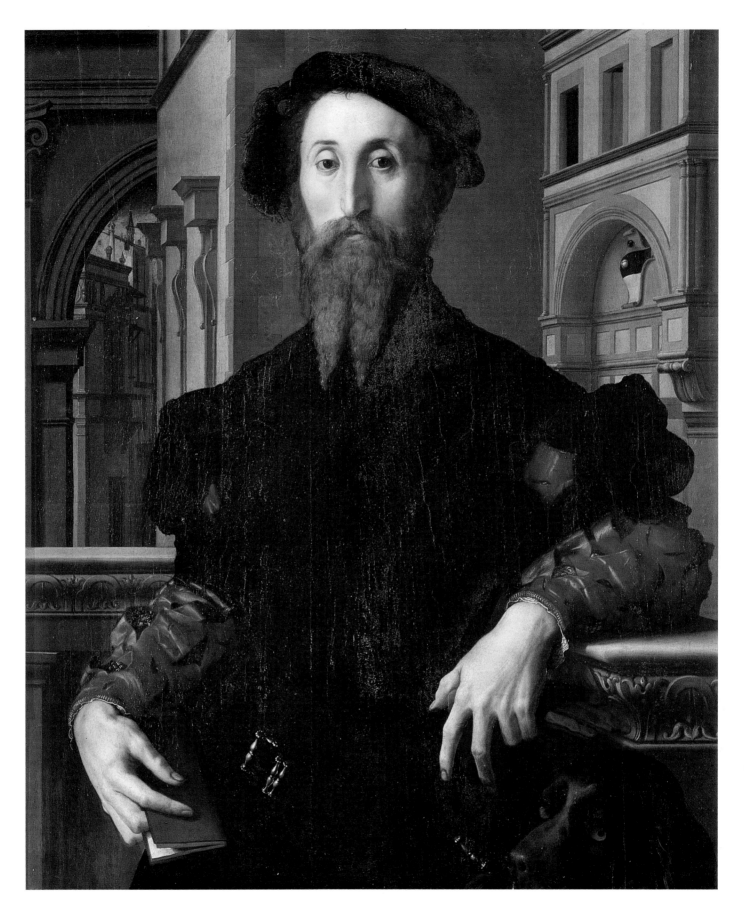

290

BRONZINO

Portrait of Bartolomeo Panciatichi

Oil on panel, 40¹⁵⁄₁₆ × 33⁷⁄₁₆ in. (104 × 85 cm)

Uffizi, Gallery; inv. 1890: no. 741

Vasari and Borghini (writing in 1584) recorded this picture in the Panciatichi house, along with the matching portrait of Bartolomeo's wife, Lucrezia. Panciatichi is shown holding a book, in front of a palace emblazoned with his family's coat of arms (the family was originally from Pistoia). The work dates from around 1540.

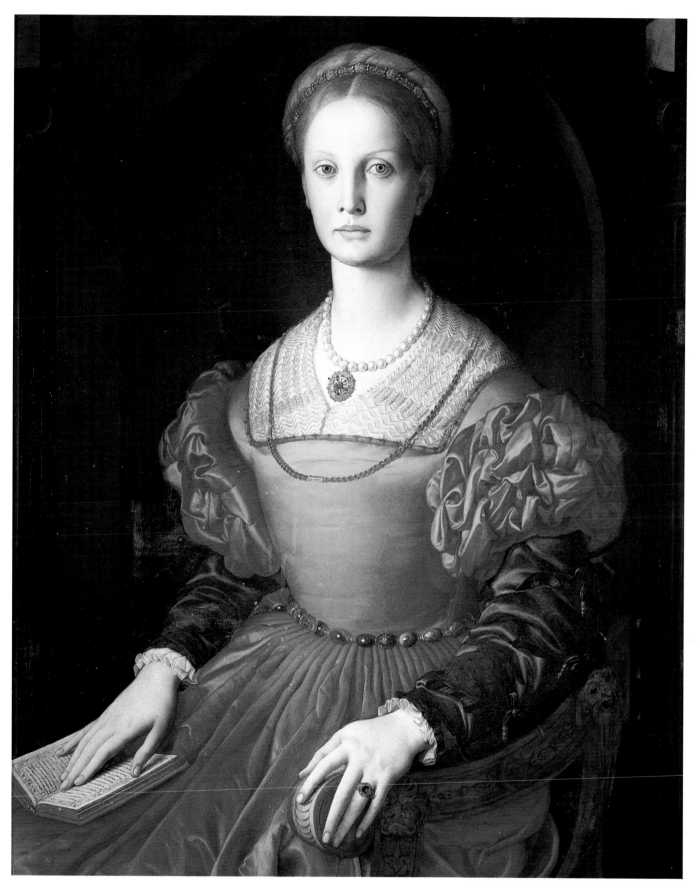

291

BRONZINO

Portrait of Lucrezia Pucci Panciatichi

Oil on panel, 39¾ × 32⅝ in. (101 × 82.8 cm)

Signed (on the back of the chair): BRONZO FIORENTINO

Uffizi, Gallery; inv. 1890: no. 736

In this portrait—noted by Vasari and Borghini (in 1584) in the Panciatichi house, together with Bronzino's likeness of her husband, Bartolomeo—Lucrezia rests her hand on a book of poetry and wears a necklace inscribed *Amour dure sans fin* ("Love lasts forever"). Like its pendant, this work is datable to around 1540.

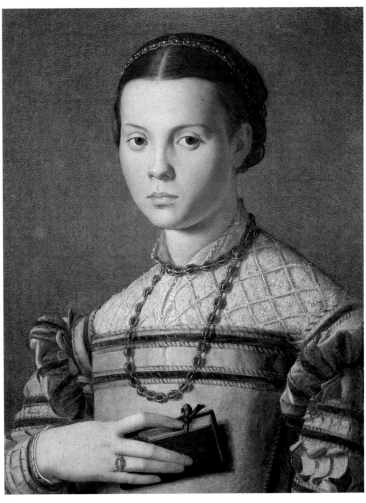

292
BRONZINO
Portrait of a Little Girl with a Book
Oil on panel, 22¹³⁄₁₆ × 18⁵⁄₁₆ in. (58 × 46.5 cm)
Uffizi, Gallery; inv. 1890: no. 770

The provenance of this painting is unknown, but its stylistic similarities to the same artist's portraits of *Bia* (Uffizi, c. 1541) and *Eleonora* (1545; National Gallery, Prague) suggest that it was produced in around 1545.

293
BRONZINO
Portrait of Bia
Oil on panel, 24¹³⁄₁₆ × 18⅞ in. (63 × 48 cm)
Uffizi, Gallery; inv. 1890: no. 1472

Prevalent opinion has it that this is Bia, Cosimo's illegitimate daughter, who died in 1542 at age five and whose portrait was painted in the last year of her life. The medallion she wears is stamped with Cosimo's profile.

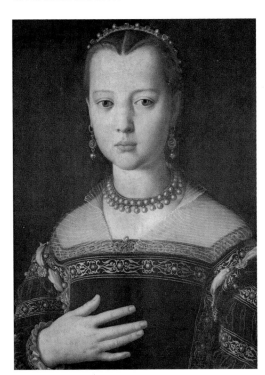

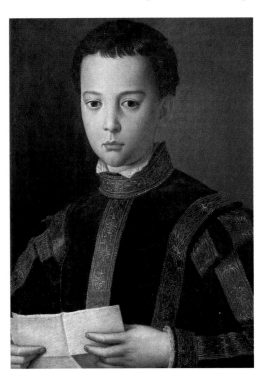

294 and 295
BRONZINO
Portrait of Maria de' Medici
Oil on panel, 20⁷⁄₁₆ × 14¹⁵⁄₁₆ in. (52 × 38 cm)
Uffizi, Gallery; inv. 1890: no. 1572
Portrait of Francesco I as a Young Man
Oil on panel, 23 × 16⁵⁄₁₆ in. (58.5 × 41.5 cm)
Uffizi, Gallery; inv. 1890: no. 1571

The young girl portrayed here has been identified as Maria, the elder daughter of Cosimo and Eleonora, through a contemporary copy of the portrait that bears her name. From documents relating to the commission, the painting of Maria is known to have been executed in December of 1550 and that of Francesco in early 1551, both in Pisa; Maria de' Medici was eleven years old at the time, and her brother ten.

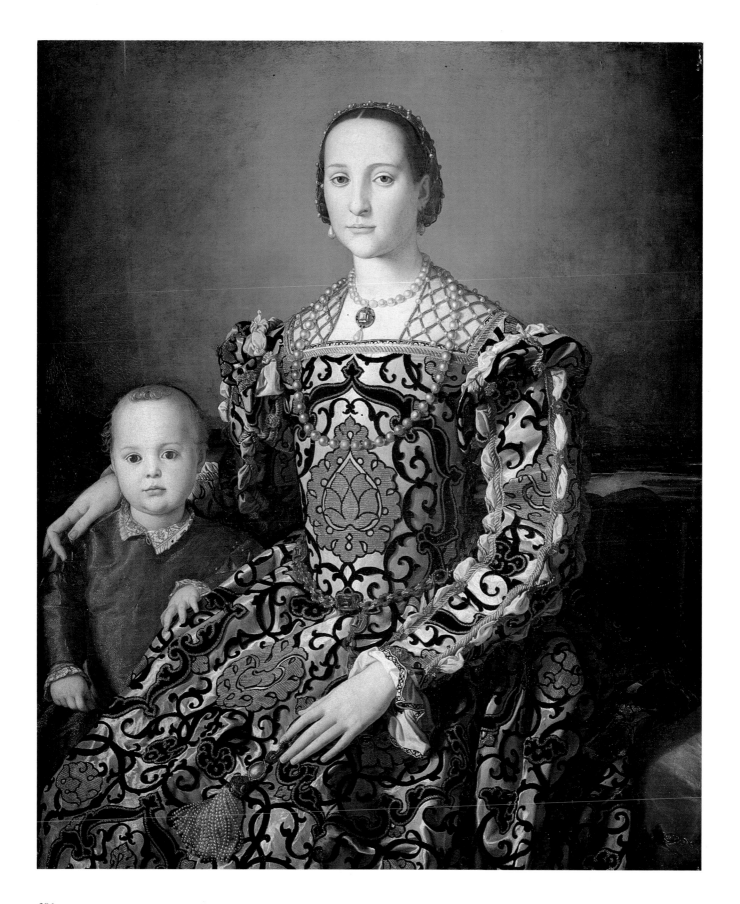

296
BRONZINO
Portrait of Eleonora of Toledo with Her Son Giovanni
Oil on panel, 45¼ × 37¹³⁄₁₆ in. (115 × 96 cm)
Uffizi, Gallery; inv. 1890: no. 748
Eleonora of Toledo, daughter of the viceroy of Naples and Cosimo's wife, is shown here with her son Giovanni in a compositional formula that Bronzino often adopted to indicate a precise dynastic significance. The bridal dress she is wearing is the same one in which she would be buried in 1562. On the basis of a letter written by the artist from Poggio a Caiano, the work has been given a date of 1545.

225

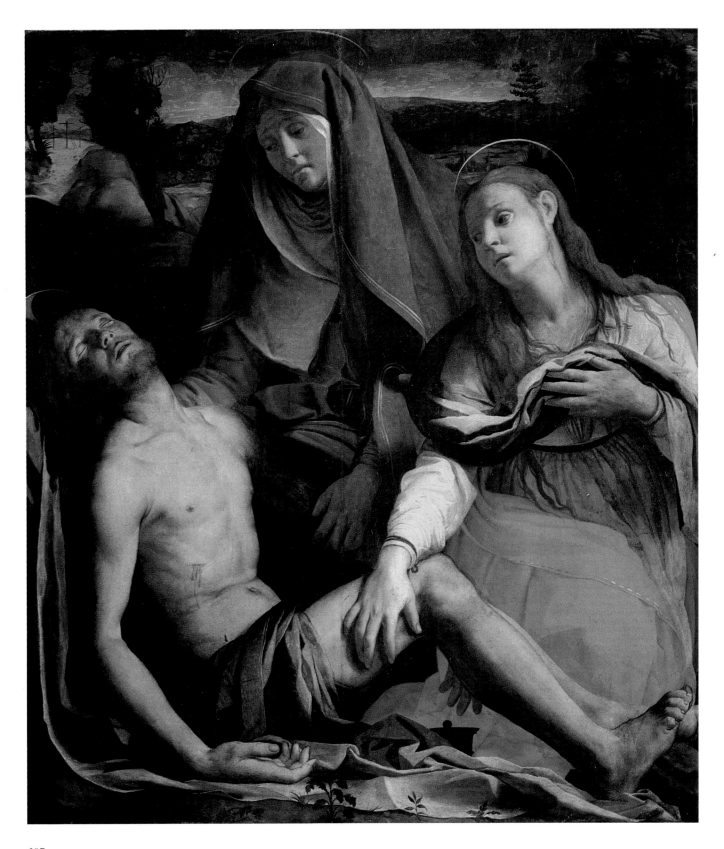

297
BRONZINO
The Dead Christ with the Madonna and Mary Magdalen
Oil on panel, 45¼ × 39⅜ in. (115 × 100 cm)
Uffizi, Gallery; inv. 1890: no. 8545
This panel may be the work described by Vasari in the church of Santa Trinita, though it lacks
the figure of St. John, and the stated dimensions do not coincide. It now seems to date from
the late 1540s.

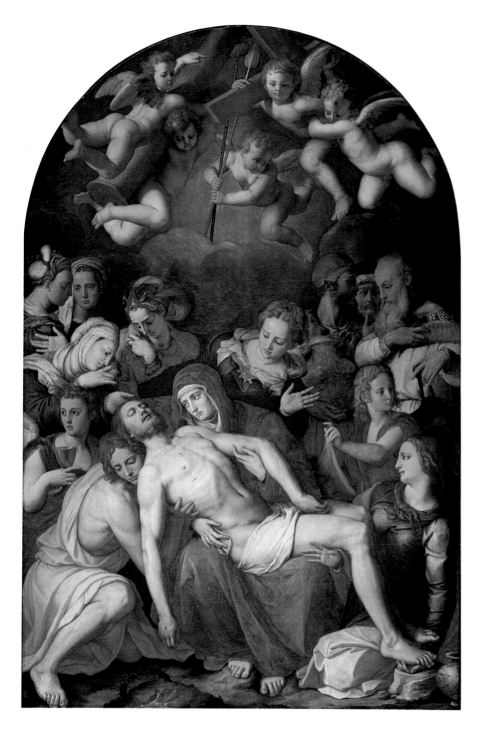

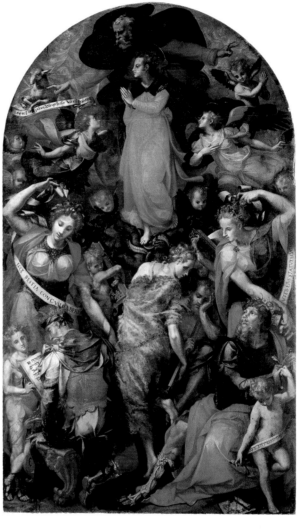

298
BRONZINO
The Deposition from the Cross
Oil on panel, 95¹¹⁄₁₆ × 68½ in. (243 × 174 cm)
Signed: OPERA DEL/ BRONZINO FIOR
Palazzo Vecchio, Chapel of Eleonora of Toledo; inv. 1890: no. 740

Datable to around 1553, this painting is regarded as a replica—with a few variations—of the *Deposition* of 1545, which was originally destined for the altar of Eleonora's chapel in the Palazzo Vecchio but was given instead by Cosimo I to Cardinal Granvelle (now in the museum in Besançon).

299
CARLO PORTELLI
The Immaculate Conception
Oil on panel, 163 × 96⅞ in. (414 x 246 cm)
Signed and dated: CAROL(US) PORTELL(US) P(ICTOR)
FLO(RENTINUS) P(INXIT) 1566
Accademia, Gallery; inv. 1890: no. 4630

Rife with doctrinal references, this panel came from an altar in the church of the Ognissanti. It was removed in 1671 because of the supposed indecency of the many nude figures (including Eve, in the center, and some angels), which were subsequently provided with clothes.

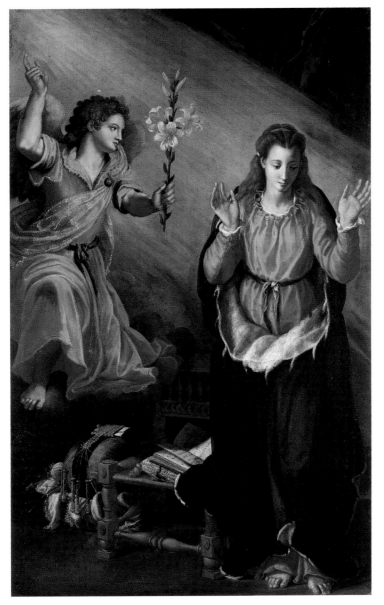

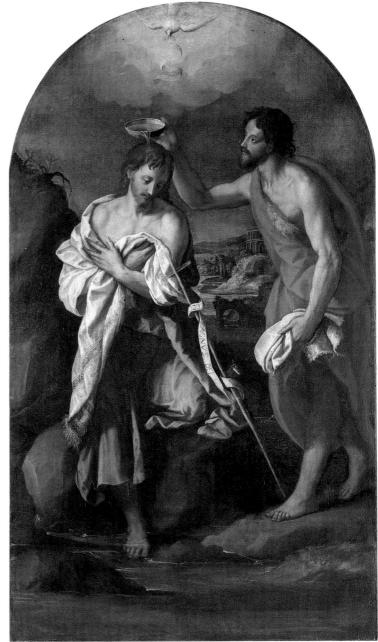

300

ALESSANDRO ALLORI

The Annunciation

Oil on canvas, 63¾ × 40⁹⁄₁₆ in. (162 × 103 cm)

Signed and dated: A.D. MDCIII ALEXANDER BRONZINUS

ALLORIUS CRISTOPHORI FILIUS DUM PINGEBAT MELIUS LINEARE

NON POTUIT

Accademia, Gallery; inv. Castello: no. 494

Great care was taken in the execution of the details in this painting, which was intended for private devotional use. The representation of the Madonna standing and facing toward the viewer with her arms raised is rare; it is found only in one other contemporary work, by Santi di Tito, for the church of Santa Maria Novella.

301

ALESSANDRO ALLORI

The Baptism of Christ

Oil on panel, 65⅛ × 38³⁄₁₆ in. (165.5.× 97 cm)

Signed: ALESSANDRO BRONZINO ALLORI FECE

Accademia, Gallery; inv. 1890: no. 2175

This panel was painted for the little chapel in the Pitti Palace apartments of Christine of Lorraine, who was married to Ferdinand I in 1589. In 1591 Allori was paid for his "small gilded grotesque stories" for the chapel, which was destroyed in 1811. On the panel, near Christ's feet, is a date that today is partly obliterated but that Adolfo Venturi read in 1933 as 1591.

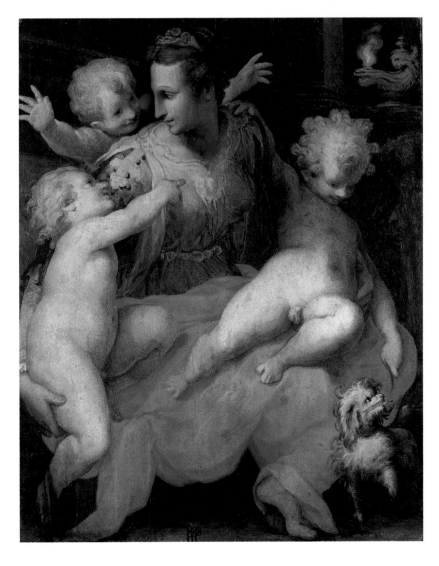

302

GIROLAMO MACCHIETTI
Venus and Adonis
Oil on panel, 66⁵⁄₁₆ in. (17 cm) in diameter
Pitti, Palatine Gallery; inv. 1890: no. 6266
This work, based on Ovid's *Metamorphoses*, may
once have been part of a painted piece of furni-
ture. Documented in the Tribune since 1704, it
probably dates from the 1560s.

303

ALESSANDRO ALLORI
Hercules Crowned by the Muses
Oil on copper, 15¾ × 11⅛ in. (40 × 29.5 cm)
Signed: ALEXANDER ALLORIUS
Uffizi, Gallery; inv. 1890: no. 1544
This painting was commissioned and paid for by
Francesco de' Medici in 1568 as one in a series of
small allegorical works produced by a variety of
artists. Hercules represents the personification
of the prince's virtues. In 1589, it was already in
the Tribune.

304

FRANCESCO MORANDINI DA POPPI
Charity
Oil on panel, 49⅝ × 40⁹⁄₁₆ in. (126 × 103 cm)
Signed: POPPI
Accademia, Gallery; inv. 1890: no. 9287
According to Borghini, writing in 1584, Morandini
painted this subject a number of times—for An-
tonio Serguidi, for Francesco del Nero, and for
Regolo Coccapani. The Accademia's version
dates from the beginning of the 1570s.

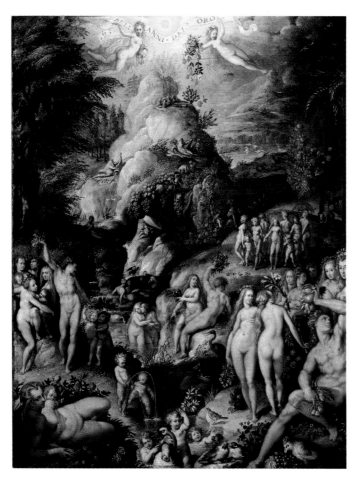

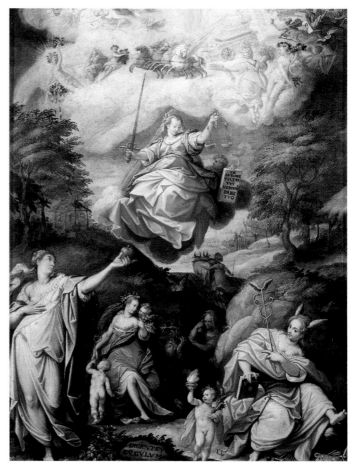

305 and 306
JACOPO ZUCCHI
The Golden Age
Oil on panel, 19¹¹⁄₁₆ × 15⅛ in. (50 × 38.5 cm)
Uffizi, Gallery; inv. 1890: no. 1548
The Silver Age
Oil on panel, 19¹¹⁄₁₆ × 15⅛ in. (50 × 38.5 cm)
Uffizi, Gallery; inv. 1890: no. 1506

These two paintings may have been executed in the 1570s for
Ferdinand de' Medici, who brought them back to Florence from
Rome for the grand-ducal coronation of 1587.

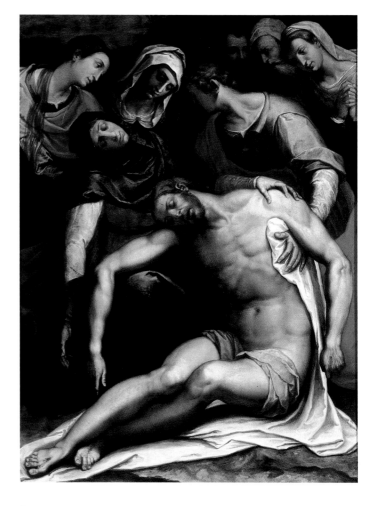

307
STEFANO PIERI
Pietà
Oil on panel, 67⁵⁄₁₆ × 50 in. (171 × 127 cm)
Signed and dated: s. 1587
Accademia, Gallery; inv. 1890: no. 1595

The sketch for the model has recently been identified.

Emilia

Between 1500 and 1525 the Emilian fascination with art from north of the Alps, and particularly with German art, spread at a fast rate through the dissemination of prints, the reports of visitors to Venice (where Northern art was all the rage), and the probable presence in Bologna of Albrecht Dürer himself.

"If a loan is offered, it means only that one has need of it," wrote Febvre. The passionate expressiveness of German painting was the answer that such artists as Amico Aspertini in Bologna and Ludovico Mazzolino in Ferrara had been waiting for; both had grown up in humanistic climates where the arcane legacy of Ercole de' Roberti had stimulated necromantic fantasies for the antique, as well as an obsessive inclination toward the tragic masks of humanity at the limits of the grotesque.

If the courtly and ultramontane aspect of Aspertini's painting was largely of Venetian origin, it was in the university town of Bologna that the two worlds—Northern and Italian—mingled most easily. (Thus, for example, Hans, the student son of Lucas Cranach, died in Bologna in 1537.) This inspired experimentation, in harmony with studies at the university, was nothing less than a romantic foray from fourteenth-century Bologna to the confrontation with Raphael and Michelangelo, from the ancient to the Northern world (exemplified by the *Pietà*, of 1519, in the church of San Petronio in Bologna).

In Ferrara, meanwhile, Mazzolino was also looking to the northern Venice (as personified by Jacopo de' Barbari, Dürer, and the young Lotto) as to lodes of precious minerals that he might mine for whimsical citations, and thus enrich his own nostalgically humanistic taste, long held captive in the bewitched workshop of Ercole de' Roberti. Mazzolino lacked the ability to open up completely to the modern style of painting; his was the miniaturist's world of the fifteenth century, where Ercole de' Roberti's legacy was joined to a taste for the antique reinvented through the Northern "grotesque."

Ferrara's geographical location on the Po delta, within the confines of the Venetian territorial empire and the papal states, was fateful for its artistic culture in the sixteenth century: it occupied a strategic position between opposing poles of the two great artistic centers of the century, Venice and Rome.

Among the most influential personalities within the singular climate of Ferraran court life were Duke Alfonso I (1505–1534) and Duke Ercole II (1534–1559). Both men summoned to their city extremely prestigious artists, including Fra Bartolomeo, Raphael, Titian, and Pordenone, as well as writers, such as Boiardo and Ariosto. The northern wind quickly swept off to Venice the young Dosso Dossi, who, along with the young Garofalo, sought out new modes beyond the devotional painting that was very much in vogue at the court of Ercole I d'Este (1471–1505). The passage from the Venetian lagoon to terra firma marked a new phase for the young Dosso, an epiphany realized in his *Nymph Pursued by a Satyr*, now in the Palatine Gallery: the antique and the mythical acquired an earthly vitality in an esoteric atmosphere of sorcery and incantations.

In the "alabaster dressing room" in a wing of the castle in Ferrara, Alfonso I decided to re-create, through painting and decoration, the sort of late Roman villas described by Pliny and Philostratus the Elder; it was to have alabaster reliefs by Antonio Lombardo and great canvases by Giovanni Bellini, Titian, and Dosso. Wandering between Raphael's Rome and Titian's Venice, and influenced as well by the Cremonese idiom of Romanino and Pordenone, Dosso came to invent an eccentric modern style "for the amusement and entertainment of the gentlemen" of the court, in Ariosto's words. The forms pull away in unexpected movements that draw them into strange landscapes: here, in the brambles and bogs, the protagonists come to life, suspended "in astonishing atmospheres that know something of magic and mystery" (Garin on the *Rest on the Flight into Egypt*). In the 1520s Dosso's optical transformation achieved a mature intensity; the lesson he had learned in Rome (through the examples of Raphael and Michelangelo) and the suggestions of Giulio Romano in Mantua, based on the chromatic classicism of Titian, combined to produce a vibrant and energetic blend of color and light. A terrestrial vitality animates the saturnine figures, moved to the limits of melancholy as they wander through luxuriant landscapes out of Ariosto (as in the *Madonna in Glory with SS. John the Baptist and John the Evangelist*). An artist and a city: Dosso advanced by leaps and bounds in the milieu of the courts, an ambience that was at once epic, Neoplatonic, and cabalistic. He produced paintings with dynamic contrasts and a continual alternating of shadows and light, combining long, delicate brushstrokes with bold applications of color, and bewitched twilights with scenes of daily life.

Not long before he died, Dosso produced *Witchcraft*, now in the Uffizi, a singular testimonial to his talent, which treats its esoteric subject—the Bacchic mysteries—almost as a genre scene, in a sort of prefiguration of seventeenth-century realism. The hidden meaning acquires truth within a conversation scene: around the table sits a "happy band," realistically lit (and thus suggestive of Cremonese painting) and explored with the clear, rapt objectivity that Caravaggio would one day bring to his painting.

"He was the first in Lombardy to begin painting in the modern style": so Vasari begins his account of the life of Correggio (1489–1534). The attempt to reconcile the geographical location signified by the name "Lombardy" with a typological interpretation of the phrase "modern style" has influenced the critical fortunes of this genius loci up to our own day. Correggio, pioneer of the modern style on the Emilian frontier, had a complicated early life. In Mantua he was introduced to the protoclassicism of Costa under the influence of Mantegna (evident in his *Madonna and Child in Glory with Angels*); he explored Ferraran methods in his lost *Madonna* of Albinea, all the while searching for suggestions and intonations in Leonardo, to incorporate into his own shadowy, introverted, "feminine" world. His journey to Rome in 1518, and his direct confrontation there with the work of Raphael and

Michelangelo, helped him to resolve the experimental crisis of his youth: in his frescoes in the chamber of San Paolo, executed in Parma in the following year, the motifs of Roman form are recast in a sublime classicism nurtured by a soft grace and a sensual naturalism. It was also during this period that Correggio produced his *Rest on the Flight into Egypt,* with its tangible and vital sense of nature against the background of a dense forest. This sacred incident, known from the gospel of Pseudo-Matthew, is here re-created through fluid, irregular rhythms that link together the protagonists—"by way of gestures and contacts," in Longhi's phrase—while the trembling shadows and light give their faces an uneasy expression that betrays the artist's undeniable fascination with Leonardo. A mature pictorial language is employed as well in the complex decoration of San Giovanni Evangelista (1520–1523) and in the cupola of the Duomo (1526–1530), where innovative illusionistic perspectives, mediated by the theater and by the "coroplastic" Emilian tradition of Antonio Begarelli, are paired with insubstantial forms inbued with a tender sensuality, in a realization of a continual fluidity that anticipates baroque taste.

A Lombard version of the modern style, Correggio's work reveals a profound vocation to privilege the feminine universe: women, from the poetess Veronica Gambara to the abbess Giovanna Piacenza, played important roles in his career. His *Adoration of the Child,* of around 1522, is a touching exploration of this affective woman's world, a pictorial representation of motherhood that manages to be, as well, a splendid painting: note, for example, the grace of the Madonna's hands, caught in midair; the meticulous folds of the drapery, molded as if in some sculpture by Begarelli; the melancholy of the hushed landscape.

After the Sack of Rome in 1527, Parmigianino came to Bologna, the second city in the papal states. By this time he was already a mature artist, having come into direct contact with Correggio in the church of San Giovanni Evangelista in Parma, and there having immediately conceived an obsessive interest in the search for formal elegance. Fundamental for Parmigianino, as for other Emilian painters, was the requisite journey to Rome, in his case in the middle of 1524. The city of Clement VII was dominated by Raphaelesque ideas and by what Zeri called the "Raphaelization" of Michelangelo, seen especially in the work of his disciple Perino del Vaga. Rosso was also in the capital at that time.

However, it was only during his stay in Bologna in 1527–1530—when that city was preparing for the coronation of Charles V and taking on a cosmopolitan role in the phantasmagoric trafficking of the patrons and collectors of the city—that Parmigianino was able to invent a stylistic code of courtly beauty. His work at the time was marked by a "sort of osmosis between the figures, and the exuberant trees with their leafy fronds, and the landscape that encloses them" (Briganti). (This style is exemplified by the *Madonna of St. Margaret,* in the Pinacoteca Nazionale in Bologna, and the *Madonna of St. Zachary.*)

This elegant, courtly style held an inevitable attraction for the taste of the European courts themselves. Suggestive testimonial to this enthusiasm was a chapel planned but never executed for Charles V in San Petronio in Bologna, in which frescoes were to depict the events of his coronation; Parmigianino was the artist chosen for the project. Upon his return to Parma he created even rarer forms: his *Madonna of the Long Neck* is a precious glyptic metaphor, its figures' unnervingly elongated hands, legs, and arms charged with a disturbing experimental tension.

In the artistic environment of sixteenth-century Emilia, Parmigianino's courtly grace served as a fundamental point of reference for those artistic centers that were subject to the politics of court. His direct heir was Niccolò dell' Abate, who in the fortresses, castles, and palaces between Modena and Bologna retuned Parmigianino's stylistic concepts in an enchanting narrative key. His intent was to illustrate the social customs of the neofeudal aristocracy—its pleasant gatherings, concerts, games, and tournaments—in paintings in which eminent personages, despite the rigid worldly etiquette, are portrayed quite naturally, in a loosening of Parmigianino's emblematic rigor. Parmigianino's own "wild humors of the woods," in Longhi's phrase, was meanwhile being reappraised as landscape according to the new visual perception of the Carracci reform.

The arrival of Raphael's *St. Cecilia* in Bologna in the spring of 1514 provided the papal state with a perfect symbol of its domination over the city: a convincing public image that overshadowed the glories of the Bentivoglio court. For a generation of artists who had been raised on the protoclassicism of Costa and Francia, this encounter with Raphael's work had, ultimately, a negative effect: this panel was an astonishing archetype that inspired little more than the mechanical reproduction of itself.

A way out of this lack of creativity had to wait for the arrival in Bologna of Baldassare Peruzzi, who, in 1522–1523, executed the cartoon for his *Adoration of the Magi* (in the National Gallery in London) for Count Giovanni Battista Bentivoglio. In Peruzzi's work the prevalent Raphaelesque culture was tempered by an interest in the antique, elaborated through theatrical effects and through a robust plasticity that recalled the painting of Giulio Romano; this facilitated a rapprochement with Raphael and showed that his innovation could be brought up to date in a less dogmatic way. An intense dialogue ensued among the three Girolamos—da Treviso, Marchesi da Cotignola, and da Carpi—the protagonists who were to unfurl the new Bolognese artistic panorama. Girolamo da Treviso looked to Florence (the school of San Marco) without, however, forgetting the Venetian and Northern roots of his early training (his *Stories of St. Anthony,* of 1525, in San Petronio in Bologna); Girolamo Marchesi da Cotignola strove for a naturalistic classicism (his altarpiece for San Michele in Bosco, of 1526, is now in Berlin's Staatliche Museen); Girolamo da Carpi, for his part, recast Peruzzi's archetype in a Lombard idiom reminiscent of Dosso and Parmigianino (his *Adoration of the Magi* was painted for the church of San Martino in Bologna between 1529 and 1532). The noblest emulation of Raphael's artistic ideas in Emilia was born of a happy marriage between the "Lombard" and the "Roman," in Lanzi's view: a naturalistic

classicism onto whose Venetian-Ferraran roots and Parman trunk (exemplified in the work of Correggio and Parmigianino) are grafted the fruits of Raphael. The latter's influence was felt not only through those of his works that were in Emilia but also, and especially, through the experience of those artists who had visited Rome. Girolamo da Carpi's portraits were thus based on models by both Raphael and Parmigianino, as can be seen in his very beautiful likeness of (probably) Archbishop Onofrio Bartolini (now in the Pitti), with its subtle interplay of nature and intellect.

Raphael's work arrived in Ferrara, meanwhile, in 1518. Garofalo's fascination with these bordered on astonishment (evident in his *Massacre of the Innocents*, of 1522, in Ferrara's Pinacoteca), but through this he was later able to reach a more mature understanding of Raphael's world. At the height of his long career, Garofalo achieved a noble classicism in which his youthful Giorgionesque education quietly resurfaced, like a distant memory (as in his *Annunciation* of around 1540).

According to Briganti, "The Etruscan demons that clamored from everywhere toward Venice—that is to say, the new mannerist formalism, with its predominantly Michelangelesque tendencies and its urge to assert itself as a universal language with its own rules, its own measurements, and its own schemes—began in the 1540s to expand their domain in Emilia." Bologna, the second-most important city in the papal states, enjoyed a privileged position at the midpoint of a bridge of a hegemonic mannerist culture that stretched from central into northern Italy. If the presence in Bologna in 1539 of Vasari and Salviati stimulated the artistic ambience and kept it current, there were also other protagonists. Prospero Fontana and Pellegrino Tibaldi became relevant models for the generation of artists who followed them—a historical climate that saw the imposition of Tridentine reform with the arrival in Bologna of Bishop Paleotti. Nosadella and Passarotti sought refuge in Tibaldi's transgressive "Michelangelism" and made a few experimental attempts at freedom through their contact with the north (Sprangher in Parma, for example, and the Campi in Cremona). Bartolomeo Passarotti in particular took Paleotti's concept of art as a popular book to the limits of orthodoxy: inventing story-portraits that teetered on a previously unseen equilibrium between truth and rhetoric, he brought to Bologna the great novelty of genre painting, in which the repertory of sixteenth-century comic theater became a pictorial art that aggressively investigated the real world by placing on center stage scenes of the daily life of the subordinate classes.

Prospero's daughter, Lavinia Fontana, in turn revived her paternal culture of international mannerism. Protected by the Bolognese Gregory XIII, she incarnated, with Anguissola, the myth of the woman artist within the civilization of the European courts of the late sixteenth century.

Meanwhile, in Bologna, the Carracci were writing the first page of a new chapter in the history of art.

Vera Fortunati

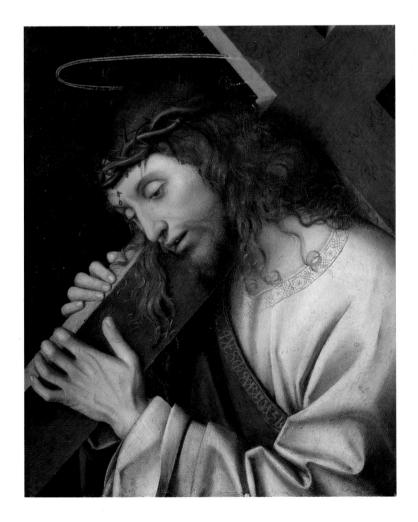

308
GIOVAN FRANCESCO MAINERI
Christ Carrying the Cross
Oil on panel, 19¹¹⁄₁₆ × 16½ in. (50 × 42 cm)
Uffizi, Gallery; inv. 1890: no. 3348
Given to the Uffizi in 1906 by Elia Volpi, this work dates from the middle of the first decade of the sixteenth century. The decoration on the border of the mantle conceals the author's signature in Latin characters.

233

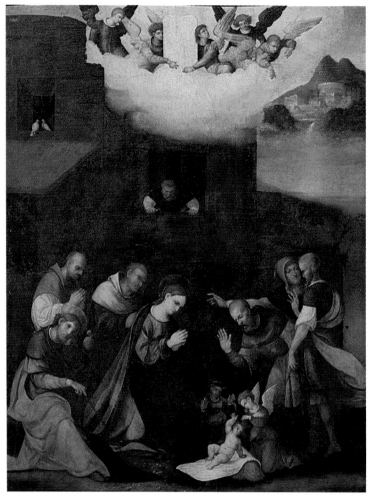

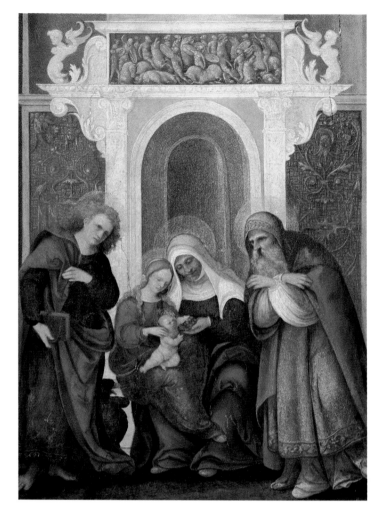

309
LUDOVICO MAZZOLINO
The Adoration of the Shepherds
Oil on panel, 31⁵⁄₁₆ × 23¹³⁄₁₆ in. (79.5 × 60.5 cm)
Uffizi, Gallery; inv. 1890: no. 1352
This panel, once exhibited in the Pitti, came out of Medici storage
in 1800. It dates from around 1510–1515.

310
LUDOVICO MAZZOLINO
Madonna and Child with St. Anne
Oil on panel, 11⁵⁄₈ × 9 in. (29.5 × 22.8 cm)
Uffizi, Gallery; inv. 1890: no. 1347
This work was probably acquired by Grand Prince Ferdinand de'
Medici; it is datable to 1522–1523.

Opposite: 311
GAROFALO
The Annunciation
Oil on panel, 21¹¹⁄₁₆ × 29¹⁵⁄₁₆ in. (55 × 76 cm)
Uffizi, Gallery; inv. 1890: no. 1365
Datable to the early 1540s, this work was in the Pitti by the begin-
ning of the eighteenth century. It came to the Uffizi in 1773.

312
GAROFALO
Augustus and the Tiburtine Sibyl
Panel, 24¹³⁄₁₆ × 16⅛ in. (63 × 41 cm)
Pitti, Palatine Gallery; inv. 1912: no. 122
Once the property of Cardinal Leopoldo de' Medici, brother of
Ferdinand II, this painting shows the sibyl revealing the mystery of
the Incarnation to Augustus.

313
DOSSO DOSSI
The Rest on the Flight into Egypt
Tempera on panel, 20⁷⁄₁₆ × 16¾ in. (52 × 42.5 cm)
Uffizi, Gallery; inv. 1890: no. 8382
The dating of this panel is controversial; it was produced either at
the end of the second or at the beginning of the third decade of the
sixteenth century.

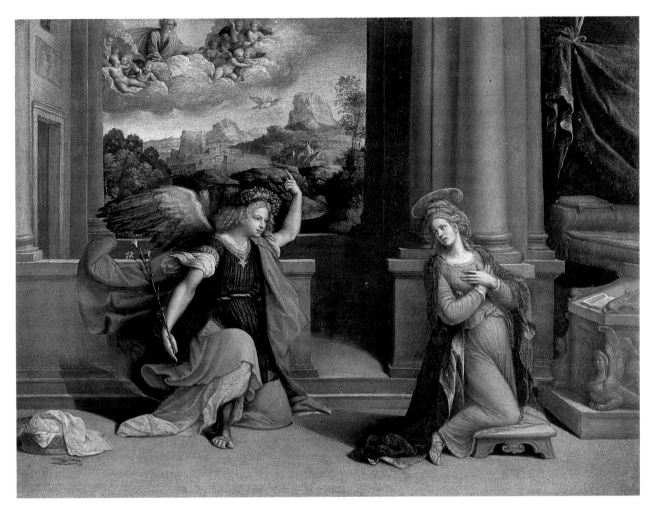

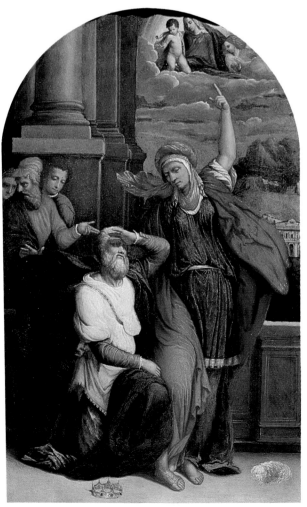

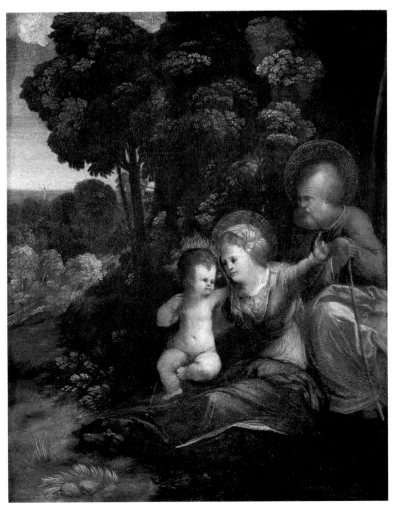

235

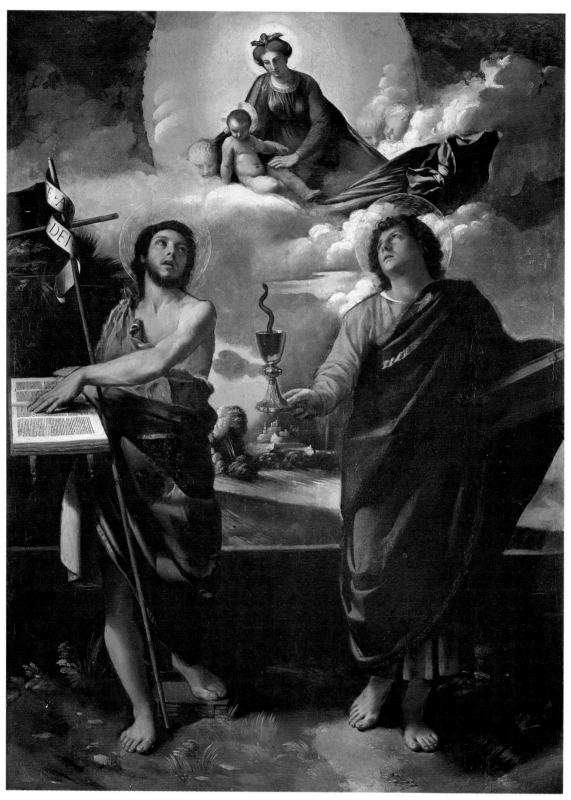

314
DOSSO DOSSI
Madonna in Glory with SS. John the Baptist and John the Evangelist
Oil on panel transferred to canvas, 60¼ × 44⅞ in. (153 × 114 cm)
Uffizi, Gallery; inv. Dep.: no. 7

Although this work can be dated to the third decade of the six-
teenth century, its original provenance is unknown. Once installed
in the church of San Martino in Codigoro, it was turned over to the
municipality in 1911 and then deposited in the Uffizi in 1913.

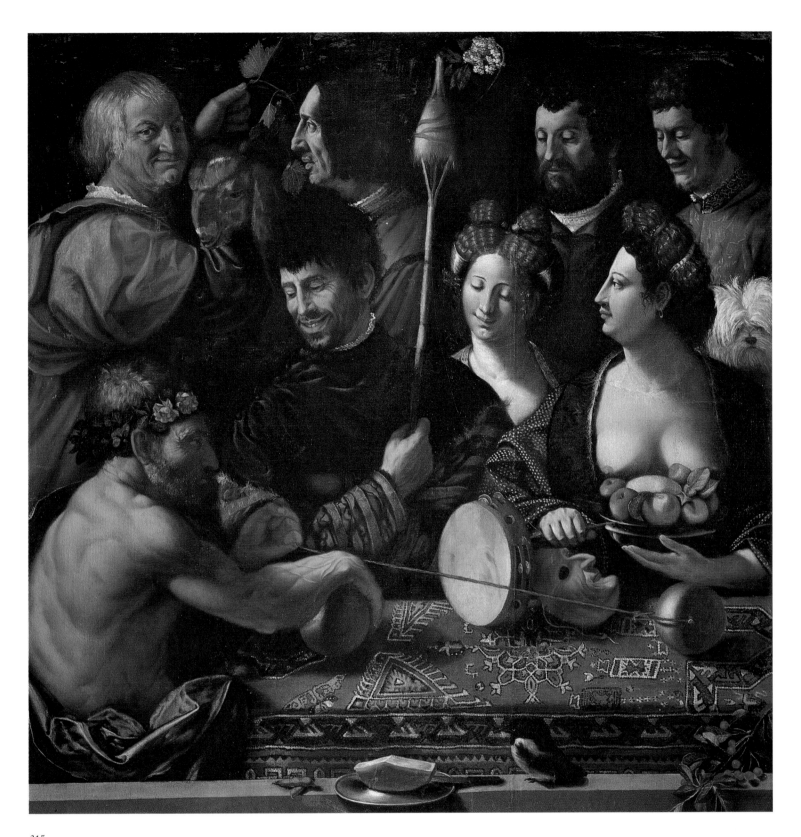

315

DOSSO DOSSI

The Allegory of Hercules ("Witchcraft")

Oil on canvas, 56½ × 56¹¹⁄₁₆ in. (143.5 × 144 cm)

Uffizi, Gallery; inv. 1912: no. 148

This painting was acquired in Siena in 1665 for Cardinal Leopoldo de' Medici; the nature of its subject has been a matter of some debate. It dates from just before the artist's death, in 1542.

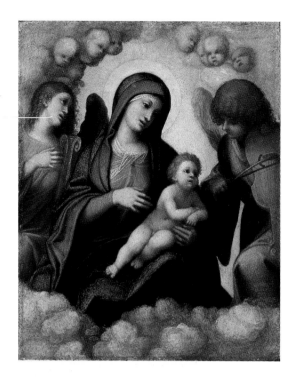

316
CORREGGIO
Madonna and Child in Glory with Angels
Oil on panel, 7⅞ × 6⁷⁄₁₆ in. (20 × 16.3 cm)
Uffizi, Gallery; inv. 1890: no. 1329
Once in the collection of Cardinal Leopoldo,
this panel passed to the Uffizi in 1789. It can
be dated to the first decade of the sixteenth
century.

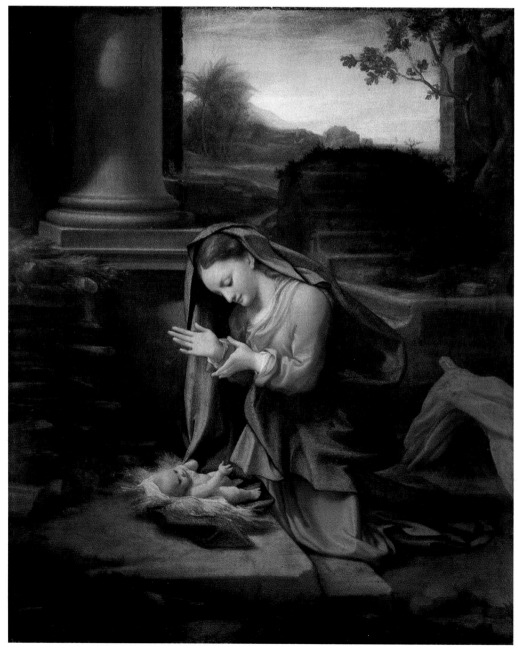

317
CORREGGIO
The Adoration of the Child
Oil on panel, 31⅞ × 30⁵⁄₁₆ in.
(81 × 77 cm)
Uffizi, Gallery; inv. 1890: no.
1453
Given to Cosimo II de' Medici
in 1617 by Ferdinando Gon-
zaga, the duke of Mantua, this
painting was displayed in the
Uffizi that same year. It dates
from the first half of the 1520s.

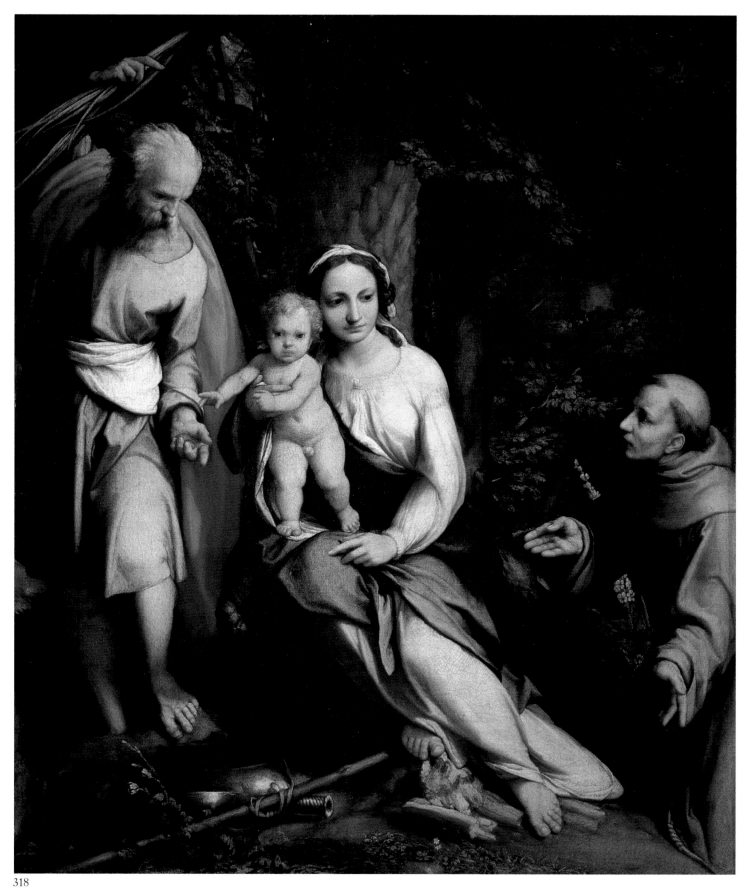

318
CORREGGIO
The Rest on the Flight into Egypt
Oil on canvas, 48⅝ × 41¹⁵⁄₁₆ in. (123.5 × 106.5 cm)
Uffizi, Gallery; inv. 1890: no. 1455

Correggio executed this painting for the Munari chapel in San Francesco in Correggio. In 1638 a copy by Boulanger was substituted for the original, which was sent to the ducal gallery in Modena; eleven years later, in 1649, Correggio's work was transferred to Florence. Its dating is controversial: some believe it was painted in 1516–1517, others around 1520.

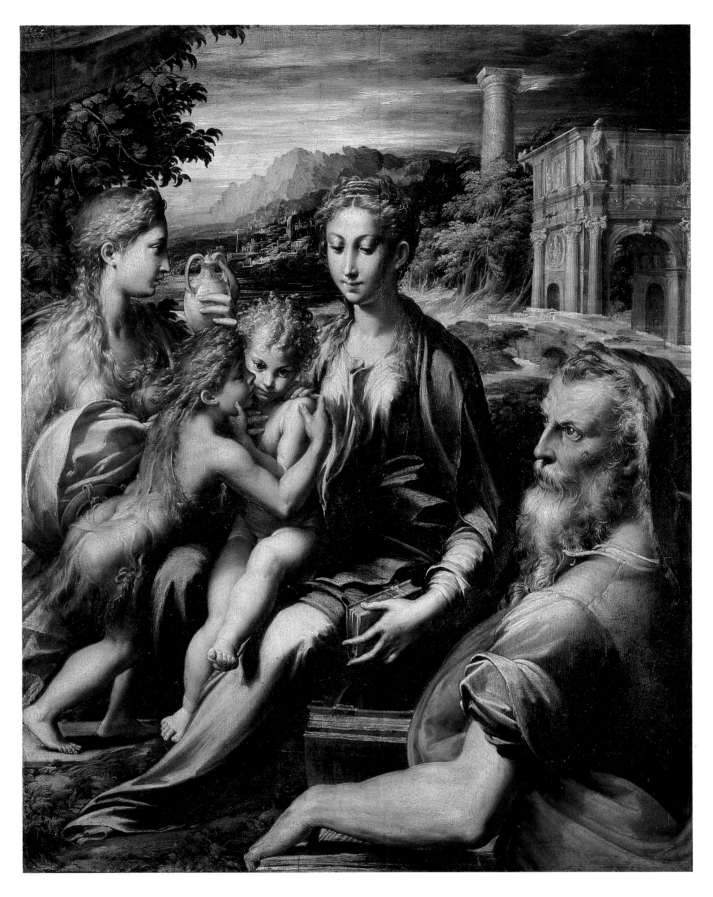

319
PARMIGIANINO
Madonna of St. Zachary
Oil on panel, 29¾ × 23⅝ in. (75.5 × 60 cm)
Uffizi, Gallery; inv. 1890: no. 1328

This painting has been identified by some scholars as that sold to
Bonifazio Gozzadini of Bologna in 1533; in 1560 it was said by Lamo
to belong to Count Giorgio Manzuoli, also of Bologna. Painted in
around 1530, it was in the Uffizi's collection by 1605.

Opposite: 320
PARMIGIANINO
Madonna of the Long Neck
Oil on panel, 86¼ × 53⅛ in. (219 × 135 cm)
Uffizi, Gallery; inv. 1912: no. 230

This panel was commissioned in 1534 by Elena Baiardi for her
chapel in the church of Santa Maria dei Servi in Parma. The
painting remained unfinished due to the death of the artist. It was
acquired by Ferdinand de' Medici in 1698.

240

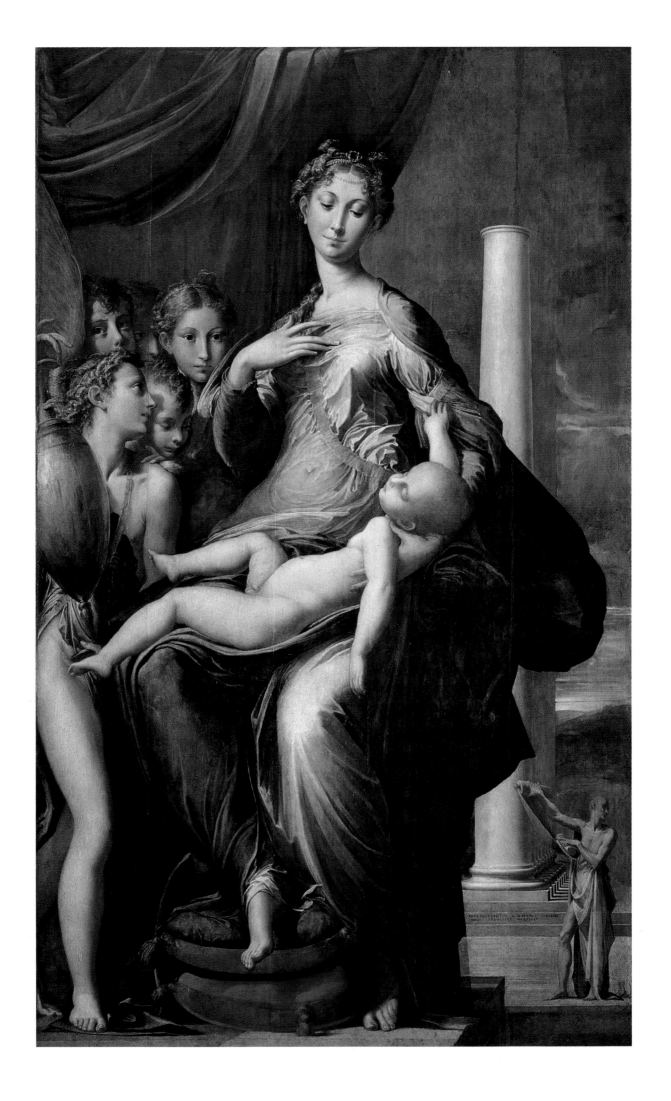

241

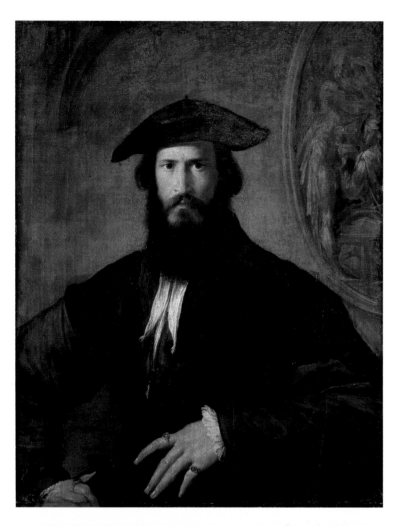

321

PARMIGIANINO

Portrait of a Man

Oil on panel, 34⅝ × 26¹⁵⁄₂₆ in. (88 × 68.5 cm)

Uffizi, Gallery; inv. 1890: no. 1623

This work dates from c. 1530–1531. It entered Leopoldo de' Medici's collection as a self-portrait, an identification eventually rejected based on the comparison with certain drawings by Parmigianino that are considered to be of the artist himself.

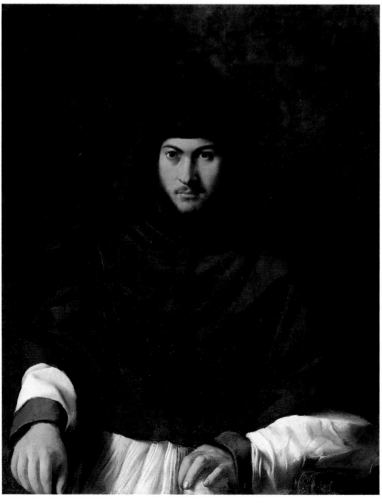

322

GIROLAMO DA CARPI

Portrait of Archbishop Bartolini Salimbeni

Oil on panel, 28¾ × 35⁷⁄₁₆ in. (73 × 90 cm)

Pitti, Palatine Gallery; inv. 1912: no. 36

Vasari, writing in 1568, identified the subject of this portrait as the Florentine Onofrio Bartolini, at a time when he frequented the university in Bologna. The work dates from a little after 1529, just before Bartolini was appointed archbishop of Pisa.

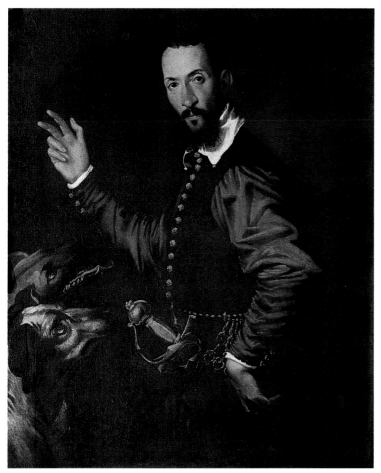

323
BARTOLOMEO PASSAROTTI
Portrait of a Gentleman with Two Dogs
Oil on canvas, 40⁹⁄₁₆ × 33¹⁄₁₆ in. (103 × 84 cm)
Pitti, Palatine Gallery; inv. 1912: no. 138
Once attributed to Federico Zuccari, this work has since been
restored to Passarotti. The portrait, which for a time was identified
as being of Guidubaldo da Montefeltro, can be dated to around
1575.

324
LAVINIA FONTANA
Noli Me Tangere
Oil on canvas, 31½ × 25¹³⁄₁₆ in. (80 × 65.5 cm)
Signed and dated: LAVINIA FONTANA DE / ZAPPIS FACIEBAT
MDLXXXI
Uffizi, Gallery; inv. 1890: no. 1383
This painting came to the Uffizi in 1632 as part of the legacy of Don
Antonio Medici da Capistrano.

The Veneto

Time, as everyone knows, is not constant but can instead travel at very different speeds. This notion may seem banal and clichéd but it was never more true than in the case of the formidable acceleration of artistic development seen in Venice in the first decade of the sixteenth century. It was a period when every daring feat of artistry seemed not only possible but within reach, growing through the creativity of exceptional protagonists and the strengthening effects of coincidental events.

The creative impetus for this acceleration can be credited to an artist who, at the beginning of the century, was barely twenty years old: Giorgione. But all that was required for the success of this revolution was already in place: toward the middle of the last decade of the fifteenth century, a series of converging lines had put Venice on the cutting edge of all that was new in art, as the true and rightful crossroads of Europe. It was in fact through their interaction in the territories of the Serenissima that elements of change were catalyzed; thus, influences from northern Europe mixed with those from central Italy and Lombardy. Then, too, the presence of Leonardo has been documented in Venice between February and April of 1500, following the fall of the Sforza in 1499 under pressure from the French armed forces.

Naturally, given his exceptional talent and the fame that preceded him, Leonardo was destined to have more impact than any other artist on the evolution of Venetian painting. The extraordinary emotional influence that Leonardo's style had on Giorgione's work can be measured by a painting that was probably executed during the very months when the Florentine master was in Venice: *The Singing Lesson* (in the Pitti Palace), generally known by its unjustified seventeenth-century title, *The Three Ages of Man*. Here Giorgione has attempted to imitate the surface treatment of a painting by Leonardo, adopting as well the latter's *sfumato:* contravening Venetian painting precedents with their compact, dense, and velvety coloring, the painting evolves in an atmospheric blur in which the pigment seems almost to dematerialize and light emerges from a sort of indistinct shading, giving rise to a totally new and visible naturalism. It is as though the artist wished to capture the essential mysteries of the air, its impalpable color.

It is certainly true that with the Pitti's *Singing Lesson*, Giorgione invented what may be termed the "situation portrait," based on a compositional format known as the *sacra conversazione* used to depict the Holy Family. The people represented in Giorgione's portraits are those figures' lay counterparts, who in their gestures, their attitudes, and their social signs reveal something of themselves and their relationships to each other. It did not take much to create stronger emotional or psychological situations as, for example, in the so-called *Gattamelata*—a young warrior in all the strength of his careless and unkempt beauty, the extraordinary play of light glinting off his breastplate and his armor, left on the parapet, while a young page behind him seems to express to those outside the painting all of his unrequited devotion. The importance of these and similar images cannot be sufficiently emphasized.

Our world is indebted to Giorgione for another great discovery as well: the use of landscape as an environment and a vehicle for personal and private emotions.

The Uffizi collection has two little paintings on biblical themes by this artist in which landscape already plays a prominent role. Fifteenth-century concerns are dealt with here, but the figures are quite small in comparison with the natural scenery; this feature, already a hallmark of the artist's style, demonstrates his continued awareness of Northern painting.

Giorgione died of the plague in October 1510, but he left behind, as Vasari said in 1550, "two excellent creations in Sebastiano Veneziano, later Fra del Piombo of Rome, and Tiziano of Cadore." As the order of their citation by Vasari suggests, the first of the two was not only the older but also the better regarded—so much so, in fact, that he was dispatched, in the summer of 1511, to Rome, where he was to fresco the suburban villa of that city's wealthiest banker. Indeed, those paintings by Sebastiano that are housed in the Florentine galleries all belong to his Roman period, even though two of these, *La Fornarina* and the *Death of Adonis,* were executed shortly after his transfer from Venice. Together they reflect, in the monumentality of their figures, Giorgione's last phase—the "modern style" (in Vasari's phrase) expressed, for example, in the grandeur of Sebastiano's *Passionate Singer,* in the Borghese galleries. The dark atmosphere and the image of Venice clouded on the horizon out beyond the lagoon have received a secondary reading as a reflection of the dramatic events of the Cambrai war. But it is certainly evident that in his first contact with Rome, Sebastiano must have reached some sort of mental agreement with Raphael, as they probably found themselves working side by side on the walls of the loggia of the Farnesina, before the Venetian's more and more evident adherence to Michelangelo's style led to an open break with Sanzio. The Raphaelesque influence on Sebastiano's *Fornarina* is evidenced by its very title, invented in the nineteenth century, when the picture was attributed to Raphael himself; and indeed the painting, impressive for its size and its internal monumentality, follows representative conventions not generally associated with Venice, such as the use of gold for the necklace, the earrings, the hair, and the design picked out below the scalloped neck of the sitter's blouse—not to mention the paint, dense and intricately enameled, no longer partaking of the naturalism that served as a vehicle for the Giorgionesque style. The subject seems abstracted from every material contingency, and fixed in an emblematic pose. This tendency toward the abstract, a characteristic feature of mannerism, of which Sebastiano was one of the greatest champions in Rome, was a metaphor for the appearance of things, expressed in smooth, reflective surfaces and in a chromatic scale of supreme virtuosity in places; the same quality is evident in later works such as the *Martyrdom of St. Agatha,*

signed and dated 1520, and the powerful *Portrait of Baccio Valori* in the Palatine Gallery (probably executed in 1530–1531), an extraordinary exercise in "black on black" for a portrait of caste.

Raphael's Rome had a similar impact—though with very different results—on Lorenzo Lotto, another Venetian painter who was a few years older than Sebastiano. Lotto is known to have worked in one of the rooms of the Vatican in the first months of 1509, and by the time he returned to Jesi, in 1511, he was giving unequivocal signs of an acquaintance with both Raphael and Florentine culture. This is particularly obvious in the Uffizi's beautiful *Portrait of a Young Man* with its striking similarity to Raphael's *Portrait of Guidubaldo da Montefeltro* in the same gallery: Lotto's strongly classical formal sentiment and calculated compositional equilibrium do not preclude a tender visual exploration, an understanding of natural skin tones, as in the slight blush seen on the shy youth's cheek. These also speak clearly, in a manner comprehensible to all, of this artist's visual fidelity in the service of a lucid intelligence and a sentiment that is never less than effusively cordial. The same qualities may also be found seven or eight years later, in one of Lotto's masterpieces, *Susanna and the Elders*, dated 1517—though less in the scrolls that convey the dialogue (and that look like ancestors of the balloons in today's comic strips) than in the painting's apparent simplicity of presentation, its veracity of gesture (almost unforgettable in the case of the two young boys at the entrance to the bath), its supreme attention to the modulated vagaries of light in a landscape where the gentle slopes, the trees, the dew on the meadows, the humid and the vaguely hazy air, and the structure of the garden all have an intensely Lombard feeling. It is as if Lotto had managed to recover and to modernize the great Foppaesque and Solariesque tradition. The clarity of the scene, the staging of the narrative, and the psychological insight evidenced in the choice of this drama all impart a sense of absolute compositional liberty, even as they demonstrate Lotto's exceptional ability to conceal the most delicate machinery of plot, interrelationship, and harmonic agreement. And what can one say, then, about a painting such as the *Holy Family with St. Jerome*, of 1534, all blazing light and shadow, whose depth of feeling is so marked as to suggest that its composition is rooted in non-Italian sources? While mannerism had by now become the standard style of nearly all of the Italian peninsula—in Rome, Florence, and central Italy—Lotto personified, in the Marches, the phenomenon of resistance to that movement, in favor of a more timeless human sentiment.

We should now turn, however, to Giorgione's other "excellent creation," Tiziano Vecellio, who maintained a preeminent position in Venice from 1511—when, at the height of his powers, he energized painting and endowed the entire century with a sentimental tone—until the end of his long life in 1576. The great number of works by him and by his workshop in the Florentine galleries—notwithstanding their diverse provenances—gives a good indication of the extraordinary success Titian enjoyed during his life, and testifies as well to his nearly automatic

elevation to mythical status virtually at the moment of his death. These works cover almost the whole space of his career and constitute one of the most substantial nuclei of Titian's paintings in any museum in the world. Not all of them are on the same qualitative level, of course, but some are among the artist's greatest masterpieces.

One such work is the *Concert*, in the Pitti, painted in the second decade of the sixteenth century. Here the scheme of the Giorgionesque "situation portrait" is emblematized by and amplified to three figures, with the emphasis placed more on physical manifestations—of gesture and incident—than on psychological content. This shift from the internal to the external, from sentiment to gesture, is evident, too, in the varying quality of color, which no longer wraps the figures in the glow of Giorgione's warm shadows but instead carefully separates tone from tone, paying the greatest attention to the structure of the visual surface through its chromatic expanses: the triangle of cloth and the other one, of ocher, formed by the clothing of the young man on the left; the rhombus of the gray cloak against that of the bright white surplice, defined and interrupted by the handle of the lute.

Or consider the painter's so-called *Flora*, one of those feminine beauties seen most often in Venetian palaces—profane reimaginings, whether of love goddesses or simply of courtesans, from which Titian nonetheless fashioned, through meager pictorial means, some of painting's most extraordinary jewels. Foregoing richer materials, the painting comes marvelously to life in the mischievous dishabille of the figure's white nightdress, in her blond hair, in the unequalled tenderness of her ivory skin, barely modeled in the shadow between her breast and arm.

To continue with these examples of Titian's greatest works, one for each decade, we must of course turn to the *Venus* that left the artist's studio in 1538 to travel to its destination in Urbino. The classical iconography of the "Modest Venus" is here lucidly and ironically undermined, as the hand tactfully placed over the goddess's pubic area becomes the center and compositional axis of the painting, marking the exact point where the background is bisected by the bed-curtain! No modern Venus had ever looked this way before; she appears to be the same woman depicted in the so-called *Flora*, and she holds the same kind of nosegay in her hand. That she is a Venus of Titian's own time is expressly indicated by the two maidservants who are getting out her clothes, a wry telltale metaphor through which the goddess becomes—or is revealed as—a blond courtesan. It is useless to search for virtue beneath her beauty; even her little dog, symbol of fidelity, like Homer himself, now "sleeps."

Titian's influence during the second and third decades of the sixteenth century, whether directly or indirectly, had an effect even on those painters whose mentality and training were somewhat more archaic than his own. One such artist was Jacopo Palma of Bergamo, called Palma Vecchio, whose *Raising of Lazarus*, produced around the same time as the *Assumption* in the Venice Accademia (datable to 1513–1514), combines the formal geometry of Bellini with Titian's new conception of color. Palma was later completely won over to the latter's stylistic modes

and managed to mechanize the formula of the "chromatic zone" into one of "cuts of color" (in Longhi's phrase)—resulting in an exaggeration, or stretching, of surfaces and a consequent loss of potential for alluding to distance and depth. His images do, it is true, derive a certain solidity and stability from this, so that even those pictures that, like his *Judith*, portray dramatic or shocking events always convey a peaceful attitude, a sense of calm and of visual quiet.

A similar argument can be made for Bonifacio Veronese, whose first known work dates from 1533 but who fell under Titian's spell as early as 1510. In his work, however, unlike Palma's, form and volume never lose all their substance, and color is not used for brilliant surface effects but is instead an innate quality born of light and air. This is evident, for example, in one of his most beautiful paintings, the *Madonna and Child with Two People* (thought to represent Constantine and St. Helen), which was completed around 1530. If the composition here alludes strongly to Titian and Palma Vecchio, there is also a new, cooler, and vaguely Lottesque coloration and a disturbing sense of distance to the landscape, rendering it almost a painting separate from Venetian art.

Beginning in the 1530s, and then more decisively after around 1540, a new manner of painting emerged in Venice, in which drafting ability, splendid fantasy, and bold handling of form took precedence over elements of visual narrative. This development surely came about through exposure to and awareness of what was going on elsewhere, especially in Rome, but it was also—and perhaps primarily—in response to a desire for cultural change on the part of wealthy Venetian patrons, who, in the spirit of general renewal sparked by Doge Gritti, wanted their own city to catch up with Roman innovations.

The only Venetian painter who can confidently be defined as a mannerist in the Roman sense was Battista Franco, who was born in Venice around 1510 but was trained in central Italy, spending his early career in Rome, Tuscany, and the Marches, before returning to Venice in 1552. Datable to this year is his *Procession to Calvary*, a work that is perfectly aligned with the Tusco-Roman canon, falling between Michelangelo and Cecchino Salviati; here the only discernible Venetian touch is the sky with its clouds bathed in light from the hidden sun.

Seizing the middle ground between the central Italian and Venetian modes was another noteworthy painter, Giovanni Demio, who collaborated with Battista Franco on the ceiling paintings in the Libreria Marciana. His *Nativity* in the Pitti, for example, exhibits complex cultural influences: notwithstanding the drapery's somewhat whimsical fluttering and certain hyperbolic dimensional details (such as the feet with their gigantic toes), Demio embraced an atmospheric and chromatic naturalism to such an extent that in the eighteenth century this work could pass for a Correggio, as is seen in an engraving by Cosimo Mogalli after a drawing by Francesco Petrucci.

But if all of these were painters of great quality, they were nonetheless "outsiders." The real protagonists of this era, from the 1540s to the end of the century, were Titian (once again) and then three other new geniuses, all heads of pictorial dynasties in their own right: Tintoretto, Jacopo Bassano, and Veronese. These four men represented two diverse strains of Venetian painting—one dark and dramatic, full of turbulent interior shadows, the other Olympian, magnificently sunny and possessed of a joyous theatrical serenity apparently never sullied by the harshness of life. The great, tragic Titian took a determinative lead in the first of these styles by the end of the 1540s; anticipating Monet by centuries, he was able in his later years to paint with something like mud—some sort of contemptible achromatic substance—and to draw from it the signs of a dense living matter. From the same dramatic artistic line came the other masterful interpreters Tintoretto and Jacopo Bassano; Paolo Veronese, meanwhile, emerged from the other line.

The oldest of these latter three artists was Jacopo da Ponte, called Bassano after the city of his birth and residence. The son of a much less talented painter, Francesco da Ponte, Jacopo trained with Bonifacio Veronese but found his own voice in around 1540 by teaching himself, studying the "modern style" of the new artists who came to Venice, and paying careful attention as well to Roman engravings. He maintained throughout the strong chromatic naturalism and deeply felt sense of volume and form that were, up till then, his peculiar gift. Testament to this moment in Jacopo's career is the notably poetic *Madonna and Child with St. John as a Child* of around 1545, which introduces some more elegant formal modulations that have their roots in Parmigianino's work. We are still indebted to Bassano for his extraordinary broadening of visible concessions to pictorial representation: in the guise of biblical stories, metaphorical choices between the more ancient and remote times in human history, here are common folk of Bassano's own day, such as shepherds, and then later animals and herds of massive aspect. Within the context of contemporary painting, a work such as *Two Dogs* now seems almost revolutionary, at once a poetic and touching statement of the artist's love for these animals and a hymn to their natural beauty and freedom, under a clearing white sky. Produced in around 1555, it is an emotional masterpiece that had no parallel in Europe at the time; it is of no consequence that, as we know from documents, similar pictures were demanded by patrons. And what can be said of those works in which the same affection is lavished on copper cooking utensils and kitchen tools, on the fire in the grate that makes the metal shine, and on vast open landscapes? One can only wonder whether the inexhaustible inventiveness displayed by Jacopo in the course of his long career would have been possible outside of the relative isolation of the provinces; despite their exact contemporaneity, it is difficult to find the same quality of poetic sincerity in the "genre scenes" that came out of Antwerp, Cremona, and even Venice proper.

This introduction of everyday life into art, from biblical to pastoral themes, and the invention of painting cycles, generally comprising four canvases for a complete allegorical development, proved a great boon to Jacopo's workshop. His many assistants (beginning with his own sons)

were able to carry out innumerable commissions, assuring him of an extraordinary success that continued well into the next century.

Jacopo Tintoretto's paintings were of an entirely different tenor. After a training period of difficult individuation under such tutelary gods as Pordenone, Titian, Bonifacio Veronese, and possibly even Giulio Romano, he seems to have became conscious in around 1540 of the new cultural dimensions emanating from Rome, and chose to position himself, according to the old accounts, Pino (1548) and Ridolfi (1648), in a difficult balance between the styles of Titian and Michelangelo. His continuous study of the latter—of his torsions and the impassioned positions of his statues—was doubtless a fundamental factor in Tintoretto's art, as was his adoption of a brushstroke that diverged from Titian's example, gradually breaking free of representational finality to portray only itself, for its own sake. The nonchalance of his gestures constituted a further innovation. Beginning in around 1550 the use of shadows, falling either forward or back, became much more common in Tintoretto's painting; working out compositions with the aid of little mannequins positioned inside puppet theaters illuminated by candlelight greatly increased his general understanding of the dramatic use of light from various sources, as well as his particular fondness for laterally radiant raking light. With this formula, space lost its common measure; it was stretched or narrowed, becoming indefinable, whereupon the atmosphere no longer needed a rational definition in terms of perspective but could instead legitimize every hyperbolic fantasy. Amid such smoky darkness, filled with flying figures in unnatural and incredible poses, Tintoretto's world is a place wholly intellectual and abstract, an almost hallucinatory and oneiric realm of possibility, awash in anguish over the loss of every reassuring link to reality. He can be seen at his best in *Athena and Arachne* and *Diana and Endymion*, the two canvases in the Pitti Meridiana that were originally intended to decorate the ceiling of a Venetian palace; almost coeval with Vasari's panels for the Palazzo Corner ceiling, Tintoretto's compositions demonstrate the great lengths to which he was willing to go to effect an inventive fantasy.

From Tintoretto we may turn to Paolo Veronese. Although these two artists' careers were long linked in the arena of Venetian art, the differences between them were so great that they might have been from different planets. Marvelous inlaid surfaces built up with cool intonations of color, surprisingly rich and transparent, are characteristic of Veronese's work, best described by the poet Boschini in 1660: "It might be said that the Painter, to obtain his effects / Blends gold, pearls, and rubies / And emeralds and sapphires, even finer, / And the purest and most perfect diamonds." Superbly distanced from the object of representation, from every obligation to the visual givens of nature and every vehicle for human passion, Veronese's settings have the luminosity of paste glass; they can be admired for their supreme ability to harmonize and for the beauty of their calligraphy, almost like a stream spun out of a minute point. These images and the stories that they tell often have the dense chromatic saturation of stained glass and the dazzling aspect of the most luxurious theater set with costumes and scenery assembled by a most exceptional property-man.

The pure and serene expression of an untroubled Olympian fantasy, Veronese's world was an almost continuous feast, replete with the highest heavens and great expanses of air, extraordinary architectonic surroundings and objects—infinite objects—astounding costumes and elegant greyhounds, fairy-tale landscapes, cupids and angels with multicolored wings, and exotic birds: a surprising pattern book of the universe. Indeed, in the course of the seventeenth century, his art would begin to seem like the only hope of escape from the darkness and threatening gloom of the post-Caravaggisti and their circle. It would have a natural appeal for the new, airy Venetian taste of the baroque era, embraced by artists from Sebastiano Ricci to Pellegrini.

The radical diversity between Veronese and his contemporaries can perhaps be explained by the former's training, which took place in the city of his birth and probably also during a journey he took to Florence in around 1550; but it must also be attributed, at least in part, to his personal geniality. Veronese was a painter who would "second joy, render beauty splendid, and make laughter more festive," in Ridolfi's lovely words of 1648; and in fact, in a work such as the *Martyrdom of St. Justina*, how can one fail to see that there is no sense of tragedy whatsoever about the saint's murder, only fascination with the mutable fabric of her dress and its indeterminate color—between pink, blue, and orange—with the black executioner in an unbelievably gaudy red cap, petal-shaped cape, and fantastic tricolored striped stockings, or with the beautiful white marble columns placed in the background for no discernible structural reason? In the Uffizi's little *St. Agatha Crowned by Angels*, the eye is once again drawn to the intricate web of brushstrokes, dense as blown glass.

Paolo Veronese and his world were the first to vanish, in 1588; the dynasty that seemed assured by his young and most noteworthy son Carletto lasted a mere eight years, until his premature death at age twenty-six. In 1592 Jacopo Bassano, too, departed this life, not long after the suicide of his most gifted son, Francesco. Although Jacopo Tintoretto died in 1594, his methods were carried on well into the seventeenth century by his son Domenico. With the passing of these three figures, the century closed on a minor note, with a long succession of followers; it had been, however, the century in which Venetian painting had triumphed on the stage of European art.

Mauro Lucco

325
GIORGIONE
Moses' Trial by Fire
Panel, 35¹⁄₁₆ × 28⅜ in. (89 × 72 cm)
Uffizi, Gallery; inv. 1890: no. 945
This panel was first documented in the collection of the Tuscan grand duke at Poggio Imperiale in 1692. After entering the Uffizi in 1795 as the work of Giovanni Bellini, it was reattributed to Giorgione and a collaborator, variously identified as Giulio Campagnola, Vincenzo Catena, an unknown Ferraran painter, or Giovanni Agostino da Lodi. It is now considered to be an early work by Giorgione alone, dating from around 1495–1496.

326
GIORGIONE
The Judgment of Solomon
Panel, 35¹⁄₁₆ × 28⅜ in. (89 × 72 cm)
Uffizi, Gallery; inv. 1890: no. 947
A pendant painting to the preceding one, with which it has shared external and critical events. Although it has long been thought that the figures betray the work of a different collaborator, weaker than Giorgione's assistant on *Moses' Trial by Fire*, the figures are in fact the only elements that appear somewhat more archaic. Like the other work, it can be dated to around 1495–1496.

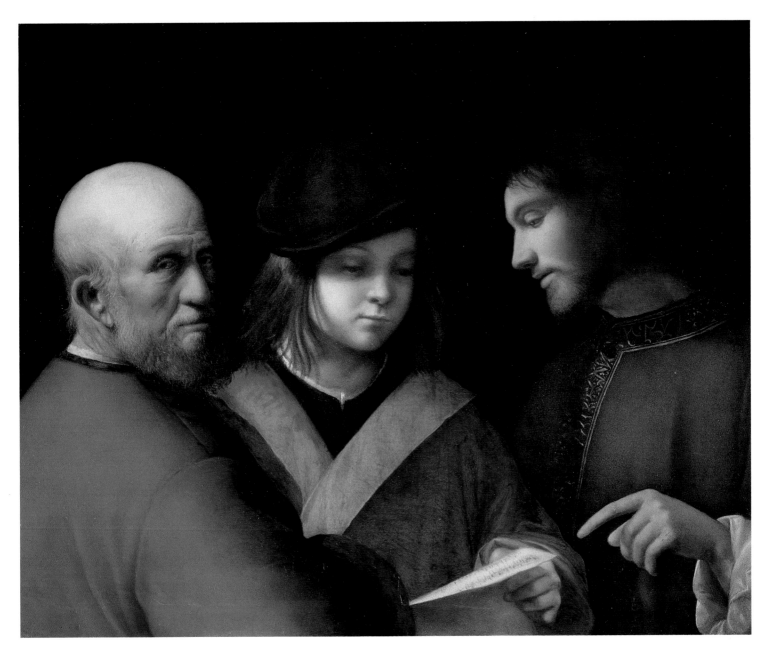

327

GIORGIONE

The Singing Lesson

Panel, 24⁷⁄₁₆ × 30⁵⁄₁₆ in. (62 × 77 cm)

Pitti, Palatine Gallery; inv. 1912: no. 110

This painting was first recorded in the collection of Grand Prince Ferdinand de' Medici in 1698. It was put up for sale in Venice in 1666 as part of Nicolò Renieri's collection, and before that was listed in an inventory of 1567–1569 as having belonged to Gabriele Vendramin. It is generally known as *The Three Ages of Man*.

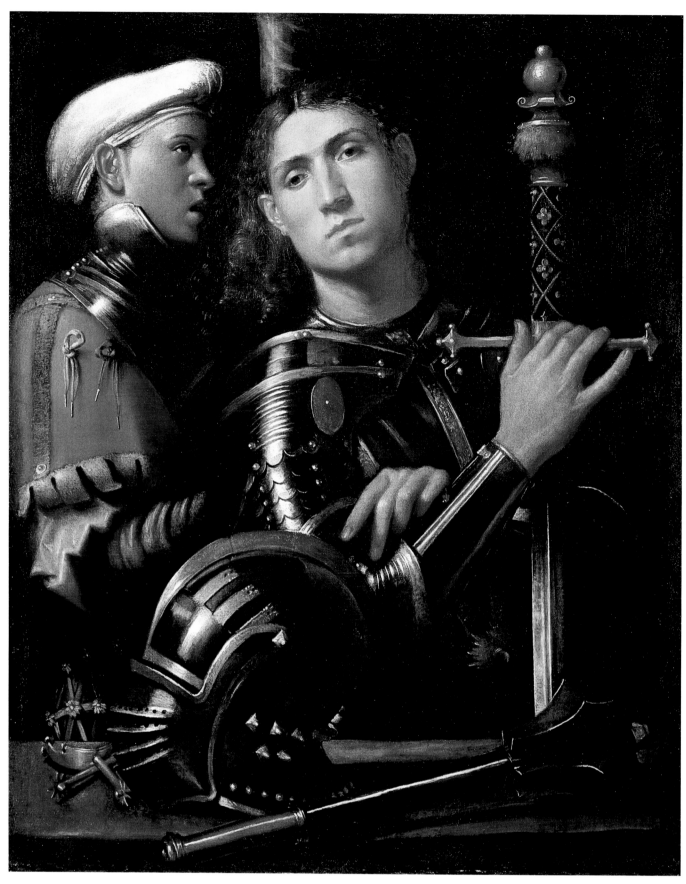

328
GIORGIONE (attributed to)
Portrait of a Man in Armor with His Page
Canvas, 35⁷⁄₁₆ × 28³⁄₄ in. (90 × 73 cm)
Uffizi, Gallery; inv. 1890: no. 911

The painting came to the Uffizi in 1821 as part of an exchange with the Imperial Gallery in Vienna. Originally attributed to Giorgione, it was later reassigned to various other painters (it was long thought, for instance, to be by Cavazzola) and is also known as the *Portrait of Gattamelata*. It dates from around the first years of the sixteenth century.

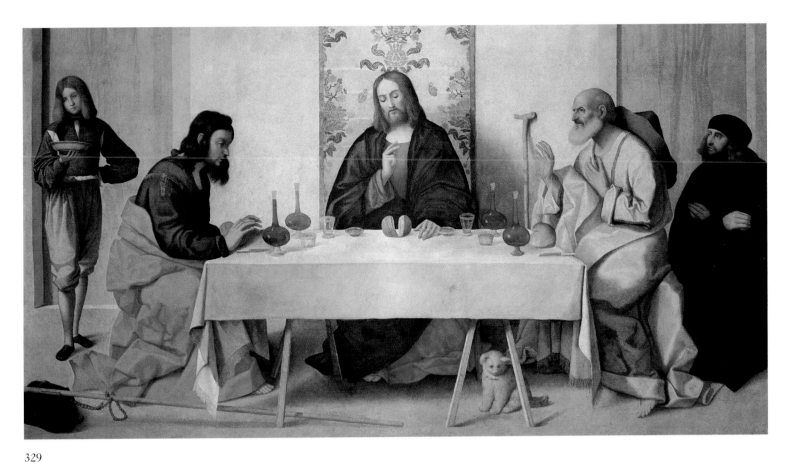

329

VINCENZO CATENA

The Supper at Emmaus

Panel, 51³⁄₁₆ × 94⅞ in. (130 × 241 cm)

Pitti, Meridiana (temporary location); inv. Contini Bonacossi, no. 15

The iconography of this work is derived largely from a painting of 1490 by Giovanni Bellini, which was destroyed in the eighteenth century in Vienna and is now known only through engravings. A late work by Catena, painted around 1525 or later, it combines Belliniesque features with elements drawn from Titian. Another version, with slight variations, can be found in the Accademia Carrara in Bergamo.

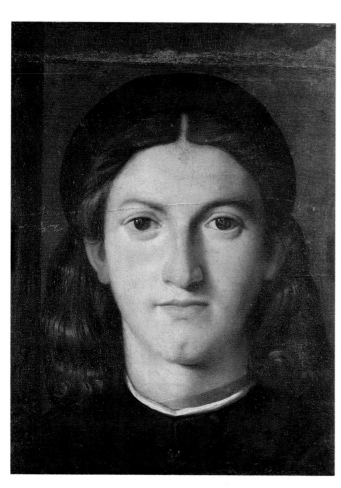

330
LORENZO LOTTO
Portrait of a Young Man
Panel, 11¹⁄₁₆ × 8¹¹⁄₁₆ in. (28 × 22 cm)
Uffizi, Gallery; inv. 1890: no. 1481
This painting came to the Uffizi in 1675 as part of Cardinal Leopoldo de' Medici's legacy, and it was thought to be a portrait of Raphael executed by Leonardo da Vinci. It was restored to Lotto in 1910 and dated to around 1505.

Opposite: 332
LORENZO LOTTO
Susanna and the Elders
Panel, 26 × 19¹¹⁄₁₆ in. (66 × 50 cm)
Signed and dated: LOTUS PICTOR 1517
Uffizi, Gallery; inv. 1890: no. 9491
One of Lotto's great masterpieces, this painting dates from the time of his stay in Bergamo. It is a perfect example of the artist's work.

331
LORENZO LOTTO
Madonna and Child with SS. Jerome, Joseph, and Anne
Oil on canvas, 27³⁄₁₆ × 34⁷⁄₁₆ in. (69 × 87.5 cm)
Signed: LORENZO LOTO 1534
Uffizi, Gallery; inv. 1890: no. 893
This painting was in the collection of Grand Prince Ferdinand de' Medici by 1713.

333
PALMA VECCHIO
The Raising of Lazarus
Panel, 37 × 43⁵⁄₁₆ in. (94 × 110 cm)
Signed: JACOBUS PALMA P.
Uffizi, Gallery; inv. 1890: no. 3256
Acquired for the gallery in 1916 from the Salvadori collection in Venice, this work dates from around 1514–1515. A smaller version is owned by the Johnson collection in Philadelphia.

335
PALMA VECCHIO
Judith with the Head of Holofernes
Panel, 35⁷⁄₁₆ × 27¹⁵⁄₁₆ in. (90 × 71 cm)
Uffizi, Gallery; inv. 1890: no. 939

Left to the gallery in 1631 as part of the Vittoria della Rovere inheritance, this panel is considered to be typical of the last phase of Palma Vecchio's career, around 1525. It is characterized by the almost Pordenonian formal expansiveness seen in Titian's *modelli*.

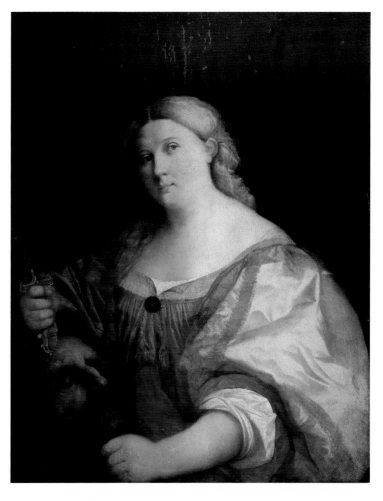

Opposite: 334
PALMA VECCHIO
The Holy Family with the Young St. John and St. Mary Magdalen
Oil on panel, 34¼ × 46¹⁄₁₆ in. (87 × 117 cm)
Uffizi, Gallery; inv. 1890: no. 950

This painting came to the Uffizi from Vienna in an exchange made in 1793. It was probably produced by Palma's workshop.

336
GIOVANNI FRANCESCO CAROTO
The Massacre of the Innocents
Panel, 63¾ × 41⁵⁄₁₆ in. (162 × 105 cm)
Signed: I. FRANCISCUS CAROTUS V. F
Uffizi, Depository; inv. 1890: no. 3392

This panel, along with another, also in the Uffizi, depicting the Flight into Egypt, was in the church of the Ospedale di San Cosimo in Verona. Recorded there in 1568 by Vasari, who placed them among the artist's earliest works, they served as doors for an altar of the Magi, at the center of which stood a Madonna and Child in terra cotta. They were acquired in 1908 from the Marchese Carlo Cavalli and can be dated from around 1505.

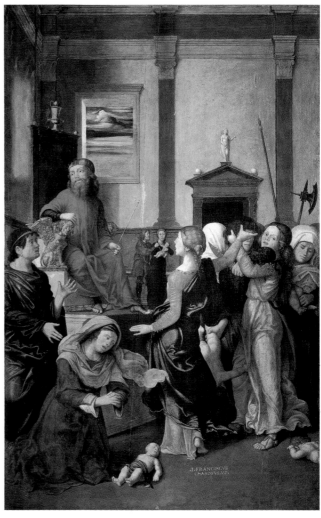

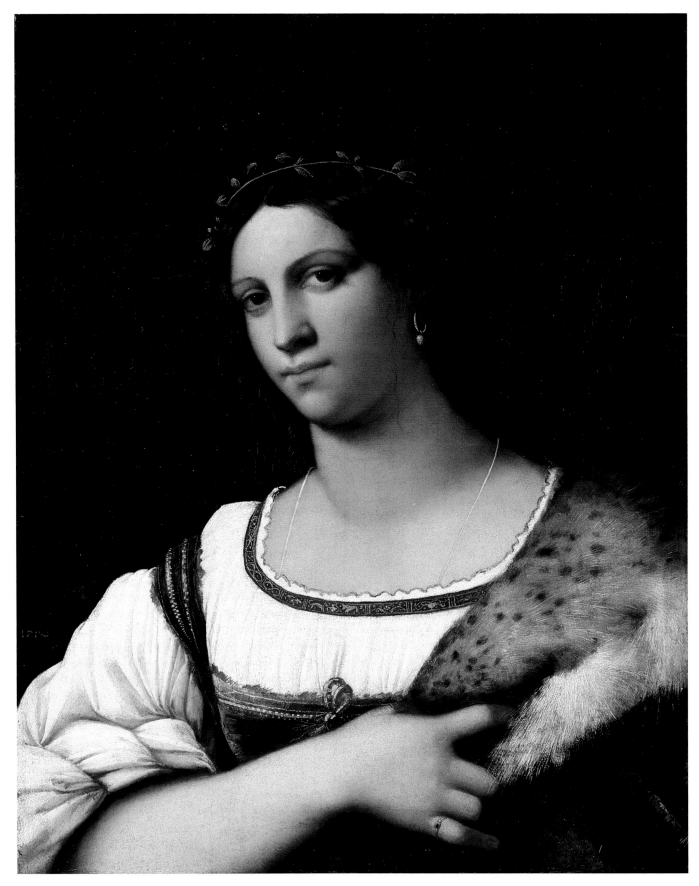

337
SEBASTIANO DEL PIOMBO
La Fornarina
Panel, 26 × 20⅞ in. (66 × 53 cm)
Dated: 1512
Uffizi, Gallery; inv. 1890: no. 1443
This painting came from the Medici collections and was displayed in the Uffizi's Tribune by 1589. Up until almost the end of the nineteenth century it was thought to be by Raphael; the title, still in use, originated at the beginning of that century, based on the conviction that it was
256 an autograph work by the artist.

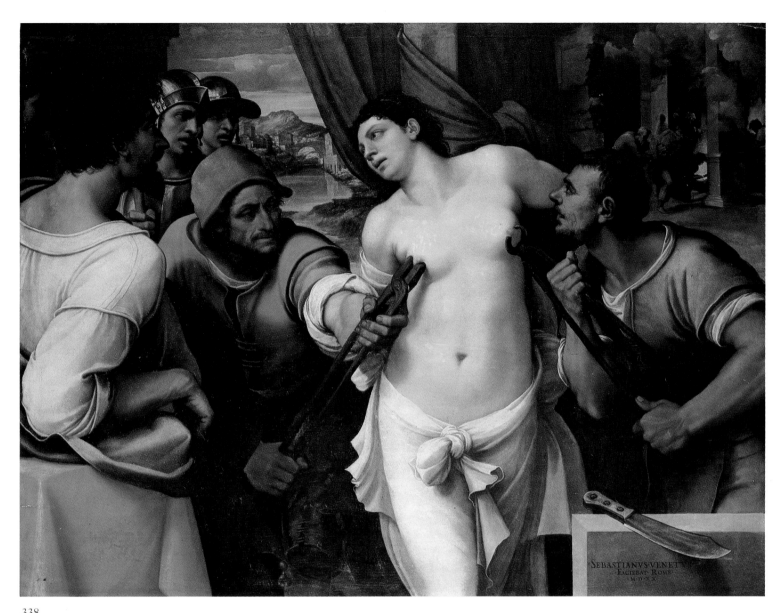

338
SEBASTIANO DEL PIOMBO
The Martyrdom of St. Agatha
Panel, 51⁹⁄₁₆ × 68⁷⁄₈ in. (131 × 175 cm)
Signed and dated: SEBASTIANUS VENETUS FACIEBAT ROMAE MDXX
Pitti, Palatine Gallery; inv. 1912: no. 179

Vasari admired this painting greatly when he recorded it in the Guardaroba in Urbino. It came to the Florentine galleries in 1631 with Vittoria della Rovere's inheritance. There is a very beautiful preparatory drawing for the figure of St. Agatha in the Cabinet des Dessins in the Louvre.

Overleaf: 339
SEBASTIANO DEL PIOMBO
The Death of Adonis
Oil on canvas, 74⁷⁄₁₆ × 112³⁄₁₆ in.
(189 × 285 cm)
Uffizi, Gallery; inv. 1890: no. 916

Then identified as the work of Moretto da Brescia, this painting came to the Uffizi as part of Cardinal Leopoldo de' Medici's inheritance. It is in fact a masterpiece from Sebastiano's first period in Rome, in 1511–1512, incorporating aspects of the work of both Raphael and Michelangelo. Its compositional arrangement and its treatment of the group of trees to the right are clearly derived from Giorgione's *Three Philosophers* in Vienna, while its morose tone seems to refer to the disastrous war of Cambrai, of 1509. The painting was damaged in the recent car-bomb explosion near the Uffizi.

257

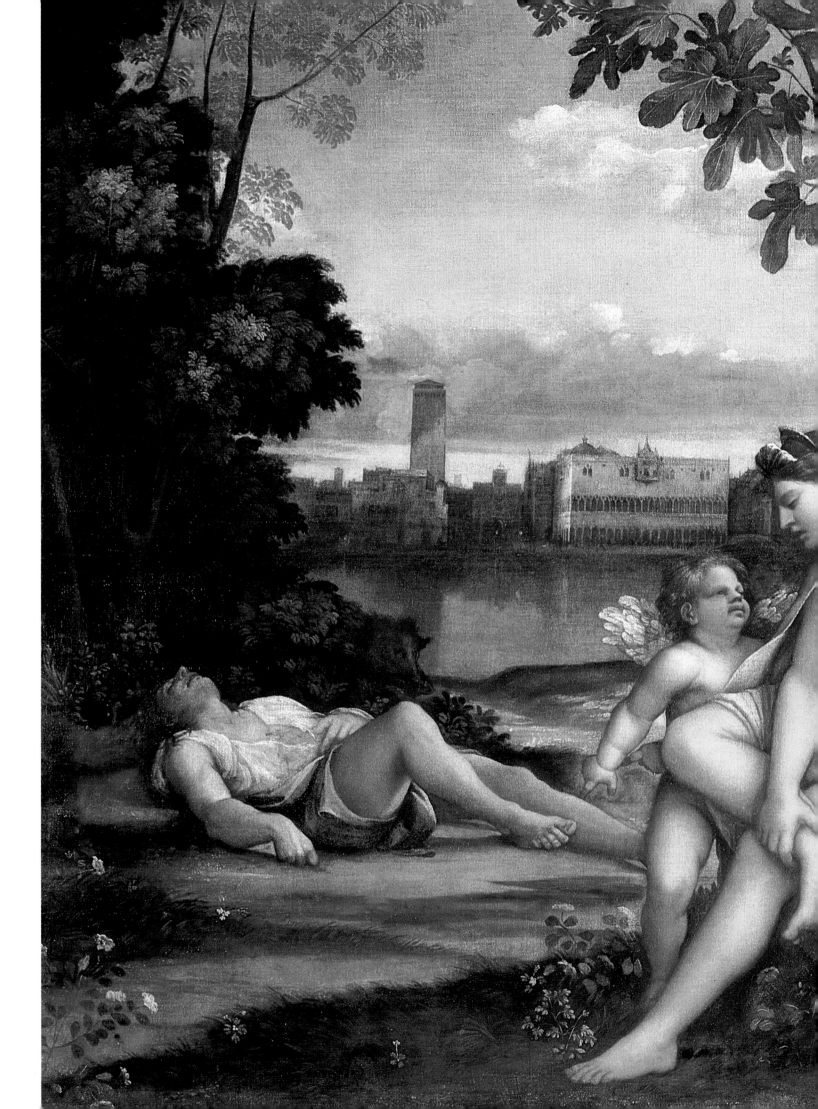

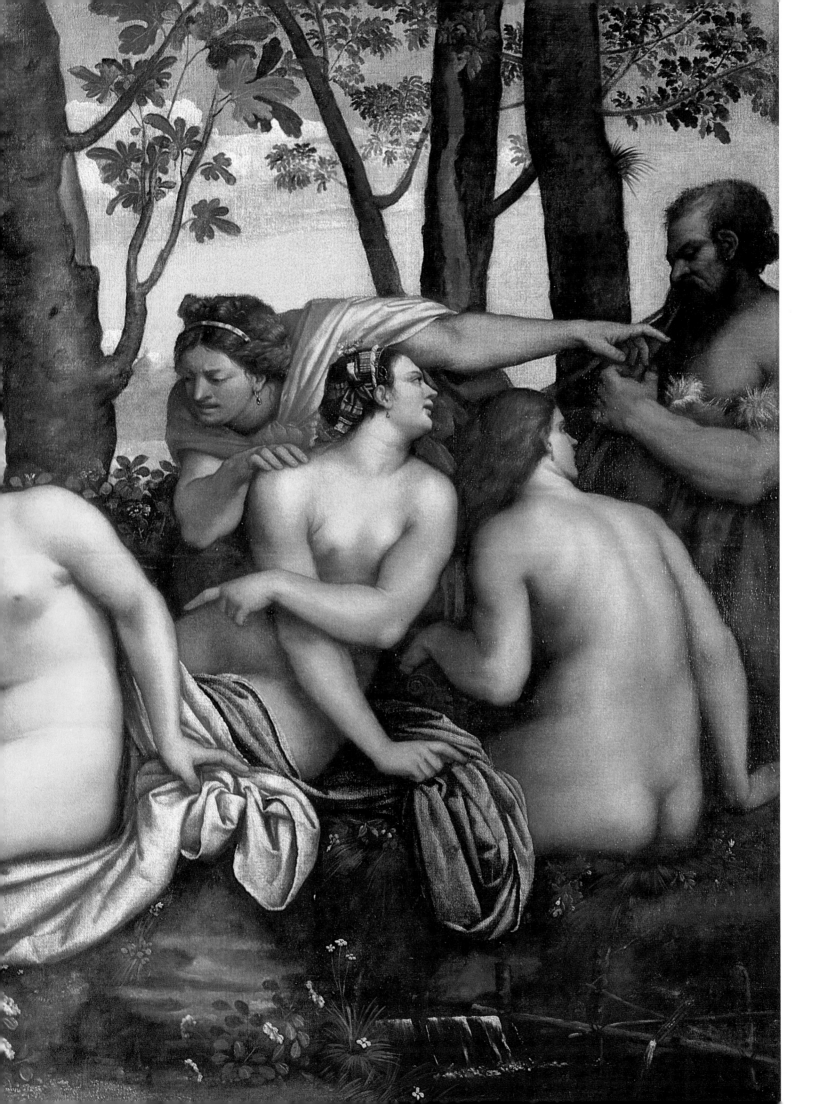

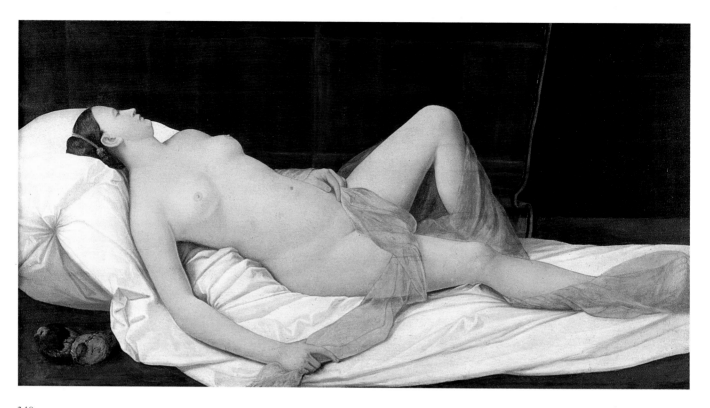

340

BERNARDINO LICINIO

Reclining Female Nude

Oil on canvas, 31¹¹⁄₁₆ × 60⅝ in. (80.5 × 154 cm)

Uffizi, Gallery; inv. 1890: no. 9943

Formerly in the Neues Galerie in Munich (1923) and in the Contini Bonacossi collection in Florence (1935), this painting was taken to Germany in 1941 and recovered by Siviero in 1953. It has been variously attributed over the years but is now considered to be a typical early work of Bernardino Licinio, from around 1510, and displays an interest in Sebastiano del Piombo's Venetian period.

341

BONIFACIO VERONESE

Moses Saved from the Water

Oil on panel, 12³⁄₁₆ × 43¹¹⁄₁₆ in. (31 × 111 cm)

Pitti, Palatine Gallery; inv. 1912: no. 161

This work came to the gallery in 1675 as part of Cardinal Leopoldo de' Medici's inheritance, with an attribution to Paolo Veronese; in the nineteenth century it was given to Giorgione. It is the front of a *cassone*, of a type commonly produced in Bonifacio's workshop, and is datable to around the 1540s.

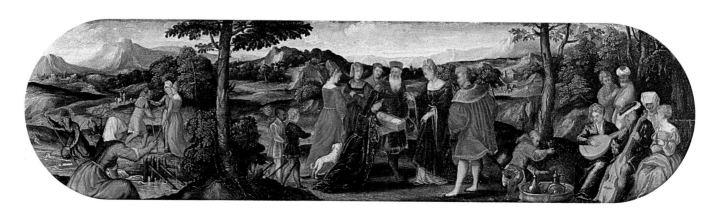

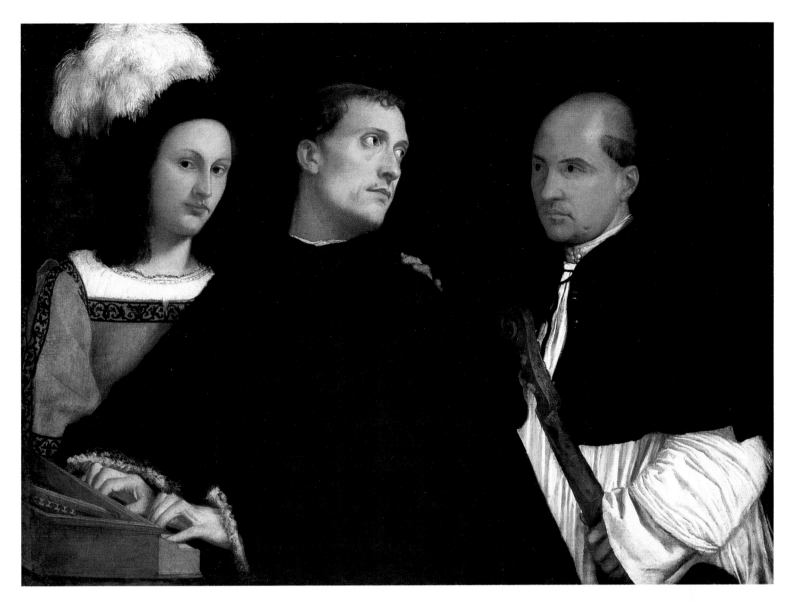

342
TITIAN
The Concert
Oil on canvas, 34¹⁄₁₆ × 48⁵⁄₈ in. (86.5 × 123.5 cm)
Pitti, Palatine Gallery; inv. 1912: no. 185

This work was given to the gallery in 1675 with the inheritance of
Cardinal Leopoldo de' Medici, who had acquired it in 1654 from
Paolo del Sera, in whose house in Venice Ridolfi had noted it in
1648. Some scholars have attempted to identify the painting as the
Portrait of Verdelot and Obrecht by Sebastiano del Piombo cited by
Vasari. The painting dates from the years immediately following
Titian's frescoes in Padua, around 1512–1513.

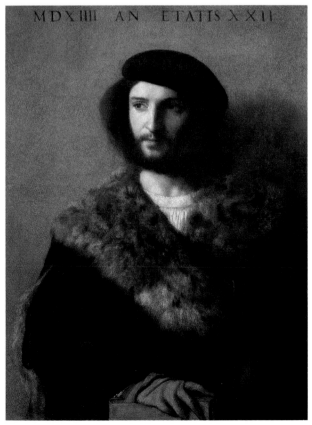

343
TITIAN
Portrait of a Man ("The Sick Man")
Oil on canvas, 31⁷⁄₈ × 23⁵⁄₈ in. (81 × 60 cm)
Dated: MDXIIII AN ETATIS XXII
Uffizi, Gallery; inv. 1890: no. 2183

This painting, too, came from Cardinal Leopoldo de' Medici's
collection. Once thought to be by Sebastiano del Piombo, it is now
generally assigned to Titian, though that attribution is still open to
question.

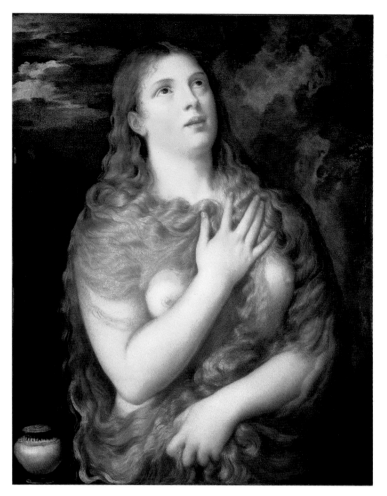

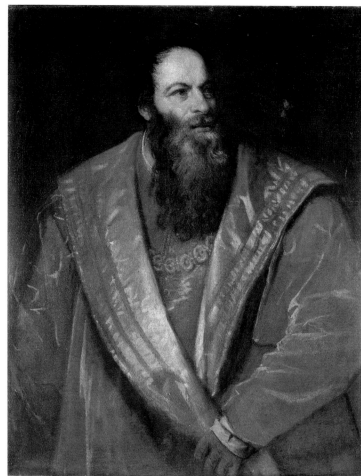

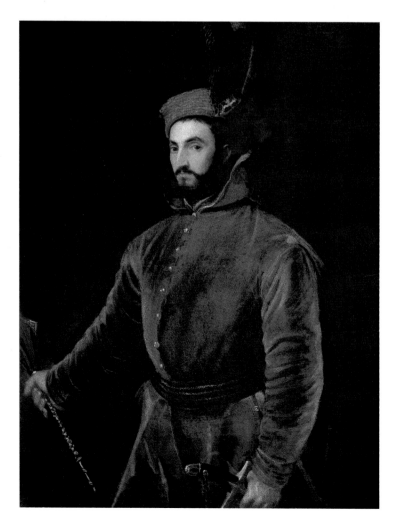

344
TITIAN
Mary Magdalen
Oil on panel, 33⅟₁₆ × 27³⁄₁₆ in. (84 × 69 cm)
Pitti, Palatine Gallery; inv. 1912: no. 67
This painting came to the gallery in 1631 as part of Vittoria della Rovere's inheritance; it is datable to around 1533–1535.

345
TITIAN
Portrait of Pietro Aretino
Oil on canvas, 38⅟₁₆ × 30⁹⁄₁₆ in. (96.7 × 77.6 cm)
Pitti, Palatine Gallery; inv. 1912: no. 54
Painted in October 1545, this portrait was presented by Aretino to Grand Duke Cosimo I that same year.

Opposite: 347
TITIAN
Flora
Oil on canvas, 31½ × 25 in. (80 × 63.5 cm)
Uffizi, Gallery; inv. 1890: no. 1492
The Uffizi acquired this work through an exchange in 1793 with the Imperial Gallery in Vienna. Among the artist's more stirring paintings, it probably dates from around 1514.

346
TITIAN
Portrait of Ippolito de' Medici in a Hungarian Costume
Oil on canvas, 54¾ × 42⅛ in. (139 × 107 cm)
Pitti, Palatine Gallery; inv. 1912: no. 201
Said by Vasari to have been executed in Bologna in 1533, this work has always been part of the Medici collection, where it was recorded for the first time in an inventory of 1595.

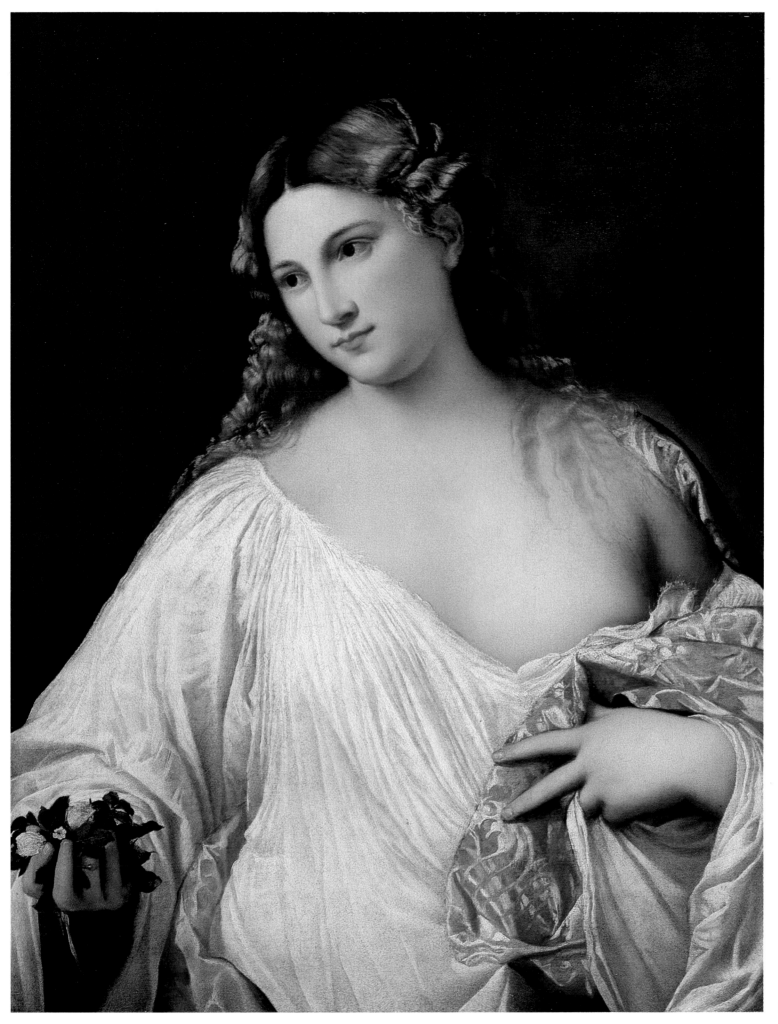

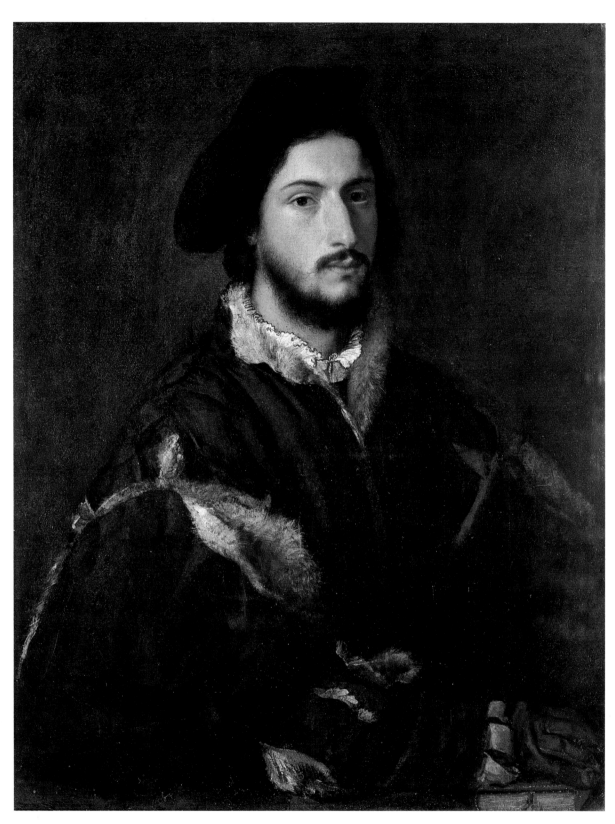

348

TITIAN

Portrait of a Gentleman ("Tommaso Mosti")

Oil on canvas, 33⁷⁄₁₆ × 26³⁄₈ in. (85 × 67 cm)

Pitti, Palatine Gallery; inv. 1912: no. 495

Catalogued in Cardinal Leopoldo de' Medici's collection in 1663,
this painting came to the galleries as part of his inheritance in 1675.
It dates from around 1516–1518.

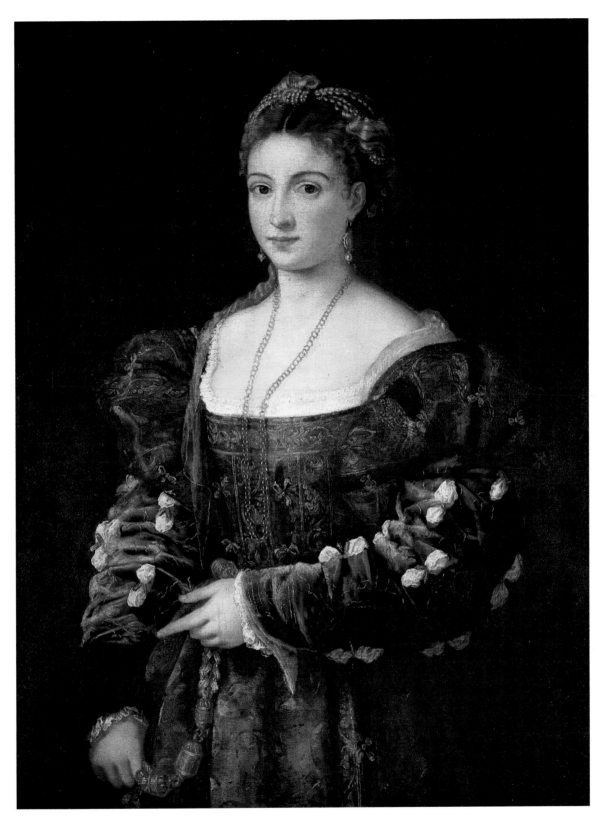

349
TITIAN
Portrait of a Woman ("La Bella")
Oil on canvas, 35 1/16 × 29 3/4 in. (89 × 75.5 cm)
Pitti, Palatine Gallery; inv. 1912: no. 18

This painting has been identified as the "portrait of the woman in a blue dress" that Duke Francesco Maria della Rovere repeatedly asked Titian about, in two letters dated May 2 and July 10, 1536, and which was carried by his agent Gian Giacomo Leonardi. It entered the gallery in 1631 as part of Vittoria della Rovere's inheritance.

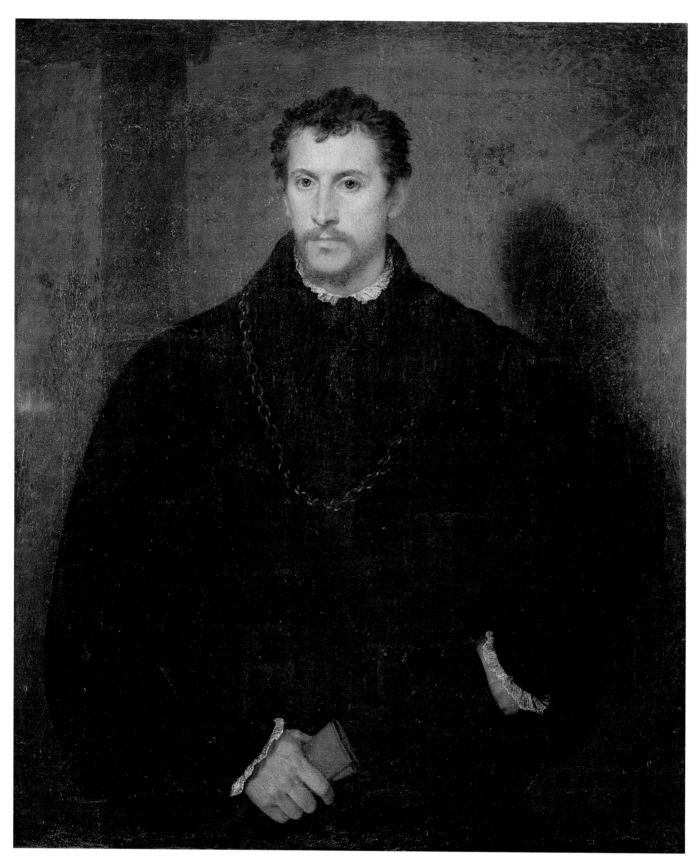

350
TITIAN
Portrait of a Gentleman ("The Young Englishman")
Oil on canvas, 43¹¹⁄₁₆ × 37¹³⁄₁₆ in. (111 × 96 cm)
Pitti, Palatine Gallery; inv. 1912: no. 92

Already in the collection of the Grand Prince Ferdinando de' Medici in 1698, this work came to the gallery in 1713. The sitter has been identified as the Ferraran jurist Ippolito Riminaldi; the portrait's traditional title, "The Young Englishman," dates only from the end of the nineteenth century. It is a splendid example of Titian's portraiture of around 1545.

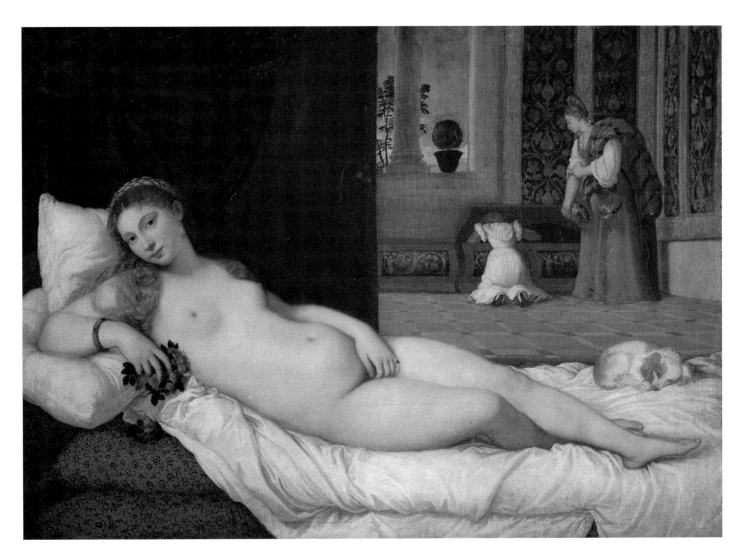

351
TITIAN
Venus ("Venus of Urbino")
Oil on canvas, 46⅞ × 65 in. (119 × 165 cm)
Uffizi, Gallery; inv. 1890: no. 1437
This painting of a "nude woman" is mentioned in two letters from Guidubaldo da Montefeltro, of March 9 and May 1, 1538. It left Titian's studio in the summer of the same year, bound for Urbino, where Vasari saw it in 1548. The painting came to the gallery in 1631 with Vittoria della Rovere's inheritance.

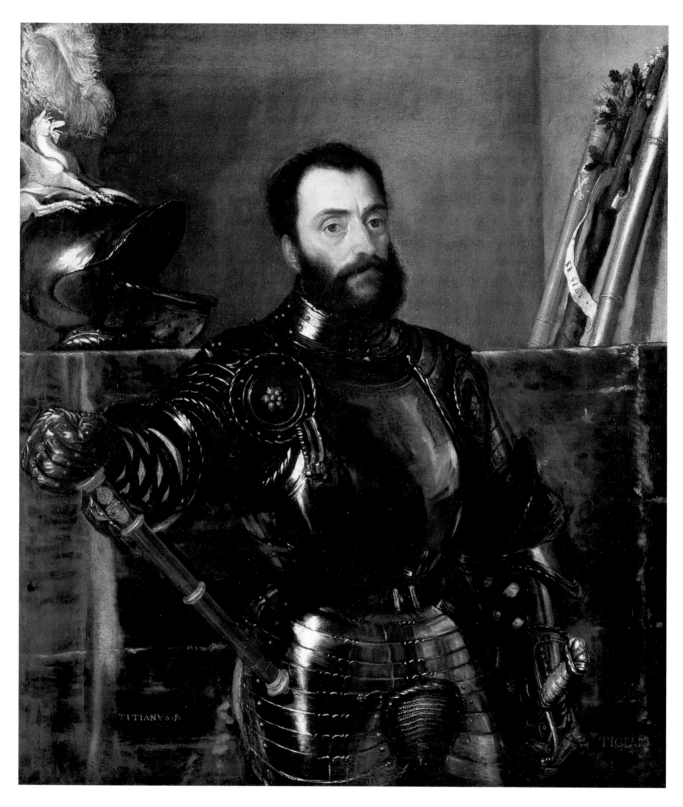

352

TITIAN

Portrait of Francesco Maria della Rovere

Oil on canvas, 44⅞ × 4⁹⁄₁₆ in. (114 × 103 cm)

Uffizi, Gallery; inv. 1890: no. 926

This portrait of Francesco Maria della Rovere was said to be nearly
finished in a letter of 1536 from the duke. It arrived in Pesaro on
April 14, 1538, and came to the gallery in 1631 with the legacy of
Vittoria della Rovere.

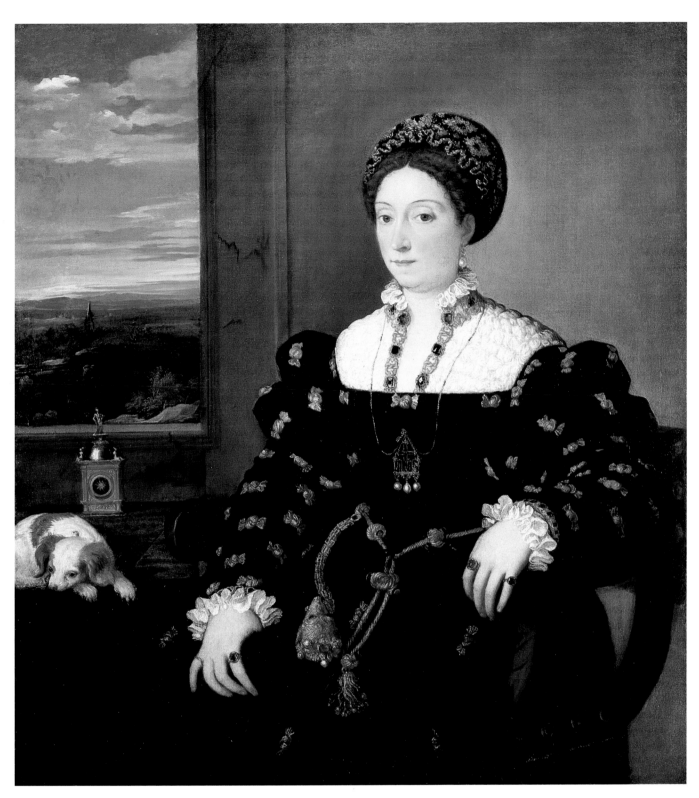

353

TITIAN

Portrait of Eleonora Gonzaga della Rovere

Oil on canvas, 44⅞ × 40⁹⁄₁₆ in. (114 × 103 cm)

Uffizi, Gallery; inv. 1890: no. 919

A letter of 1537 from Pietro Aretino to Veronica Gambara announced that this portrait, along with that of Francesco Maria della Rovere, was almost done. Both pictures reached Pesaro on April 14, 1538, and entered the Florentine gallery in 1631 as part of Vittoria della Rovere's inheritance. Eleonora's portrait was probably begun during her journey to Venice in 1536–1537.

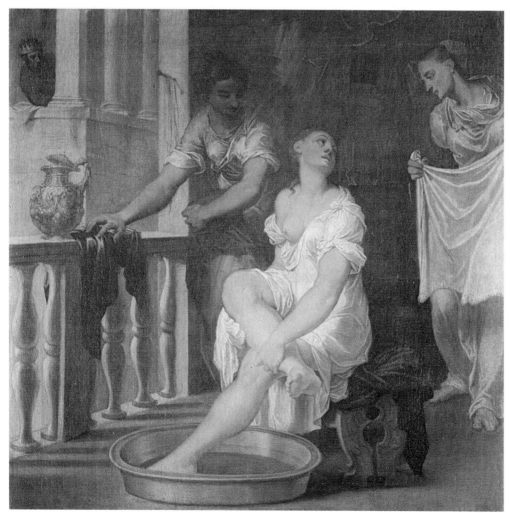

356
DOMENICO BRUSASORCI
Bathsheba at Her Bath
Oil on canvas, 35¹³⁄₁₆ × 38⁹⁄₁₆ in. (91 × 98 cm)
Uffizi, Gallery; inv. 1890: no. 953
This painting came to the gallery in 1675 as part of Cardinal Leopoldo de' Medici's legacy. Attributed to Brusasorci in 1929 by Venturi, it is considered to be a typical work by this artist, executed shortly after his paintings of 1552 for the Duomo in Mantua.

270

357
SEBASTIANO FLORIGERIO
Portrait of Raffaele Grassi
Oil on canvas, 50 × 40⁹⁄₁₆ in. (127 × 103 cm)
Uffizi, Gallery; inv. 1890: no. 894

The gallery acquired this work (then given to Titian) in 1675 with Cardinal Leopoldo de' Medici's inheritance. Gamba, writing in 1924, recognized the hand of Florigerio and identified the portrait with the likeness of Grassi, father of the Udinese painter Giambattista Grassi, that was mentioned by Vasari in 1568. It can be dated to a little after 1530.

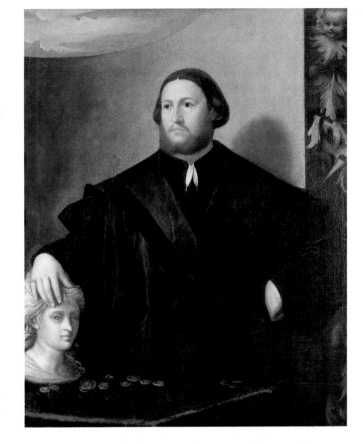

Opposite: 354
PARIS BORDONE
Portrait of a Woman ("Balia dei Medici")
Oil on canvas, 42⅛ × 32¹¹⁄₁₆ in. (107 × 83 cm)
Pitti, Palatine Gallery; inv. 1912: no. 109

Part of Cardinal Leopoldo de' Medici's inheritance, this portrait is considered typical of the artist's work, with strong mannerist overtones. It dates from around 1545–1550.

355
AMICO FRIULANO DEL DOSSO
Portrait of an Unknown Man
Oil on canvas, 30¹¹⁄₁₆ × 23⅝ in. (78 × 60 cm)
Uffizi, Gallery; inv. 1890: no. 1688

This painting came to the gallery in 1691 through the efforts of Cosimo III de' Medici; at that time it was believed to be a self-portrait by Sodoma. Ascribed in turn to Alessandro Oliverio and Sebastiano del Piombo, the painting belongs to a group of works linked together by Longhi (in 1960) under the descriptive name "Amico Friulano del Dosso" (or "Friulian friend of Dosso").

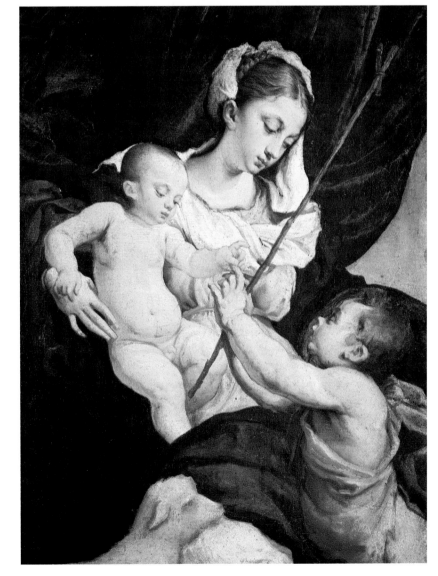

358
JACOPO BASSANO
Madonna and Child with St. John as a Child
Oil on canvas, 31⅛ × 23⅝ in. (79 × 60 cm)
Signed: JAC. S A. PONTE BASSANES PINXIT
Pitti, Meridiana (temporary location); inv.
Contini Bonacossi: no. 18

Datable to around 1545, this painting is a reworking of a similar composition today in the Accademia Carrara in Bergamo.

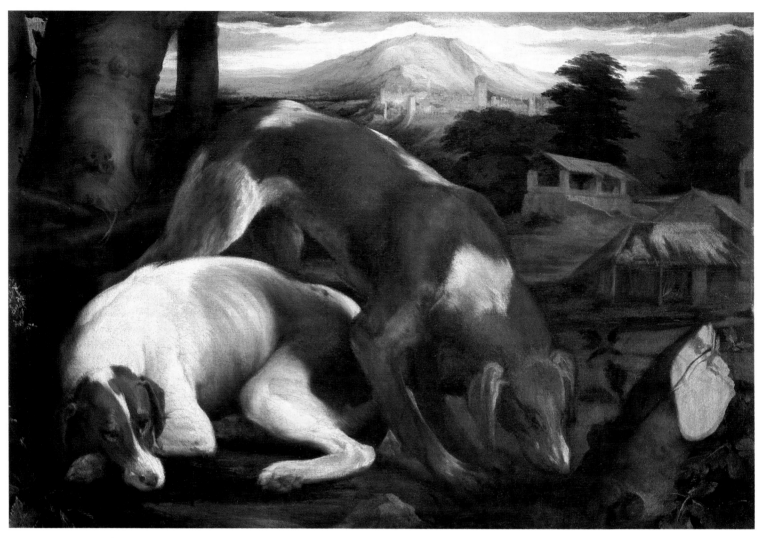

359
JACOPO BASSANO
Two Dogs
Oil on canvas, 33⁷⁄₁₆ × 49⁵⁄₈ in. (85 × 126 cm)
Uffizi, Gallery; inv. 1890: no. 965
Once in the collections of Giovan Carlo de' Medici (in 1663) and Cardinal Leopoldo
de' Medici, this canvas shows Jacopo at his most poetic. It dates from around 1555.

Opposite: 360
FRANCESCO BASSANO
Rural Scene
Oil on canvas, 36⁵⁄₈ × 48 in. (93 × 122 cm)
Pitti, Palatine Gallery; inv. 1912: no. 383
Painted as a pendant to a *Rustic Scene* by
the same artist.

361
LEANDRO BASSANO
The Concert
Oil on canvas, 44⁷⁄₈ × 70¹⁄₁₆ in. (114 × 178 cm)
Uffizi, Gallery; inv. 1890: no. 915
Listed under the name of Jacopo Bassano in
a gallery inventory from 1704, this is in fact
a characteristic work by his son Leandro,
datable from around 1590.

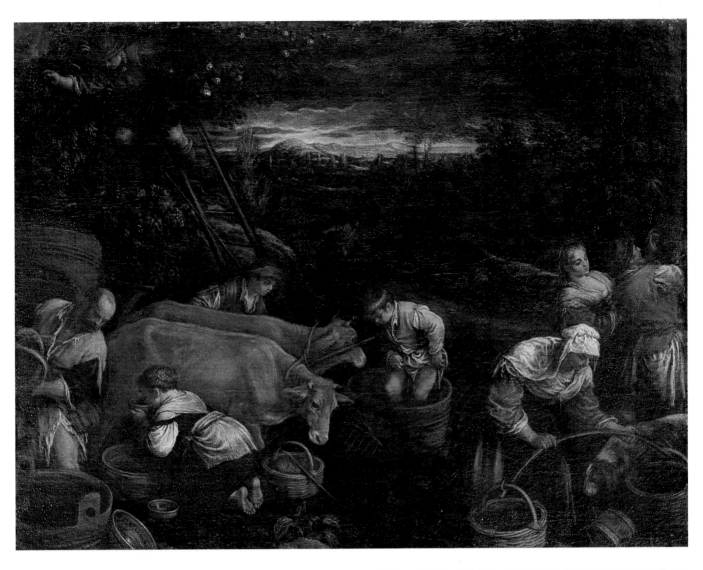

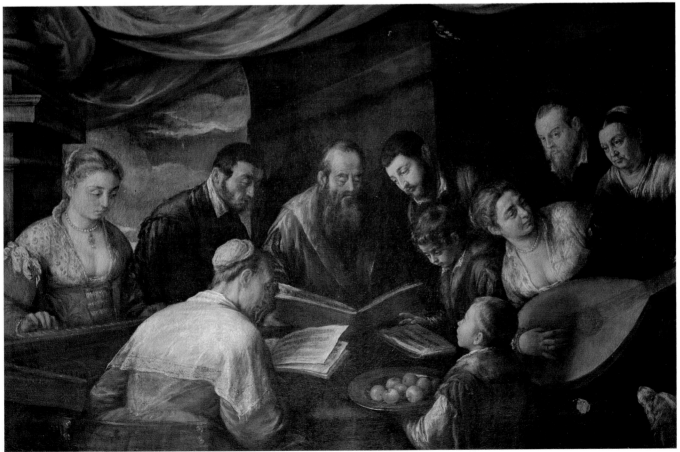

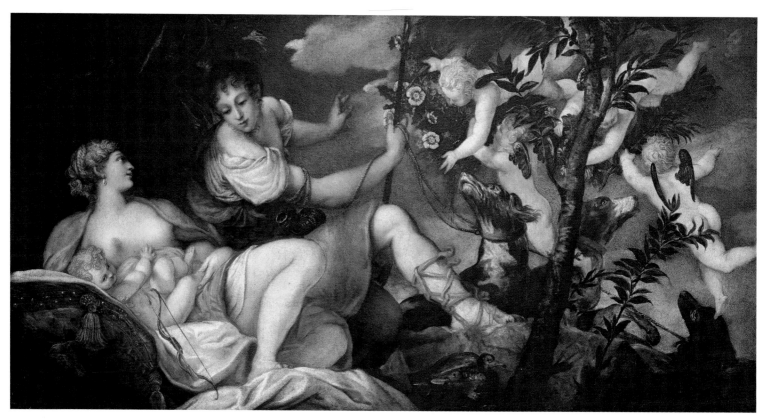

362 and 363

JACOPO TINTORETTO

Diana and Endymion

Oil on canvas, 57¹⁄₁₆ × 107¹⁄₁₆ in. (145 × 272 cm)

Pitti, Meridiana (temporary location); inv. Contini Bonacossi: no. 34

Athena and Arachne

Oil on canvas, 57¹⁄₁₆ × 107¹⁄₁₆ in. (145 × 272 cm)

Pitti, Meridiana (temporary location); inv. Contini Bonacossi: no. 35

These two canvases were originally part of a ceiling decoration, as their heavy foreshortening indicates. Such artifice recalls the "modern style" imported to Venice by Salviati and Vasari, suggesting a date of around 1543–1544 for the works.

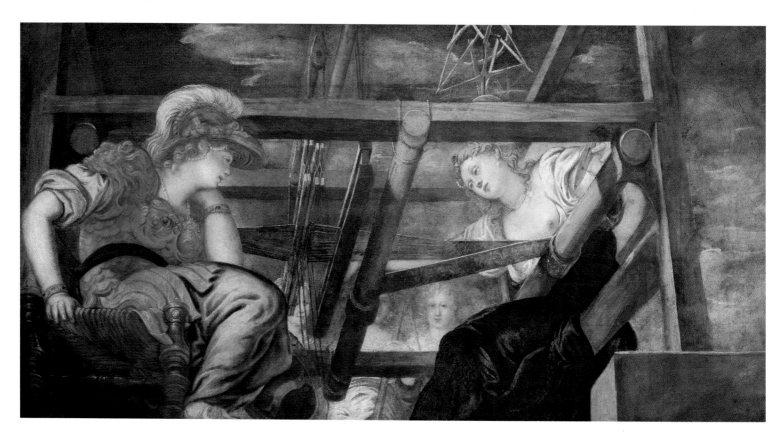

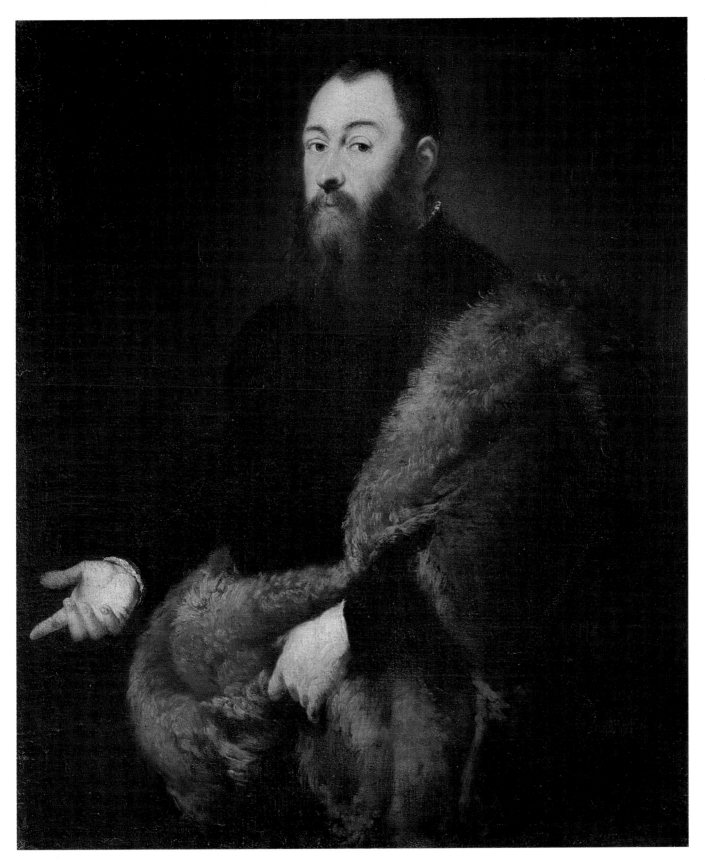

364
JACOPO TINTORETTO
Portrait of a Gentleman in a Fur
Oil on canvas, 42¹⁵⁄₁₆ × 35¹³⁄₁₆ in. (109 × 91 cm)
Pitti, Meridiana (temporary location); inv. Contini Bonacossi: no. 33
This is judged to be one of the best examples of Tintoretto's portrai-
ture during the first years of the 1550s; it is stylistically similar to the
Portrait of a Thirty-five-year-old Man in Vienna, dated 1553.

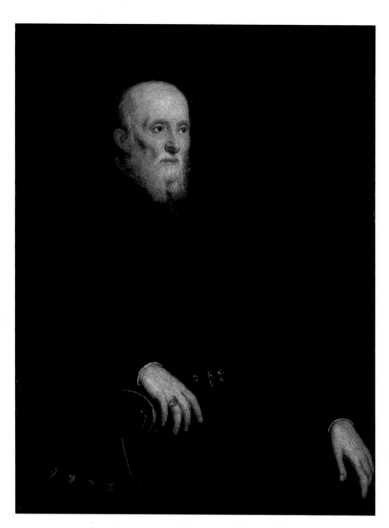

365

JACOPO TINTORETTO

Portrait of Alvise Cornaro

Oil on canvas, 44½ × 33⁷⁄₁₆ in. (113 × 85 cm)

Pitti, Palatine Gallery; inv. 1912: no. 83

This painting came from the collection of Grand Prince Ferdinand de' Medici, where it was registered for the first time in 1698. Cornaro, the celebrated Paduan humanist who died in 1566 at the age of ninety-one, is already quite old in this portrait, which may therefore date from the first half of the 1560s.

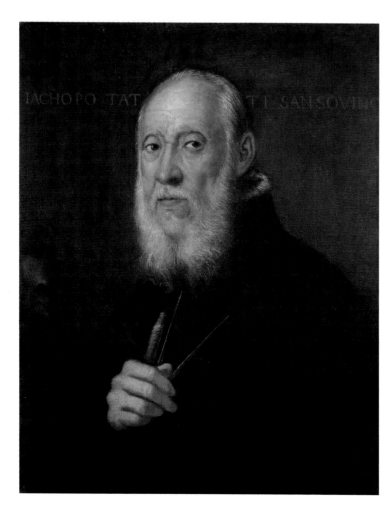

366

JACOPO TINTORETTO

Portrait of Jacopo Sansovino

Oil on canvas, 27⁹⁄₁₆ × 25⁹⁄₁₆ in. (70 × 65 cm)

Uffizi, Depository; inv. 1890: no. 957

Borghini, writing in 1584, recorded this portrait in the possession of Grand Duke Francesco de' Medici. It is likely that, as proposed by Rossi in 1974, Tintoretto produced it as an homage to the grand duke on the occasion of his 1566 nomination for membership in the Florentine Academy.

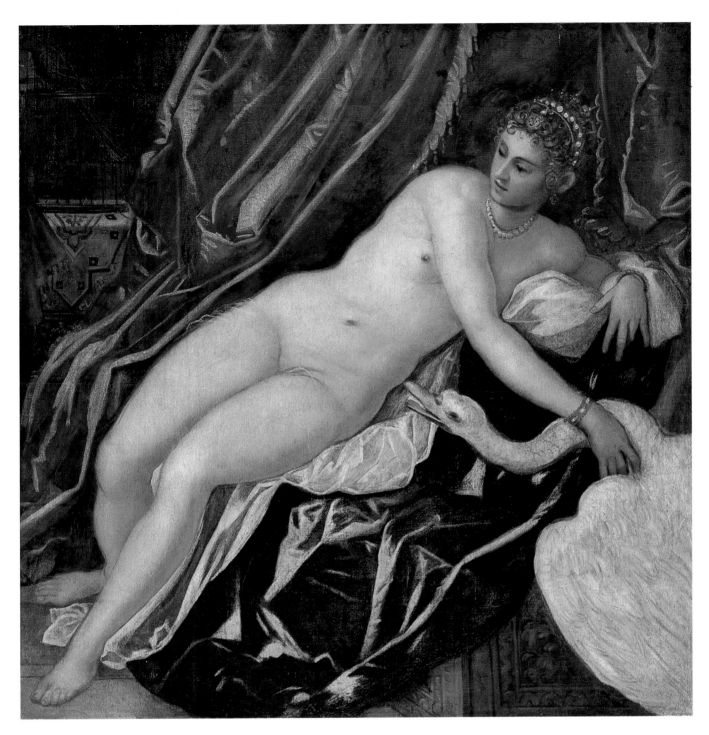

367
JACOPO TINTORETTO
Leda and the Swan
Oil on canvas, 58⅟₁₆ × 58⅟₁₆ in. (147.5 × 147.5 cm)
Uffizi, Depository; inv. 1890: no. 9946

Formerly in the Contini Bonacossi collection, this was the prototype for a much later version
of the same subject—of inferior quality—which is also in the Uffizi (no. 368). It dates from
around 1555.

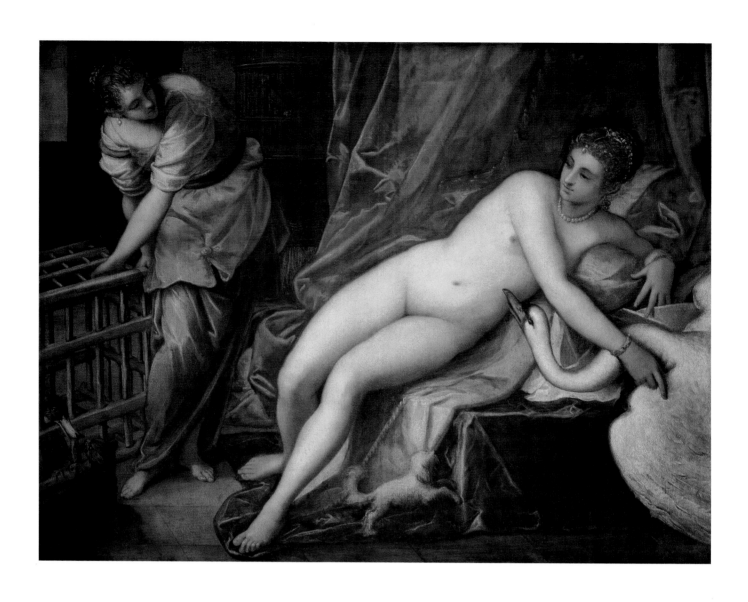

371
PAOLO VERONESE
The Annunciation
Oil on canvas, 56⁵⁄₁₆ × 114⁹⁄₁₆ in. (143 × 291 cm)
Uffizi, Gallery; inv. 1890: no. 899

The Medici agent Paolo del Sera acquired this picture in Venice; it later entered Cardinal
Leopoldo's collection and from there passed into the Uffizi in 1675. Usually dated to 1551
or 1556, it may in fact have been painted as late as 1558 based on a stylistic comparison with
the frescoes in the Venetian church of San Sebastiano.

Opposite: 368
JACOPO TINTORETTO
Leda and the Swan
Oil on canvas, 64³⁄₁₆ × 85¹³⁄₁₆ in. (163 × 218 cm)
Uffizi, Gallery; inv. 1890: no. 3084

Left to the gallery in 1893 by De Noè Walker, in the eighteenth
century this painting was in the Parisian collection of the regent of
Orléans. It is a later variation, perhaps produced by Tintoretto's
workshop, of a work that once belonged to the Contini Bonacossi
collection, and is now in the Uffizi (no. 367). It dates from around
1578.

369 and 370
JACOPO TINTORETTO
Christ at the Well
Oil on canvas, 45¹¹⁄₁₆ × 36⁵⁄₈ in. (116 × 93 cm)
Uffizi, Gallery; inv. 1890: no. 3497
The Samaritan Woman at the Well
Oil on canvas, 45¹¹⁄₁₆ × 36⁵⁄₈ in. (116 × 93 cm)
Uffizi, Gallery; inv. 1890: no. 3498

These pictures, together with two images depicting the *Annuncia-*
tion, now in the Rijksmuseum in Amsterdam, comprised the doors
to the organ in the church of San Benedetto in Venice, noted by
Borghini in 1584. They are datable to around 1580.

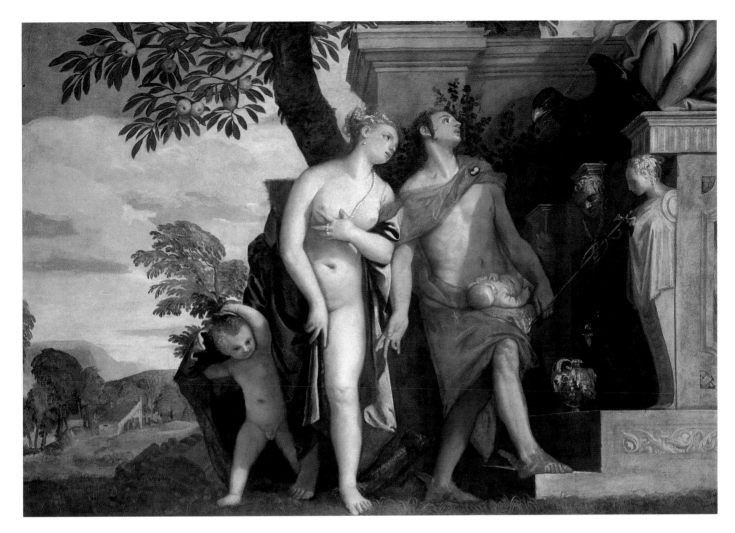

373
PAOLO VERONESE
Venus and Mercury Present Eros and Anteros to Jupiter
Oil on canvas, 59¹⁄₁₆ × 95¹¹⁄₁₆ in. (150 × 243 cm)
Uffizi, Gallery; inv. 1890: no. 9942

This canvas was linked by Pallucchini to a narrative of
Eros and Anteros recorded by Ridolfi (writing in 1648) in
the Sanudo house in Venice. The expanse of cloud-
streaked sky in particular recalls Veronese's frescoes at
Maser, suggesting a date of around 1562 for this work.

Opposite: 372
PAOLO VERONESE
Portrait of Iseppo da Porto and His Son Adriano
Oil on canvas, 97¼ × 52⅜ in. (247 × 133 cm)
Pitti, Meridiana (temporary location); inv. Contini
Bonacossi: no. 16

The pendant to this portrait, depicting da Porto's wife,
Lucia da Porto Thiene, and their daughter Porzia, is in
the Walters Art Gallery in Baltimore.

374
PAOLO VERONESE
Portrait of a Gentleman in a Fur
Oil on canvas, 55⅛ × 42⅛ in. (140 × 107 cm)
Pitti, Palatine Gallery; inv. 1912: no. 216

Part of Cardinal Leopoldo de' Medici's inheritance
(1675), this painting was traditionally thought to portray
Daniele Barbaro; however, that identification now seems
incorrect, as Barbaro looks very different in the portrait of
him in the Rijksmuseum in Amsterdam. This painting
dates from around 1565.

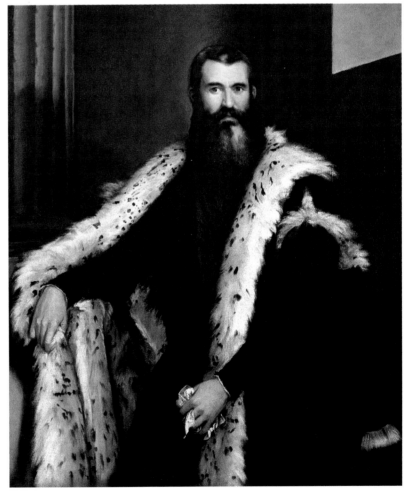

281

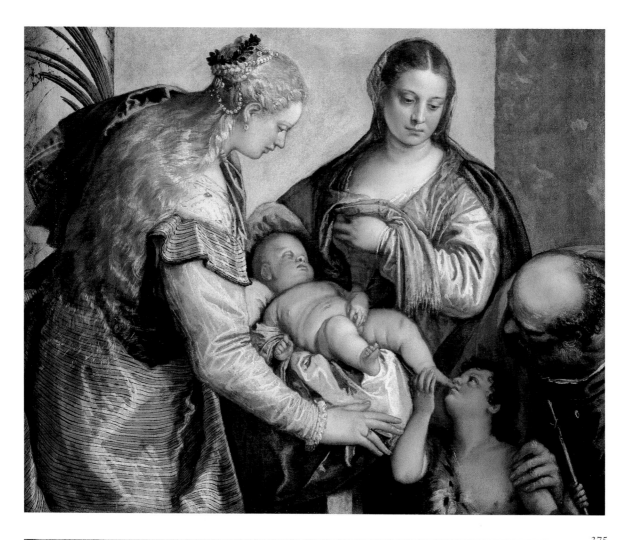

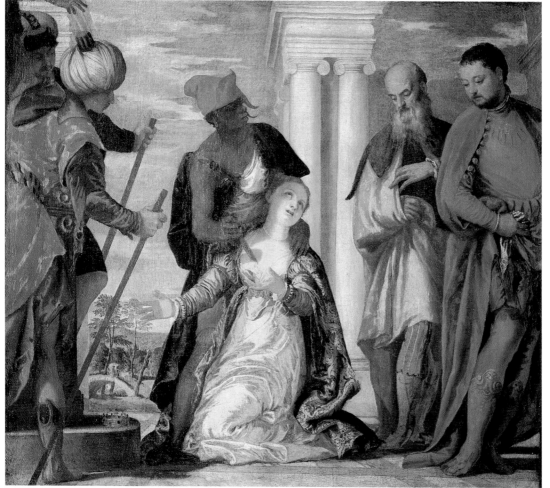

375
PAOLO VERONESE
The Holy Family with
St. Barbara and the Young
St. John the Baptist
Oil on canvas, 33⅞ × 48¹⁄₁₆ in.
(86 × 122 cm)
Uffizi, Gallery; inv. 1890: no.
1433

In 1648 this splendid little
painting could be found in the
Widmann house in Venice.
The Medici agent Paolo del
Sera later acquired it for Cardi-
nal Leopoldo de' Medici, who
left it to the Uffizi in 1675. It
can be dated to c. 1564.

376
PAOLO VERONESE
The Martyrdom of St. Justina
Oil on canvas, 40⁹⁄₁₆ × 44½ in.
(103 × 113 cm)
Uffizi, Gallery; inv. 1890: no.
946

This perhaps can be identified
as the painting acquired from
the Canonici collection in Fer-
rara (where it was recorded
in 1632) by Paolo del Sera,
who sent it on to Cardinal
Leopoldo de' Medici. It came
to the Uffizi in 1675. Its bright
coloring links it to two can-
vases in San Sebastiano in Ve-
nice, of around 1570.

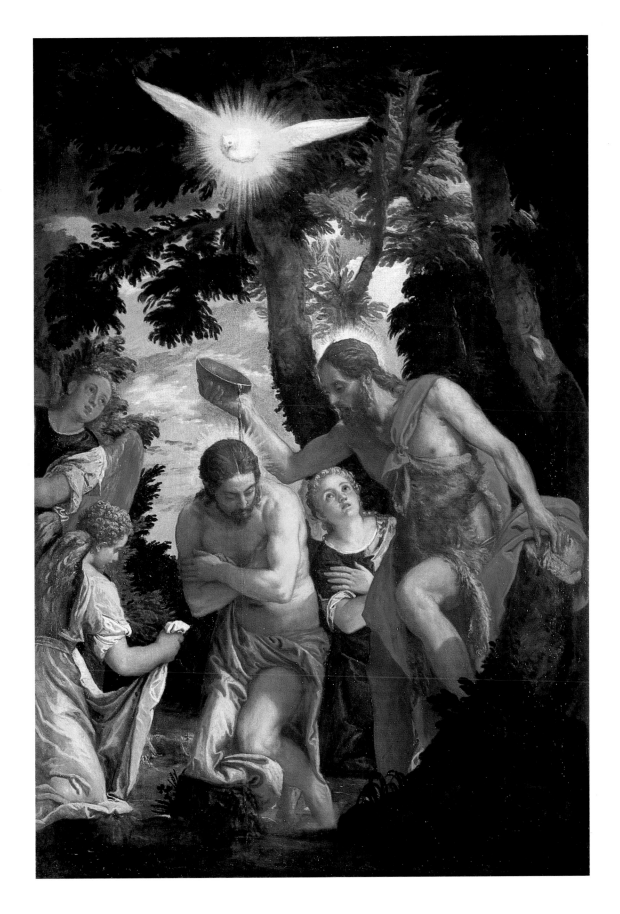

377
PAOLO VERONESE
The Baptism of Christ
Oil on canvas, 77³/₁₆ × 52³/₈ in. (196 × 133 cm)
Pitti, Palatine Gallery; inv. 1912: no. 186

In a Pitti inventory of 1688, this work was recorded as having come from Ancona. In 1935, Byam Shaw discovered a preparatory drawing on the back of a folio of sketches relating to Veronese's ceiling paintings for the Palazzo Ducale in Venice (1576–1578); a date around the beginning of the 1580s thus seems likely.

Lombardy, Piedmont, and Liguria

It was above all the inspired acquisitions of Prince Leopoldo de' Medici, a man of liberal and in many ways even avant-garde tastes, that guaranteed the establishment, beginning in the second half of the seventeenth century, of a first important nucleus of sixteenth-century Lombard painting in the Florentine galleries. Leopoldo's interest in the Renaissance art of northern Italy is well known and well documented, demonstrated, among other ways, by the elaborate network of contacts that the prince and future cardinal set up with collectors and emissaries who were resident not only in Venice but also in Lombardy. He consulted these scouts constantly for information on paintings that were coming onto the market.

One of those who figured prominently in this network was Paolo del Sera, with whom Leopoldo maintained an intense epistolary relationship for over thirty years. A Florentine by birth, del Sera resided in Venice and possessed one of the most extraordinary collections in that city. While in Venice, del Sera developed a close rapport with the great scholar Marcantonio Boschini, whose *Map for Pictorial Navigation,* published in 1660, admiringly described many works owned by his friend. Notable among these was Giovanni Gerolamo Savoldo's *Transfiguration,* which not long after became the property of the Florentine prince; today it is considered to be one of the most significant Lombard pictures in the Uffizi.

In analyzing Leopoldo's choices, it is not difficult to recognize a particular predilection for portraiture, testified to by the inclusion of five portraits by Giovanni Battista Moroni in his collection. Two of these paintings, the *Portrait of a Gentleman with a Book* (sold to Leopoldo by del Sera) and the *Portrait of a Noblewoman* (tracked down in Bergamo by the painter Ciro Ferri, who advised Leopoldo to buy it), were rightly represented as autograph works of the Bergamese artist; the other three came to the collection ascribed to an anonymous Cremonese artist, a curious attribution that can be explained by the fact that they were probably acquired in Cremona through the painter Giovan Battista Natali, another of the prince's "suppliers." This fact serves only to emphasize, however, Leopoldo's high regard for these works and his precocious appreciation of them: not knowing who had painted them, and unconcerned with their uncertain authorship, he nonetheless evidently admired them for their impeccable naturalism and the unconventional immediacy of their approach to their subjects.

Other important Lombard works entered the Florentine collections after Leopoldo's prestigious bequest. In 1683 Giulio Campi's *Portrait of the Artist's Father, Galeazzo Campi,* then erroneously considered to be a self-portrait by the same Galeazzo, was acquired to enrich the self-portrait collection. A little later, inventories recorded the presence in Grand Prince Ferdinand's apartments of yet another portrait by Moroni, believed to be of a member of the Suardo family (now in the Uffizi); and, later still, in 1783, Pietro Leopoldo de' Medici acquired, from the Company of San Sebastiano in Camollia in Siena, Sodoma's important *Gonfalone* (today in the Pitti).

Another important addition to the early Lombard nucleus acquired by Leopoldo dates from the very recent past, following a stipulated agreement in 1969, that brought to the Uffizi paintings from the Contini Bonacossi collection, today in the Meridiana of the Pitti Palace. It is well known that in building his prodigious collection, Alessandro Contini Bonacossi availed himself of Roberto Longhi's inspired advice, and it was no doubt inevitable that the great scholar's decided predilection for sixteenth-century Lombard and Piedmontese art should be reflected in the ample selection of works from the Contini collection that came to the Uffizi. Among these are such masterpieces as *St. Matthew* and *St. John the Evangelist* by Boccaccio Boccaccino, Boltraffio's *Portrait of a Magistrate,* the great altarpiece by Bramantino, and Savoldo's *Mary Magdalen.*

Notwithstanding its heterodox provenance, the galleries' collection of sixteenth-century Lombard paintings, considered in its entirety, appears today to be highly significant, not least for the way in which it documents the various pictorial schools that were active in the area. These begin with what might properly be called the Milanese school, represented here by works of the highest quality by Bramantino and Boltraffio, two important exponents of Florentine culture in Milan between the fifteenth and sixteenth centuries.

Roughly coeval with the extraordinary Casio altarpiece, executed in 1500 for the church of the Misericordia in Bologna and now in the Louvre, Boltraffio's *Portrait of a Magistrate* belongs to the artist's most intense phase of productivity, when he was a precocious frequenter of Leonardo's workshop in Milan. Boltraffio certainly numbered among the most significant artistic personalities in the circle of Lombard painters who were directly influenced by the great Tuscan genius. Developed through the study of Leonardo's works, Boltraffio's definition of the effects of light in this portrait seems extremely attentive and controlled; however, the linear rendering of the subject's smooth oval face is evidence of the painter's search for a new, synthetic perception of volume, in line with the analogous intellectual experiences that then distinguished the Lombard artistic scene.

Bramantino, for his part, was an excellent promulgator of this new direction. His great *Madonna and Child with Eight Saints,* from the church of Santa Maria del Giardino in Milan, is a late work, but one that nonetheless bears the stamp of the sophisticated climate characteristic of all of this painter's production. Bramantino's almost visionary focus is articulated by the perfectly symmetrical arrangement of the scene, in which, as if in a perspectival theorem, the saints who surround the Virgin are scaled into the background with infallible rigor, while even further back some classical buildings bring to the picture a metaphysical order.

A clear dependence on Leonardesque models, in contrast, distinguishes both the delicate *Narcissus* in the Uffizi—attributed to an anonymous and typically Milanese artist who is sometimes known as Pseudo-

Boltraffio—and *Leda and the Swan,* once in the Spiridon collection. The latter is based on an example of the analogous subject elaborated by Leonardo in the last years of his activity, a little before his second stay in Milan, beginning in 1506. Of Leonardo's pictorial studies on this mythological theme, there remain but a few famous drawings, all of which depict Leda crouching down; the existence of several copies in which Leda is shown standing, as in the Spiridon painting, attests to the fact that the master at least conceived of a second version of this subject, which must have been enthusiastically received, as even Raphael made a drawing of it.

The works in the Uffizi and the Pitti also amply document the lively history of the Cremonese school that was inaugurated at the beginning of the sixteenth century by the noteworthy activity of Boccaccio Boccaccino. An artist of singular talents, Boccaccino was able to fashion a luminous and refined pictorial language out of elements picked up on youthful sojourns in Ferrara and Milan and in his study of the work of Bellini and Giorgione. His own interpretation of Giorgione's elegiac and enigmatic inventions can be seen in the Uffizi's enchanting *Gypsy Girl,* a diminutive triumph of evocative fascination in which the precious and iridescent effect of the pictorial material and the optic luminosity of its details both play a part. The same qualities are evident as well in the magnificent *St. Matthew* and *St. John the Evangelist,* in which the artist reveals his appreciation of Dürer's poignant naturalism.

Along with Boccaccio's son Camillo Boccaccino, Giulio Campi was perhaps the most precocious interpreter of the new mannerism in the Cremonese area. His arresting portrait of his father, dating from around 1535, displays the complexity of cultural references that inevitably accompanies mannerism: the articulated pose and *contrapposto* of the figure recall Andrea del Sarto's work, while the soft treatment of chiaroscuro in the face and the vivid atmospheric perception of light as it crosses the canvas presuppose a knowledge of the work of Lorenzo Lotto and Correggio.

The *Portrait of a Gentleman with Mandolin* is also generally attributed to Giulio Campi (though the matter still needs further study). Originally this picture was in the collection of Paolo del Sera, whose friend Boschini believed it to be a masterpeice by Giovanni Battista Moroni, the great Bergamese portraitist and founder of the so-called "painting of reality" that characterized the figurative context of Bergamo and Brescia up to the eighteenth century. As to the work of Moroni himself, the Florentine galleries own an extremely important core of paintings that is of much help in understanding the more singular connotations of his portraits. These latter are distinguished by a confidential, familiar approach that always downplays the sitter's importance—as for example in the *Portrait of Giovanni Antonio Pantera,* where the man of letters, seemingly caught by surprise, turns brusquely toward the painter in an attitude of complete informality. Moroni's propensity toward simple presentation and a lack of rhetoric is again in evidence in his *Portrait of a Priest in his Cap* and *Portrait of an Old Man* (perhaps depicting the painter's father), in which the close take of the sitter allows the artist to explore the naturalistic rendering of the complexion and of the clothes, and at the same time to enliven and intensify his psychological dialogue with his model.

It is a well-known fact that, in the sixteenth century, Bergamo and Brescia both belonged to the Venetian republic. One result of this political dependence was the development of a prolific relationship with the lagoon on the part of many local artists, among them the Brescians Moretto and Giovanni Gerolamo Savoldo, in whose work the fundamentally antinaturalistic attitude characteristic of Lombardy blended with the influences derived from Venice, in particular through exposure to Titian's art. This unique and fascinating dialectic can be seen in the paintings by these artists that hang in the Florentine galleries, but more especially in the two works by Savoldo, a rare and sophisticated painter who, it must be remembered, actually resided in Venice for most of his working life. His *Transfiguration* and *Mary Magdalen* owe an obvious debt to Titian, but here, in contrast to that artist's vibrant and disturbing painterliness, Savoldo develops a more severe and controlled draftsmanship. This approach is marked by an increasing resort to chiaroscuro (a preference that the young Caravaggio certainly subscribed to) and by a sense of an almost mimetic veracity that characterizes the rendering of clothes according to one of the prerogatives of the Brescian school.

Set against this throng of painters from Lombardy (which also included Lorenzo Leonbruno, an artist of Mantegnesque education, author of the *Sleeping Nymph* and a cultivated protagonist of Mantuan painting in the years preceding the arrival in that city of Giulio Romano) is the decidedly less conspicuous and significant artistic patrimony of sixteenth-century Piedmontese and Ligurian works in the Florentine galleries. These are in fact limited to Luca Cambiaso's *Madonna and Child,* which was in the Uffizi's Tribune by 1635. This shadowy testament to the study of nocturnal light was inspired in part by analogous Correggiesque experiments, conducted in the last years of his working life by this prominent representative of Genoese mannerism. As far as Piedmontese artists, next to Defendente Ferrari's *Madonna and Child,* we can look to the Pitti's *Gonfalone* dedicated to St. Sebastian, which was commissioned from Giovanni Antonio Bazzi, called Sodoma, by a Sienese confraternity. Although Sodoma was born in Vercelli his work for the most part fell well outside the great traditions of the Piedmontese Renaissance. Very early in his career he moved to Siena, where he developed an eclectic pictorial language, which joined the Leonardesque influences of his youth with the newer strains of Raphael's style. This synthesis is most visible in the Pitti *Gonfalone,* or banner, with its vibrant and compassionate image of St. Sebastian, whose elegance vanquishes even the atrocities of martyrdom.

Francesco Frangi

378
GIOVANNI ANTONIO BOLTRAFFIO
Portrait of a Magistrate
Panel, 20⁵⁄₁₆ × 14⁹⁄₁₆ in. (51.5 × 37 cm)
Pitti, Meridiana (temporary location);
inv. Contini Bonacossi: no. 28

Roughly coeval with the Casio altarpiece, painted by Boltraffio in 1500 and now in the Louvre, this portrait was once in the Frizzoni collection in Milan.

379 and 380
BOCCACCIO BOCCACCINO
St. John the Evangelist
Panel, 29½ × 22¹³⁄₁₆ in. (75 × 58 cm)
Pitti, Meridiana (temporary location);
inv. Contini Bonacossi: no. 13
St. Matthew
Panel, 29¹⁵⁄₁₆ × 23¼ in. (76 × 59 cm)
Pitti, Meridiana (temporary location);
inv. Contini Bonacossi: no. 14

Once part of a single series whose original location and other constituent parts remain unknown, these two surviving panels document the moment of Boccaccino's greatest adherence to the art of Giorgione; for this reason, a date at the beginning of the 1500s seems likely.

381

BOCCACCIO BOCCACCINO
Gypsy Girl
Panel, 9⁷⁄₁₆ × 7½ in. (24 × 19 cm)
Uffizi, Gallery; inv. 1890: no. 8539

Its stylistic proximity to the *Mystic Marriage of St. Catherine* in the gallery of the Accademia in Venice suggests a date of around 1505 for this painting. In the seventeenth century the painting was part of Prince Leopoldo de' Medici's collection.

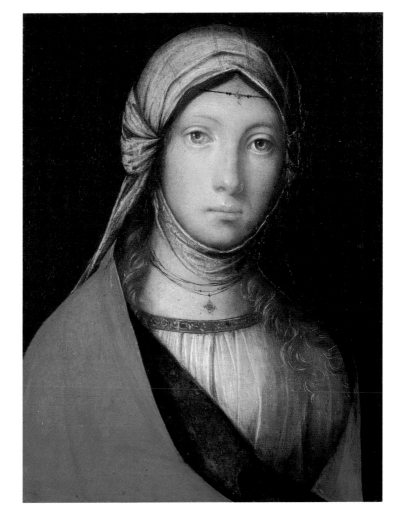

382

ANONYMOUS ARTIST WORKING IN THE STYLE OF LEONARDO
Narcissus
Panel, 7½ × 12³⁄₁₆ in. (19 × 31 cm)
Uffizi, Gallery; inv. 1890: no. 2184

Though traditionally attributed to Boltraffio, this panel should instead be included among a group of works of markedly Leonardesque influence that today are ascribed to the so-called Pseudo-Boltraffio. It presumably dates from the first decade of the sixteenth century.

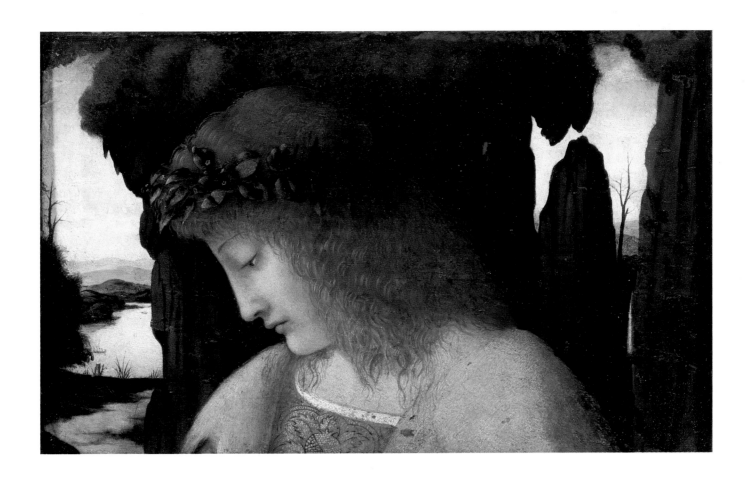

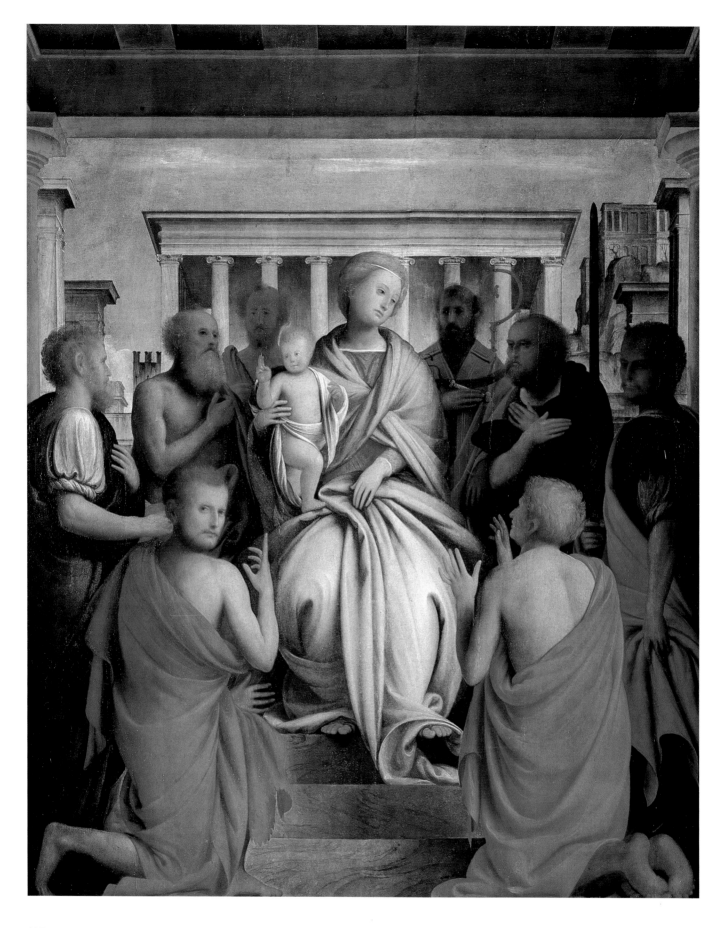

383

BARTOLOMEO SUARDI called BRAMANTINO

Madonna and Child with Eight Saints

Oil on panel, 79¹⁵⁄₁₆ × 65¾ in. (203 × 167 cm)

Pitti, Meridiana (temporary location); inv. Contini Bonacossi: no. 3

This panel dates from the later phase of Bramantino's career, perhaps within the 1520s. Its provenance is the church of Santa Maria del Giardino in Milan; from there it passed through the collections of Castelbarco, Poldi Pezzoli, Trivulzio, and Contini Bonacossi.

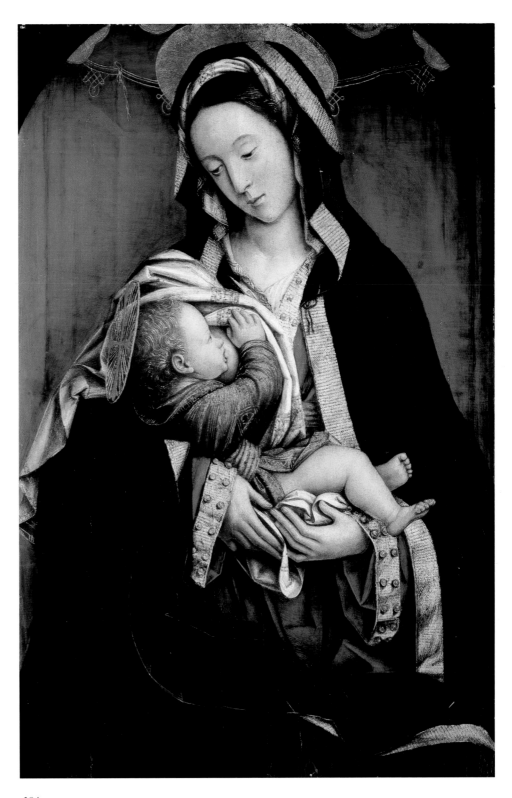

384

DEFENDENTE FERRARI
Madonna and Child
Panel, 29⅛ × 19⅟₁₆ in. (74 × 48.5 cm)
Pitti, Meridiana (temporary location); inv. Contini Bonacossi: no. 8

Datable to around the 1520s, this panel exemplifies the mass production of devotional works—all marked by a calligraphic Northern sensibility—practiced by the Piedmontese painter.

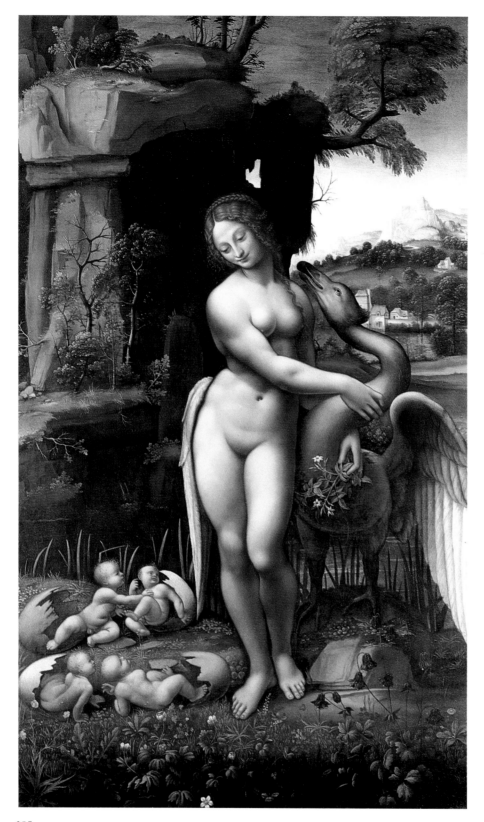

Opposite: 386

GIOVANNI ANTONIO BAZZI called
SODOMA
St. Sebastian
Oil on canvas, 80⁵⁄₁₆ × 57¹⁄₁₆ in. (204 ×
145 cm)
Pitti, Palatine Gallery; inv. 1890: no.
1590

This scene constitutes one of the two
sides of a *gonfalone* commissioned from
Sodoma on May 3, 1525, by the Com-
pany of San Sebastiano in Camollia in
Siena. The painter received several
payments for the work in 1526 but he
had to wait until 1531 for the final
installment. Sold in 1786 to Pietro
Leopoldo I, the banner was displayed at
first in the Uffizi and then, from 1928, in
the Pitti Palace. On the verso is the *Ma-
donna and Child in Glory Adored by SS.
Rocco and Gismondo and Brethren of St.
Sebastian.*

385
SCHOOL OF LEONARDO
Leda and the Swan
Panel, 51³⁄₁₆ × 30½ in. (130 × 77.5 cm)
Uffizi, Depository; inv. 1890: no. 9953

This painting is one of the best-known copies after a lost original produced by Leonardo
during the last years of his activity. In 1874 it could be found in the de la Rozière collection
in Paris, from which it passed to the Spiridon collection in Rome. It was sold to Herman
Göring in 1941 and recovered in 1948.

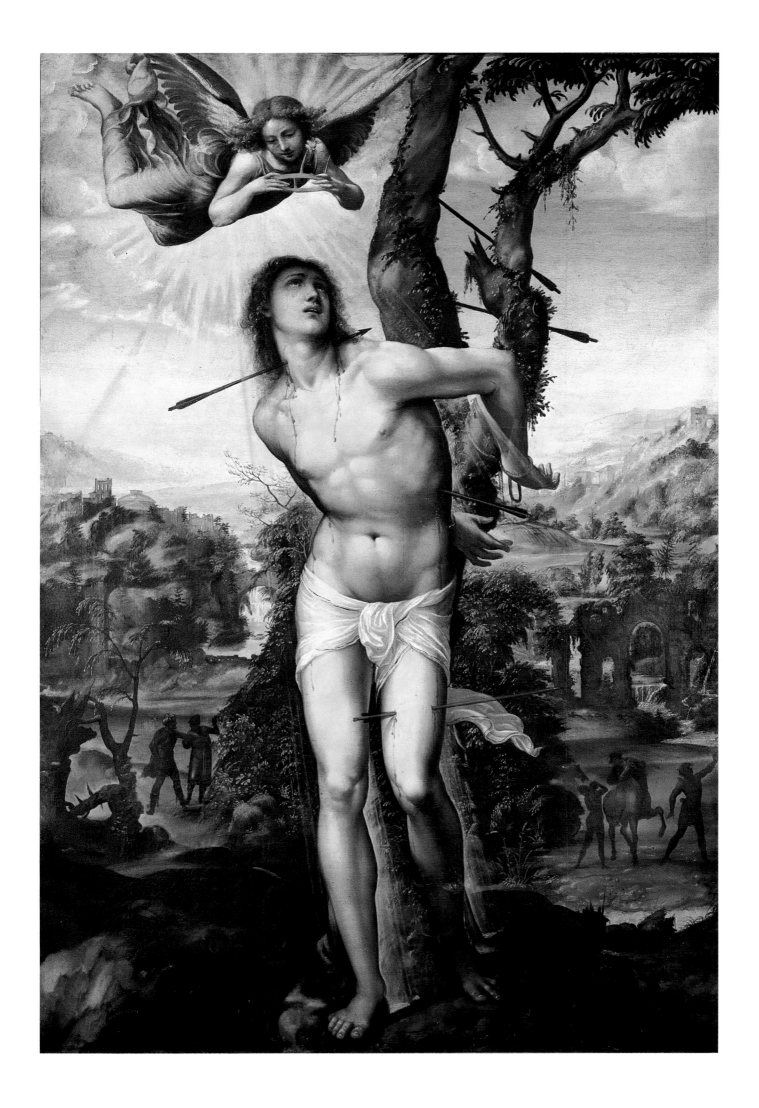

387
GIULIO CAMPI (attributed to)
Portrait of a Gentleman with Mandolin
Oil on canvas, 29⅛ × 22¹³⁄₁₆ in. (74 × 58 cm)
Uffizi, Depository; inv. 1890: no. 958

Arguably an early work by Giulio Campi, produced around 1530, this portrait has been identified as that recorded in 1660 in Paolo del Sera's collection in Venice by Boschini, who thought it was by Moroni. It was acquired by Leopoldo de' Medici and placed in the Medici Guardaroba, from which it passed to the Uffizi in 1800.

388
GIULIO CAMPI
Portrait of the Artist's Father, Galeazzo Campi
Oil on canvas, 30¹⁵⁄₁₆ × 24⁷⁄₁₆ in. (78.5 × 62 cm)
Uffizi, Gallery; inv. 1890: no. 1628

An inscription on the back of this painting reveals its author, the identity of the person depicted, and the year of its execution, 1535. On its acquisition, in 1683, the work was thought to be a self-portrait of Galeazzo Campi.

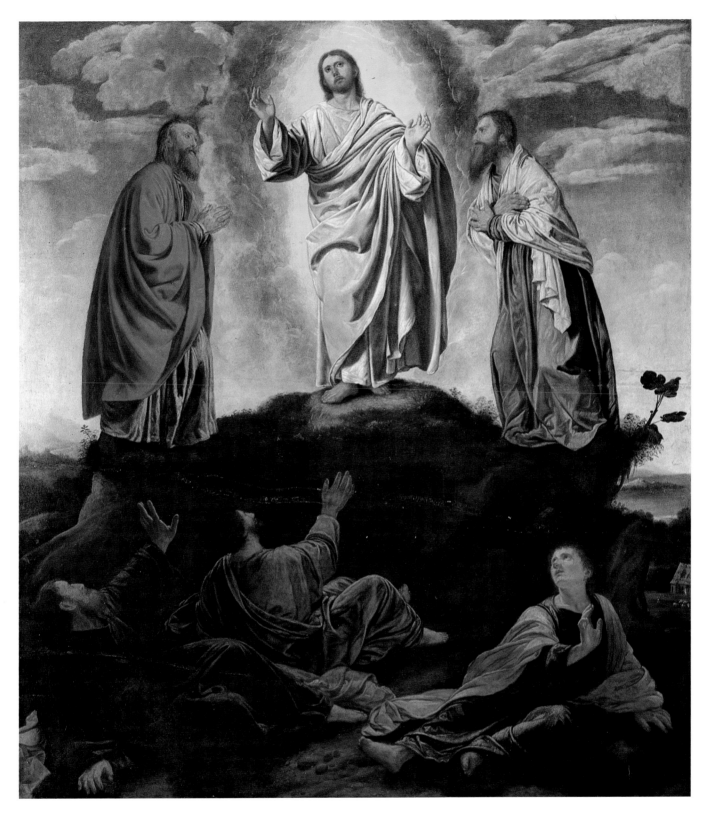

389

GIOVANNI GEROLAMO SAVOLDO

The Transfiguration

Panel, 54¾ × 49⅝ in. (139 × 126 cm)

Uffizi, Gallery; inv. 1890: no. 930

Datable to the later phase of Savoldo's career, around the 1530s, this was acquired by Leopoldo de' Medici from Paolo del Sera, in Venice, where it was admired by Boschini in 1660. It was recorded as being in the Medici Guardaroba in 1675 and came to the Uffizi in 1780.

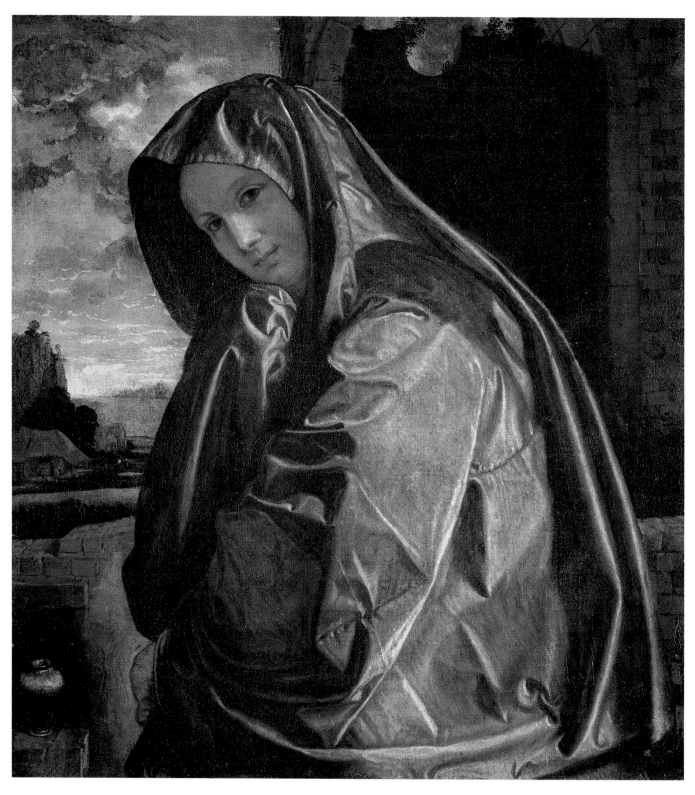

390

GIOVANNI GEROLAMO SAVOLDO

Mary Magdalen

Oil on canvas, 33⁷⁄₁₆ × 31⅛ in. (85 × 79 cm)

Pitti, Meridiana (temporary location); inv. Contini Bonacossi: no. 17

An analogue to other versions of the same subject by the artist, this canvas can very probably be dated to the 1530s. It was in the Giovanelli collection in Venice until 1932, and thereafter entered the Contini Bonacossi collection.

391

GIOVANNI BATTISTA MORONI
Portrait of a Noblewoman
Oil on canvas, 20⅞ × 17¹⁵⁄₁₆ in. (53 × 45.6 cm)
Pitti, Palatine Gallery; inv. 1912: no. 128

This portrait, executed around the end of the 1550s, was acquired by Leopoldo de' Medici in Bergamo in 1665 through Ciro Ferri. On arriving at the Pitti Palace in 1675, it was hung in the rooms of Grand Prince Ferdinand de' Medici. In 1799 it was requisitioned by Napoleonic functionaries and transported to the Musée Napoléon in Paris, where it remained until 1815.

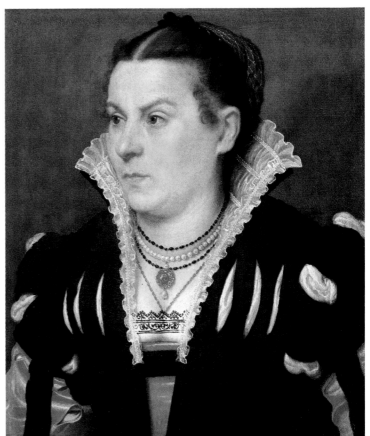

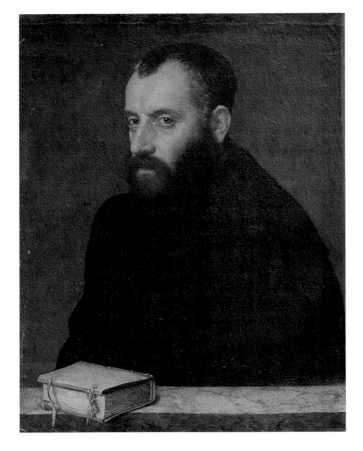

392

GIOVANNI BATTISTA MORONI
Portrait of a Gentleman with a Book
Oil on canvas, 27³⁄₁₆ × 24 in. (69 × 61 cm)
Uffizi, Gallery; inv. 1890; no. 933

This portrait dates from around the end of the 1550s. It was sold in Venice in 1660 by the merchant Giovanni da Udine to Paolo del Sera, who in turn ceded it to Leopoldo de' Medici. Bequeathed in 1675 to the Pitti Palace, it was soon moved to the Uffizi, where in 1704 it was recorded as being in the Tribune.

393

GIOVANNI BATTISTA MORONI
Portrait of Giovanni Antonio Pantera
Oil on canvas, 31⅞ × 24¹³⁄₁₆ in. (81 × 63 cm)
Uffizi, Gallery; inv. 1890: no. 941

Datable to the end of the 1550s or the beginning of the 1560s, this painting was acquired by Leopoldo de' Medici and installed in the Pitti apartments of Grand Prince Ferdinand de' Medici by 1688. It was later transferred to the Medici villa at Poggio Imperiale and thence, in 1795, to the Uffizi.

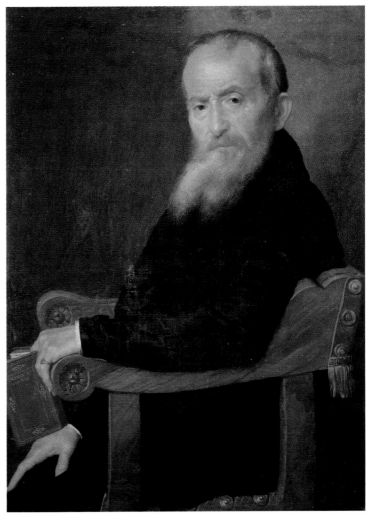

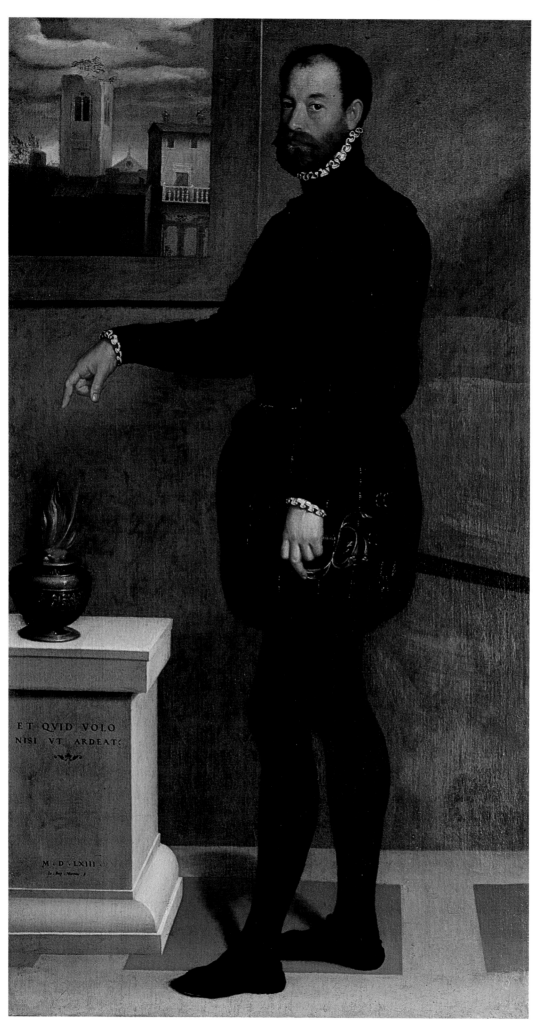

394

GIOVANNI BATTISTA
MORONI
Portrait of Pietro Secco Suardo
Oil on canvas, 72¹⁄₁₆ × 40³⁄₁₆ in. (183
× 102 cm)
Signed and dated at lower left, on
the pedestal: MDLXIII / IO. BAB.
MORONUS P.
Uffizi, Gallery; inv. 1890: no. 906
Cited in 1713 among the paintings
in Prince Ferdinand's Pitti Palace
apartments, this portrait came to the
Uffizi in 1797. The identification of
the subject as Pietro Secco Suardo, a
knight from Bergamo who served as
ambassador to Venice from 1545, is
very probably correct, given that the
flames in the vase on the pedestal
correspond to the heraldic symbol of
the Suardi family. The motto *Et quid
volo nisi ut ardeat* is taken from the
Gospel according to Luke.

395

GIOVANNI BATTISTA MORONI

Portrait of an Old Man

Oil on canvas, 20¹¹⁄₁₆ × 17⅞ in. (52.6 × 45.5 cm)

Pitti, Palatine Gallery; inv. 1912: no. 121

Assuredly a late work by Moroni, this picture dates from around 1570; it once belonged to the collection of Leopoldo de' Medici, who probably acquired it in Cremona in 1668 through Giovan Battista Natali. It came to the Pitti Palace in 1675 and was initially placed in Grand Prince Ferdinand de' Medici's rooms, where it was noted in an account of 1723.

396

LUCA CAMBIASO

Madonna and Child

Oil on canvas, 29¼ × 23⁷⁄₁₆ in. (74.3 × 59.5 cm)

Uffizi, Gallery; inv. 1890: no. 776

This painting was executed by Cambiaso around the 1570s. Once part of Leopoldo de' Medici's collection, it was recorded as being in the Uffizi's Tribune in 1635 and was exhibited in the Pitti in 1688.

Painting in Flanders, Holland, Germany, France, and Spain in the Sixteenth Century

We are at last beginning to see a reappraisal of an overly dismissive opinion that is still pervasive today, which holds that sixteenth-century Netherlandish painting represents little more than a transition between two golden ages in Northern art—one the so-called primitive period, and the other that of Rubens, Van Dyck, and Jordaens, the triad of great masters in Antwerp, and Rembrandt and certain of his followers in Holland. It must be pointed out that on the contrary, the pictorial panorama of the Low Countries in the sixteenth century was rich, variegated, complex, and replete with heights of quality and great originality. For an eyewitness account of the Netherlandish question, we may turn to Lodovico Guicciardini's *Description of All the Low Countries*, written in Antwerp in 1567, in which the author says of the local artistic situation, "The art of painting is in its utility and its honorability a momentous thing, not only in Antwerp and in Mechlin, where it is a trade of great importance, but in all the other countries as well . . . And I should say first that in these regions alone there are more painters of every type and profession than there are in many other provinces combined: the number of them here is great, and great is their production, and some of them are very great indeed."

Nonetheless, at least up until the death of Michelangelo and Titian—the last great masters of the group that began with Leonardo—there existed a certain uniformity of opinion among art critics in Italy and the Low Countries. In general, Italian painters were thought to be superior in their modeling of men and gods, in their narrative compositions and allegorical depictions, while the Northern painters were considered champions of color, of the natural rendering of materials, of details and landscape— all elements of minor weight in the balance of artistic expression. According to this view, the Northern artists were particularly lacking in the ability to capture human form in the perfectly harmonious proportions required by the ideals of classical Renaissance beauty, and lacking too in a proper procedure for learning them; in order to address this, it was thought, they would need to examine works of ancient art and those by modern masters, beginning with Raphael. To get some idea of the enormous quantity and the manifold quality of figurative works being produced in Italy, Northern artists needed to make the journey across the Alps, though over the course of the century their study of this material was facilitated by the circulation of prints reproducing paintings by both great and lesser Italian masters. To supply this demand, Northern painters began, with increasing frequency and in ever greater numbers, to come to Italy to study and work, mostly in Rome but later in other cities as well, including Florence and Venice.

Albrecht Dürer's visits to Venice and Rome, on horseback in the year 1500, were exemplary in the sense that they were followed by similar Roman journeys by Jan Gossaert, Maarten van Heemskerck, and others. Recognized as a great German artist by both Vasari and van Mander, Dürer himself was nonetheless classified as belonging to one of several categories that embraced the Netherlandish painters: the "Germans," "Flemings," or, in the case of the latter critic, the "school of the Low Countries."

The fact that sixteenth-century Italian art criticism, in confronting non-Italian work, came to focus directly and almost exclusively on the art of the Low Countries—with Dürer being one of the few exceptions—serves to indicate that the latter was Italian art's only real rival, thanks to its noteworthy qualities of continuity and consistency, which in that century assigned it an inarguably important role. However, at this time, and particularly in the earlier part of the century, there were other painters of high quality in Germany besides Dürer, among them Albrecht Altdorfer, Lucas Cranach the Elder, and most notably, Hans Holbein the Younger, portraitist to the English court. Holbein's exceptional abilities inspired Karel van Mander to dedicate to him, as well as to the other painter-engraver from Nuremberg, a "life," in his book of 1604, which, despite its stated emphasis on Northern painters, focused almost exclusively on Netherlandish artists.

Van Mander tells how several copies of Holbein's paintings were executed by Federico Zuccari during his visit to England in 1574; the Italian master considered the originals to be equal to Raphael's best work. This kind of unreserved appreciation for a Northern painter was rare at this time among Italians and is in sharp contrast to the animosity shown, for example, by artists working in Rome toward Jan van Scorel, who in 1522 was in charge of the Belvedere collection. The Roman artistic world considered van Scorel, who won the post through the support of Pope Adrian VI, his fellow countryman, to be a foreign interloper in Roman artistic affairs. Consequently, the brief reign of the Dutch pope himself was destined from the first to be forgotten as quickly as possible.

Nevertheless, at the beginning of the sixteenth century, Italian interest in Northern artists was far from nonexistent. Beyond the so-called primitive painters, among them Hans Memling and Gerard David, and such artists as Hieronymous Bosch, this interest was directed mainly toward the "painter-engravers" Albrecht Dürer and Lucas van Leyden. Although Vasari reproached them for their insufficient anatomical knowledge and their physiognomic eccentricities, Dürer's and van Leyden's highest-level graphic art—and it was largely through this that they became renowned throughout all Italy—served as an ex-

ample for many Italians, from Polidoro da Caravaggio in Rome to Andrea del Sarto, Pontormo, and Bachiacca in Florence, Girolamo da Carpi in Modena, Titian and Tintoretto in Venice, and many others.

The works by Dürer that are to be found in Florence today were not executed in Italy and arrived there only long after his death, but this does not alter the fact that on his various Italian trips he left behind paintings done for churches and private houses. The most important and celebrated of these is the great triptych of the *Feast of the Rosary* (now in Prague), painted for a chapel in the German church of San Bartolomeo in Venice. Dürer's works were greatly admired and much imitated by local painters, causing the German painter to complain about the "borrowings" of his ideas by his Venetian colleagues, and of their envy. The extraordinary fame that Dürer won in Italy during the sixteenth century was achieved by very few other Northern artists of that era.

Toward the end of the sixteenth century the interest in Dürer was quite diffused, not only in Germany and the Low Countries, but also at the court of Rudolph II. This interest was manifested, among other ways, by a proliferation of copies and imitations of his work. In the next century, Dürer's reputation was revived to some degree by the arrival in Florence, in 1608, of Maria Maddalena of Austria, whose dowry for her marriage to Cosimo II de' Medici contained a drawing by Dürer. This so-called *Great Calvary*, with various scenes of the Passion of Christ, was accompanied by a copy made by the renowned Jan Brueghel the Elder in Prague in 1604 (ninety-nine years after the original), probably for Emperor Rudolph II, Maria Maddalena's cousin. The two works came to the Florentine court along with a third, the *Landscape with a City by a River*, in which buildings from Prague, such as the Karlsbrücke and the Teynkirche, serve as a backdrop for the scene that begins the Passion, the *Entrance of Christ into Jerusalem*. This last painting, on copper, was executed in Prague by Brueghel in his very refined style, characterized by infinite little figures and the most minute details—a style greatly admired in the artist's native Antwerp, at the imperial court in Prague, and in Italy, by important patrons such as Cardinal Federigo Borromeo of Milan. On their arrival in Florence, these three works, as Stefania Bedoni has shown (in a paper published in 1983), formed or were made to form a little triptych in the shape of a cupboardlike box.

Throughout the sixteenth century there were Northern artists living for more or less prolonged periods in almost all of the cities of Italy, often working in the ateliers of local masters. Among these was Pieter de Witte, known in Italy as Pietro Candido, who before settling in Bavaria spent some time in Florence assimilating elements of Florentine mannerism as practiced by Rosso Fiorentino, Bronzino, Vasari, and others. His style was in fact so close to theirs as to fool later scholars into attributing his *Madonna and Child with Saints* to one of the aforementioned Florentine mannerists. Other Northern painters settled permanently in Italy, where, after apprenticing themselves to local masters, they established careers in their own right; such was the case with Denis Calvaert in

Bologna, Giovanni Stradano in Florence, and Paolo Fiammingo in Venice, to name but a few.

The arrival in Italy of so many Netherlandish artists—who alternated between studying ancient and more modern art and collaborating with contemporary Italian painters, and who either remained in Italy for good or returned to their own countries with a new, Italianate aesthetic outlook—contributed greatly to bringing Netherlandish painting closer to Italian artistic styles. Thus Jan van Scorel, one of those who returned home, brought with him from Rome the light of the "good Italian style" of painting (as van Mander called it), while Frans Floris, for his part, was the first to import the capacity to render musculature and foreshortened figures in a naturalistic way. Other painters, too, introduced additional elements, until there was a reduction in the qualitative difference between North and South with regard to what were thought to be the particular strengths of Italian painting.

It is not unreasonable to wonder whether after the death of Michelangelo and Titian there still existed any effective or marked qualitative disparity between the better artists of the South and the North, at least in terms of their production of religious and mythological scenes. The same holds true for portraiture, which, notwithstanding the national differences noted above, underwent a synthesis developed in accordance with certain almost international schemes adhered to by artists of varying backgrounds, including such great foreign masters as Hans Holbein, Antonis Mor, and others.

The achievement of Northern artists in Rome manifested itself in around 1570 in the awarding of papal and public commissions to a group of artists led by Bartolomeus Spranger, whose works were characterized by a style derived from Raphael, Giambologna, and the Parman painters. Hans Speckaert was another artist who distinguished himself in the Eternal City, producing paintings and drawings in a post-Michelangelesque and occasionally manneristic idiom; the very elements that constituted his art also formed the basis of El Greco's style. In Rome these two Flemish painters operated within the same milieus as their Spanish colleague: on the one hand they were associated with the great patron and "amateur" Cardinal Alessandro Farnese and his painter-miniaturist, Croatian Giulio Clovio (with whom Pieter Brueghel the Elder was also allied during his stay in Rome); on the other hand, they belonged to the circle of the Accademia di San Luca, in which, along with other foreign painters, they were enrolled alongside their Italian counterparts.

Running parallel to the Netherlandish painters' approach to compositions in the narrative genre were the efforts of Northern landscape artists who were likewise fascinated by the Italian style. The artists who visited Rome in the first decades of the century brought back to their own lands elements of a classically Raphaelesque and post-Raphaelesque concept of landscape, along with an almost archaeological interest in ruins. Other masters, including Hieronymus Cock, the great Pieter Brueghel the Elder, and Hendrick Goltzius, fell under the influence of

Titian. Particularly instructive for the Netherlandish painters, according to van Mander, were the wood engravings of Venetian landscapes, notable for their well-balanced spatial structure, which created a striking harmony among the various planes, the terrain, and the buildings, with a light that varied in intensity from foreground to background.

By the middle of the century Netherlandish landscape artists and their works had become so popular on the peninsula that Vasari could claim that not even the poorest cobbler's house was without its Flemish landscape painting—his way of expressing his contempt for the Netherlandish artists' limited abilities and the superficial tastes of their customers.

Among the most often cited landscape artists in Italy was Herri met de Bles, known as Il Civetta ("The Little Owl"), who was probably active south of the Alps and died in Ferrara sometime after 1550. His panel painting of *The Copper Mines* was acquired not long after its creation and installed in the prestigious Tribune of the Uffizi, where it was listed in an inventory taken in 1589, two years after the death of Francis I, who was known for his great interest in the mechanical and technical processes. Indeed, as Franca Calmotti demonstrated in 1991, the Uffizi's rather large painting presents, in the foreground reading from right to left, a fascinating catalog of the successive steps involved in the extraction and processing of ferrous minerals. Countless tiny figures are depicted with the tools of their trade, following a procedure that utilized the smaller ovens typical of the preceding era to carry out the new "indirect method," which consisted of two phases: "the fusion of minerals, achieved through high temperatures and resulting in an alloy with the carbon produced by the combustion of wood in the shape of cast-iron bars; and the successive decarbonization (with a mallet) in order to obtain the iron." The group of travelers in the lower part of the painting, derived from a Martin Schongauer print of the *Flight into Egypt,* demonstrated the propensity of Civetta and his cohorts to employ small figures to impart a specific theme or religious significance to their landscapes.

Painters of Bernard van Orley's generation were very much aware of the art of Raphael, particularly after the arrival in Brussels, in 1517, of the cartoons of the *Acts of the Apostles,* which were taken to the Flemish capital for the manufacture of tapestries based on them and destined for the Sistine Chapel. Before this time, the Leonardesque style of Quentin Metsys and of Joos van Cleve had derived at least in part from France, where Leonardo had spent his last years and where van Cleve had been summoned to serve Francis I and others of his court. In Paris and at Fontainebleau, beginning in around 1540, Italian and Netherlandish painting crossed paths more frequently with French art, resulting in such works as François Clouet's portraits and the anonymous *Women Bathing* part of the group recovered by Rodolfo Siviero.

From the sixteenth century on, Italian collections generally have only a rather limited representation of foreign artists and their works. Even this is restricted largely to a few names, often local examples of those foreigners who worked as independent artists in Italy and achieved a certain renown in their adopted land. From various sixteenth-century inventories emerge the best-known and most (and most often wrongly) cited names: Dürer, Lucas van Leyden, Civetta (which may indicate either de Bles or Hieronymous Bosch, Brueghel the Elder, and a few others. Not suprisingly, this limited knowledge of non-Italian artists also led to incorrect attributions; thus, for example, Gerard David's *Deposition from the Cross* once appeared in the Uffizi's Tribune as the work of Luca of Holland, and later, as that of Dürer. Likewise attributed to the latter artist were, in the seventeenth-century grand-ducal collection, Lucas Cranach's diptych *Adam and Eve* and, in the eighteenth century, the *Madonna and Child with Saints Catherine and Barbara* by the anonymous Master of Hoogstraten. Similarly, before its author was properly identified, the Uffizi's panel painting of the *Madonna and Child* by Alonso Berruguete—who spent several years in Rome and Florence during the first decades of the sixteenth century—was thought to be by Rosso Fiorentino.

The reasons for these errors may be found, first of all, in Italy's centuries-old lack of useful criteria upon which to base well-founded judgments. Another reason is the low esteem in which works from this time and place have long been and are still held, particularly works by those foreign painters who studied Italian art so attentively. Quite significant in this regard is the observation of Edmondo de Amicis in his 1874 book *Holland,* written following his travels to the Low Countries: "Heemskerck imitated Michelangelo; Bloemaert, Correggio; and Mor, Titian, not to mention many others. They were pedantic imitators, adding to their exaggeration of the Italian style a certain German clumsiness, resulting in a kind of bastardized art that is quite inferior to earlier works, which, though almost infantile, rigid in design, crude in coloring, and wholly lacking in chiaroscuro, are at least disinclined to imitation. Indeed, these latter works many be seen as a distant prelude to the real art of Holland"—by which he meant the art of the seventeenth century. However, times and tastes change, and in our own day these "bastard" artists have come to be fully reevaluated.

Bert W. Meijer

397
MASTER OF THE VIRGO INTER VIRGINES
The Crucifixion
Oil on panel, 22⁷⁄₁₆ × 18½ in. (57 × 47 cm)
Uffizi, Gallery; inv. 1890: no. 1237

This panel, which can be dated to between 1475 and 1500, could be found at Poggio
Imperiale by the seventeenth century. Much influenced by the work of Hugo van der Goes,
the unknown Dutch master who painted it can be distinguished from his Flemish counter-
parts through his iconographic originality and his capacity to express deep emotion.

398 and 399
JOOS VAN CLEVE
Portrait of a Man
Oil on panel, 22⁷/₁₆ × 16⁹/₁₆ in. (57 × 42 cm)
Uffizi, Gallery; inv. 1890: no. 1643
Portrait of a Woman
Oil on panel, 22⁷/₁₆ × 16⁹/₁₆ in. (57 × 42 cm)
Dated: 1520
Uffizi, Gallery; inv. 1890: no. 1644

In an Uffizi inventory of 1753, this diptych was listed as a self-portrait by Quentin Metsys with his wife. The work was later attributed to the "Master of the Death of Mary" before finally being given to Joos van Cleve. Engraved on the man's ring is an unidentified coat of arms.

400
MASTER OF HOOGSTRATEN
Madonna and Child Enthroned with SS. Catherine and Barbara
Oil on panel, 34¼ × 28¾ in. (87 × 73 cm)
Uffizi, Gallery; inv. 1890: no. 1019

Once attributed to Dürer, this work was later recognized as being by the hand of an anonymous artist from Antwerp. The picture's architectonic forms, inspired by those of the Italian Renaissance, are characteristic of painting produced in that city in around 1520.

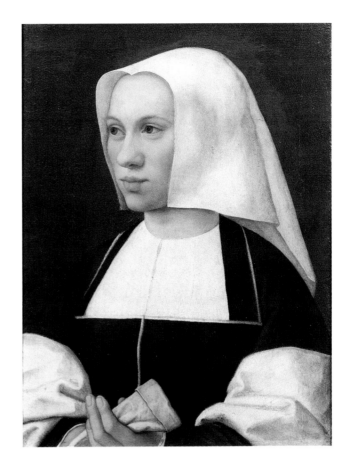

401 and 402
BERNARD VAN ORLEY
Portrait of a Man
Oil on panel, 14⁹⁄₁₆ × 10⅝ in. (37 × 27 cm)
Uffizi, Gallery; inv. 1890: no. 1140
Portrait of a Woman
Oil on panel, 14⁹⁄₁₆ × 11⁷⁄₁₆ in. (37 × 29 cm)
Uffizi, Gallery; inv. 1890: no. 1161

These portraits were listed as the work of Hans Holbein in an inventory of the grand-ducal Guardaroba at the beginning of the seventeenth century. None of the pictures' details has proved to be of any help in identifying the couple portrayed.

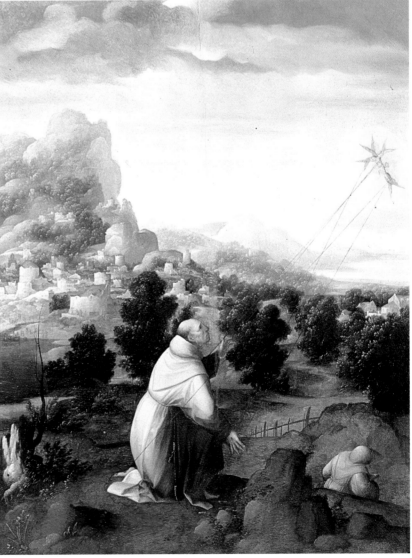

403
JAN VAN SCOREL
The Stigmata of St. Francis
Oil on panel, 27³⁄₁₆ × 21¼ in. (69 × 54 cm)
Pitti, Palatine Gallery; inv. 1912: no. 482

This painting of unknown provenance is characteristic of Jan van Scorel's work; it was probably executed during his stay in Italy, around 1521.

303

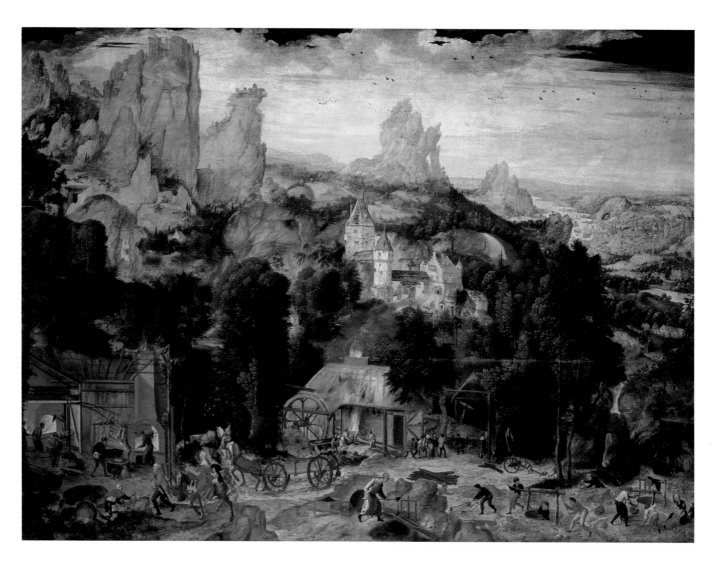

404
CIVETTA
The Copper Mines
Oil on panel, 32¹¹⁄₁₆ × 44⅞ in. (83 × 114 cm)
Uffizi, Gallery; inv. 1890: no. 1051

In the Uffizi collection (Tribune) since 1589 with a consistent attribution to Civetta, this work has become the point of departure for reconstructing the career of the artist. It dates from 1525–1527.

Opposite: 405 and 406
LUCAS CRANACH THE ELDER
Adam
Oil on panel, 67¹¹⁄₁₆ × 24¹³⁄₁₆ in. (172 × 63 cm)
Initialed and dated: 1528
Uffizi, Gallery; inv. 1890: no. 1459
Eve
Oil on panel, 65¾ × 27¹⁵⁄₁₆ in. (167 × 71 cm)
Uffizi, Gallery; inv. 1890; no. 1458

This diptych was noted in the grand-ducal collection in 1688 by Baldinucci; it was then thought to be by Dürer, who had in fact inspired Cranach.

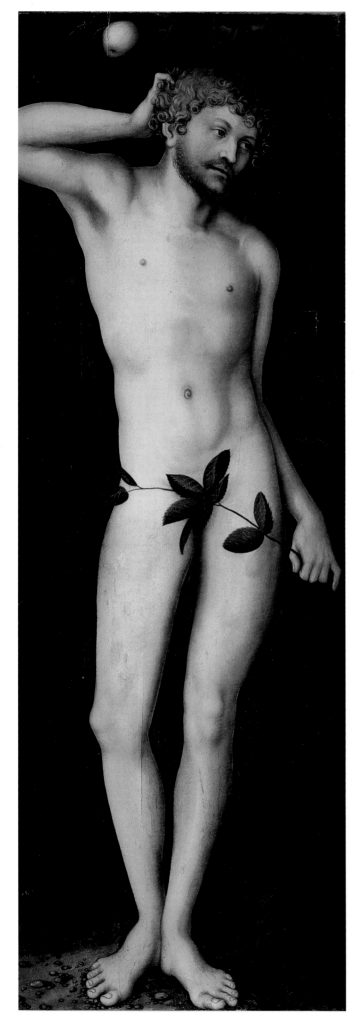
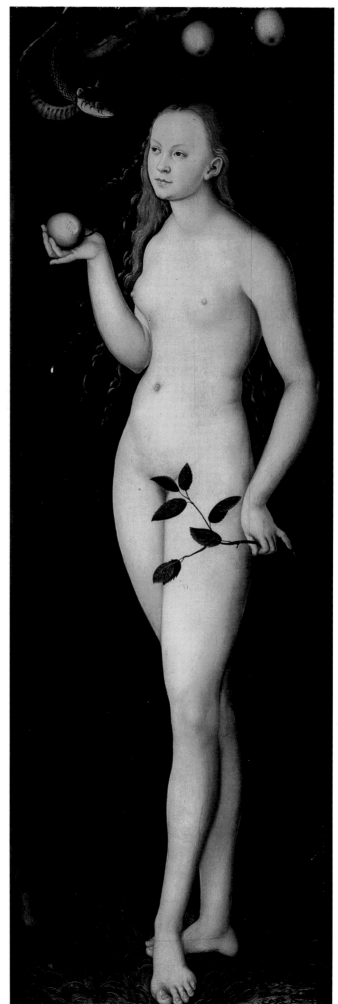

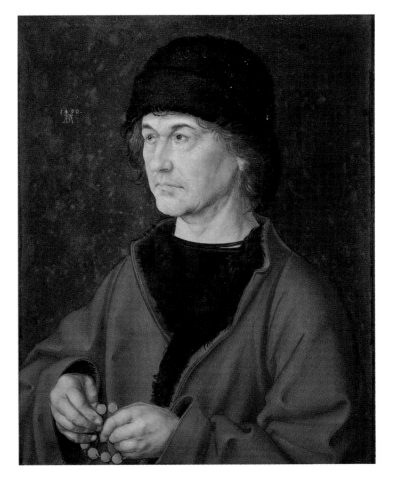

407

ALBRECHT DÜRER

Portrait of the Artist's Father

Oil on panel, 18¹¹⁄₁₆ × 15⁹⁄₁₆ in. (47.5 × 39.5 cm)

Dated on the back: 1490

Uffizi, Gallery; inv. 1890: no. 1086

Dürer painted this portrait of his father a little after his apprenticeship with Michael Wolgemut, whose style is still strongly reflected here. The date "1490" and the monogram "AD" to the left of the figure were added at a later date, perhaps by a different hand. The painting came to the Uffizi through the collections of Rudolph II and Leopoldo de' Medici.

408

ALBRECHT DÜRER

The Great Calvary

Pen and brush with heightening in white lead on green prepared paper, 22¹³⁄₁₆ × 15¾ in. (58 × 40 cm)

Uffizi, Gallery; inv. 1890: no. 8406

Initialed and dated 1505, this is one of a series of twelve drawings (the others are in the Albertina Museum in Vienna) that together make up the so-called *Green Passion*.

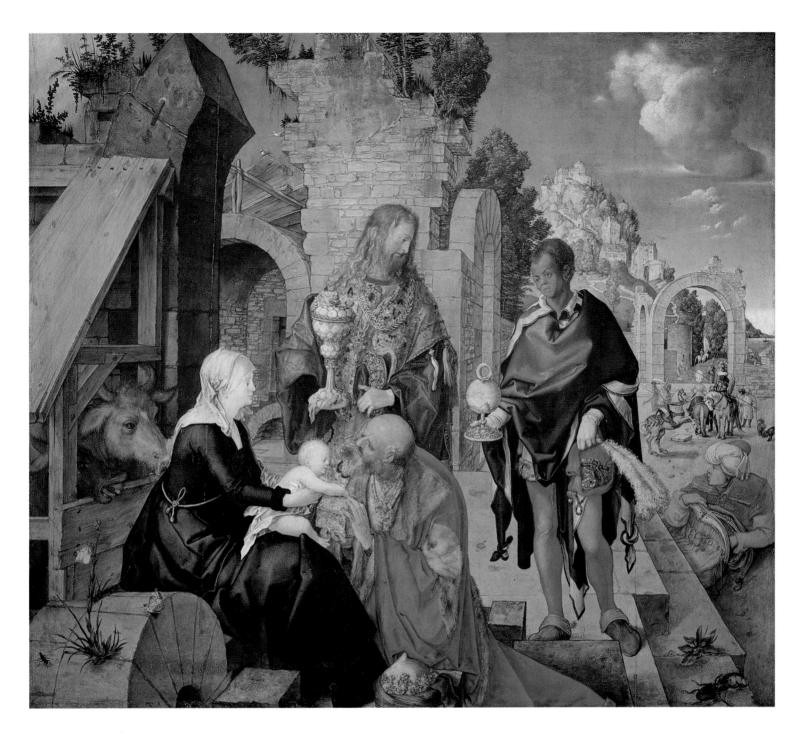

409
ALBRECHT DÜRER
The Adoration of the Magi
Oil on panel, 39 × 44⅟₁₆ in. (99 × 113.5 cm)
Signed with a monogram and dated: AD 1504
Uffizi, Gallery; inv. 1890: no. 1434

This work was executed for Frederick III, elector of Saxony. In 1603 Christian II, elector of Saxony, gave it to Emperor Rudolph II; historical sources suggest that its provenance was Wittenberg. In 1792 it was transferred from the imperial galleries in Vienna to the Uffizi in an exchange for Fra Bartolomeo's *Presentation in the Temple*.

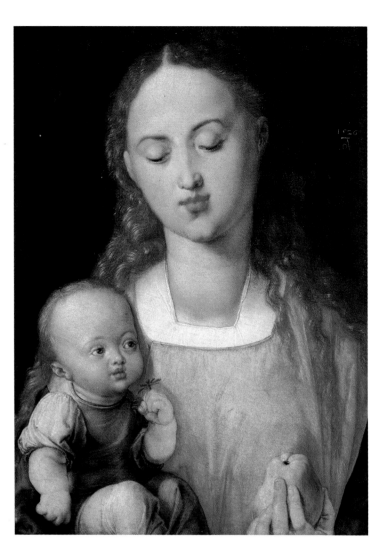

410
ALBRECHT DÜRER
Madonna of the Pear
Oil on panel, 16¹⁵⁄₁₆ × 12³⁄₁₆ in. (43 × 31 cm)
Signed with a monogram and dated: AD 1526
Uffizi, Gallery; inv. 1890: no. 1171

This painting came to the Uffizi in 1773, but it was in the grand-ducal Guardaroba by the beginning of the eighteenth century. The pear, symbol of Christ's universal love of humanity, was first painted larger and then scaled down.

411 and 412
ALBRECHT DÜRER
St. James the Apostle
Tempera on canvas, 18⅛ × 14⁹⁄₁₆ in. (46 × 37 cm)
Signed and dated: AD 1516
Inscription: SANCTE JACOBE ORA PRO NOBIS
Uffizi, Gallery; inv. 1890: no. 1099
St. Philip the Apostle
Tempera on canvas, 17¹¹⁄₁₆ × 15 in. (45 × 38 cm)
Signed and dated: AD 1516
Inscription: SANCTE PHILIPPE ORA PRO NOBIS
Uffizi, Gallery; inv. 1890: no. 1089

In 1620 Emperor Ferdinand II gave these two canvases to Cosimo II de' Medici. It is likely that they were originally part of a series depicting all of the Apostles.

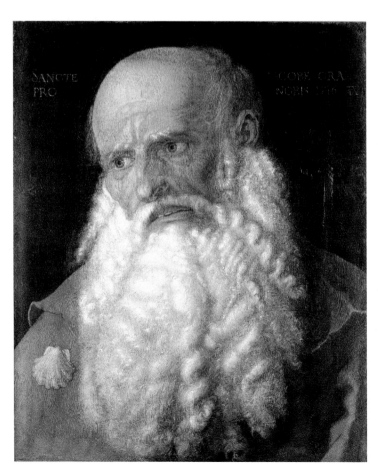

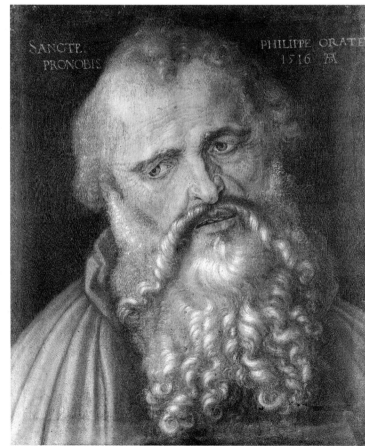

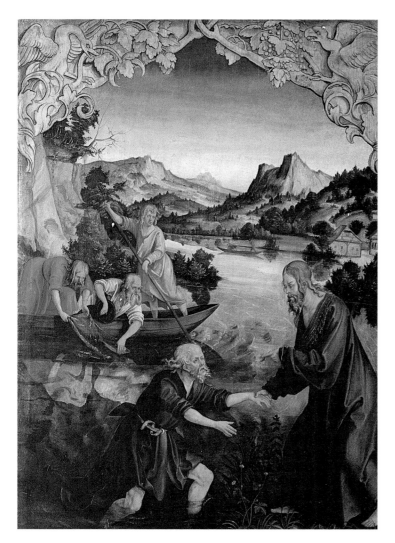

413 and 414
HANS SUESS VON KULMBACH
The Calling of St. Peter and *The Arrest of St. Paul*
Oil on panel, 51¹⁵⁄₁₆ × 37⅝ in. (130.9 × 95.6 cm) (each panel)
Uffizi, Gallery; inv. 1890: nos. 1034, 1044

Along with another six panels (all in the Uffizi), these two scenes belong to a series that was once in the grand-ducal Guardaroba; it was transferred from the Palazzo Vecchio to the Uffizi in 1843. Originally part of an altarpiece that was subsequently dismantled, they were perhaps executed in around 1510 for a church in Kraków.

415
HANS BURGKMAIR
Portrait of a Man
Parchment over panel, 10¹¹⁄₁₆ × 8⅞ in. (27.2 × 22.5 cm)
Signed and dated: BURGKMAIR PIN: IN AUGUSTA REGIA 1506
Uffizi, Gallery; inv. 1912: no. 432

When this painting was discovered in the Pitti's Depository in 1939, it was recognized, despite some repainting, as a possible Burgkmair. Its restoration in 1950 revealed the signature and date that had formerly been visible only through radiography.

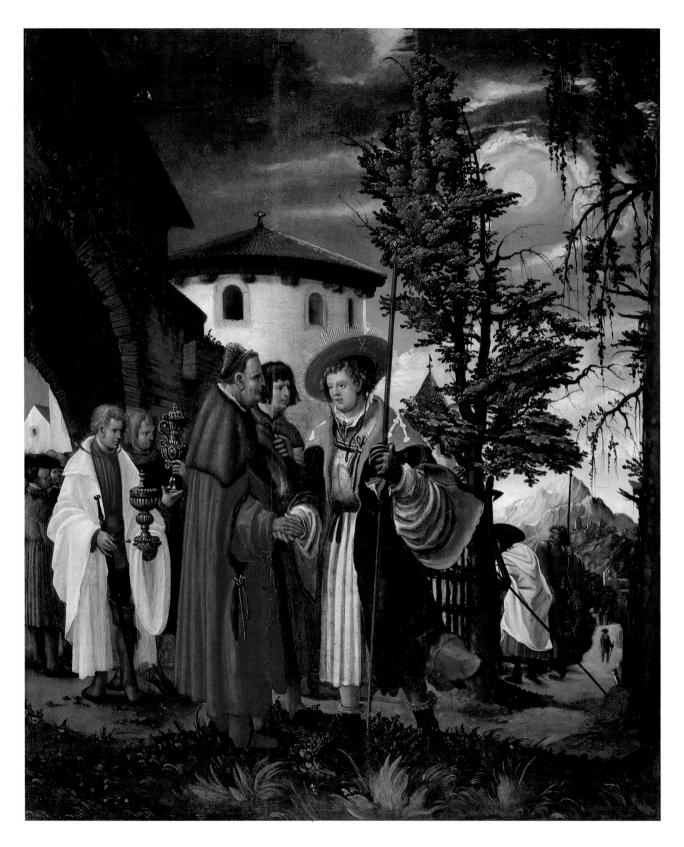

416
ALBRECHT ALTDORFER
The Departure of St. Florian
Oil on panel, 31⅞ × 26⅜ in. (81.4 × 67 cm)
Uffizi, Gallery; inv. Depository: no. 5

Acquired from the Siena Pinacoteca in 1914, this picture and its companion piece, the *Martyrdom of St. Florian*, once belonged to a series of panels that are today divided among museums in Nuremberg and Prague, the Uffizi, and a private collection in Berlin.

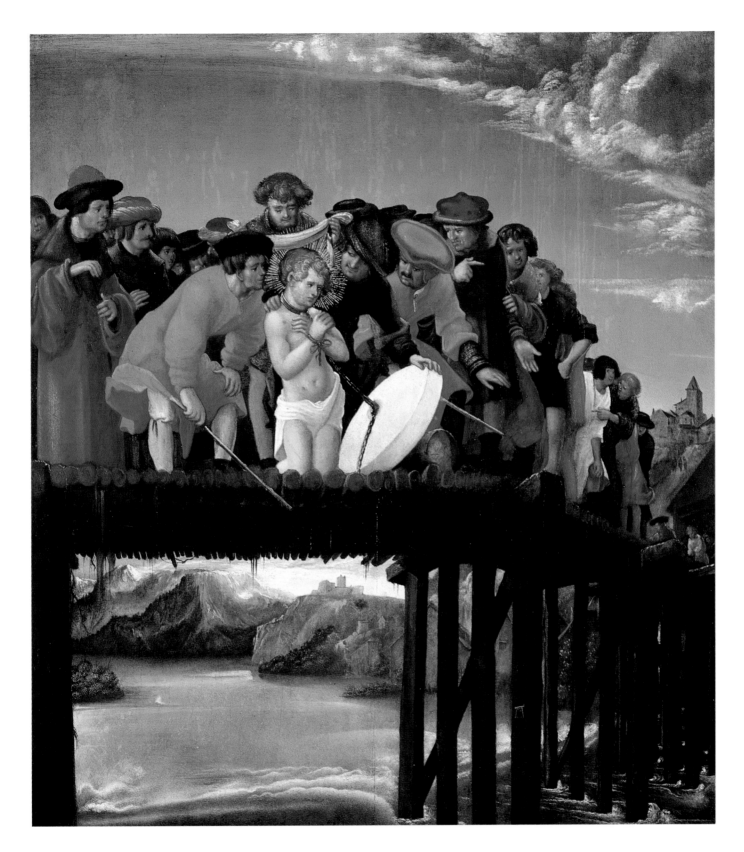

417
ALBRECHT ALTDORFER
The Martyrdom of St. Florian
Oil on panel, 30⅛₆ × 26⅞₆ in. (76.4 × 67.2 cm)
Signed with a monogram: A with an A
Uffizi, Gallery; inv. Depository: no. 4
Like the *Departure of St. Florian* this panel came from the abbey of St. Florian, near Linz.

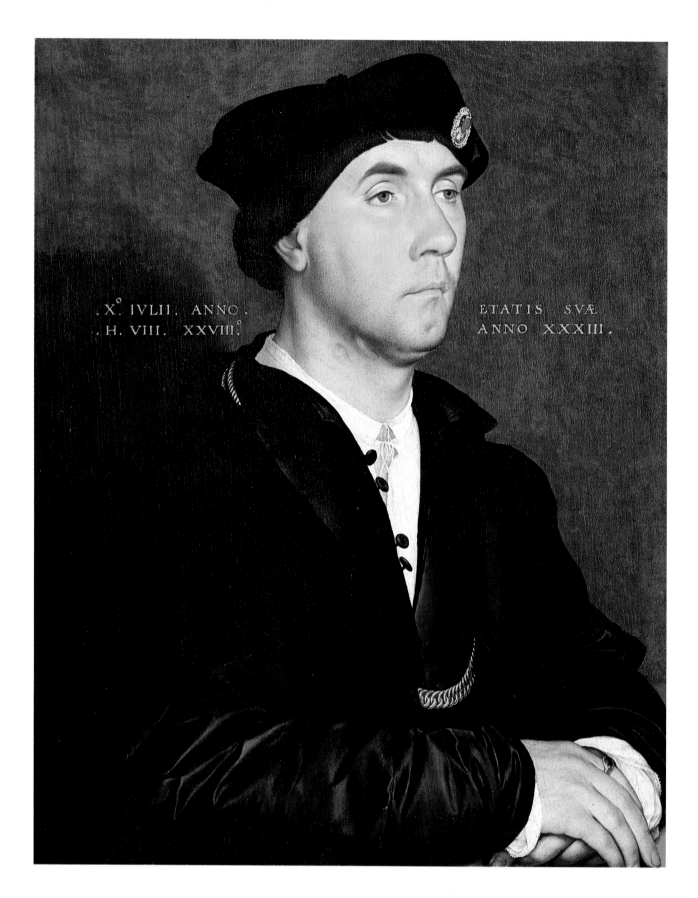

.X°. IVLII. ANNO. ETATIS SVÆ
.H. VIII. XXVIII°. ANNO XXXIII.

418

HANS HOLBEIN THE YOUNGER

Portrait of Sir Richard Southwell

Oil on panel, 18¹¹⁄₁₆ × 15 in. (47.5 × 38 cm)

Dated: X IVLII.ANNO H.VIII.XXVIII.ETATIS SVAE. ANNO XXXIII

Uffizi, Gallery; inv. 1890: no. 1087

Sent in 1621 by the earl of Arundel to Cosimo II de' Medici at the latter's request, this portrait once had a rich ebony frame with four silver medallions bearing the Medici and Arundel coats of arms, the name of the painter, and the name of the sitter, one of Henry VIII's confidants.

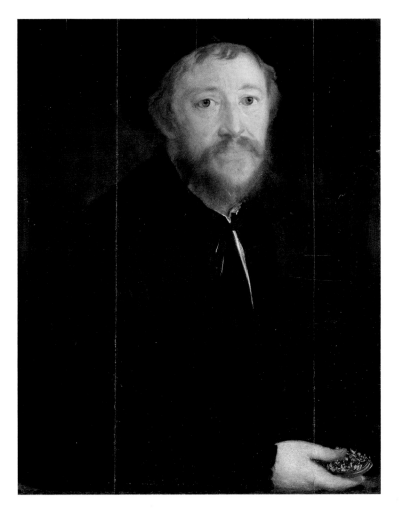

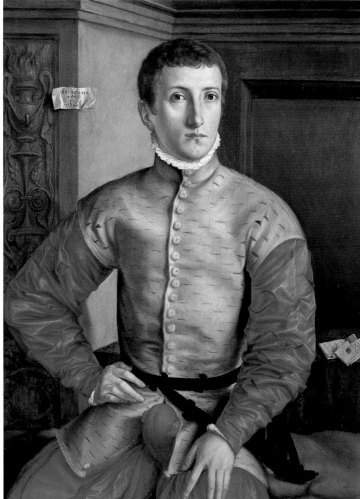

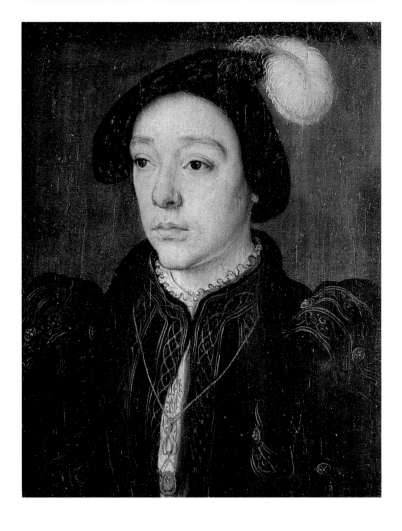

419
CHRISTOPH AMBERGER
Portrait of Cornelius Gros
Oil on panel, 21 × 16¹⁵⁄₁₆ in. (53.4 × 43 cm)
Dated: MDXLIIII CORNELIUS GROS AETATIS XLIII
Uffizi, Gallery; inv. 1890: no. 1110

This picture was once in the Tribune, where it was listed in an inventory of 1635 as being by Dürer. A portrait of a woman by the same hand, now at the Pitti, is probably a pendant to this one.

420
GEORG PENCZ
Portrait of a Young Man
Oil on panel, 35¹³⁄₁₆ × 27⁹⁄₁₆ in. (91 × 70 cm)
Signed and dated on a scroll at the upper left: AETATIS SUE XVIII
15 GP 44
Uffizi, Gallery; inv. 1890: no. 1891

This picture came from Poggio Imperiale as a presumed self-portrait and entered the self-portrait collection as such. The identity of the sitter is not known, but the flaming amphora, a symbol of love, suggests that this may have been a marriage portrait.

421
CORNEILLE DE LYON
Duke Charles of Angoulême
Oil on panel, 6 × 4⅞ in. (15.5 × 12.5 cm)
Uffizi, Vasari Corridor; inv. 1890, no. 1003

Painted in 1536, during a period de Lyon spent at the French court at Lyons, this portrait probably was part of the bequest of Catherine de' Medici to Christine of Lorraine upon her marriage to Ferdinand I in 1589.

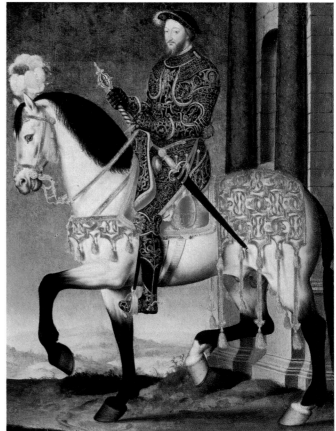

423

FRANÇOIS CLOUET

Francis I on Horseback

Oil on panel, 10⅝ × 8¹¹⁄₁₆ in. (27 × 22 cm)

Uffizi, Gallery; inv. 1890: no. 987

It is possible that this little painting, attributed in an eighteenth-century inventory to Holbein, came to Florence as part of the dowry of Christine of Lorraine. The niece and heir of Catherine de' Medici, wife of Henry II of France, she married Ferdinand de' Medici in 1589.

422

FRANÇOIS CLOUET

Portrait of Henry II

Oil on canvas, 75⅝ × 41⅜ in. (192 × 105 cm)

Inscription: HENRY II DE CE NOM/ROY DE FRANCE

Pitti, Palatine Gallery; inv. 1890; no. 2445

This painting, whose provenance is unknown, came to Florence in 1589 as part of Christine of Lorraine's dowry.

424

JEAN CLOUET

Portrait of Claude of Lorraine, Duke of Guisa

Oil on panel, 11⁷⁄₁₆ × 10¼ in. (29 × 26 cm)

Pitti, Palatine Gallery; inv. 1912; no. 252

This portrait is one of the very few works that can confidently be ascribed to Jean Clouet.

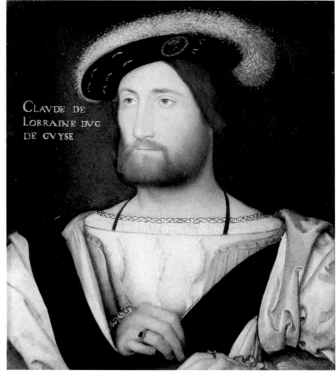

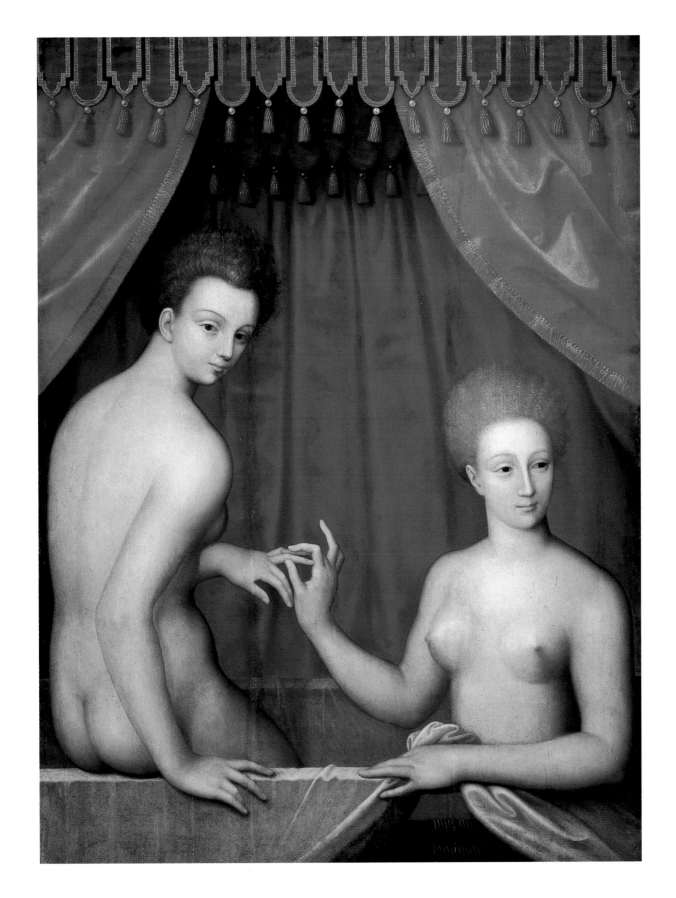

425

ANONYMOUS FRENCH ARTIST

Women Bathing

Oil on panel, 50¹³⁄₁₆ × 38³⁄₁₆ in. (129 × 97 cm)

Uffizi, Gallery; inv. 1890: no. 9958

This painting, which came to Florence from Genoa as a work by Rogier van der Weyden, was sold to Hermann Göring in 1941; it was later recovered from Germany by Rodolfo Siviero. A French work dating from the sixteenth century, it is related to the school of Fontainebleau.

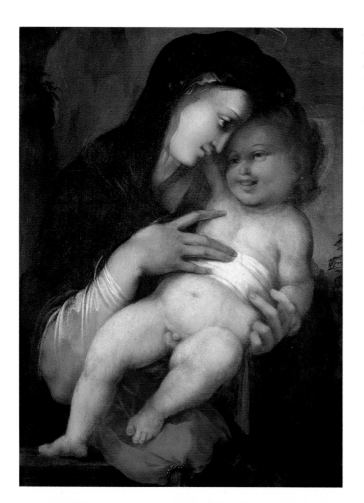

426
ALONSO BERRUGUETE
Madonna and Child
Oil on panel, 35⅟₁₆ × 25³⁄₁₆ in. (89 × 64 cm)
Uffizi, Gallery; inv. 1890: no. 5852
Once ascribed to Rosso, this panel is now recognized as being by the Spanish painter, executed during his stay in Italy.

427
ALONSO BERRUGUETE
Salome with the Head of John the Baptist
Oil on panel, 34⅞₁₆ × 27¹⁵⁄₁₆ in. (87.5 × 71 cm)
Uffizi, Gallery; inv. 1890: no. 5374
Stored at the time in the grand-ducal Guardaroba, this painting appeared in a 1795 inventory with an attribution to Federico Barocci. It dates from Berruguete's Italian period.

428
EL GRECO
S.S. John the Evangelist and Francis
Oil on canvas, 42¹⁵⁄₁₆ × 33⅞ in. (109 × 86 cm)
Signed: DOMINICOS THEOTOKOPULOS EPOIESE
Uffizi, Gallery; inv. 1890: no. 9493

In addition to this canvas—itself typical of the artist's work in around 1600—there exist
two other versions of the same composition, both considered to be workshop productions.
The Uffizi's painting, perhaps acquired by a member of the family of the dukes of Sueca,
passed through the inheritance of Ruspoli y Godoy and came to the gallery in 1976.

429

JOACHIM BEUCKELAER

Pilate Shows Jesus to the People

Oil on panel, 43⁵⁄₁₆ × 55⅛ in. (110 × 140 cm)

Signed and dated: JB 1566

Uffizi, Gallery; inv. 1890: no. 2215

There exist two contemporaneous versions of this painting. As is usual in this artist's work, the main episode—the subject of the painting—is in the background, while the foreground is taken up with a market scene.

430
FRANS FLORIS DE VRIENDT
Adam and Eve
Oil on panel, 69⅝ × 59⅛ in. (176 × 150 cm)
Signed and dated: F. FLORIS F. A. 1560
Pitti, Palatine Gallery; inv. 1890: no. 1082

Exhibited in the Uffizi when it came from the Pitti's Guardaroba in 1779, this panel
was first cited in a 1668 inventory of the Pitti Palace.

Federico Barocci

In the middle of the sixteenth century, the period of Federico Barocci's formation as an artist, the dominant artistic principles were those of the *maniera,* or mannerism. During the same years, the Church was shaken to its foundation by a revolution brought about not only by the Counter-Reformation but also by the establishment of new religious orders and the recovery of older forms of spirituality. Barocci was the first artist who thought to exploit the cardinal precepts of the mannerist aesthetic to produce a kind of painting with renewed religious content.

The principal characteristics of Barocci's paintings were the qualities of mannerism, but here used to an entirely new end, to capture the viewer emotionally, to arouse his devotion, to make him share in the spiritual state of the sacred persons represented.

The composition of his works is complex, based on diagonals that pull the eye from above toward a central point of interest, according to directives chosen by the painter, as in the *Burial of Christ* of 1582 (Senigallia, Santa Croce) and the *Nativity* of 1579 (Madrid, Prado). To accentuate the emotional impact of particular dramatic or supernatural themes, such as scenes of miracles or ecstasies, Federico did not hesitate to adopt a double perspective that, by creating an almost dizzying effect, could more strongly communicate the mystic experience (as, for example, in the *Pardon of Assisi* of c. 1574–1576 in San Francesco in Urbino, or in the *Madonna of the Rosary* of c. 1589–1593 in the Palazzo Vescovile in Senigallia, or in the *Crucifixion with St. Sebastian* of 1596, a most important work whose destination, the Duomo in Genoa, was well known to Rubens and Van Dyck). In his paintings the figures are often severely foreshortened and positioned in such a way as to bring about specific spatial effects; but since Barocci's intention is to convince the viewer of the true faith being represented, his figures never appear in exaggerated or unnatural attitudes, as is frequently the case in manneristic works. Every detail has been graphically studied in real life to ensure that "in that gesture," for example, the posed model does not feel "the least strain," as Barocci's biographer Bellori wrote. The theatricality of the artist's compositions is emphasized by colors that, though naturalistic, tend toward such an aesthetic gratification that they become absolutely improbable; this then lends another important element to the network of devices that serve to tune in the viewer's state of mind to that of the persons depicted. The iridescence of the colors is accentuated by a flickering light that falls on objects and figures from above, contributing to the definition of space (in the background the colors and contours are often "eaten up" by the light) and creating an illusionistic sense of air being circulated. This scenographic ability in the use of lighting is particularly evident in a technique that Barocci borrowed from the engraver's art, whereby a specific area was masked and worked up several different times; the process was to enjoy widespread popularity among contemporary artists.

The matching of color, in Barocci's paintings, as Bellori described it, may have been in response to the notion of musical harmony, a concept that also underlies the gestures and expressions of his figures (as in the *Deposition of Christ* of 1569, in the Duomo in Perugia, and the *Rest on the Flight to Egypt* of 1570–1573, in the Vatican and in Santo Stefano in Piobbico). The manifestation and communication of emotional states, a primary element of the Urbino picture, were worked out at great length on paper, but it was in the pictorial realization of his portraits that Barocci obtained the particularly vital effects that most distinguished his work.

Barocci's paintings inspired an immediately perceptible religiosity, the communication of which is based on a strongly established narrative that is sometimes enhanced by the inclusion of humble everyday objects (as in the *Circumcision of Christ* of c. 1590, in the Louvre), animals (as with the cat in the *Annunciation* of c. 1584 for Loreto, now in the Vatican), or landscapes made up of views that would be familiar to his countrymen, such as the prospect of the ducal castle at Urbino, replicated in innumerable variations. The choice of narrative simplicity and of a message that was more sentimental than intellectual brought Barocci's spirituality into line with that of the mendicant orders (indeed, he was often in contact with the Franciscans and the Carmelites) and the new order of the Oratorians, to which the artist was introduced during his stay in Rome. His painting seems to respond to the principles of joy and the serene communion of the faithful.

Barocci's personal Counter-Reformational rejection of mannerism, little exported outside the Marches, met with immediate local success and a slower diffusion elsewhere (during the last decade of the sixteenth century, Siena was converted to the "baroque" style by Francesco Vanni and Ventura Salimbeni; and likewise—though only partially—Naples by Ippolito Borghese), but it never really reached the great artistic centers. In light of the new demands of the Church, mannerism, as exemplified by the work of Vasari and his followers, came to be irredeemably condemned for its aesthetic pagan pleasures and its excessively intellectual aspect.

The importance of Federico Barocci's painting was to be grasped only by artists a generation or two younger than he, who made him one of the pillars on which they built their own radical innovations. First among these were the Carracci and the Bolognese painters (especially Guido Reni), for whom Barocci's work constituted a unique precedent in its attempt to involve the viewer emotionally. Along with the Emilians, there were the Florentines: the *Madonna of the People,* brought to Arezzo in 1579, would serve as the chief text for the young Cigoli and Pagani, the key to the comprehension of a potential that still lay unexplored in Correggio's art and that of the Venetians; the study of Barocci was thus to become a canonical element in the artistic formation of the young painters. Echoes of Barocci's tenderness, profoundly religious but at the same time possessed of a

worldly grace, could be perceived in the middle of the seventeenth century in Volterrano's painting; and again, in the eighteenth century, the intimacy and warmth of his elaboration of sacred themes would be of interest to Giuseppe Maria Crespi. In the Northern countries, too, several of Barocci's ideas, reproduced in the form of engravings, had a profound and widespread impact.

Marta Privitera

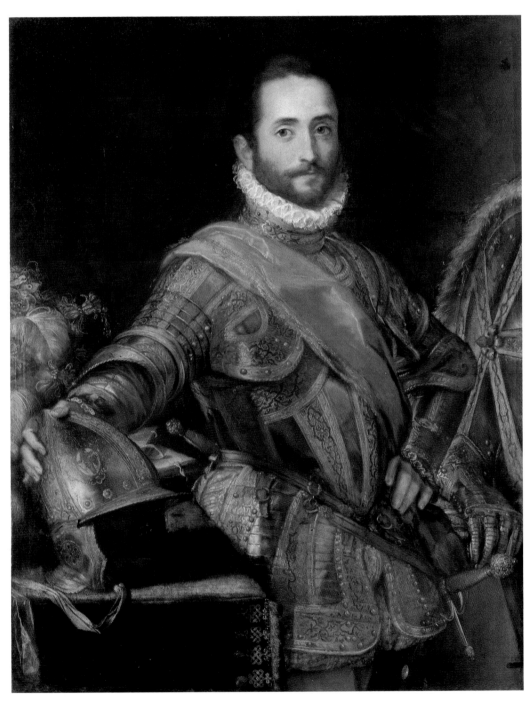

431
FEDERICO BAROCCI
Portrait of Francesco Maria II della Rovere
Oil on canvas, 44½ × 36⅝ in. (113 × 93 cm)
Uffizi, Gallery; inv. 1890: no. 1438
The oldest inventories record the subject of this portrait, Francesco Maria della Rovere, duke of Urbino, with the notation "when he returned from the army"—after the battle of Lepanto, in 1572. The painting became the property of the Medici family in 1631; it has been in the Uffizi since the nineteenth century.

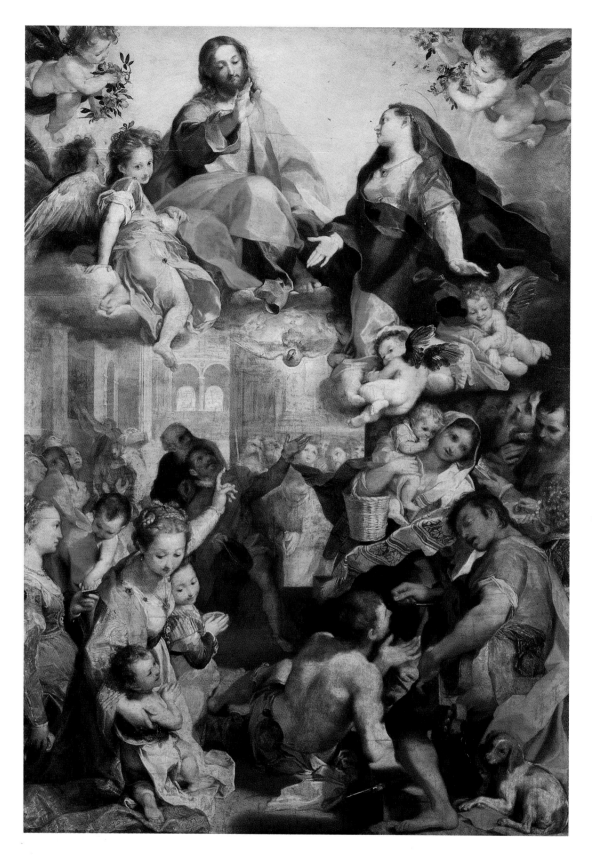

432

FEDERICO BAROCCI

Madonna of the People

Oil on canvas, 141⁵⁄₁₆ × 99³⁄₁₆ in. (359 × 252 cm)

Uffizi, Gallery; inv. 1890: no. 751

This painting was commissioned from Barocci by the confraternity of the lay brothers of Santa Maria della Misericordia in Arezzo for their chapel in Santa Maria della Pieve. The painter began the designs for the work in 1576 and completed it in the spring of 1579. Although this canvas was acquired by Grand Duke Pietro Leopoldo in 1786, the lunette with God the Father is still in the Arezzo Museum.

433

FEDERICO BAROCCI

Portrait of a Maiden

Oil on paper, 17¹¹⁄₁₆ × 13 in. (45 × 33 cm)

Uffizi, Gallery; inv. 1890: no. 765

Nothing in this painting securely identifies the sitter. She may be Lavinia Feltria della Rovere, sister of Francesco Maria della Rovere, duke of Urbino, who was born in 1558. Suggestions as to the date of the work vary from 1570–1575 to 1583 (the year of Lavinia's marriage to Alfonso Felice d'Avalos). From 1773 it was documented as being at Poggio a Caiano.

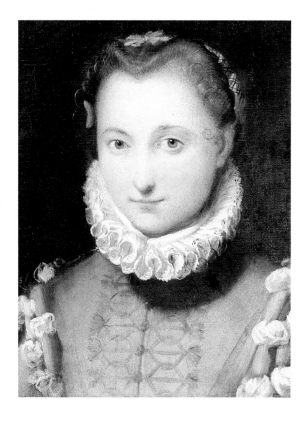

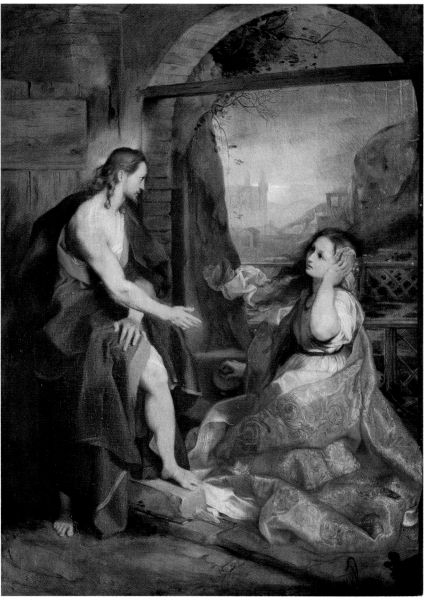

434

FEDERICO BAROCCI

Noli Me Tangere

Oil on canvas, 48 × 35¹³⁄₁₆ in. (122 × 91 cm)

Uffizi, Gallery; inv. 1890: no. 798

This is in fact a smaller replica of a painting now in the Alte Pinakotek in Munich, which is signed and dated 1590. This canvas can be dated to immediately after 1590, though nothing is known of its provenance. The background depicts the ducal castle at Urbino. Barocci also executed a third version of the same subject, with certain variants (now in the Allendale collection, Bywell Hall).

Caravaggio and the Caravaggisti

Considering that Michelangelo Merisi, according to sources and archival documents in our possession, never set foot in Florence, and considering that no local Florentine school was ever developed by his followers, the group of Caravaggesque paintings in the Florentine galleries is particularly noteworthy; indeed, for both quality and quantity, it is without equal outside Rome. Its presence can be explained by the rapport that existed between the Medici and Rome in the first decades of the seventeenth century. A decisive figure in this relationship was Cardinal Francesco Maria Del Monte, the grand duke's representative in the papal city and Caravaggio's first important protector; and in fact, Grand Duke Cosimo II himself showed an interest in Caravaggesque painting on more than one occasion in the course of the second decade of the seventeenth century. Six canvases by Caravaggio are divided equally between the Uffizi and the Palatine Gallery in the Pitti Palace, with the three Uffizi pictures dating from the artist's Roman period—which lasted from 1592 until the beginning of the summer of 1606—and the three Pitti Palace paintings from the last years of his activity, between 1608 and 1609.

The works in the Uffizi (and in particular the *Bacchus* and the *Medusa*) are examples of Caravaggio's early production, when he was living in the household of Cardinal Del Monte (the present Palazzo Madama). In these youthful efforts Caravaggio never deviated from those qualities that were to be fundamental to all his artistic activity: a faithfulness to nature, a likeness transformed into a picture without the "improvement" typical of academic principles, which ever sought to rectify, to purify, the simple and contingent reality before the artist's eyes. Thus the boy who posed for the *Bacchus* in the Uffizi is also recognizable in other works from this early period (such as the *Fortune-teller* in the Louvre and the *Lute Player* in St. Petersburg), as a result of Caravaggio's practice of not modifying his models' physiognomic features, and not denying their physical presence in front of him.

The *Bacchus* is one of the best illustrations of the Lombard cultural baggage that Caravaggio brought with him when he arrived in Rome in 1592, which had more than a marginal influence on his artistic development and choices in those early Roman years, as the masterful study by Roberto Longhi has long since demonstrated. It is possible that this painting came to Florence as a gift from Cardinal Del Monte to Grand Duke Ferdinand de' Medici, as was assuredly the case with the artist's other sixteenth-century work in the Uffizi, the *Medusa,* which was painted on a shield that very probably decorated the armory of the Florentine grand duke. This extremely strong and disturbing image, which treats, with great vigor and energy, the theme of the shriek—also addressed in the *Boy Bitten by a Lizard* (London, National Gallery of Art; Florence, Roberto Longhi Foundation) and taken up again in two other famous depictions by Caravaggesque figures, the screaming altar boy of the *Martyrdom of St.*

Matthew and Holofernes in the Barberini *Judith*—is yet another of the painter's formidable inventions. Fascinated by the myth of the Gorgon decapitated by Perseus, Caravaggio here elaborates an original iconography, focusing attention on an event that has already happened, but at the same time transcending that event by making the screaming head into an emblem outside of the story, like the masks associated with Greek tragedy.

The third Uffizi canvas, the *Sacrifice of Isaac,* seems to date from around 1603–1604 and was painted for Maffeo Barberini, the future Pope Urban VIII. This beautiful picture is distinctive for the vast landscape visible on the right (something of a rarity for Caravaggio, who inserted similar pastoral passages in the Doria *Rest on the Flight into Egypt,* in the Odescalchi-Balbi *Conversion of Saul,* and in the *St. Francis in Ecstasy* in Hartford), with its suggestions of Giorgione's work. As with the model for the Uffizi's *Bacchus,* the real-life model for Isaac was used more than once by the painter (for example, in the *Amor Victorious* in Berlin and in the Capitoline *The Young St. John*); he has recently been identified as the young Francesco Boneri, nicknamed Cecco del Caravaggio, who would one day become one of the painter's greatest followers.

The three Palatine Gallery paintings display a completely different aspect of the artist. The clear and luminous tones of the Uffizi pictures are all but abandoned; instead, figures and objects emerge from the darkness of the background with an almost feverish velocity and "pull" created by long brushstrokes laid down with a prodigious confidence, the brush never leaving the canvas.

The *Sleeping Cupid* was executed by Caravaggio in 1608 during his sojourn in Malta. This depiction of a sleeping child (the glinting of wings in the darkness hints that he is Cupid) could hardly seem further removed from Caravaggio's earlier search for beauty in the faces and bodies of his models.

The identity of the sitter in the *Portrait of a Knight of Malta,* reattributed to Caravaggio in 1966 by Gregori, remains unknown. A recent attempt on the part of Marco Chiarini to single out a member of the Florentine Martelli family who was the prior of the Order of Malta at Messina in 1604 would put the execution of the painting in around 1609, during the artist's stay in that Sicilian city. The portrait was painted very quickly, with a reddish underlayer that shows up a thin brown surface layer; in both strength and immediacy, it easily surpasses the more stately and naturalistic *Portrait of Alof de Vignacourt* (Paris, Louvre), long considered to be one of the most memorable of seventeenth-century portraits.

The last painting by Caravaggio in the Pitti is the *Tooth Puller.* Assigned to Caravaggio with reservations by Schleier and unreservedly by Gregori in 1974, it has aroused sharp controversy as to its authorship, a question that seems finally to have been settled in recent years. It is thought in any case to be a late work—perhaps the latest of all those in Florence—executed either toward the end of Caravaggio's time in Malta or, more likely, in Sicily; it represents a return on his part to a genre subject, like those that had occupied him in Rome during the last years of the sixteenth century.

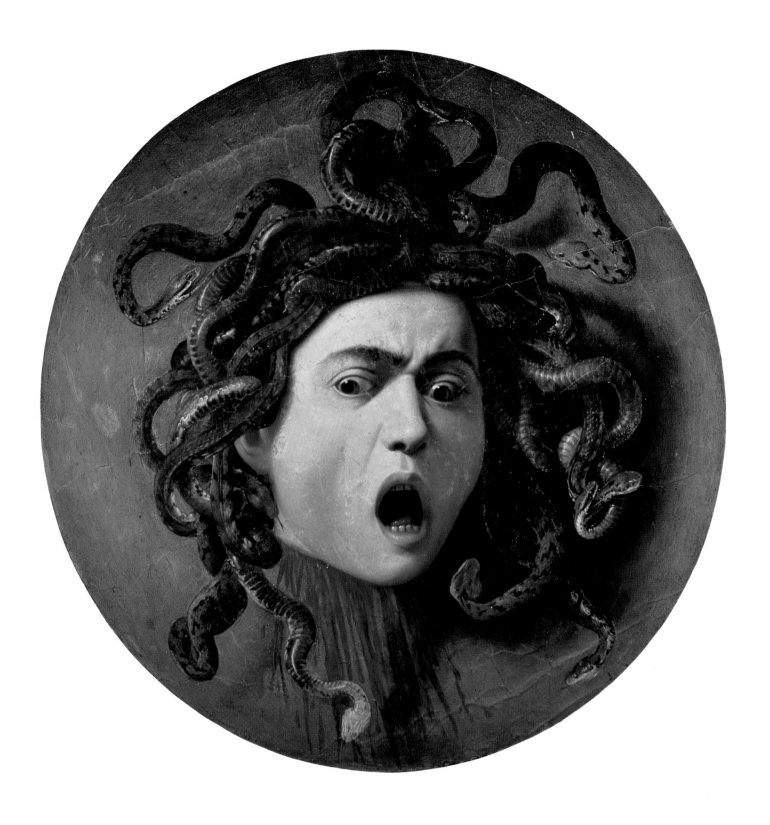

435
CARAVAGGIO
Medusa
Oil on canvas applied to a poplar-wood shield, 23⅝ × 21¹¹⁄₁₆ in.
(60 × 55 cm)
Uffizi, Gallery; inv. 1890: no. 1351
A gift sent by Cardinal Del Monte to Grand Duke Ferdinand de'
Medici for his armory, this is supposed to be a shield for the parade
ground. It probably dates from between 1595 and 1597.

As has already been mentioned, Florence did not develop a Caravaggisti movement, unlike those places where the painter stayed for a greater amount of time, such as Rome, Naples, and Sicily. Nor were Florentine artists much influenced by Caravaggio's new way of understanding painting—that is, as an adherence to nature and its faithful representation through an exclusive emphasis on the physical reality of the model; in Rome, by way of contrast, he turned the artistic panorama inside out. It was mainly through the interest of Grand Duke Cosimo II, who was in power during the very period (1609–1621) when the vogue for Caravaggesque painting reached its apex, that such protagonists of the Roman and Neapolitan scenes as Artemisia Gentileschi and Battistello Caracciolo came to Florence, along with a number of prestigious works by other Caravaggisti.

In the paintings she executed either in Florence, where she lived from 1613 to 1620, or for Florentine patrons, Artemisia confirmed her vocation for a naturalism that adhered strictly to Caravaggesque concepts but was at the same time sustained by a component draftsmanship that rendered the integral elements in a clear and well-balanced manner. Neither did she neglect the details, emulating in that respect the great skill in portraying the substance of fabrics for which her father, Orazio, had been famous. This supreme virtuosity is displayed, for instance, in the decoration and draping of the clothes of the Pitti's *Judith and Her Maidservant*. However, Artemisia also introduced to Florence the crueler and more savage aspects of Caravaggesque painting, offering in her *Judith Beheading Holofernes*—a work that reiterates and expands on the violence of Caravaggio's Coppi *Judith*, one of the most extreme and disturbing representations of sadism ever created. Not coincidentally, this great canvas by Gentileschi was relegated, in the eighteenth century, to the darkest corner of the Uffizi because the grand duchess could not bear to look at it.

The Florentine galleries also boast the most significant nucleus of works (six canvases, two of which were completely destroyed in the attack on the Uffizi in May 1993) by Bartolomeo Manfredi. Manfredi was the best-known disseminator, with the help of a cosmopolitan multitude of followers, of the kinds of genre scenes that Caravaggio specialized in during his early years, as in Manfredi's *Card Players*, the *Concert*, and the *Fortune-teller*, or the sacred iconographies into which he was able to introduce similarly worldly passages, such as the *Fall of the Merchants from the Temple* or the *Calling of St. Matthew*.

Cosimo II's predilection for paintings on convivial subjects in horizontal format (five of Manfredi's canvases meet this latter criterion) is confirmed by the Medici emissaries' pursuit on the Roman market, documented in old sources, of pictures by Gerrit van Honthorst. That this Dutch painter was one of the grand duke's favorites (above all for his nocturnal scenes) is attested to by the paintings by him at the Uffizi, including three banquet scenes and a possible *Adoration of the Child*. Perhaps his most important work, the great *Adoration of the Shepherds*, was painted in 1619–1620 for the Guicciardini chapel in Santa Felicita in Florence.

The interest of another Medici, Grand Prince Ferdinand, who lived at the end of the seventeenth and the beginning of the eighteenth centuries, was responsible for the inclusion in the Uffizi of two masterpieces (*Love Victorious* and the *Martyrdom of St. Cecilia*) by the Pisan Orazio Riminaldi. Riminaldi spent the greater part of his career in Rome, where, during his fifteen-year residence—up until 1627, after which he returned to Pisa, only to die three years later—he combined the Caravaggesque pictorial language of his master Manfredi with the protobaroque innovations of Giovanni Lanfranco, at last approaching the grand and sumptuous style of the last Roman years of Simon Vouet.

These important nuclei must be added to other masterpieces of the Caravaggisti movement, such as the sublime *St. Jerome with Two Angels*, acquired in 1617, by Bartolomeo Cavarozzi, one of the rarest and most refined practitioners of Roman naturalism. The mysterious but nonetheless noteworthy *Liberation of St. Peter*, for its part, has inspired a whirlwind of attributions by the major Caravaggisti scholars but has never been convincingly assigned. No less significant, finally, is the presence of a canvas on a profane subject by Spadarino (the only one, other than his *Narcissus* in the National Gallery in Rome): the Uffizi's *Banquet of the Gods*, acquired in 1793 through an exchange with the Imperial collection in Vienna.

Gianni Papi

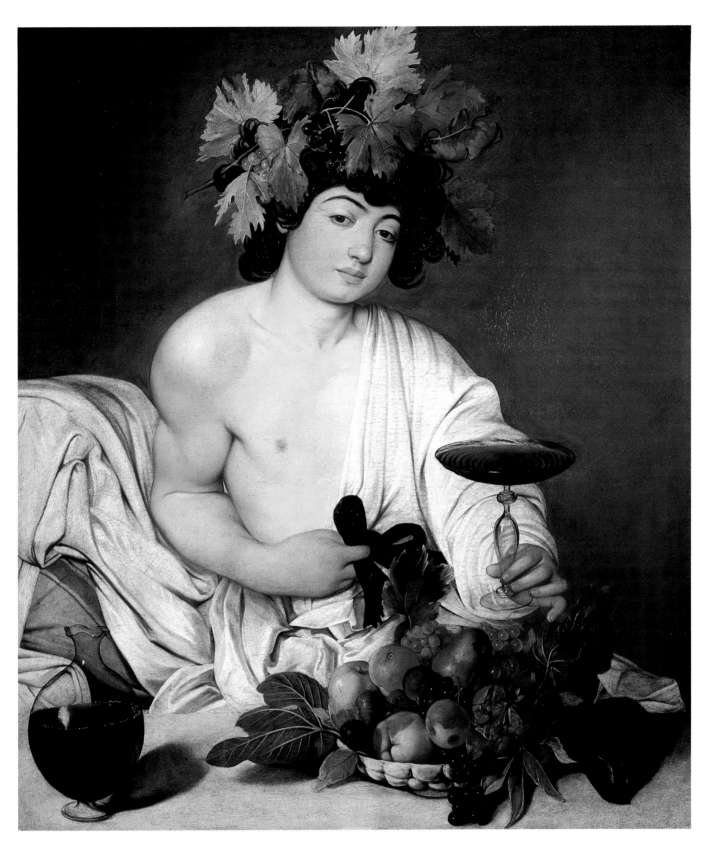

436
CARAVAGGIO
Bacchus
Oil on canvas, 37⅜ × 33⁷⁄₁₆ in. (95 × 85 cm)
Uffizi, Gallery; inv. 1890: no. 5312

This painting was probably executed in around 1596–1597, when Caravaggio was the guest of Cardinal Del Monte; it is possible that, as with the *Medusa*, it was later given by the cardinal to his friend Ferdinand I de' Medici. It was rediscovered in the Uffizi's Depository in 1916 and recognized by Roberto Longhi as an autograph work of the artist.

Overleaf:
Bacchus (detail)

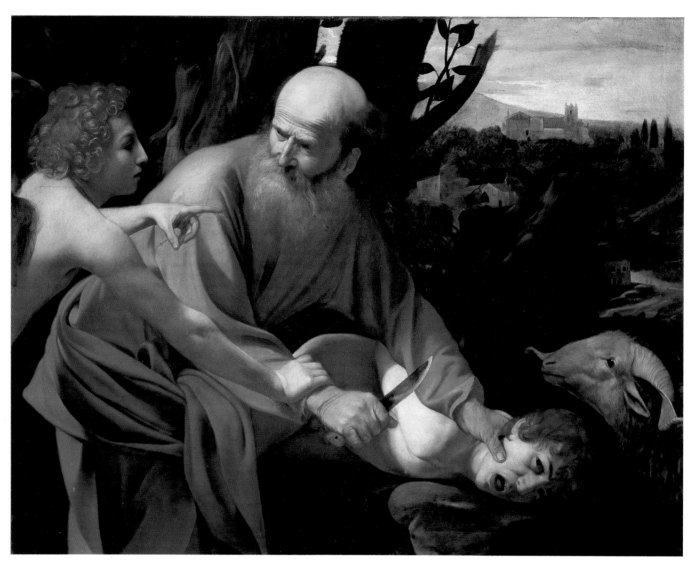

437
CARAVAGGIO
The Sacrifice of Isaac
Oil on canvas, 40¹⁵⁄₁₆ × 53⅛ in. (104 × 135 cm)
Uffizi, Gallery; inv. 1890: no. 4659

This picture can with all probability be associated with a series of payments totaling one hundred scudi, made by Monsignor Maffeo Barberini to Caravaggio between the spring of 1603 and January 1604. Cited in inventories of the Barberini house and, in the nineteenth century, in the Sciarra collection, it came to the Uffizi through a donation by John Fairfax Murray.

438
CARAVAGGIO
Sleeping Cupid
Oil on canvas, 28⅜ × 41⁵⁄₁₆ in. (72 × 105
cm)
Pitti, Palatine Gallery; inv. 1912: no. 183
The artist painted this work during his stay
in Malta in 1608. Shipped off the island by
Francesco dell'Antella, a knight of St. John,
by July 1609 it was already installed in the
Antella family palace in Florence. It was
acquired for the Medici collection in 1667
by Cardinal Leopoldo.

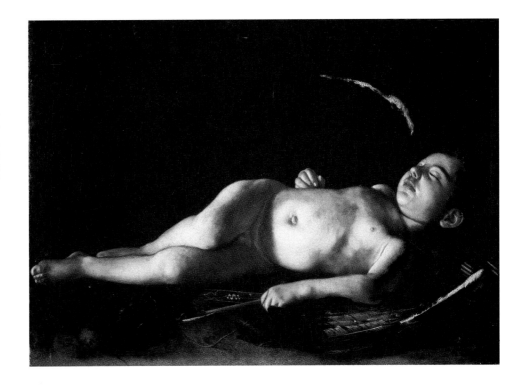

439
CARAVAGGIO
Portrait of a Knight of Malta
Oil on canvas, 46⅝ × 76⁹⁄₁₆ in. (118.5 ×
95.5 cm)
Pitti, Royal Apartments; inv. Oggetti
d'arte: no. 717
Marco Chiarini has hypothesized, on the
basis of an inventory citation, that the sitter
in this portrait may be identified as Mar-
cantonio Martelli, prior of the Order of
Malta at Messina in 1604; this suggests that
the picture was painted in Messina in
around 1609. It is not known how it came to
the Florentine collections. Its attribution to
Caravaggio, made by Mina Gregori, has
been unanimously agreed to by other
scholars of the artist.

440
CARAVAGGIO
The Tooth Puller
Oil on canvas, 54¹⁵⁄₁₆ × 76⁹⁄₁₆ in. (139.5 × 194.5 cm)
Pitti, Palatine Gallery; inv. 1890: no. 5682

A painting on this subject was ascribed to Caravaggio in an inventory of the Pitti Palace dated March 4, 1637. The object of heated critical debate, the attribution has at last found a consensus on the part of most Caravaggio scholars following Mina Gregori's convincing 1974 argument.

Opposite: 441
BARTOLOMEO MANFREDI
The Card Players
Oil on canvas, 51³⁄₁₆ × 75⅜ in. (130 × 191.5 cm)
Uffizi, Vasari Corridor; s.n.

This picture was destroyed in the May 1993 attack on the Uffizi. Like the *Concert* by the same artist (caption 442), and with a similar attribution to Manfredi, it was given by Ferdinand de' Medici to his mother, Maria Maddalena of Austria, as a New Year's gift in 1626. Derived from Caravaggio's *Cardsharps*, now in Fort Worth, it was much imitated by Caravaggio's followers as well as by those of Manfredi.

442
BARTOLOMEO MANFREDI
The Concert
Oil on canvas, 51³⁄₁₆ × 74⅝ in. (130 × 189.5 cm)
Uffizi, Vasari Corridor; inv. 1890: no. 4359

This painting entered the Medici collection as a work "by the hand of Manfredi Mantovano" when Grand Duke Ferdinand II de' Medici gave it, along with the same artist's *The Card Players* (caption 441), to his mother, Maria Maddalena of Austria in 1626. Lost in the same circumstances as that work, it was a prototype whose influence is evident in analogous scenes by Tournier, Régnier, and Valentin.

443

BARTOLOMEO MANFREDI

Tribute to Caesar

Oil on canvas, 51³⁄₁₆ × 75³⁄₁₆ in. (130 × 191 cm)

Uffizi, Vasari Corridor; inv. 1890: no. 778

In 1666 this painting, along with a *Christ among the Doctors*, was recorded in Cardinal Carlo de' Medici's inventory as the work of Caravaggio. Between 1772 and 1779 it was exhibited in the Uffizi's Tribune, where Zoffany painted it. Voss and Longhi, in 1924 and 1943 respectively, attributed it to Manfredi.

444
BARTOLOMEO MANFREDI
Cain and Abel
Oil on canvas, 67⁵⁄₁₆ × 48 in. (171 × 122 cm)
Pitti, Depository; inv. 1890: no. 5842

This painting's provenance is unknown; it was found in 1943 in the
Depository of the Pitti Palace by Roberto Longhi, who ascribed it
to the Mantuan painter. Later it was given to Orazio Riminaldi, but
the more recent reattribution to Manfredi is now widely accepted.

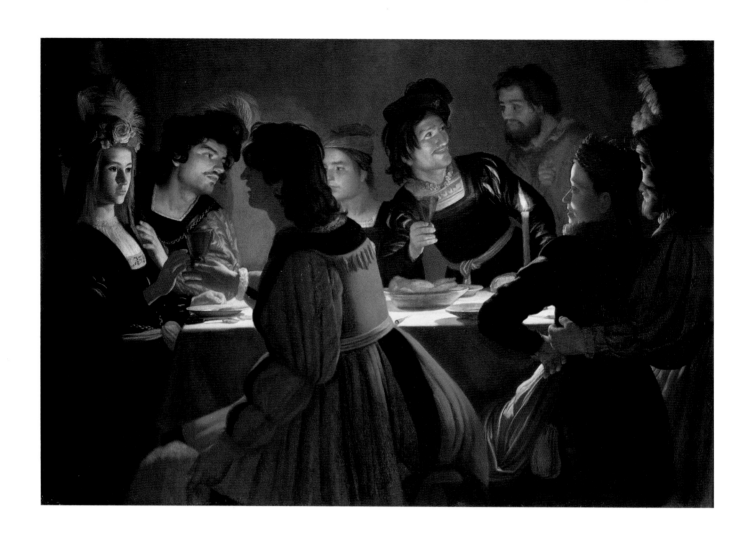

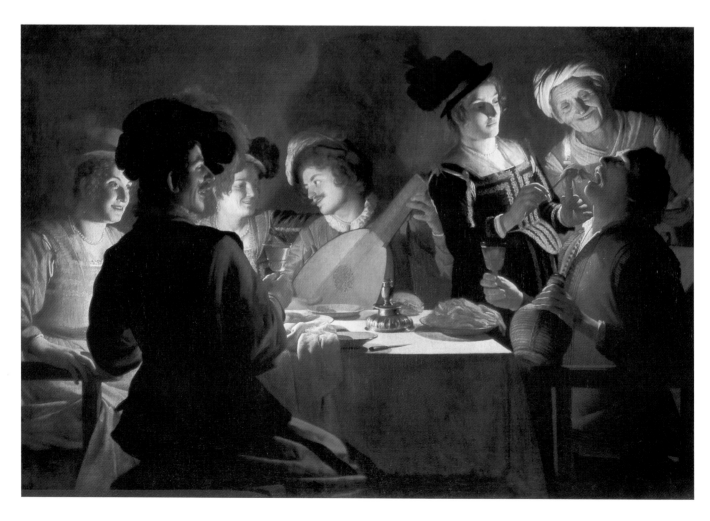

Opposite: 445
GERRIT VAN HONTHORST
The Wedding Supper
Oil on canvas, 54⁵⁄₁₆ × 79¹⁵⁄₁₆ in. (138 × 203 cm)
Uffizi, Vasari Corridor; inv. 1890: no. 735

Described in the 1695 inventory of the villa at Poggio Imperiale as being by Caravaggio, this work was correctly given to Honthorst in 1782 by Lanzi. It dates from around 1615.

446
GERRIT VAN HONTHORST
Supper with a Lute Player
Oil on canvas, 56¹¹⁄₁₆ × 83⁷⁄₁₆ in. (144 × 212 cm)
Uffizi, Vasari Corridor; inv. 1890: no. 730

This picture can probably be linked with a citation by the biographer Giulio Mancini, who, writing around 1620, noted that a work had "lately" been painted "for His Most Serene Highness of Tuscany, a Supper with a Revelry that takes its light from two artificial lamps"; it may in fact be the same painting by Honthorst that was sent from Rome to the grand duke on February 15, 1620. It suffered severe damage in the May 1993 explosion.

447
GERRIT VAN HONTHORST
The Adoration of the Shepherds
Oil on canvas, 89¾ × 78⅛ in. (228 × 198.5 cm)
Uffizi, Vasari Corridor; inv. 1890: no. 772

This painting was executed for the Guicciardini chapel in the church of Santa Felicita in Florence between October 1619 and April 1620, just before Honthorst returned to Utrecht. It was completely destroyed in the May 1993 explosion.

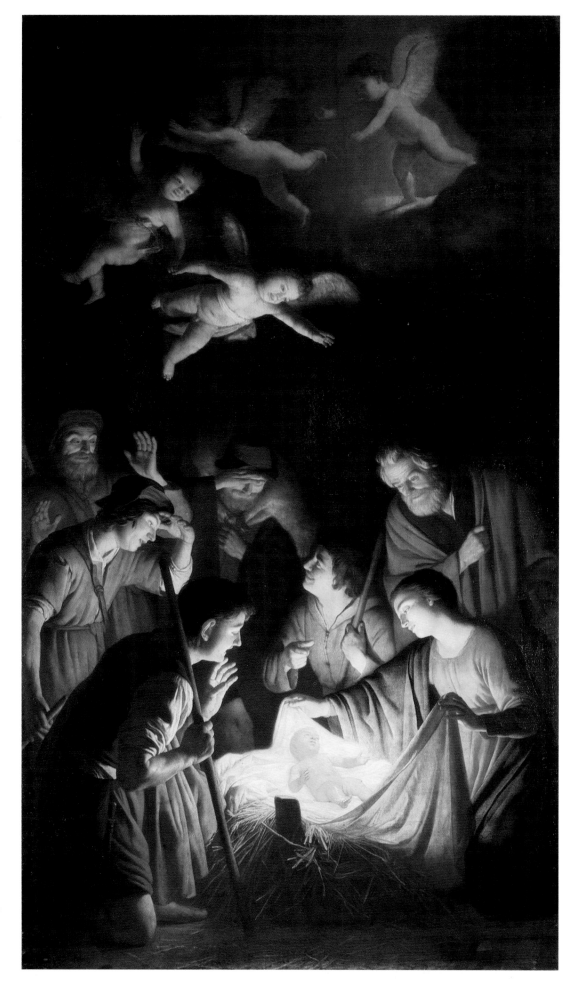

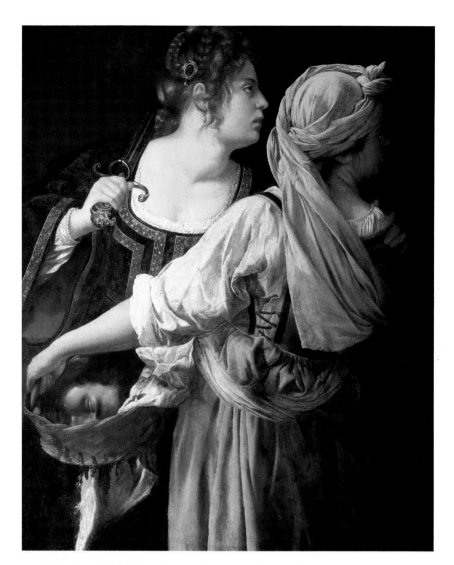

448
ARTEMISIA GENTILESCHI
Judith and Her Maidservant
Oil on canvas, 44⅞ × 36¹³⁄₁₆ in. (114 × 93.5 cm)
Pitti, Palatine Gallery; inv. 1912: no. 398
Recorded in the Medici collections since 1637, this work probably dates from the beginning of the artist's stay in Florence in 1613; however, it may also have been sent ahead from Rome in 1612 as a calling card in anticipation of her arrival.

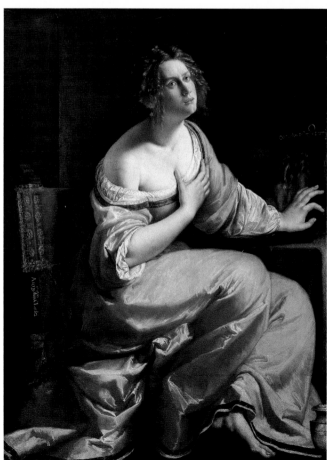

449
ARTEMISIA GENTILESCHI
Mary Magdalen
Oil on canvas, 57¹¹⁄₁₆ × 42½ in. (146.5 × 108 cm)
Signed: ARTIMITIA LOMI
Pitti, Palatine Gallery; inv. 1912: no. 142
This painting may have been commissioned by Grand Duke Cosimo II; certainly the theme was dear to the heart of his consort, Maria Maddalena of Austria. It dates from the artist's Florentine years, between 1613 and 1620.

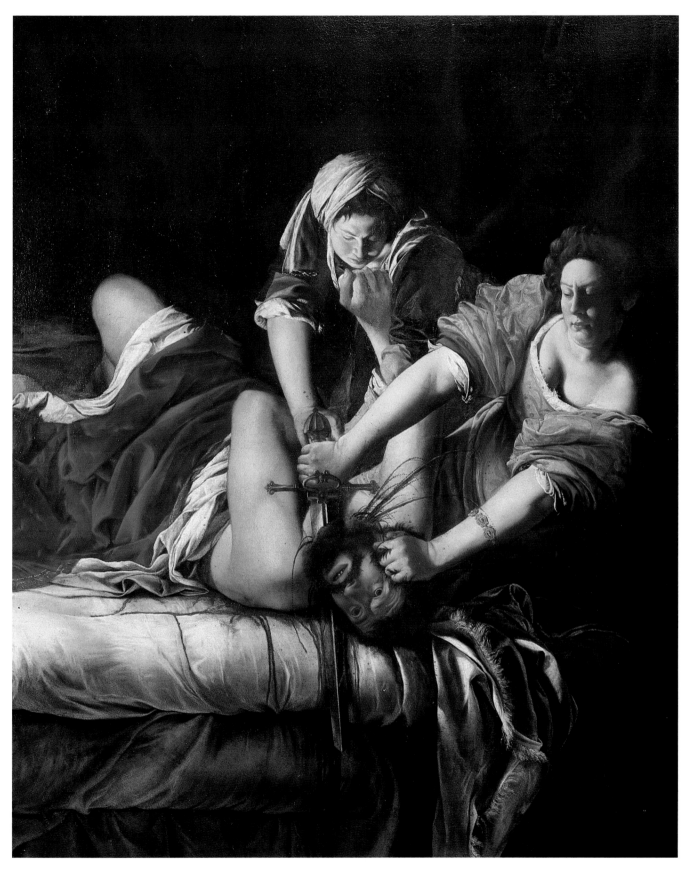

450

ARTEMISIA GENTILESCHI

Judith Beheading Holofernes

Oil on canvas, 78⅜ × 64 in. (199 × 162.5 cm)

Signed: EGO ARTEMITIA LOMI FEC.

Uffizi, Vasari Corridor,; inv. 1890: no. 1567

Despite its signature, this work was never precisely recorded in seventeenth-century inventories. Cited in *Etruria Pittrice* (*Woman Painter of Etruria*, of 1795) as one of the gallery's most important paintings, it was likely executed in Rome, not long after Artemisia's return from Florence in February 1620, and sent to Grand Duke Cosimo II, who had probably commissioned it sometime before.

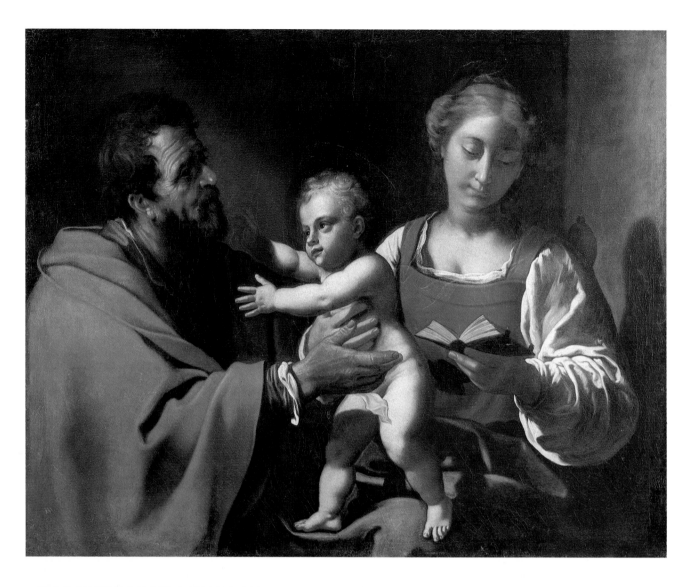

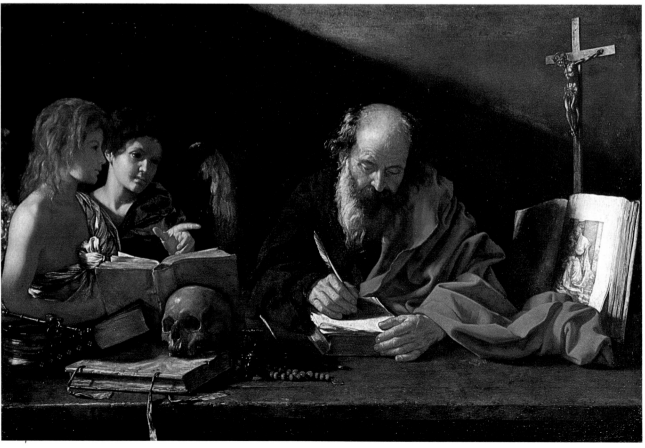

Opposite: 451
ANTIVEDUTO GRAMATICA
The Holy Family
Oil on canvas, 39¾ × 49³⁄₁₆ in. (101 × 125 cm)
Pitti, Palatine Gallery, Director's Office; inv. Petraia: no. 251
The original provenance of this picture is unknown; it came to the Florentine galleries in the Medici-Lorraine collection.

452
BARTOLOMEO CAVAROZZI
St. Jerome with Two Angels
Oil on canvas, 45¹¹⁄₁₆ × 68⅛ in. (116 × 173 cm)
Pitti, Palatine Gallery; inv. 1912: no. 417
This work was probably commissioned by Cosimo II de' Medici and paid for in 1617. The painting was left off the 1638 inventory of the Pitti Palace; Cavarozzi's name was suggested again by Longhi in 1943.

453
ORAZIO RIMINALDI
The Martyrdom of St. Cecilia
Oil on canvas, 124 × 67⅝₁₆ in. (315 × 171 cm) (measurements of original picture; with additions, 131³⁄₁₆ × 85⅝ in. [333.2 × 217.5 cm])
Pitti, Palatine Gallery; inv. 1890: no. 8767
Painted in Rome, probably at the beginning of the 1620s, this picture was not accepted by the monks at Santa Maria della Rotonda, near the Pantheon, who had commissioned it. It was transferred instead to Pisa and installed in the church of Santa Caterina, from which it was taken in 1697 by Ferdinand de' Medici for his collection.

454

ORAZIO RIMINALDI

Love Victorious

Oil on canvas, 55¹⁵⁄₁₆ × 44¹⁄₁₆ in. (142 × 112 cm)

Pitti, Palatine Gallery; inv. 1912: no. 422

This painting is referred to as the "Genius of Virtue" and attributed to the Pisan painter in an undated, late-seventeenth-century inventory of the Pitti Palace; it was probably acquired from Pisa by Grand Prince Ferdinand de' Medici, like Riminaldi's *Martyrdom of St. Cecilia* (caption 453). A mature work by this artist, it was perhaps executed after his return to his native city in 1627.

455

NICOLAS RÉGNIER

Scene of a Game with a Fortune-teller

Oil on canvas, 67¹¹⁄₁₆ × 91⁵⁄₁₆ in. (172 × 232 cm)

Uffizi, Vasari Corridor; inv. 1890: no. 9460

A recent acquisition by the gallery, this picture was ascribed to Régnier, an important follower of Manfredi, by Evelina Borea. It was probably painted during the artist's Venetian period, after 1625.

Painting in Italy in the Seventeenth and Eighteenth Centuries

Emilia and Romagna

Before every other Italian city, it was Bologna that reduced to a coherent formula the need for renewal that late-sixteenth-century painting almost everywhere displayed. The altered spiritual situation engendered by the closure of the Council of Trent brought with it new demands on sacred painting, which was now charged with cleaving as closely as possible, in terms of its subject matter, to the sensibility of the common people. While other attempts had been made to restore to painting the capacity for communication that mannerism had lost, these were stifled by refined formulations imposed from above and destined for unvaried iterations (as in the art "without time" promoted in Rome by Scipione Pulzone and other artists who gravitated around the papal court). In the end, it was the solution proposed by the three Carracci, from the early 1580s onward, that appeared to vindicate the very reasons for art and the role of the painter within society. The importance of the Carracci at the end of the reinvention of the Italian figurative language was known from the treatises immediately following, though it remains to be discovered how such a language was developed and acquired credibility in a city like Bologna, known for its strong corporatism. (The Carracci were Cremonese in origin and came from a family traditionally engaged in other occupations.) Then, too, as the second center of the papal states, Bologna was subject to strict control on the part of the ecclesiastical authority.

As most of their biographers have recognized, at the base of the Carracci artistic adventure was Ludovico, who was older than his cousins Agostino and Annibale. And in fact the few works ascribed to his early years demonstrate a confident intention to liberate himself from mannerist formulas, which were good for every occasion, in favor of a more intimate and direct style of painting. There is no doubt, however, that it was Annibale, the youngest of the three, who threw off premises in the most strikingly subversive way, endowed as he was with a prodigious innate talent and an explosive will to oppose orthodox schemes, expressed on a technical level in his adoption of a style at once harsh and deliberately disagreeable. Standing as the manifesto of his youthful poetics is the great *Butcher's Shop* in Christ Church College, Oxford, in which the approach to the truth, already prepared by Bartolomeo Passerotti's experiments, is without any intellectual barriers. Still, the choices made by the young Annibale must have seemed even more scandalous to the Bolognese when he confronted sacred painting in an analogous fashion. In his *Crucifixion* of 1583 for the church of San Niccolò, he brought to bear on the altarpiece technical and expressive standards developed through frequent painting from life

(the portrait as a "slice of life," stripped of any courtly or lordly intentions). The Bolognese painters did not stint in their criticism of this work (their comments were gathered and reported in 1678 by Carlo Cesare Malvasia) and they maintained that the pictorial style adopted by Annibale in this instance was better suited to a sketch or a private study not destined for public consumption.

Subsequent works produced in collaboration with his two relatives (the Palazzo Fava frescoes of 1584 and those in the Palazzo Magnani, of 1590) clarify Annibale's position at the precise moment when he made his peace with earlier pictorial traditions—in the first place with those of Correggio and the Venetians, to whom he turned for their anti-Roman and anti-Tuscan sentiments and their reaffirmation of his belief in the artist's obligation to confront reality and to exorcise every danger of academicism. A "furious love for truly great Italian painting," in Longhi's words, set a fundamentally evocative and romantic tone, never banally repetitive, for the pictorial methods put into practice by Annibale, even when his move to Rome (in 1595) brought him face to face with Raphael and the antique. The painter's Roman activity, the result of an invitation extended to him by Cardinal Odoardo Farnese (who also appears in the little votive altarpiece in the Pitti), was to be a determining factor in redirecting Italian figurative culture toward classicism, from Domenichino to Nicolas Poussin. At the same time, illusionistic baroque experiments were being put into play by such painters as Giovanni Lanfranco, thanks to the knowledge gained during their own turns with Farnese. Other Bolognese painters rushed to Rome in the wake of his success, among them Francesco Albani and the aforementioned Domenichino—who developed, along different lines, the themes of "classical" landscape that Annibale had inaugurated with the Aldobrandini lunettes (now in the Doria gallery in Rome)—as well as Sisto Badalocchio.

At first glance the results of Ludovico's activity seem less prestigious. He conducted his career almost exclusively in Bologna and was known for his profound fidelity to his own original intentions, which were always to produce a feeling of emotional participation in whatever was being represented, whether intimate or heroic, dramatic or happy. If Annibale is represented in the Medici collection by some of his major works, Ludovico fares less well: there is only the beautiful canvas, *Rebecca and Eleazar at the Well*, which unfortunately has become very dark and therefore is not reproduced in this work. Contemporary scholars are unanimous in acknowledging his great didactic ability, evident in his encouragement and stimulation of the more genuine talents of his students. At his side grew up such diverse but complementary artistic figures as Francesco Albani, who was destined to distinguish himself in the Roman workshop led by Annibale and whose most characteristic phase is well represented in the collection; Lucio Massari and Alessandro Tiarini, both of

whom had a particular rapport with Florence; Giacomo Cavedoni; and Guido Reni, whose artistic personality was perhaps too strong and too uniquely his own to be restricted to only a Ludovician reference. Also among the paintings chosen for inclusion here are works by several minor painters who were influenced by Ludovico's poetics and produced their own particular versions of them.

With Reni, the protagonist of an intense Roman period (1601–1614) that put him in the vanguard of that city's artistic development, a new chapter began, one that made Bologna a point of reference for an international taste characterized by elegant gestures and melodramatic expressions. If Annibale's movement was fundamentally "secular" in its restoration of a reality profoundly permeated by the prerogatives of man, Reni set himself a problem that Caravaggio had also struggled with—the question of sacred art, and how to translate the Christian message onto canvas. The same quality of sentimental effusiveness in sacred scenes, as practiced by Ludovico Carracci, was not fully successful in penetrating the profundity and grandeur of the Christian mystery. It was, rather, a knowledge of Caravaggio and of his thoughtful and realistic solution to the problem that spurred Guido Reni on to a choice that, though analogous, was nevertheless brought about through quite different means: in Reni's work there is a constant straining (up until the formal refinement of his last paintings) toward a "beautiful" ideal that takes leave of sensory experience to cross over into a perfect and precious empyrean, where the ineffable can be expressed and where a knowledge of Raphael and the antique is of no little help.

Much sought after by the principal European courts, Reni soon came into direct contact with the Medici; in 1642, for example, he thanked Cardinal Leopoldo in person for the fee paid for a painting that may perhaps be identifiable as the *Cleopatra*. On other occasions, the Medici used intermediaries, including Reni's own pupil, Giovanni Andrea Sarani, who, however, did not hesitate to send along his own *Rebecca and Eleazar* as a work by the master. The Florentine collections also contain works by two of Guido's most brilliant students, Michele Desubleo and Simone Cantarini, whose adherence to the artistic language of their master was to evolve in a very personal way. Desubleo allied himself with other champions of a classicism that was perceived in almost "purist" terms, while Simone, for his part, managed to lead Reni's followers away from blind obedience to their master and toward a consideration, with Flaminio Torri and, later, Lorenzo Pasinelli, of new solutions.

The Romagnan artist Guido Cagnacci has sometimes been compared to Reni—however inappropriately. Cagnacci's style, characterized by a naturalism derived directly from Caravaggio (he had journeyed as a young man to Rome), left no traces whatsoever in Bologna, despite his long stay there; the reconstruction of his extraordinary personality is based entirely on recent studies. Subsequently, he transferred to Venice, and then to Vienna, where he died. His *Mary Magdalen Carried to the Heavens by an Angel* was brought to the attention of Grand Prince Ferdinand by Niccolò Cassana, who praised it for its "cool coloring and good draftsmanship" and emphasized its illusory naturalism and quality of formal invention.

In the meantime, with Giacomo Cavedoni sidelined by a series of tragic events and Alessandro Tiarini having left Bologna to work elsewhere, not even Giovan Francesco Barbieri, better known as Guercino, succeeded in the difficult task of resisting Reni's success and promoting the opposing ideals of Ludovico Carracci's naturalism. Guercino was prevented from undermining Reni's beliefs first by trying to compete with the Bolognese painter and then, after his death, by attempting to take his place on high-ranking commissions. His early career in his native Cento had been most brilliant and promising, as the aged Ludovico himself had acknowledged in two justly famous letters of 1617, which read like a passing of the torch from the old master to the bold young Centese. Guercino at that time was producing a kind of painting that was strongly Ludovician in its use of light as a vehicle for expressing emotion ("smudged," the early biographers called it); the *Apollo and Marsyas* in the Palatine Gallery belongs to this period. On a journey to Rome in 1621–1624, the artist came into contact with the classical poetics promoted in the cultural circles of Monsignor Agucchi, and he began to search for a new order. Though always distinguished by high standards of craftsmanship, his subsequent activity, which saw him at the head of a workshop organized along almost industrial lines, lost in sincerity and expressive force whatever it may have gained in compositional shrewdness and literary knowledge. Leaving aside the Gennari, who were related to the painter and employed by him as assistants (the work of Cesare, undoubtedly the most interesting member of the family, is represented in the Uffizi), Guercino's later experience proved to be of little use to the Bolognese painters who succeeded him, who, if they looked to him at all (as in the case of Crespi), greatly preferred his early period. In the end it is Reni—particularly through the mediation of his best pupils—who provides the most helpful keys to the understanding of Bolognese painting in the second half of the century, however much the "Emilian way" to the eighteenth century may have passed through a canny rehabilitation of the Carracci, and especially of Ludovico. The lighter palette of the late Reni and of Simone Cantarini, combined with courtly poses and a touching sense of weightlessness, informs the work of Lorenzo Pasinelli, who was responsible for the neo-Veronesean style that Luigi Lanzi identified as one of the determining motives for the "change" in Bolognese figurative culture at the end of the third quarter of the century. Pasinelli, a more important figure in Bolognese painting than the scattered few of his surviving works might indicate, in turn became a point of reference for such artists as Giovan Gioseffo Dal Sole and Donato Creti. (The latter painter, whose nostalgic grace prefigured neoclassical solutions, is unfortunately not represented in the Florentine collections.)

Reaching further back, directly to Albani and, past him, to Annibale Carracci's classical naturalism, Carlo Cignani closed the century on a note of mature classicism; he, more than any other artist, best represented Bolognese culture, not least for his long-desired founding, in 1706, of

the Accademia Clementina, of which he was consequently named president in perpetuity. Cignani presents us with yet another example of a great artist (and such he was, as the Uffizi's *Madonna and Child* can testify) who was also a great organizer; his numerous enterprises employed a well-trained squad of artists, out of which emerged, quite early on, Marcantonio Franceschini.

In this way, however, we can trace a precise classical tendency whose possibilities the Bolognese school had by no means exhausted by the end of the century. We may cite at this point the singular presence within the problematic baroque of the great Domenico Maria Canuti, a well-known painter of frescoes who left behind only a very few canvases (none of them in Florence). Alongside him, Giovanni Antonio Burrini developed his own ideas as did the Viani, father and son, and, most of all, Giuseppe Maria Crespi ("Lo Spagnolo"), the standard-bearer for the Carraccesque revival mentioned above, which was reinforced as well by current theory. (Another contributing factor was the lively reaction on the part of painters to the reflections of Malvasia, whose *Felsina Pittrice* or *Felsina Painter*, was published in 1678.)

Given the multiplicity of his interests and the novelty of the solutions he adopted in the various fields in which he was active (from sacred painting to mythological, from genre scenes to still-life to portraiture), Crespi is certainly a figure almost beyond national identification. To the important end of getting into focus certain aspects of the artist's poetics and, more generally, his confrontation with the wider culture, Francis Haskell has carefully considered Crespi's frequenting of the Florentine milieu. Crespi's knowledge of Dutch prototypes in the grandducal collections had a profound effect on his activity when he returned to Bologna: almost all of the works presented here can be conducted to that juncture, and they exemplify the variety of the painter's modes of expression during the central phase of his career. It has been said of Crespi that he was a great experimenter in the most diverse genres, but it is necessary to point out that all of these genres had a common denominator in the good-natured and dispassionate sympathy with which he regarded his figures. The impetus subsequently given to genre scenes is but one example of his far-reaching influence (it is enough to remember here the playful *Family of the Painter*). In the hands of his followers, unfortunately, the language he created was petrified into a conventional formula of gestures and attitudes, with Giuseppe Gambarini and Stefano Gherardini preferring to emphasize the arcadian and sentimental side, and Antonio Beccadelli and Antonio Crespi the ironic and caricatured.

Significantly, the number of works by Marcantonio Franceschini in the historical Florentine collection is not nearly so great as the number of paintings by Crespi; as Borea (1975) noted, "Grand Prince Ferdinand, who adored Crespi, evidently did not appreciate his counterpart." Franceschini's *Amor Victorious* is nonetheless an example of a painting that in the marble-smoothness of its forms and the composure of its figures' postures betrays the most authentic signs of the Bolognese tradition. At the same time, the figures' elegant cut points toward the successive dissolution of rococo taste, which flowered in Bologna in the work of painters from Vittorio Maria Bigari to Francesco Monti.

In the second half of the eighteenth century, two brothers, Ubaldo and Gaetano Gandolfi, reestablished the Bolognese tradition in a mode of great formal elegance and intense emotional content. The expressive prerogatives of their school are manifest in their prolific production of "character heads," a genre of vaguely Carraccesque origin that was practiced by, among others, Pasinelli, Burrini, and Creti. Even in the Gandolfi's constant reference to established typologies, their capacity to vary their modes of expression and continually to achieve new pictorial effects constitutes an important aspect of their work, which is characterized by a very precise inclination on the part of each brother. The Gandolfi served as worthy representatives of Bolognese culture in the vast artistic network they established with painters in Venice and France, where, for example, there was an incipient taste for neoclassicism. Thus it can be confirmed that in its central place within the greater European context, and thanks largely to the stable structure of its Academy, Bologna had lost none of its interest over the course of two centuries.

Daniele Benati

345

456
ANNIBALE CARRACCI
Portrait of a Young Man with a Monkey
Oil on canvas, 25⁹⁄₁₆ × 22¹⁵⁄₁₆ in. (65 × 58.3 cm)
Uffizi, Depository; inv. 1890: no. 799
One of Annibale's early paintings "from life," this portrait
was perhaps completed at the end of the 1580s. The charac-
ter of this brilliant "slice of life" may hold some allegorical
significance; for instance, the monkey may allude to folly.

Opposite: 458
ANNIBALE CARRACCI
*Christ in Glory and SS. Peter, John the Evangelist, Mary Mag-
dalen, and Ermengild Martyr with Odoardo Farnese*
Oil on canvas, 76⁷⁄₁₆ × 56¹⁄₁₆ in. (194.2 × 142.4 cm)
Pitti, Palatine Gallery; inv. 1912: no. 220
Possibly executed around 1597, and added to at the top, the
painting was recorded in a Pitti Palace inventory of 1698. In
1713 its provenance was specified as Camaldoli.

457
ANNIBALE CARRACCI
Bacchante with a Satyr and Two Cupids
Oil on canvas, 44¹⁄₁₆ × 55⁷⁄₈ in. (112 × 142 cm)
Uffizi, Gallery; inv. 1890: no. 1452
Another version of this painting by the same artist, signed
and dated 1588, is in a private collection; it appears to ante-
date slightly the Uffizi composition.

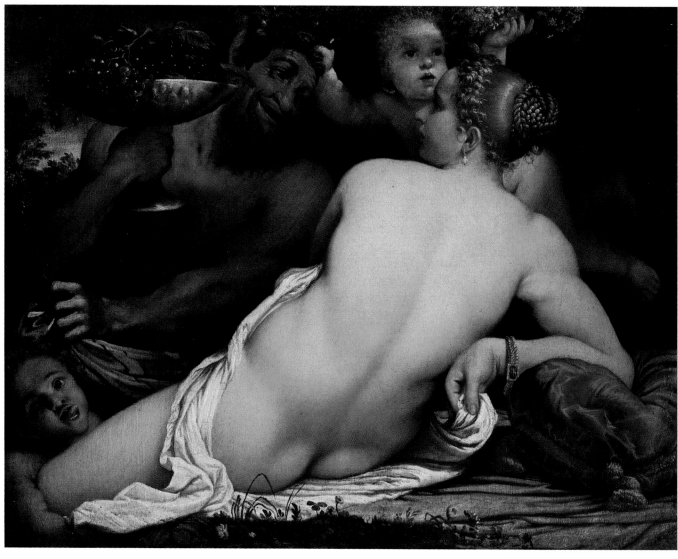

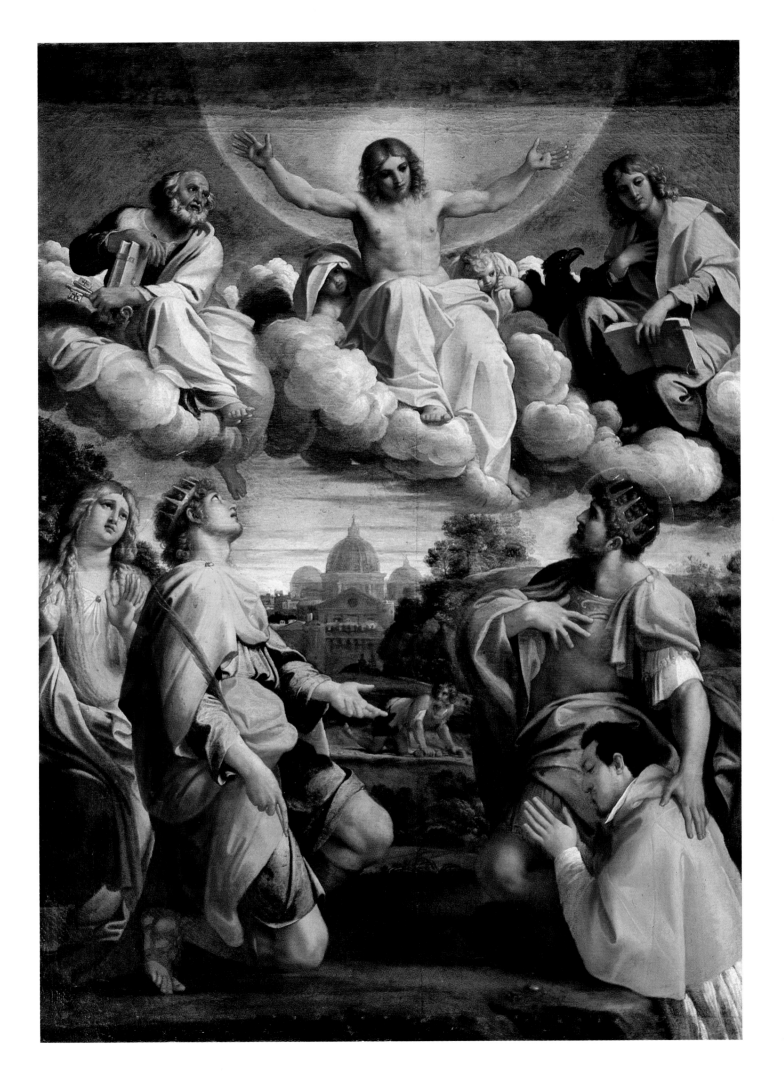

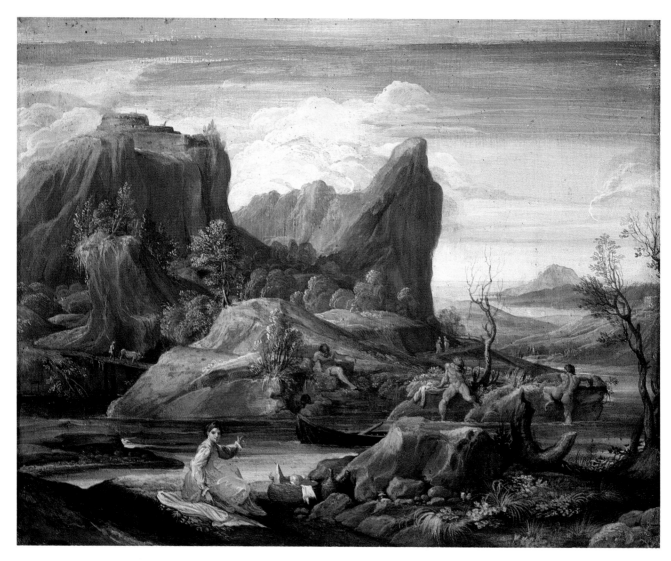

459

AGOSTINO CARRACCI

Landscape with Bathers

Tempera on canvas, 15⅝ × 19⅛ in. (40 × 49 cm)

Pitti, Palatine Gallery; inv. 1912: no. 320

This work was acquired in 1818 from the Gerini collection, Florence.

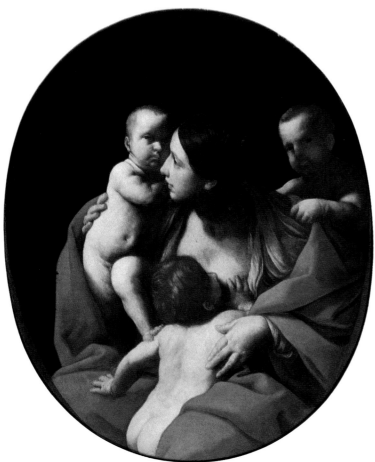

460

GUIDO RENI

Christian Charity

Oil on canvas, 45¹¹⁄₁₆ × 35⅝ in. (116 × 90.5 cm)

Pitti, Palatine Gallery; inv. 1912: no. 197

This painting can be dated to around 1620, and its presence in the Pitti documented from 1675.

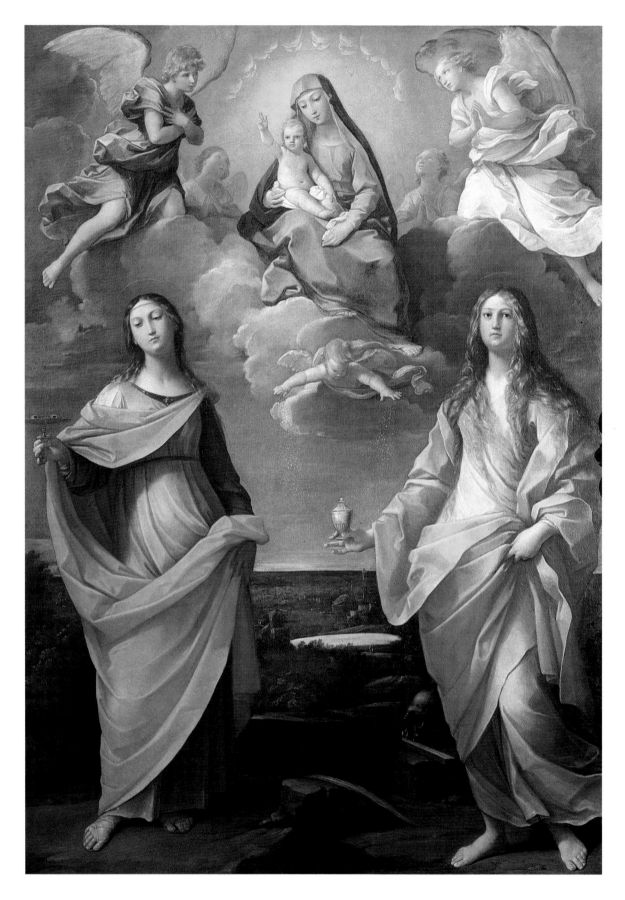

461

GUIDO RENI

Madonna of the Snow with SS. Lucy and Mary Magdalen

Oil on canvas, 98⁷⁄₁₆ × 69⁵⁄₁₆ in. (250 x 176 cm)

Uffizi, Gallery; inv. 1890: no. 3088

This altarpiece's provenance is the Luccan church of Santa Maria di Corte Orlandini, for which it was painted in around 1622–1623, along with a *Crucifixion and Saints* now in the Museo di Villa Guinigi. Requisitioned after 1829 by Carlo Ludovico Borbone, it was later sent to England and given to the Uffizi in 1893.

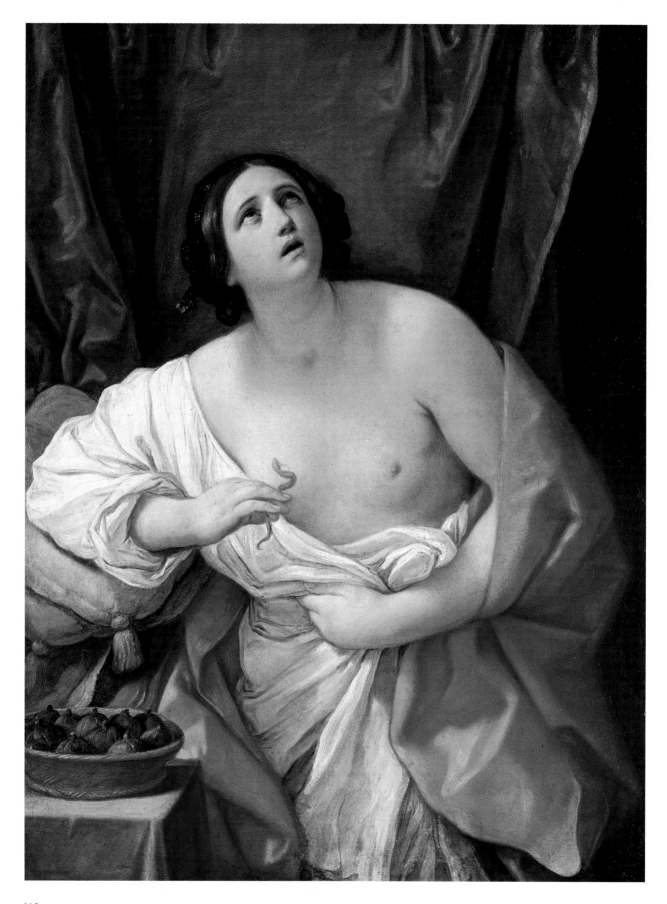

462
GUIDO RENI
Cleopatra
Oil on canvas, 48¹/₁₆ × 38³/₁₆ in. (122.5 × 97 cm)
Pitti, Palatine Gallery; inv. 1912: no. 270
This masterpiece from the artist's old age was painted around the end of the 1630s.
It is mentioned in a 1675 inventory of Leopoldo de' Medici's collection.

463

DOMENICHINO

Mary Magdalen

Oil on canvas, 34¹⁵/₁₆ × 29¹⁵/₁₆ in. (88.7 × 76 cm)

Pitti, Palatine Gallery; inv. 1912: no. 176

This is one of Domenichino's last Roman works, painted in around 1630. Formerly in the Brentazzuoli house in Bologna and in Count Cesare Bianchetti's collection, it was acquired in 1819 by Grand Duke Ferdinand III of Lorraine.

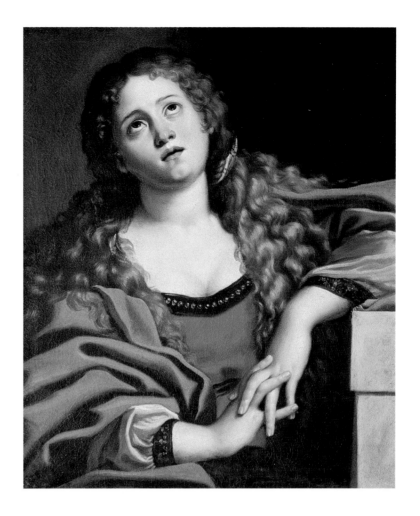

464

DOMENICHINO

Portrait of Cardinal Girolamo Agucchi

Oil on canvas, 55⅞ × 44¹/₁₆ in. (142 × 112 cm)

Uffizi, Vasari Corridor; inv. 1890: no. 1428

Following the conventions of court and ceremonial portraits, this canvas depicts the brother of Giovan Battista Agucchi, who was elected cardinal in 1604 and died the following year; the date of its execution falls within that interval.

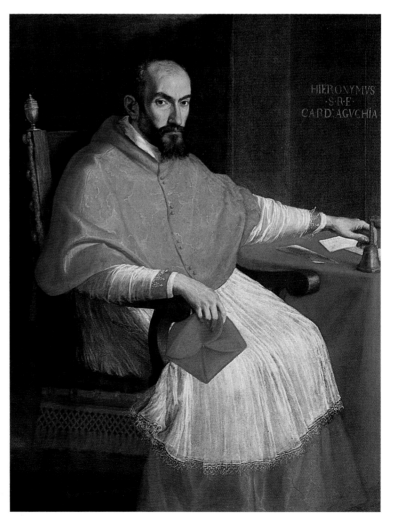

465
LUCIO MASSARI
The Holy Family
("Madonna of the Laundry")
Oil on canvas, 20¾ × 15⁵⁄₁₆ in. (52.7 × 38.8 cm)
Uffizi, Director's Office; inv. 1890: no. 6719
Datable to the first decade of the seventeenth century, this painting is ascribed to Albani in a 1675 inventory of Cardinal Leopoldo de' Medici's collection. Luigi Lanzi corrected the attribution in 1782.

466
ALESSANDRO TIARINI
The Nativity
Oil on copper, 13 × 16¹³⁄₁₆ in. (33 × 42.7 cm)
Uffizi, Vasari Corridor; inv. 1890: no. 1371

As is always the case with Tiarini, the episode depicted here is rich in narrative innovations. The work dates from around 1610 and was in the Pitti by the early years of the eighteenth century, only to be transferred temporarily to the Medici residence at Poggio a Caiano.

467

FRANCESCO ALBANI
The Rape of Europa
Oil on canvas, 30 × 38³⁄₁₆ in. (76.3 × 97 cm)
Uffizi, Vasari Corridor; inv. 1890: no. 1366

Sold in 1639 to the Perugian Angelo Oddi and acquired the following year by Marquis Ferdinando Cospi on behalf of Grand Duke Ferdinand de' Medici, this picture was executed sometime earlier, presumably in around 1630. A smaller version on copper is also owned by the Florentine galleries.

468

FRANCESCO ALBANI
Cupids' Dance
Oil on copper, 12½ × 16³⁄₁₆ in. (31.8 × 41.2 cm)
Uffizi, Gallery; inv. 1890: no. 1314

This work seems to date from around 1630, when the painter was caught up in the current of neo-Venetian developments in Roman culture. He treated the same theme in a famous painting that was once in the Sampieri collection in Bologna and is now in the Brera.

469
GIOVANNI LANFRANCO
The Ecstasy of St. Margaret of Cortona
Oil on canvas, 98¾ × 72¹³⁄₁₆ in. (230.5 × 185 cm)
Pitti, Palatine Gallery; inv. 1912: no. 318
This painting was once the altarpiece for the Venuti chapel in Santa Maria Nuova in
Cortona, consecrated in 1621. Acquired by Ferdinand de' Medici, it was in the Pitti
by the first years of the eighteenth century.

354

470
GUERCINO
Concert Champêtre
Oil on copper, 13⅜ × 18⅛ in. (34 × 46 cm)
Uffizi, Gallery; inv. 1890: no. 1379

Datable to around 1617, within the Centese artist's first period of production, this painting was probably acquired by Grand Prince Ferdinand de' Medici. It is mentioned in a Pitti Palace inventory around 1705.

471

GUERCINO

Apollo and Marsyas

Oil on canvas, 73⅜ × 80¹¹⁄₁₆ in. (186.3 × 205 cm)

Pitti, Palatine Gallery; inv. 1912: no. 8

This masterpiece from the artist's early maturity was painted, according to Malvasia (1678) for Grand Duke Cosimo II de' Medici in 1618. The shepherds on the left were originally done for a separate canvas, on which Guercino subsequently conferred an allegorical significance (*Et in Arcadia Ego*, in the Galleria Nazionale di Arte Antica in Rome).

472

GUERCINO

St. Peter Revives Tabitha

Oil on canvas, 52⁵⁄₁₆ × 62¹³⁄₁₆ in. (132.8 × 159.6 cm)

Pitti, Palatine Gallery; inv. 1912: no. 50

Executed for Cardinal Alessandro Ludovisi, the future Pope Gregory XV, in around 1618, this work was in the Pitti by the beginning of the eighteenth century. It was acquired by Ferdinand de' Medici, perhaps at the suggestion of Giuseppe Maria Crespi.

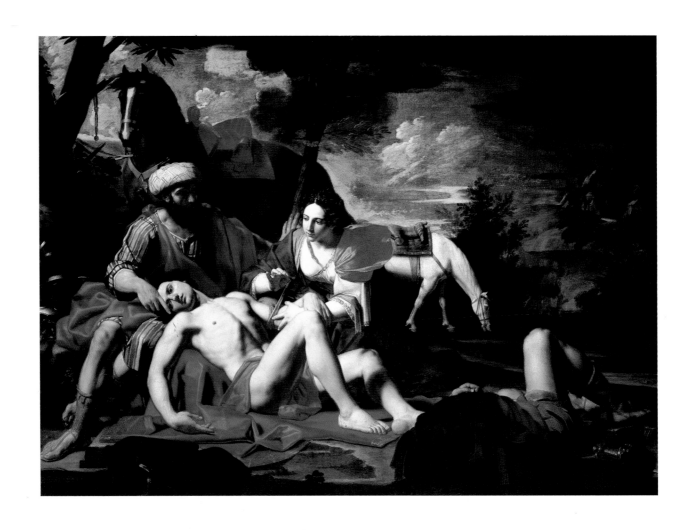

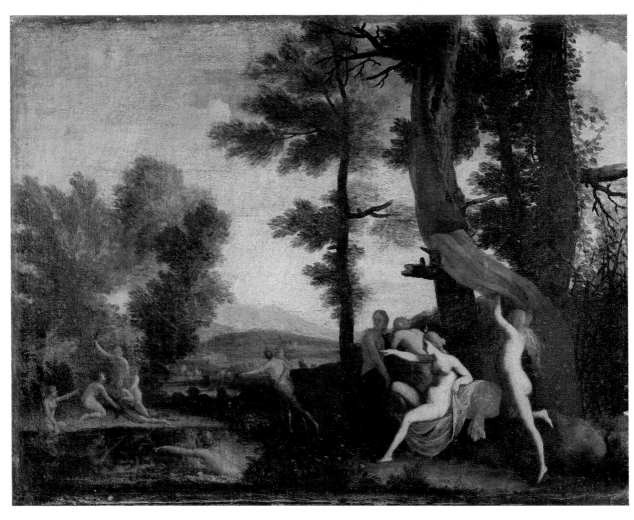

475
GUIDO CAGNACCI
Mary Magdalen Carried to the Heavens by an Angel
Oil on canvas, 75¹³⁄₁₆ × 54½ in. (192.5 × 138.5 cm)
Pitti, Palatine Gallery; inv. 1912: no. 75
A product of the painter's Venetian activity, this work was acquired in 1705 by Niccolò Cassana on behalf of Grand Prince Ferdinand de' Medici.

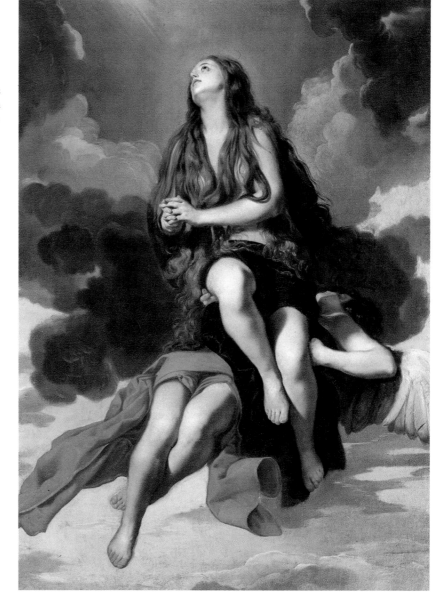

Opposite: 473
MICHELE DESUBLEO
Herminia and Tancredi
Oil on canvas, 92⅛ × 126 in. (234 × 320 cm)
Pitti, Depository; inv. 1890: no. 1591
This painting was commissioned by Don Lorenzo de' Medici for his villa at Petraia in 1641. Later misattributed to Vannini, it is in fact one of this Flemish painter's greatest works.

Opposite: 474
PIETRO PAOLO BONZI
Diana and Callisto
Oil on canvas, 29⅛ × 37¹³⁄₁₆ in. (74 × 96 cm)
Pitti, Depository; inv. San Marco e Cenacoli: no. 148
This picture can be related to Bonzi's landscape paintings through comparison with other, autograph works; it was in the Feroni collection. The Uffizi has a drawing of the same subject that has traditionally been assigned to Gobbo.

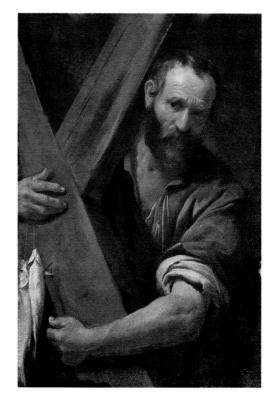

476
SIMONE CANTARINI
St. Andrew
Oil on canvas, 40³⁄₁₆ × 27¼ in. (102 × 69.2 cm)
Pitti, Palatine Gallery; inv. 1912: no. 48
Described in a Pitti inventory of circa 1705, this may be the "most beautiful painting by Simone da Pesaro" given to Ferdinand de' Medici in 1699 by the Bolognese Giovan Battista Belluzzi.

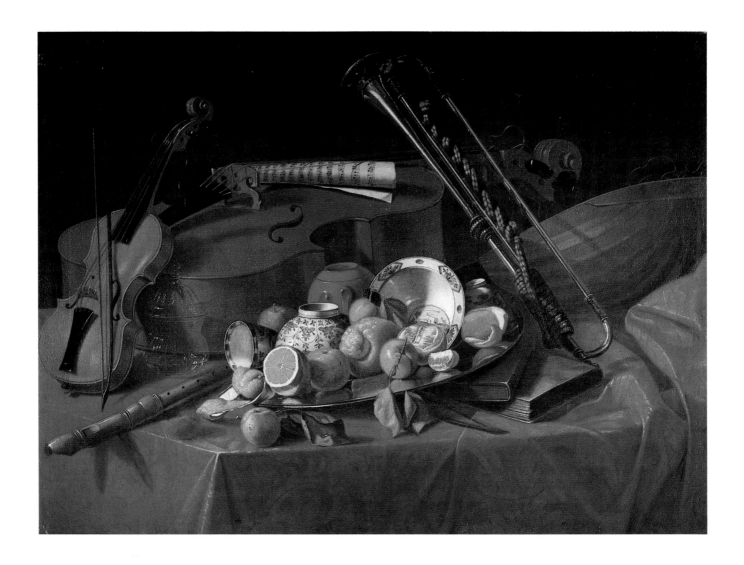

477
CRISTOFORO MUNARI
Still Life with Fruit, a Dish, a Book, and a Flute
Oil on canvas, 16⁹⁄₁₆ × 26⅜ in. (42 × 67 cm)
Uffizi, Vasari Corridor; inv. Poggio Imperiale, 1860: no. 135

This work from the villa at Poggio a Caiano probably dates from Munari's Florentine sojourn of 1706–1715. It was likely commissioned by Grand Prince Ferdinand de' Medici, to whom the painter sent pictures from Rome before he moved to Florence.

Opposite: 478
GIUSEPPE MARIA CRESPI
Cupid and Psyche
Oil on canvas, 51³⁄₁₆ × 84⅝ in. (130 × 215 cm)
Uffizi, Vasari Corridor; inv. 1890: no. 5443

Painted for the Medici court between 1707 and 1709, this is among the very few examples of large-scale mythological works by the painter, who here is elaborating the theme of Apuleius's *Metamorphoses* 5:22.

479
GIUSEPPE MARIA CRESPI
The Massacre of the Innocents
Oil on canvas, 52⅜ × 74⁷⁄₁₆ in. (133 × 189 cm)
Uffizi, Vasari Corridor; inv. Depository: no. 25

This canvas, depicting a subject treated quite frequently by Crespi, was requested in 1706 by Don Carlo Silva as a gift for Grand Prince Ferdinand de' Medici. When Silva later decided to keep it for himself, the painter showed it, in 1708, to Ferdinand, who at once went into raptures over it and bore it off to the prelate.

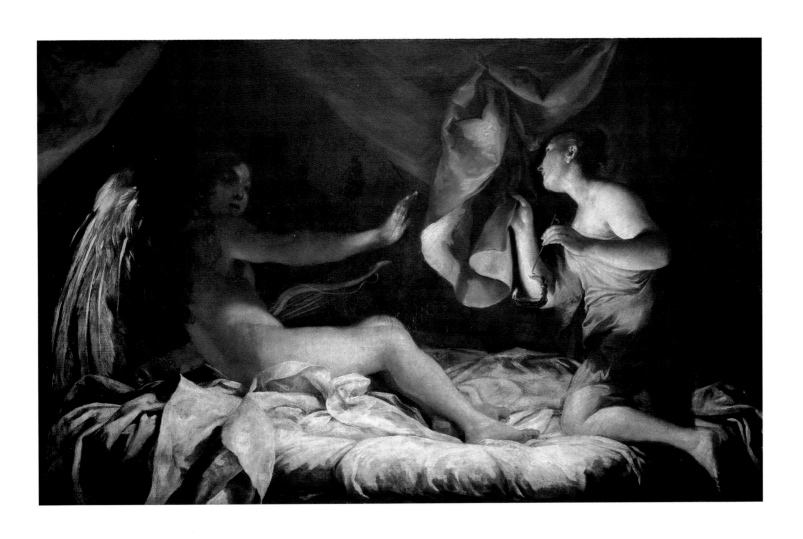

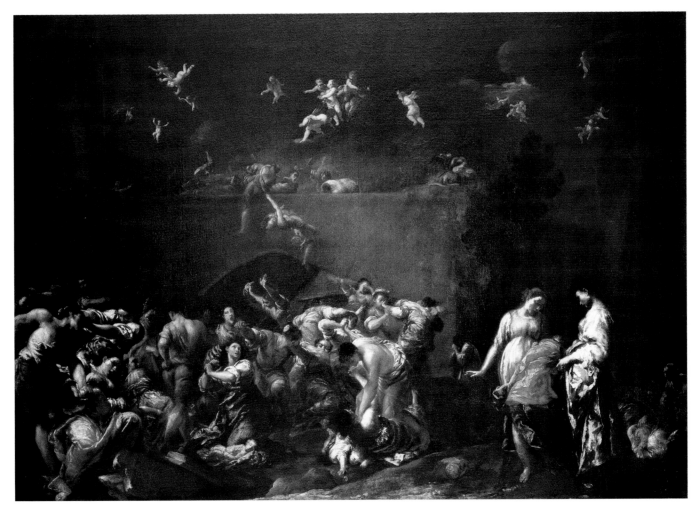

361

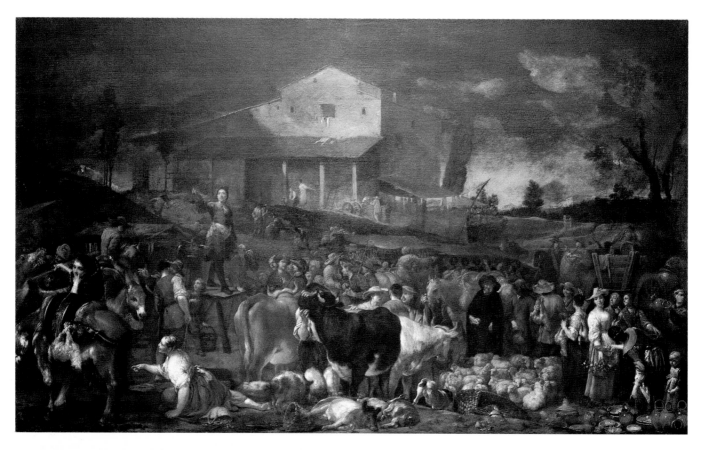

480
GIUSEPPE MARIA CRESPI
The Fair at Poggio a Caiano
Oil on panel, 45¹⁵⁄₁₆ × 77⁵⁄₁₆ in. (116.7 × 196.3 cm)
Uffizi, Vasari Corridor; inv. Depository: no. 26
This work was executed in 1709, when the painter was a guest at the Medici villa in Pratolino. Inspired by Callot and taking as its pretext a noisy "slice of life," it offers a new interpretation of the *bambocciata* genre.

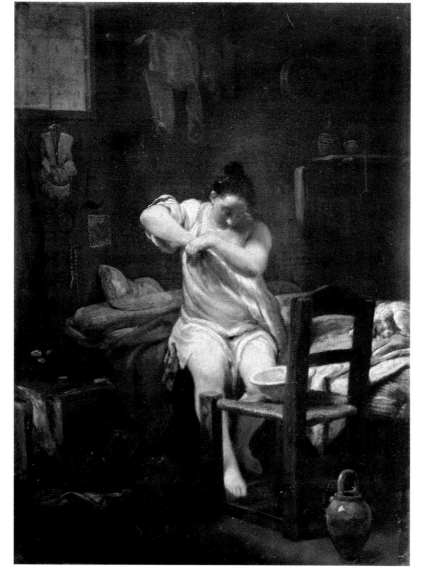

481
GIUSEPPE MARIA CRESPI
The Flea
Oil on copper, 18¼ × 13⅜ in. (46.3 × 34 cm)
Uffizi, Gallery; inv. 1890: no. 1408
This picture is part of an incomplete series known as *The Singer*, which narrates the rapid rise and equally rapid fall from grace of a beautiful girl. This scene, which had its own autonomous fortune, dates from the first decade of the eighteenth century.

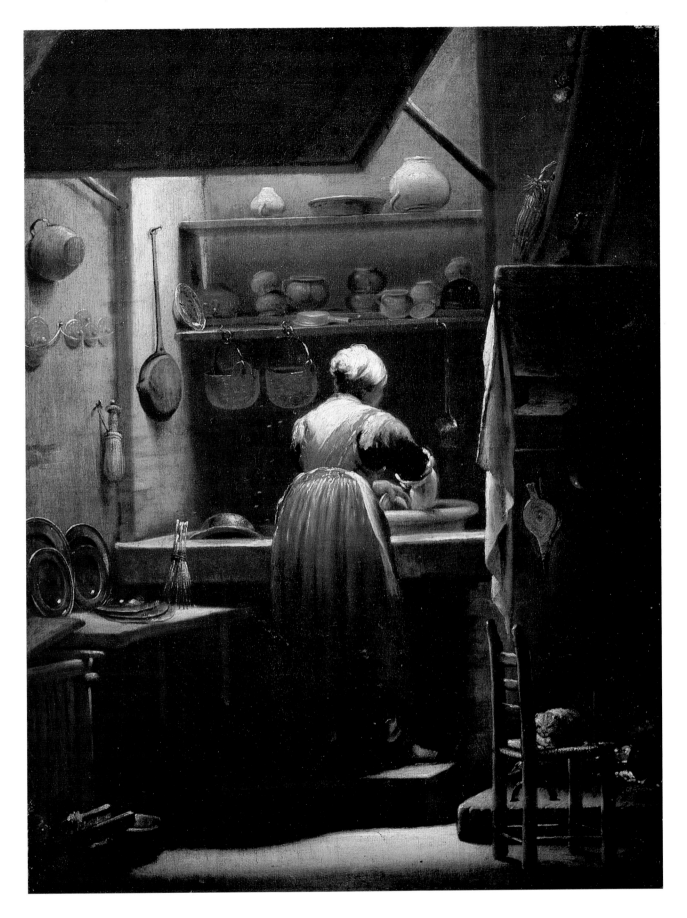

482
GIUSEPPE MARIA CRESPI
The Scullery Maid
Oil on canvas, 22⁷⁄₁₆ × 16¹⁵⁄₁₆ in. (57 × 43 cm)
Pitti, Meridiana (temporary location); inv. Contini Bonacossi: no. 20

Painted in around 1720, this work derives its composition from an engraving by Geertruyd
Roghman, but it absorbs and conceals its source in a personal statement that aims to
restore the scene's existential truth.

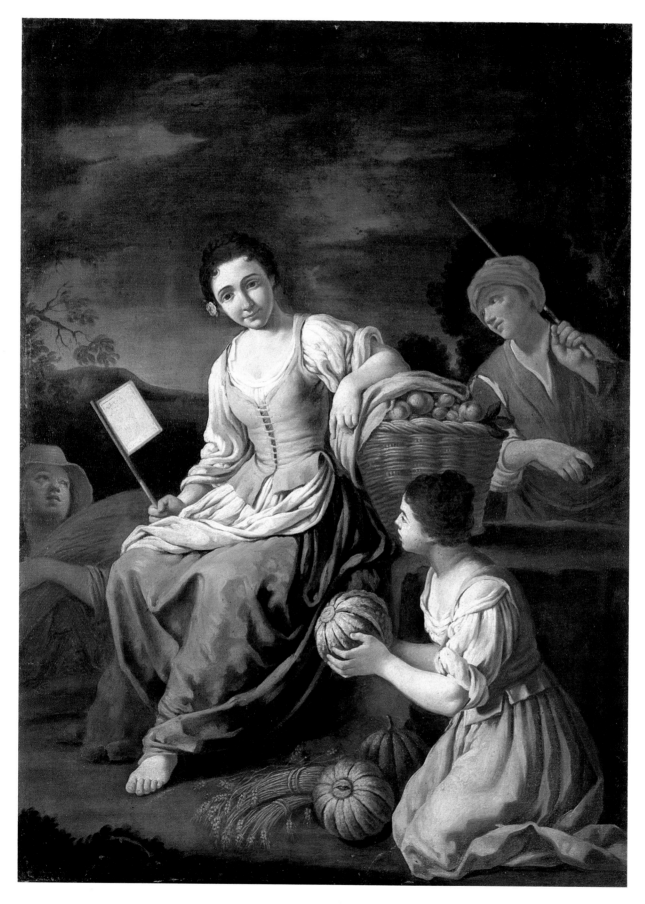

483

STEFANO GHERARDINI

Summer

Oil on canvas, 37⅜ × 27⅜ in. (95 × 69.5 cm)

Uffizi, Director's Office; inv. 1890: no. 9421

Acquired in 1960 as the work of Giuseppe Gambarini, it is much more likely to be by his pupil Gherardini. The figure of the girl with the fan reappears in a painting signed and dated 1741 (*Peasant Girl,* Bologna, private collection).

484

STEFANO GHERARDINI

Winter

Oil on panel, 37⅜ × 27⅜ in. (95 × 69.5 cm)

Uffizi, Director's Office; inv. 1890: no. 9419

Along with the preceding canvas, this was once part of
a series of four depicting the seasons.

485
UBALDO GANDOLFI
Madonna in Glory and Saints
Oil on canvas, 38¼ × 26⅛ in. (98 × 67 cm)
Uffizi, Vasari Corridor; inv. 1890: no. 9408
A model for the altarpiece of the parish church of Castelsanpietro, near Bologna, this work was painted in 1759.

486
FRANCESCO SIMONINI
The Cavalry Charge
Oil on canvas, 20⅞ × 30½ in. (53 × 77.5 cm)
Pitti, Depository; inv. 1890: no. 9478
Acquired through right of preemption in 1971, this oil sketch exhibits qualities of lightness and speed of execution that date it to Simonini's journey to Venice.

Florence in the Seventeenth Century

The seventeenth-century revival of the Tuscan school of painting really began in the 1580s, when there sprang up in Florence, in opposition to the dissipated late mannerism of the followers of Vasarian culture, the "normalized" style of Santi di Tito. This style—the exact opposite of mannerism, with its tendency toward hyperbole—elaborated a figurative language that was easily understandable and rich in "feelings" and that recovered the narrative potential of early sixteenth-century Florentine painting even as it answered the growing sense, during the Council of Trent, that painters should make art an effective vehicle for education. In the furrow plowed by Tito and in the ongoing search for a painting style that was less idealized and that adhered more closely to "nature," the true reformers of local artistic culture, such as Lodovico Cigoli and Gregorio Pagani, were fascinated by the kind of "natural" designs that Federico Zuccari was experimenting with in Florence, which seemed a valid antidote to the persistent late-mannerist culture. Of interest, too, were the aesthetics of the Venetian school, represented by Domenico Passignano, and the passion for Correggio that was interpreted by Federico Barocci. Cigoli, more gifted than the others, succeeded in combining the pictorial softness of Allegri and Barocci with rich and vibrant Venetian colors, beginning a line that would run through the next century; his sense of composition, meanwhile, was developed under the influence of Passignano, who was active in Venice and was the "importer" to Florence of the grandeur of Venetian inventions, along with the Veronese Jacopo Ligozzi. In his altarpieces Cigoli managed to put a modern stamp on sacred themes, employing a new protobaroque spatial ambience and an emotional efficacy that would merit the admiration of Rubens. In his works for private consumption, however, he amplified his emphasis on those "feelings" that would be widely popular with seventeenth-century Florentine painters.

Gregorio Pagani also started off on this line, contributing to the dissemination of the soft painting of Correggio and to the knowledge of the Carracci among the Tuscan painters whom he (and Cigoli) influenced. Through them, these artists developed a taste for precious minutiae, for theatrical movement, for sumptuous materials, for grandly structured compositions and profound colors. Responsible for the attention paid to details researched and investigated with painstaking precision were Ligozzi, the refined miniaturist of *naturalia*, and, later, Alessandro Allori, who inserted into his own compositions interesting "natural" notations, subsequently of use in tracing the nascent genre of still-life.

Domenico Passignano was, finally, of great importance to the Florentine pictorial school; he knew well how to marry Tuscan narrative clarity to the warm and vibrant tones of Venetian coloration. Ligozzi (who had a Northern artistic education) and the "international mannerist" Andrea Boscoli, for their part, enriched the variegated pictorial environment of Florence in other ways.

If the reforms went in a Venetian and baroque direction thanks to Cigoli and Pagani, this did not prevent the progress of the exquisitely Santi di Tito–derived strain of Florentine painting exemplified by the work of two exceptional "storytellers," Bernardino Poccetti and Jacopo da Empoli. Poccetti was the author of several of the most significant fresco cycles produced in Tuscany in the sixteenth and seventeenth centuries, in which he was able to express, within the limits of the best local traditions, a clear and strongly communicative language of controlled emotional pathos. Empoli, meanwhile, produced altarpieces that were rigorously planned and impeccably executed. A careful investigator of the "natural" and a very able draftsman, Empoli built on what he had learned from Alessandro Allori to create a great interest in still-life painting as an autonomous genre, as is demonstrated by a number of paintings in the Uffizi.

Turning in the "purist" direction of Santi di Tito were Cosimo Gamberucci and, to a lesser degree, Andrea Commodi, who had long been active in Rome, where he had come into contact with the Caravaggesque painting that would partly influence his own work. Among the other Florentine artists operating in the papal city and interested in Roman naturalism, and especially in Orazio Gentileschi, were Anastagio Fontebuoni—the champion, in Florence, of a "clear" luminism that was to enjoy a particular popularity thanks to the presence of Gentileschi's daughter Artemisia—and Filippo Tarchiani. Fabrizio Boschi was fascinated by the work of the young Rubens as is evidenced by the paintings Boschi executed immediately after his return from Rome and later.

The first decade of the seventeenth century saw, among other things, the affirmation of Cristofano Allori as the right and proper initiator of the most intimate and cultivated strain of Florentine painting, vibrant with feelings explored through psychological investigation and sensual control, expressed via a vibrating brushstroke derived from such masters as Gregorio Pagani and Cigoli. From these latter, two more masters of the Florentine seventeenth century also took their cue—Matteo Rosselli and Giovanni Bilivert, who created a lush and "flowery" style of painting.

Also significant for the course of Florentine painting at the beginning of the seventeenth century was the presence in the city of foreign artists, and particularly of Jacques Callot and Filippo Napoletano. The latter contributed to the birth of modern landscape painting and stimulated an interest in nature, while the former, an exceptional draftsman of grotesque figures and a keen observer of real life, was responsible for the neomanneristic revival that counted among its adherents Jacopo Vignali, Giovanni da San Giovanni, and Domenico Pugliani, with Baccio del Bianco and Stefano Della Bella in the vanguard.

Giovanni da San Giovanni, a nonconformist and anticlassicist, distanced himself from Rosselli to pursue a fiercely ironic and often irreverent kind of painting. This style is elegantly displayed in his unforgettable fresco cycles, such as those in the Argenti room in the Pitti Palace, which remained unfinished on the painter's death.

Both Domenico Pugliani, who accentuated the most pauperistic aspects of that characteristic trend in seventeenth-century Florentine painting, and Jacopo Vignali, in his initial phase, rightfully joined the circle of those "transgressive" artists, but they were still a long way from the peaceful and didactic efficacy of Matteo Rosselli, their master, or of the ever more mystical and abstract Francesco Curradi, given to strong and shared devotion.

A "saturnine" and unconventional quality is evident in the youthful activity of Cecco Bravo, whose work later evolved in the direction of the rarefied sensuality of Furini; Jacopo Vignali, meanwhile, after passing through the "humorist" phase represented in the Casa Buonarroti frescoes, directed his research toward Gentileschi's luminosity and Guercino's style.

Cristofano Allori's heritage—his sentimental and sensual way of painting—was very quickly revived by Francesco Furini, active at the beginning of the 1620s in Rome. There Furini was able to study both antique sculpture and contemporary pieces by Gian Lorenzo Bernini, the style of which he carefully transposed to his own work through refined drawings, which were delicate and soft and neo-Leonardesque in complexion.

This sort of sensual painting was also practiced by Cesare Dandini, creator of several of the more memorable "half-figures" of the Italian seventeenth century. He abandoned the bronze flesh color of his early pictures and strove for pearly skin tones, opalescent and moonlit, with hyperrealistic interpretations of the materials, such as fabric and worked metal, that filled his paintings.

The 1630s also saw the first attempts of one of the principal fresco painters of the century, Baldassare Franceschini, known as Volterrano. In 1636 he began the decoration of the courtyard of the Villa La Petraia with a cycle of paintings celebrating the Medici; it was finished in around 1648. The well-traveled Volterrano studied painting in many of the major artistic centers of the peninsula, from Parma to Bologna to Rome, elaborating a personal style that combined Correggio's softness, the baroque of Pietro da Cortona, and the Florentine design tradition. It may be useful to mention that Cortona was in Florence in 1637, having been summoned there by Ferdinand II to decorate the "stove room" of the Pitti Palace; initially his grand and sunny style was not absorbed by the Florentine artistic community, with the sole exception of Volterrano, who in fact was strongly influenced.

There was tenacious resistance to Cortona's style on the part of the painters Giovanni Martinelli and Lorenzo Lippi, who were involved, respectively, in luministic experimentations "in chiaro" and in the recovery of Santi di Tito's neo-fifteenth-century purism. Martinelli, active in Rome, had an artistic relationship with the Caravaggisti and brought back to Florence a strongly idealized luminous naturalism. Combined with a perfect application of design, this gave him a place among the great Florentine interpreters of half-figure paintings. Lippi, for his part, after first studying with Matteo Rosselli and practicing his pictorial richness reminiscent of Cigoli, began in the 1640s to engage in solitary reflection, leading to a formal purism, which simplified the composition and movement of his work. This was the clear antithesis of both Cortona's style and that of Venice, which was being adopted around this time by such artists as Felice Ficherelli, called Felice Riposo. The latter was the creator of a kind of painting that was noteworthy as much for its rarefied draftsmanship and corroded colors as for its themes, which were treated with a dramatic theatricality.

A certain detachment from the currents that regulated the artistic world in the 1640s in Florence is evident as well in the work of Carlo Dolci, a pupil of Jacopo Vignali who, after a youthful period during which his art was marked by his master's spotted style, achieved a kind of enameled naturalism that was almost sculptural in its rendering of surfaces. His painting had an iconic, languid, spiritually aware quality that was unfortunately too often labeled as devotional.

The 1640s saw the arrival in Florence of Salvator Rosa, who introduced a taste for grand landscapes and battle scenes, which were taken up by the Dutchman Livio Mehus. After the departure of Cortona, in 1647, his teaching came to be recast by Volterrano in an extremely original pictorial idiom, visible in the airy spaces of the cupolas of the Colloredo chapel in Santissima Annunziata (1650–1652) and the Niccolini chapel in Santa Croce (1653–1661) and on the ceilings of various palaces, where the painter displayed a playful spirit combined with the clear colors and the brightness of Berrettini.

The entrenchment of Volterrano's baroque in the city did not, however, impede the progress of more native currents within seventeenth-century Florentine painting; chief among these was the neo-Venetian "softness" that was assiduously practiced until his death by Cecco Bravo, Felice Riposo, and Simone Pignoni. The latter artist, a pupil of Furini, knew how to synthesize this tendency in an original intensity, managing to expand his own paintings, whose palette was likewise Venetian, into compositions characterized by pathos. Livio Mehus arrived at similar effects, adding onto a Cortonesque base analogous blends of color, a method he learned both in Florence and on journeys to Venice; Mehus was an eclectic and original painter known for the multiple aspects of his art.

The neo-Venetian and neo-Correggesque coloristic tendency that was affirmed in Florence at the beginning of the century—thanks principally to Cigoli—was consolidated in the local environment in a very uneven way. These ideas met with resistance from artists who objected to their unconditional alignment with the more common practices of seventeenth-century painting in its various forms (such as Caravaggism, Bolognese classicism, and the Roman baroque); in itself, this tendency marked the passing of the 1570s, when the new grand duke Cosimo III, conscious of the stagnation of Tuscan art after the brilliant period under the rule of Ferdinand and convinced that intellectual innovation could take place only in Rome, ordered the founding of an academy in that city, where he would send young artists to study.

Of this new group, Pier Dandini, a son and grandson of artists, was largely bound to traditional local coloring, while Anton Domenico Gabbiani, who had trained in Rome under Ciro Ferri, became an interpreter of a bright,

elegant, and refined "classicized Cortonism." The most original personality of the late seventeenth century, however, was Alessandro Gherardini, an artist who learned the lessons imparted by Luca Giordano, active in Florence from 1682 to 1685. Gherardini's inventive vivacity, borrowed from Giordano, is evident in frescoes that were influenced, as well, by contemporary Bolognese painting, and that in their lightened palette served as a kind of prelude to the eighteenth century.

Seventeenth-century painting in other Tuscan cities was by and large indifferent, with the notable exception of Siena, where an important school flourished at the beginning of the century; it had strong ties to its counterpart in Florence, though it placed greater emphasis on the work of Barocci. Francesco Vanni, Ventura Salimbeni, and the young Rutilio Manetti all demonstrated a great narrative ability, fully equal to that of Poccetti or Passignano. Rutilio, alongside Francesco Rustici, soon turned toward a more exacting study of "reality" that brought him into the Caravaggisti's orbit, making him one of the most interesting Tuscan interpreters of this style; he was fascinated by the work of the two Gentileschi (Orazio and Artemisia), by the Northern luminism of Honthorst, and by the French artists working in Rome, above all Valentin and Vouet.

The most purely Florentine components can be seen in the work of Astolfo Petrazzi, who observed the attention paid to costume by Cigoli and his followers and admired Matteo Rosselli and Passignano's impasto tones. Raffaello Vanni, meanwhile, having worked as a young man in Venice, restored a Venetian pictorialism to Florence (along with Pietro Sorri), only to turn later toward Rome, toward the Carracci and Lanfranco, and achieve a kind of "baroque classicism" analogous to that of Romanelli.

Beginning in the 1640s, the papal city became the principal magnet for Sienese artists, notably Niccolò Tornioli, who was interested in French Caravaggism and in the "Manfredi method," which, in accordance with the application of the young Mattia Preti, produced compositions that were animated and filled with "movement." In his last works, Tornioli showed an increased adherence to the painting of Pietro da Cortona, as did the mature Raffaello Vanni, who thus became—through the protection accorded him by the Chigi—one of the primary artists active in the capital between the sixth and seventh decades of the seventeenth century.

The 1650s also saw the complete acceptance in Siena of Bernardino Mei, a pupil of Rutilio Manetti who intelligently assimilated his master's naturalism and eye for detail. He evolved eventually toward grand and moving forms and structures that evoked Lanfranco, Mattia Preti's chiaroscuro, and the extraordinary attention paid to precious fabrics by the followers of Cigoli. In the loose rhythm of his compositions, Mei recalls Pietro da Cortona, even though the intense expressiveness of his figures is owed in equal parts to the sentimentalism of Bernini and to mid-seventeenth-century theatrical Florentine painting.

If other artists working in Siena in the middle of the seventeenth century were of lesser interest, the 1680s saw the ascendancy of Giuseppe Nicola Nasini, a prolific decorator who studied at the academy created by Cosimo III in Rome. Nasini brought back with him a kind of Cortonesque art that had become an international style by then.

Arezzo and the Aretine, the native soil of great painters who worked elsewhere—among them Pietro da Cortona, Jacopo Vignali, and Giovanni da San Giovanni—did not shine the spotlight on artistic personalities of great skill, preferring instead to import manufactured articles from other cities. In the capital one could find Bernardino Santini, an interesting interpreter of a naturalistic Tuscan style, who was not unaware of Florentine pictorial values; in the provinces, Salvi Castellucci championed the pictorial language of his master Pietro da Cortona.

Pisa, an even more lively artistic center than Arezzo, did not produce an original school in the seventeenth century, though it counted among its citizens artists of the caliber of Orazio Gentileschi—who deserted the city and worked incognito on the altars of the city churches—and Orazio Riminaldi, who was active primarily in Rome. The trail left by Aurelio Lomi, a creator of lush and elegant painting that owed much to the Florentines Cigoli and Passignano, was useless in a local environment that privileged the importation of works from other towns, particularly Florence but also Siena and Genoa. The paintings in the Tribune and in the lateral naves of the Duomo, on the altars of San Francesco and San Frediano, and on the ceiling of Santo Stefano dei Cavalieri all offer significant examples of these varied and flowing presences, among whom one must point out, for their local importance, the Luccan Paolo Guidotti, a thunderstruck Caravaggisto with strong pauperistic tendencies, and Orazio Riminaldi. The latter was perhaps the greatest star in the firmament of naturalism not only in Tuscany but beyond; he is represented in Pisa by numerous works, including the Lanfranchesque frescoes in the Duomo. These two painters did not have many followers, however, as the artistic needs of town and countryside continued to be served through imported works. The situation was the same in Livorno and Volterra, where the paintings decorating the altars were of preponderantly Florentine origin.

One particular chapter regards Lucca, the native city of both Paolo Guidotti and Pietro Paolini, who through their naturalism influenced the greater part of local painting in the seventeenth century. Paolini, founder in 1640 of an academy of painting, offered Luccan artists the opportunity to emerge; among these were Simone del Tintore (a specialist in still-life), Girolamo Scaglia, and Antonio Franchi, who would earn, thanks to his excellence as a portraitist, a preeminent post in Florence at the last Medici court.

Riccardo Spinelli

Florence in the Eighteenth Century

The years of Grand Duke Cosimo III de' Medici (1670–1723) coincided in Tuscany, and especially in its capital, with the definitive affirmation of the baroque style derived principally from works left in Florence by Pietro da Cortona and by the classicist culture popularized in Rome by the followers of Carlo Maratta. However, the Renaissance "dimension" of the City of Lilies allowed small possibility of urban transformation in the baroque sense, and the establishment of the new style was manifest in decorative displays and in the architectural renovation of the interiors of ancient structures. The fundamental stimulus for the birth of a native figurative language came from the same Grand Duke Cosimo, who, conscious of Florence's cultural stagnation, founded an academy in Rome. In this school, directed by Ciro Ferri and Ercole Ferrata, first-rate artistic personalities were formed, among them those of the painter Anton Domenico Gabbiani and the sculptors Giovan Battista Foggini, Massimiliano Soldani Benzi, and Giuseppe Piamontini. Inititated into the study of art in Florence under the guidance of Vincenzo Dandini, Gabbiani was one of the most celebrated talents of the Medici court for his execution of easel paintings, altarpieces, and frescoes. His works decreed the affirmation of academic taste and classical style in Tuscany. In line with the experiences of this particular master we might mention other, lesser artists such as Antonio Puglieschi, the Tuscan heir to Maratta; Tommaso Redi, who was also attracted to Venetian taste; Giovanni Antonio Pucci and Ignazio Hugford, pupils of Gabbiani and somewhat unoriginal imitators of his style. Bound to the classical tradition was Antonio Franchi, an artist educated first in Lucca, in Matteo Roselli's workshop, and then in Florence, alongside Felice Riposo and Volterrano.

Franchi's paintings, characterized by balanced composite schemes and by a tonality lacking in strong luministic effects, were in great demand for private art collections and "cult" places. In 1681, on the death of Justus Sustermans, Franchi became the official Medici court painter and began to execute works inspired by the French taste of Pierre Mignard. In the panorama of Florentine portraiture of the first part of the eighteenth century, pride of place was likewise given to the painter Carlo Ventura Sacconi and the pastel artists Domenico Tempesti and Giovanna Fratellini, known as the Tuscan Rosalba Carriera.

If Anton Domenico Gabbiani and his followers turned their attention toward classical trends, the late-Cortonesque Florentines had a protagonist in Pier Dandini, the author of great baroque efforts executed with a pictorial liberty that betrayed a knowledge of Rubens. These qualities caused him to be much in demand for the decoration, on canvas and fresco, of the town and country houses of patrician Florentine families, and he consequently had a school of many followers. The taste for the Cortonesque Tuscan style was also popularized by Giuseppe Nicola Nasini, a painter who was greatly appreci-ated by Grand Duke Cosimo III and active mostly in Siena and Rome, and by the brothers Francesco and Giuseppe Melani, two very able fresco painters who worked largely in Pisa.

A decisive factor in the evolution of late-seventeenth-century painting in Tuscany was the presence in Florence, in 1682 and 1685, of the Neapolitan Luca Giordano, who was responsible for the fresco decoration in the cupola of the Corsini chapel in Santa Maria del Carmine and in the library and gallery of the Palazzo Medici-Riccardi. The novelty that Giordano brought with him breathed new life into the local baroque artistic scene and was assimilated and diffused by several of the most promising young artists of the day. The Neapolitan set an example for the style of Alessandro Gherardini, who would become the master of Sebastiano Galeotti, and Nicolò Francesco Lapi.

In the first decade of the new century, a group of artists began working under the guidance of Giovan Camillo Sagrestani, anticipating by some years the *rocaille* taste of other Italian schools. Among the most prominent practitioners of this emergent strain, along with Sagrestani, were the Florentine Matteo Bonechi and the Pisan Ranieri del Pace, two gifted painters who are worthy of mention in the context of their individual careers. The arcadian and lively tone of their compositions, and their brushstrokes, marked by an exaltation of cool and diaphanous colors, achieved noteworthy results, most particularly on certain ceilings in the Capponi Palace, which may be considered among the most significant examples of European painting in the first part of the eighteenth century.

Francesco Conti held a position slightly separate from the environment of Tuscan visual culture in the first half of the eighteenth century. A pupil of Pignoni in Florence, and then of Morandi and Maratta in Rome, he was the author of several works on canvas whose exalted chromatic tonality was accessible and vibrant. The elegant and precious rendering of the composition and the typological characterization link Conti's images not only with Sagrestani's but also with the Venetian style of Sebastiano Ricci and the Emilian style of Francesco Monti.

One of the most interesting genres in late baroque Florentine painting is that of still-life, a field in which Andrea Scacciati and Bartolomeo Bimbi distinguished themselves, skilled as they were in both scientific illustration and ornamental painting. Bimbi, an artist whom Cosimo III de' Medici particularly favored, was kept busy producing works depicting rare and anomalous animals and vegetables, all destined for the grand-ducal villas at Topaia, Castello, and Ambrogiana. Andrea Scacciati was known for his floral depictions, with bouquets that were harmoniously and chromatically arranged. A friend and sometime collaborator of Pier Dandini, Scacciati was responsible for the diffusion in Tuscany of works following the example set by contemporary Flemish and Dutch paintings. Into this artistic line we may also insert Pietro Neri Scacciati, the son of Andrea and author of animal scenes that were executed with a measure of fantasy, as if to distinguish them from Bimbi's more faithful and rigid scientific formulas.

Giovan Domenico Ferretti was an original interpreter and disseminator of the Emilian style in eighteenth-century Tuscany. This artist, today the most famous personality in Florentine painting of this period, was the creator of numerous frescoes, altarpieces, and easel paintings. The Emilian lesson he learned from Felice Torelli in Bologna, after his apprenticeship in the Medici city with Redi, had a profound impact on Ferretti's work, which is particularly evident in his compositional exuberance and in the plasticity of his images. Although Ferretti is best known as an illustrator of profane stories and sacred episodes, he also did paintings of buffooneries and *caramogi*, the latter inspired by portraits by the Brescian Faustino Bocchi, who had worked for the Medici.

Also engaged in the kinds of commissions that occupied Ferretti were Vincenzo Meucci and Mauro Soderini, who were trained in Florence and perfected their skills, like other Tuscans, in Bologna. Of the two, the dominant personality seems to have been that of Meucci, who was put in great demand by the grand dukes and patrician families of Florence for his choice of iridescent watercolors and the compositional grace of his imagination. Not far removed from the artistic ornamentation of Ferretti and Meucci—but with much experience gained north of the Alps—was the Fleming Giuseppe Grison, or Grisoni, who is documented as residing in Tuscany beginning in the 1720s.

The first half of the eighteenth century was characterized largely by the patronage offered by members of the Medici family, and especially by Grand Prince Ferdinand. Before his death in 1713, he was responsible for the arrival in Florence of such important non-native painters as Marco and Sebastiano Ricci, Niccolò Cassana, Alessandro Magnasco, Giuseppe Maria Crespi, Cristoforo Munari, and Crescenzio Onofri.

The glorious Tuscan dynasty, for lack of any direct heirs, moved inevitably toward an epilogue: 1723 and 1737 saw the deaths, respectively, of Cosimo III and his son Giovan Gastone, the last Medici grand dukes. The heiress to the family's property and artistic patrimony was Anna Maria Luisa de' Medici, daughter of Cosimo III and widow of the palatine elector of Dusseldorf, Johann Wilhelm von der Pfalz-Neuburg. On her return to Florence in 1717, the princess, conscious of the imminent extinction of her line, gave local artistic patronage one last push, engaging greater and lesser painters and sculptors in the decoration of public and private buildings. Among other projects, she set artisans back to work on the chapel of the Princes, which had been left unfinished for some time and was completed only in the nineteenth century; and in 1740 she hired the painter Vincenzo Meucci to fresco a *Glory of the Florentine Saints* in the cupola of San Lorenzo, the last significant tribute in the Medici basilica-mausoleum. As a testament to her love for her native city and her family's collection, Anna Maria Luisa had a most important document drawn up just before her death in 1743; traditionally known as the Family Agreement, it decreed that all the Medici goods were to be given over for the benefit of the Florentine state and should never be separated from the collection. This act was intended to safeguard the art collection and maintain it essentially intact after the Tuscan grand dukes from Lorraine took over. These latter, burdened by enormous war debts, were in fact very anxious to sell off many of the jewels and masterpieces of art from the Tuscan collections in order to acquire disposable income.

The end of the Tuscan dynasty effected a pause in artistic activity, both in ecclesiastic sites and in private grand-ducal and Florentine buildings. Symptomatic of the looming crisis was the closure, in 1737, of the Medici tapestry workshop, which had been operating continuously for almost two centuries and had attained a level of quality as high as that of the most renowned European ateliers.

The first years of the Lorraine grand dukes were characterized by sporadic city commissions, among them the fresco decorations produced by Meucci in Santa Verdiana, by Sigismondo Betti in San Giuseppe, and by Agostino Veracini in San Giovannino degli Scolopi. Outside the circle of these mural painters, the most appreciated artist may have been Ferretti, who worked on public and private projects, especially in Pisa and Siena, until the 1760s.

The position of preeminence among the artists of the new generation belonged, at this time, to the Florentine Giuseppe Zocchi, known as a painter of "historical" themes with a lively narrative. His fame rested particularly on two series of engravings with views of the Tuscan capital and countryside, based stylistically on the compositions of van Wittel and Canaletto and published in 1744.

A stimulus toward change in the local artistic panorama in the second half of the eighteenth century was provided by Grand Duke Pietro Leopoldo of Hapsburg-Lorraine, who ascended to the Florentine throne in 1765. The new sovereign favored a radical change in Tuscan artistic taste by orienting it toward the new French style; the "restoration" of the old Medici villa at Poggio Imperiale, for example, confirmed the new stylistic tendencies in the furnishing of interior spaces. All of those Tuscan artists who were considered to be the most representative of the moment were employed on this project, including Antonio Cioci and Giuseppe Maria Terreni.

This epilogue to late-eighteenth-century Tuscan painting, finally turned to neoclassicism, reached its conclusion with the work of Giovan Battista Tempesti and Stefano Tofanelli. The former was active in the city of Pisa and the Pitti Palace in Florence, while the latter, a painter much in demand in important artistic centers throughout Italy, was the author of frescoes in several Luccan villas.

Sandro Bellesi

487
SANTI DI TITO
Christ's Entrance into Jerusalem
Oil on panel, 137¹³⁄₁₆ × 90⁹⁄₁₆ in. (350 × 230 cm)
Accademia, Gallery; inv. 1890: no. 8667
This painting was executed in the 1570s for the high altar for the church of the Montoliveto Convent in Florence.

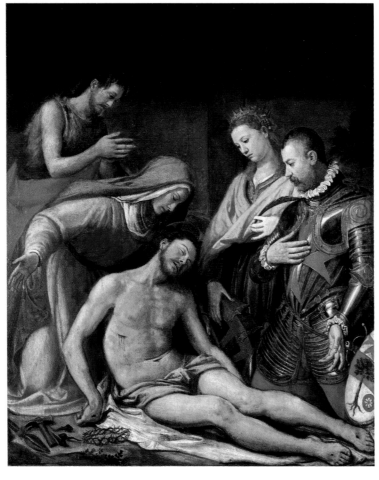

488
SANTI DI TITO
The Deposition from the Cross with the Virgin, SS. John the Baptist and Catherine of Alexandria, and the Patron, Baldassarre Suarez
Oil on panel, 78¾ × 66⅛ in. (200 × 168 cm)
Accademia, Gallery; inv. 1890: no. 4637
Datable to around 1575–1580, this panel was commissioned by a knight of St. Stephen, Baldassarre Suarez, for the interior chapel of the Fortezza di Basso in Florence.

489
ANDREA BOSCOLI
St. Sebastian
Oil on panel, 17¹⁵⁄₁₆ × 10¼ in. (45.5 × 26 cm)
Uffizi, Gallery; inv. 1890: no. 6204
This panel dates from the artist's last period of activity.

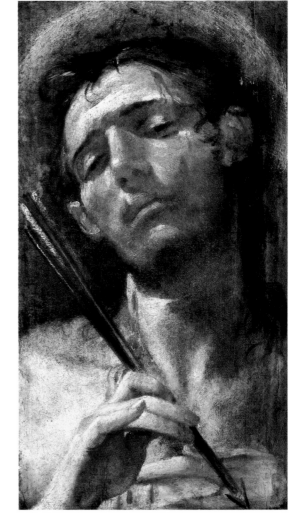

490
ANDREA BOSCOLI
The Marriage at Cana
Oil on canvas, 50³⁄₁₆ × 75³⁄₁₆ in. (127.5 × 191 cm)
Signed: OPA D'ANDREA BOSCOLI FIO.O
Uffizi, Gallery; inv. 1890: no. 8025

Datable to around 1580–1585, this is probably the work that is recorded, along with a pendant (no longer traceable) of the *Supper in the House of the Pharisee,* in a 1624 inventory of the Medici villa at Poggio Imperiale.

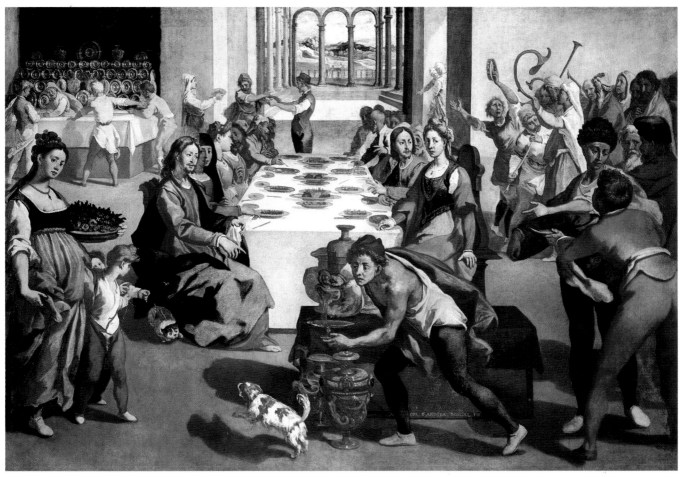

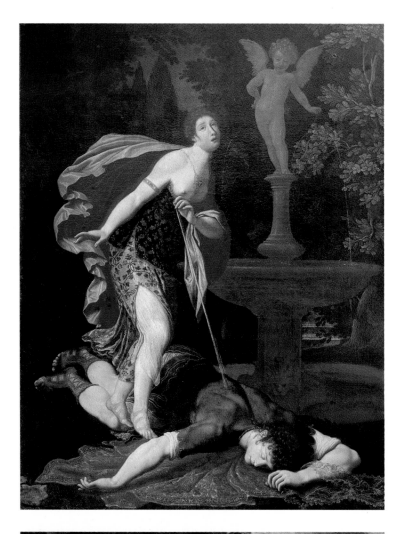

491
GREGORIO PAGANI
Pyramus and Thisbe
Oil on canvas, 94⅛ × 70⅞ in. (239 × 180 cm)
Uffizi, Gallery; inv. 1890: no. 5472
A depiction of an event in Ovid's *Metamorphoses*, this work belongs to Pagani's mature period.

493
LUDOVICO CIGOLI
The Martyrdom of St. Stephen
Oil on canvas, 177³⁄₁₆ × 113 in. (450 × 287 cm)
Signed and dated: LOD CIG. F. 1597
Pitti, Palatine Gallery; inv. 1890: no. 8713
This painting was executed for the church of the Franciscan monastery of Santa Maria di Montedomini in Florence.

492
LUDOVICO CIGOLI
St. Francis in Prayer
Oil on canvas, 55⁵⁄₁₆ × 45¹⁄₁₆ in. (140.5 × 114.5 cm)
Signed: L.C.
Pitti, Palatine Gallery; inv. 1912: no. 46
Once owned by Cardinal Leopoldo de' Medici and recorded in a 1675 inventory of his collection, this canvas most probably dates from around 1600.

494
LUDOVICO CIGOLI
The Sacrifice of Isaac
Oil on canvas, 69⅛ × 52⅟₁₆ in. (175.5 × 132.2 cm)
Pitti, Palatine Gallery; inv. 1912: no. 95
Commissioned from Cigoli by Cardinal Pompeo Arrigoni, this picture was probably executed in 1604 or 1605, during the artist's first stay in Rome. On the death of the cardinal it entered the Medici collection, where it was recorded in the villa at Poggio Imperiale beginning in 1654.

Opposite: 496
LUDOVICO CIGOLI
The Deposition from the Cross
Oil on panel, 126⅜ × 81⅛ in. (321 × 206 cm)
Pitti, Palatine Gallery; inv. 1912: no. 51

This panel was commissioned sometime after 1600 by the members of the Confraternity of the Cross in Empoli, who placed it on the high altar of their oratory in January 1608. In 1690 Grand Prince Ferdinand de' Medici acquired it for his own collection.

495
LUDOVICO CIGOLI
Ecce Homo
Oil on canvas, 68⅞ × 53⅜ in. (175 × 135.5 cm)
Pitti, Palatine Gallery: inv. 1912: no. 90
Massimo Massimi commissioned this picture in 1607 as a pendant to a painting by Caravaggio, thought to be either the *Ecce Homo* in the Palazzo Bianco in Genoa or, according to a more recent hypothesis, the *Christ Crowned with Thorns* in the gallery of the Palazzo degli Alberti in Prato. The painting belonged to Don Lorenzo de' Medici, who gave it to the musician Giovan Battista Severi. It later entered the collection of Grand Duke Ferdinand II.

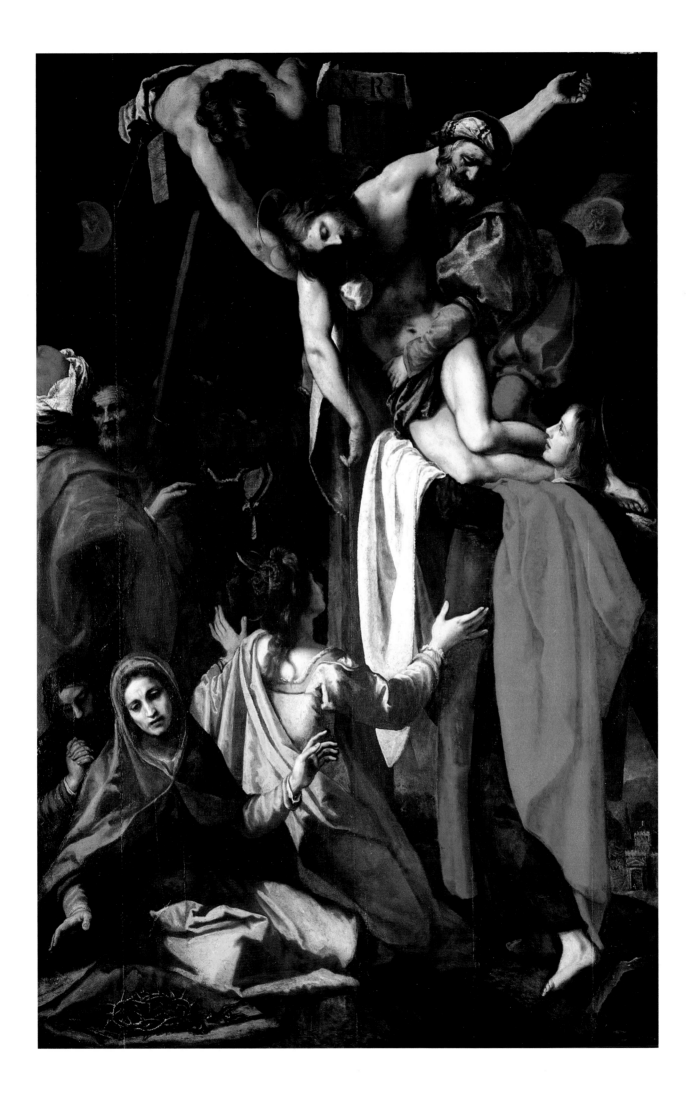

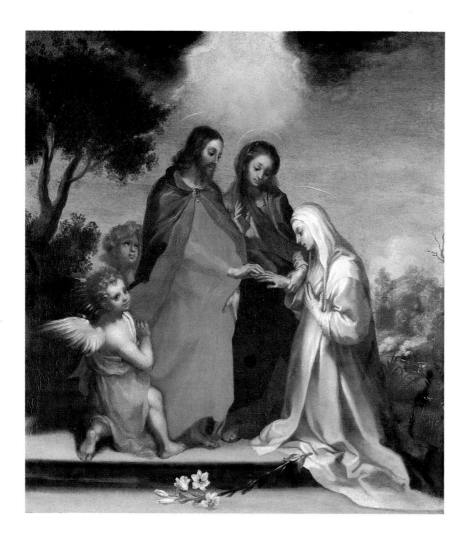

497
FRANCESCO VANNI
The Mystic Marriage of St. Catherine of Siena
Oil on canvas, 26⅜ × 24 in. (67 × 61 cm)
Pitti, Palatine Gallery; inv. 1912: no. 32
This painting is a reproduction in miniature of the altarpiece executed by Vanni in 1602 for the Sienese church of San Raimondo al Refugio.

Opposite: 499
CRISTOFANO ALLORI
The Hospitality of St. Julian
Oil on canvas, 102 × 79⁹⁄₁₆ in. (259 × 202 cm)
Pitti, Palatine Gallery; inv. 1912: no. 41
This painting, datable to the second decade of the seventeenth century, was in the Pitti Palace by 1638. Left unfinished at the time of Allori's death, it was completed, according to Baldinucci, by Onorio Marinari, working on behalf of Cosimo III de' Medici.

498
CRISTOFANO ALLORI
Portrait of a Man in Black
Oil on canvas, 21¹¹⁄₁₆ × 12⅝ in. (55 × 32 cm)
Pitti, Palatine Gallery; inv. 1912: no. 301
Traditionally attributed to Ludovico Cigoli, this work was restored to Allori by Marco Chiarini. It appears to date from the first decade of the seventeenth century.

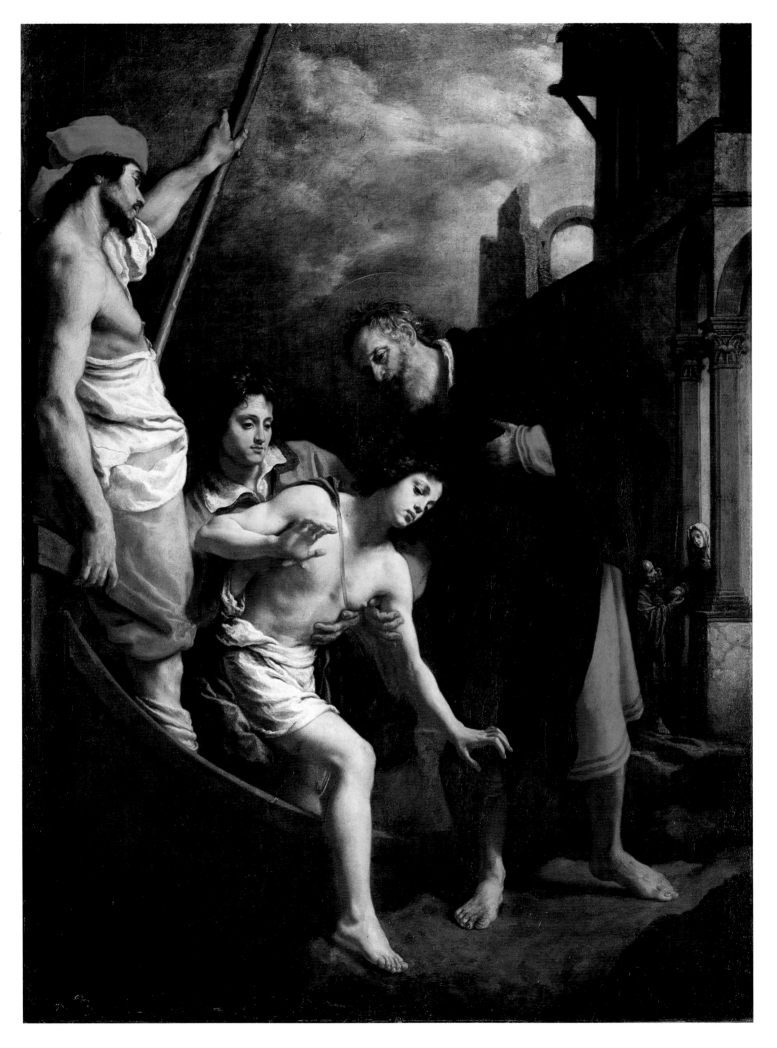

379

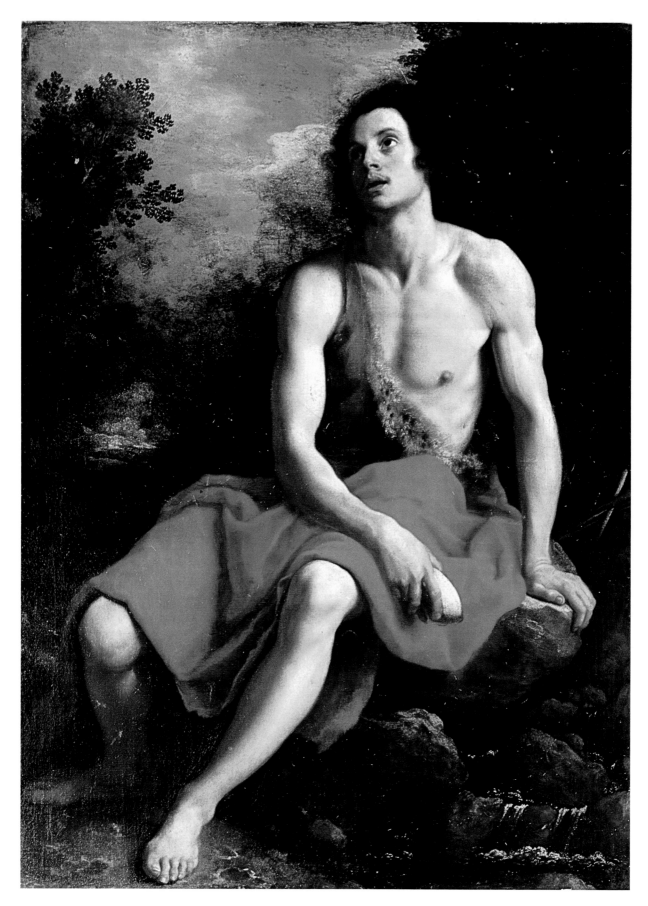

500

CRISTOFANO ALLORI

St. John the Baptist in the Desert

Oil on canvas, 69¹¹⁄₁₆ × 62⅝ in. (177 × 159 cm)

Pitti, Palatine Gallery; inv. 1912: no. 305

This canvas was painted in the second decade of the seventeenth century and once belonged to Cardinal Carlo de' Medici, who in fact may have commissioned it.

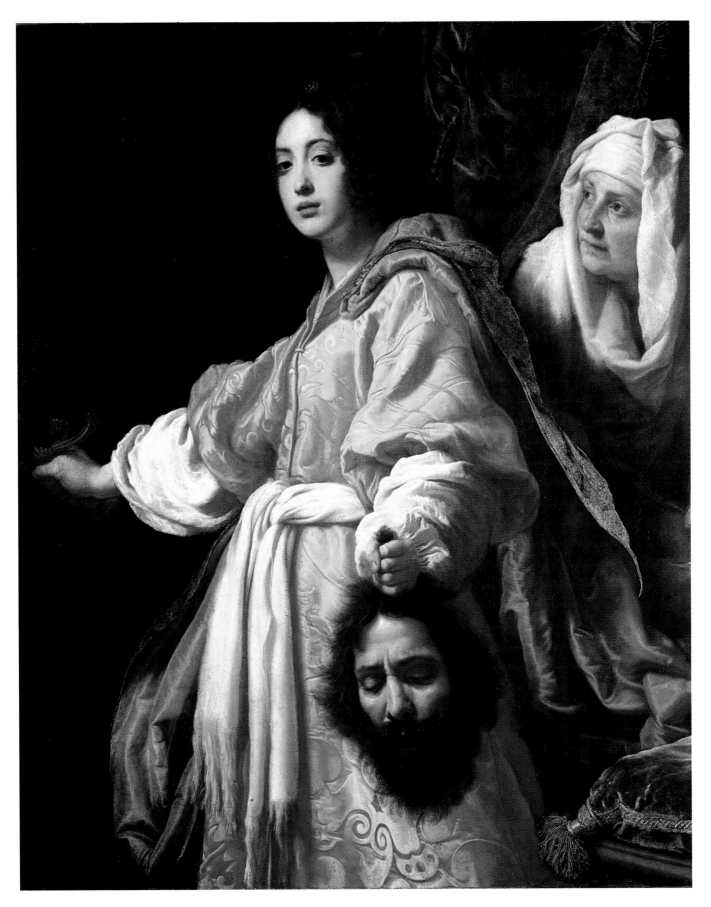

501

CRISTOFANO ALLORI

Judith with the Head of Holofernes

Oil on canvas, 54¾ × 45¹¹⁄₁₆ in. (139 × 116 cm)

Pitti, Palatine Gallery; inv. 1912: no. 96

This is perhaps the most famous and most admired picture in seventeenth-century Florentine art. It was painted in 1619–1620 and delivered by Allori to the Medici Guardaroba in the same year. In 1626 Grand Duke Ferdinand II gave it to his uncle Cardinal Carlo de' Medici. Much later it was removed to Paris and exhibited in the Musée Napoléon from 1799 to 1815.

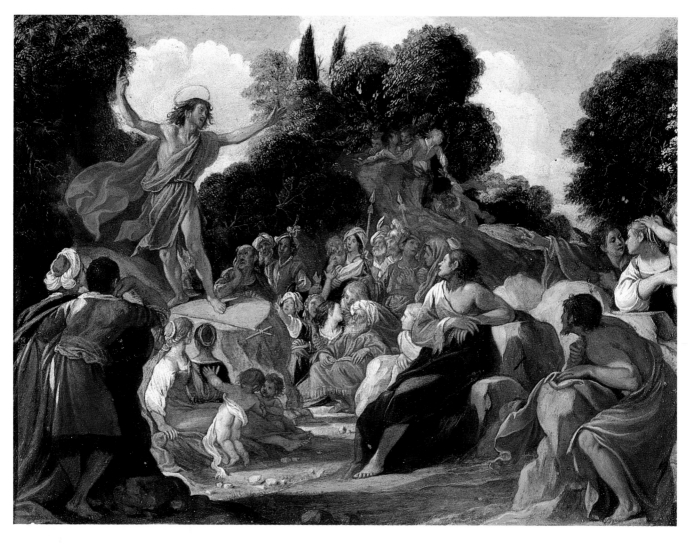

502

ANASTAGIO FONTEBUONI
St. John the Baptist Preaching
Oil on copper, 7⁹⁄₁₆ × 10¹⁄₁₆ in. (19.2 × 25.5 cm)
Pitti, Palatine Gallery; inv. 1912: no. 366

In light of the fact that this work on copper was a gift from the painter to Cosimo II de' Medici, it can be dated to between 1615 and 1620, the year of the grand duke's death.

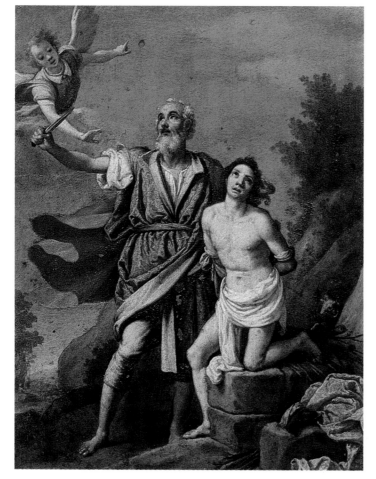

503

JACOPO DA EMPOLI
The Sacrifice of Isaac
Oil on copper, 12⁵⁄₈ × 9¹³⁄₁₆ in. (32 × 25 cm)
Uffizi, Gallery; inv. 1890: no. 1463

Datable to 1610–1620, this picture was painted as a pendant to the *Drunkenness of Noah*, also in the Uffizi. It was acquired by the gallery in 1779 from the estate of the artist Ignazio Hugford.

504

JACOPO DA EMPOLI

The Integrity of St. Eligius

Oil on panel, 118⅛ × 74¹³⁄₁₆ in. (300 × 190 cm)

Uffizi, Vasari Corridor; inv. 1890: no. 8663

Executed in 1614 for the altar of the Company of the Goldsmiths on Via della Crocetta, this is an important example of the "flowery" Florentine style. The face of the saint has been recognized as that of the sculptor Pietro Francavilla.

505

JACOPO DA EMPOLI

St. Ivo, Protector of Widows and Orphans

Oil on panel, 113⅜ × 83⁷⁄₁₆ in. (288 × 212 cm)

Pitti, Palatine Gallery; inv. 1890: no. 1569

According to an inscription on the back that also bears the date of its execution and the painter's signature, this work was commissioned by Benedetto Giugni, magistrate of wards as well as administrator and *camarlingo*. In 1617 Giugni hung the painting in the official residence of the thirteen magistrates; he himself is represented in the picture, to the left of Ivo, in the act of presenting the orphans and widows to the saint.

506

JACOPO DA EMPOLI
Still Life with Game
Oil on canvas, 46⅞ × 59¹³⁄₁₆ in.
(119 × 152 cm)
Signed and dated: JACOPO DA
EMPOLI 1624
Uffizi, Vasari Corridor; inv. 1890:
no. 8441

This canvas came to the Uffizi in
1922 along with no. 507 (below); it
is typical of nature painting as
it was practiced in Empoli's work-
shop.

507

JACOPO DA EMPOLI
Still Life with Game
Oil on canvas, 50¹³⁄₁₆ × 59⁷⁄₁₆ in.
(129 × 151 cm)
Signed and dated: JACOPO DA
EMPOLI 1621 IN FIRENZE
Uffizi, Vasari Corridor; inv. 1890:
no. 8442

Compared to Empoli's previous at-
tempts at still-life, this composition
is more elaborate and its collection
of foodstuffs more varied, with the
added interest of crockery.

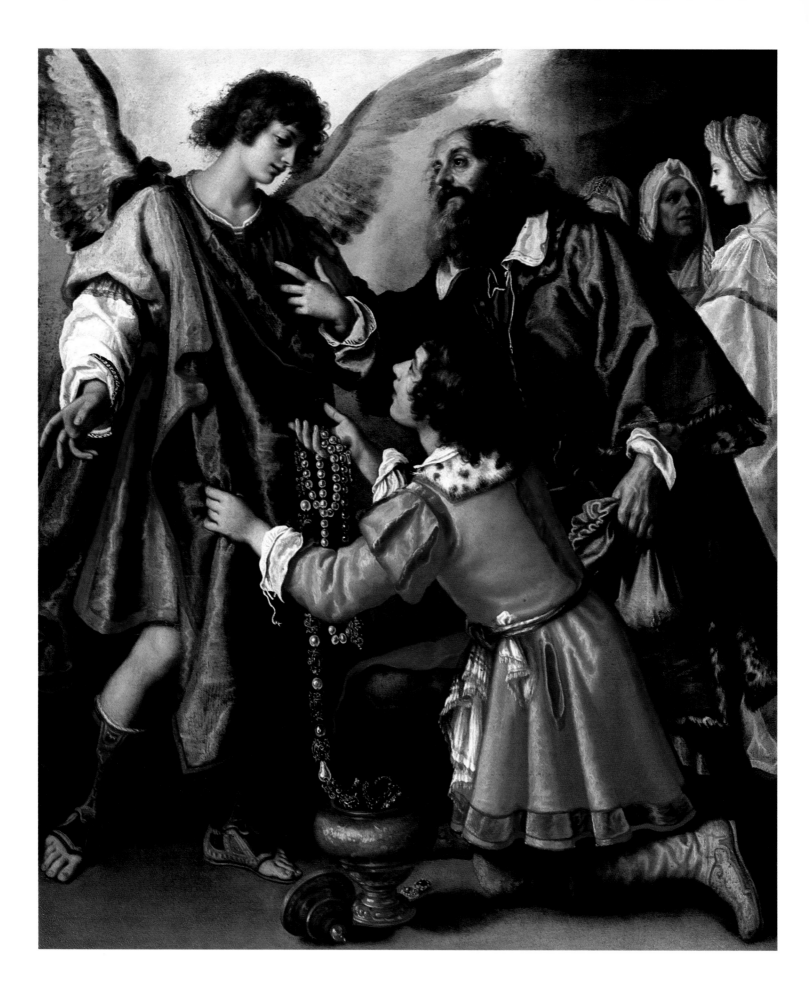

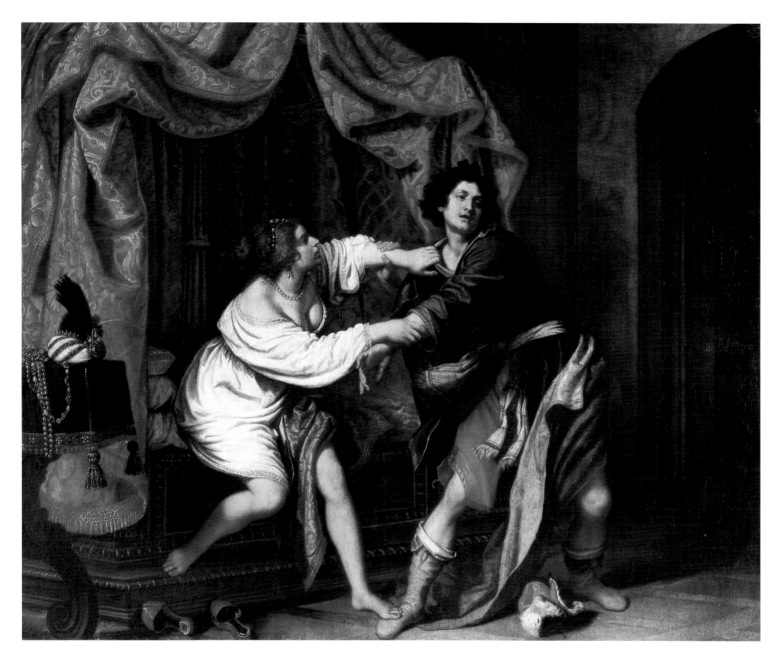

509

GIOVANNI BILIVERT

Joseph's Chastity

Oil on canvas, 94½ × 118⅛ in. (240 × 300 cm)

Signed and dated: GIO. BILIVERT F. 1619

Pitti, Palatine Gallery; inv. 1890: no. 1585

Commissioned by Cardinal Carlo de' Medici for his residence, the Casino di San Marco in Florence, this work was produced in 1618–1619. After the prelate's death, the painting was transferred to the Medici villa at Castello before being returned to Florence, where it entered the Uffizi in 1779.

Opposite: 508

GIOVANNI BILIVERT

The Archangel Refuses Tobias's Offerings

Oil on canvas, 68⅞ × 57½ in. (175 × 146 cm)

Signed and dated: G. B. F. 1612

Pitti, Palatine Gallery; inv. 1912: no. 202

One of the artist's masterpieces, this picture was painted for Filippo Ricci Comi and subsequently acquired by Niccolò Cerretani. In 1832 it was sold to Grand Duke Leopoldo II of Lorraine.

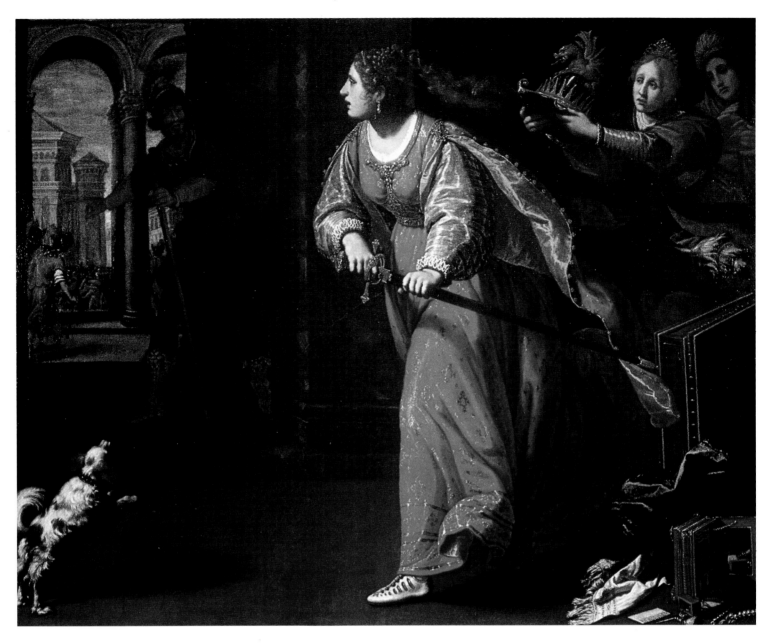

510

MATTEO ROSSELLI

Semiramis

Oil on canvas, 68⅞ × 86¼ in. (175 × 219 cm)

Deposited in the Villa La Petraia; inv. 1890: no. 3821

Along with three other episodes from the lives of famous women of antiquity, this canvas decorated one of the walls of the audience chamber of Grand Duchess Maria Maddalena of Austria in the villa at Poggio Imperiale. Produced between 1623 and 1625, the painting remained in its original location until 1784.

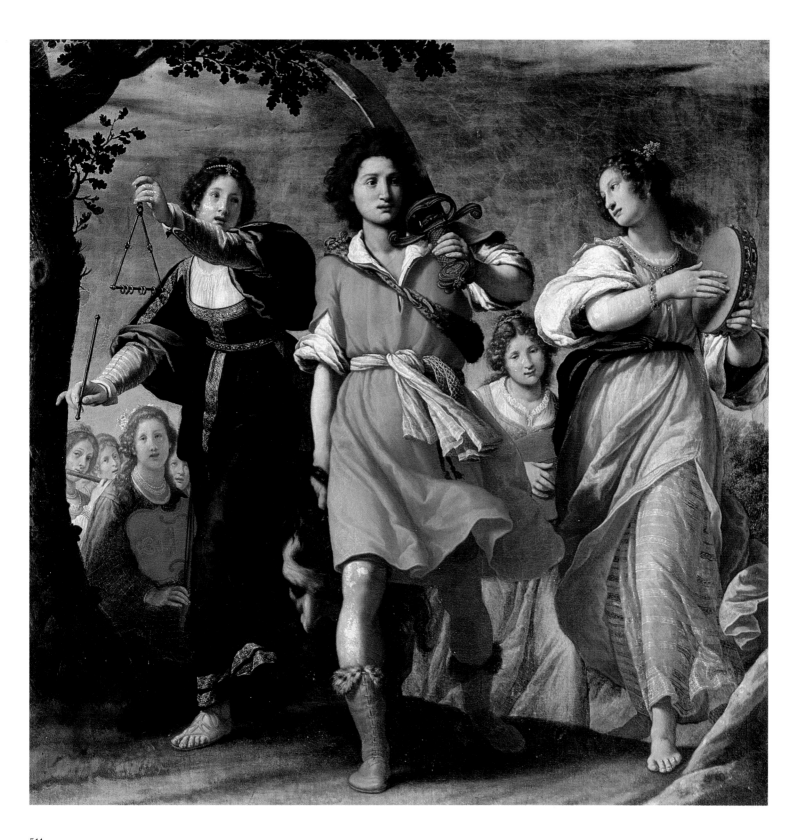

511

MATTEO ROSSELLI

The Triumph of David

Oil on canvas, 79¹⁵⁄₁₆ × 79⅛ in. (203 × 201 cm)

Pitti, Palatine Gallery; inv. 1912: no. 13

A series of payments for this painting were recorded in 1620. It was commissioned by Cardinal Carlo de' Medici for his Florentine residence in the Casino di San Marco.

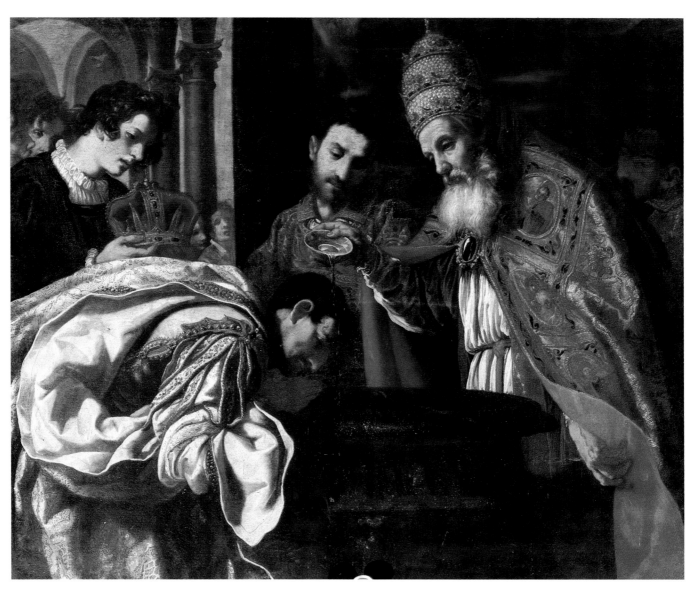

512

JACOPO VIGNALI

St. Silvester, Pope, Baptizes the Emperor Constantine

Oil on canvas, 51$^{13}/_{16}$ × 63 in. (130 × 160 cm)

Pitti, Palatine Gallery; inv. 1890: no. 8682

This picture, executed along with the *Tobias and the Angel* in the Museum of San Marco (no. 513), was described by the biographer Sebastiano Benedetto Bartolozzi in the spicery of the convent of San Marco. Like its companion piece, it dates from around 1623–1624.

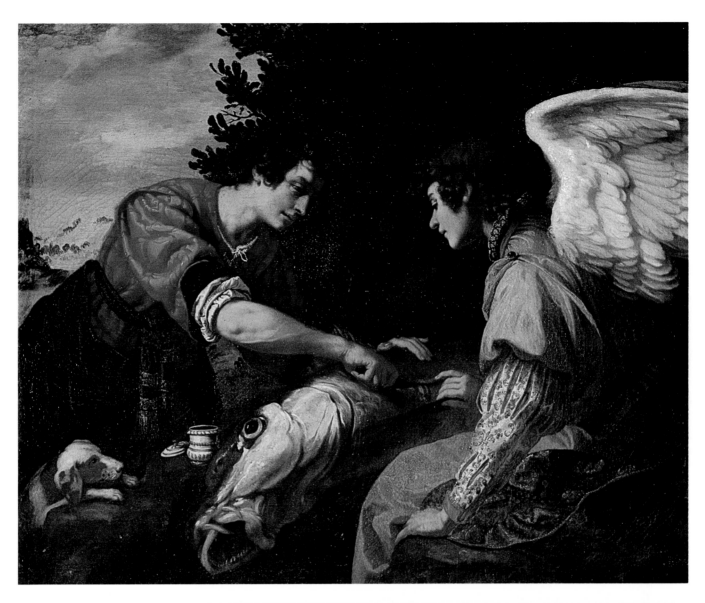

513
JACOPO VIGNALI
Tobias and the Angel
Oil on canvas, 52⅜ × 63⅜ in.
(133 × 161 cm)
Signed and dated: IAC.
VIGNALI F. ET. DON. 1623
San Marco, Museum; inv.
1890: no. 8681

Painted at the same time as *St. Silvester, Pope, Baptizes the Emperor Constantine* (no. 512), this work was located by Vignali's biographer, Bartolozzi, in the spicery of the convent of San Marco in Florence.

514
BARTOLOMEO LIGOZZI
Still Life with a Vase of Flowers and Fruit
Oil on canvas, 14⁹⁄₁₆ × 18½ in.
(37 × 47 cm)
Pitti, Depository; inv. Castello: no. 556

In a Pitti Palace inventory for the years 1702–1710, this painting is paired with another work (inv. Castello: no. 559).

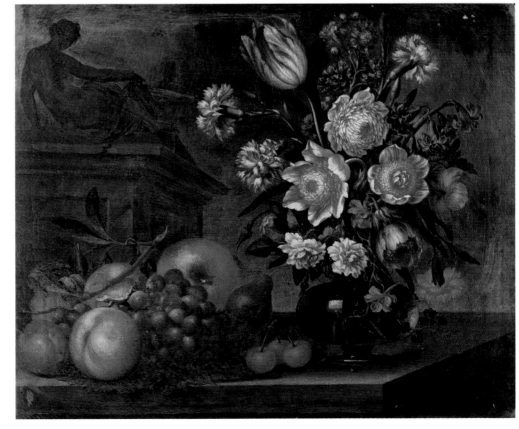

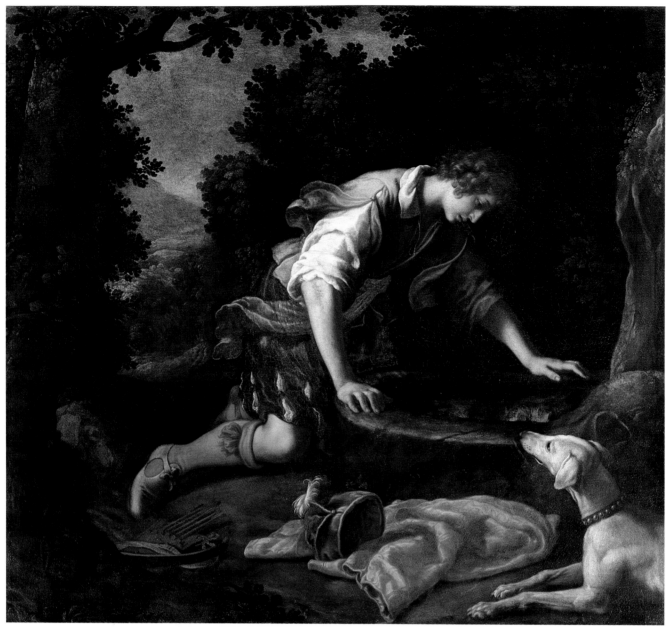

515

FRANCESCO CURRADI

Narcissus at the Spring

Oil on canvas, 70⅞ × 81½ in. (180 × 207 cm)

Signed and dated: FRANC.O CORRADI P.F. 1622

Pitti, Palatine Gallery; inv. 1912: no. 10

This canvas, commissioned by Cardinal Carlo de' Medici for the Casino di San Marco in Florence, appears in the inventory of the cardinal's estate, which was drawn up in 1666–1667.

516

FRANCESCO RUSTICI

Allegory of Painting and Architecture

Oil on canvas, 51 × 38⅜ in. (129.5 × 97 cm)

Uffizi, Vasari Corridor; inv. 1890: no. 1588

This picture, which can be dated to the beginning of
the 1620s, was recorded in 1675, with a correct attribu-
tion to Rustici, in the collection of Cardinal Leopoldo
de' Medici.

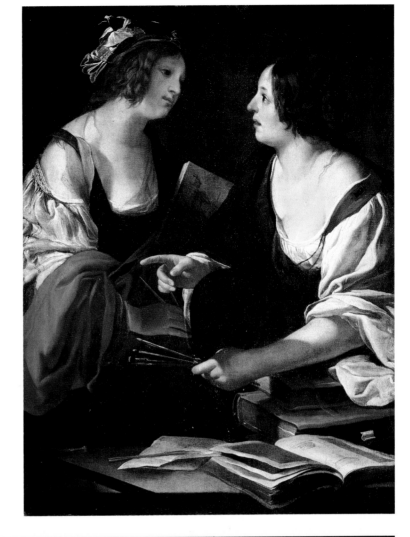

517

FRANCESCO RUSTICI

The Death of Lucretia

Oil on canvas, 68¹¹⁄₁₆ × 102³⁄₁₆ in. (175 × 259.5 cm)

Uffizi, Vasari Corridor; inv. 1890: no. 6421

Destined for the audience chamber of the Medici villa
at Poggio Imperiale, this picture was executed for
Grand Duchess Maria Maddalena of Austria in around
1623–1625 as part of a series of four paintings depicting
episodes from the lives of famous women of antiquity.

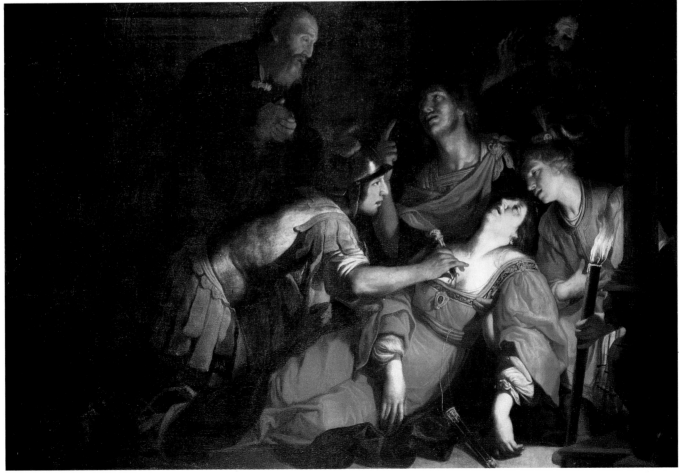

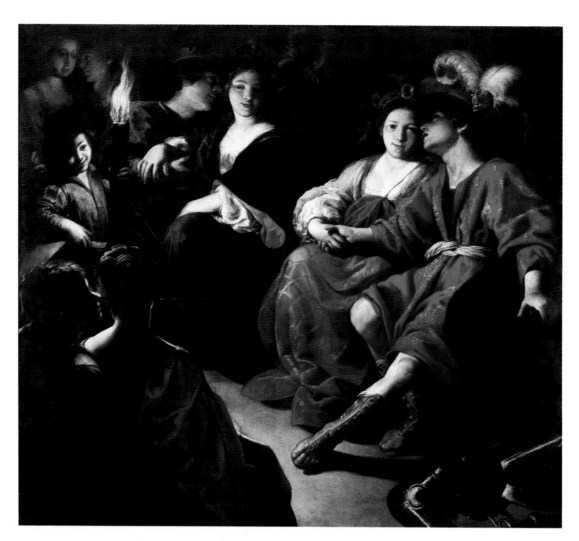

518
RUTILIO MANETTI
Rogero and Alcina
Oil on canvas, 70¹¹⁄₁₆ × 80½ in.
(179.5 × 204.5 cm)
Signed: RUTILIUS MANETTUS
Pitti, Palatine Gallery; inv. 1912:
no. 12

This painting was executed in
around 1622–1623 as a commission
for the Casino di San Marco, the
Florentine residence of Cardinal
Carlo de' Medici. On Carlo's death,
in 1666, it entered the grand-ducal
collections.

519
RUTILIO MANETTI
Masinissa and Sophonisba
Oil on canvas, 66⅛ × 104⁵⁄₁₆ in.
(168 × 265 cm)
Uffizi, Vasari Corridor; inv. 1890:
no. 5484

This work was commissioned by
Grand Duchess Maria Maddalena
of Austria for the audience cham-
ber in the Medici villa at Poggio
Imperiale. Probably painted in
1623–1625, it remained in the villa
until the last years of the eigh-
teenth century.

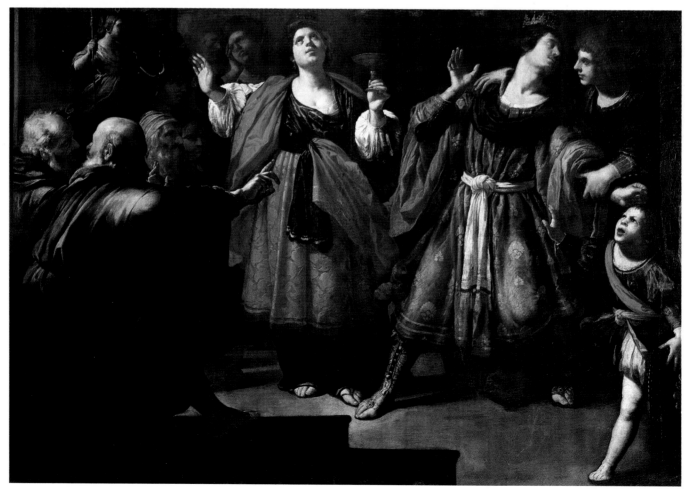

520
GIOVANNI DA SAN GIOVANNI
Venus Combing Cupid's Hair
Oil on canvas, 90³⁄₁₆ × 68⅛ in. (229 × 173 cm)
Pitti, Palatine Gallery; inv. 1890: no. 2123

This delightful painting was produced in the middle of the 1630s for Don Lorenzo de' Medici's residence at Petraia; it seems to have entered the grand-ducal collections very soon thereafter.

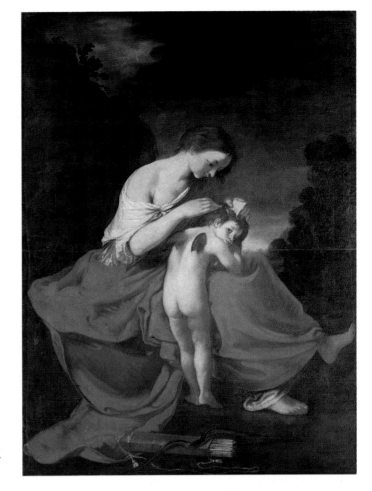

521
GIOVANNI DA SAN GIOVANNI
The Wedding Night
Oil on canvas, 90¹⁵⁄₁₆ × 137 in. (231 × 348 cm)
Pitti, Palatine Gallery; inv. 1890: no. 2120

This canvas, filled with allusions, was probably executed for Don Lorenzo de' Medici as a gift for his nephew on the occasion of his marriage to the most devoted Vittoria della Rovere. In the Pitti Palace by 1637, it later became part of Grand Prince Ferdinand de' Medici's collection.

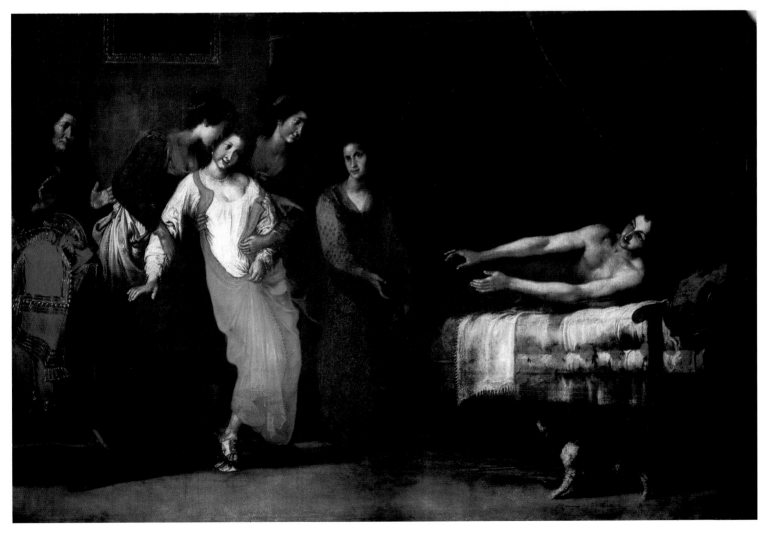

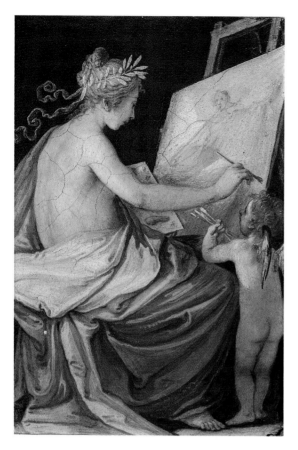

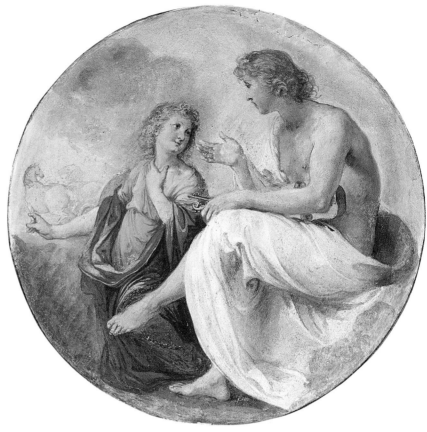

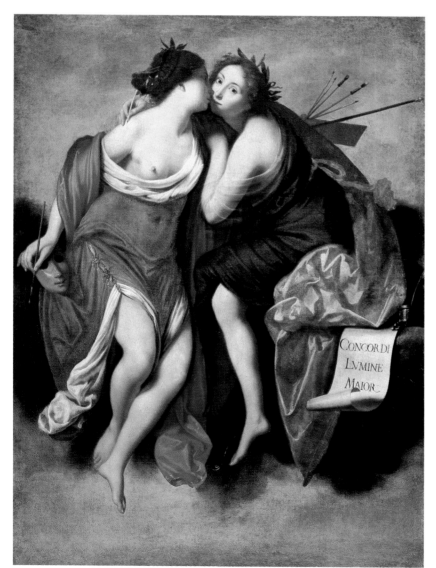

522

GIOVANNI DA SAN GIOVANNI

Painting Depicting Fame

Fresco on terra cotta, $20^{11}/_{16} \times 14^{15}/_{16}$ in. (52.5 × 38 cm)

Signed: GIOV.NI DA S. GIO.NI F.

Pitti, Palatine Gallery; inv. 1890: no. 1533

Probably completed in around 1624, this fresco once belonged to Grand Prince Ferdinand de' Medici, a passionate collector of small-scale works.

523

GIOVANNI DA SAN GIOVANNI

Phaeton and Apollo

Fresco on plaster on matwork, $24^{7}/_{8}$ in. (62 cm) in diameter

Uffizi, Director's Office; inv. 1890: no. 5419

This work was once part of a series of nine *capricci*, or caprices, of which eight survive. Commissioned by Don Lorenzo de' Medici for the Villa La Petraia, it was listed in an inventory drawn up after the prince's death, in 1649. The nine *paniere* were produced in 1634.

524

FRANCESCO FURINI

Poetry and Painting

Oil on canvas, $70^{7}/_{8} \times 56^{5}/_{16}$ in. (180 × 143 cm)

Signed and dated: FRANCISCUS FURINUS FACIEBAT 1626

Pitti, Palatine Gallery; inv. 1890: no. 6466

This canvas was commissioned in 1624 by the Florentine Accademia del Disegno along with analogous treatments of allegorical subjects by three other painters (Salvestrini, Morosini and Ghidoni).

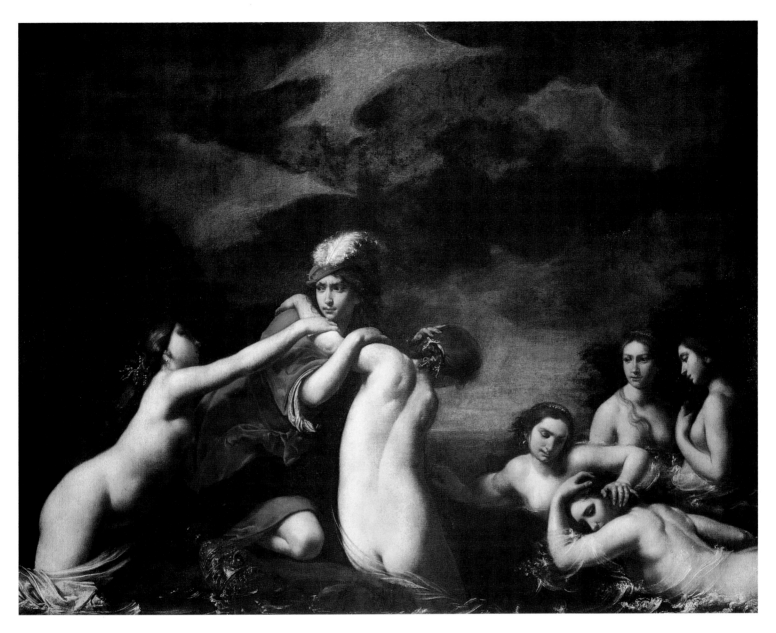

525

FRANCESCO FURINI

Ila and the Nymphs

Oil on canvas, 90⁹⁄₁₆ × 102¾ in. (230 × 261 cm)

Pitti, Palatine Gallery; inv. 1890: no. 3562

This paradigm of seventeenth-century Florentine painting was commissioned by Agnolo Gaddi at the beginning of the 1630s and acquired for the Florentine galleries by the state in 1910.

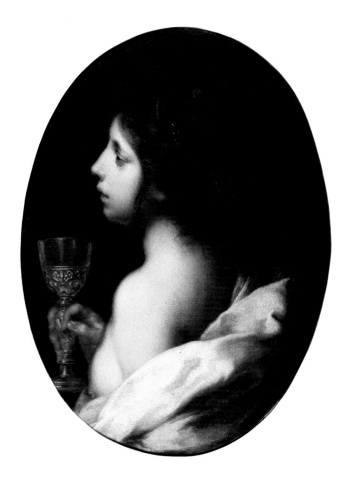

526
FRANCESCO FURINI
Faith
Oil on canvas, 25⁹⁄₁₆ × 19⁵⁄₁₆ in. (65 × 49 cm)
Pitti, Palatine Gallery; inv. 1912: no. 428

This painting, the artist's masterpiece, was executed in the middle of the 1630s; it can be identified as the work described by Baldinucci in the house of Pier Francesco Vitelli.

527
FRANCESCO FURINI
Adam and Eve in the Garden of Eden
Oil on canvas, 76 × 95¼ in. (193 × 242 cm)
Pitti, Palatine Gallery; inv. 1912: no. 426

Datable to the beginning of the 1630s, this work was produced, according to Filippo Baldinucci, for Bernardo Giunchi; it subsequently belonged to Gerini, from whom it was acquired for the grand-ducal collection in 1818.

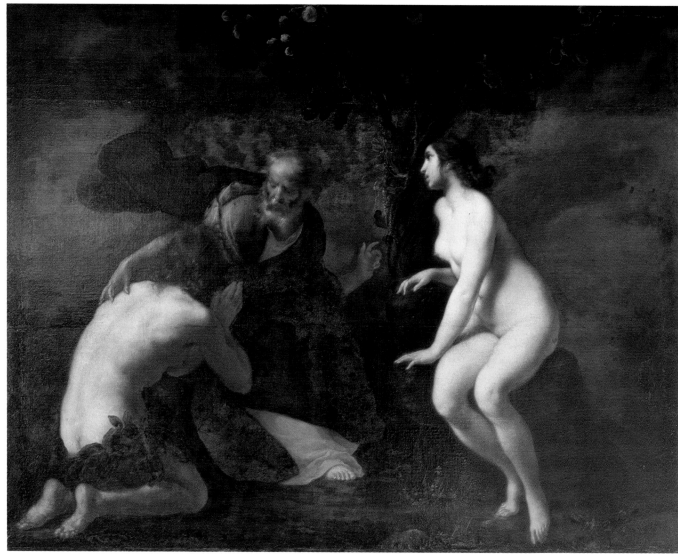

528

CESARE DANDINI

Portrait of a Young Man

Oil on canvas, 21⅞ × 17¹⁵⁄₁₆ in. (55.5 × 45.5 cm)
(oval)

Pitti, Palatine Gallery; inv. 1890: no. 2189

This work has been linked to another, similar picture by the same artist, executed for Don Lorenzo de' Medici between the end of the 1630s and the beginning of the 1640s (now in the Florentine galleries' Depository). It is one of the painter's best-known male portraits.

529

CESARE DANDINI

Rinaldo and Armida

Oil on canvas, 51³⁄₁₆ × 119⁵⁄₁₆ in. (130 × 303 cm)

Uffizi, Depository; inv. 1890: no. 3823

One of the artist's best-known profane works, this painting was executed in 1635 for Cardinal Carlo de' Medici.

530
CESARE DANDINI
Two Hanging Mallards
Oil on canvas, 32�5/16 × 27½ in. (82 × 69.8 cm)
Uffizi, Depository; inv. 1890: no. 4716
Painted between the end of the 1630s and the beginning of the 1640s, this rare example of still-life by the artist was commissioned by Cardinal Giovan Carlo de' Medici for the Casino in Via della Scala in Florence.

Opposite: 531
VINCENZO MANNOZZI
Hell
Oil on touchstone, 17⅛ × 23¼ in. (43.5 × 59 cm)
Uffizi, Depository; inv. 1890: no. 4973
This picture was painted in around 1643 for Prince Don Lorenzo de' Medici, as a pendant to Stefano Della Bella's *Burning of Troy* (no. 532).

532
STEFANO DELLA BELLA
The Burning of Troy
Oil on touchstone, 17⅛ × 23⅛ in. (43.5 × 58.8 cm)
Uffizi, Depository; inv. 1890: no. 4974
This painting is unique in the oeuvre of Della Bella, who was known primarily as an engraver and draftsman.

533
VINCENZO DANDINI
The Adoration of Niobe
Oil on canvas, 90¹⁵⁄₁₆ × 134¹⁄₁₆ in. (231 × 340.5 cm)
Pitti, Depository; inv. 1890: no. 8318

This painting, which illustrates an episode from Ovid's *Metamorphoses*, was executed in 1637–1638 for Don Lorenzo de' Medici and was destined for the Villa La Petraia. Several preparatory drawings are known to exist for it, and it is considered to be the artist's masterpiece.

Opposite: 534
ORAZIO FIDANI
Angelica and Medoro
Oil on canvas, 90⁹⁄₁₆ × 133⁷⁄₈ in. (230 × 340 cm)
Signed and dated: ORAZIO FIDANI 1634
Uffizi, Gallery; inv. 1890: no. 3559

Fidani produced this work for Don Lorenzo de' Medici, who hung it in his residence at the Villa La Petraia; it was still to be found there in 1760.

535
GIOVANNI PINI
Young Man with a Picnic
Oil on canvas, 59¹⁄₁₆ × 80⁵⁄₁₆ in. (150 × 204 cm)
Initialed: GP
Pitti, Depository; inv. 1890: no. 5287

Cited in a 1649 inventory of the Villa La Petraia, this work was ascribed to Pini on the basis of the initials on the straw basket. It may correspond to a picture for which the artist was paid in 1633–1634.

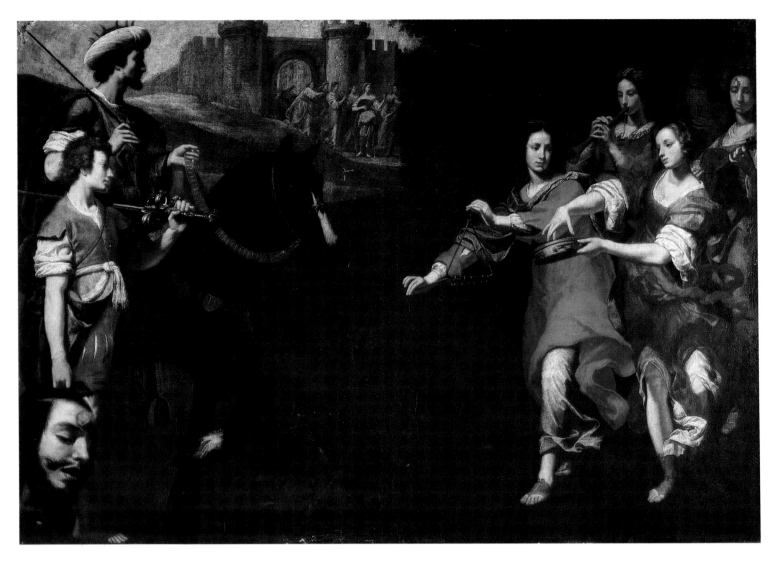

536
LORENZO LIPPI
The Triumph of David
Oil on canvas, 90½ × 133⁵⁄₁₆ in. (232 × 342 cm)
Pitti, Palatine Gallery; inv. 1890: no. 3476

Executed during the early 1650s by Alessandro Passerini, this canvas is a pendant to the
Rebecca at the Well, which has been kept at the Pitti Palace (inv. 1890: no. 3477). Acquired by
the state in 1910 and placed in the Accademia, it came to the Palatine Gallery in 1928.

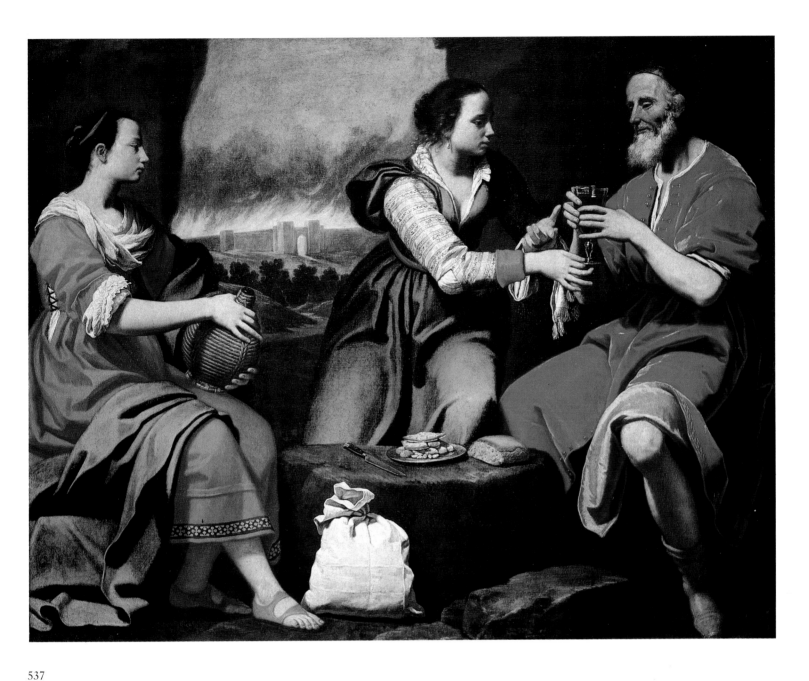

537
LORENZO LIPPI
Lot and His Daughters
Oil on canvas, 58¼ × 72¹³⁄₁₆ in. (148 × 185 cm)
Uffizi, Vasari Corridor; inv. San Marco e Cenacoli: no. 55

This painting came to the Florentine galleries as part of the Ferroni collection, a gift to the
city. A work from the artist's period of maturity, it dates from the early 1650s.

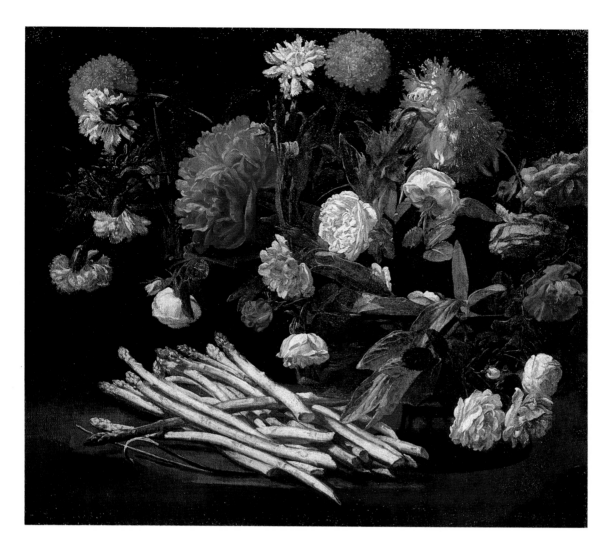

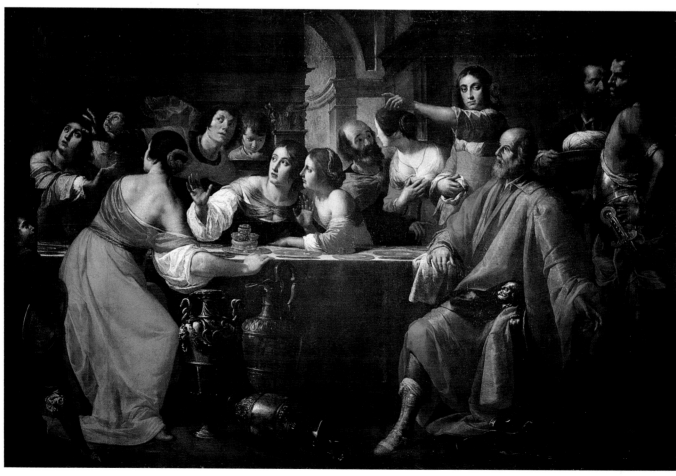

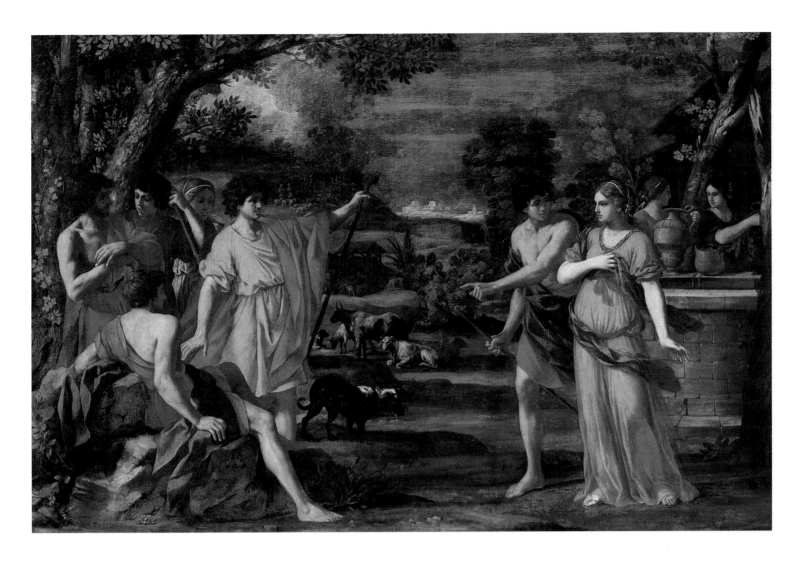

540

GIACINTO GIMIGNANI

Rebecca at the Well

Oil on canvas, 37 × 56¹¹⁄₁₆ in. (94 × 144 cm)

Pitti, Palatine Gallery; inv. 1912: no. 368

Datable to the middle of the 1630s, this work was recorded at Poggio Imperiale in the 1691
inventory of Grand Duchess Vittoria della Rovere's inheritance.

Opposite: 538

GIOVANNI MARTINELLI

Still Life with Roses, Asparagus, Peonies, and Carnations

Oil on canvas, 23⅜ × 27½ in. (59.4 × 69.8 cm)

Pitti, Depository; inv. 1890: no. 6688

Discovered in 1964, this painting was attributed
to Martinelli in 1974 on the basis of a comparison with the flowers in the *Madonna of the Rosary*
in the church of Santo Stefano a Pozzolatico in
Florence. It is datable to around 1647.

539

GIOVANNI MARTINELLI

Belshazzar's Feast

Oil on canvas, 89¾ × 134¼ in. (228 × 341 cm)

Uffizi, Gallery; inv. 1890: no. 2125

This painting was produced in 1653 for Ridolfo
Dei; it was acquired in 1777 and immediately
exhibited in the gallery.

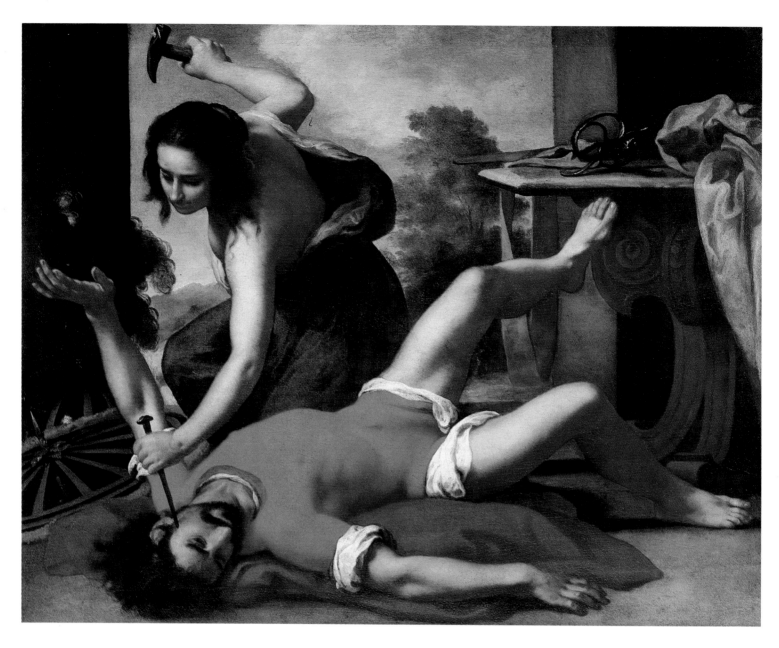

541
FELICE FICHERELLI
Jael and Sisera
Oil on canvas, 47⅝ × 61 in. (121 × 155 cm)
Pitti, Depository; inv. Ogetti d'Arte: no. 1616
The soft brushstrokes and veiled sensual tone of this painting place it within
Ficherelli's later period.

542
CARLO DOLCI
Portrait of Stefano Della Bella
Oil on canvas, 23³⁄₁₆ × 18⅞ in. (59 × 48 cm)
Pitti, Palatine Gallery; inv. 1912: no. 316
An old inscription on the back of this picture assigns it to
Dolci, who painted it in 1631, when he was fifty years old. It
was commissioned by Don Lorenzo de' Medici and is men-
tioned in the inventory taken in 1649 on the prince's death.

543
CARLO DOLCI
Portrait of Ainolfo de' Bardi
Oil on canvas, 58⅞ × 46⅞ in. (149.5 × 119 cm)
Uffizi, Vasari Corridor; inv. 1890: no. 9298
This work, which is signed and dated 1632 on
the back, came to the Florentine galleries in
1954 as a bequest of Count Alberto Bardi Ser-
zelli. It has been in the Uffizi since 1972.

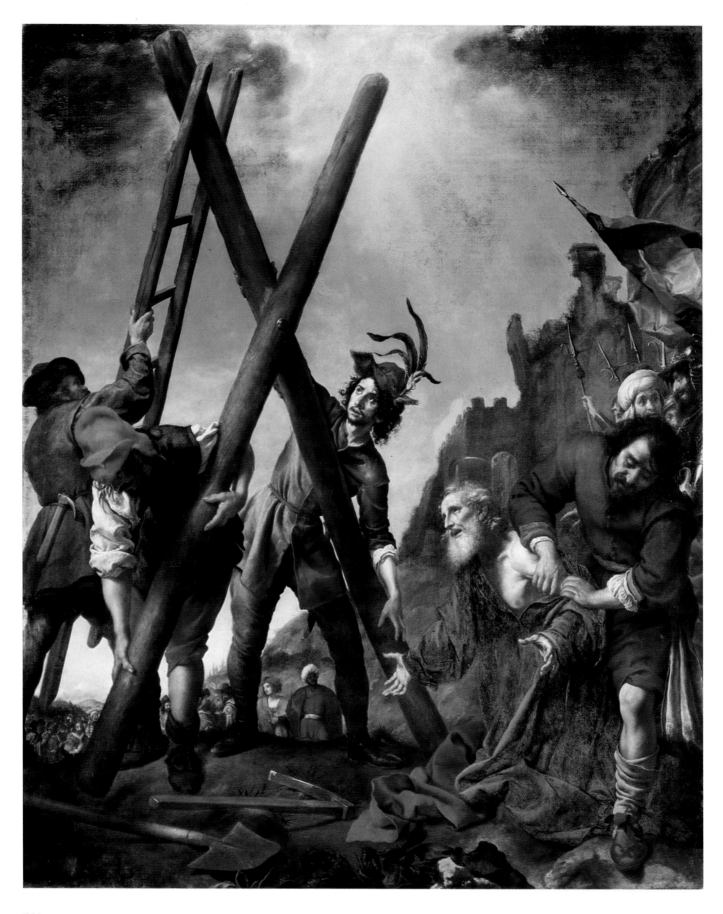

544

CARLO DOLCI

St. Andrew before the Cross

Oil on canvas, 48 x 22¼ in. (122 × 56.5 cm)

Signed and dated: 1646 CAROLUS DOLCIUS FAC.T

Pitti, Palatine Gallery; inv. 1890: no. 768

Painted, according to Filippo Baldinucci, for the marquis Carlo Gerini, this work was
acquired for the grand-ducal collection in 1818 by Ferdinand III of Lorraine.

545

CARLO DOLCI

A Vase of Flowers and a Basin

Oil on canvas, 27⁹⁄₁₆ × 21¹¹⁄₁₆ in. (70 × 55 cm)

Uffizi, Vasari Corridor: inv. Poggio Imperiale 1860: no. 100

Commissioned from Dolci in 1662 by Giovan Carlo de' Medici, whose coat of arms is depicted on the vase, this is a rare example of a still-life by the artist, inviting, in its "frozen" beauty, contemplation of and meditation on the vanity of life.

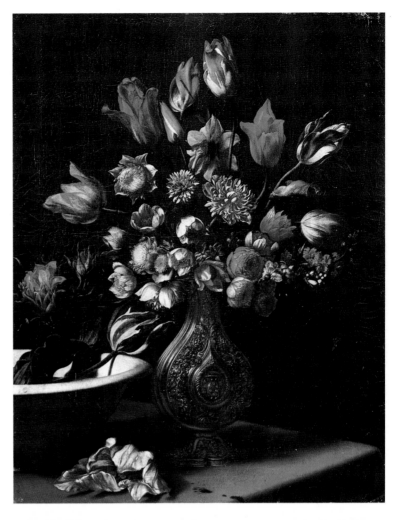

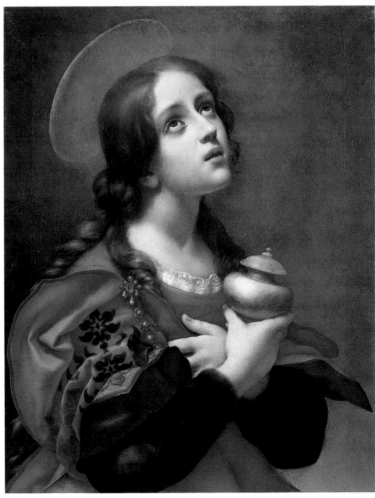

546

CARLO DOLCI

St. Mary Magdalen

Oil on canvas, 28¹⁵⁄₁₆ × 22¼ in. (73.5 × 56.5 cm)

Pitti, Palatine Gallery; inv. 1890: no. 768

This painting dates from the 1660s and once belonged to Grand Prince Ferdinand de' Medici, in whose inventory, compiled in 1713–1714, it is described in detail.

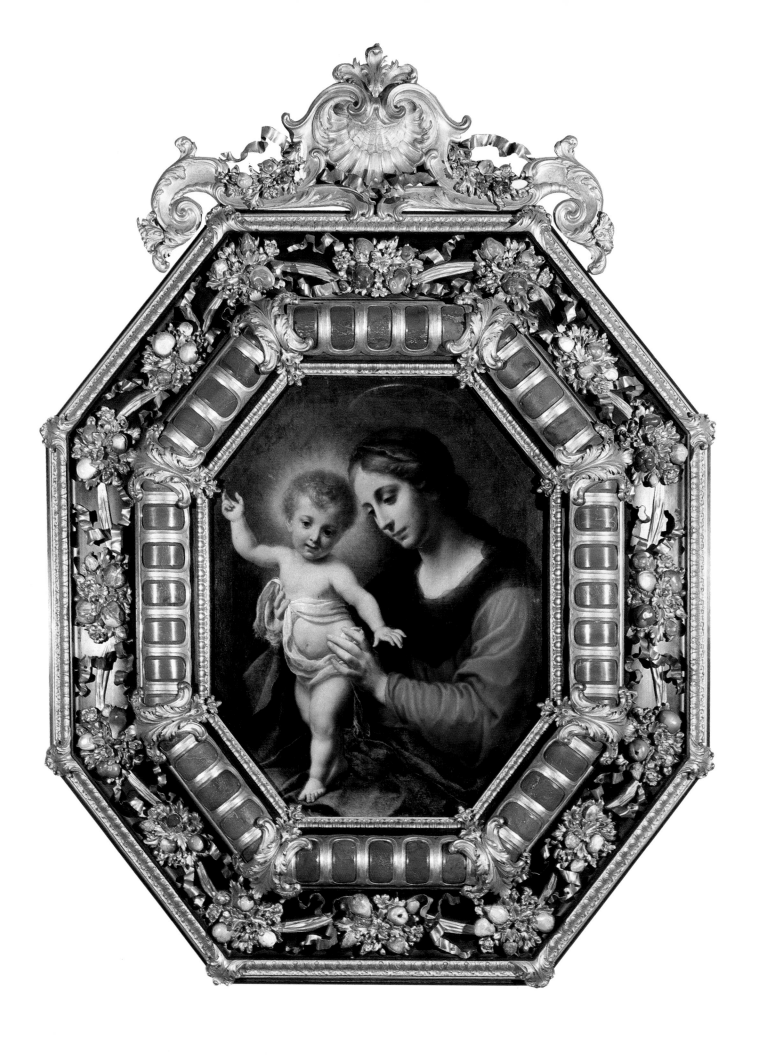

548
VOLTERRANO
Sleeping Cupid
Fresco on plaster on matwork, 28¾ × 16¹⁵⁄₁₆ in. (73 × 43 cm)
Pitti, Palatine Gallery; inv. 1912: no. 107

This fresco, which was executed in the second half of the 1650s, once belonged to Grand Prince Ferdinand de' Medici. It was listed in a 1698 inventory of paintings in the Pitti Palace, as well as in a successive one of 1713–1714, prepared after the death of the prince.

Opposite: 547
CARLO DOLCI
Madonna and Child
Oil on canvas, 33⅞ × 26¾ in. (86 × 68 cm)
Pitti, Appartamenti Reali; inv. Oggetti d'Arte 1912: no. 751

Painted in 1675 for Grand Duchess Vittoria della Rovere, this work subsequently passed to her nephew Gian Gastone and in 1697 was furnished with an elaborate frame of ebony, semi-precious stones, and gilded bronze; the frame was constructed in the grand-ducal workshop after a design by Giovan Battista Foggini.

549
VOLTERRANO
The Wine Trick of Parson Arlotto
Tempera on canvas, 42⅛ × 59¹⁄₁₆ in. (107 × 150 cm)
Pitti, Palatine Gallery; inv. 1890: no. 582

This painting was produced in the middle of the 1640s for Vincenzo Parrocchiani, a courtier of Don Lorenzo de' Medici. It later belonged to Cardinal Carlo de' Medici and became part of Grand Prince Ferdinand's collection.

550

VOLTERRANO

Portrait of Antonio Baldinucci

Pastel on paper, 16¹⁵⁄₁₆ × 14¹⁵⁄₁₆ in. (43 × 38 cm)

Pitti, Palatine Gallery; inv. 1890: no. 2578

The subject of this portrait has been identified through an inscription on the back. The likeness was commissioned from the artist by Filippo Baldinucci, just before his son Antonio donned the Jesuit habit in 1681.

551

VOLTERRANO

Portrait of Cardinal Giovan Carlo de' Medici

Oil on canvas, 57½ × 46¹⁄₁₆ in. (146 × 117 cm)

Pitti, Appartamenti Reali; inv. Oggetti d'Arte 1911: no. 775

The year 1653 provides an initial cutoff for the execution of this portrait, which belonged to the uncle of the sitter, Cardinal Carlo. Traditionally attributed to Sustermans, it may in fact be the work for which corresponding payments were made to Volterrano in December 1663, a date that would fit with the painting's style.

552

LORENZO TODINI

A Vase Decorated in Bronze with Roses, Anemones, and Narcissi
Tempera on parchment, 18½ × 14³⁄₁₆ in. (47 × 36 cm)
Pitti, Palatine Gallery; inv. 1890: no. 3521

An inscription in seventeenth-century handwriting on the
back of this painting bears the date 1684 as well as the
painter's signature. It is one of a group of "miniature paint-
ings on sheep's hide of flowers, birds, and fruit, by the hand
of Todini," cited in a 1697 inventory of the villa at Poggio a
Caiano.

553

LIVIO MEHUS

The Genius of Sculpture
Oil on canvas, 27⁹⁄₁₆ × 31⅛ in. (70 × 79 cm)
Inscription: GENIO
Pitti, Palatine Gallery; inv. 1890: no. 5337

This painting once belonged to Grand Prince Ferdinand de'
Medici. The very popular subject was replicated many times
by the artist. This version dates from around 1655.

554
LIVIO MEHUS
Episode in the Life of Scipio Africanus
Oil on canvas, 39⅜ × 50 in. (100 × 127 cm)
Initialed: LVMS
Pitti, Depository; inv. 1890: no. 3868

Correctly assigned to Livio Mehus in the inventory of Grand Prince Ferdinand de'
Medici's inheritance, this work bears the artist's initials and can be dated to around
the beginning of the 1660s.

555

LIVIO MEHUS

Neptune and Amphitrite

Oil on canvas, 64⅝ × 70⅞ in. (163 × 180 cm)

Uffizi, Depository; inv. 1890: no. 5631

This picture once belonged to Grand Prince Ferdinand de' Medici, in whose inventory, drawn up in 1713–1714, it is described very precisely. It dates from the end of the 1670s and the beginning of the 1680s.

556
PANDOLFO RESCHI
An Armed Assault on a Convent
Oil on canvas, 36¼ × 53⅛ in. (92 × 135 cm)
Pitti, Depository; inv. 1890: no. 583
This late work by Reschi (who died in 1696) was listed among the paintings of Cardinal
Francesco Maria de' Medici, the protector and patron of the artist, in a 1691 inventory
of the villa at Poggio Imperiale.

557
PANDOLFO RESCHI
A Miracle of St. John the Baptist
Oil on canvas, 42⅛ × 51⅟₁₆ in. (108 × 131 cm)
Pitti, Palatine Gallery, Administrative Office; inv. 1890: no. 583

Together with the preceding work, and recorded in the inventory of 1691 of the apartment of Cardinal Francesco Maria de' Medici at the villa at Poggio Imperiale, this canvas is datable to around 1690.

558
PANDOLFO RESCHI
A Vase of Roses
Oil on canvas, 23⅝ × 20⅟₁₆ in. (60 × 51 cm)
Pitti, Depository; inv. Poggio Imperiale 1860: no. 1539

This picture was cited in an inventory of the property of Cosimo III de' Medici compiled in 1714–1717. It is unique in Reschi's corpus and seems almost to foreshadow nineteenth-century painting.

559
FRANCESCO BOTTI
Minerva
Oil on canvas, 29⅛ × 22⅟³⁄₁₆ in. (74 × 58 cm)
Pitti, Depository; inv. San Marco a Cenacoli: no. 98

This picture, once attributed to Simone Pignoni and only recently restored to Botti, came to the galleries from the Ferroni collection in Florence. It is similar to paintings by the same artist in Montepulciano and in the Corsini chapel in Santo Spirito in Florence.

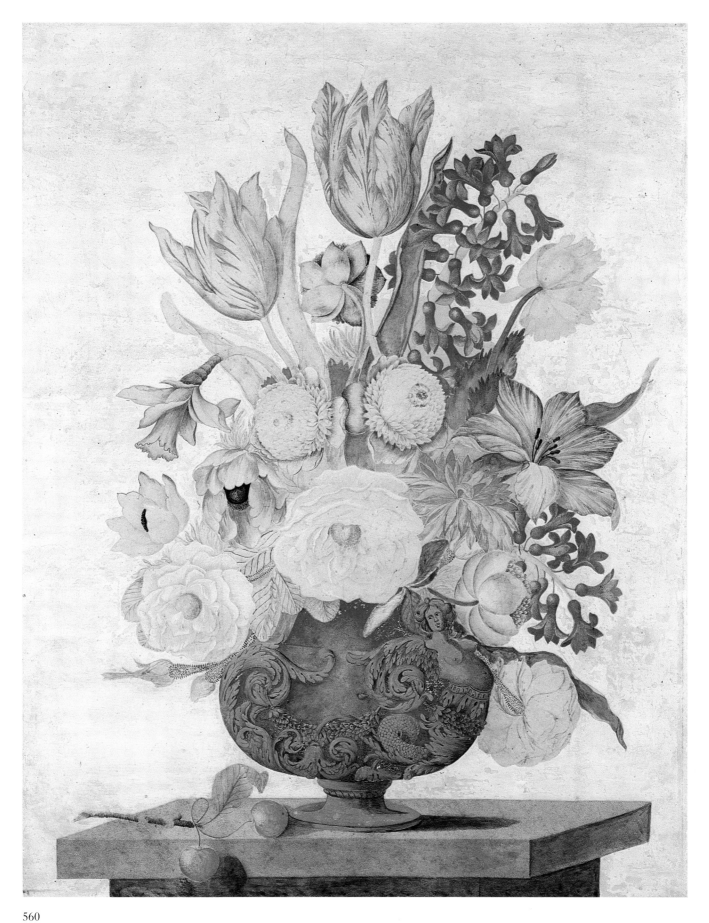

560
ANDREA SCACCIATI
Gilded and Embossed Vase Filled with Snowballs, Roses, and Tulips
Oil on canvas, 39¾ × 30¹¹/₁₆ in. (101 × 78 cm)
Pitti, Depository; inv. Castello: no. 604

This painting belonged to the collection of Cosimo III de' Medici in the Villa di Castello. It is comparable both to an exemplar signed "Lo Scacciato 1674" and to two pendant paintings that were once the property of Nystadt in the Hague, one of which is signed and dated 1678.

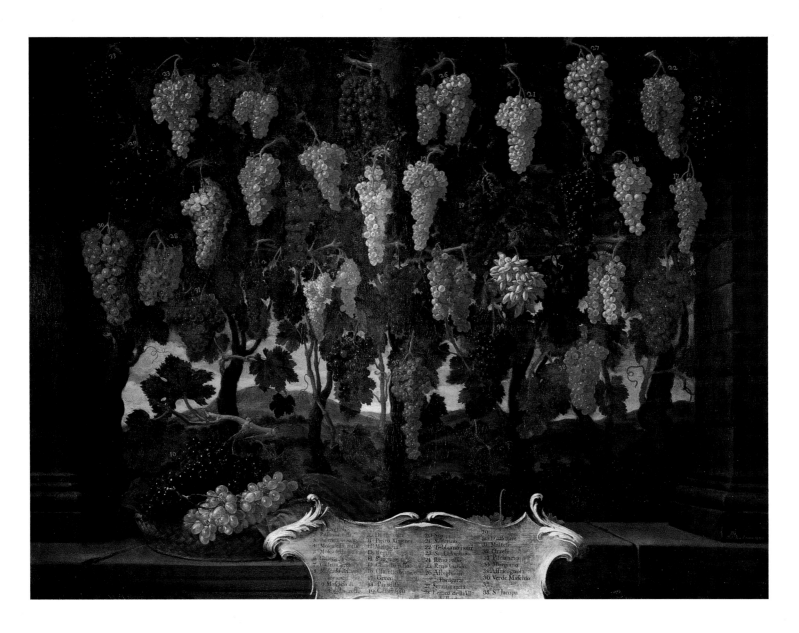

561

BARTOLOMEO BIMBI

Grapes

Oil on canvas, 67⅞ × 88¹⁵⁄₁₆ in. (174 × 228 cm)

Signed and dated: BB ANNO 1700

Poggio a Caiano; inv. Castello: no. 593

This painting exists as a pendant representing many types of grapes. With the basket of grapes resting on the floor, the composition introduces the far-distant landscape and the catalogue of bunches of grapes that occupy three-quarters of the canvas, which is reminiscent of earlier Florentine still-lifes.

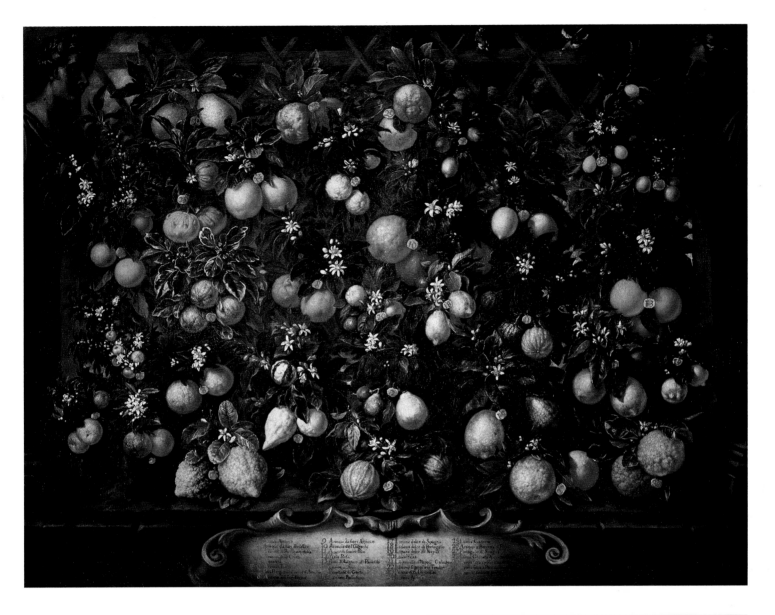

562
BARTOLOMEO BIMBI
Citrus Fruit
Oil on canvas, 77⅝ × 95⁹⁄₁₆ in. (199 × 245 cm)
Poggio a Caiano; inv. Castello: no. 594
Bimbi painted several espaliers of citrus trees. In this example, thirty-one
examples of oranges and lemons are represented.

563
BARTOLOMEO BIMBI
A Bunch of Dates
Oil on canvas, 37¼ × 30¼ in. (95.5 × 77.5 cm)
Signed and dated: B. BIMBI 1720 D'ANNI 72
Pitti, Depository; inv. 1890: no. 6765

The exotic origin of the fruit represented in this painting is emphasized by
the presence of palm trees in the background landscape and by the pyramidal
building at the left.

564
BARTOLOMEO BIMBI
Cherries

Oil on canvas, 45¹¹⁄₁₆ × 61 in. (116 × 155 cm)

Initialed and dated: BB 1699

Poggio a Caiano; inv. Castello: no. 610

This canvas presents a sampling of all the kinds of cherries grown in Tuscany, which are listed on the base of the column on the left. Bimbi executed a number of paintings of this type for Cosimo III, all destined for the Topaia casino above the Villa di Castello.

Pages 426–427:
BARTOLOMEO BIMBI
Cherries (detail)

Opposite: 566
BARTOLOMEO BIMBI
Sunflower

Oil on canvas, 39¾ × 30¹¹⁄₁₆ in. (101 × 78 cm)

Pitti, Depository; inv. 1890: no. 6932

It is known from a Medici inventory that this "double-faced yellow sunflower" by Bimbi, an example of the so-called "Peruvian chrysanthemum," was sent out in July 1721 to be framed for installation at Topaia.

565
BARTOLOMEO BIMBI
Pears

Oil on canvas, 80¾ × 109¹⁵⁄₁₆ in. (207 × 264 cm)

Signed and dated:
BARTOLOMMEO BIMBI
FACEVA L'ANNO 1699

Poggio a Caiano; inv. Castello: no. 611

As the specifications on the scroll ornament at the base of the canvas suggest, the painting represents several kinds of pears of "June, July, August, September, October, winter." The fruit is arranged in groups, mostly in baskets and on plates, in accordance with one of the old-fashioned compositional forms used by painters for this genre of representation.

567
ANTON DOMENICO GABBIANI
Portrait of Musicians at the Medici Court
Oil on canvas, 55½ × 81⅞ in. (141 × 208 cm)
Pitti, Depository; inv. 1890: no. 2802

This painting, executed around 1685, was one of a series of portraits of musicians and servants at the court of Ferdinand de' Medici that once hung in the villa at Pratolino. The positioning of the sitters and the analytical attention to the details of clothing attest to Gabbiani's study and knowledge of the art of Sebastiano Bombelli, whom Gabbiani admired during his years in Venice.

Opposite: 568
PIETRO NERI SCACCIATI
A Barbary Ape, a Jay, a Stork, a Parrot, and a Wild Hen
Oil on canvas, 49³⁄₁₆ × 34¼ in. (125 × 87 cm)
Pitti, Depository; inv. 1890: no. 4713

This work from the Medici villa at Ambrogiana was executed in 1734. Of particular note are the careful rendering of the morphology and details of the five species of animal and the "comic" tone of the assemblage.

569
GIOVAN DOMENICO FERRETTI
The Rape of Europa
Oil on canvas, 57⅞ × 80¹¹⁄₁₆ in. (147 × 205 cm)
Uffizi, Depository; inv. 1890: no. 5447

Dating from between 1728 and 1737, this canvas was probably commissioned by Arazzeria
Medicea for a series depicting the *Four Elements*. A larger version of the painting is in the
collection of the Palazzo di Montecitorio in Rome, on loan from the Florentine galleries.

570

ANTONIO CIOCI

The Jockeys' Race in the Ancient Piazza of Santa Maria Novella

Oil on canvas, 22⁷/₁₆ × 45⁷/₈ in. (57 × 116.5 cm)

Signed and dated: ANT. CIOCI F. 178

Museo di Firenze; inv. 1890: no. 2604

This picture, an integral part of a series of works dedicated to the subject of festivals and city horse races, dates from the painter's last period of activity.

571

GIUSEPPE MARIA TERRENI

Festival at the Cascine in Honor of Ferdinand III of Lorraine

("The Vulcan at Night")

Tempera on paper, 26³/₈ × 48⁷/₁₆ in. (67 × 123 cm)

Museo di Firenze; inv. 1890: no. 2596

This is one of a series of six paintings in tempera depicting one of the festivals at the Cascine between July 3 and 5, 1791, on the occasion of Grand Duke Ferdinand III's accession.

Lombardy and Liguria

The maturation of a new generation of artists of prominent personalities, linked by a language of strong dramatic accents and intense emotional overtones, brought a radical change to the different types of Lombard painting in the last years of the sixteenth century. Among the protagonists of this "new wave" of the great season of the early seventeenth century in Lombardy—dominated culturally by the charismatic figures of Carlo and Federico Borromeo—were Giovan Battista Crespi, called Cerano, and Pier Francesco Mazzucchelli, called Morazzone. Both artists are represented in the Florentine galleries, Morazzone by the Uffizi's dazzling *Perseus and Andromeda,* which was probably executed in the first or second decade of the seventeenth century, around the same time as his famous *Magdalen Transported to the Heavens* in the church of San Vittore in Varese and his frescoes in the *Ecce Homo* chapel of Sacro Monte in Varallo. In the precious definition of the elongated and sinewy figures and in the lively dynamism that colors the scene, the Uffizi painting reveals features characteristic of Morazzone's style, which is ever marked by a reinterpretation of late mannerist models but which modulates into a liberated and glittering type of painting that is entirely an invention of the seventeenth century. The devotional climate of the Borromeo years is instead revived in Cerano's *Madonna and Child with Saints,* a work of extreme severity that can be dated to the last phase of the Novarese artist's activity, probably around the end of the 1620s. The attribution of the painting to this date is corroborated by some uncertainties in the execution, which demonstrate quite clearly the intervention of the workshop, as in other late works by Cerano.

Another prominent exponent of Lombard Piedmontese painting of the first decades of the century was Giuseppe Vermiglio, an artist who, recent studies suggest, was trained in Rome, like Morazzone and Cerano, in the years when Caravaggio was a dominant force there. A faithful interpreter of Caravaggio's naturalism during his long stay in the papal city, Vermiglio, after his return to the north, at the beginning of the 1620s, adopted a cultivated and academic language shot through with piety and Renesque classicism, to which the *St. Peter at Prayer,* only recently restored to the Piedmontese, is a testament. For the second half of the century we may look to Giovanni Ghisolfi's *Landscape with Ruins and a Sacrificial Scene,* inventoried in the late-seventeenth-century collection of Grand Prince Ferdinand de' Medici but only recently rediscovered in the Pitti Palace. This canvas provides significant evidence of the Milanese artist's early fortunes as a landscape painter, a genre in which he became a specialist following his documented journey to Rome in 1650. His works betray a clear relationship to the ruin-strewn landscapes that were being popularized in Rome, particularly by Codazzi, in the middle part of the century.

Other recent investigations into paintings in the Palatine Gallery's collection have resulted in the discovery of a work by Giacomo Ceruti, the best-known figure, along with Fra Galgario, in eighteenth-century Lombard painting and an emblematic exponent of that current of Bergamesque-Brescian "painting of reality" which was inaugurated in the sixteenth century by Moroni. All of the elements most peculiar to Ceruti's art can be seen in his *Boy with a Basket of Fish,* the finest testimony both to the artist's interested participation in themes of a pauperistic character and to the rigorous naturalistic discipline of his painting. This latter attitude is especially evident in the still-life section, resolved with an extraordinary optical precision, that dominates the immediate picture plane.

A completely different cultural register, notwithstanding the contemporaneity of the works (the fourth decade of the eighteenth century), is represented by the two *Mysteries of the Rosary* by the Mantuan Giuseppe Bazzani. Bazzani, another prominent protagonist of eighteenth-century Lombard art, was nonetheless sensible to the whimsical spirit of the international rococo, both Venetian and Austrian. Once part of a series with other works that are now dispersed to various private collections, these two canvases from the parish of Borgoforte, near Mantua, display the painter's effervescent pictorialism. He was capable of achieving, in small compositions, a kind of freedom of execution and a fragility of form like what is found in the sacred works of Gian Antonio Guardi.

The gradual passing of the rococo and the imposition of the classical prerogative that became clearly pronounced in the years around and after the middle of the century are exemplified by Giuseppe Bottani's *Armida's Attempt to Kill Herself.* Bottani, another Mantuan artist trained in the ambience of Roman protoclassicism, sent the painting from Rome to Florence in 1767 for an exhibition at the Santissima Annunziata. But if the controlled theatricality of the scene betrays the artist's study of Guido Reni's work, the cool coloring, the academic rigor of the draftsmanship, and the ivory smoothness of the line indicate his understanding that neoclassicism was knocking at the door.

Francesco Frangi

Genoa

The collection of seventeenth- and eighteenth-century Genoese paintings in the Uffizi documents above all those artists who were working in Tuscany. It owes its existence primarily to Grand Prince Ferdinand de' Medici's appreciation of the pictorial quality and thematic novelty practiced by a number of Ligurian painters.

For all of the fifteenth century and a large part of the sixteenth, Genoese painting was defined strictly in terms of the art of Provence, Tuscany, Flanders, and Lombardy. It began to emerge as an autonomous and significant

school with the advent of Luca Cambiaso, but only in the first years of the 1620s did it assume its own independent shape. Taking a decisive role in the formation of this style, which was born from the fusion and reelaboration of different cultural components, was Giovanni Battista Paggi, who spent a long period of time in Florence (1579–1599). During this time he was under the protection of the personal secretary to Francesco I de' Medici, Niccolò Gaddi, who entrusted him with several important commissions, including the fresco of the *Miracle of St. Catherine* for the great cloister in Santa Maria Novella. It was Gaddi, too, who called upon the Genoese painter to participate in the arrangements for the 1589 marriage of Ferdinand de' Medici to Christine of Lorraine and who perhaps commissioned the self-portrait by Paggi that hangs in the Vasari Corridor. In Florence Paggi also painted various altarpieces, among them the *Madonna and Child with St. Anthony of Padua, Tobias, and the Archangel Raphael* for the convent of the Tertiary Franciscans of Santa Lucia, and a *Nativity* (1589) for the Giambologna chapel in the Santissima Annunziata.

The most important local painters were trained in Paggi's Genoese school. Bernardo Strozzi initially came under his influence but at the same time was inclined to preserve the chromatic range and late-mannerist compositions of his first master, the Sienese Pietro Sorri (in Genoa in 1595–1597 and 1612–1613), as well as the complex and passionate elegance and tonality of contemporary Lombard painters, particularly Giulio Cesare Procaccini. To Strozzi we owe the creation of a more pictorial style based on the use of a free brushstroke, with a vivid chromaticism and a constant attention to reality that were certainly stimulated by his knowledge of the work of Caravaggio and his followers, including Battistello, in Genoa in 1618, Orazio Gentileschi and his daughter Artemisia, there in 1621, and the Sarzanese Domenico Fiasella. This last artist, who returned to Genoa after a stay in Rome in 1607–1616, immediately assumed a guiding role in the development of Genoese painting through his style, which combined Tuscan and Genoese elements derived from his apprenticeship under Paggi with the two prevailing tendencies of Roman art of the day, those of the Carracci and the Caravaggisti.

Fundamental to the definition of Genoese painting are the works of Peter Paul Rubens, which were extremely well represented in the collections of the Ligurian nobility even before the artist's stay in Genoa in 1606–1607. Rubens's influence on local painting is exemplified by two paintings by Strozzi in the Uffizi: the *Tribute Money*, in 1666 the property of Carlo de' Medici, and an oil sketch of the *Parable of the Wedding Guest*. However, the strongly innovative—in a baroque sense—character of the Rubensian style only began to be really understood by Genoese painters during the third decade of the century, and then thanks only to the mediation of the numerous Flemish artists who were working in Genoa, among them the De Wael brothers, Jan Roos, and Vincenzo Malò. But it was above all Anthony Van Dyck, portraitist to the most important aristocratic families, who proposed an elegant and worldly formulation of Flemish style and adapted Rubensian tendencies to the commemorative requests of Genoese patrons.

Giovanni Benedetto Castiglione was also initially influenced by Rubens and by the Flemish still-life painters, whose style he attached to more complex themes. Frequent journeys to Rome enabled him to deepen his pictorial language in light of the innovations of Bernini and Pietro da Cortona and to bring to bear on his images the profound moral significance suggested by such inspired history painters as Nicolas Poussin, Pietro Testa, and Pier Francesco Mola. A precocious follower of the neo-Venetian current of the 1630s, Grechetto was greatly admired by Giovan Carlo de' Medici, who heard of him in a letter of 1647 from Fabrizio Piermattei. Such was the esteem in which Grechetto was held in Florence at mid-century, both by painters such as Livio Mehus, who looked to him as an alternative to the prevalent Cortonesque style, and by collectors, who were attracted by his sketching ability and by the symbolic and philosophical content that is expressed, for example, in the Uffizi's *Circe*.

It is owing to Ferdinand de' Medici's taste, too, that Valerio Castello's *Rape of the Sabine Women* is in the Medici collection. Valerio was responsible, along with Grechetto, for the baroque renovation of Ligurian painting. But if Castiglione's example was especially important for easel painting, in Genoa Valerio's work greatly influenced fresco decoration for a good part of the seventeenth century.

Avoiding the kind of artistic tendencies described above, Alessandro Magnasco left Genoa quite early on to work in Milan, though he always treasured the stylistic lessons he learned from the quick sketches of Valerio Castello and Grechetto. Far removed from the decorative demands and commemorative requests of the mercantile aristocracy of his native city, Magnasco found his fortune among the enlightened Milanese patriciate and, in Tuscany, with Grand Prince Ferdinand and the collectors of his circle, for whom he executed various works. Representative of these is the *Friars' Journey*, now in the Sabauda Gallery in Turin, which bears the Medici coat of arms next to that of the unidentified patron. In Florence, where he was introduced by Antonio Francesco Peruzzini and where he remained from 1703 to 1710, working within the courtly environment and living on a stipend provided by Ferdinand, Magnasco defined his own style through the study of Callot's prints and his admiration for the art of Salvator Rosa and Livio Mehus. His predilection for bitter and grotesque narratives found a congenial climate in Florence, thanks to the grand prince's open tastes and the Tuscan's wit. In a Florentine cultural environment that favored the development of minor painting, Magnasco established himself as a figurative artist who could work with different sorts of landscape specialists.

Angela Acordon

433

572
MORAZZONE
Perseus and Andromeda
Oil on canvas, 46⅞ × 36⁷⁄₁₆ in. (119 × 92.5 cm)
Uffizi, Gallery; inv. 1890: no. 5403
This painting was probably produced between the first and second decades of the
seventeenth century, around the same time as the frescoes in the *Ecce Homo* chapel of
Sacro Monte in Varallo. It came to the Uffizi from the Guardaroba in 1711.

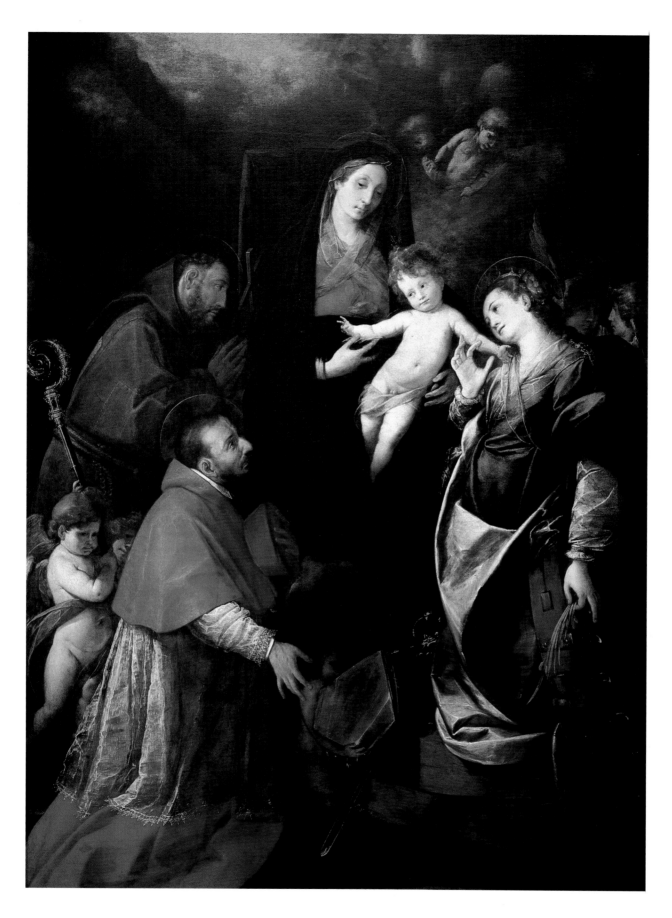

573

CERANO

Madonna and Child with SS. Francis, Charles, and Catherine of Alexandria

Oil on canvas, 105⁵⁄₁₆ × 79⅛ in. (265.5 × 210 cm)

Uffizi, Vasari Corridor; inv. 1890: no. 3884

This belongs to the canon of very late works by Cerano, in many of which, as in this case, the intervention of other hands may be discerned. Noted in 1864 in the Palazzo Mansi in Lucca, it was acquired by the Uffizi in 1913 from the Burlamacchi collection.

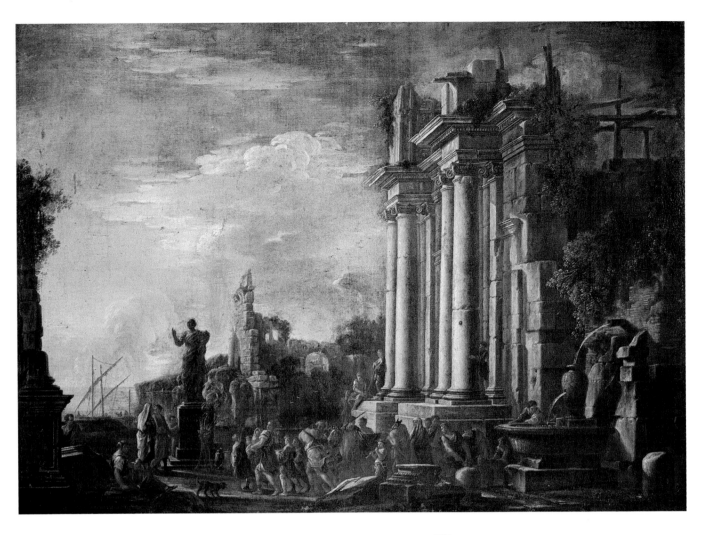

574

GIOVANNI GHISOLFI
Landscape with Ruins and a Sacrificial Scene
Oil on canvas, 31⅞ × 45¼ in. (81 × 115 cm)
Deposited in the Archaeological Superintendency
for Tuscany; inv. 1890: no. 553

This painting certainly dates from after the artist's
main Roman stay, in 1650. At the beginning of the
eighteenth century it belonged to Grand Prince Fer-
dinand de' Medici, in whose inventory it is listed as a
work by the Milanese painter; it came to the Uffizi in
the nineteenth century.

575

GIUSEPPE BAZZANI
Christ in the Garden of Olives
Oil on canvas, 16⁹⁄₁₆ × 14³⁄₁₆ in. (42 × 36 cm) (oval)
Uffizi, Vasari Corridor; inv. 1890: no. 9285

This picture belongs, along with other canvases now
in the Uffizi and in various private collections, to the
series of *Mysteries of the Rosary* executed for the parish
church of Borgoforte, near Mantua. It was probably
produced prior to Bazzani's first securely datable
work, the *Handing Over of the Keys* for the parish of
Goito in 1739.

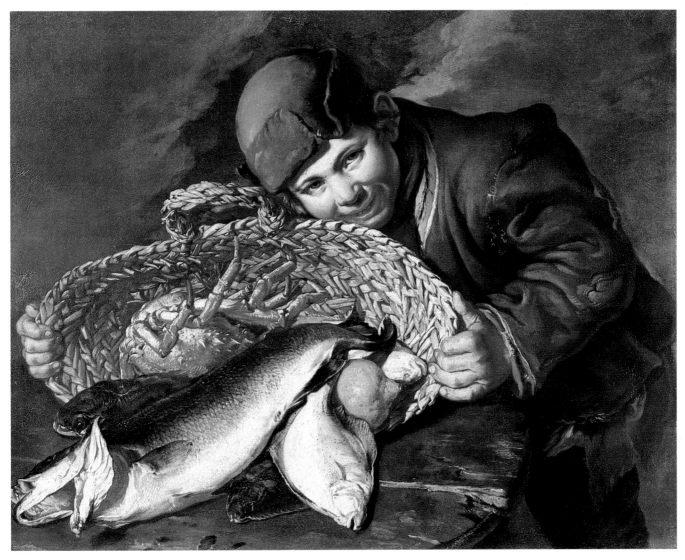

576

GIACOMO CERUTI

Boy with a Basket of Fish

Oil on canvas, 22 1/16 × 28 3/4 in. (56 × 73 cm)

Pitti, Depository; inv. Oggetti d'Arte 1911: no. 301

Once in the royal collection at Parma, this painting came to the Pitti Palace in 1861. For a long time it was inventoried without any attribution; it has only recently been ascribed to the Lombard painter and can be dated to around the middle of the 1730s.

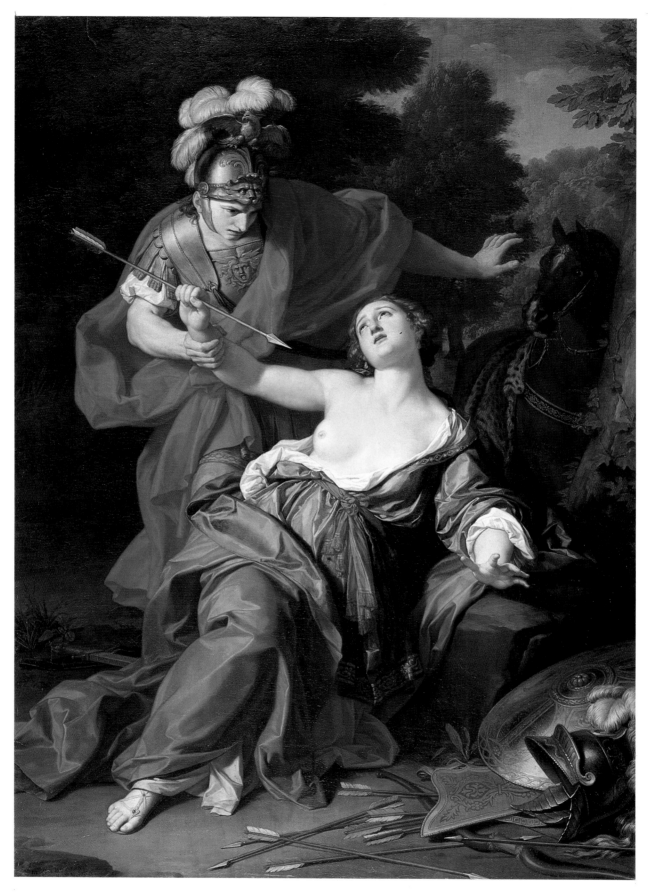

577

GIUSEPPE BOTTANI

Armida's Attempt to Kill Herself

Oil on canvas, 80¹¹⁄₁₆ × 57⁷⁄₈ in. (205 × 147 cm)

Signed and dated: JOSEPH BOTTANI FECIT ROMAE 1766

Uffizi, Depository; inv. 1890: no. 3765

After being sent to Florence by the artist in 1767 for inclusion in an exhibition mounted at the Santissima Annunziata by the professors of design, this painting entered the collection of the Tuscan grand duke Pietro Leopoldo I of Lorraine.

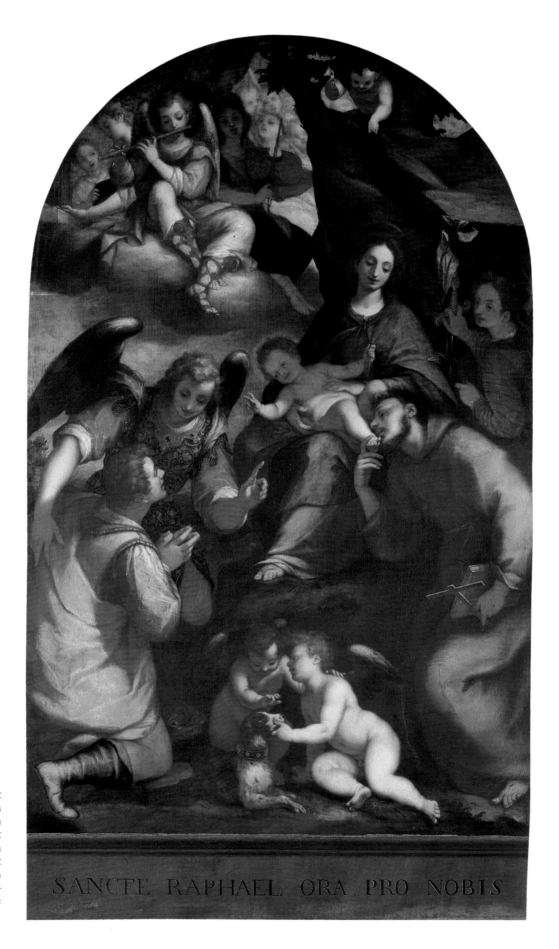

578
GIOVANNI BATTISTA PAGGI
Madonna and Child with St. Anthony of Padua, Tobias, and the Archangel Raphael
Oil on canvas, 143¹¹⁄₁₆ × 82¹¹⁄₁₆ in. (365 × 210 cm)
Signed and dated: GIO BATTISTA PAGGI GENOVESE 1592
Inscription: SANCTE RAPHAEL ORA PRO NOBIS
Cenacolo di San Salvi; inv. 1890: no. 3209

Seen by Richa in 1761 in the convent of the Tertiary Franciscans of Santa Lucia, this altarpiece later passed on to Santa Maria Nuova, from which it was acquired by the state in 1900. An example of Paggi's Tuscan period, it combines characteristics derived from Cambiaso and the Venetianism of Cesare Corte, as well as the Florentine style of Passignano's circle.

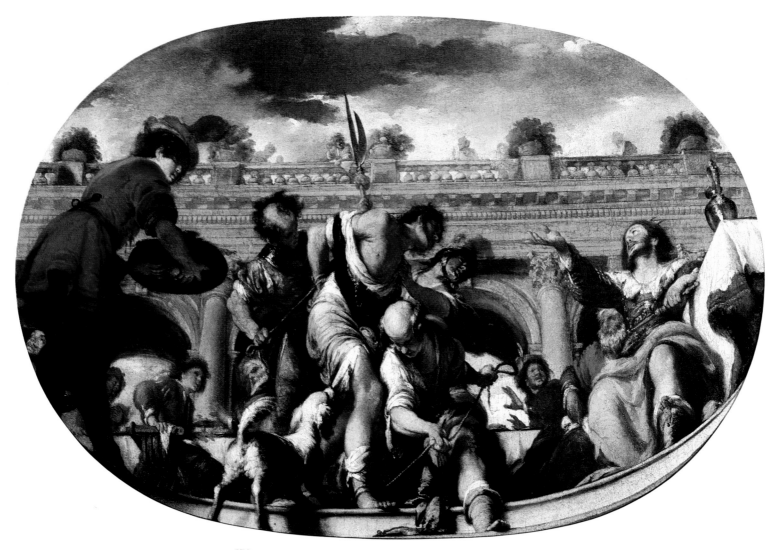

579

BERNARDO STROZZI

The Parable of the Wedding Guest

Oil on canvas, 50 × 74¹³⁄₁₆ in. (127 × 190 cm)

Uffizi, Vasari Corridor; inv. 1890: no. 2191

This is thought to be one of Strozzi's sketches produced for his ceiling painting of 1636 in the church of the Incurabili in Venice, a lost work in which the painter demonstrated his ability to assimilate the Venetian artistic language. Of unknown provenance, the canvas was exhibited at the Uffizi in 1825.

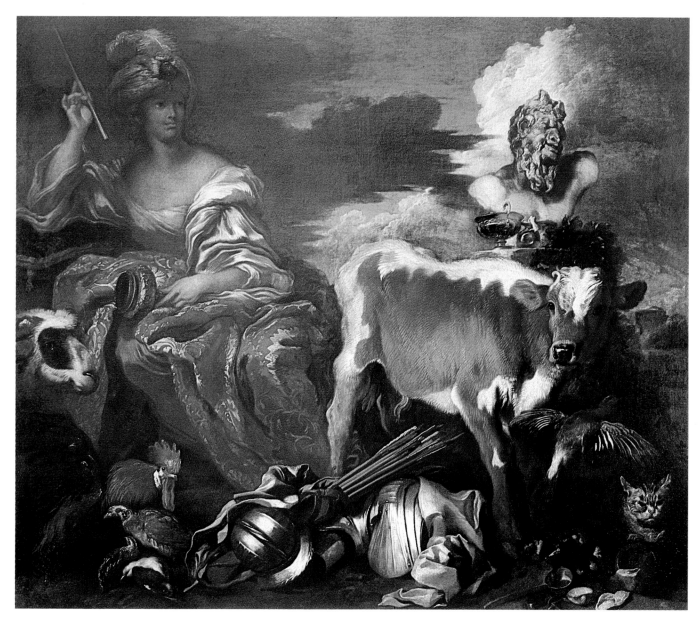

580
GRECHETTO
Circe
Oil on canvas, 73¼ × 85¹³⁄₁₆ in. (186 × 218 cm)
Uffizi, Vasari Corridor; inv. 1890: no. 6464

According to sources, this painting was commissioned from Grechetto by Giovan Carlo de'
Medici for the Pitti Palace, along with another work that has not yet been located. In-
ventoried in Ferdinand de' Medici's rooms between 1698 and 1713, the work was executed
around 1650, perhaps on the occasion of Grechetto's stay in Florence on his return journey
to Genoa from Rome.

581
VALERIO CASTELLO
The Rape of the Sabine Women
Oil on canvas, 81⅛ × 97¼ in. (206 × 247 cm)
Uffizi, Vasari Corridor; inv. 1890: no. 587

This work was seen in Livorno in 1704 by Ferdinand de' Medici, who remained quite fascinated by it and in a letter of February 13 instructed the painter Niccolò Cassana to acquire it for him. Datable to around 1650–1655, it entered the Pitti Palace sometime before 1710.

583

ALESSANDRO MAGNASCO

Training the Magpie

Oil on canvas, 18⅝₁₆ × 23¹³⁄₁₆ in. (47 × 61 cm)

Uffizi, Depository; inv. 1890: no. 5051

Mentioned together with its companion, the *Gypsy Family*, in the Beni inventory of Ferdinand de' Medici, compiled at his death (1713), this work is datable to about 1703–1710. It was inspired, according to Fausta Franchini Guelfi, by some scenes from Raffaele Frianoro's book *Il Vagabondo* (1621), which provided an important source of subjects for the entire seventeenth and the beginning of the eighteenth centuries.

Opposite: 582

ALESSANDRO MAGNASCO

The Gypsies' Meal

Oil on canvas, 22⅛₁₆ × 27¹⁵⁄₁₆ in. (56 × 71 cm)

Uffizi, Vasari Corridor; inv. 1890: no. 8470

This painting, of unknown provenance, was acquired by the state in 1923 for the Uffizi Gallery. Attributed to Magnasco by common consent, it was produced by the painter in the last years of his residence in Florence (c. 1708–1710).

Venice

In the first decade of the seventeenth century, the Medici had very little interest in the work of contemporary Venetian painters. Furthermore, the acquisition of paintings by the great Venetian masters of the sixteenth century became significant only around the middle of the 1630s, with Grand Duke Ferdinand II, who ruled between 1625 and 1670, and especially his brother Leopoldo, a cardinal from 1667 and an active collector from around 1634.

Venice and its territories, at least in the first twenty years of the seventeenth century, had little new to offer in artistic terms. From the last quarter of the sixteenth century, painters had been largely imitating Tintoretto's figurative forms, and weakening them through the practice of repetition. The crisis of Venetian late mannerism, which continued well into the seventeenth century, was aggravated by the necessity of producing a great quantity of paintings at a moment when the strength of sixteenth-century examples had been exhausted in satisfying, on the one hand, the many requests of churches and convents for paintings that responded to Counter-Reformation strictures, and, on the other, the public appetite for great commemorative paintings to replace the masterpieces lost in the fires at the Ducal Palace in 1574 and 1577.

Participating in the decoration of the Ducal Palace with the various "drapers" was Andrea Vicentino, who established himself as a fine narrative artist, specializing in a documentary and commemorative repertoire whose schemes derived from both Veronese and Palma Giovane, the leader of the late-mannerist culture that dominated Venice at that time. In Vicentino's palette one can note the ascendancy of Veronese, though the tones are cooler than those of either that painter or Palma, as can be seen in the Pitti's *Solomon's Banquet*.

The tendency of Venetian artists to hang back and to embrace a much more conservative position than their counterparts in the livelier centers of Bologna, Rome, and Naples was certainly exacerbated by the conflict of 1605–1607 between the Signoria and Paul V, which culminated in the interdiction and consequent interruption of relations between the Serenissima and the papal state. But if Venetian artists were not developing their own reform in painting, Venetian art nonetheless provided the whole of Europe with a chromaticism that would become a principal means of artistic expression.

Between 1600 and 1620, there occurred in Rome a number of important events that would have a significant effect on the development of Venetian artistic culture. The year 1600 saw the arrival of the German Adam Elsheimer, returned from a brief stay in Venice; around him worked several Northern painters as well as the Venetian Carlo Saraceni (resident in Rome since 1588), the author of small paintings and nocturnal scenes lit by artificial light. Domenico Fetti, formerly a pupil of the Florentines Commodi and Cigoli, also looked to this group of artists and their revival of landscape painting.

Fetti's *Ecce Homo,* with its reflections of Cigoli and its echoes of Caravaggio, was presumably painted in around 1613, before the artist left Rome in the retinue of his protector, Cardinal Ferdinand Gonzaga, who became duke of Mantua in 1616. It is almost certainly the painting that Duke Ferdinand, on a visit to the Florentine court in 1618, gave to Grand Duke Cosimo II; in a letter sent from Florence in November of that year to one of his advisers, the duke expressed his desire to present Cosimo with a painting by Fetti, which would be selected by the painter himself (then in his service at Mantua) as the best among those at the Ducal Palace or in his studio. It is interesting to note that Fetti chose for the Medici collection a "Florentine" type of painting, almost an homage to his master Cigoli, inspired by the latter's *Ecce Homo* in the Pitti—a gift that should also be considered in light of the relationship that Duke Ferdinand Gonzaga had lately sealed with the Florentine court through his marriage, in 1617, to Catherine de' Medici. The latter was the instigator of the *Pietà with SS. Catherine and John the Baptist* by the Capucin of Verona, signed and dated 1621 and executed at the end of the same year, when the friar was spending time at the court of Mantua. The strong luminism of this work, again shot through with certain elements of sixteenth-century elegance, can be likened to the Veronese examples by Alessandro Turchi, with whom the friar seems to have worked in "full consonance" (Pallucchini).

A little while before 1616, Alessandro Turchi went to Rome with his compatriots Marcantonio Bassetti and Pasquale Ottino, who were considered to be the principal reformers, along with Turchi himself, of Veronese painting in the first half of the seventeenth century. Turchi, without doubt the most learned of the three, distanced himself from his companions—who chose a strongly naturalistic approach to painting—by adopting a softer style that was halfway between Caravaggism and classicism. His paintings, for the most part of profane subjects, portrayed female nudes in arcadian settings, à la Domenichino, all imbued with a profoundly Venetian chromaticism. Probably linked to a Veronese commission is his sketch of the *Allegory of the City of Verona,* executed on touchstone. This support, popularized by Brusasorzi—whom Turchi studied under—was common among the Veronese and appreciated for its dark coloring, which underlined the composition's nocturnal tones.

The classicism of the Bolognese in Rome was also explored by Padovanino, who at that moment was attempting to revive Titian's early style. His 1619 return to Venice, which anticipated Carlo Saraceni's by a little while, signified the introduction of new ideas into the panorama of the lagoon, such as the updating of the most recent tendencies in Roman classicism and the adoption of Caravaggism, though with a clearer intonation. During the same period, results of the Roman experiences of the aforementioned Veronese painters reached the city.

Between 1621 and 1622 Fetti was in Venice, where he painted his last masterpieces. His quick and fluid brushstroke and his free hand made him one of the initiators of seventeenth-century pictorialism. In 1622 Van Dyck, too, arrived in Venice, followed shortly thereafter (in 1624) by

Liss and Vouet (the latter had been in Venice once before, in 1612–1613). The isolation of the city was over.

Looking to Fetti's Venetian work, Liss began to produce a freer and more daringly baroque kind of painting. The three paintings by him in the Florentine galleries probably date from the beginning of his stay on the lagoon: the *Prodigal Son*, inspired by Fetti's *Parables; Venus at Her Mirror*, where the artist brings to his mythological theme the luminous clarity of Veronese tones; and the *Sacrifice of Isaac*, in which Liss's strength asserts itself in the dramatic subject, emphasized by the rhythm that unites the three figures. These paintings once belonged, along with two evangelical parables (now thought to be workshop productions) and three drawings by Fetti, to Cardinal Leopoldo de' Medici's collection.

Thanks to Cardinal Leopoldo's marvelous acquisitions, the Florentine collections were greatly enriched with Venetian works of the sixteenth and early seventeenth centuries. The high quality of the Venetian paintings collected by him is owed to the mediation of the Florentine painter Paolo del Sera, who from his home in Venice—where he himself had built up one of the finest art collections in the city—was for years Leopoldo's correspondent and artistic adviser. (In 1654 he sold him his first group of pictures.) Del Sera owned, among other works, the splendid *Portrait of the Poet Giulio Strozzi*, one of Tiberio Tinelli's greatest works, dating from around 1630 and characterized by a pictorial tenderness that recalls Van Dyck. This painting was left in del Sera's 1672 will to the cardinal, who in the same year acquired his adviser's collection of forty-one small portraits, predominantly by Venetian artists. (The rest of the paintings from the del Sera collection came to the Florentine galleries only in 1777.)

Along with Padovanino, Tinelli played an important part in the reform of Venetian painting between the third and fourth decades of the seventeenth century. His portraits, which betray the influence of Van Dyck and the modernity of Vouet and Strozzi (in Venice after 1631), would have an important impact on the development of Forabosco's art, as can be seen in the latter's *Portrait of a Woman* in the Uffizi; Tinelli's mythological works, meanwhile, were carefully studied by Carpioni. Carpioni's paintings are thought to reflect, above all, a reappraisal of the young Titian on the part of Padovanino and the latter's preference for profane painting—a fundamental example, as well, for Pietro della Vecchia and for Liberi. Carpioni's *Winged Putto with Still Life and Flowers*, datable to around 1665, belongs to a most felicitous moment of his activity in Vicenza, after the departure of Francesco Maffei in 1657; together, the two artists had long dominated the artistic panorama of the city, distinguishing themselves with a brand of classicism that was suitable primarily for private patronage.

Also intended for private consumption were the profane subjects painted by Pietro Liberi, of an explicitly erotic character and libertine inspiration. Liberi, too, worked in Florence, where he produced the beautiful *Diana and Callisto*.

At the same time, in the second half of the century, the "mysterious" current was being affirmed in Venice, where it was practiced by "foreign" painters such as Giovanni Battista Langetti (from Genoa), Antonio Zanchi (a native of the Adige region), and Johann Carl Loth (a Bavarian). These artists proposed a naturalism derived from distant Caravaggesque origins as filtered through the more dramatic and darker tones of Ribera, combined with the contemporary example of the painting of Luca Giordano, who was repeatedly active in Venice between 1650 and 1682.

The vigorous style of these painters particularly pleased Grand Prince Ferdinand de' Medici, an admirer and collector of paintings characterized by a quick touch. During his first visit to Venice, in 1687 (he undertook a second journey in 1696), he met Loth and acquired from him a considerable number of works, including the two sketches of the *Adoration of the Shepherds* and the *Resurrection of Christ*, paintings of an extraordinary immediacy. Loth also sent the grand prince his great *Lamentation of Abel* and *Apollo Flaying Marsyas*—in which the influence of Giordano is evident in the splendid colors and the fluency of the pictorial material—along with a copy of Titian's *Martyrdom of St. Peter*, then in San Zanipolo in Venice (the copy now replaces the original, which was destroyed in the nineteenth century).

Ferdinand's interest in contemporary Venetian painting very probably grew out of his knowledge of the few works that Giordano had left behind in Florence in 1682–1685. His appreciation of this agile and speedy kind of art led him to collect sketches, destined for the "cabinet of small works" that he was setting up in his villa at Poggio a Caiano.

On the same journey to Venice in 1687, the grand prince also met Niccolò Cassana, who a few years earlier had sent a *Self-portrait* to the Florentine court and with whom he would enjoy frequent correspondence between 1691 and 1709. Cassana, who was to assume the role of Medici agent for the acquisition of Venetian paintings, subsequently traveled to Florence repeatedly to execute portraits of the grand prince and his wife, Violante, as well as the various personalities who frequented the court and accompanied Ferdinand on his hunting parties. To this latter category belongs *Hunter with a Dog*, in which the character of the sitter is vivaciously underlined.

The clear intonation of these later works also pleased the painter Sebastiano Ricci, who expressed his explicit admiration for Cassana's *Cook*, as the grand prince took care to note in a letter he sent to Cassana immediately after the painting arrived from Venice in 1707.

Grand Prince Ferdinand was also responsible for the presence in the Florentine galleries of the floral *Trelises* by Margherita Caffi. Though probably Milanese by birth, Caffi was described as a "Venetian" in a 1695 inventory of the works at the villa at Poggio a Caiano; likewise, she was included by Abbot Lanzi, writing in 1789, among the artists of the "Venetian school." Her still-lifes, distinctive for their notable compositional liberty and their filmy smudges of color, are reminiscent of the work of Vicenzino, with whom she trained in Milan, and also, in her later activity, of the Venetian still-life painter Elisabetta Marchioni.

445

It was Sebastiano Ricci, however, who represented better than any other artist the elegant atmosphere of Ferdinand's court, which also supported, in the field of music, composers such as Scarlatti and Handel. In 1704 the grand prince commissioned from Ricci the *Crucifixion with the Madonna and SS. John, Charles Borromeo, and Francis* for the Florentine church of San Francesco de' Macci. Ricci had just left Vienna in order to place himself at the service of the Tuscan court as a consultant to Ferdinand on the purchase of paintings on the Venetian market. In a letter of May 1706, he announced to the grand prince that he was sending him a crate of paintings for his own collection and that of Cavalier Marucelli (included were two landscapes by Ricci's nephew Marco). Not long after, Sebastiano was in Florence, engaged in the frescoing of the rooms in the summer apartment on the ground floor of the Palazzo Marucelli, which he completed in 1707. The sketches of *Hercules and Cacus* and *Hercules at the Crossroads,* painted with an extraordinary freshness of touch, are preparatory works for two of the scenes illustrated in the Salone d'Ercole, the last room to be completed and, in its ornamental conception, considered to be a model for the rococo. Probably dating from the same time as the Marucelli frescoes is Ricci's *Rest on the Flight into Egypt,* which perhaps decorated a private chapel in one of the Medici villas (Chiarini). The two sketches mentioned above ended up in the grand prince's collection, as did an *Allegory of Tuscany* that documents a fresco planned but never executed—due to the high price stipulated by the artist—for a Gaddi family ceiling, as one might deduce from the foreshortening of the figures.

Ferdinand, having designated the gallery of the villa at Poggio a Caiano as the exhibition place for "models" of the Venetian school, assigned the decoration of the vault to Sebastiano Ricci, who in 1706 frescoed it with an *Allegory of the Arts,* which was lost in the nineteenth century. That the grand prince's enthusiasm must have encouraged Ricci to undertake the promised renovations is attested to by the frescoes (on which his nephew Marco collaborated) that decorate what was once the antechamber of Ferdinand's summer apartments in the Pitti Palace, among Sebastiano's last works in Florence. The clear tone and airiness of the ceiling section depicting *Venus and Adonis,* handled with a delicacy and lightness of touch, were something quite new in the field of European painting at that moment.

A considerable distance, on a stylistic level, separates Sebastiano's Florentine works from such paintings as his *Jove and Semele.* The latter may date from the last decade of the seventeenth century, given its affinity with the frescoes in the church of San Bernardino delle Ossa in Milan (executed, according to Pallucchini, a little before 1695) and given the perfect rendering of the figures in a composition that explicitly refers to late sixteenth-century outlines. It is a work independent from the group tied to the collecting interests of the Medici, and there is no trace of its original provenance; it is integrated into the Florentine collections as an interesting exemplar for understanding the reference points that Ricci judged to be fundamental, in particular the art of Paolo Veronese (Chiarini).

This rich season of Venetian works of art and artists in Florence came to a close with the illness and premature death of Grand Prince Ferdinand in 1713. In 1711 Cassana was in Dusseldorf, at that time one of the most culturally exciting courts in Europe thanks to the palatine elector Johann Wilhelm von der Pfalz, a great patron of the arts who had married Anna Maria Luisa de' Medici, sister of Grand Prince Ferdinand, in 1691. The couple cultivated an interest in Venetian painting that paralleled that of the Florentine court and was served, in terms of the acquisition of works from this school, by the agency of the same artists, Cassana and Sebastiano Ricci. Several Venetian paintings were added to the Florentine collections thanks to this last of the Medici, who returned to Florence after the death of her husband, in 1716, bringing numerous works of art along with her.

It has been hypothesized that Cassana's portrait of *Anna Maria Luisa de' Medici* may have been executed prior to the princess's departure for Düsseldorf in 1691; however, considering that she is no longer very young in this depiction, it is more likely to have been commissioned when the Venetian artist was himself in Düsseldorf. His presence at the German court in 1711 is documented in correspondence from Rosalba Carriera (Sani).

At the Medici court, Grand Prince Ferdinand's widow, Violante of Bavaria, continued to exercise her personal preference for Venetian painting: from her residence at the villa at Lappeggi come three portraits of the daughters of Duke Rinaldo d'Este—*Anna Amalia Giuseppa, Benedetta Ernestina Maria,* and *Enrichetta Anna Sofia*—which the pastel artist Rosalba Carriera executed during a journey to Modena in 1723. The duke, who wanted to marry off the three princesses, had decided to send out their portraits to all the European courts (there were multiple likenesses), employing the services of the Venetian painter, whose works were well known and appreciated throughout the continent. Carriera's refined and elegant pictures, such as *Flora* and the extraordinary *Portrait of a Woman in Turkish Costume,* inaugurated a new genre of portraiture that was extremely free and informal. The figures acquire a tenderness and a vitality thanks to the striking possibilities afforded by pastel technique, which the painter well knew how to utilize, and which would be further developed over the course of the eighteenth century, particularly by the French.

Venetian painting had acquired a European dimension, and its principal representatives contributed to its diffusion throughout the various capitals of Europe. Still tied to Venice were the heirs to the so-called "mysterious" style, Federico Bencovich and Giovanni Battista Piazzetta, the authors of preponderantly religious paintings destined for ecclesiastical patrons. Piazzetta's fame was assured in the 1720s with a group of works of intense naturalism (though not in the Caravaggesque sense of the word), such as the *St. James Taken to Martyrdom* (1722) in San Stae in Venice, which is stylistically close to his *Susanna and the Elders:* the dramatic chiaroscuro that underlines the diagonal structure of the composition recalls the "mysterious" style, while the pictorial impasto suggests a strict relationship with the painting of Giuseppe Maria

Crespi, in whose Bolognese workshop Piazzetta completed his training. Dating from a few years later, around 1725–1727, is Pittoni's canvas *David before the Tomb*. This work rediscovers the strong sense of pathos felt by Piazzetta, whom Pittoni had known in his youth; notwithstanding its great smudge of shadow, it appears to be built up out of even clearer tones. In moving from an early, youthful phase of "clarity" to a moment of "mysteriousness" in the 1710s, and then returning, in the middle of the 1720s, to a clear kind of painting, Pittoni's style followed the general tendency of Venetian painting in the first decades of the century. From neo-Veronese compositions and the delicate hues of a Sebastiano Ricci or a Pellegrini in the first years of the eighteenth century, the school of Venice evolved in the second decade toward darker and more dramatic tones with the arrival of a Bolognese stimulus—particularly caused by Crespi—and then later, on the initiative of Piazzetta and Bencovich, toward a recapturing, around the middle of the 1730s, of newly sunny intonations.

Although trained in Bologna, Pietro Longhi was able to illustrate fragments of Venetian life in an often ironic manner, describing in tones of lively realism such quotidian scenes as the *Confession*, one of a famous series of *Sacraments*, conceived in his maturity, around 1750–1755, and derived from a similar series by Crespi. Longhi's son Alessandro preferred to dedicate himself largely to portraits of local patrons—whether notables, clerics, or men of government—of which one example is the *Portrait of a Prelate*, of 1776, a product of the artist's most prolific period.

Pietro Longhi's paintings of interiors are of great use in reconstructing not only the fashions and costumes of the period but also the taste in furnishings and the interest in works of art: the domestic walls are often decorated with pictures by contemporary artists, hung in pendant and sometimes in groups of four or more. In this context we may also mention Francesco Guardi's series of *Caprices*, whose scenes of indoor ceremonies are equally useful for an understanding of the taste of the time.

One may deduce from these works that Venetian *vedute*, or views, were popular not only with foreign tourists—especially English ones—but also with the nobility and bourgeoisie of the city (whose interest is well documented in inventories), perhaps for reasons of self-celebration at a moment when Venice was about to lose its power.

Paintings of views were also of singular importance in the affirmation of Venetian painting in the eighteenth century; by marking its peculiarity, thanks to its best-known representatives—Canaletto, Francesco Guardi, and Bernardo Bellotto—the genre started from the examples of the Dutch Gaspar van Wittel (1653–1736) and the Friulan Luca Carlevarijs (1663–1729). Canaletto enjoyed striking success in England, where a large number of his views were destined to end up. His paintings were based on complicated perspectival rules applied through the use of an "optical camera," but with a luminous, "tactile" rendering. The *View of the Ducal Palace in Venice* presents one of the most popular perspectival views, which Canaletto repeated, with variations, in other paintings. Guardi, for his part, distinguished himself by adopting a vital brushstroke that altered the stability of Canaletto's vision, as in the two *Caprices*, presumably once part of a larger series. Bellotto's views, meanwhile, reprised Canaletto's perspectival interests.

Corresponding to the diffusion throughout Europe of the works of these *vedute* painters was the intense international activity of Giovanni Battista Tiepolo, during the same year, in the decoration of monumental spaces. Tiepolo began his painting in the "mysterious" circle of Piazzetta and established himself as a painter of frescoes and canvases of extraordinary luminosity, which were the heir to that taste for the grand decoration of narrative subjects which had been disseminated throughout Europe at the beginning of the century by the airy paintings of Sebastiano Ricci.

Tiepolo's first commission outside of Italy, which is considered to be his absolute masterpiece, was for the commemorative decorations for the bishop-prince of Franconia in the Würzburg residence, completed between 1750 and 1753. During this period he developed profane themes, picking up in particular episodes from Tasso's *Jerusalem Liberated,* which he used to great effect in the extensive fresco cycle of the Villa Valmarana, of 1757. In two pendant paintings from the same era, *Rinaldo Sees Himself in Ubaldo's Shield* and *Rinaldo Abandons Armida*, there is a revival of Veronese's architecture, characteristic of Tiepolo's work in the 1750s. Giovanni Battista's son Gian Domenico worked in Würzburg with his father on the Villa Valmarana as well as on other occasions. On a journey to Spain in 1762 with his father, the artist produced the *Portrait of a Page Boy*, one of a number of half-figures he painted of young men in costume.

The eighteenth century in Venice closed with a kind of "amused humanity," described with corrosive gusto by Gian Domenico Tiepolo in the frescoes of the *New World* in his family's villa at Zianigo (now in Venice, in the Ca' Rezzonico), a work that preceded by a few years the entrance of the French troops into Venice (in 1797) and the end of the city's independence.

If the paintings of the Venetian school dating from around the second decade of the eighteenth century have entered the Florentine galleries for the most part through Medici acquisitions, it is more difficult to delineate the provenance of works from successive periods, which came by diverse routes. One cohesive and significant group of works arrived in Florence in 1777, as part of Paolo del Sera's inheritance.

Tiziana Zennaro

584

JOHANN LISS
Venus at Her Mirror
Oil on canvas, 34⅝ × 27³⁄₁₆ in. (88 × 69 cm)
Uffizi, Vasari Corridor; inv. 1890: no. 2179

This work, which dates from around 1625, can probably be identified as a painting of the same subject listed in a 1663 inventory of Cardinal Gian Carlo de' Medici's collection at the villa in Castello. After first passing to the Pitti, it was transferred to the Uffizi in 1727. Another version of the same painting, on panel, is in the von Schönborn Wiesentheid collection in the castle at Pommersfelden.

585
JOHANN LISS
The Sacrifice of Isaac
Oil on canvas, 34⅝ × 27⅜ in. (88 × 69.5 cm)
Uffizi, Vasari Corridor; inv. 1890: no. 1376
This painting belonged to Cardinal Leopoldo de' Medici's collection in the Pitti Palace, where it was inventoried in 1675 and where it remained until the eighteenth century. It was then transferred to the villa at Poggio a Caiano and, in 1836, to the Uffizi. It dates from around 1625–1626.

586
DOMENICO FETTI
Ecce Homo
Oil on canvas, 53⁹⁄₁₆ × 44¹⁄₁₆ in. (136 × 112 cm)
Uffizi, Vasari Corridor; inv. 1890: no. 6279
This painting, which can probably be identified as the work by Fetti that Ferdinand Gonzaga gave to Cosimo II in 1618, was listed in a Pitti Palace inventory of 1687. It dates from around 1613, at the end of the artist's time in Rome.

587
TIBERIO TINELLI
Portrait of the Poet Giulio Strozzi
Oil on canvas, 32¹¹⁄₁₆ × 25³⁄₁₆ in. (83 × 64 cm)
Uffizi, Depository; inv. 1890: no. 962
Bequeathed to Cardinal Leopoldo de' Medici by Paolo del Sera in 1672, this work is mentioned in the cardinal's inventory of 1675. It was painted in around 1630.

588

GIULIO CARPIONI

Neptune Pursuing Coronis

Oil on canvas, 26⅜ × 19¹¹⁄₁₆ in. (67 × 50 cm)

Uffizi, Gallery; inv. 1890: no. 1404

Cited in the Pitti Palace at the beginning of the eighteenth century, this painting was subsequently removed to Grand Prince Ferdinand de' Medici's collection in the villa at Poggio a Caiano. It dates from around 1665–1670.

589

GIROLAMO FORABOSCO

Portrait of a Woman

Oil on canvas, 26³⁄₁₆ × 20⅞ in. (66.5 × 53 cm)

Uffizi, Vasari Corridor; inv. 1890: no. 4276

As with the other two half-length female portraits in the Uffizi (inv. 1890: nos. 2513 and 4326), this likeness has often been identified as that of a courtesan; according to Pallucchini, however, her magnificent costume is not sufficient proof of her vocation. The work dates from around 1665.

590

JOHANN CARL LOTH

The Resurrection of Christ

Oil on canvas, 29½ × 38⁹⁄₁₆ in. (74 × 98 cm)

Uffizi, Depository (near the Cenacolo di San Salvi); inv. 1890: no. 5674

This is one of two pendant sketches for two canvases of analogous subjects in the Duomo at Trent. Already known to Grand Prince Ferdinand de' Medici when they were in the hands of Abbot Baglioni in Venice in 1704, the two "models" were in Ferdinand's Pitti Palace apartments by 1710. They date from around 1685.

591

NICCOLÒ CASSANA

Anna Maria Luisa de' Medici

Oil on canvas, 45¼ × 33⁷⁄₁₆ in. (115 × 85 cm)

Pitti, Depository; inv. 1890: no. 2584

Anna Maria Luisa, daughter of Cosimo III and Marguerite-Louise of Orléans and the last of the Medici, stipulated conditions in a treaty with the dukes of Lorraine that assured that the Medici collection would remain in Florence. This portrait, which is not mentioned in Medici inventories, may have been painted just before the princess left for Düsseldorf (1691), where she married the palatine elector (Chiarini).

592

NICCOLÒ CASSANA

The Cook

Oil on canvas, 60⅝ × 43½ in. (154 × 110.5 cm)

Uffizi, Vasari Corridor; inv. 1890: no. 7571

This painting was executed in Venice and sent by the artist to Grand Prince Ferdinand de' Medici, who received it on September 3, 1707. It is thought to be the pendant to a portrait of a dwarf in the retinue of Violante of Bavaria, the grand prince's wife, painted a little earlier (inv. 180: no. 5140). It has been hypothesized that the copper pots and the animals may be the work of Niccolò's brother Giovanni Agostino Cassana (Chiarini).

453

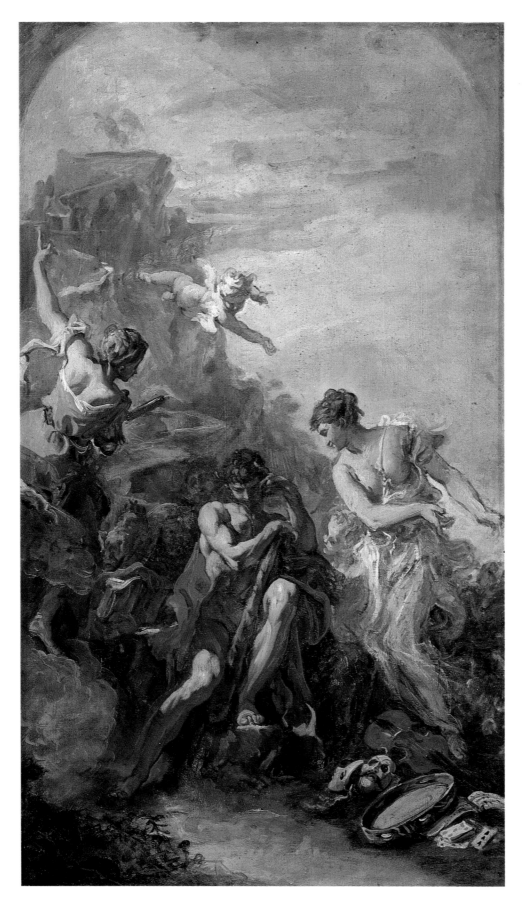

Opposite: 594
SEBASTIANO RICCI
Allegory of Tuscany
Oil on canvas, 34⁷⁄₁₆ × 27¾ in.
(90 × 70.5 cm)
Uffizi, Vasari Corridor; inv. 1890:
no. 3234

Probably dating from Ricci's stay
in Florence in 1706, this is a
preparatory work for a never-
executed ceiling painting in the
Gaddi Palace in Florence, based
on a drawing now in the Biblio-
teca Marucelliana. It is cited in a
1713 inventory of Grand Prince
Ferdinand de' Medici's collection.

593
SEBASTIANO RICCI
Hercules at the Crossroads
Oil on canvas, 25⁹⁄₁₆ × 15³⁄₁₆ in. (65 × 38.5 cm)
Uffizi, Vasari Corridor; inv. 1890: no. 9156

This canvas and its pendant, *Hercules and Cacus,* came from the villa at Poggio Imperiale. A
preparatory sketch for the frescoes in the Salone d'Ercole in the Palazzo Marucelli in
Florence, it was executed in 1706–1707.

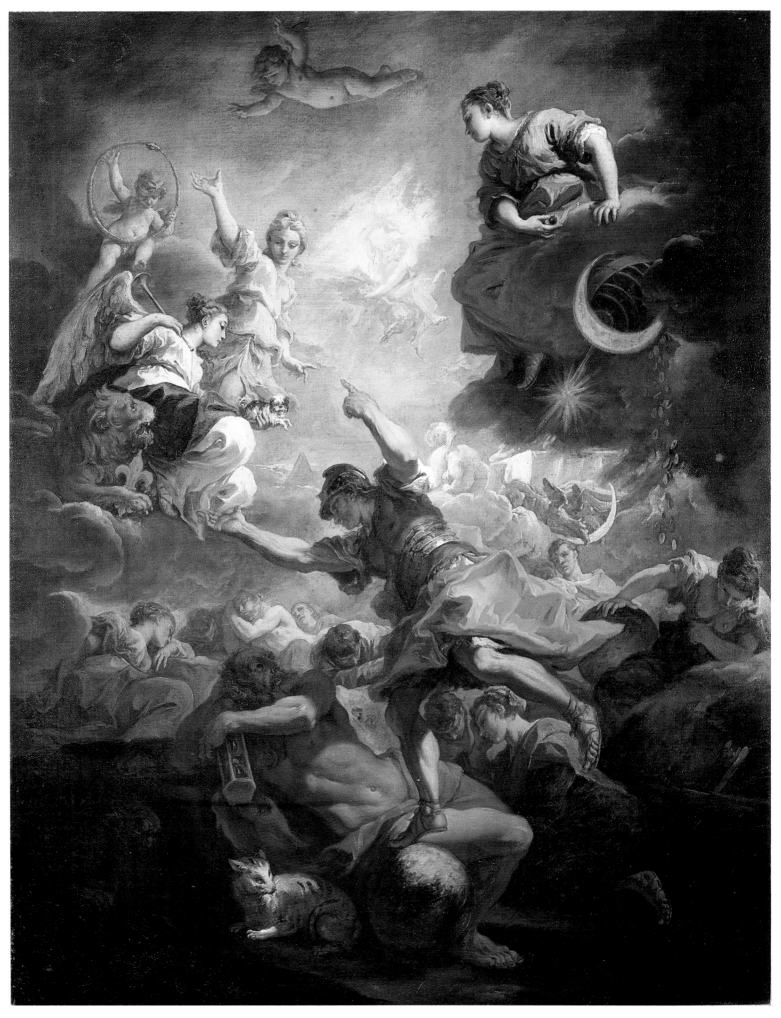

455

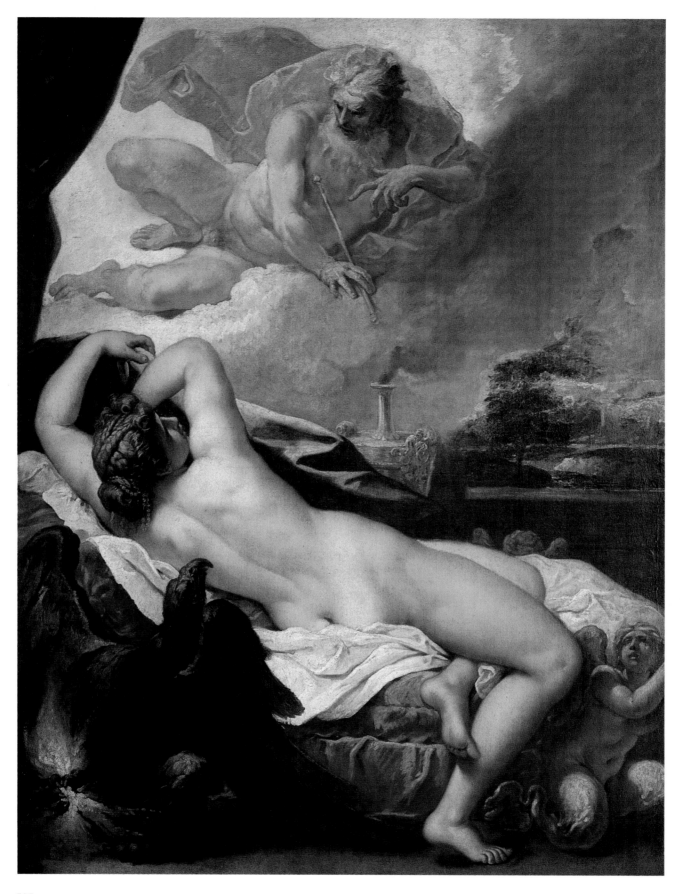

595
SEBASTIANO RICCI
Jove and Semele
Oil on canvas, 75³⁄₁₆ × 59⁷⁄₁₆ in. (181 × 151 cm)
Uffizi, Depository; inv. 1890: no. 9986

This work, whose provenance is the Alessandro Morandotti collection in Rome, was recovered in Germany in 1948. It dates from around the same time as the frescoes for the church of San Bernardino delle Ossa in Milan, which were completed a little before 1695 (Pallucchini).

596
ROSALBA CARRIERA
Flora
Pastel on paper, 18¹⁵⁄₁₆ × 13 in. (48.5 × 33.5 cm)
Uffizi, Depository; inv. 1890: no. 820
Originally probably in the possession of Violante of Bavaria, this work entered the Uffizi in 1861.

597
ROSALBA CARRIERA
Enrichetta Anna Sofia of Modena
Pastel on paper, 23⁷⁄₁₆ × 18⁵⁄₁₆ in. (59.5 × 46.5 cm)
Uffizi, Vasari Corridor; inv. 1890: no. 829
Together with portraits of the sitter's two sisters, this picture came from Violante of Bavaria's collection in the villa at Lappeggi. It was executed in 1723 on the occasion of the artist's journey to Modena, at the request of Rinaldo d'Este, father of the three princesses.

598
ROSALBA CARRIERA
Portrait of a Woman in Turkish Costume
Pastel on paper, 27⁹⁄₁₆ × 21⁵⁄₈ in. (70 × 55 cm)
Uffizi, Gallery; inv. 1890: no. 9988
This is believed to be a portrait of Felicita Sartori, dating from between 1728 and 1741, when this favorite pupil of Rosalba's was living in the artist's house. Once in the Contini Bonacossi collection, it ended up in Germany but was recovered in 1953.

599
GIOVANNI BATTISTA PIAZZETTA
Susanna and the Elders
Oil on canvas, 39⅜ × 53⅛ in. (100 × 135 cm)
Uffizi, Gallery; inv. 1890: no. 8419

The provenance of this painting is the Bonomo Algarotti collection, where it was cited in 1740; it entered the Uffizi in 1920. It dates from the second decade of the eighteenth century, contemporary with Piazzetta's *Sacrifice of Abraham* in the Fenwick-Owen collection in London.

600

ALESSANDRO LONGHI

Portrait of a Prelate

Oil on canvas, 37 × 30¹¹⁄₁₆ in. (94 × 78 cm)

Uffizi, Vasari Corridor; inv. 1890: no. 9181

This portrait, once in the Venetian collection of the painter Italico Brass, was acquired by the Uffizi through a donation in 1931. An inscription on the back of the original canvas, "Alessandro Longhi pinx. an. 1776," has since been covered over by relining.

601

PIETRO LONGHI

The Confession

Oil on canvas, 24 × 19½ in. (61 × 49.5 cm)

Uffizi, Gallery; inv. 1890: no. 9275

This work came to the Uffizi in 1951 through the right of preemption. It is one of a group of paintings of the seven sacraments that Longhi painted between 1755 and 1760, whose iconography he derived from a well-known series by Giuseppe Maria Crespi. The prototype for this and other versions appears to be a painting in the Pinacoteca Querini-Stampalia in Venice.

602

GIOVANNI BATTISTA TIEPOLO

Erection of a Statue to an Emperor

Oil on canvas, 163⅞ × 68¼ in. (420 × 175 cm)

Uffizi, Gallery; inv. 1890: no. 3139

This was originally the central work of a series painted in 1735–1736 for the Arcivesacovile seminary in Udine. A recent restoration has confirmed the autograph of the painting, documenting the remainder of the payments for it as well as for the four ovals that surrounded it.

603
GIAN DOMENICO TIEPOLO
Portrait of a Page Boy
Oil on canvas, 25³⁄₁₆ × 18⅛ in. (64 × 46 cm)
Uffizi, Vasari Corridor; inv. 1890: no. 3111
Donated to the Uffizi in 1893, this picture can be dated to Tiepolo's Spanish period. It is one of several imaginary portraits done by the artist of young men in costume.

604 and 605
GIOVANNI BATTISTA TIEPOLO
Rinaldo Sees Himself in Ubaldo's Shield
Oil on canvas, 27³⁄₁₆ × 52 in. (69 × 132 cm)
Uffizi, Gallery; inv. 1890: no. 9991
Overleaf:
Rinaldo Abandons Armida
Oil on canvas, 27⁹⁄₁₆ × 52 in. (70 × 132 cm)
Uffizi, Gallery; inv. 1890: no. 9992

These two canvases were among the group of paintings that Hitler took to furnish his museum at Linz; they were restored to the Uffizi in 1954. They date from the same period as the Würzburg frescoes, which were executed between 1750 and 1755.

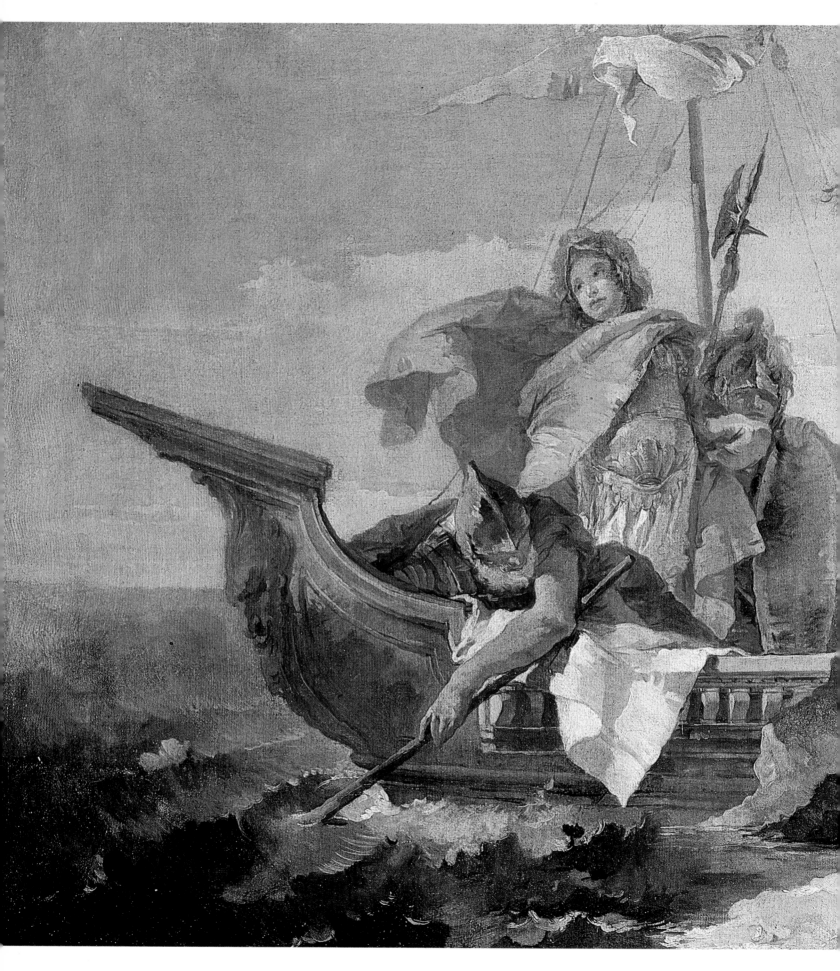

462

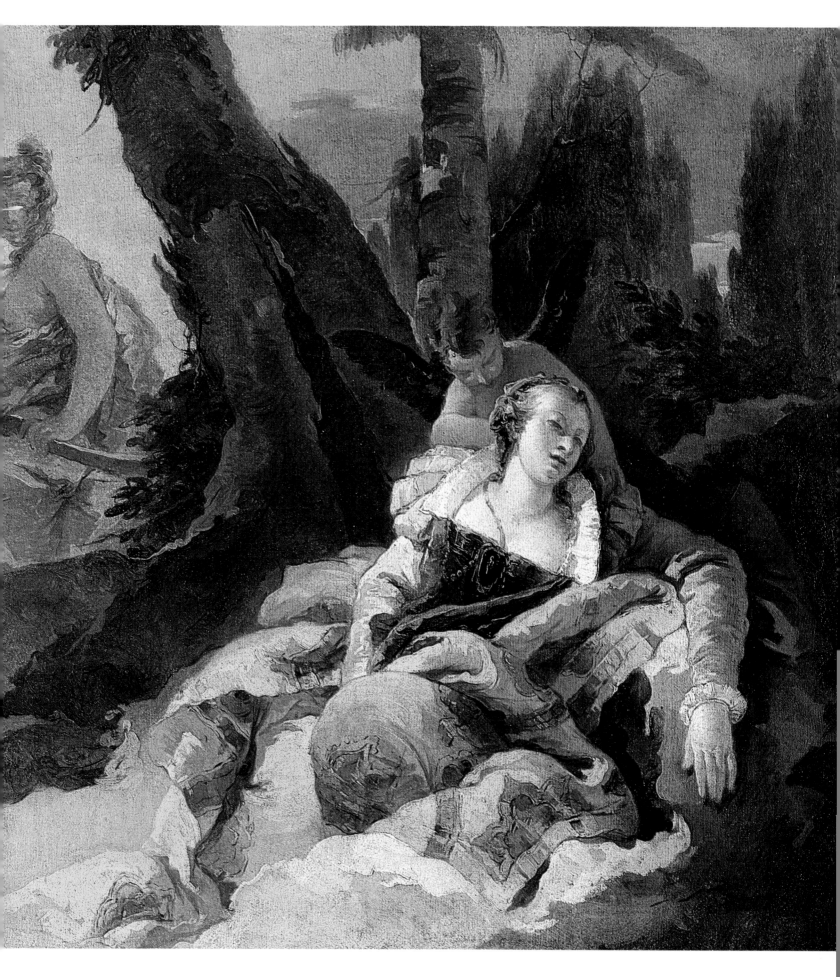

463

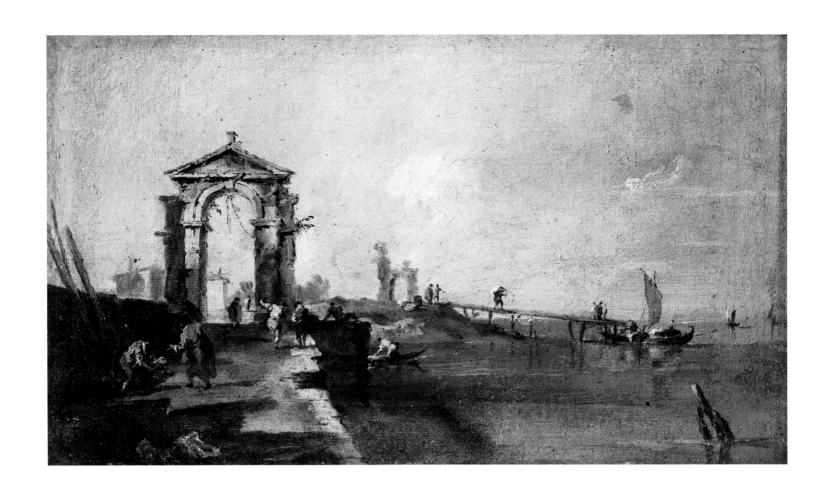

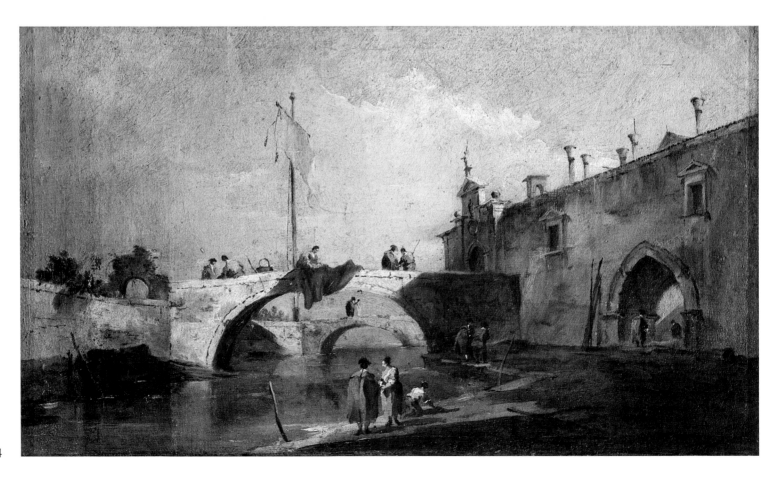

464

608
CANALETTO
A View of the Ducal Palace in Venice
Oil on canvas, 20¹³⁄₁₆ × 32¹¹⁄₁₆ in. (51 × 83 cm)
Uffizi, Gallery; inv. 1890: no. 1334

This painting, whose provenance is Poggio Imperiale, must be dated prior to 1755, before
the completion of the clock tower, which does not appear here. As with other variants of
the same view, it can be related to a drawing in Windsor Castle (no. 7451).

Opposite: 606 and 607
FRANCESCO GUARDI
Caprice with Arch and Pier
Oil on canvas, 11¹³⁄₁₆ × 20⅞ in. (30 × 53 cm)
Uffizi, Gallery; inv. 1890: no. 3358
Caprice with Bridges over a Canal
Oil on canvas, 11¹³⁄₁₆ × 20⅞ in. (30 × 53 cm)
Uffizi, Gallery; inv. 1890: no. 3359

These two pendant paintings of uncertain date were acquired in
1906. They probably once belonged to the same series as two other
fantastic landscapes in the Serristori collection in Florence.

At the end of the second decade of the seventeenth century, Giulio Mancini could draw an outline of the Roman milieu by classifying the painters working in the city at that time as belonging to different schools: the school of Caravaggio; the school of the Carracci and their pupils; the school of Giuseppe Cesari, known as the Cavalier d'Arpino; and, finally, the autonomous school, represented by a number of painters who followed their own tendencies regardless of the other three trends. Mancini's subdivisions faithfully reflected the situation in Rome in the first twenty years of the century, a period that opened with the completion of various projects, including the gallery vault in the Palazzo Farnese by Annibale Carracci (around 1601) and the decorative cycles in the transept of San Giovanni in Laterano (1599–1601) and in the Palazzo dei Conservatori, carried out under the direction of d'Arpino, who developed the characteristic style of official Roman painting at the beginning of the seventeenth century. Almost simultaneously, with his unveiling of the lateral paintings in the Contarelli chapel in San Luigi dei Francesi (1600), Caravaggio presented his revolutionary style to the Roman public. Although he did not have true and proper pupils in the usual sense, many native and foreign painters (Flemish, Dutch, French, and Spanish, in great numbers in Rome after 1610) were attracted to his art, both for its faithful imitation of nature and for its use of strong chiaroscuro, which suited modern subjects (scenes of entertainment and games) as well as it did biblical episodes. The Caravaggesque movement in the Roman environment had a massive development between the second and third decades of the seventeenth century, and was exhausted just as soon. The same sort of rise and fall touched the Cavalier d'Arpino's style, which reached a peak around 1620 and then progressively declined, although Cesari did not die until 1640. Annibale Carracci's pictorial language and that of the Emilian school profoundly influenced the course of painting in Rome during the seventeenth and eighteenth centuries. The great fortune of Guido Reni, Francesco Albani, and Domenichino in the course of their activity in the papal city between the beginning of the seventeenth century and the 1740s remained a durable example for that classical line, and that example continued to be the principal tendency of Roman painting. Also among the Emilians, a primary role in Rome was played by Giovanni Lanfranco, who, on the basis of his profound interpretations of the lessons of Correggio, precociously developed the baroque language.

In the course of the 1620s, within a variegated artistic situation that accommodated a number of quite different strains, two *Bacchanal*s by Titian—which were transferred from Ferrara to Rome in 1598 and from the Aldobrandini to the Ludovisi collection in 1621—had a great impact on the Roman ambience. The revelation of Venetian color and the expression of the sentiments that ran through such works breathed new life into Roman art and showed the way to a neo-Venetian style that would persist, to varying degrees and in varying manifestations, until at least the end of the 1680s. Pietro da Cortona and Nicolas Poussin were the first to benefit from the lesson of Titian. Protected and patronized by a circle of erudite collectors and "antiquarians" at the center of the court of Urban VIII Barberini (1624–1644), the two painters found their principal sources of inspiration in the study of works by Titian and of antiquity. After rather undistinguished beginnings, particularly in the 1620s, both men found their own way. Cortona, creator of a style that would be perpetuated up until the end of the century by the many artists who frequented his school, played a fundamental role in the panorama of great fresco decoration in Rome. In the first decades of the century, the genre had counted among its protagonists the Emilians Domenichino and Lanfranco, the one faithful to the lessons of his master Annibale Carracci, the other an important inventor of dynamic and illusionistic solutions of a neo-Correggesque matrix and the first in his field to move toward a definition of the baroque. It was in Pietro da Cortona, however, that the fresco found its greatest interpreter. In its experimentation with perennially altered schemes, in its hard-won interpretation of painted space liberated from the chains of architecture that delimited it, in its airiness, movement, and color, Cortona's work in villas and palaces (the Villa Sacchetti-Chigi in Castelfusano, the Palazzo Barberini, the Palazzo Pamphilj in the Piazza Navona, and the Palazzo del Quirinale) and in churches (Santa Maria in Vallicella) represented some of the most important expressions of seventeenth-century painting in Rome.

From the beginning of the 1630s, the delineation of two predominant artistic tendencies in Rome, the classical and the baroque—the former spearheaded by Andrea Sacchi, a pupil of Francesco Albani and heir to the Carracci tradition, the latter championed by Cortona—should not be understood exclusively in oppositional terms. (Consider, for example, the discussions conducted in these years at the Academy of San Luca on the problem of illustrating "historical" themes in painting.) Rather, it provided an opportunity for the exchange of ideas and the presence, within the oeuvre of several artists of the period, of the character of one or the other style (hence the form of expression defined by modern critics as baroque classicism, a constant of the Roman artistic environment between the last decades of the seventeenth century and the first decades of the eighteenth century). Among the pupils of Pietro da Cortona, the Pistoian Giacinto Gimignani and the Viterban Giovan Francesco Romanelli were strongly susceptible to the influence of classicizing trends, while others, such as Ciro Ferri, remained faithful disseminators of their master's pictorial language. For his part, Andrea Sacchi himself was influenced, from the beginning of his career, by the same Venetian painting that attracted Cortona, though the style he conveyed with warm, strong, chromatic tones always had the Emilian school as its point of reference. Sacchi's pupil Carlo Maratta would become the principal exponent of the classical tendency in Rome in the second half of the seventeenth century. In the field of decoration, his ceiling fresco for the

Palazzo Altieri (the *Allegory of Clemency,* of 1670–1676) became, because of the clarity of its composition, its moderated illusionism, and its lack of typical baroque dynamism, the prototype for a series of analogous works executed mostly by his pupils in the city's churches and palaces between the seventeenth and eighteenth centuries. In the same way, the compositional and chromatic solutions adopted for paintings of religious subject matter constituted a standard followed for a long time. Cortona died in 1669; the role of opposing the classicism for which Maratta stood was taken on by the Genoese Giovan Battista Gaulli, called Baciccio. His close attention to Gian Lorenzo Bernini and his repeated participation in Bernini's assignments made Baciccio the leader in painting who most closely shared the Bernini vision. This is characterized as much in the dynamism of drapery folds as in the expressiveness of his figures and his vision of the ecstasy of the divine. The decoration of the cupola and the vaults of the church of the Gesù (1672–1685) expressed through multiple illusionary devices the strength of the Jesuit message, the same message that in the immediately successive years would inspire Andrea Pozzo to produce decorations according to rigorous quadratic geometric principles in a second church of the same order, Sant' Ignazio.

In addition to history painting, briefly touched upon above, other genres flourished in the seventeenth century, including those that were considered minor, such as landscape painting and studies of daily life, architecture, and still-life. Contributing greatly to the development of such genres were foreign artists, always present in large numbers in Rome and organized into their own sort of union. In the field of landscape painting we need only state that here, too, Annibale Carracci and his school played an extremely important role in introducing a type of idealized representation of nature into the Roman ambience, which had been dominated, at the end of the previous century, by the Flemish, with their analytical rendering of the minute and their fascination with natural phenomena. Over the course of the century Rome would boast of the presence of exceptional landscape painters such as Claude Lorraine, Nicolas Poussin, Gaspard Dughet, and Salvator Rosa. Paintings of everyday life, for the most part depicting people of humble status, also became very popular, thanks to the presence in Rome of Northern artists such as Pieter Van Laer, on the scene from the 1630s. In the second half of the century the genre had another prominent champion in the Dane Eberhard Keihlau, known as Monsù Bernardo. It was the same for paintings of architecture, both real and fantastic (for which ancient Rome supplied more than a few inspirations); battle scenes also enjoyed a new vogue.

Baciccio and Maratta were both active up until the eighteenth century (they died in 1709 and 1713, respectively), but it was the latter's pupils—among them Giuseppe Chiari, Giuseppe Passeri, Luigi Garzi, and Niccolò Berrettoni—who dominated the Roman scene in the last two decades of the 1600s, causing even those who had been trained elsewhere to be influenced by Maratta's style.

While Gaulli's last important commission—for the church of Santi Apostoli (completed in 1707 by his pupil Giuseppe Odazzi)—decreed the end of the spatial illusionism that had been the basis of great seventeenth-century decoration, the baroque classicism that Maratta had developed and elaborated turned at the beginning of the new century toward a sweeter expression of sentiment and toward more delicate and deferential tones, which were adopted at first by painters of small works, both devotional and mythological. Also contributing to this development were the Venetian Francesco Trevisani, who precociously joined in the literary environment of Arcadia, and Sebastiano Conca, both of whom showed themselves to be susceptible to the new course of painting.

However, the legacy of the seventeenth century and the variety of influences represented by the diverse artistic personalities make it impossible to trace one unified strain of painting in Rome as the eighteenth century proceeded. Guiding personalities such as Pietro da Cortona and Carlo Maratta were now missing. Instead, the most important decorative cycles commissioned during this time by both the pope and private patrons—including the *Prophets* series in the nave of San Giovanni in Laterano, the *Stories of the Saints* in the nave of San Clemente, and the ceiling paintings in the De Carolis Palace—were awarded to whomever happened to be the painter of the moment; these projects bear witness to the multiplicity of artistic accents deriving from the same cultural language.

Among the personalities who distinguished themselves in the first half of the eighteenth century were Giuseppe Chiari, the most faithful disciple of Maratta's pictorial language, who was not, however, immune to the nascent rococo; Luigi Garzi, a prolific author of fresco decorations, altarpieces, and easel paintings; and Benedetto Luti, a harmonious interpreter of mythological fables fully attuned to the arcadian taste, which profited from his delicate chromatic sensibility. Francesco Trevisani moved beyond his Venetian training in the "mysterious" style to open up a path between the arcadian circle and the artistic environment, distinguishing himself through his porcelain surfaces and brilliant coloring. The style of Marco Benefial, with its reforming urge to "dramatic naturalism," practically resists description. Sebastiano Conca offered Rome real novelty in the first half of the eighteenth century; his legacy was taken up by his pupil and fellow countryman Corrado Giaquinto, who became one of the most important proponents of rococo tendencies. Placido Costanzi may be termed a protoneoclassicist, as may Maratta's last pupil, Agostino Masucci, in a phase that began in the 1740s. These years, which corresponded with the pontificate of Benedetto XIV, saw, on the one hand, the last decorations of Corrado Giaquinto before his departure for Spain and, on the other, the superseding trend of the rococo toward more monumental and classical forms.

In a Rome that was beginning to react to the archaeological discoveries at Herculaneum and Pompeii, and that always welcomed the presence of travelers (particularly English ones) and the interaction of foreign artists in the cultural life of the city, Pompeo Batoni was anointed the major portraitist of the day and the most fashionable interpreter of classicism in what was perhaps classicism's

international capital. In 1761 Anton Raphael Mengs painted, in the gallery vault of a villa owned by Cardinal Albani, friend and protector of Winckelmann, the same Parnassus that had become, thanks to this latter, a sort of manifestation of the principles of neoclassicism, later fostered by the presence on the Roman scene of such prominent personalities as Joseph Vien, Jacques-Louis David, and Gavin Hamilton. However, more than twenty years would pass from the date of the frescoes' execution to the time of the full affirmation of the neoclassical movement, during which period Rome would see a variety of artistic trends still growing out of the traditional roots of baroque classicism. An overview of this multiplicity of expressions may yet be glimpsed in the great decorative cycles of the Villa Albani and the Villa Borghese.

Elena Fumagalli

609
GIAN LORENZO BERNINI
Head of a Young Man
Oil on canvas, 24¹³⁄₁₆ × 24⅜ in. (63 × 62 cm)
Uffizi, Gallery; inv. 1890: no. 4882
A fragment of a larger work, this portrait was cut down and inserted obliquely into an eighteenth-century oval frame. On the back, an old inscription reads "Del Cav. Bernino." The painting can be dated to around 1625–1630.

610

ANDREA SACCHI

The Three Magdalens

Oil and tempera on canvas, 113 × 77⁹⁄₁₆ in. (287 × 197 cm)

Uffizi, Vasari Corridor; inv. 1890: no. 8764

This painting, which depicts SS. Mary Magdalen of Japan, the Penitent Mary Magdalen, and Mary Magdalen dei Pazzi, was commissioned by Urban VIII Barberini for the Florentine convent of Santa Maria Maddalena dei Pazzi, where two of the pope's sisters lived from 1628 to 1639.

611
VIVIANO CODAZZI
Architectural View with Two Arches
Oil on canvas, 28¾ × 38⁹⁄₁₆ in. (73 × 98 cm)
Pitti, Appartamenti Reali; inv. Oggetti d'Arte: no. 774

This painting is described, with no attribution given, in a Pitti Palace inventory from the
end of the seventeenth century. It dates from around 1647.

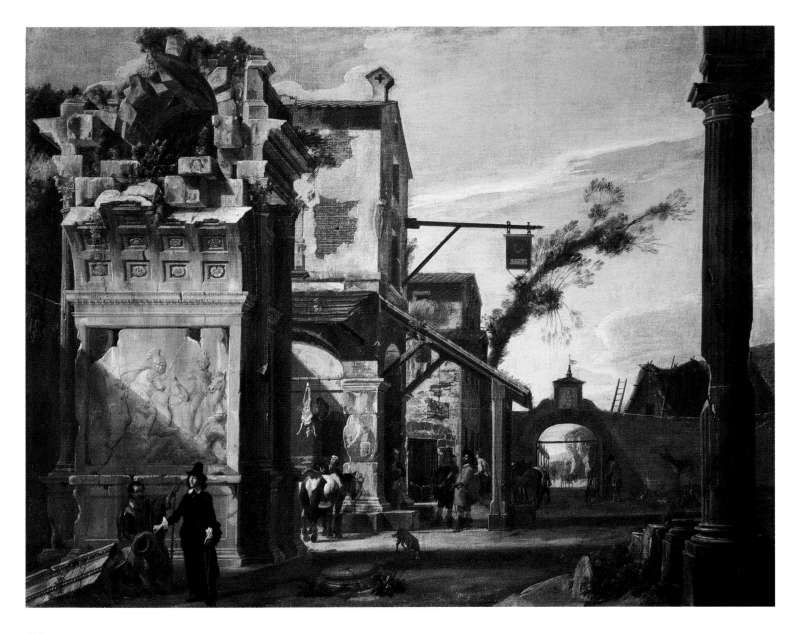

612
VIVIANO CODAZZI
Architectural View with an Inn
Oil on canvas, 28¾ × 38⁹⁄₁₆ in. (73 × 98 cm)
Pitti, Appartamenti Reali; inv. Oggetti d'Arte: no. 773
This and the previous work have been seen as examples of the fusion of two genres, the
veduta and the *bambocciata*.

613
MICHELANGELO CERQUOZZI
The Linen Carder
Oil on slate, 8¼ × 9⁹⁄₁₆ in. (21 × 23 cm)
Pitti, Palatine Gallery; inv. 1890: no. 1250
Of unknown provenance, this picture was recorded for the first time in the Uffizi in around 1905, together with its pendant, *Man with a Dog* (Palatine Gallery; inv. 1890: no. 1252). It has been dated to around 1630.

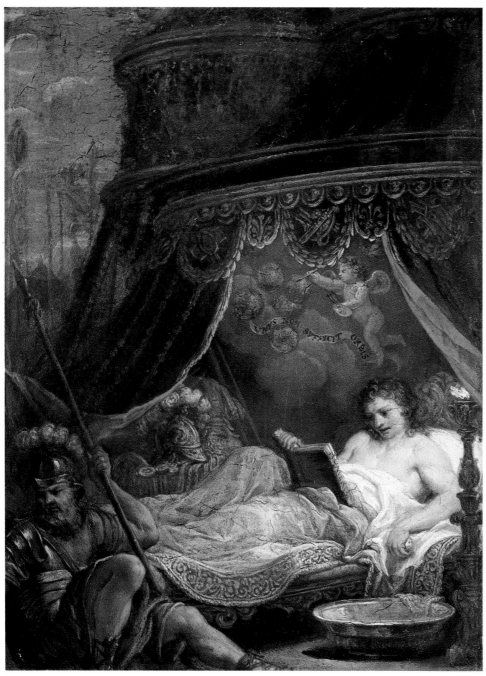

614
CIRO FERRI
Alexander Reading Homer
Oil on copper, 10¼ × 7½ in. (26 × 19 cm)
Inscription: UNUS NON SUFFICIT ORBIS
Uffizi, Vasari Corridor; inv. 1890: no. 1417
This picture probably dates from Ferri's stay in Florence in 1656–1659. The motto has been seen as an allusion to the government of Grand Duke Ferdinand II, who was assisted by his brothers Leopoldo, Giovancarlo, and Mattias.

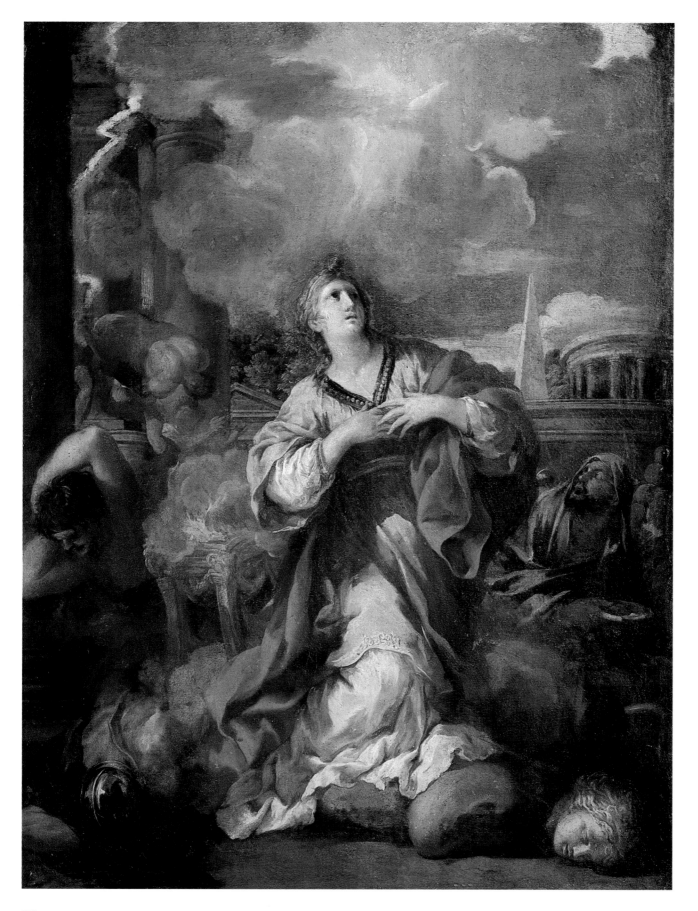

615

PIETRO DA CORTONA

St. Martina Refusing to Worship Idols

Oil on canvas, 39⅜ × 30¹¹/₁₆ in. (100 × 78 cm)

Pitti, Palatine Gallery; inv. 1912: no. 21

Briganti dates this to around 1656 and suggests that it may represent an early idea, later altered in both subject and composition, for Cortona's altarpiece for the church of San Francesco in Siena. Several copies and variations also exist.

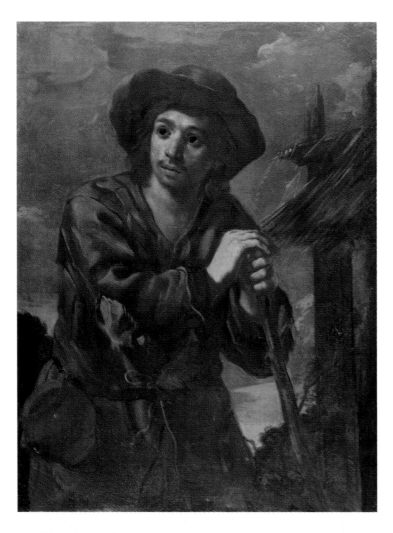

616
MONSÙ BERNARDO
Young Peasant Boy
Oil on canvas, 38³⁄₁₆ × 28¾ in. (97 × 73 cm)
Pitti, Depository; inv. San Marco e Cenacoli: no. 18

The provenance of this painting, and of its pendant, *Boy with a Dog* (inv. San Marco a Cenacoli: no. 22), is the Ferroni collection. The latter work has a barely legible inscription on the back, in which the name "Keihlau" is discernible.

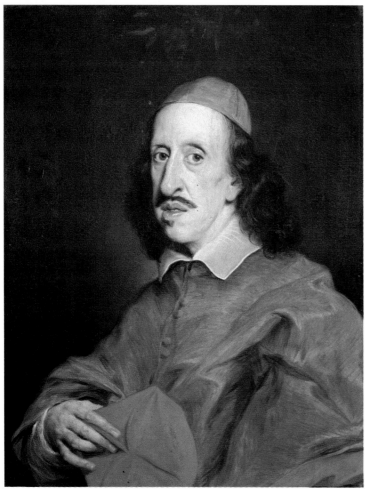

617
BACICCIO
Cardinal Leopoldo de' Medici
Oil on canvas, 28¹³⁄₁₆ × 23½ in. (73.2 × 59.6 cm)
Uffizi, Vasari Corridor; inv. 1890: no. 2194

This portrait, cited in the inventory of Cardinal Leopoldo de' Medici's property, can be dated to around 1672–1675. It is justly considered to be one of the greatest of Gaulli's portraits.

474

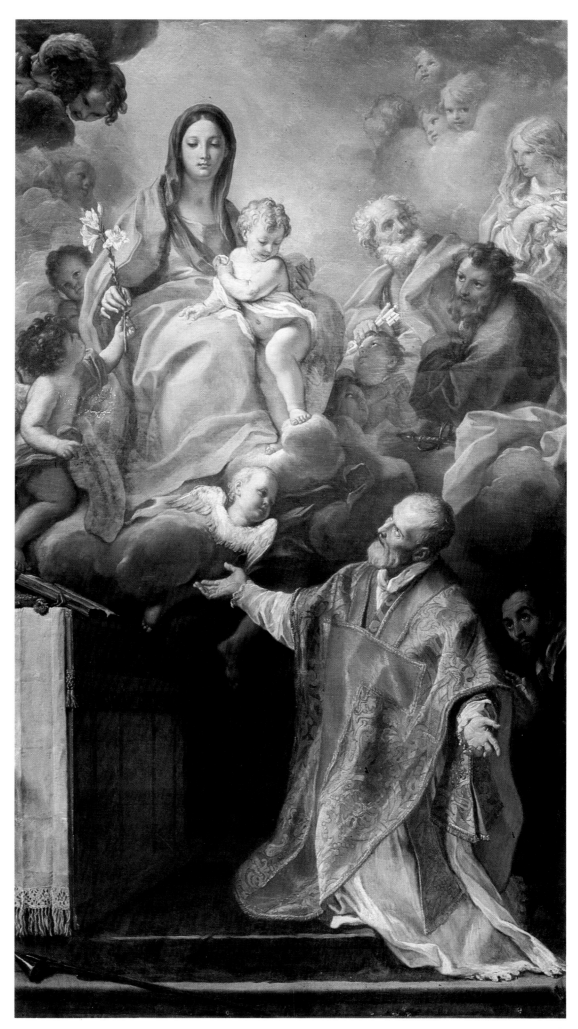

618

CARLO MARATTA

The Madonna Appearing to
St. Philip Neri

Oil on canvas, 77⁹⁄₁₆ × 135¹⁄₁₆
in. (197 × 343 cm)

Pitti, Palatine Gallery; inv.
1912: no. 71

Executed in 1672 for the
chapel of Senator Pietro Ner-
li in the church of San Gio-
vanni dei Fiorentini in
Rome, this canvas was ac-
quired in 1692 by Grand
Prince Ferdinand de' Me-
dici. It represents a restate-
ment, in a classico-baroque
idiom, of the subject's Re-
nesque iconographic tradi-
tion.

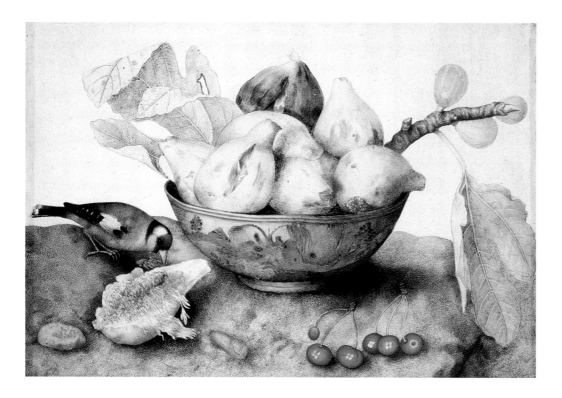

619
GIOVANNA GARZONI
Chinese Cup with Figs, Cherries, and Goldfinch
Tempera on paper, 10¼ × 14¾ in. (26 × 37.5 cm)
Pitti, Palatine Gallery; inv. 1890: no. 4750
This work came from the villa at Poggio Imperiale.

620
GIOVANNA GARZONI
Plate of Plums with Jasmine and Nuts
Tempera on parchment, 9¼ × 15³⁄₁₆ in. (23.5 × 38.5 cm)
Pitti, Palatine Gallery; inv. 1890: no. 4751

This miniature is one of twenty little paintings cited in the 1691 inventory of the villa at Poggio Imperiale, all executed for Ferdinand II de' Medici between the fifth and sixth decades of the seventeenth century.

621

MARIO DEI FIORI

Three Caper Flowers, a Carnation, a Bindweed, and a Tulip

Oil on canvas, 16⅛ × 13 in. (41 × 33 cm)

Pitti, Poggio Imperiale Depository; inv. 1860: no. 157

This work, attributed to Mario dei Fiori in 1988, very likely once belonged to Grand Duke Cosimo III.

622

GIOVANNI STANCHI

Garland of Flowers and Butterflies

Oil on canvas, 38⁹⁄₁₆ × 50 in. (98 × 127 cm)

Pitti, Depository; inv. Castello: no. 586

Datable to around 1670 through its similarity to a flower garland painted on a mirror in the Colonna Gallery in Rome, this work was catalogued among the works owned by Vittoria della Rovere at the end of 1691, along with another *Garland* once thought to be by Caffi (inv. Castello: no. 581).

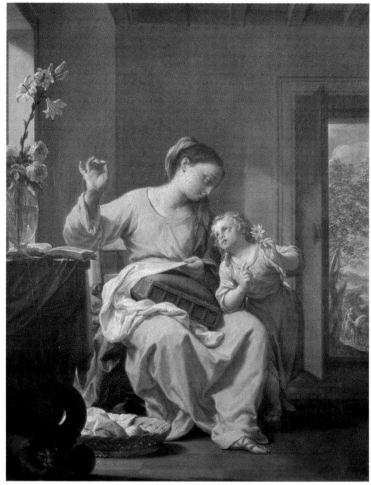

623 and 624
FRANCESCO TREVISANI
Joseph's Dream
Oil on copper, 15⅜ × 11¹³⁄₁₆ in. (39 × 30 cm)
Uffizi, Depository; inv. 1890: no. 1378
Madonna Sewing with Child
Oil on copper, 14¹⁵⁄₁₆ × 11¹³⁄₁₆ in. (38 × 30 cm)
Uffizi, Vasari Corridor; inv. 1890: no. 1362

These works on copper, of which other versions are known, come from Grand Prince Ferdinand de' Medici's collection. Dating from the last decade of the seventeenth century, they are typical of the small-scale painting to which Trevisani dedicated his last years.

625
MONSÙ LEANDRO (CHRISTIAN REDER)
After the Battle
Oil on canvas, 22¹⁄₁₆ × 64¹⁵⁄₁₆ in. (56 × 165 cm)
Pitti, Depository; inv. San Marco a Cenacoli: no. 28

Once generically attributed to the school of Borgognone, this painting was reassigned to Reder on stylistic grounds and because of the eighteenth-century inscription that appears on its pendant (*The Battle between Christians and Turks*, inv. San Marco a Cenacoli: no. 40). It was painted after 1710 and came to the Florentine galleries from the Ferroni collection.

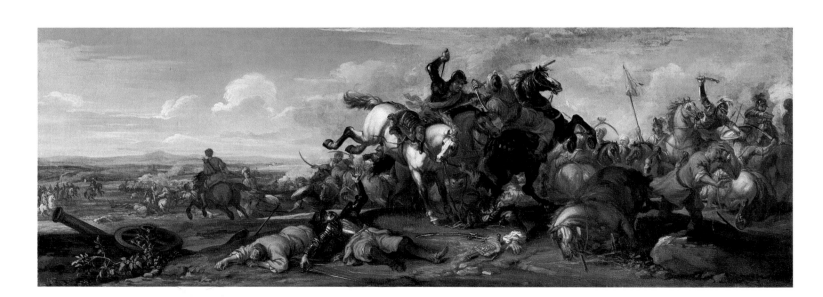

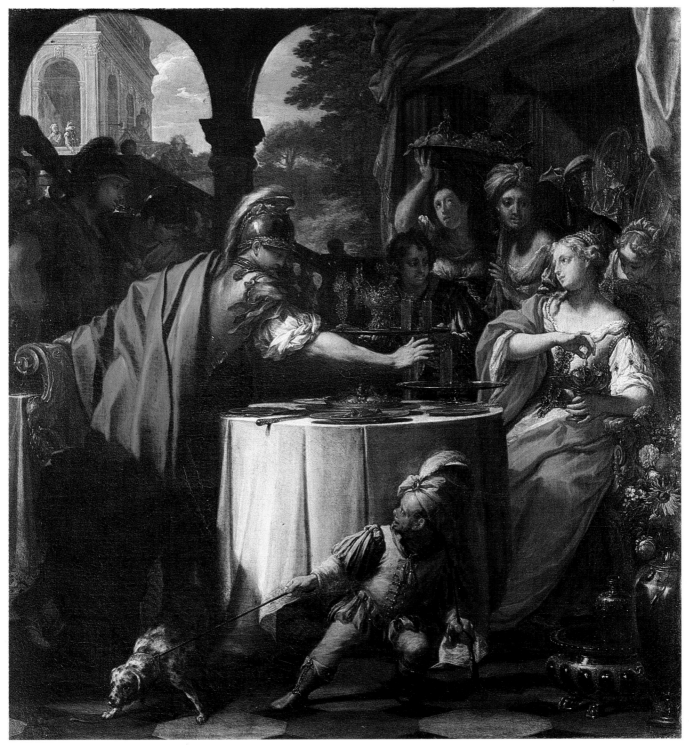

626

FRANCESCO TREVISANI

The Banquet of Mark Antony and Cleopatra

Oil on canvas, 25⁹⁄₁₆ × 24¹³⁄₁₆ in. (65 × 63 cm)

Initialed: F.T.

Uffizi, Vasari Corridor; inv. 1890: no. 6242

This work is a sketch for one of Trevisani's best-known paintings (now in the Spada Gallery in Rome), which was probably executed at the end of the first decade of the eighteenth century for Cardinal Fabrizio Spada Veralli. The sketch was sent by the artist to Ferdinand de' Medici.

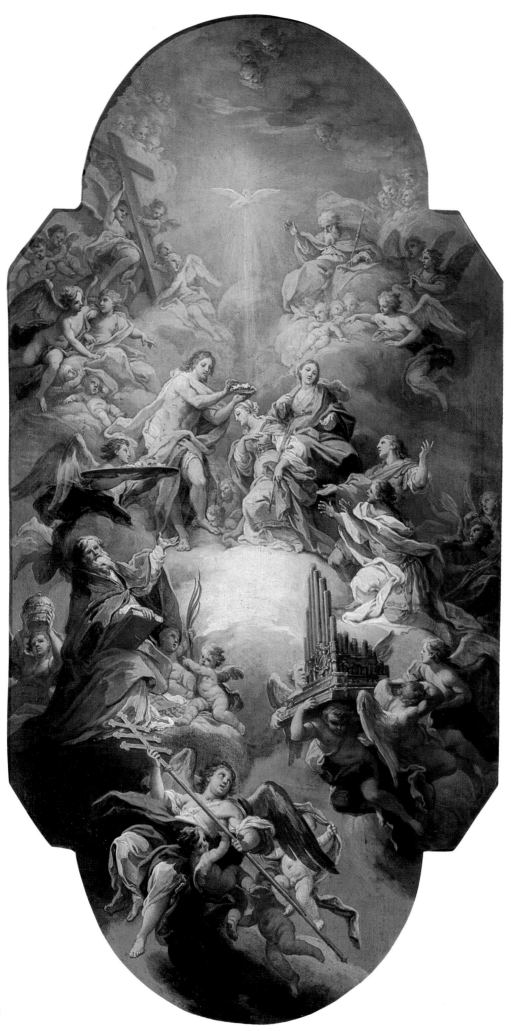

627
SEBASTIANO CONCA
The Glorification of St. Cecilia
Oil on canvas, 39⅜ × 19¹¹⁄₁₆ in. (100 × 50 cm)
Pitti, Appartamenti Reali; inv. Oggetti d'Arte: no. 807

This study for a fresco in the vault of the Roman church of Santa Cecilia was executed in 1724. It was given to the duke of Parma and came to the Pitti in 1868.

Opposite: 629
BENEDETTO LUTI
Portrait of a Young Girl
Pastel on paper, 13 × 10¼ in. (33 × 26 cm)
Pitti, Palatine Gallery; inv. 1890: no. 819

This work came to the Pitti from the Uffizi in 1928.

Opposite: 630
POMPEO GIROLAMO BATONI
Hercules at the Crossroads
Oil on canvas, 37⅝ × 28¹⁵⁄₁₆ in. (95.5 × 73.5 cm)
Initialed and dated: P.B. 1742
Pitti, Gallery of Modern Art; inv. 1890: no. 8547

Executed by Batoni for Marchese Gerini, this canvas was acquired in 1818 by Ferdinand III along with a number of other works from the same collection. Here the painter exhibits, particularly in its composition, considerable independence from schemes or models.

628
LUIGI GARZI
The Finding of Moses
Oil on canvas, 89¾ × 99⅝ in.
(228 × 253 cm)
Pitti, Depository; inv. 1890: no.
518

Perhaps executed for Grand Duchess Vittoria della Rovere, this canvas came from the villa at Poggio Imperiale and is mentioned in the 1692 inventory. The theme is one that was particularly dear to the artist, who painted multiple versions of it.

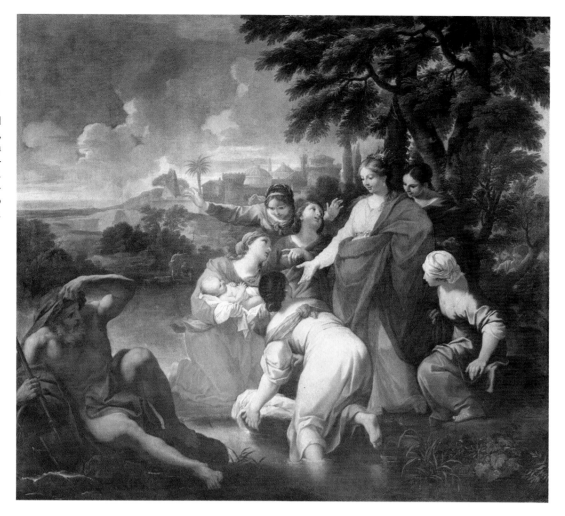

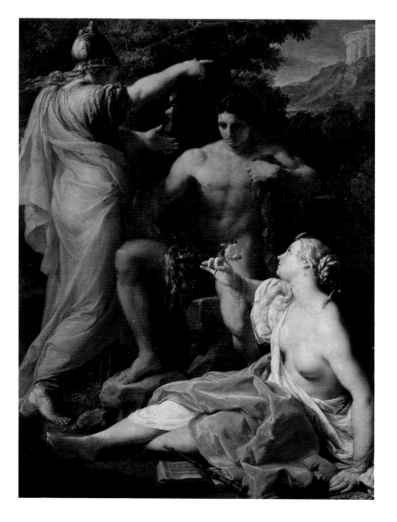

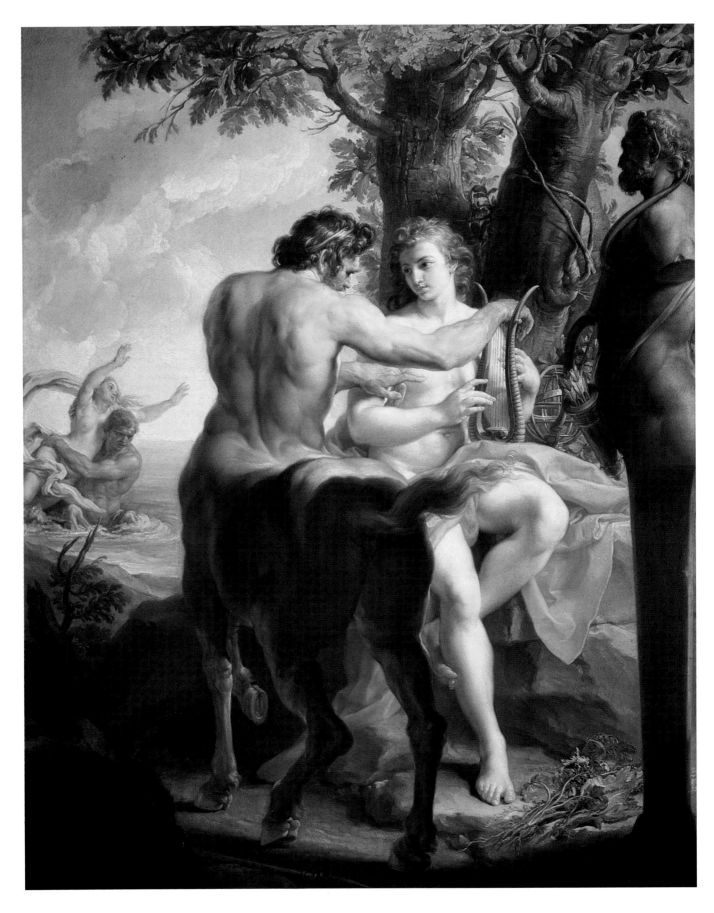

631

POMPEO GIROLAMO BATONI

Achilles and the Centaur Chiron

Oil on canvas, 62⅜ × 49¹³⁄₁₆ in. (158.5 × 126.5 cm)

Initialed and dated: P.B. P. 1746

Uffizi, Vasari Corridor; inv. 1890: no. 549

This work was painted for the Marchese Francesco Buonvisi of Lucca, one of Batoni's first
patrons. A descendant of Buonvisi's sold it to the grand-ducal galleries in 1838.

632

POMPEO GIROLAMO BATONI

Achilles at the Court of Lycomedes

Oil on canvas, 62⅜ × 49¹³⁄₁₆ in. (158.5 × 126.5 cm)

Uffizi, Vasari Corridor; inv. 1890: no. 544

This painting and its pendant (no. 631) betray Batoni's inclination toward the classico-rococo tendency that was then in vogue in artistic circles in Rome.

633
MARCELLO BACCIARELLI
Portrait of Stanislaus Augustus Poniatowski, King of Poland
Oil on canvas, 58⁷⁄₁₆ × 42⅛ in. (148.5 × 107 cm)
Pitti, Depository; inv. 1890: no. 2136
Acquired by the Florentine galleries in 1890 with an attribution to Angelica Kauffmann,
this work was later recognized as being by Bacciarelli. Judging from the age of the sitter, it
484 can be dated to around 1768.

Naples

In seventeenth-century Naples, patronage of the arts was given a considerable incentive by the presence of the Spanish viceroy who, allied with ecclesiastical patronage, allowed the splendid development of both indigenous and foreign painters. In the preceding century, Naples had opened up to the greatest national exponents of the arts and to those outside of Tuscano-Roman culture, from Vasari to Marco Pino, Pedro Roviale to Polidoro da Caravaggio, Teodoro d'Errico to Venceslao Cobergher. All were well versed in the varieties of refined European culture, which prevented local artists, or "the wits of late Neopolitan mannerism," from moving in an increasingly anachronistic provincial ambience.

Francesco Curia and Gerolamo Imparato, Ippolito Borghese and Fabrizio Santafede developed their own original styles, which were influenced by the Florentine mannerism of Passignano and Cigoli and by the Roman style personified by the Cavalier d'Arpino. Belisario Corenzio, who is often considered an anachronistic personality in all senses of the word, participated with his inexhaustible narrative art both as spectator of and, in a way, actor in the new naturalistic atmosphere. His career ended late, in 1646, after the death of many other protagonists; he received many of the most prestigious royal and ecclesiastical commissions, and it was under his tutelage that many of the greatest protagonists of the Neapolitan school emerged. The artistic panorama in Naples was already lively and varied, even before the arrival of Caravaggio, whom many artists knew from his celebrated paintings in San Luigi dei Francesi and Santa Maria del Popolo. Today it is known that Corenzio made drawings of the works of Roman Caravaggisti and of those of the Tuscan Gregorio Pagani.

At the beginning of the seventeenth century, the art of Caravaggio had a revolutionary impact that proved capable of changing the destiny of Neapolitan painting. In his two visits to Naples, in 1606–1607 and 1609–1610, the great Lombard left an indelible mark on the city, of which the only remaining traces are the *Works of the Misericordia* for the church of the Pio Monte and the *Flagellation* for the church of San Domenico Maggiore. Although the local artistic climate was full of genius and trends, the presence of Caravaggio and his works was to constitute the central locus at which younger and more vigorous artists learned about art, resulting in the formation of a school characterized by a coherent and unified ideal of naturalistic truth, articulated through plasticity and revealed by light. And indeed the culture at the root of this environment, long accustomed to absorbing the most varied of influences and living and commingling with them, made Caravaggism an active participant; by aligning itself with the new, Caravaggism opened itself up to the possibility of taking on local color.

If no Neapolitan artist was entirely a member of the Caravaggisti, nor did any completely resist the Caravaggesque; then there were those who, "thunderstruck" by the Lombard master's work, copied over salient examples, often in the most literal way.

Battistello Caracciolo was the most passionate and rigorous of the Caravaggesque painters, as well as the first: his adherence to the style was immediate, as can be seen in his *Immaculate Conception* for the church of Santa Maria della Stella in Naples, contemporaneous with Caravaggio's *Works of the Misericordia* of 1607. Eight years later, his *Liberation of St. Peter* in the church of Pio Monte displayed a tempered and elegant Caravaggism that was further refined in the *Washing of the Feet* in the choir of the church of San Martino, a manifestation of a cultivated and ancient naturalistic civilization. It is difficult to associate this picture with Guido Reni's delicate *Adoration of the Magi* painted in the same year, or Ribera's blazing *Communion of the Apostles* of thirty years later. The coupling of Caravaggio's manneristic culture with the later Tuscano-Roman style, along with experience in drawing and in fresco, constitutes the fundamental difference between Battistello and his mentor; the former was in favor of a slower, more peaceful, more profound development of his chosen themes. Battistello Caracciolo, Carlo Sellitto—who died prematurely in 1614—and Filippo Vitale all fit into the oldest of Caravaggesque traditions; after them, Neapolitan painting progressively lost its emphasis on figures and began to favor solutions of dialogue instead. Jusepe de Ribera took charge of the situation in Naples from 1616; after doing away with Caravaggesque naturalism, he proposed a rarer and more highly colored version of reality: the pomegranate splits and the seeds spill out, vividly filling the entire picture plane with the "decaying quibbles," in Longhi's words, of the "before" and the dilated pictoricism of the "after." Ribera's Naples workshop was opened to Domenico Gargiuolo, Aniello Falcone, and Andrea De Lione; Luca Giordano made a brief appearance there as well. When Battistello and his pupils, and along with them Andrea Vaccaro, Francesco Fracanzano, Paolo Finiglia, and Massino Stanzione came to fresco the chapels in the Certosa di San Martino, it would be Ribera's *Deposition* in the Tesoro chapel that would serve to guide Stanzione in the ornamental panel for the transom of the church. Stanzione, destined to become the new voice of Ribera's school, was capable of great outbursts of pathos, but his spirit was willing and benign. Stanzione, an elegant painter of postures and nuances, in small-format works as well as in larger ones, became a protagonist who interwove relations with artists from the ambience of reformed Roman Caravaggism, from Simon Vouet to Artemisia Gentileschi. The number of artists coming to Naples to take on religious commissions can scarcely be counted: Antiveduto Gramatica and Finsonius, Domenichino and Guido Reni, Lanfranco and Simon Vouet, Artemisia and Stomer, Hendrick van Somer and Monrealese, Castiglione, and others who stayed for longer or shorter periods of time. They would strongly impose themselves on the Neapolitan environment, either negating, or developing variations on, the initial Caravaggesque thesis.

One rather distorted and strained branch of naturalism is that of the Bergamesque painter Giovan Battista

Spinelli, who was in Naples between 1651 and 1652, but there are other salient episodes that enlarge the local panorama and record its resurgence: Giovanni Do and Francesco Guarino, Bartolomeo Bassante and the Master of the Annunciation, Francesco Fracanzano and Nunzio Rossi, who were now resolute in sustaining—perhaps also under the direct influence of Velázquez—iconographic themes that had instances of the poetics of daily life. Onofrio Palumbo and Agostino Beltrano, Pacecco de Rosa and Dianella de Rosa, Giuseppe Marullo and Carlo Rosa were all interpreters of these demands for reality who used stylistic and color variations.

Andrea Vaccaro is an interesting figure, contradictory and little studied, who occupied a position between the purism of Francesco de Maria and the gracious and classical naturalism evident in the church of San Martino or, even better, in the two mythological pendants in the Royal Palace. In Apulia, meanwhile, Giovanni Andrea Coppola was demonstrating a brilliant and lively dynamic in updating the traditional altarpieces for the cathedrals of Gallipoli and Lucca. From 1633 to 1646, Giovanni Lanfranco created grand baroque decorations through his work in numerous churches, including the cupola of the Duomo, that of Santi Apostoli, and the Certosa ceiling. He also modernized, with slow but decisive actions, local personalities, who from time immemorial had been used to sharing commissions with foreign painters whose cultures they quickly absorbed in order to keep up with the times.

Bernardo Cavallino was another kind of figure entirely, cultivated and learned, with a predilection for the stories of Tasso and religious themes that had a mystical, almost mournful elegance of attitude—as in Antonio de Bellis—whose natural origins were smoothed by polished invention. If Stanzione displays an unbridled and brilliant colorism, Cavallino's tender impasto dissolves, as does that of Francesco Fracanzano, leaning toward Ribera's style, with the forms fading through veils and damask.

The year 1656 brought the plague, which claimed the lives of many of the protagonists of great seventeenth-century art; but the same year also provided a useful understanding of the new artistic demands of the day.

Perhaps a decade earlier, Cavallino's *Singer* had launched modern painting, but in fact it was also the result of an extremely lyrical decantation that attempted to find original solutions different from those that were already obsolete. The new way would be that of Luca Giordano, who, working independently by the middle of the 1650s, had been educated among Ribera's circle; he drew inspiration as well from Venetian classicism and the Roman ceilings of Andrea Pozzo and Pietro da Cortona. Meanwhile, Angelo Solimena, the father of Francesco, sought to revive Caravaggism in his own altarpieces. In 1660 Mattia Preti, who had been in Naples since 1653, departed for Rome and then Malta, leaving behind his beautiful ceiling painting for the church of San Pietro a Maiella, *Stories from the Life of SS. Peter Celestino and Catherine*, which drew liberally on the work of Guercino and Lanfranco.

These were the main avenues that the masters traveled, but as is often the case, the side streets had much to offer as well. Filippo d'Angeli, for instance, who delighted in small and bizarre compositions, was a landscape artist of rare inventiveness, the head of a group of local artists who would influence the microcosms of Paul Brill, who was called from Rome to Naples in 1602. Most prominent and greatest of them all was Salvator Rosa, a deserter from Naples after the 1640s, who worked between Rome and Florence on his imaginative and romantic landscapes, at once literary and necromantic. At the same time Domenico Gargiuolo was frescoing in San Martino the life of the Carthusians *en plein air,* or rendering on canvas sacred scenes—in strongly poetic fashion, à la Aniello Falcone—and chronicles of his own day. In his *reportages,* the triplicate figures have a nervous quality to them, not divine or possessed but rather human and mournful. The same sense of crowdedness and of enclosure in clear geometry can be seen in the work of Viviano Codazzi, another Bergamese artist who was in Naples from 1634 to around 1649. Scipione Compagno and Johann Heinrich Schönfeld were among Gargiuolo's followers, but the scenic tradition would be maintained by François de Nomé, Didier Barra, Thomas Wyck, Johannes Lingelbach, and Jan Asselijn.

In the field of Neapolitan landscape painting, miraculously revived, it was foreign artists of the past and present who had always been the most attentive and the most affected practitioners. This was a phenomenon that continued well into the nineteenth century.

Another genre destined to give glory and character to the seventeenth century in Naples and to accord with analogous and contemporary research, was that of still-life painting, whose chief protagonist was Paolo Porpora, a painter who produced flowers, fruit, and animals in much the same way as a member of the Caravaggisti would have done. Flourishing between the 1620s and 1630s were Giacomo Recco and Luca Forte, two representatives of the "early years of Neapolitan still-life." The genre, fashionable at first, would later become conventional and repetitive, a study in how light would fall on the iridescent scales of fish or on shining copper pots beautifully laid out on a table. Giuseppe Recco and Giovan Battista Ruoppolo were the champions of this sort of painting. Like landscape, still-life had a long and qualitatively differentiated history; the balance swung not only between leaders and followers but also between foreigners—in particular Flemings—and the local artists, who at one time preferred exuberance in naturalistic and decorative presentation. Despite the discontinuity between popular and aristocratic tendencies, the development of this genre was never more fertile, and it opened the door to the new century.

The eighteenth century, in fact, began with a brilliant ending, when Luca Giordano, on his return from Spain, executed the frescoes in the vault of the Tesoro chapel in San Martino. Giordano died in 1704, but those frescoes would point the way to the century to come, predicting motifs that would appear only gradually in the work of local artistic personalities up to the middle of the century and beyond. If Giordano's adherents were on one side of the debate, however, on the other were the followers of Francesco Solimena who was, up until his death in 1757,

the absolute protagonist of Neapolitan painting. Unlike Giordano, Solimena, after an early period of fresh and happy Giordanesque flourishes, retreated into the neo-Caravaggesque shadows, creating as an homage to the power of the Carracci and Lanfranco a solemn and dense kind of painting that was reminiscent of Preti's work, with a great deal of presence. In 1738, his pupil Francesco De Mura painted on a ceiling in the Royal Palace the *Virtues of Charles and Maria Amalia of Saxony* on the occasion of their marriage, twenty years before Charles of Bourbon left Naples to ascend the throne of Spain.

Great patronage called De Matteis to Paris, De Mura to Turin, Giacomo del Po, Nicola Maria Rossi and Solimena to Vienna, and Corrado Giaquinto (in the ten-year-old footsteps of Giordano) to Spain to become director of the Academy of San Fernando between 1652 and 1662. European success came to eighteenth-century Naples in the beautiful and fecund works that the "grandchildren of Giordano and Solimena" (De Dominici) were creating. It was sometimes difficult to discern which elements were taken from which of the masters they had emulated, as what was common to all was a pleasing and elegant decoration. Mythology and symbolism embellished the royal residences in Naples and Capodimonte, Caserta, and Portici, as well as patrician homes, the villas of Vesuvius, and the country houses of San Leucio and Carditello, until the idea initiated by Luigi Vanvitelli of using only foreign artists for the decoration of Caserta was abandoned. The Cistercians and other churches in the area bought large and small paintings, each according to its own taste. Every local artist had his place, including Domenico Antonio Vaccaro, Giuseppe Bonito, Jacopo Cestaro, Francesco Celebrano, Felice Fischetti, Giancinto Diano, Gaetano Starace, Pietro Bardellino, Filippo Falciatore, Mozzillo, and Lorenzo De Caro. The royal apotheoses were assigned to Pietro Bardellino in the Palazzo degli Studi and Domenico Mondo in the Palazzo di Caserta: they depicted figures among wreaths and garlands, putti and clouds, in a free navigation within space without time, coloring increasingly soft and gentle.

Landscape painting was meanwhile dominated by the optical and lyrical views of Gaspard van Wittel, who was summoned to Naples by the duke of Medinacoeli in 1700; by then van Wittel had already been in Italy for almost forty years and was the father of Luigi, who was baptized in that same year with the duke as his godfather. His topographical style would see its most illustrious descendant two centuries later, in Anton Sminck Pitloo. Gaetano Martoriello and Michele Pagano were now working, as were Leonardo Coccorante and Carlo Bonavia, with a preromantic landscape filled with ruins. The direct and most famous disciple of van Wittel was Antonio Joli, who also painted for the king of Spain and, from 1772 to 1777, provided the scenery for the theater of San Carlo in Naples. Indeed, scenery and costumes, with the added element of chronicle—Joli was to record Charles of Bourbon's departure from Naples and then his arrival in Spain—became fully integrated into landscape painting, even as still-life continued to thrive. The latter was now, however, invested with symbolism and recast in a decora-tive and ornamental key; it was no longer the pure representation of truth proposed by Giacomo Nani and Baldassare de Caro, or the monodic and almost decadently elegant vision of Andrea Belvedere. Isolated cases of naturalistic revival, in both the sacred and the profane, may nonetheless be found in the work of Gaspare Traversi, active in both Rome and Piacenza, who adopted the more affable aspects of the genre scenes, and in the portraits painted by Giuseppe Bonito and Carlo Amalfi. In Naples the manufacture of porcelain and of tapestries also encouraged other decorative efforts, as with the preparatory cartoons for the Gobelin series of *Don Quixote*, the *Elements*, and the fable of *Cupid and Psyche*.

The phenomenon of the "grand tour" raised landscape painting to its acme, making use of such natural phenomena as the eruption of Vesuvius, clefts and caverns, fumaroles and solfataras to create phantasmagoric visions that were both choreographic and sublime. The foreign influx was the sine qua non; from the last echoes of van Wittel to Wright of Derby, from Thomas Jones to Richard Wilson, from Horace Vernet to Volaire, they blossomed in gouache. The arrival of Goethe renewed the German faction in Naples: he found Philipp Hackert at the Neapolitan court and brought Tischbein and Kniep with him, but even before that, Füger, Thorwaldsen, Mengs, and Kauffmann had been working within the circle of the beautiful Lady Hamilton. Goethe's friend Tischbein remained in Naples and in 1789 shared the directorship of the Accademia di Belle Arti with Domenico Mondo. The century closed with a statutory and rigorous call to order and a return, in forms and themes, to the classical world. In looking at the local efforts, in the last decades of the century, of such artists as Giuseppe Cammarano and Salvatore Giusti, we must speak of the eighteenth century *in* Naples rather than *of* Naples. Kant's remarks of 1790 ring true in this case: "Drawing alone, even contour without any shadow, is enough to truly represent an object. Color is superfluous."

Marina Causa Picone

634
FILIPPO NAPOLETANO
Two Shells
Oil on canvas, 15⅜ × 22¹⁄₁₆ in. (39 × 56 cm)
Pitti, Depository; inv. 1890: no. 6580
This canvas was consigned to the Medici Guardaroba on July 16, 1618. An example of the painter's interest in the representation of nature, it may in fact be a reference to Dutch still-life painting.

635
FILIPPO NAPOLETANO
The Temptation of St. Anthony
Oil on pietra paesina, 12⅝ × 12³⁄₁₆ in. (32 × 31 cm)
Pitti, Palatine Gallery; inv. 1890: no. 5567
This is one of a group of works executed in Florence for Cosimo II de' Medici.

636

FILIPPO NAPOLETANO

Cooler

Oil on canvas, 14⁹⁄₁₆ × 18⅛ in. (37 × 46 cm)

Pitti, Depository; inv. 1890: no. 4804

Recorded in inventories of the Medici Guardaroba, this painting was executed between 1617 and 1621, during the painter's residence at the Florentine court.

637

FILIPPO NAPOLETANO

The Alchemist

Oil on canvas, 36¼ × 53⅛ in. (92 × 135 cm)

Pitti, Palatine Gallery, Director's office; inv. Poggio Imperiale: no. 1237

This picture was painted for Cosimo II de' Medici during the artist's stay in Florence.

638
GIOVANNI BATTISTA CARACCIOLO
Salome with the Head of John the Baptist
Oil on canvas, 52 × 61⁷⁄₁₆ in. (132 × 156 cm)
Uffizi, Vasari Corridor; inv. Depository: no. 30

This work dates from Caracciolo's period in Florence, around 1618. It betrays a knowledge
of Giovanni Bilivert and of Artemisia Gentileschi, and contains Roman echoes of Orazio
Gentileschi.

639

GIOVANNI BATTISTA CARACCIOLO

The Rest on the Flight into Egypt

Oil on canvas, 80¹¹⁄₁₆ × 73¼ in. (205 × 186 cm)

Pitti, Palatine Gallery; inv. Oggetti d'Arte: no. 420

This canvas, which was executed in 1618 for the grand duchess's apartments, is cited repeatedly in Pitti Palace inventories. Only recently restored to Caracciolo, it is the only surviving work that can be securely attributed to the Neapolitan artist's sojourn in Florence.

640
BERNARDO CAVALLINO
Esther before Ahasuerus
Oil on canvas, 29¹⁵⁄₁₆ × 40³⁄₁₆ in. (76 × 102 cm)
Uffizi, Vasari Corridor; inv. 1890: no. 6387

The provenance of this work is the Agostino Conte collection in Naples; it was acquired by Ettore Sestieri in 1917 and thence came to the Uffizi. Stylistically, it seems to date from after 1645, the date affixed to the Capodimonte *St. Cecilia*.

641
GIOVANNI BATTISTA SPINELLI
David Soothing Saul's Anguish with His Harp
Oil on canvas, 99⅝ × 121¹¹⁄₁₆ in. (253 × 309 cm)
Uffizi, Vasari Corridor; inv. 1890: no. 9467

This painting came from a villa near Florence; it was acquired by the Uffizi in 1970. The taste
for costume and the vaguely profane tone recall Massimo Stanzione's works from the end of
the 1630s.

642

SALVATOR ROSA

Seascape with Towers

Oil on canvas, 40³⁄₁₆ × 50 in. (102 × 127 cm)

Pitti, Palatine Gallery; inv. 1912: no. 312

This canvas, once in the Ricciardi household, was acquired from Grand Duke Ferdinand
III by the painter Acciai in 1820. Rosa painted it for Giancarlo de' Medici at the beginning
of his stay in Florence, around 1640.

643
SALVATOR ROSA
Seascape at Sunset
Oil on canvas, 91¾ × 157⅟₁₆ in. (233 × 399 cm)
Signed: ROSA
Pitti, Palatine Gallery; inv. 1912: no. 4
This painting is mentioned by Baldinucci as being among those works executed for Cardinal Giancarlo de' Medici. The influence of Claude Lorrain is evident.

644
SALVATOR ROSA
The Lie
Oil on canvas, 53⁹⁄₁₆ × 37¹³⁄₁₆ in. (136 × 96 cm)
Pitti, Palatine Gallery; inv. 1912: no. 2
This example of Rosa's clearer and more classical style was executed for Giancarlo de' Medici and is datable to around 1650, or a little before.

645
SALVATOR ROSA
The Ruined Bridge
Oil on canvas, 77³⁄₁₆ × 50 in. (196 × 127 cm)
Pitti, Palatine Gallery; inv. 1912: no. 306
As the coat of arms on the bridge indicates, this picture was executed for Giancarlo de' Medici. It dates from the first months of the painter's visit to Florence, around 1640.

Opposite: 646
SALVATOR ROSA
The Philosophers' Wood
Oil on canvas, 58¹¹⁄₁₆ × 87¹³⁄₁₆ in.
(149 × 223 cm)
Signed: ROSA
Pitti, Palatine Gallery; inv. 1912: no. 470
The provenance of this work is the collection of the marchese Gerini, whose descendants sold it to Ferdinand III in 1818. It was painted in around 1645.

647
SALVATOR ROSA
Battle between Christians and Turks
Oil on canvas, 92⅛ × 137¹³⁄₁₆ in.
(234 × 350 cm)
Signed: SARO
Pitti, Palatine Gallery; inv. 1912: no. 133
Dating from the beginning of Rosa's Florentine period, this painting was among the most celebrated and imitated of battle works for more than two centuries. It was brought to Paris in 1799.

648

GIACOMO RECCO

Vase with Crown Imperial, Tulips, and Anemones

Oil on canvas, 26¾ × 20¹⁄₁₆ in. (68 × 51 cm)

Pitti, Depository; inv. Poggio a Caiano: no. 240

Like the paintings of Giuseppe Recco, this work probably once belonged to Grand Prince
Ferdinand de' Medici. It dates from 1626.

649
MATTIA PRETI
Vanity
Oil on canvas, 36¹³⁄₁₆ × 25⅝ in. (93.5 × 65 cm)
Uffizi, Gallery; inv. 1890: no. 9283

This canvas came to the Uffizi from a private collection in 1951. It was painted between
1650 and 1670, in the period of the artist's most intense activity in Naples.

650

LUCA GIORDANO

The Triumph of Galatea, with Acis Transformed into a Spring

Oil on canvas, 103⅛ × 120¹/₁₆ in. (262 × 305 cm)

Pitti, Palatine Gallery; inv. 1890: no. 2218

The provenance of this painting is the Sanminiati collection in Florence, which in 1677 also possessed two other paintings by the artist. In the last century it passed to the Pazzi family, and in 1865 Marchesa Eleonora Torrigiani Pazzi left it on deposit at the Uffizi. It was acquired for the Florentine galleries in 1897.

651
LUCA GIORDANO
Rape of Deianira
Oil on canvas, 20⅑₆ × 26 in.
(51 × 66 cm)
Uffizi, Depository; inv.
1890: no. 1364
This sketch dates from
around 1682 and once be-
longed to Grand Prince
Ferdinand de' Medici's col-
lection. There is a replica of
it at Burghley House.

652
CORRADO GIAQUINTO
Birth of the Virgin
Oil on canvas, 28⅜ × 40⁹⁄₁₆
in. (72 × 103 cm)
Uffizi, Vasari Corridor; inv.
1890: no. 9166
This is thought to be a pre-
paratory sketch for an altar-
piece painted for the Duomo
in Pisa in 1753, just before
the artist left for the Spanish
court. It came to the Uffizi in
1930.

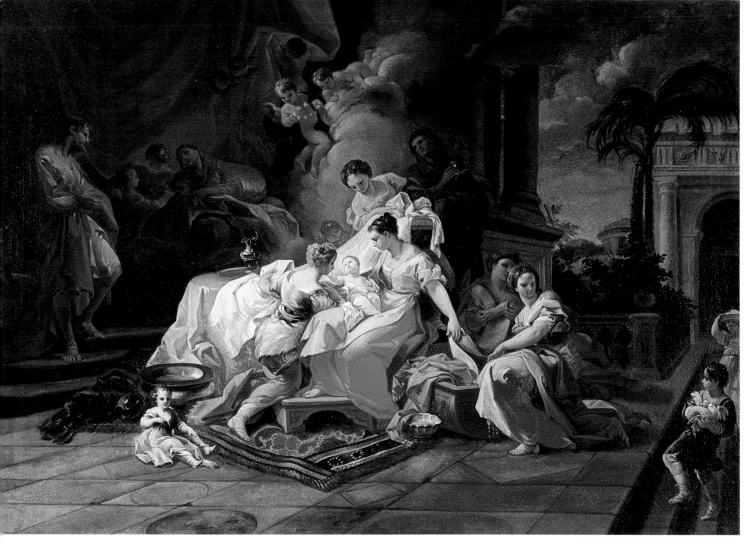

501

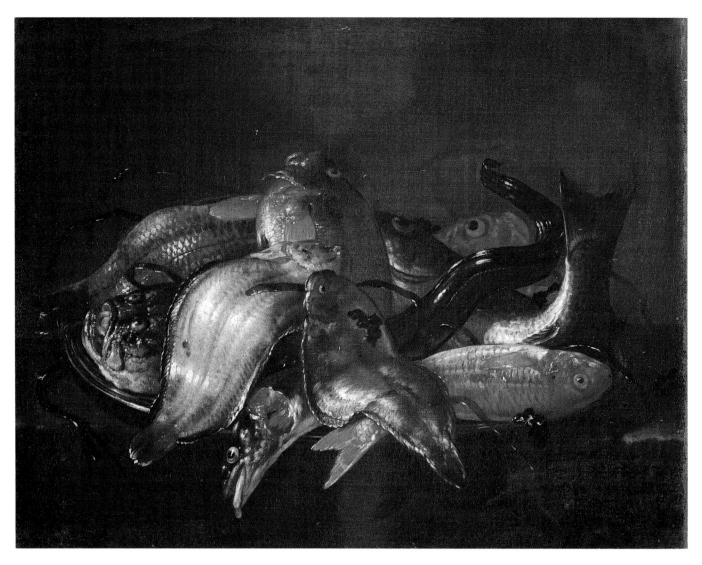

653
GIUSEPPE RECCO
Fish
Oil on canvas, 20¹⁄₁₆ × 25 in. (51 × 63.5 cm)
Signed: GIOS. RECCO
Uffizi, Vasari Corridor; inv. 1890: no. 7119
This painting, formerly in Grand Prince Ferdinand de' Medici's collection at Poggio a Caiano, can be placed within the later phase of the artist's activity, around 1670–1680.

Opposite: 654
ANDREA BELVEDERE
Composition with Ducks, Cascade of Flowers on Water, and Engraved Vase with Flowers and Thistle Leaves
Oil on canvas, 49⅝ × 61 in. (126 × 155 cm)
Signed: ANDREA BELVEDERE
Pitti, Appartamenti Reali; inv. Oggetti d'Arte: no. 777
This painting once belonged to Grand Prince Ferdinand de' Medici; it was produced sometime before the artist's departure for Spain in 1694.

655
GASPARE LOPEZ
Tulips
Oil on canvas, 22¹⁄₁₆ × 27⅝ in. (56 × 70.2 cm)
Pitti, Depositi; inv. Castello: no. 278
This canvas came from the collection of Anna Maria Luisa de' Medici.

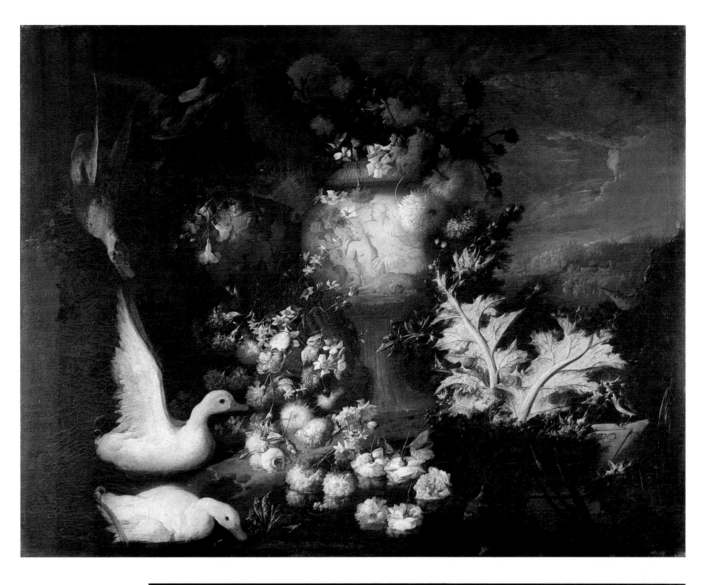

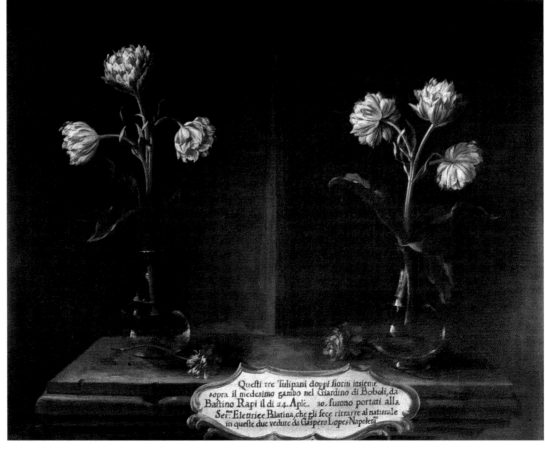

Quefti tre Tulipani doppi fioriti infieme
fopra il medesimo gambo nel Giardino di Boboli, da
Baftino Rapi il di 24.Aple. 30. furono portati alla
Serma Elettrice Palatina, che gli fece ritrarre al naturale
in quefte due vedute da Gaspero Lopes Napoleti

503

Painting in Europe in the Seventeenth and Eighteenth Centuries

Flanders

To speak of seventeenth-century painting in the southern Netherlands (modern-day Belgium) is to speak of Pieter Paul Rubens: the painter is a sort of national hero, in much the same way that Rembrandt is for the Dutch. The recognition of his importance as an artist is underscored by the fact that works by him are owned by all the great European and American collections and were sought after by all the great collectors of the past. Certainly the Medici did not escape this "obligation," for dynastic reasons as well as those of admiration. The cycle dedicated to Maria de' Medici in the Luxembourg Palace in Paris can be singled out as the central event in Rubens's fortunes in Florence, as it was through this work that Cosimo III came to own two paintings by him. These were part of the second great cycle that the artist had to execute for Maria, this time revolving around her husband, Henry IV of France. The two masterly paintings in the Uffizi, *Henry IV at the Battle of Ivry* and *The Triumphal Entrance of Henry IV into Paris* (of around 1630), were acquired by Cosimo III de' Medici for the Florentine collection in 1686 and joined the already substantial nucleus of paintings there by the artist.

Rubens's earliest work in Florence is a fine *Portrait of a Knight* (in the Pitti) that has been variously attributed in the past but is today recognizable as being by the artist for its pictorial quality, by far superior to that of Frans Pourbus the Younger. A more typical example of the artist's power is the *Four Philosophers*, of around 1615, famous for its inclusion of a self-portrait, which is not much earlier than the one on panel owned by the Uffizi. The painting is a masterpiece of lively chromatic harmony dominated by red, with the depictions of the figures, the still-life of books, and the oriental carpet rendered with incredible ease and transparency. Rubens's well-known abilities in portraiture are further proven in a portrait of his first wife, Isabella Brant (c. 1625), of great psychological acuity and unparalleled pictorial mastery. The same sentiments are reflected in the "Madonna of the Basket" of around 1615, in which elements of sixteenth-century Italian painting are combined with a pure pictorial worth, as in the coverlet in the wicker cradle that gives the picture its familiar title. The extraordinarily powerful *Christ Risen* of around 1616, notwithstanding a certain academic quality to the nude, has an exceptional freedom and thus anticipates the painter's final period, particularly in the two little angels in the upper left-hand corner.

Although the Florentine collections do not contain any of the famous sketches by the artist that would prove so fundamental to the development of European painting of the eighteenth and nineteenth centuries, the monochromatic *Three Graces*, of around 1620–1623—perhaps a study for a composition that was to have been translated into an ivory relief—possesses all the characteristics of the "unfinished" Rubenses that are so fascinating in his work.

The Florentine collections also own other outstanding examples from the artist's long and tireless career, including two landscapes painted on panel, *Ulysses on the Island of the Phaeacians* and the *Return of the Peasants from the Fields* of around 1630–1634. The later phase in the evolution of Rubens's style is represented by the magnificent *Consequences of War* (Pitti, 1637–1638), a work of extremely high pictorial quality and great dramatic invention, which would win the admiration of many artists and writers.

One should not forget that Rubens found, for a number of aspects, an example to follow in the art of Frans Pourbus the Younger, the able portraitist of the Mantuan court whom the Antwerpen artist knew during his early work for the Gonzaga. There are in Florence a large number of very high quality works by Pourbus, which came to the city through relations with the duchy of Mantua and through Maria de' Medici's marriage to Henry IV of France. The beautiful portraits of Eleonora de' Medici and the infant Eleonora Gonzaga, Henry IV and Maria, Louis XIII of France as a boy, and the sculptor Francavilla give ample proof of the talents of this painter who, in his chromatic richness and psychological research, anticipated Rubens's more complex palette.

It is well known that Rubens's prodigious output was aided by a great many pupils who helped in the preparation of his countless commissions. Some of these assistants are also represented in Florence by works of high quality, as for example Anthony Van Dyck's masterpiece that closed the Italian period of his career in around 1623: the *Portrait of Cardinal Guido Bentivoglio*. Orchestrated by a splendid range of reds—evoking memories of Raphael and Titian—that lights up the laces and trim of his cardinal's cloak, the work captures our attention by the intense portrayal of Bentivoglio's subtly intellectual face and his hands, which hold a letter. Another very fine work by Van Dyck, also dating from his period in Italy (in fact, in Genoa), is a study on card, enlarged in the seventeenth century, of the head of Caterina Durazzo Adorno; it was later used for the great full-length portrait of the noblewoman with her two sons at the Galleria Durazzo Pallavicini in Genoa. Although Rubensian in style, the face presents the classical stamp that was to become a dominant feature of Van Dyck's portraiture during his period in England, represented in Florence by the *Portrait of an English Gentleman*. Dating from Van Dyck's final period in Flanders are the *Rest on the Flight into Egypt*, *Charles V on Horseback*, the *Portrait of Jan de Montfort*, the *Portrait of Marguerite of Lorraine, Duchess of Orléans*, which demonstrate the artist's progressive development in the representation of pre-

cious fabric, a skill that would reach its apex in his English period.

Maintaining a position slightly apart in Antwerpen painting was the portrait painter Cornelis de Vos, on whom Van Dyck had a particular influence. The former's style, however, is marked by an objectivity of representation that is quite far removed from that of his more famous colleague and that constitutes Vos's artistic character. Other works from this school based on Rubens's style are Jan van den Hoecke's *Triumphal Entrance of Young Cardinal Ferdinand*, the *Bacchus* and *Philip IV on Horseback* in the Uffizi, and the portraits of the *Duke of Buckingham* and the *Young Woman* in the Pitti.

Of the master's second-most gifted pupil, Jacob Jordaens, the Florentine galleries possess only two autograph works: a figure of a man that has often been supposed to be a self-portrait of the artist (in the Uffizi) and a "model" for a tapestry, *Neptune Creates the Horse*. Both are representative of the malleable, intensely plastic style of an artist who remained profoundly faithful to the Rubenesque language in interpreting extremely personal compositional ideas.

Justus Suttermans (or Sustermans), also from Antwerp, was an able portraitist who did not succeed in developing an individual style, probably because he came to Italy too young. In his eclectic training he came under the influence of major personalities active in the field of painting, from Frans Pourbus the Younger to Rubens, Van Dyck, and finally Velázquez.

Within Rubens's large studio, for practical reasons, space was also made for "specialists" in such genres as animal painting, flower painting, and others. Finding fame in the first of these categories were Jan Fyt, Pieter Boel, and particularly, Frans Snyders, who often painted the animals in his master's compositions and was also much appreciated as a painter of still-lifes.

Also active in Rubens's orbit was one of the sons of the great Pieter Brueghel. Jan, called "Velvet" for his subtlety and drafting ability, was a specialist in landscapes and still-lifes with flowers, and it was through this latter genre that he won international fame. (He was patronized by Federico Borromeo, who owned a number of his works.) His almost miniaturistic capacity for populating his landscape scenes, as well as his religious and mythological representations with myriad figures and episodes is exemplified in Florence by his *Orpheus in the Underworld* in the Pitti. This artist developed a style of the most intimate character for rooms of houses, based on a technical virtuosity with pictorial material that was widely cultivated in the southern Low Countries, which for us constitutes one of the most characteristic aspects of Northern art.

Also following the example of Pieter Brueghel, through a reductive interpretation that combined elements from different sources (the Frankenthal school), was Paul Brill, who moved to Rome toward the end of the sixteenth century and is represented in the Florentine collections by a large number of works. These paintings showed the way from a type of landscape that was completely Flemish to a typology that anticipated the developments of Roman landscape artists at the height of the seventeenth century.

His *Seascape* would serve as an important example for Agostino Tassi and Claude Lorraine.

Although landscape painting, and particularly Rubens's work, had an important role, it was in floral pictures that Flemish painting found the expression of all that distinguished it from its counterpart in Holland. The Dutch were devoted to still-lifes of objects, and therefore also of flowers, but their intent and their meaning were quite different. "Rubensism" seems to have affected this field as well, in a sensual explosion of forms and colors first seen in works by the aforementioned Jan "Velvet" Brueghel. The sumptuousness of his bunches of choreographically arranged flowers testifies to the heights reached by Flemish painting, whose other "specialist" practitioners included Jerome Galle (represented in Florence by the *Festoon of Flowers*), Daniel Seghers (*Garland of Flowers with a Portrait of Archduke Leopoldo Guglielmo*), Nicolaes van Veerendael (*Bouquet of Flowers*), Clara Peeters (*Flowers and Fruit*), and others, such as Andries Daniels, Nicola van Houbraken, Jean-Philippe van Thielen, and Francois Ykens. Jan van Kessel also experimented in this direction, but the real specialty of this artist, a grandson of Jan Brueghel II and David Teniers the Younger, was the painting of small-scale animal pictures on copper, often symbolizing the "four parts of the world."

The great Rubensesque school also touched on other typical aspects of seventeenth-century Flemish art, such as genre scenes and representations of interiors. Rubens's own best examples of this type profoundly influenced artistic activity in Antwerp (as suggested by Cornelis de Bailleur's *Rubens's Studio* and Louis de Caulery's *Party with Italian Comedians*) and reached the peak of its popularity with David Teniers the Younger, the best painter of genre scenes in the Flemish school (*Interior with Peasants*). Another representative of this style was David Ryckaert III, who also loved to paint fantastic landscapes, such as his *Temptation of St. Anthony*.

Paintings of church interiors found a proponent in Pieter Neefs the Elder, who was, however, unable to achieve the heights attained by the Dutch painters in this genre. (His son, Pieter Neefs the Younger, continued his father's tradition.) Notwithstanding the fact that the school of Rubens was uncontested in its domination of Antwerp and the larger part of the southern Low Countries, the demands of collectors were such as to leave room for more traditional minor personalities who did not then belong to that movement. Among these latter, and well represented in the Florentine collections, was Frans Francken II, an Antwerpen painter who had a flourishing workshop. His small-scale paintings of religious and mythological subjects (the *Crucifixion*, the *Walk to Calvary*, the *Triumph of Neptune and Amphitrite*) are expressions of the refined execution of this painter who worked in the still-active field of international mannerism.

Marco Chiarini

656
PAUL BRILL
The Stag Hunt
Oil on copper, 8¼ × 11 in. (21 × 28 cm)
Pitti, Palatine Gallery; inv. 1890: no. 1129
Signed and dated 1595, this picture was in the Tribune by 1635.

657
PAUL BRILL
Seascape
Oil on canvas, 33⅞ × 45¹¹⁄₁₆ in. (86 × 116 cm)
Uffizi, Vasari Corridor; inv. 1890: no. 1052
Painted in Rome in 1617 for Cardinal Carlo de' Medici, this picture was sent to the Casino di San Marco in the same year.

658
JAN "VELVET" BRUEGHEL
The Great Calvary
Oil on panel, 24⅜ × 16⁹⁄₁₆ in. (62 × 42 cm)
Signed and dated: A.D. INVENTOR. 1505. BRUEGHEL FEC. 1604
Uffizi, Depository; inv. 1890: no. 1083

This panel, mentioned for the first time in a Uffizi inventory of 1784, was part of the protective structure painted by the artist (documented in Prague in 1604) for Dürer's *Great Calvary*, which was then in Rudolph II's collection in Prague.

Opposite: 661
JAN "VELVET" BRUEGHEL
Vase of Flowers with Irises
Oil on panel, 24¹³⁄₁₆ × 17¹¹⁄₁₆ in. (63 × 45 cm)
Poggio Imperiale; inv. no. 165 red
Transferred to the Palatine Gallery from the Guardaroba in 1773, this picture is now in the villa at Poggio Imperiale. It is of interest not only artistically but also botanically.

659
JAN "VELVET" BRUEGHEL
Orpheus in the Underworld
Oil on copper, 10⅝ × 14³⁄₁₆ in. (27 × 36 cm)
Signed and dated: BRUEGHEL A.O. 1594
Pitti, Palatine Gallery; inv. 1890: no. 1298

The date inscribed on the copper support indicates that this work was executed during the artist's period in Italy. In the Uffizi by 1704, the painting was transferred to the Pitti in 1928.

660
JAN "VELVET" BRUEGHEL
Landscape with a Ford
Oil on copper, 9⁷⁄₁₆ × 13¾ in. (24 × 35 cm)
Signed and dated: 1607
Uffizi, Depository; inv. 1890: no. 1179

In an Uffizi inventory of 1704, this work, notwithstanding its signature, was given to Paul Brill, an error corrected by the time of the 1769 inventory.

662
FRANS POURBUS THE YOUNGER
Portrait of Louis XIII of France at Ten Years of Age
Oil on canvas, 64¹⁵⁄₁₆ × 39⅜ in. (165 × 100 cm)
Signed and dated: AN.O SAL. 1611. AETA. SUAE AN.O 10
Pitti, Depository; inv. 1890: no. 2405

This is probably the painting mentioned in documents as having been executed by Pourbus and sent to Spain in that year, 1611. Later on, after 1860, it was one of a group of portraits of the French royal family that was transferred from Parma to the Uffizi. It passed to the Pitti in 1928.

663

FRANS POURBUS THE YOUNGER

Marie de Médicis, Queen of France

Oil on canvas, 55⅞ × 50 in. (142 × 127 cm)

Pitti, Appartamenti Reali; inv. 1890: no. 2259

Dated 1611, this portrait was commissioned by Marchese Botti, the Tuscan ambassador to Paris.

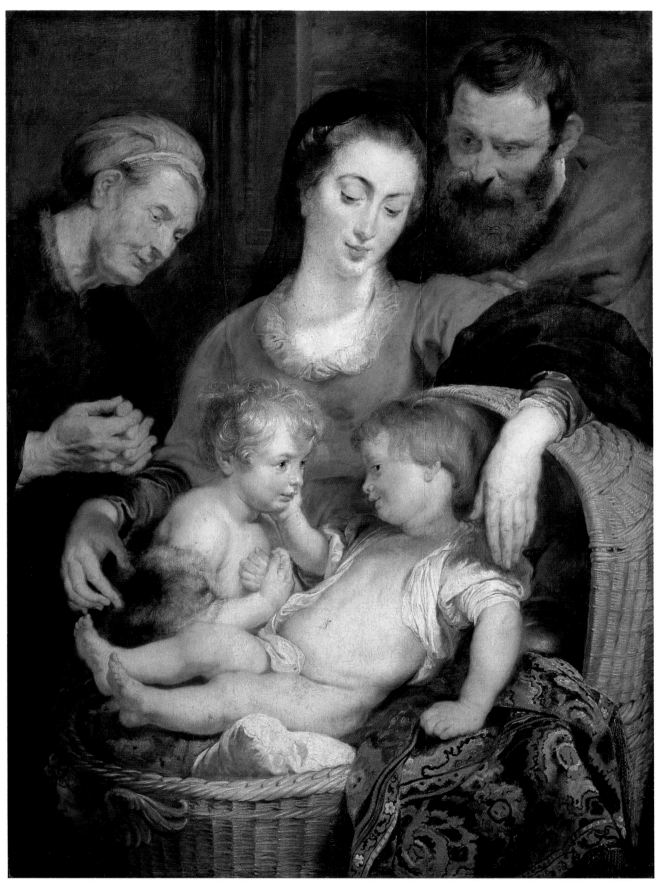

664

PIETER PAUL RUBENS

Holy Family with St. Elizabeth

("Madonna of the Basket")

Oil on canvas, 44⅞ × 34⅝ in. (114 × 88 cm)

Pitti, Palatine Gallery; inv. 1912: no. 139

This picture was executed around 1615 and documented among the furnishings of the Medici villa at Poggio Imperiale from 1654–1655. It was requisitioned by Napoleon in 1799 and recovered in 1816.

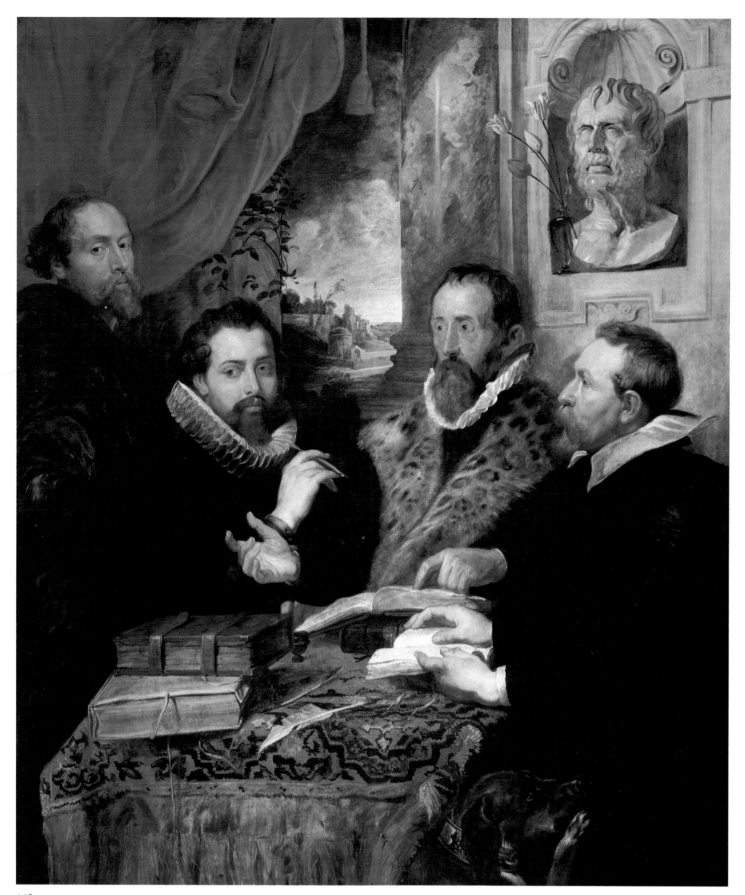

665
PIETER PAUL RUBENS
The Four Philosophers
Oil on panel, 64⁹⁄₁₆ × 54¹¹⁄₁₆ in. (164 × 139 cm)
Pitti, Palatine Gallery; inv. 1912: no. 85

The figures portrayed in this work are, from the left, the artist, his brother Philip, and the philosophers and humanists Justus Lipsius and Jan Woverius. Of unknown provenance, the painting dates from around 1611–1612. Documented as being in the Pitti Palace from the end of the seventeenth century, it was commandeered by the French in 1799 and returned in 1815.

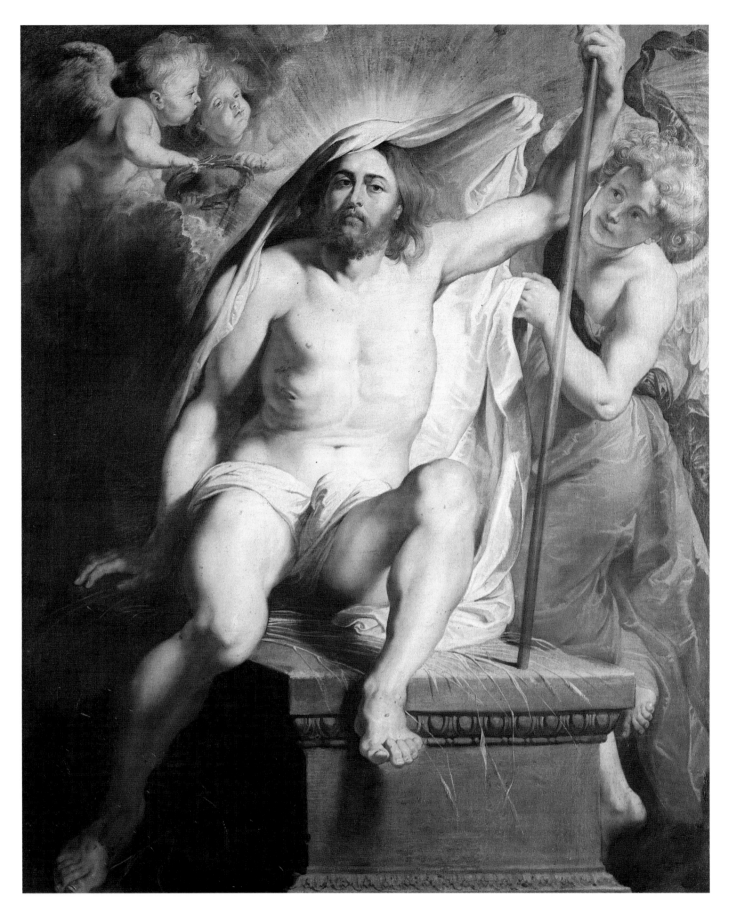

666
PIETER PAUL RUBENS
Christ Risen
Oil on canvas, 74 × 61 in. (188 × 155 cm)
Pitti, Palatine Gallery; inv. Oggetti d'Arte 1911: no. 479
This is very probably the painting of this subject that the palatine elector of Düsseldorf gave
to his brother-in-law Ferdinand de' Medici at the end of the seventeenth century. Executed
in 1616, it is documented in the Medici collection from 1713.

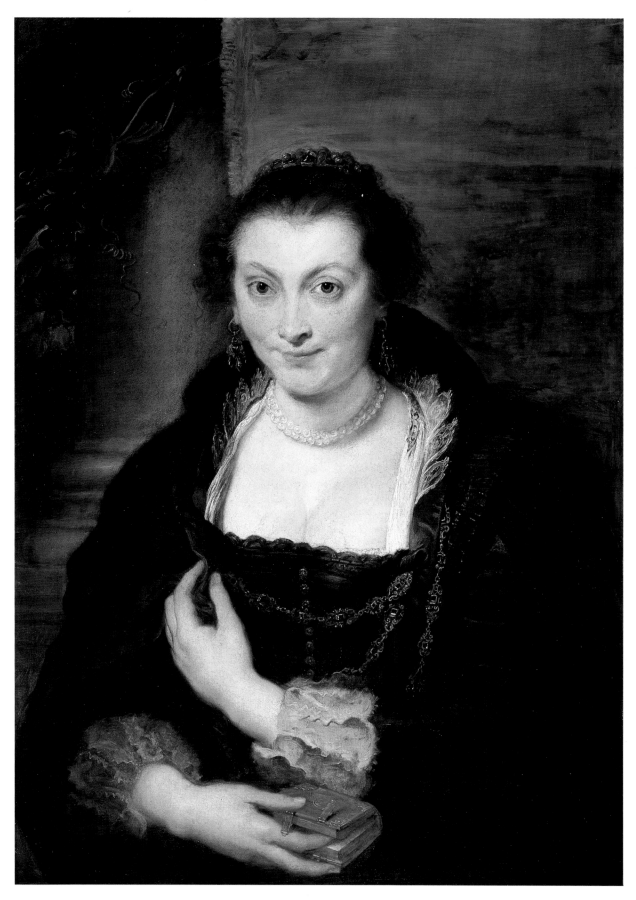

667

PIETER PAUL RUBENS
Portrait of Isabella Brant
Oil on panel, 33⅞ × 28⅜ in. (86 × 72 cm)
Uffizi, Gallery; inv. 1890: no. 779

This portrait can be dated to around 1625–1626, a little while before the death of the sitter, Rubens's first wife. In 1705 it was given by the palatine elector of Düsseldorf to his brother-in-law Ferdinand de' Medici, who kept it at the villa at Poggio a Caiano. It remained there until 1773, when it was transferred to the Uffizi.

668
PIETER PAUL RUBENS
Henry IV at the Battle of Ivry
Oil on canvas, 144½ × 272¹³/₁₆ in. (367 × 693 cm)
Uffizi, Gallery; inv. 1890: no. 722

This work once belonged to a series dedicated to the life of Henry IV, commissioned by Maria de' Medici and executed by Rubens in around 1627–1630.

669
PIETER PAUL RUBENS
Judith with the Head of Holofernes
Oil on canvas, 44½ × 35 in. (113 × 89 cm)
Uffizi, Gallery; inv. 1890: no. 9966

This canvas dates from around 1620–1622 and originally came from the Maria Borghesani collection in Bologna. Following its sale in London in 1924, it entered the Contini Bonacossi collection in Florence. Confiscated by the Nazis in 1942, it was later reclaimed by the Italian state.

670

PIETER PAUL RUBENS

The Triumphal Entrance of Henry IV into Paris

Oil on canvas, 149⅝ × 272⁴⁄₁₆ in. (380 × 692 cm)

Uffizi, Gallery; inv. 1890: no. 729

This painting and its pendant (no. 668) were acquired in 1686 by Grand Duke Cosimo III, who hung them in the Pitti Palace. In 1773 they were moved to the Uffizi.

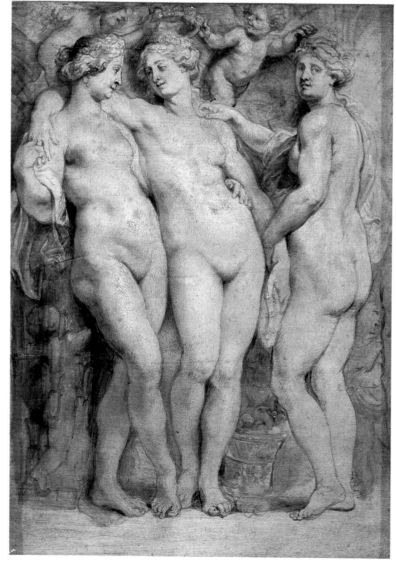

671

PIETER PAUL RUBENS

The Three Graces

Oil on canvas, 18¹¹⁄₁₆ × 13¾ in. (47.5 × 35 cm)

Pitti, Palatine Gallery; inv. 1890: no. 1165

Dating from before 1628–1630, this painting in monochrome is a model for the decoration of an ivory pitcher. In 1671 it was offered as a gift by Monsignor Francesco Airoldi to Cardinal Leopoldo de' Medici, who placed it in the Pitti.

672
PIETER PAUL RUBENS
Ulysses on the Island of the Phaeacians
Oil on panel, 50⅜ × 81½ in. (128 × 207 cm)
Pitti, Palatine Gallery; inv. 1912: no. 9

Painted in around 1630–1635, this panel was catalogued as a *View of Cadiz* in a 1677
inventory of the duke of Richelieu's collection in Paris. It probably came to Florence in
the course of the eighteenth century with the dukes of Lorraine. Requisitioned by the
French in 1799, it was restored to the Pitti in 1815.

673
PIETER PAUL RUBENS
Return of the Peasants from the Fields
Oil on panel, 47⅝ × 76⅜ in. (121 × 194 cm)
Pitti, Palatine Gallery; inv. 1912: no. 14

Rubens executed this work around 1632–1634, perhaps with the collaboration of Lucas van Uden. It was taken by the Napoleonic commission in 1799 and recovered in 1815.

Overleaf: 674
PIETER PAUL RUBENS
The Consequences of War
Oil on canvas, 81⅛ × 135¹³⁄₁₆ in. (206 × 345 cm)
Pitti, Palatine Gallery; inv. 1912: no. 86

Sent to Florence by Rubens in 1638, this painting was sold by the heirs of the patron, Justus Suttermans, to Ferdinand de' Medici, in whose Pitti Palace collection the work may have been inventoried beginning in 1691. Requisitioned by the French in 1799, it was recovered in 1815.

676

ANTHONY VAN DYCK

Portrait of a Noblewoman

Oil on paper glued on canvas, 13⅜ × 10⅝ in. (34 × 27 cm); with additions, 20⅞ × 16¹⁵⁄₁₆ in. (53 × 43 cm)

Pitti, Appartamenti Reali; inv. Oggetti d'Arte 1911: no. 748

This little portrait, which was originally even smaller, is a sketch for the *Portrait of Caterina Durazzo Adorno*, known as "The Golden Lady" (Genoa, Galleria Durazzo Pallavicini), of around 1621–1622. Once part of Grand Prince Ferdinand de' Medici's collection, it was requisitioned by the French in 1799 and recovered in 1815.

Opposite: 675

ANTHONY VAN DYCK

Charles V on Horseback

Oil on canvas, 75³⁄₁₆ × 48⁷⁄₁₆ in. (191 × 123 cm)

Uffizi, Gallery; inv. 1890: no. 1439

This portrait (perhaps one of the first examples of Van Dyck's equestrian painting) can be dated to around 1620. How it came to Florence is not known; it was first documented in 1713, in Grand Prince Ferdinand's collection in the Pitti Palace. It was transferred to the Uffizi in 1753.

677

ANTHONY VAN DYCK

Portrait of an English Gentleman

Oil on canvas, 53⅛ × 37⅜ in. (135 × 95 cm)

Pitti, Palatine Gallery; inv. 1912: no. 258

Van Dyck painted this portrait in around 1635, during his stay in England. Inventoried in 1704 among the paintings exhibited in the Tribune in the Uffizi, it was transferred to the Pitti Palace in 1780.

678
ANTHONY VAN DYCK
The Rest on the Flight into Egypt
Oil on canvas, 52¾ × 76¾ in. (134 × 195 cm)
Pitti, Palatine Gallery; inv. 1912: no. 437
This picture, of which a larger version with slight variations exists in the Hermitage, came from the Gerini Gallery in Florence, where it was documented from 1786. In 1818 it was acquired by the Palatine Gallery. It dates from around 1630.

Opposite: 679
ANTHONY VAN DYCK
Portrait of Cardinal Guido Bentivoglio
Oil on canvas, 76¾ × 57⅞ in. (195 × 147 cm)
Inscription: A MON COUSIN LE CARD.AL/ BENTIVOGLIO COMPROTECTEUR/DE MES AFFAIRS/EN COUR DE ROME
Pitti, Palatine Gallery; inv. 1912: no. 82
Commissioned by the cardinal himself and executed in around 1622, this portrait was given by another Bentivoglio to Ferdinand II de' Medici in 1653. It was exhibited in the Uffizi Tribune in 1687 and then transferred to Grand Prince Ferdinand de' Medici's apartments in the Pitti Palace. Taken by the French in 1799, it was returned to Italy in 1815.

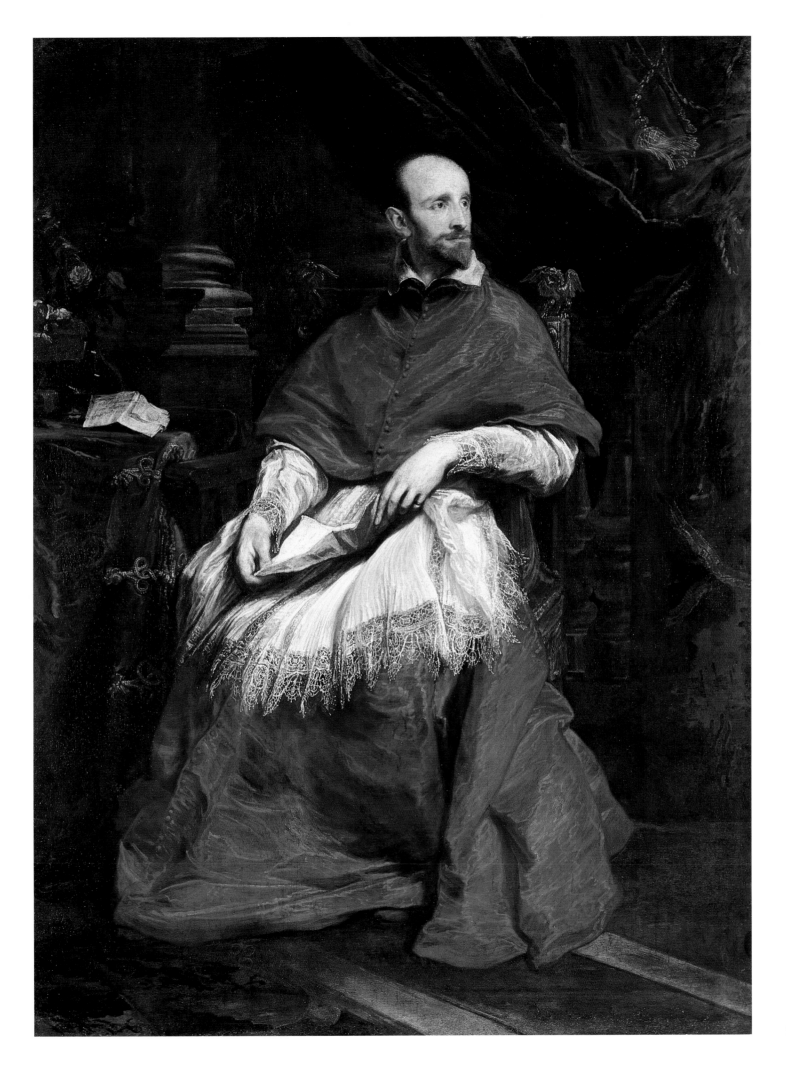

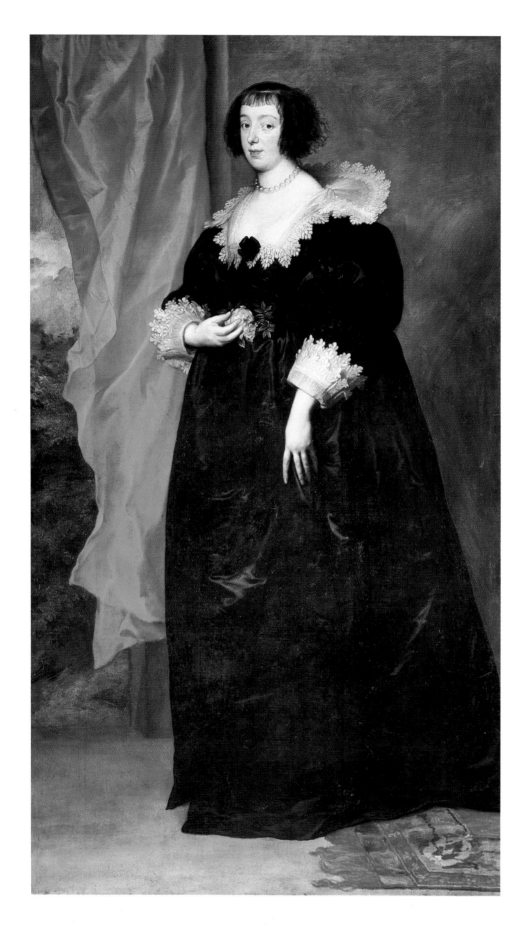

680
ANTHONY VAN DYCK
Portrait of Marguerite of Lorraine, Duchess of Orléans
Oil on canvas, 80⁵⁄₁₆ × 46¹⁄₁₆ in. (204 × 117 cm)
Uffizi, Gallery; inv. 1890: no. 777
This work was probably executed by Van Dyck in around 1634, at the time of his last stay
in Flanders. It is listed for the first time in a Uffizi inventory of 1753.

681

CORNELIS DE VOS

Portrait of a Lady with a Fan

Oil on canvas, 38⁵/₁₆ × 28⁵/₁₆ in. (98 × 72.5 cm)

Pitti, Palatine Gallery; inv. 1912: no. 440

Once thought to be by the school of Van Dyck, this portrait was given to Vos on its restoration in 1977. Based on its stylistic characteristics, it may date from the end of the 1620s.

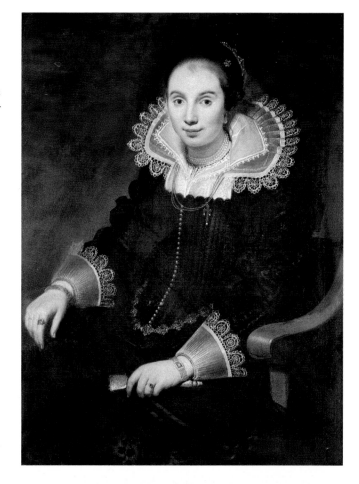

682

JAN VAN DEN HOECKE

Hercules between Vice and Virtue

Oil on canvas, 57⁵/₁₆ × 76³/₈ in. (145.5 × 194 cm)

Uffizi, Gallery; inv. 1890: no. 194

This canvas was listed, with a correct attribution, in the inventory drawn up on the death of Ferdinand, prince of Tuscany, in 1713.

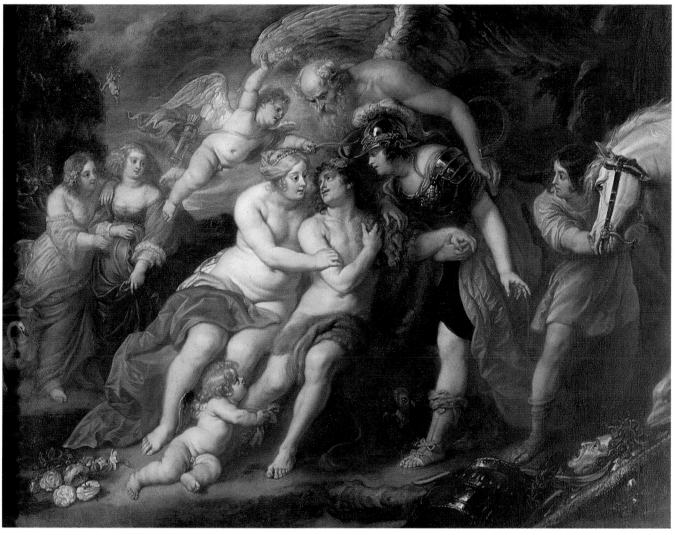

683
JUSTUS SUTTERMANS
Portrait of Canon Pandolfo Ricasoli
Oil on canvas, 45¹¹⁄₁₆ × 33⅞ in. (116 × 86 cm)
Pitti, Palatine Gallery; inv. 1912: no. 401
This portrait of the Jesuit canon Pandolfo Ricasoli (1581–1657) was painted by Suttermans in around 1630. Sometime after 1641, when the canon was condemned, the scroll and the imp were added on the right. The work once belonged to Ferdinand II.

Opposite: 685
JUSTUS SUTTERMANS
Portrait of Prince Waldemar Christian of Denmark
Oil on canvas, 27¹⁵⁄₁₆ × 21⁷⁄₁₆ in.
(71 × 54.5 cm)
Pitti, Palatine Gallery; inv. 1912: no. 190

The circumstances surrounding the execution of this portrait of Waldemar (1603–1647), the son of King Christian IV of Denmark, are unknown. Based on the approximate age of the sitter, the painting cannot date from much later than the early 1620s.

684
JUSTUS SUTTERMANS
Portrait of Galileo Galilei
Oil on canvas, 26 × 22¹⁄₁₆ in. (66 × 56 cm)
Uffizi, Gallery; inv. 1890: no. 745
Painted in 1636, this portrait was sent by Galileo himself to a French admirer from whom it was later acquired by Ferdinand II, grand duke of Tuscany.

686
JUSTUS SUTTERMANS
The Hunters' Gathering
Oil on canvas, 57⅞ × 79½ in. (147 × 202 cm)
Pitti, Palatine Gallery; inv. 1912: no. 137
Recorded in the Medici collection in 1663 with an attribution to Suttermans, this work had previously been given to Giovanni da San Giovanni.

Opposite: 687
JUSTUS SUTTERMANS
Portrait of Mattias de' Medici
Oil on canvas, 29¹⁵⁄₁₆ × 24 in. (76 × 61 cm)
Pitti, Palatine Gallery; inv. 1912: no. 265
This portrait of Cosimo II de' Medici's third son was painted by Suttermans in around 1632.

688

FRANS FRANCKEN II

The Triumph of Neptune and Amphitrite

Oil on panel, 20⅟₁₆ × 27⁹⁄₁₆ in. (51 × 70 cm)

Signed: D.J.F.FRANCK. INV. ET FT. A.

Pitti, Palatine Gallery; inv. 1890: no. 1068

The exact provenance of this painting, which was probably executed between 1610 and 1616, is not known. Its relocation from the Pitti Guardaroba to the Uffizi was recorded in 1796; it was transferred back to the Pitti in 1928.

689
FRANS SNYDERS
Wild Boar Hunt
Oil on canvas, 84¼ × 122⁷⁄₁₆ in. (214 × 311 cm)
Pitti, Depository; inv. 1890: no. 805

This picture came to the Uffizi in 1821 in an exchange with the museum in Vienna. It is a typical example of the work of this artist, a specialist in still-lifes and scenes with animals.

690
DAVID RYCKAERT III
The Temptation of St. Anthony
Oil on panel, 19⅝ × 24¹³⁄₁₆ in. (49 × 63 cm)
Pitti, Palatine Gallery; inv. 1890: no. 1144

This panel can be dated on the basis of its subject, which the artist rendered repeatedly between 1650 and 1660. How it came to the Pitti is unknown, though it seems to have entered the collection at the beginning of the eighteenth century.

691
JACOB JORDAENS
Neptune Creates the Horse
Oil on canvas, 26⅜ × 51⁹⁄₁₆ in. (67 × 131 cm)
Pitti, Palatine Gallery; inv. 1890: no. 1234

This model was executed by Jordaens in 1640–1650 as the cartoon for a tapestry in a series entitled *Equestrian Education*. It was documented for the first time in 1728, in the Pitti Palace.

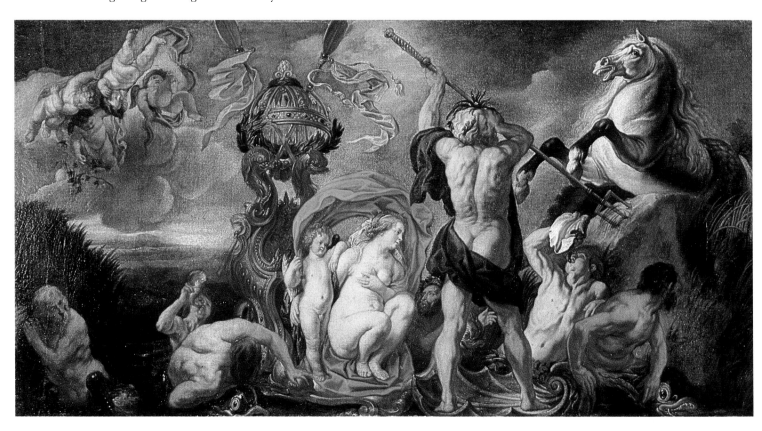

692

**DAVID TENIERS
THE YOUNGER**

The Alchemist

Oil on canvas, 17⁵⁄₁₆ × 23 in. (44
× 58.5 cm)

Pitti, Palatine Gallery; inv. 1890:
no. 1067

Originally in the Pitti, this picture
was transferred to the Uffizi in
1796, only to return to the Pitti in
1928.

693

**PIETER NEEFS
THE ELDER**

Interior of the Cathedral at Antwerp

Oil on panel, 11⁵⁄₈ × 17⅛ in.
(29.5 × 43.5 cm)

Uffizi, Depository; inv. 1890: no.
1021

Traditionally attributed to Pieter
Neefs the Elder, this picture
has also been given, by certain
scholars, to his son, Pieter Neefs
the Younger.

694
JAN VAN KESSEL
Fish on the Seashore
Oil on copper, 7 1/16 × 11 in.
(18 × 28 cm)
Pitti, Palatine Gallery; inv.
1890: no. 1069
Signed and dated 1661, this
work was probably acquired
by Cosimo III de' Medici in
Antwerp in 1668.

695
JAN VAN KESSEL
Still Life with Fruit and Shellfish
Oil on canvas, 12 3/16 × 17 5/16 in. (31 × 44 cm)
Pitti, Palatine Gallery; inv. 1890: no. 1119
This picture, signed and dated 1653, was ac-
quired in 1818.

696

JAN DAVIDSZ DE HEEM
Still Life of Flowers and Fruit
Oil on canvas, 23⅝ × 28¾ in. (60 × 73 cm)
Pitti, Palatine Gallery; inv. 1890: no. 1244

The objects depicted in this painting are characteristic of the artist's repertoire. It is probable that these two paintings by de Heem (nos. 696 and 697) were acquired by Grand Duke Cosimo III during one of his journeys to the low countries in 1667 and 1669.

Overleaf:
Still Life of Flowers and Fruit (detail)

697

JAN DAVIDSZ DE HEEM
A Festoon of Flowers and Fruit
Oil on canvas, 22⁷⁄₁₆ × 31⅞ in. (57 × 81 cm)
Signed: J.D. DE HEEM
Pitti, Palatine Gallery; inv. 1890: no. 1261

This painting dates from around 1660 and came from Grand Prince Ferdinand de' Medici's collection. It is typical of the work of the Dutch master, who produced similar floral pictures now in museums in Antwerp, the Hague, and Karlsruhe.

The Netherlands

A country's history and fortunes are undoubtedly reflected in its artistic production, and this is particularly true of the northern low countries at the moment when they gained their independence in 1579 and became the modern Netherlands. An artistic flowering corresponding to a country's newly won independence can occur on various levels, but none has ever been quite so extraordinary as that experienced in the Netherlands in the seventeenth century—the golden age of Dutch art. If seventeenth-century Flemish art can be condensed into the work of Rubens and his more important followers (Van Dyck and Jordaens), who engaged in the production of large narrative paintings of historical and religious subjects (those of the Catholic faith), the Protestant Netherlands—which rejected religious iconography out of hand—spawned a series of schools around the liveliest artistic centers (Amsterdam, Delft, Utrecht, Haarlem). These schools brought a versatility and a great variety of different accents, along with an impressive unity of ideas, to their painting; in fact the other arts never developed to the same extent and never attained the same high standard of quality. The world that knew how to effect political and economic independence (through commercial developments that led the country to prosperity) was reflected precisely in painting and in its widespread dissemination. Dutch painting is often thought to be virtually exemplified by the greatest artistic figure of the century, Rembrandt van Rijn, but there were other artists as well who knew how to create another kind of reality on their canvases, among them Jan Vermeer, Jan Steen, Frans Hals, Jan van Goyen, and Jacob van Ruisdael. Every painter responded to the demands of a diverse public, resulting in a flowering of genre paintings that had an exceptional development. Biblical subjects, especially dear to the painters of the Amsterdam school, were second in popularity only to portraiture, a field that produced a series of artists of the highest quality among whom loomed such giants as Rembrandt and Hals.

The Uffizi possesses two self-portraits by Rembrandt (the one of him as an old man is among the most dramatic of his later works) as well as a portrait by him said to be of a rabbi; all three serve to demonstrate the psychological depths plumbed by the artist. Lacking any examples of his biblical works, interior scenes, or landscapes (though there is one by Hercules Seghers, discussed below), the Florentine collections give the impression that Rembrandt's was a dense, "modern" kind of painting, demonstrating a technique that evolved from the optical precision of the early self-portrait to the emotionality—almost recalling that of the older Titian—of the late works, a prelude to much of eighteenth- and nineteenth-century European art. Turning to Seghers, the Uffizi owns one of his masterpieces in the great *Mountainous Landscape;* with its preromantic tones, this work was fundamental to the artistic education of Rembrandt himself, who seems at one point to have possessed it and to have added a few details.

In any event, the complexity of seventeenth-century Dutch art can only be glimpsed in the holdings of the Florentine galleries. In fact, the Medici and the dukes of Lorraine preferred to collect those minor artists whose works were better adapted to the rising "bourgeois" taste for the *cabinet de l'amateur.* History, too, sometimes played a role in the selection, as in the case of the "Italianate" landscape artist Cornelis van Poelenburgh, from Utrecht, who particularly appealed to the collecting inclinations of Grand Duke Cosimo II and his brother Carlo. It was probably upon their request that the painter worked directly in Florence, though for a short time.

The same taste for the "Italianate" that led landscape artists to periods of activity in Rome also brought to Florence works by Pieter van Laer, known, because of a deformity, as Bamboccio ("little clumsy one"). Van Laer worked in Rome for several years and opened up the way for Northern painters, such as Jan Asselijn, who became his followers (whence their nickname, the *bamboccianti*). Like their master, these artists dedicated themselves to the representation of daily life in the streets of Rome and the surrounding countryside, anticipating the vogue for Roman landscape that would last from the seventeenth century to the end of the nineteenth.

At the beginning of the seventeenth century in Rome, Caravaggio's figurative "revolution" was having significant repercussions through its creation of an intense realism, which would conquer entire generations of artists and from which not even the young Rubens would escape. This revolution also echoed resoundingly through a school of Dutch painting founded in Utrecht. Perhaps its most famous exponent was Gerrit van Honthorst, known in Italy as Gherardo delle Notti for his ability to paint subjects in candlelight. Florence possesses several fine examples of this artist's work, which came directly from his studio through the express interest of Cosimo II de' Medici; their presence in the Florentine collections had a considerable impact on contemporary Tuscan painters such as Rustici, Manetti, and Riminaldi.

One well-documented aspect of Dutch art is that of the *petits-maîtres* who preceded Rembrandt and had a certain role in his development. Among these were the aforementioned Poelenburgh (represented in Florence by a series of small landscapes of Italian inspiration, often with biblical or mythological subject matter) as well as Jacob Pynas, Cornelis Moeyaert, Leonaert Bramer, and the great Hercules Seghers, whose mature masterpiece in the Uffizi shows him turning in a new direction, toward a landscape already romantic in its conception of infinite space and its dramatic lighting, which formed the basis for Rembrandt's own representation of nature. While the typically Dutch landscapes of Jan van Goyen are not represented in the Florentine galleries, there is one by Pieter Molyn, a minor artist who nonetheless had an influence on the formation of Jacob van Ruisdael. Of the latter's work there are only two small but high-quality examples in Florence: the Uffizi's *Landscape with Shepherds and Peasants,* with its dappling of golden light, and the Pitti's *Landscape with Waterfall,* characterized by a beautiful sunset atmosphere. These two paintings give some idea of the great composi-

tional variety achieved by the painter, who established a sort of preromantic vision that would win him a large following among English and French artists of the eighteenth and nineteenth centuries.

A quite different type of landscape painting was produced by those Dutch painters who were strongly influenced by Italian nature, such as Frederick de Moucheron and Hermann van Swanevelt, only later to conceive, as in the case of Gaspard van Wittel (known in Italy as Vanvitelli), a preponderant interest in the aspect of the Italian city, beginning with Rome. This would be the dominant theme behind van Wittel's painting, itself the true and proper precedent for the eighteenth-century vogue for views. Gerrit Berckheyde and Jan van der Heyden were already mining this vein in their native land, and several examples of their work are in the Florentine collections.

Although there are few works in Florence by the more typical Dutch masters of the golden age (excepting minor works by such artists as Ter Borch, Steen, Metsu, Molenaer, Codde, and Ostade), there is no lack of examples of particular genres. In marine painting, for example, there are the great grisailles of Willem van de Velde the Elder and a little panel by one of the forerunners of the genre, Cornelis Vroom; works by Ludolf Bakhuysen, the best follower of Willem van de Velde the Younger, and Dubbels; two small pictures by the rare Reinier Nooms; and the "Italianized" art of Adriaen van der Cabel.

In regard to still-life, the Medici and Lorraine focused their collecting tastes on a number of specialists in flower painting, including Jan Davidsz de Heem, Maria van Oosterwyck, Elias van den Broeck, and Abraham Mignon. They also secured several outstanding examples by the great Rachel Ruysch, the favorite painter of international courts who brought the era of this typical Dutch genre to a close with her sumptuous baroque compositions.

The collections also contain a number of works by two minor masters who represent a different tendency in this genre, Willem van Aelst and Otto Marseus van Schrieck. This is due largely to the fact that both artists came first to Rome and then to the Florentine court, where Aelst produced a series of paintings inspired by the Medici collection of precious objects. His compositions reflect a richness of detail and of color that is unusual in Dutch painting and that was evidently occasioned by his Italian environment. Marseus, for his part, was the first proponent of a kind of painting dedicated to the representation of "living nature," which was to influence a whole series of artists beginning with the aforementioned Rachel Ruysch. In his pictures of reptiles, flowers, and field and woodland plants, the painter exhibited a detailed imagination that won him great success.

In the area of post-Rembrandt Dutch portraiture, the Florentine collections possess several paintings by Peter van der Faes, known as Peter Lely, who replaced Anthony Van Dyck in London from 1641. Although Lely is usually characterized as an English artist, his refined and subtly introspective portraits reveal a strong Flemish influence superimposed over Dutch origins.

The best Dutch works in Florence, however, may well be those by the *petits-maîtres* who depicted the daily life of the bourgeoisie in the seventeenth-century Netherlands; these pictures greatly pleased Medici taste. It was this affinity that brought Florence the small paintings on copper by Gerrit Dou, a pupil of Rembrandt and the founder in Leiden of a school of *Feinmaler* (or "fine painters") led by himself and his best pupil, Frans van Mieris. Dou's *Fritter Seller* is a masterpiece of genre painting which even in its minute descriptive details reveals a study of warm, Rembrandtesque light. Dou's pupil Mieris involved himself even more than his master in the technical vertices pursued by the Leiden school; an acute observer and describer of the surroundings and situations of daily life, he lavished his pictorial abilities on objects and materials, and it was these precious luministic reflections that made him famous and earned him numerous Medici commissions. Joining these works in the collection are little paintings by other artists in search of "refined" effects, such as Cornelis Bega, Job Berckheyde (whose *Self-portrait* reflects the influence of the great Vermeer of Delft), Pieter de Bloot, Willem van Mieris (son of Frans), Eglon Hendrick van der Neer, Caspar Netscher, Adriaen van der Werff, and Godfried Schalcken (famous for his ability, as the "new Gherardo delle Notti," to achieve a delicate chiaroscuro with artificial light, as in his *Girl with a Candle*, in the Pitti). With these artists, active into the eighteenth century, the most glorious epoch of Dutch painting ended.

Marco Chiarini

698
HERCULES SEGHERS
Mountainous Landscape
Oil on canvas mounted on panel, 21¹¹⁄₁₆ × 39⅜ in. (55 × 100 cm)
Uffizi, Gallery; inv. 1890: no. 1303
Stylistically, this work appears to date from the 1620s; it may correspond to the painting by Seghers that is listed in the 1656 inventory of Rembrandt's collection. It entered the Uffizi in 1839 as the gift of Baroness Maria Hadfield Cosway.

699
LEONARD BRAMER
The Adoration of the Shepherds
Oil on panel, 37⅜ × 32⅞ in. (95 × 83.5 cm)
Initialed: LB
Uffizi, Vasari Corridor; inv. 1890: no. 9458
Datable on the basis of its style to around 1640, this painting was acquired on the antiques market in 1968 by the Florentine galleries through right of preemption.

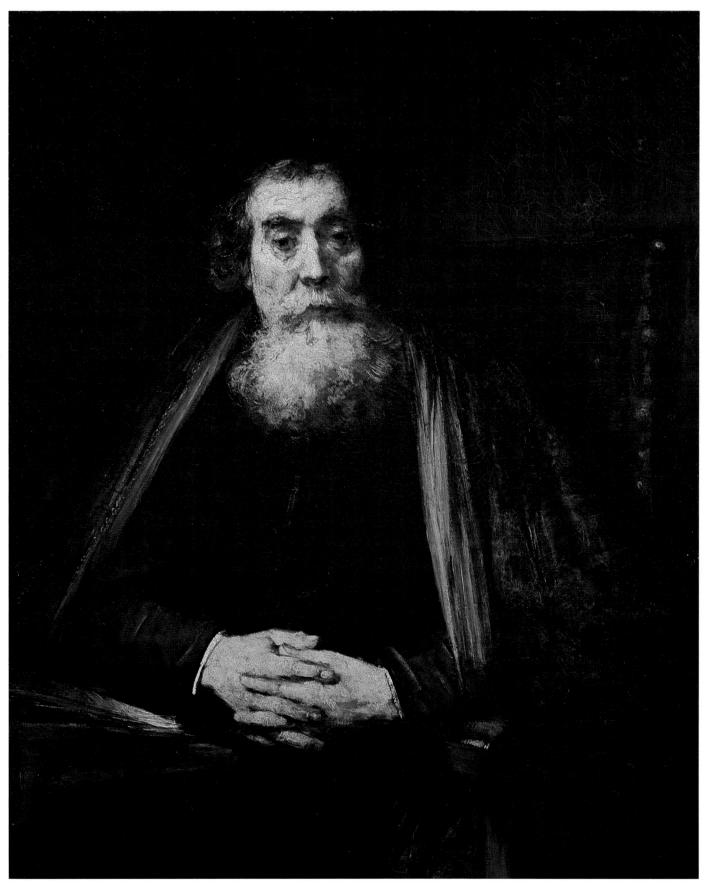

700
REMBRANDT HARMENSZOON VAN RIJN
Portrait of an Old Man ("The Rabbi")
Oil on canvas, 40¹⁵/₁₆ × 33⅞ in. (104 × 86 cm)
Signed and dated: REMBRANDT F. 1664–1665
Uffizi, Gallery; inv. 1890: no. 8435

The date given on the back of this picture seems to correspond with its style. At the
end of the seventeenth century the portrait entered the Pitti as part of Ferdinand
de' Medici's collection.

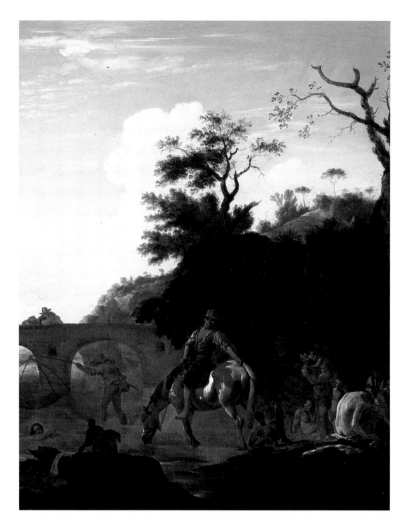

701
BAMBOCCIO
The Bath
Oil on canvas, 24³⁄₁₆ × 19⁵⁄₁₆ in. (61.5 × 49 cm)
Uffizi, Depository; inv. 1890: no. 1202

Judging from its style, this canvas was painted in around 1636. It may have been bought in Rome by Cardinal Leopoldo de' Medici, who placed it in his own collection in the Pitti in 1675. In the eighteenth century it could be found in the villa at Poggio Imperiale.

702
CORNELIS VAN POELENBURGH
The Dance of the Satyrs
Oil on copper, 17¹¹⁄₁₆ × 24¹³⁄₁₆ in. (45 × 63 cm)
Pitti, Gallery; inv. 1890: no. 1221

This is one of four paintings on copper executed for Cosimo II de' Medici between 1620 and 1622.

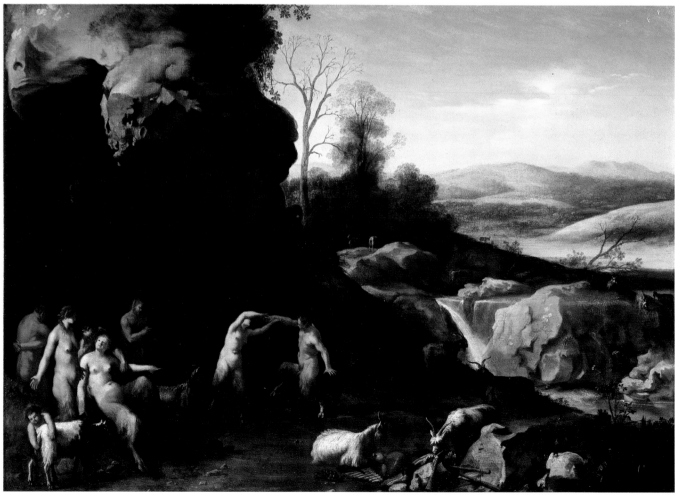

703
CORNELIS BEGA
Lute Player
Oil on canvas mounted on panel, 14½ × 11¾
in. (36.8 × 29.8 cm)
Signed and dated: C. BEGA 1664/5–8
Uffizi, Depository; inv. 1890: no. 1182

This work, executed in 1664, was in the Uffizi
by 1704. It is not known whether it was ac-
quired by Cosimo III on one of his journeys to
the low countries (in 1667 and 1669) or given
to him by the palatine elector or his consort,
Anna Maria Luisa de' Medici.

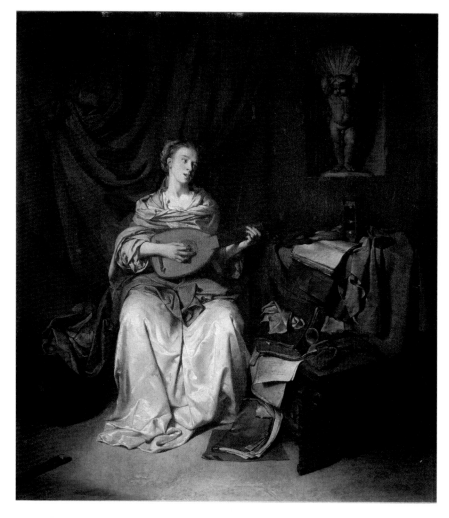

704
JAN ASSELIJN
Landscape with Waterfall
Oil on canvas, 18½ × 21¼ in. (47 × 54 cm)
Initialed: JA
Pitti, Palatine Gallery; inv. 1890: no. 1045
Stylistically, this painting can be dated be-
tween 1640 and 1653.

705
JAN MIENSE MOLENAER
The Inn
Oil on panel, 27³⁄₁₆ × 44¹⁄₁₆ in. (69 × 112 cm)
Signed on the tabletop in the center: . . . OLENAER
Uffizi, Gallery; inv. 1890: no. 1278
The style of this work suggests a date of around 1640. It may have come to Florence from the Viennese collections.

706
JAN STEEN
The Meal
Oil on panel, 15¾ × 19⅜ in. (40 × 49.3 cm)
Signed: J. STEEN
Uffizi, Gallery; inv. 1890: no. 1301
Painted in 1650–1660, this panel was recorded in the Pitti Palace at the beginning of the eighteenth century.

707

GERRIT DOU

The Fritter Seller

Oil on panel, 17⅜ × 13⅜ in. (44.2 × 34 cm)

Uffizi, Depository; inv. 1890: no. 1246

Datable to 1650–1655, this panel was probably acquired by Cosimo III de' Medici on one
of his trips to the low countries (1667 and 1669).

708
FRANS VAN MIERIS
The Painter with His Family
Oil on panel, 20⁷⁄₁₆ × 15¾ in. (52 × 40 cm)
Uffizi, Gallery; inv. 1890: no. 1305
Signed and dated 1675, this picture was acquired by Cosimo III de' Medici during a trip to the low countries.

709
ADRIAEN VAN DER WERFF
The Adoration of the Shepherds
Oil on panel, 20⅞ × 14³⁄₁₆ in. (53 × 36 cm)
Uffizi, Gallery; inv. 1890: no. 1313
This work, signed and dated 1703, is said in the artist's memoirs to have been executed for the palatine electress Maria Luisa de' Medici, who brought it to Florence in 1716.

710
GABRIEL METSU
A Lady and a Cavalier
Oil on panel, 22¹³/₁₆ × 16¹¹/₁₆ in. (58 × 42.3 cm)
Uffizi, Gallery; inv. 1890: no. 1296

This painting dates from around 1660; it came to the Pitti Palace at the beginning of
the eighteenth century.

711
JACOB VAN RUISDAEL
Landscape with Waterfall
Oil on canvas, 20¹¹⁄₁₆ × 24⁵⁄₈ in. (52.5 × 62.5 cm)
Signed: JV RUISDAEL
Pitti, Palatine Gallery; inv. 1890: no. 8436

Datable to around 1670, this painting was acquired on the antiques
market in 1827 by the Florentine galleries.

712
JACOB VAN RUISDAEL
Landscape with Shepherds and Peasants
Oil on canvas, 20½ × 23⅝ in. (52 × 60 cm)
Uffizi, Gallery; inv. 1890: no. 1201

This canvas was acquired in 1797 and exhibited in the gallery the
following year.

713
WILLEM VAN DE VELDE THE ELDER
The Battle of the Sont
Oil on canvas, 56½ × 116⅝ in. (143.5 × 295.5 cm)
Pitti, Palatine Gallery; inv. Oggetti d'Arte 1911: no. 327

Signed and dated 1665, this canvas was probably acquired by Cosimo III de' Medici during his first trip to the low countries in 1667.

715
LUDOLF BACKHUYSEN
Seascape with Ships
Oil on canvas, 25⁹⁄₁₆ × 31⅛ in. (65 × 79 cm)
Pitti, Palatine Gallery; inv. 1912: no. 464
In the early nineteenth century this painting could be found in the
Schweitzer collection in Frankfurt; it was acquired for the Floren-
tine galleries in 1823.

Opposite: 714
WILLEM VAN DE VELDE THE ELDER
The Dutch Navy Sailing
Oil on canvas, 44⅛ × 79¹⁵⁄₁₆ in. (112 × 203 cm)
Signed and dated: W. V. VELDE F. 1672
Pitti, Palatine Gallery; inv. Oggetti d'Arte 1911: no. 328
Acquired in July 1674 by Pieter Blaeu, acting on behalf of Leopoldo
de' Medici, this work was listed in a 1675 inventory of the cardinal's
goods in the Pitti.

719
OTTO MARSEUS VAN SCHRIECK
Reptiles, Butterflies, and Plants at the Base of a Tree
Oil on canvas, 23⅝ × 18½ in. (60 × 47 cm)
Signed : O. MARSEUS D.
Pitti, Palatine Gallery; inv. Oggetti d'Arte 1911: no. 502
This picture is datable to around 1668, the year in which it was acquired in Amsterdam by Grand Duke Cosimo III.

720
OTTO MARSEUS VAN SCHRIECK
Still Life with Mushrooms and Butterflies
Canvas, 14¹⁵⁄₁₆ × 18⅞ in. (38 × 48 cm)
Signed at lower left: OTTO MARSEVS/DE SCHRIECK FECŸT IN ROMA/1655 LY 10 AUG . . .
Pitti, Palatine Gallery; inv. 1890: no. 5268
This work was sent in 1699 to the villa at Topaia, where Cosimo III de' Medici assembled a collection of paintings depicting the various animal and botanical species.

715
LUDOLF BACKHUYSEN
Seascape with Ships
Oil on canvas, 25⁹⁄₁₆ × 31⅛ in. (65 × 79 cm)
Pitti, Palatine Gallery; inv. 1912: no. 464

In the early nineteenth century this painting could be found in the
Schweitzer collection in Frankfurt; it was acquired for the Floren-
tine galleries in 1823.

Opposite: 714
WILLEM VAN DE VELDE THE ELDER
The Dutch Navy Sailing
Oil on canvas, 44⅛ × 79¹⁵⁄₁₆ in. (112 × 203 cm)
Signed and dated: W. V. VELDE F. 1672
Pitti, Palatine Gallery; inv. Oggetti d'Arte 1911: no. 328

Acquired in July 1674 by Pieter Blaeu, acting on behalf of Leopoldo
de' Medici, this work was listed in a 1675 inventory of the cardinal's
goods in the Pitti.

716
GERRIT BERCKHEYDE
The Market Place and the Grote Kerk at Haarlem
Oil on canvas, 21¼ × 25³⁄₁₆ in. (54 × 64 cm)
Uffizi, Gallery; inv. 1890: no. 1219

This canvas is signed and dated 1693. The subject was a very popular one; this and another
version in the National Gallery in London are among the best examples of the scene.

Opposite: 718
GASPARD VAN WITTEL
View of Florence
Oil on canvas, 40¾ × 52⅜ in. (103.5 × 133
cm)
Pitti, Depository; inv. Oggetti d'Arte 1911:
no. 505

This painting can be identified as that exe-
cuted in 1694 for Ferdinand de' Medici, in
whose 1713 inventory it is cited.

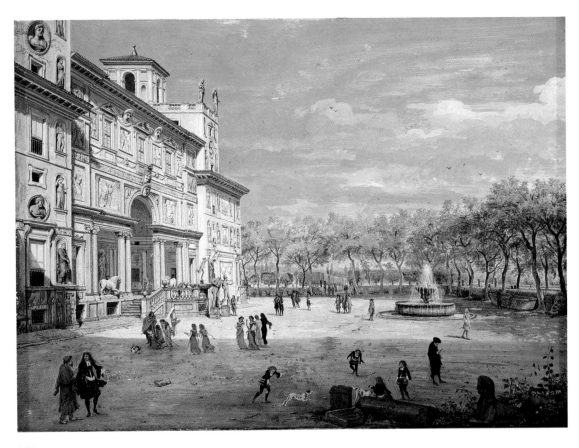

717
GASPARD VAN WITTEL
The Villa Medici in Rome
Tempera on parchment, 11⁷⁄₁₆ × 16⅛ in. (29 × 41 cm)
Pitti, Palatine Gallery; inv. 1890: no. 1256
This work, datable to 1685, presents the garden side of the Medici villa in Rome, built for
Ferdinand I.

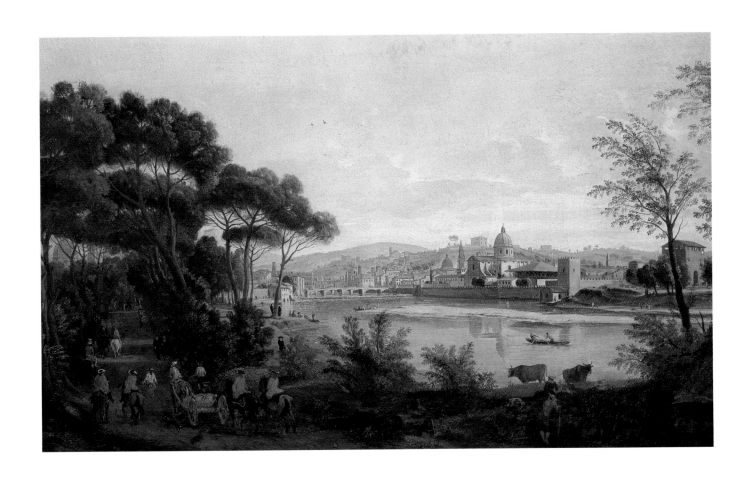

719
OTTO MARSEUS VAN SCHRIECK
Reptiles, Butterflies, and Plants at the Base of a Tree
Oil on canvas, 23⅝ × 18½ in. (60 × 47 cm)
Signed : O. MARSEUS D.
Pitti, Palatine Gallery; inv. Oggetti d'Arte 1911: no. 502
This picture is datable to around 1668, the year in which it was acquired in Amsterdam by Grand Duke Cosimo III.

720
OTTO MARSEUS VAN SCHRIECK
Still Life with Mushrooms and Butterflies
Canvas, 14¹⁵⁄₁₆ × 18⅞ in. (38 × 48 cm)
Signed at lower left: OTTO MARSEVS/DE SCHRIECK FECŸT IN ROMA/1655 LY 10 AUG . . .
Pitti, Palatine Gallery; inv. 1890: no. 5268
This work was sent in 1699 to the villa at Topaia, where Cosimo III de' Medici assembled a collection of paintings depicting the various animal and botanical species.

721
JACOB VAN HULSDONCK
Still Life with Fruit
Oil on panel, 24 × 36⅝ in. (61 × 93 cm)
Pitti, Palatine Gallery, Director's office; inv. 1890: no. 3118
This picture was given to the galleries in 1896 by Arturo De Noè Walker.

722
WILLEM VAN AELST
Still Life with Fruit and Silverware
Oil on canvas, 30½ × 39¹⁵⁄₁₆ in. (77.5 × 101.5 cm)
Pitti, Palatine Gallery; inv. 1912: no. 469
Dated 1653, this canvas was painted in Florence for Ferdinand II de' Medici.

723
RACHEL RUYSCH
Fruit and Insects
Oil on canvas, 17⁵⁄₁₆ × 23⁵⁄₈ in. (44 × 60 cm)
Uffizi, Gallery; inv. 1890: no. 1276
Signed and dated 1711, this work was probably sent to Cosimo III de' Medici in the same
year by his son-in-law, the palatine elector of the Rhine.

Opposite: 724
RACHEL RUYSCH
Fruit, Flowers, and Insects
Oil on canvas, 35¹⁄₁₆ × 27 in. (89 × 68.5 cm)
Signed and dated: RACHEL RUYSCH 1716
Pitti, Palatine Gallery; inv. 1912: no. 451

This picture and the *Bouquet of Flowers in a Vase* (Palatine Gallery; inv. no. 455) were acquired for the Pitti Palace in 1823, when Dutch painters of still-lifes and genre paintings were being sought out by Grand Duke Leopoldo II of Lorraine.

Germany

By a quirk of fate, the Florentine collections lost what has come to be considered the masterpiece of the greatest painter of seventeenth-century Germany, Adam Elsheimer. The work in question is the small altarpiece of the *Glorification of the Cross,* now at the Städelsches Kunstinstitut in Frankfurt. Acquired by Cosimo II de' Medici in 1619, the altarpiece was then lost and reached its current location only in the last decades. The painting's presence in the collections would have filled an important gap in this school, as Elsheimer, despite the brevity of his career, had a decisive effect on German art, on that of the low countries and, through the latter, on Italian painting as well. Notwithstanding the loss of this picture, Elsheimer's influence can be perceived in works still present in Florence, such as the copies of his ten *Saints* made by Cornelis van Poelenburgh (in the Pitti), and Anastasio Fontebuoni's copy of a lost original, the *Baptist Preaching* (Pitti).

Because Johann Liss—who is represented in the Florentine collections by several exemplary works—is now characterized as an Italian painter, his place as the most important German artist of the seventeenth century has fallen to Joachim von Sandrart, a noteworthy painter in his own right. Portraitist, history painter, and painter of still-lifes, Sandrart derived the "international" tone of his painting from the Netherlands (his master was Honthorst) and from Flanders (Rubens), no less than from Elsheimer himself. He is best known, however, as the founder of the German Academy in Nuremberg and the author of a history of the lives of German artists.

Carl Ruthart was a minor artist whose specialty was animal painting. The two pictures by him in the Pitti, which probably belong to his Italian period (after 1672), exemplify his ability to depict the natural hunting imperatives of wild animals and are clearly influenced by the work of Frans Snyders. Also working in this genre was Johann Heinrich Roos, whose Dutch training is evident in pastoral landscapes—the two paintings by him in the Pitti are particularly good examples—saturated by the golden light of the Roman countryside, a light taken up by so many of the Italianized Netherlandish painters. Dutch culture likewise influenced the Hamburg artist Frans-Werner Tamm (1658–1724), who is represented in the galleries by a beautiful bunch of flowers with a Medici provenance.

Marco Chiarini

726

JOACHIM VON SANDRART

Apollo and the Serpent Python

Oil on canvas, 31½ × 42¹⁵⁄₁₆ in. (80 × 109 cm)

Uffizi, Depository; inv. 1890: no. 1097

The provenance of this painting, which entered the Uffizi in the nineteenth century, is unknown. It dates from the 1650s or 1660s.

Opposite: 725

CARL ANDREAS RUTHART

Stag and Wild Beasts

Oil on canvas, 40⁹⁄₁₆ × 56⁵⁄₁₆ in. (103 × 143 cm)

Pitti, Palatine Gallery; inv. 1912: no. 438

As an inscription on the back indicates, this painting was kept in the Medici villa at Castello. It was acquired in Naples on behalf of Grand Duke Cosimo III de' Medici in 1676, along with another (signed) painting by Ruthart, now in the Pitti, acquired by Abbot Giovanni Pietro Cella.

727

JOHANN HEINRICH ROOS
Landscape with Shepherds and Animals
Oil on canvas, 33¹¹/₁₆ × 43⅛ in. (85.5 × 109.5 cm)
Signed and dated: JHROOS PINXIT 1684
Pitti, Palatine Gallery; inv. Oggetti d'Arte 1911: no. 704
Along with a pendant painting of a pastoral scene, similarly signed but dated 1683, this work belongs to the later phase of Roos's activity. The two pictures both came to Florence from the Imperial Gallery in Vienna, through an exchange with that collection in 1793.

728

MARTIN VAN MEYTENS THE YOUNGER
The Imperial Family of Austria
Oil on canvas, 79¹⁵/₁₆ × 70½ in. (203 × 179 cm)
Pitti, Museo degli Argenti; inv. Opere d'Arte: no. 1431
This official portrait of the Austrian imperial family was painted in around 1756. Empress Maria Theresa is shown with her husband, Francesco Stefano of Lorraine, and their thirteen children, with the gardens of Schönbrunn in the background.

Spain

There were at least four painters who dominated the artistic panorama of Spain of the seventeenth century—Ribera, Zurbarán, Velázquez, and Murillo—and each is represented by at least one painting in the Florentine collections. If these do not provide an exhaustive documentation of seventeenth-century Spanish painting, with variations from the schools of Valencia, Toledo, Madrid, and Andalusia, they at least serve to indicate its characteristics. Jusepe de Ribera, from Valencia, was a great realistic painter who stood out for his highly dramatic vision, which was driven, particularly at the beginning of his career, by a Caravaggesque chiaroscuro. The *Martyrdom of St. Bartholomew* is a fine example of his work, in which the pathos evoked by the apostle's lacerated figure dominates the scene. His *St. Francis,* a late work, is enlivened by the same religious intensity, which in fact characterizes the entire oeuvre of this painter, a central figure of the Neapolitan school as well.

Diego Velázquez established himself in Madrid in 1623 and became Philip IV's court painter. He developed the painting of portraits into a study of contemporary society, a concept that brought him celebrity and influence over other painters until modern times. After an early venture into Caravaggesque "mysteriousness" with a series of pictures produced when he was still in Seville—to which series the Pitti's *El Aguador de Sevilla* belongs—his painting assumed bright and silver tones and a fluidity of brushstroke, qualities which accompany both his compositions and his solidly realistic portraits, such as *Philip IV on Horseback,* which reach their peak in his most famous canvas, *Las Meninas,* in the Prado.

The art of Velázquez, however, did not influence the contemporaneous painting of Madrid, and painting in Seville also took a different direction with the work of Francisco de Zurbarán and Bartolomé Esteban Murillo. The former was especially dedicated to religious subject matter, which he interpreted using light as a mystic element. In his later years he filled his canvases with brighter tones (as in his *St. Anthony Abbot*) and also produced admirable still-lifes, which confirmed the innovative style he had developed out of a simplified technique and an essential chromatic range. Murillo, for his part, was certainly the most popular personality of the Seville school, known above all—almost as a new Raphael—for his extremely beautiful Madonnas, two of which are in the Pitti. One of these, depicting the young Virgin with the Christ child standing in her lap, is perhaps the most perfect example of a type that won the artist great fame. But beyond their popular appeal, Murillo's images inaugurated new techniques and found a large group of followers in eighteenth-century European painting for their soft delineations and the transparency of the color of their oils, which look almost like pastels.

Among the painters of Madrid, Antonio de Pereda is represented by a work in the Florentine collections. A particular devotee of religious subjects, in the 1640s he also produced still-lifes with moralizing themes such as the Uffizi's *Allegory of Vanity,* in which the dramatic sense of the memento mori, so often present in Spanish painting, is exalted almost to the point of being macabre.

After the great season of the baroque, Spanish painting lost its momentum. At the beginning of the eighteenth century, foreign painters such as Corrado Giaquinto, Giovan Battista Tiepolo, and Anton Raphael Mengs, a proponent of neoclassical principles, arrived in Spain. It was this situation that forged the personality of the artist who was to dominate the Spanish scene for the last three decades of the eighteenth century and into the nineteenth, Francisco Goya. After establishing himself as a portraitist to the Spanish court and Madrid nobility, Goya seems to have continued the work of Velázquez, evolving from the rococo style employed in a number of his decorative likenesses to the romantic pathos of his most important works, the portraits that served to comment on contemporary society. The artist's introspective psychological power is most intense and harmonious—and technically best—in his portraits, where he created with chromatic virtuosity and pictorial transparency a fundamental example for nineteenth-century European painting.

Marco Chiarini

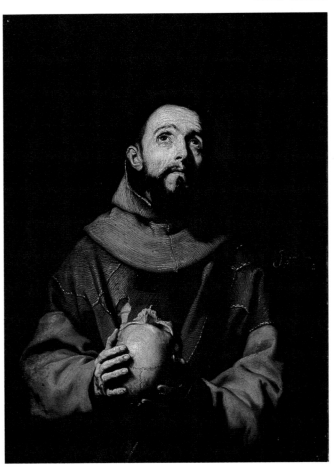

729

JUSEPE DE RIBERA
St. Francis
Oil on canvas, 40⁹⁄₁₆ × 30⁵⁄₁₆ in. (103 × 77 cm)
Signed and dated: JUSEPE DE RIBERA / ESPANOL F 1643
Pitti, Palatine Gallery; inv. 1912: no. 73

Of a particularly forceful expressiveness, this figure of a saint belongs to Ribera's fully mature period. The painting, cited in a 1659 inventory of Mattias de' Medici's property, was in Cosimo III's collection in the Pitti Palace by 1669.

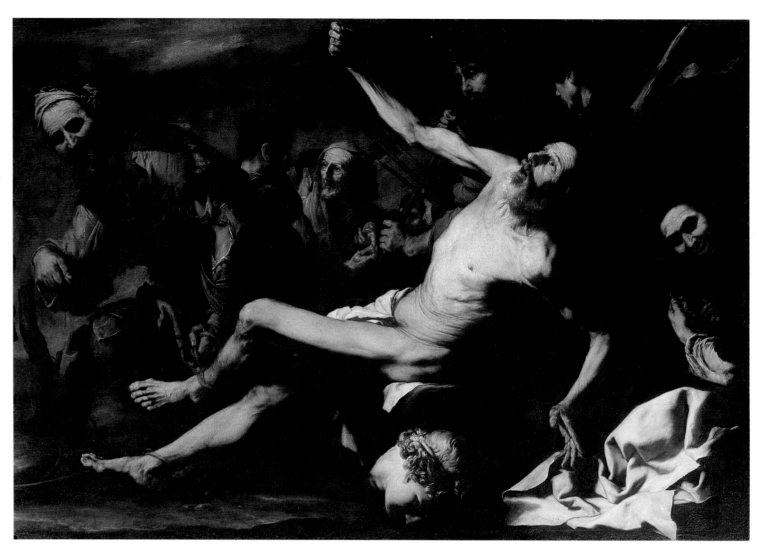

730
JUSEPE DE RIBERA
The Martyrdom of St. Bartholomew
Oil on canvas, 57¹⁄₁₆ × 85 in. (145 × 216 cm)
Pitti, Palatine Gallery; inv. 1912: no. 19

Related to an engraving of 1624 by Ribera, this painting dates from around 1628–1630. It comes from the Capponi collection in San Friano, where it was documented in 1677; it was probably acquired for the Pitti Palace collection during the Lorraine era.

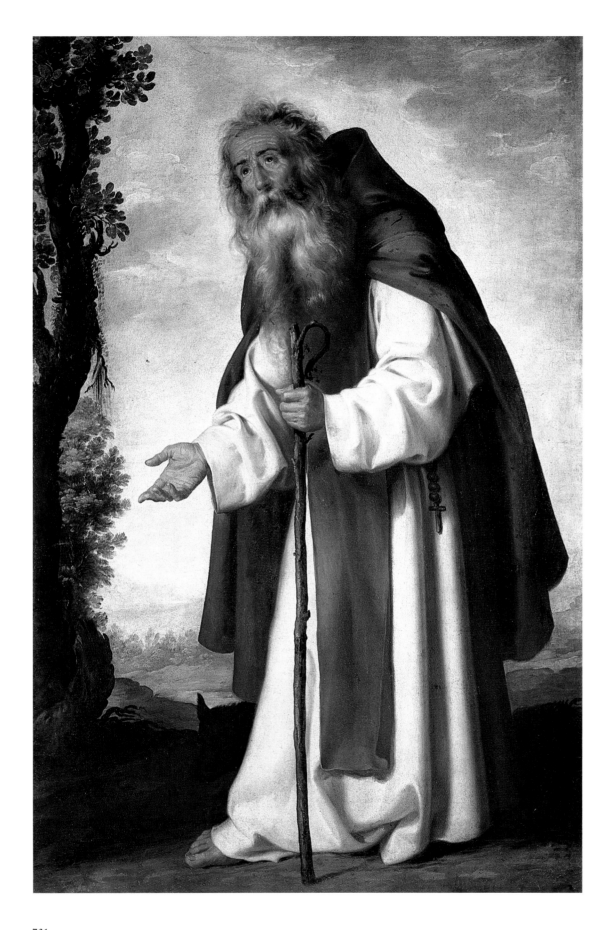

731

FRANCISCO DE ZURBARÁN

St. Anthony Abbot

Oil on canvas, 63¾ × 47¼ in. (162 × 120 cm)

Pitti, Meridiana (temporary location); inv. Contini Bonacossi: no. 23

This painting is closely related to one of the same subject in the Valdés collection in Bilbao, which is signed and dated 1636 and whose provenance is the church of the monastery of San José at Seville. The softer modeling of this version suggests a date a little after the execution of the other work.

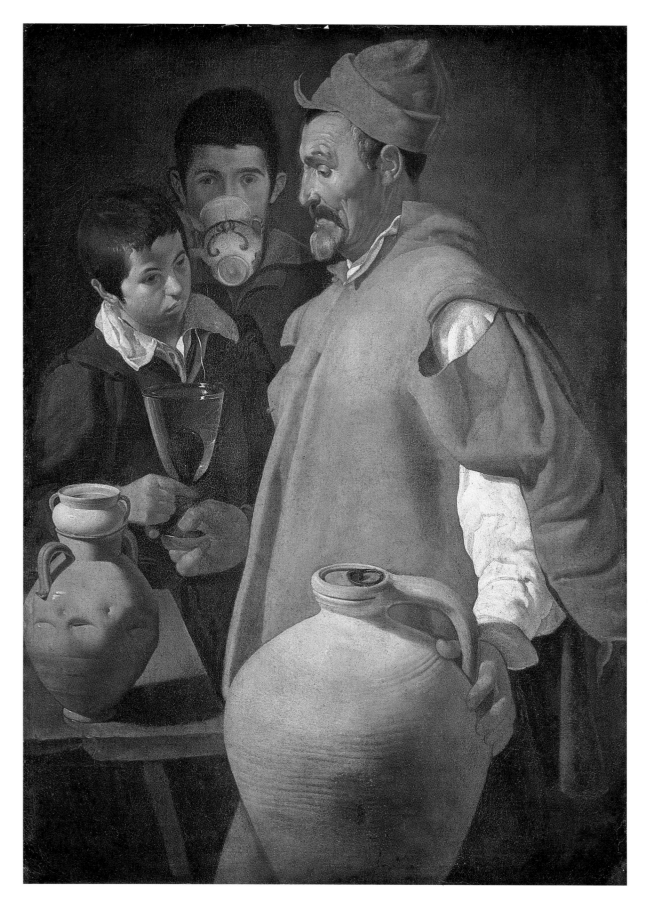

732
DIEGO VELÁZQUEZ
El Aguador de Sevilla
Oil on canvas, 40¹⁵⁄₁₆ × 29½ in. (104 × 75 cm)
Pitti, Meridiana (temporary location); inv. Contini Bonacossi: no. 24

This is thought to be an earlier version of the better-known painting in the Wellington Museum in London, dating from the artist's period in Seville, between 1619 and 1622. The Pitti's canvas is differentiated by the presence of a hat on the head of the "water seller," which may confirm that it is by Velázquez's hand.

733
DIEGO VELÁZQUEZ
Philip IV on Horseback
Oil on canvas, 49⅝ × 35¹³⁄₁₆ in. (126 × 91 cm)
Pitti, Palatine Gallery; inv. 1912: no. 243

This small-scale version of a painting in the Prado (of around 1635) was probably painted by the artist himself. It was sent to Florence by the sculptor Pietro Tacca, who used it as an inspiration for the bronze statue that is now in the Plaza de Oriente in Madrid.

734
ANTONIO DE PEREDA
Allegory of Vanity
Oil on canvas, 64³⁄₁₆ × 80¹¹⁄₁₆ in. (163 × 205 cm)
Uffizi, Gallery; inv. 1890: no. 9435
This important example of the artist's later activity, executed in around 1668, relates to a slightly earlier painting of the same subject that is now in the Kunsthistorisches Museum in Vienna. In both paintings a portrait of Charles V can be seen above the globe.

Opposite: 736
BARTOLOMÉ ESTEBAN
MURILLO
Madonna and Child
Oil on canvas, 61 × 42⅛ in.
(155 × 107 cm)
Pitti, Palatine Gallery; inv.
1912: no. 63
Perhaps identifiable as one of two Madonnas by Murillo whose provenance was a convent in Ypres, this work was acquired by Grand Duke Ferdinand III of Lorraine. It belongs to a later period than the *Madonna of the Rosary* (no. 735).

735
BARTOLOMÉ ESTEBAN MURILLO
Madonna of the Rosary
Oil on canvas, 65 × 42¹⁵⁄₁₆ in. (165 × 109 cm)
Pitti, Palatine Gallery; inv. 1912: no. 56
Along with other versions of the same subject, this painting can be dated to around 1650, the artist's first period of maturity. It was acquired by Grand Duke Ferdinand III of Lorraine in 1822.

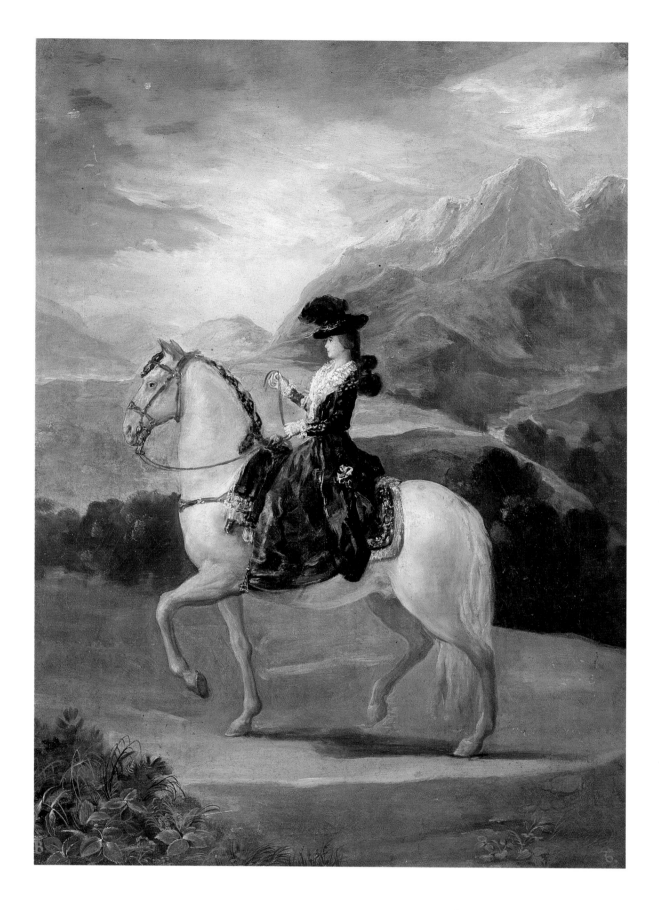

737
FRANCISCO GOYA
Portrait of Maria Teresa de Vallabriga, on Horseback
Oil on canvas, 32½ × 24⁵⁄₁₆ in. (82.5 × 61.7 cm)
Uffizi, Gallery; inv. 1890: no. 9485

This portrait, cited in a letter from Goya, was painted during the artist's 1783 visit to
Boadilla del Monte, the residence of Don Luis de Borbón, brother of King Charles III and
husband of Maria Teresa, the sitter. The picture came to Florence through the inheritance
of the Ruspoli family, from whom it was acquired along with number 738.

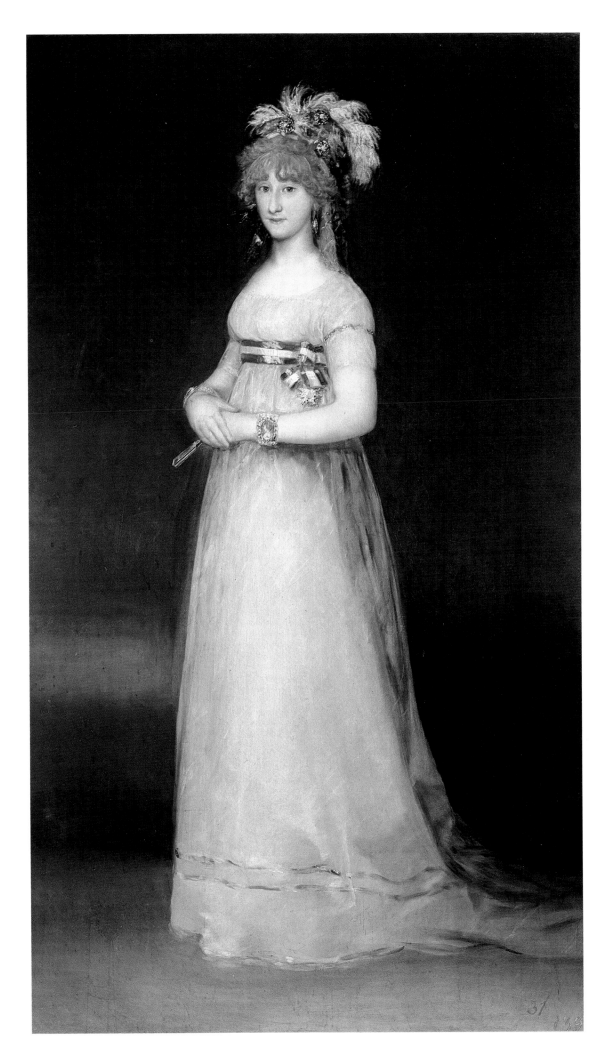

738
FRANCISCO GOYA
*Full-length Portrait of the
Countess of Chinchón*
Oil on canvas, 86⅝ × 55⅛
in. (220 × 140 cm)
Uffizi, Gallery; inv. 1890:
no. 9484

This portrait of the daughter
of Maria Teresa de Vallabriga
and Don Luis de Borbón
probably hung in the Palace
of Boadilla del Monte in
Arena de San Pedro at the
end of the eighteenth cen-
tury. It presumably dates
from around 1797, the year
of her marriage, and came to
the Uffizi, along with the
preceding painting (no. 737),
by way of the Ruspoli family.

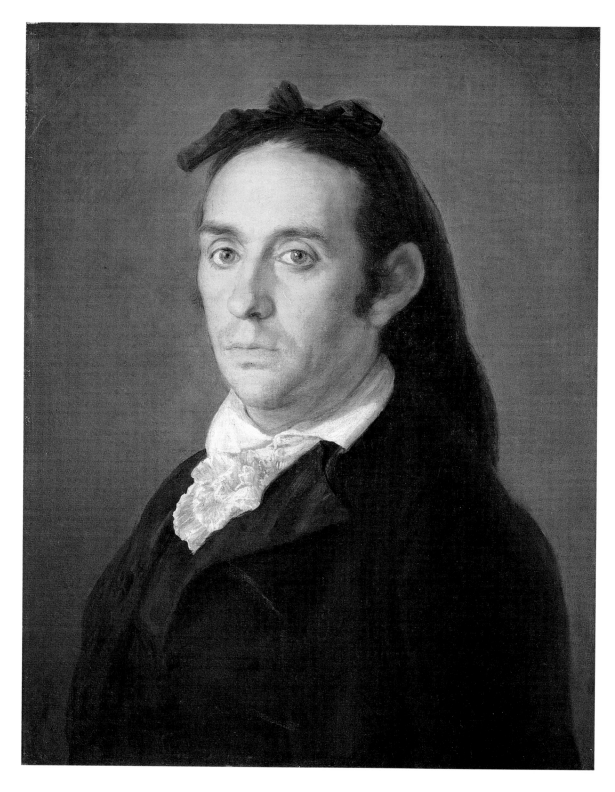

739
FRANCISCO GOYA
Portrait of the Bullfighter Pedro Romero
Oil on canvas, 20⅞ × 16½ in. (53 × 42 cm)
Pitti, Meridiana (temporary location); inv. Contini Bonacossi: no. *22*

The famous toreador, aged about forty-two in this picture, was also the subject of other noteworthy paintings by the artist. Similarities between this and a portrait in the gallery of Francisco Zapater, Goya's friend and biographer, suggest a date of around 1797.

France

The collection of seventeenth- and eighteenth-century French paintings in the Florentine galleries is anything but the fragmentary and almost chance assemblage that the Medici's lack of interest in this school of art might suggest. Particularly important are the holdings of "royal" portraits by artists from Pourbus the Younger (usually considered to be a Fleming) to Nattier, which came to Florence for historical reasons. Catherine de' Medici's marriage to Henry II of France was the beginning of a relationship between the families that would eventually bear its fruit, above all with the nuptials of Maria de' Medici and Henry IV. Pourbus's series of portraits is very important, although his style must be considered in the context of the Flemish school. The pastel painter Nanteuil, portraitist to the court of Louis XIV, is also represented in the Florentine collections as much for dynastic reasons as for artistic ones: his portraits of the Sun King and of the famous General Turenne, as well as his own splendid self-portrait, reached Florence by way of the marriage of Marguerite-Louise of Orléans to Cosimo III de' Medici, and because the Florentine Domenico Tempesti was Nanteuil's favorite pupil.

A certain number of seventeenth-century French paintings were acquired in Paris in 1792 by Grand Duke Ferdinand III of Lorraine, who wished to fill what was then a notable gap in the Florentine collections. Cardinal Giancarlo de' Medici once owned a work of great quality by Nicolas Poussin—the *Adoration of the Magi*, today in the National Gallery in London—but it was sold off on his death by his brother Ferdinand II. Today the only work in Florence by this greatest master of seventeenth-century French painting is a replica of *Theseus Finding His Father's Arms;* this canvas gives some idea of the severe monumentality of this artist, who, though he always lived in Rome, had a decisive influence on the history of French painting.

Of the second great French master, Claude Gellée, called Claude Lorraine—the greatest landscape artist of seventeenth-century Europe, who also chose Rome as his second home—Florence possesses, thanks to its having been acquired by Cardinal Carlo de' Medici, a first-period masterpiece (around 1637), the *Port with the Villa Medici.* This work presents all the mature elements of the painter's contact with the scenery and antiquities of Rome, from which he extracted the secret of light in its various phases during the day, producing a perfect interpretation never before seen in painting. A second canvas, the *Landscape with a Shepherds' Dance,* acquired by Leopoldo de' Medici, presents another side of the artist's work, the representation of the bucolic.

Considered to be a French artist even though he was born and always lived in Rome, Gaspard Dughet was called Poussin because he was the brother-in-law of the great Nicolas. The Florentine galleries have several paintings by him, all from his later period, which demonstrate his most romantic attitude and anticipate nineteenth-century art in their objective interpretation of the Roman countryside.

Thanks to Mattias de' Medici's interest in military matters, the Medici collection contains several masterpieces by the most famous battle painter of the century, Jacques Courtois, known as Borgognone. The *Taking of Radicofani,* which depicts one of the four incidents of war in which Mattias actually participated, is masterly proof of the painter's ability to reconstruct an episode realistically and to set it within a landscape that bears objective witness to the feats of arms.

The collections possess only a few examples of paintings by the more typical French artists. These include a beautiful *Madonna of the Basket* from the end of Simon Vouet's Roman period, which displays, in its rich chromatic impasto, the influence of Rubens; a *Fortune-teller* by the *bambocciante* Sébastien Bourdon; Jacques Stella's *Christ Served by the Angels;* Dufresnoy's *Socrates Drinking Hemlock;* an *Annunciation* by Dorigny; Jean Jouvenet's *Education of the Virgin;* and, by Charles Le Brun, the most celebrated of Louis XIV's court painters, *Jephthah's Sacrifice.* All of these artists moved in the classical orbit defined by Poussin's influence.

If Ferdinand's acquisition of 1792 brought no great masterpieces of eighteenth-century French painting to Florence, it did, however, bring a Boucher (the *Baby Jesus and the Infant St. John*), two Parrocels (the *Cavalry Battle* and the *Hunt*), two *Pilgrims* by Grimoux, a Rigaud (*Portrait of Jacques-Bénigne Bossuet*), and a Largillière (*Portrait of Jean-Baptiste Rousseau*), as well as a little painting, the *Flautist,* which introduced the city to the magical world and pictorial musicality of Antoine Watteau. (This last painting has now been reattributed to a sympathetic follower of Watteau, Pierre-Antoine Quillard, rather than the master himself.)

The presence in the Florentine collections of several eighteenth-century paintings of the highest quality once again came about almost by chance. Again, it was for historical reasons that portraits of the French royal family came from Parma to Florence, including the beautiful pictures *Louis XV as a Baby with the Infanta of Spain* by Jean-François de Troy, *Maria Leszczyńska* by Carle van Loo, *Marie-Adélaïde of France Dressed in Turkish Costume* by the fine pastel painter Jean-Étienne Liotard, and the spirited small portrait of the young Marie Zéphyrine, niece of Louis XV, by Jean-Marc Nattier. Nattier also painted two classical portraits of Louis XV's daughters, *Henrietta of France as Flora* and *Marie-Adélaïde of France as Diana,* which represent with supreme elegance the essence of the court portrait on the eve of the revolution. Of a different world, more real and concrete in their use of light, are the two charming pendant portraits of children by Jean-Baptiste-Siméon Chardin, *Young Girl with a Shuttlecock* and *Young Boy with a House of Cards,* variations on a theme that the painter repeated on a number of occasions with a great deal of insight into the representation of the spirit of childhood. Finally, the works of Claude-Joseph Vernet, the two superb pastel paintings by Jean Pillement, and the *Arch of Titus* attributed to Hubert Robert brought French painting toward the romantic climate that heralded the new century.

Marco Chiarini

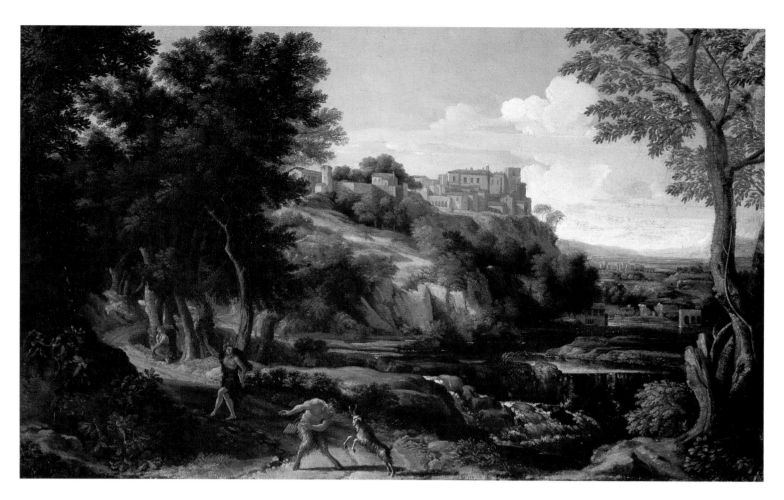

740
GASPARD DUGHET
Landscape with a Dancing Faun
Oil on canvas, 20½ × 34¼ in. (52 × 87 cm)
Pitti, Palatine Gallery; inv. 1912: no. 416
This painting was in the Medici collections by the beginning of the eighteenth century.

741
JACQUES STELLA
Christ Served by the Angels
Oil on canvas, 43¹¹⁄₁₆ × 62³⁄₁₆ in. (111 × 158 cm)
Uffizi, Gallery; inv. 1890: no. 996
This canvas is mentioned in a 1693 inventory of the property of Claudine-Bouzonnet Stella, the artist's niece. It was acquired in Paris in 1793 by Grand Duke Ferdinand III of Lorraine, through Francesco Favi. It dates from around 1650.

742
SIMON VOUET
Madonna of the Basket
Oil on panel, 52 × 38⅜ in. (132 × 98 cm)
Uffizi, Gallery; inv. 1890: no. 984

Transferred a number of times between the Pitti and the Uffizi and at one point exhibited under the name of de la Hyre, this panel is now recognized as the work of Vouet. He painted it during the last years of his period in Rome (c. 1625–1626), when he was working for Cardinal Francesco Barberini.

743

NICOLAS POUSSIN

Theseus Finding His Father's Arms

Oil on canvas, 38⁹/₁₆ × 50¹³/₁₆ in. (98 × 129 cm)

Uffizi, Depository; inv. 1890: no. 1004

This famous painting, of which many replicas and engravings were made, dates from around 1633–1634. It was acquired in Paris in 1793 by Francesco Favi on behalf of Grand Duke Ferdinand III of Lorraine. It has been suggested that Lemaire may have assisted in the execution of the architecture.

744

CLAUDE GELLÉE, called LE LORRAINE

Port with the Villa Medici

Oil on canvas, 40³⁄₁₆ × 52³⁄₈ in. (102 × 133 cm)

Signed and dated: ROMAE 1637 CLA(. . .)

Uffizi, Gallery; inv. 1890: no. 1096

This masterpiece by Claude Lorraine was executed in Rome in 1637 for Cardinal Carlo de' Medici and came to the Uffizi in 1773. It is an architectural fantasy that depicts, in homage to its patron, the facade of the Medici villa on an imaginary site facing out onto a seaport, a genre for which Lorraine was famous.

745
ROBERT NANTEUIL
Portrait of Louis XIV, King of France
Pastel on paper, 21¹/₁₆ × 17⅛ in. (53.5 × 43.5 cm)
Uffizi, Gallery; inv. 1890: no. 824
It is not known whether this painting, signed and dated 1670 on the back, was acquired by Grand Duke Cosimo III during his visit to France in 1669–1670 or whether it came to Florence through Nanteuil's pupil Domenico Tempesti.

746
SÉBASTIEN BOURDON
The Fortune-teller
Oil on copper, 18⅞ × 15⅜ in. (48 × 39 cm)
Uffizi, Gallery; inv. 1890: no. 1206
In the eighteenth century this painting was kept in the Pitti Palace. Only recently given to Bourdon, it depicts a typical subject of the *bambocciata* genre and was executed around 1636–1638, during the French painter's period in Italy.

747

CHARLES LE BRUN

Jephthah's Sacrifice

Oil on canvas, 52 in. (132 cm) in diameter

Uffizi, Gallery; inv. 1890: no. 1006

Probably executed around 1656, this tondo was acquired in Paris in 1793 by Grand Duke Ferdinand III, along with other French paintings. Le Brun is known to have painted this subject (of which a replica exists in Moscow) for both Signor Poncet and Louis-Henri de Loménie, count of Brienne.

748
JACQUES COURTOIS, called BORGOGNONE
The Battle of Lützen
Oil on panel, 55⅛ × 108¼ in. (140 × 275 cm)
Pitti; inv. Oggetti d'Arte 1911: no. 451

This work portrays an episode in the battle fought in November 1632, during the Thirty
Years' War. It ended in victory for the Swedes, though not without the loss of their king,
Gustav Adolph II.

749

JACQUES COURTOIS, called BORGOGNONE

The Taking of Radicofani

Oil on canvas, 55½ × 108¼ in. (141 × 275 cm)

Uffizi, Gallery; inv. 1890: no. 972

Executed for the villa of Lappeggi, the property of Mattias de' Medici, this work celebrates one of Mattias's victories in the "war of Castro" of 1641–1643, against the Papal State. It probably dates from around 1652, during the artist's stay in Tuscany at the service of the prince.

750

JOSEPH PARROCEL

Cavalry Battle

Oil on canvas, 19¹¹⁄₁₆ × 26⅜ in. (50 × 67 cm)

Uffizi, Gallery; inv. 1890: no. 974

One of the group of French paintings acquired in Paris in 1793 by Grand Duke Ferdinand III of Lorraine through his agent Francesco Favi, this painting was attributed to Parrocel at the time of its sale. It dates from the end of the seventeenth century.

751

JEAN JOUVENET

The Education of the Virgin

Oil on canvas, 40⅛ × 27¹⁵⁄₁₆ in. (102 × 71 cm)

Uffizi, Gallery; inv. 1890: no. 998

This painting can probably be dated to around 1700, as it is stylistically later than the version in the church of Haramont, in Aisne, which is signed and dated 1699. This canvas was acquired in Paris in 1793 by Ferdinand III of Lorraine, through Francesco Favi.

752

HYACINTHE RIGAUD

Portrait of Jacques-Bénigne Bossuet

Oil on canvas, 28⅜ × 23 in. (72 × 58.5 cm)

Uffizi, Gallery; inv. 1890: no. 995

This famous portrait, which was copied many times and also made into an engraving, depicts Jacques-Bénigne Bossuet (1627–1704), bishop of Meaux and a famous orator. It was executed in 1698, as an inscription on the back indicates, for Grand Duke Cosimo III de' Medici.

753
NICOLAS DE LARGILLIÈRE
Portrait of Jean-Baptiste Rousseau
Oil on canvas, 35⁷⁄₁₆ × 28⁹⁄₁₆ in. (90 × 72.5 cm)
Uffizi, Gallery; inv. 1890: no. 997

Executed, as a label on the back indicates, in 1710, this portrait once belonged to the
painter Ignazio Hugford. It was acquired in 1779.

754
JEAN-MARC NATTIER
Henrietta of France as Flora
Oil on canvas, 37³⁄₁₆ × 50⅝ in. (94.5 × 128.5 cm)
Signed and dated: NATTIER PINXIT 1742
Pitti, Appartamenti Reali; inv. Depository: no. 23

This portrait, executed in 1742, presents its subject in allegorical dress. Henrietta was the
twin sister of Louisa Élisabeth and the bride of the infante Don Filippo of Spain. The
picture came to the Pitti in 1865, when Florence became the capital.

755

JEAN-MARC NATTIER

Marie-Adélaïde of France as Diana

Oil on canvas, 37⅜ × 50⅜ in. (95 × 128 cm)

Signed and dated: NATTIER PINXIT 1745

Pitti, Appartamenti Reali; inv. Depository: no. 21

Painted in 1745 as a pendant to number 754, this portrait depicts Marie-Adélaïde, sister of Henrietta and daughter of King Louis XV of France. It came to the Pitti in 1865.

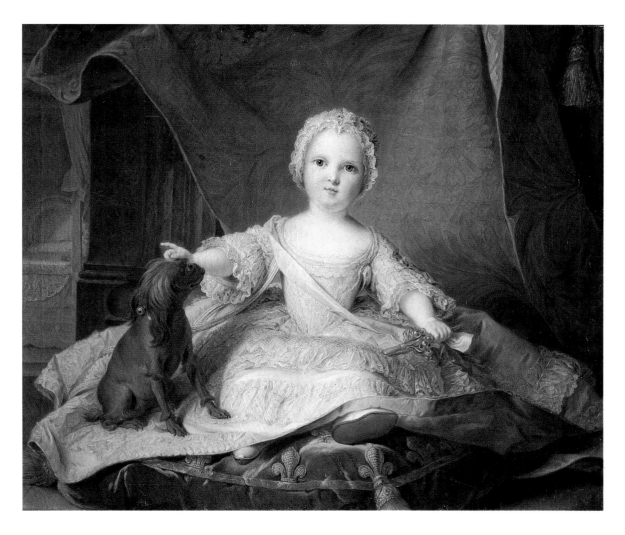

756

JEAN-MARC NATTIER
Marie Zéphyrine of France as a Baby
Oil on canvas, 27⁹⁄₁₆ × 32⁵⁄₁₆ in. (70 × 82 cm)
Dated: 1751
Pitti, Appartamenti Reali; inv. Depository: no. 22

This painting, dated 1751, depicts Marie Zéphyrine (1750–1755), granddaughter of Louis XV, at one year of age. It came to the Pitti in 1865 with the two preceding works by the artist (nos. 754 and 755).

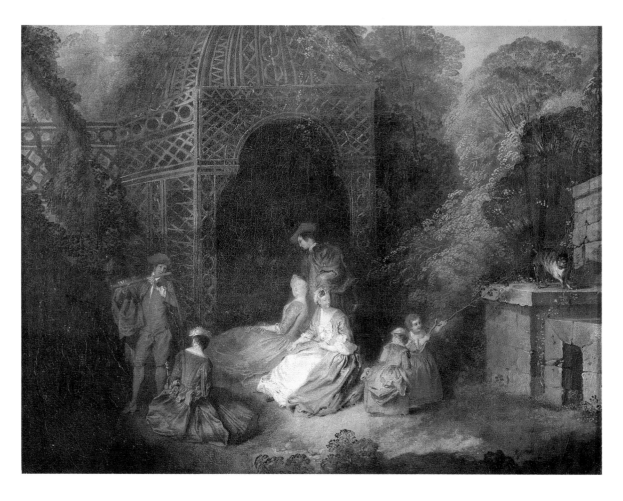

757

JEAN-ANTOINE WATTEAU (Circle of)
The Flautist
Oil on canvas, 14⁹⁄₁₆ × 18⁷⁄₈ in. (37 × 48 cm)
Uffizi, Gallery; inv. 1890: no. 990

The provenance of the painting is unknown; it probably came to the Uffizi from the Pitti Guardaroba. Once attributed to Jean-Antoine Watteau, it has more recently been given to Pierre-Antoine Quillard (Paris, c. 1701–Lisbon, 1733), a painter of *fêtes gallantes* in the style of Watteau.

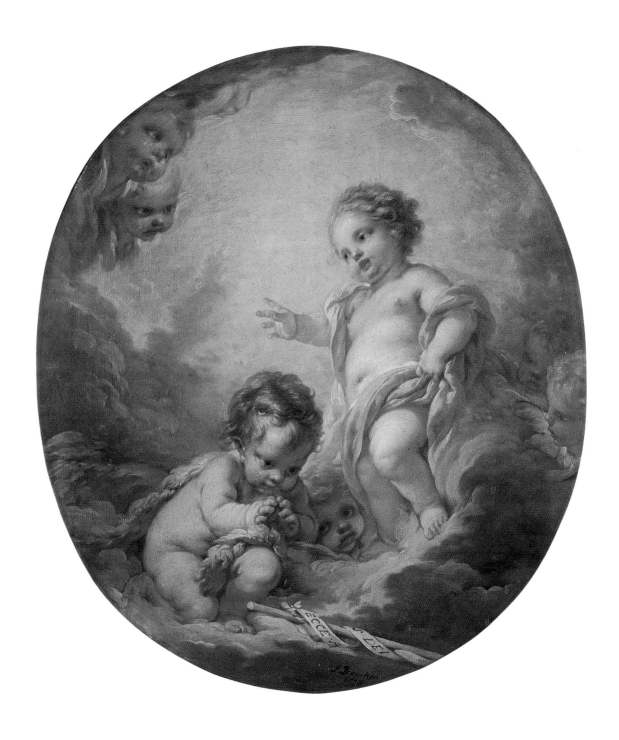

758

FRANÇOIS BOUCHER

The Baby Jesus and the Infant St. John

Oil on canvas, 19¹¹⁄₁₆ × 17⁵⁄₁₆ in. (50 × 44 cm)

Signed and dated: F. BOUCHER 1758

Uffizi, Gallery; inv. 1890: no. 976

As the signature and the date 1758 confirm, this is an autograph work of Boucher's full maturity. Once in the collection of the marquise of Pompadour, it was acquired, along with other French paintings, by Francesco Favi in 1793 on behalf of Grand Duke Ferdinand III.

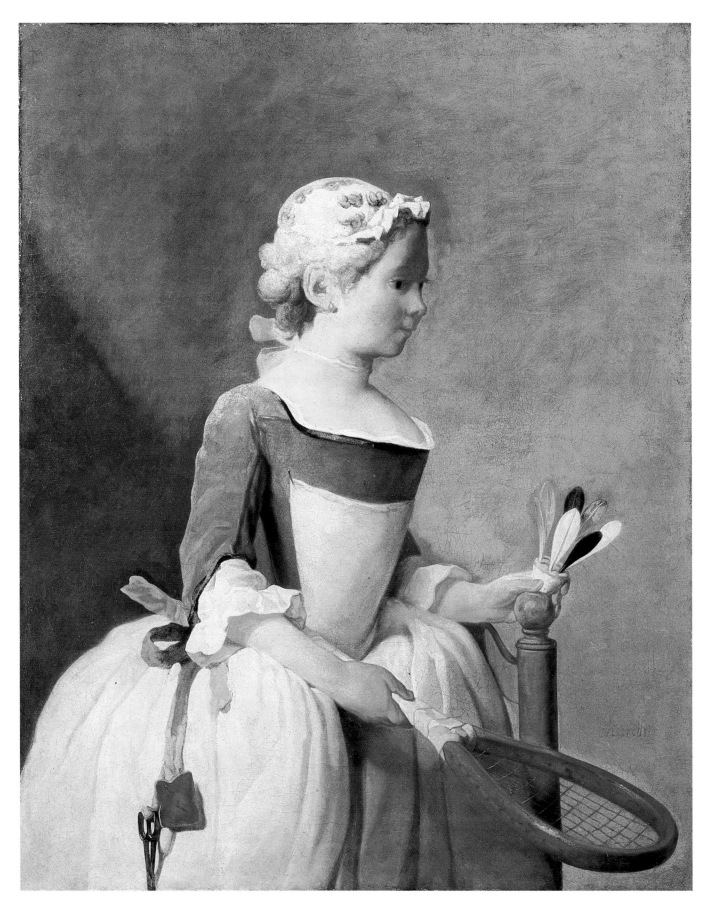

759
JEAN-BAPTISTE-SIMÉON CHARDIN
Young Girl with a Shuttlecock
Oil on canvas, 32⅚₁₆ × 26 in. (82 × 66 cm)
Signed: CHARDIN
Uffizi, Gallery; inv. 1890: no. 9274

Signed by the artist and datable to around 1740, this work came from the Pallavicino
collection.

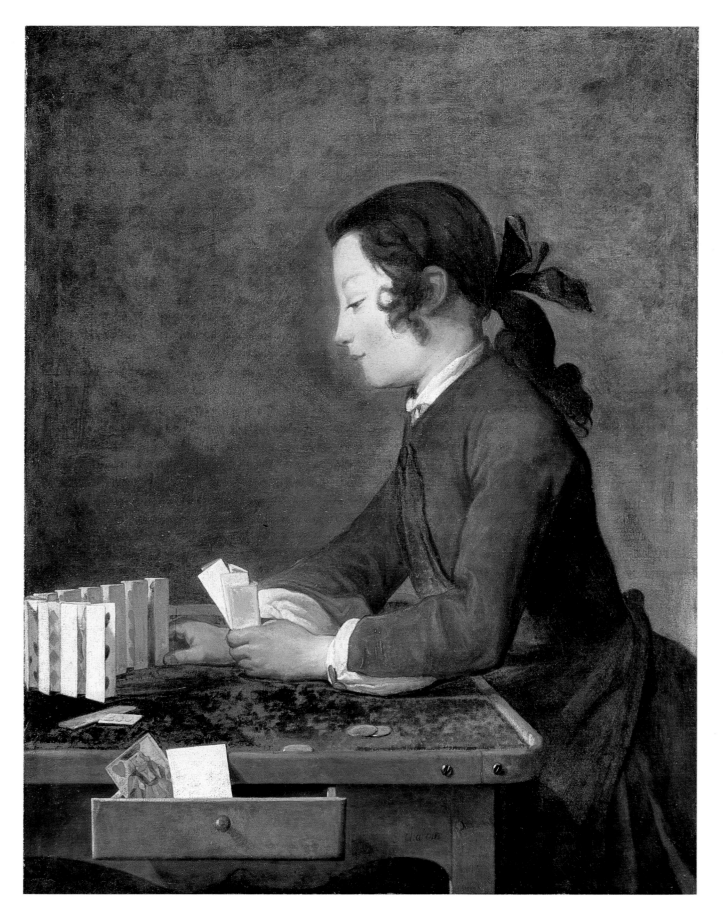

760
JEAN-BAPTISTE-SIMÉON CHARDIN
Young Boy with a House of Cards
Oil on canvas, 32⅚₁₆ × 26 in. (82 × 66 cm)
Signed: CHARDIN
Uffizi, Gallery; inv. 1890: no. 9273

This picture was painted as a pendant to number 759, with which it came to the Uffizi
through an acquisition in 1951.

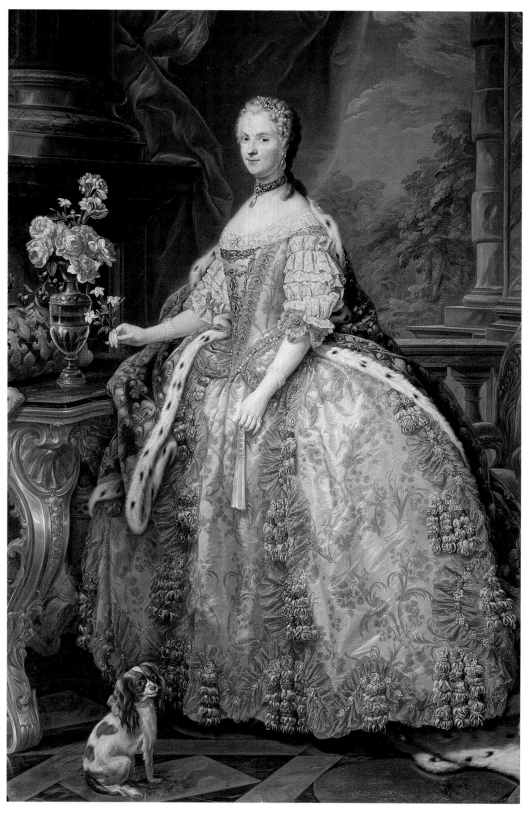

761
CARLE VAN LOO
Portrait of Maria Leszczyńska
Oil on canvas, 88³⁄₁₆ × 59¹³⁄₁₆ in. (224 × 152 cm)
Pitti, Appartamenti Reali; inv. Oggetti d'Arte: no. 714
This canvas came to the Florentine galleries in the 1860s from the ducal palace in Parma.

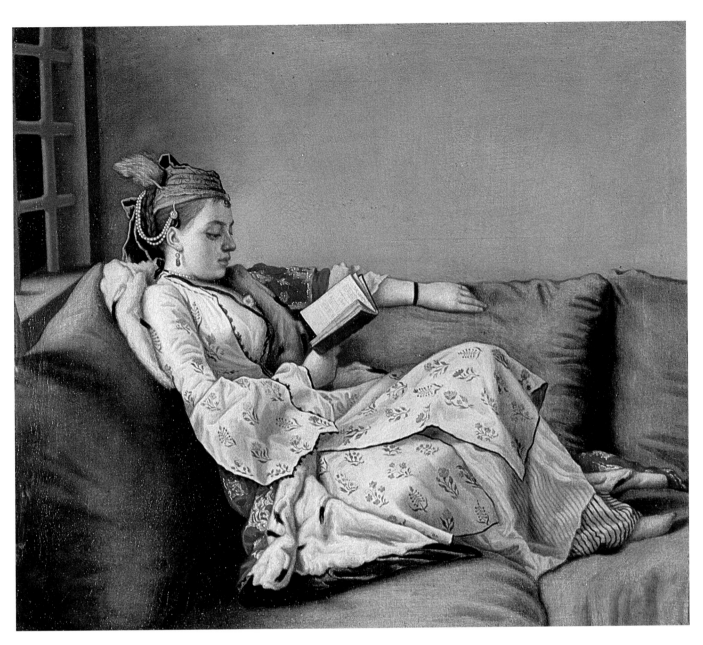

762
JEAN-ÉTIENNE LIOTARD
Marie-Adélaïde of France Dressed in Turkish Costume
Oil on canvas, 19¹¹⁄₁₆ × 22¹⁄₁₆ in. (50 × 56 cm)
Uffizi, Gallery; inv. 1890: no. 1055

An inscription on the back of this painting indicates a date of execution of 1753 and permits the sitter to be identified, albeit with some doubt, as Marie-Adélaïde of France, daughter of Louis XV. (A Nattier portrait of her, in allegorical dress, is in the Uffizi [no. 755].)

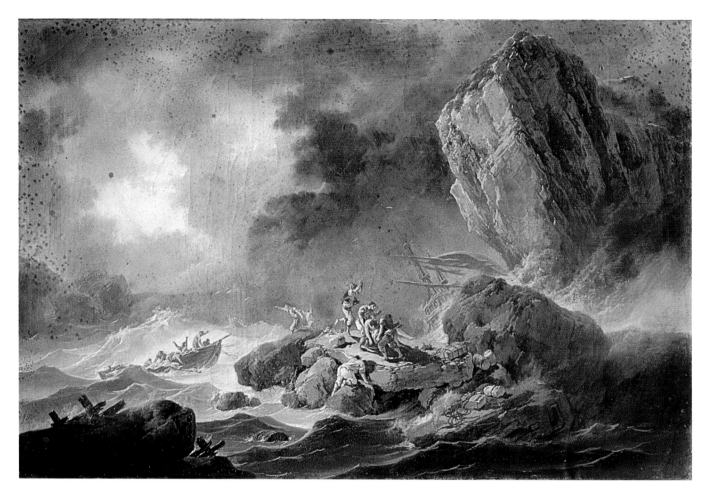

763
JEAN PILLEMENT
Seascape with a Shipwreck
Pastel, 22⁷⁄₁₆ × 35¹⁄₁₆ in. (57 × 89 cm)
Uffizi, Gallery; inv. 1890: no. 1007

Inspired by the genre made famous by Claude Lorrain and Vernet, Pillement produced this work in pendant with another depicting calm seas. Recorded in the Uffizi from 1791, it was probably executed not long before that date.

Opposite: 764
CLAUDE-JOSEPH VERNET
Seascape with a Shipwreck
Oil on canvas, 20¹⁄₁₆ × 15¾ in. (51 × 40 cm)
Uffizi, Gallery; inv. 1890: no. 985

This is one of two pendant paintings acquired in 1801 on the advice of the painters Fabre and Boguet; it is datable to 1743–1748.

The Collection of Painters' Self-Portraits

Although a few artists from the Middle Ages painted portraits of themselves as painted or sculpted "faces in the crowd," distinctive for looking "outside the picture" (e.g. Andrea Orcagna in the *Death and Assumption of the Virgin* behind the altar of Orsanmichele), it was only in the Renaissance that the figure of the painter acquired social status and a sense of pictorial worth. The artist's personality began to be transmitted not only through written notices but also through a figurative record of his own physiognomy—an aspect that had been considered essential to capture in words since Plutarch's *Lives* and a custom continued by later biographers, often with lively results. "He used to dress in clothes that looked as if they had been thrown on him out of the window"; "he was small in stature and very sturdy, with a red face, more ugly than handsome, bulbous and very big eyes, and a thin mouth": thus did Baldinucci, father and son, describe Giovanni da San Giovanni and Gherardini, respectively. Leon Battista Alberti was the first to leave a painted portrait of himself, though the fifteenth century produced a number of pictures of famous dead artists, such as the group portrait, now in the Louvre, of Brunelleschi, Manetti, Giotto, Paolo Uccello, and Donatello, and the one in the Uffizi of three generations of the Gaddi, in frontal, profile, and three-quarter views. This type of documentary portrait took a decisive step forward in Florence in the middle of the sixteenth century on the initiative of Cosimo I de' Medici and Vasari, when the former ordered the latter to fill the Palazzo Vecchio with images of illustrious men, some of whom were also artists. (In the original collection there were also self-portraits of professional painters, of which the only remaining are those of Dürer and Titian.) When Vasari founded the Academy of Design in 1562, he wanted the portraits of those artists who were examples for the Florentine school (there would ultimately be about thirty of these, many produced by the young painters as a sort of calling card), and in the second edition of his *Lives,* each of the biographical pieces was accompanied by a likeness carefully (if not always accurately) drawn from contemporary sources. Without a doubt, the book's success contributed to the fortune of the self-portrait as a genre; from the late sixteenth century onward, it was practically an obligatory theme for artists, and the variety of ways in which they depicted themselves constitutes one of the most fascinating fields of historical and critical research.

Indeed, the self-portrait is a very special kind of work, a miraculous fusion of author and theme, of subject and object, always extremely rich in significance both hidden and manifest, in which every element has a precise reason for being and the personality of the creator is revealed through his intentions. The serenely fulfilled painter portrays himself with no flattery of attempted rejuvenation, no symbols of importance, often even without the tools of his trade (which change, over the years, from a simple brush to a whole bunch of brushes and a palette, to a neoclassical sketchbook, to didactic books). The young painter just out of school wears the first elegant clothes he has bought with the profits from his work; the court painter shows off his patrons and the honors they have lavished on him (gold chains, orders, medals); the genre specialist displays his subjects (flowers or animals); the sentimentalist, his relatives (his father-teacher, his collaborative wife); and the Renaissance man, his other abilities (musical instruments, compasses) or the classical books and statues that inspire him. And then there are the apotropaic charms (the trompe l'oeil corner of the torn canvas, the fly) or the symbols of the passage of time or the struggle between good and evil (the skull, the dog and the cat) or even, sometimes, explicit written declarations of the desire to live beyond the grave through the self-portrait.

The Uffizi collection, with its 2,300 examples, is the greatest in the world; it has been imitated but never equaled. Many academies and some museums have sought to compete with it (including the Accademia di San Luca in Rome, the Brera, and the National Academy of Design in New York, with which an exchange of self-portraits for exhibition has been effected), but none has succeeded. Today only the Florentine galleries can exemplify every aspect of the panorama of self-portraiture. This clever concept of the greatest collector among the Medici princes, Leopoldo, son of Cosimo II, began in 1664 with a scientific system. First, painters already known to the Medici were sought out for gifts or acquisitions, among them Pietro da Cortona, Guercino, Ciro Ferri, and Volterrano; next, contemporary artists who were farther afield were approached through agents and friends in other states, European rulers, or travelers. In eleven years the collection grew to eighty paintings, a number doubled by Leopoldo's successor, Grand Duke Cosimo III, who also saw to the portraits' installation, in 1682, in a room presided over by a statue of his uncle. Cosimo's children Ferdinand, Gian Gastone, and Anna Maria Luisa in turn nurtured the collection, until the family finally died out. However, during the thirty-year reign of the dukes of Lorraine, the absent empress Maria Teresa and Emperor Francis I had other works sent from Vienna (by Liotard, Seybold, and Rotari), and in 1765 their son Pietro Leopoldo acquired a collection of 120 self-portraits that had belonged to Abbot Antonio Pozzi, which he added to that of the deceased grand-ducal doctor, Tommaso Puccini. Visiting foreigners who often wished to copy famous paintings in the gallery were also solicited, sometimes after the fact, through appeals (rarely in vain) to their memories of Florence. Thus did the portraits of many English artists enter the collection, those of all the French *prix de Rome* winners, and, in the nineteenth century, the first Russian examples. When the state of Tuscany was subsumed into a united Italy, the fame of the collection was such that not only the directors of the Uffizi but also

ministers, ambassadors, and organizers of international exhibitions (such as Vittorio Pica at the beginning of the Bienniale) had their requests for paintings easily satisfied. The rate of growth varied, but every new initiative— including the most recent, launched by the director, Luciano Berti, after the compilation of the *General Catalogue of the Uffizi* (1979), in which all the portraits were illustrated, some of them for the first time—met with great success. The effort completed in the 1980s saw the addition of more than two hundred new self-portraits by both Italian and foreign painters, which were presented in two exhibitions in 1981 and 1983. In the last few years several works have been found in the inexhaustible depository (Francesco Marmi, Assunta Bocchi), others have been newly acquired (Giacomo Gavotti), and two dozen more have come in as gifts (including the extremely important picture by Giacomo Balla), ample testimony to the collection's vitality.

The self-portraits were by far the most copied paintings in the museum while this practice lasted, and they have been featured in monographic exhibitions all over the world; often the self-portrait is the only record of what an artist looked like, and sometimes it is the only secure work of a painter whose entire oeuvre has been dispersed. And although the genesis of the collection is today so well known that it is possible to put all the arrivals in chronological order, not only yearly but also daily, about twenty such paintings are still unidentified. These works, as well as historical references to others that once existed but whose present location is unknown, stimulate the desire to investigate further.

Silvia Meloni

765
RAPHAEL
Self-portrait
Panel, 18⅝ × 13¹¹⁄₁₆ in. (47.3 × 34.8 cm)
Uffizi, Gallery; inv. 1890: no. 1706
This picture was executed in around 1506 and brought to Florence from Urbino in 1631 with Vittoria della Rovere's inheritance. Vittoria probably gave it to her brother-in-law Leopoldo for his self-portrait collection; it entered the gallery in 1682.

766
ANDREA DEL SARTO
Self-portrait
Flat tile, 20¼ × 14¾ in. (51.5 × 37.5 cm)
Uffizi, Vasari Corridor; inv. 1890: no. 1694
Painted at Vallombrosa in 1528 or 1529, as Vasari recounts, and in the possession of the painter's widow for forty years, this work came to the Uffizi before 1635 and has remained there ever since.

767
LUCA CAMBIASO
Self-portrait of the Artist While Painting His Father
Oil on canvas, 34⅟₁₆ × 27¹⁵⁄₁₆ in. (6.5 × 71 cm)
Uffizi, Vasari Corridor; inv. 1890: no. 1811
This portrait was acquired from the Micone house in Genoa in March 1675 by Bolognetti, acting on behalf of Leopoldo de' Medici; it entered the Uffizi in 1682. Probably a replica of a self-portrait once belonging to the Spinola family, it can be dated to around 1570.

768

FEDERICO BAROCCI

Self-portrait as an Old Man

Oil on canvas, 16⅝ × 13 in. (42.2 × 33.1 cm)

Uffizi, Vasari Corridor; inv. 1890: no. 1848

This work was in the inheritance of Cardinal Leopoldo de' Medici who received one from the Urbino patrimony when it arrived in Florence in 1631 and acquired another in the Marches in 1667. A preparatory drawing for the picture is in the Würzburg Museum.

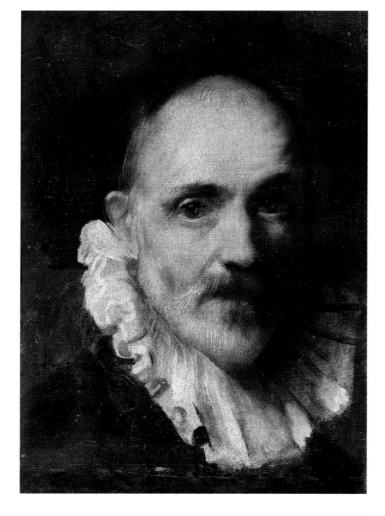

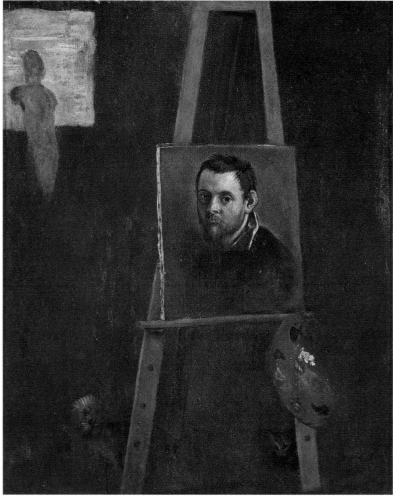

769

ANNIBALE CARRACCI

Self-portrait on an Easel

Oil on canvas, 14³⁄₁₆ × 11¾ in. (36.5 × 29.8 cm)

Uffizi, Vasari Corridor; inv. 1890: no. 1774

Although this painting was in Leopoldo de' Medici's collection by 1675, it joined the other self-portraits in the Uffizi only at the end of the eighteenth century. It dates from around 1595. Another version of the portrait is in the Hermitage in St. Petersburg.

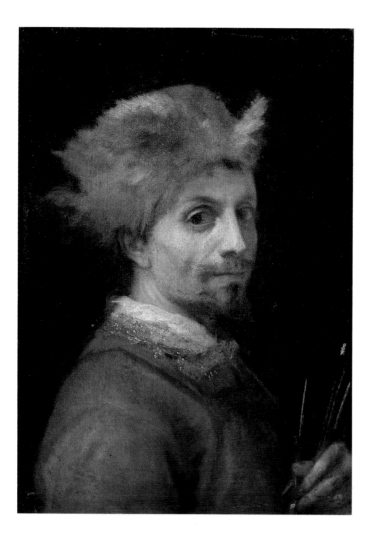

770

LUDOVICO CIGOLI

Self-portrait

Oil on canvas, 23 × 17⁵⁄₁₆ in. (58.5 × 44 cm)

Uffizi, Vasari Corridor; inv. 1890: no. 1729

Once owned by Cardinal Carlo de' Medici, this picture entered the Uffizi in 1682 in the collection of Carlo's nephew Leopoldo. It can be dated to around 1606. The brush and compasses indicate the double profession of painter and architect.

771

VENTURA SALIMBENI or FRANCESCO VANNI

Self-portrait with Parents and Half-brother

Oil on canvas, 33¹¹⁄₁₆ × 40¹⁵⁄₁₆ in. (85.5 × 104 cm)

Uffizi, Vasari Corridor; inv. 1890: no. 1759

Catalogued in the Uffizi in 1695 as a portrait of three painter brothers, this picture is in fact two half-brothers with their mother, Battista Focardi, and her second husband, Arcangelo Salimbeni. It was probably painted by both men in the first decade of the seventeenth century.

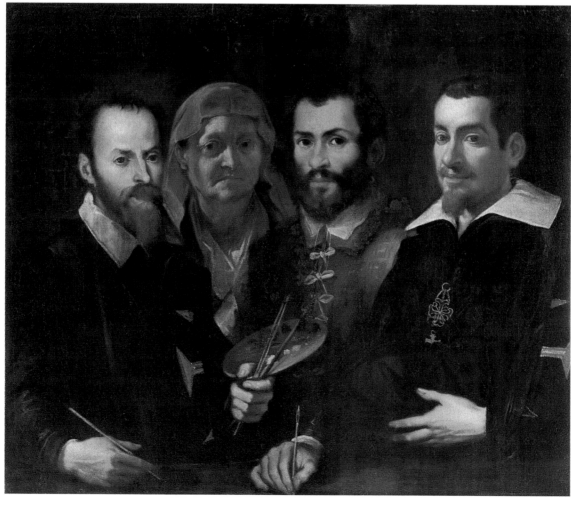

772

CARLO DOLCI

Self-portrait

Oil on canvas, 29⁵⁄₁₆ × 23¹³⁄₁₆ in. (74.5 × 60.5 cm)

Signed and dated: A. S.R/1674/ DI ANNI 58 / PER SUA
ALTEZZA R.M.A 10 CARLO DOLCI

Uffizi, Vasari Corridor; inv. 1890: no. 1676

Both the depicted drawing (in the Uffizi, inv. 1173 F)
and this painting were commissioned from the artist
by Leopoldo de' Medici. Dolci has here depicted him-
self in both profile and frontal views, in country and
town dress.

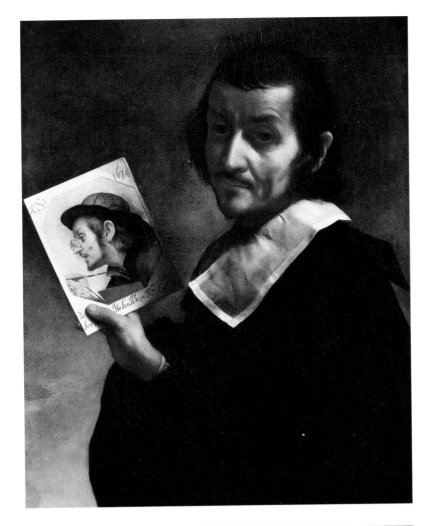

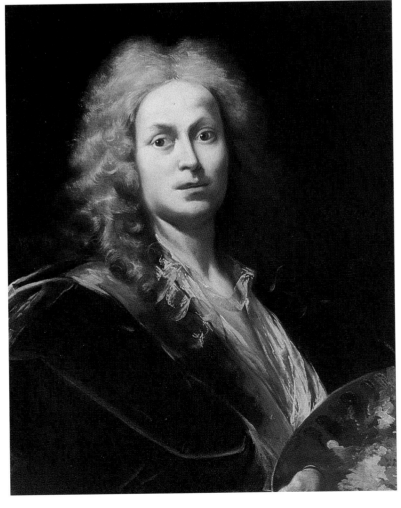

773

GIOVAN DOMENICO FERRETTI

Self-portrait

Oil on canvas, 28⁹⁄₁₆ × 22¹¹⁄₁₆ in. (72.5 × 57.7 cm)

Signed and dated on the reverse: GIO: DOM:
FERRETTI SE DIPINSE L'ANNO 1719

Uffizi, Vasari Corridor; inv. 1890: no. 1747

This work belonged first to the grand-ducal doctor
Tommaso Puccini (whose house was frescoed by the
artist) and then to the engraver Abbot Antonio Pazzi,
who sold it to the gallery in 1768.

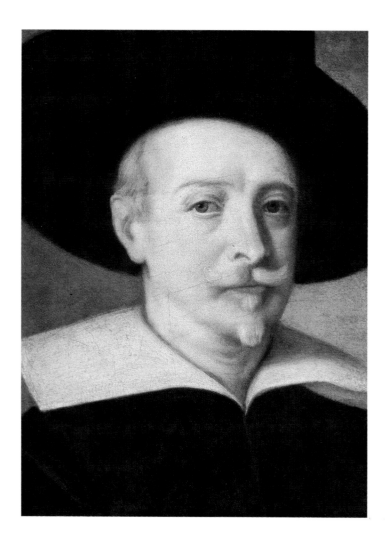

774
GUIDO RENI
Self-portrait
Oil on canvas, 17⅞ × 13⅜ in. (45.4 × 34 cm)
Uffizi, Vasari Corridor; inv. 1890: no. 1827
Datable to 1632, this picture came to the gallery in 1690 through the good offices of Cosimo III de' Medici.

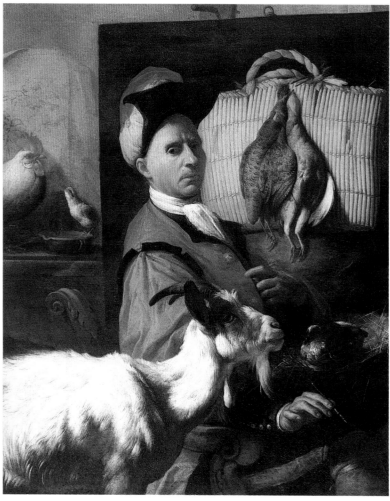

775
ARCANGELO RESANI
Self-portrait
Oil on canvas, 39⁹⁄₁₆ × 34⅜ in. (100.5 × 87.3 cm)
Uffizi, Vasari Corridor; inv. 1890: no. 1754
Grand Duke Cosimo III sent this portrait to the gallery in 1713. It was probably executed to demonstrate the repertoire of the painter, a specialist in still-life.

776

FRANCESCO CAIRO

Self-portrait

Oil on canvas, 23⅝ × 19¹⁄₁₆ in. (60 × 48.5 cm)

Uffizi, Vasari Corridor; inv. 1890: no. 1822

Acquired by Cosimo III de' Medici from an unknown source, this painting entered the gallery in 1693. It dates from around 1630.

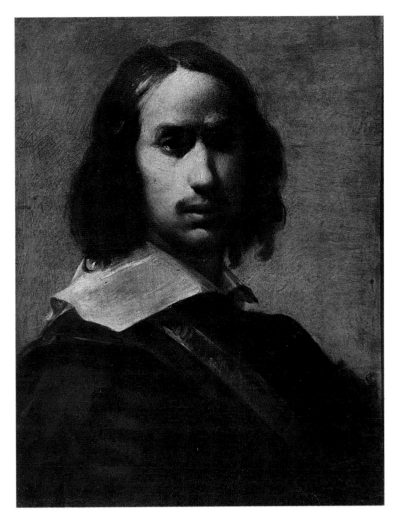

777

ROSALBA CARRIERA

Self-portrait with a Portrait of Her Sister

Pastel on paper, 27¹⁵⁄₁₆ × 22⁷⁄₁₆ in. (71 × 57 cm)

Uffizi, Vasari Corridor; inv. 1890: no. 1786

Once the property of Grand Prince Ferdinand de' Medici, this picture came to the gallery in 1714 with others from his inheritance; it is documented as having been painted in 1709. The painter has portrayed herself with her sister and collaborator Giovanna.

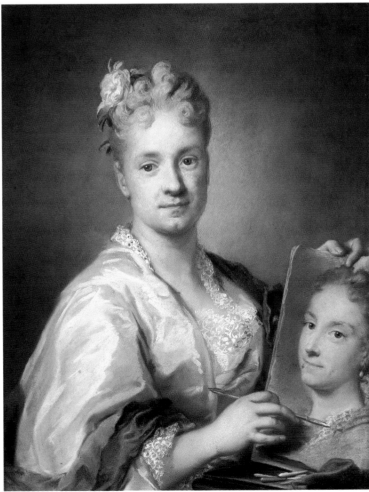

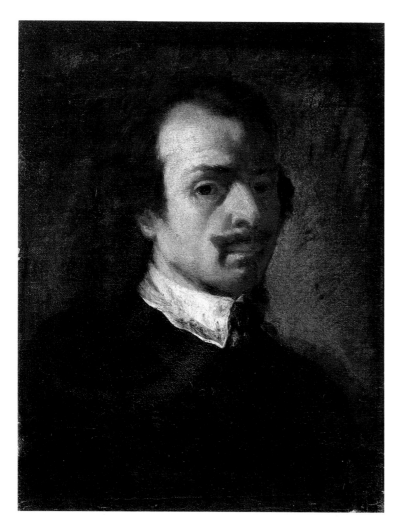

778
PIER FRANCESCO MOLA
Self-portrait
Pastel on paper, 13¹¹⁄₁₆ × 9¹³⁄₁₆ in. (34.7 × 24.9 cm)
Uffizi, Cabinet of Drawings and Prints; inv. 823 E
Sent to the gallery in 1692 by Cosimo III de' Medici, this picture was kept, framed, with the other self-portraits throughout the eighteenth century.

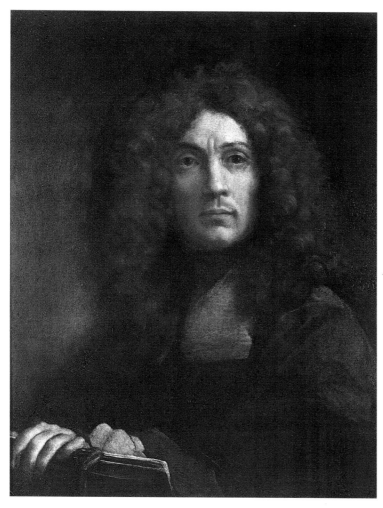

779
CARLO MARATTA
Self-portrait
Oil on canvas, 28⁹⁄₁₆ × 23 in. (72.5 × 58.5 cm)
Uffizi, Vasari Corridor; inv. 1890: no. 1686
Grand Duke Cosimo III de' Medici requested this portrait from the artist in 1681, and Maratta sent it to him the following year. His payment was a golden medal and some medicinal liquor.

780

BACICCIO

Self-portrait

Oil on canvas, 26⅜ × 20¹⁄₁₆ in. (67 × 51 cm)

Uffizi, Vasari Corridor; inv. 1890: no. 1828

This portrait, Cosimo III's final acquisition, entered the gallery in 1723. It was painted after the middle of the seventeenth century, in around 1667–1668, when the painter was beginning to develop a reputation in Rome.

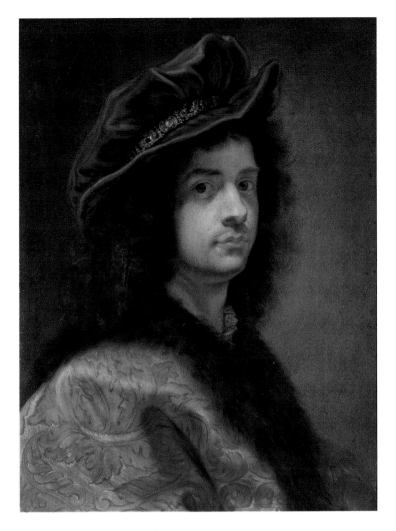

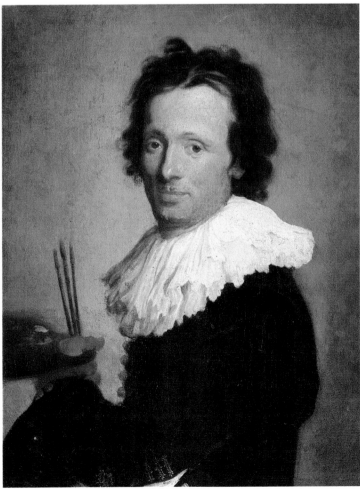

781

NICCOLÒ CASSANA

Portrait of a Painter

Oil on canvas, 29⁵⁄₁₆ × 23¼ in. (74.5 × 59 cm)

Uffizi, Vasari Corridor; inv. 1890: no. 1712

Once thought to be a self-portrait by Salvator Rosa, this picture was restored to Cassana in 1975 by Chiarini on the basis of documentary evidence.

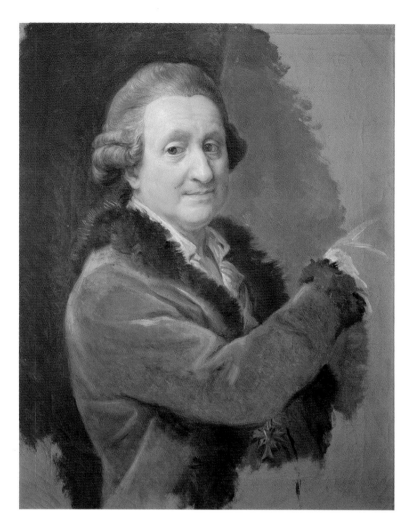

782
POMPEO BATONI
Self-portrait
Oil on canvas, 29¾ × 24 in. (75.5 × 61 cm)
Uffizi, Vasari Corridor; inv. 1890: no. 1853

Begun at the request of the gallery in 1773, this portrait remained unfinished on the artist's death; it was acquired from Batoni's widow in 1787. It was conceived as a much larger work; its present size reflects the fact that only the finished part was framed.

783
MARIO DEI FIORI
Self-portrait with a Servant and Flowers
Oil on canvas, 53⁹⁄₁₆ × 82¹⁄₁₆ in. (136 × 208.5 cm)
Uffizi, Vasari Corridor; inv. 1890: no. 2114

Acquired in Naples from the marchese of Carpio's collection for 50 piasters, this work arrived in Florence in 1697. It was not exhibited for a century because of its size, and indeed, an effort was made to cut it into three parts.

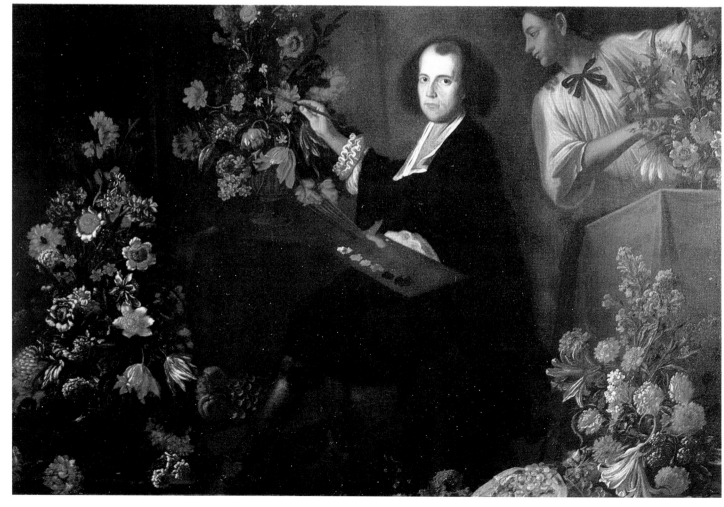

784

LUCA GIORDANO

Self-portrait

Oil on canvas, 28⁹⁄₁₆ × 22⅝ in. (72.5 × 57.5 cm)

Uffizi, Vasari Corridor; inv. 1890: no. 1629

This picture may have been commissioned in 1665 by Cardinal Leopoldo de' Medici, in whose collection it came to the Uffizi in 1682. The gallery also has a self-portrait by Giordano in charcoal (inv. 1002 E), as well as another of him as an older man.

785

FRANCESCO SOLIMENA

Self-portrait

Oil on canvas, 51³⁄₁₆ × 44⅞ in. (130 × 114 cm)

Uffizi, Vasari Corridor; inv. 1890: no. 1758

The palatine electress probably commissioned this painting from the artist during 1729, when it was spoken of by Montesquieu. It came to Florence in 1731 and was placed in the gallery in 1732.

786
LUCAS CRANACH THE YOUNGER
Portrait of Lucas Cranach the Elder
Oil on panel, 25 3/16 × 19 5/16 in. (64 × 49 cm)
Uffizi, Gallery; inv. 1890: no. 1631

Once believed to be a self-portrait by the elder Cranach, this painting is now thought to be
by his son, Lucas Cranach the Younger. It is dated 1550.

787

HANS HOLBEIN THE YOUNGER

Self-portrait

Colored drawing on paper, 12⁹⁄₁₆ × 10¼ in. (32 × 26 cm)

Signed at the top: IOANNES HOLPENIUS BASILEENSIS SUI IPSIUS EFFIGIATOR AE. XLV.

Uffizi, Gallery; inv. 1890: no. 1630

This work was acquired in London in 1681 for Cosimo III de' Medici. It may be a preparatory drawing, perhaps colored in later, for Holbein's self-portrait that is now in Indianapolis (Clowes Foundation).

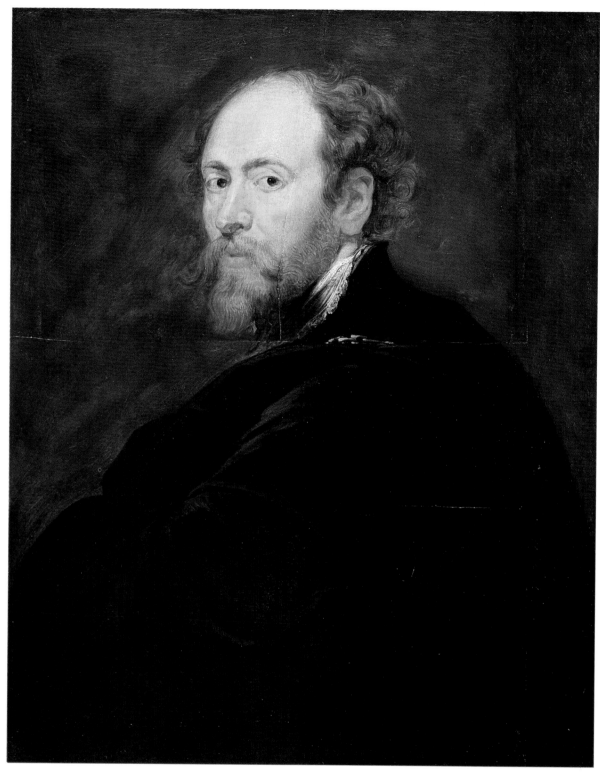

788

PIETER PAUL RUBENS

Self-portrait without a Hat

Oil on canvas, 30¹¹⁄₁₆ × 24 in. (78 × 61 cm)

Uffizi, Vasari Corridor; inv. 1890: no. 1890

This portrait was given to Cosimo III de' Medici in 1713 by his brother-in-law Johann Wilhelm von der Pfalz. It has been enlarged on the right and at the bottom. Together with its "hatted" companion piece (inv. 1884, unsigned), this was one of the most copied paintings in the Uffizi.

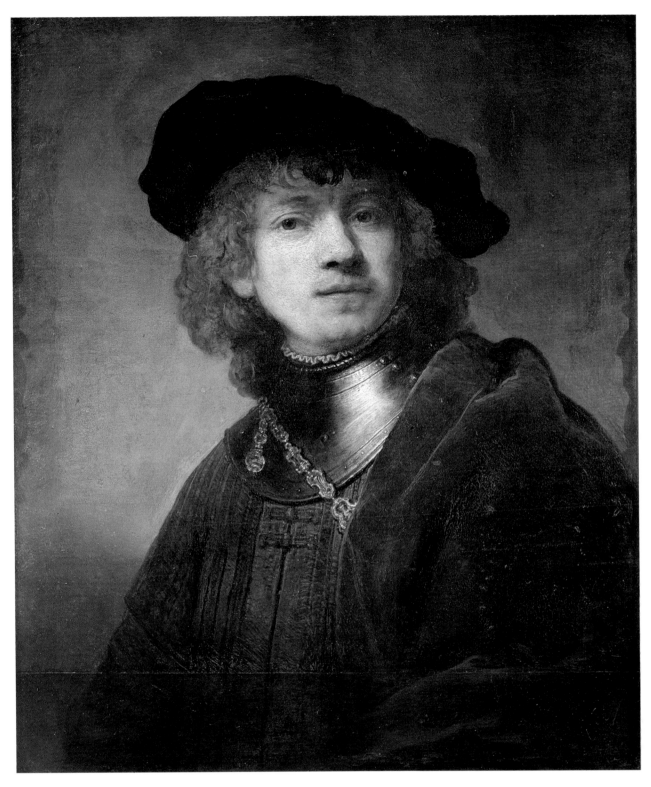

789
REMBRANDT HARMENSZOON VAN RIJN
Self-portrait
Panel, 24⅝ × 21¼ in. (62.5 × 54 cm)
Uffizi, Gallery; inv. 1890: no. 3890

This portrait was a gift from the palatine elector to the Gerinis, who sold it to Grand Duke
Ferdinand III of Lorraine in 1818. It dates from around 1634; the lower part was added
sometime before the middle of the eighteenth century.

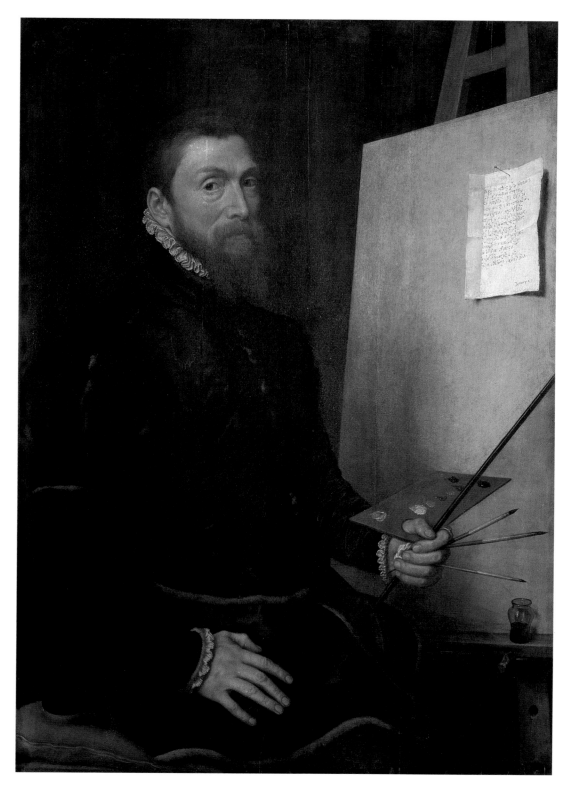

790
ANTONIS MOR
Self-portrait
Panel, 44½ × 33⅛ in. (113 × 84 cm)
Signed: ANT. MORUS PHILIPPI HISP. REG. PICTOR SUA IPSE DEPICTUS MANU 1558
Uffizi, Gallery; inv. 1890: no. 1637
This painting once belonged to Peter Lely; it was acquired in London for Cosimo III de'
Medici in 1682. The Greek text affixed to the easel alludes to the painter's virtue.

612

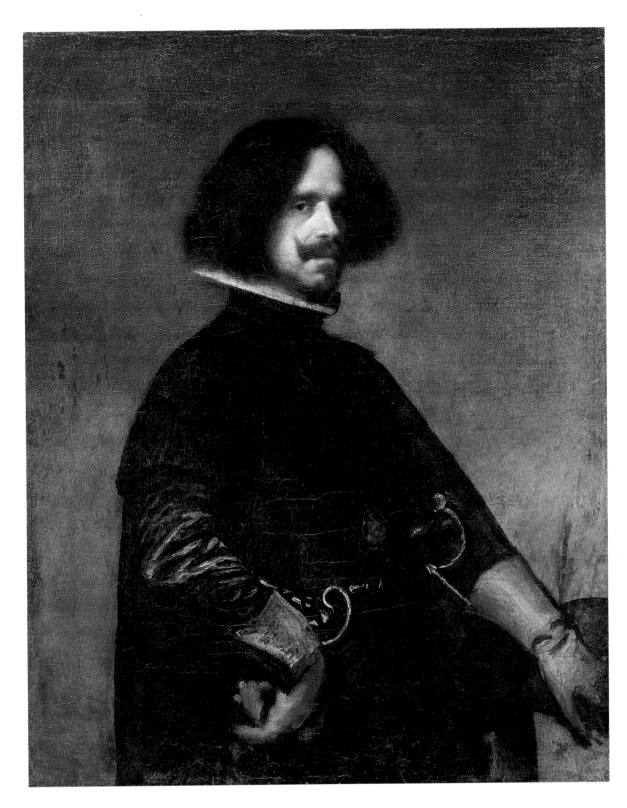

791

DIEGO DE SILVA Y VELÁZQUEZ

Self-portrait

Oil on canvas, 40¾ × 32¼ in. (103.5 × 82.5 cm)

Uffizi, Gallery; inv. 1890: no. 1707

This painting entered the gallery in 1690, but was probably bought in Spain the year before. It must date from after 1643, as the artist is wearing the insignia of the King's Gentleman of the Bedchamber (the key at his belt).

792
BORGOGNONE
Self-portrait
Oil on canvas, 32¹¹⁄₁₆ × 26 in. (83 × 66 cm)
Uffizi, Vasari Corridor; inv. 1890: no. 1653
This portrait was commissioned from the Jesuit artist in 1675 by Cosimo III de' Medici. Borgognone executed it at the villa at Castello and filled the background with a battle painting, the genre in which he was a specialist.

793
CHARLES LE BRUN
Self-portrait
Oil on canvas, 31½ × 25⁹⁄₁₆ in. (80 × 65 cm)
Signed: C. LE BRUN PR[EMIER] PEINTRE DU ROY
TRESCHRESTIEN
Uffizi, Vasari Corridor; inv. 1890: no. 1858
Grand Duke Cosimo III de' Medici asked for this work in 1681 and followed up his request with gifts; the painter sent the portrait to Florence in 1684. Le Brun is shown holding a portrait of his king encircled by diamonds, a gift from Louis XIV.

794

FRANÇOIS DE TROY

Self-portrait

Oil on canvas, 28⅜ × 22¹⁄₁₆ in. (72 × 56 cm)

Signed and dated: FRAN:US DE TROY, PATRIA
TOLOSANUS PARISIIS REGIUS PICTURAE PROFESSOR
ACADEMICUS SIC SE IPSUM PINXIT ANNO 1696

Uffizi, Vasari Corridor; inv. 1890: no. 1860

This work was given to Cosimo III de' Medici
in 1696 through the artist's son, a brother of the
Feuillants order, which was established in Flor-
ence by grand-ducal request.

795

JEAN-ÉTIENNE LIOTARD

Self-portrait

Pastel on paper, 24 × 19⁵⁄₁₆ in. (61 × 49 cm)

Signed and dated: J.E. LIOTARD DE GENÉVE
SURNOMMÉ LE PEINTRE TURC PEINT PAR LUI
MÊME À VIENNE 1744

Uffizi, Vasari Corridor; inv. 1890: no. 1936

This picture was commissioned by Grand Duke
Francis Stephen of Lorraine upon the pastel
painter's return from Constantinople, and sent by
him to Florence for the gallery's collection.

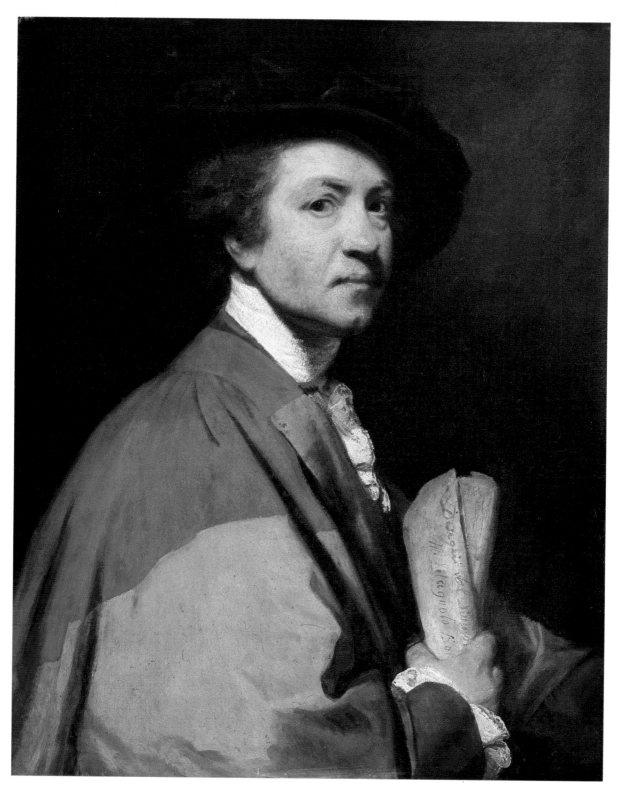

796

JOSHUA REYNOLDS

Self-portrait

Oil on canvas, 28⅛ × 22¹³⁄₁₆ in. (71.5 × 58 cm)

Uffizi, Vasari Corridor; inv. 1890: no. 1932

This portrait was requested from the artist, whom the grand duke rewarded with a gold medal, on the suggestion of Zoffany in 1774. Reynolds is shown wearing the cap and gown of an Oxonian doctor; the inscription on the folios reads "Drawings by the Divine Michelangelo Bon. . . ." On the back is an inscription with a signature and the date 1775.

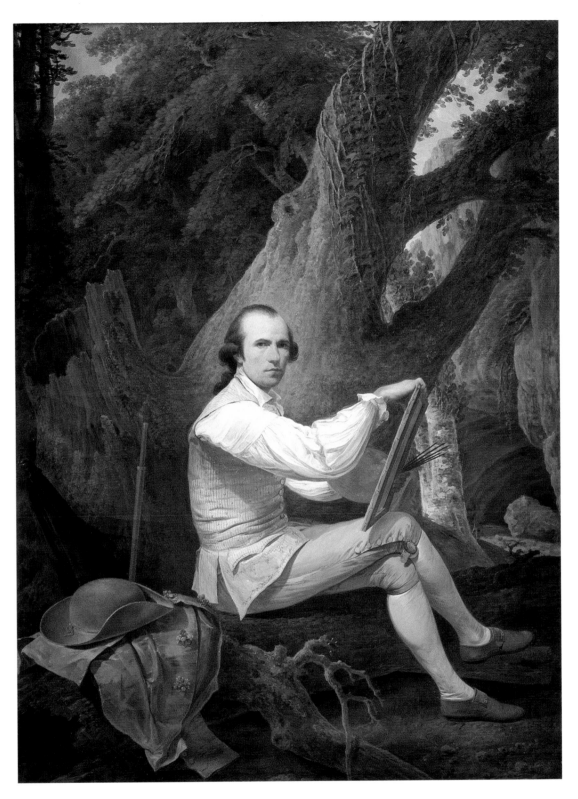

797
JACOB MORE
Self-portrait
Oil on canvas, 77¹⁵/₁₆ × 58¹/₁₆ in. (198 × 147.5 cm)
Signed and dated : JACOB MORE PINX.T ROMA 1783
Uffizi, Vasari Corridor; inv. 1890: no. 2092

Given by the Scottish artist to the gallery during his visit to Florence in May 1784, this painting demonstrates More's landscape art in great style.

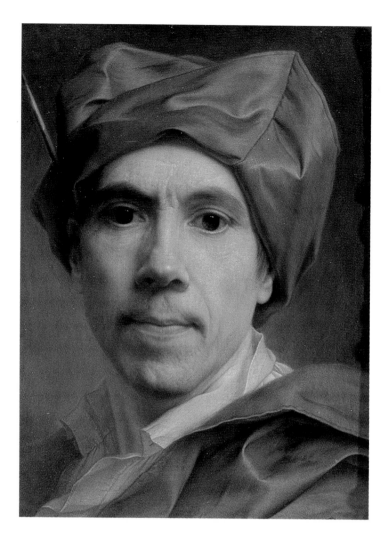

798
CHRISTIAN SEYBOLD
Self-portrait
Oil on copper, 12⅝ × 22⅝ in. (32 × 29.5 cm)
Signed and dated: CHRISTIANUS SEYBOLT MOGUNTINUS
REGIS POLONIAE PICTOR AULICUS AETATIS ANNORUM 49
HANC PROPRIAM EFFIGIEM PINXIT ANNO 1747
Uffizi, Depository; inv. 1890: no. 1869

Mentioned in a gallery inventory of 1753, this portrait came from Vienna, where from 1749 the artist was an imperial *Kammermaler,* or court painter. It is an excellent example of German "fine painting."

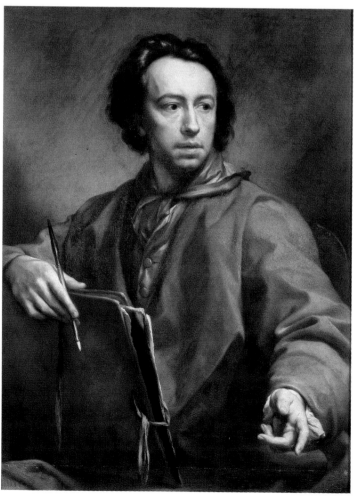

799
ANTON RAPHAEL MENGS
Self-portrait
Panel, 38³⁄₁₆ × 28⁹⁄₁₆ in. (97 × 72.6 cm)
Uffizi, Vasari Corridor; inv. 1890: no. 1927

This picture was brought and given to the gallery by the artist himself in October 1773, as a long inscription on the back explains. A contemporary addition at the bottom bears a depiction of Mengs's fingers.

800

ANGELICA KAUFFMANN
Self-portrait
Oil on canvas, 50⅜ × 36¹³⁄₁₆ in. (128 × 93.5 cm)
Signed and dated: ANGELICA KAUFFMANN PINX ROMAE
1787
Uffizi, Vasari Corridor; inv. 1890: no. 1928
The painter herself gave this portrait to the gallery in 1788. It joined another picture of her as a young girl in regional costume (given by Cosimo Siries), executed in memory of her visit to Florence in 1762.

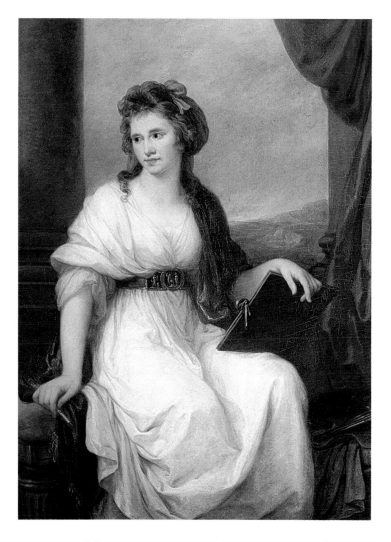

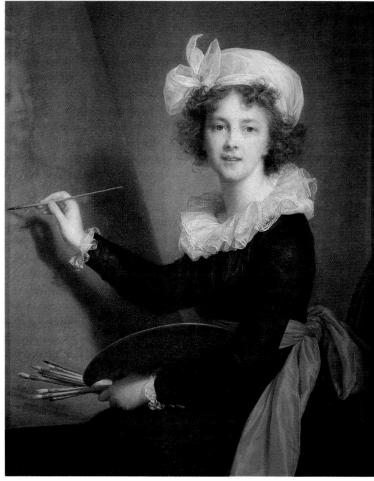

801

MARIE-LOUISE-ÉLISABETH VIGÉE-LEBRUN
Self-portrait
Oil on canvas, 39⅜ × 31⅞ in. (100 × 81 cm)
Uffizi, Vasari Corridor; inv. 1890: no. 1905
Requested from the artist when she was passing through Florence in 1789 and executed in Rome in 1790, this portrait was added to the Uffizi collection in 1791. Along with Angelica Kauffmann's self-portrait, it was one of the most admired and copied works in the collection. Vigée-Lebrun is shown painting the figure of her queen, Marie Antoinette.

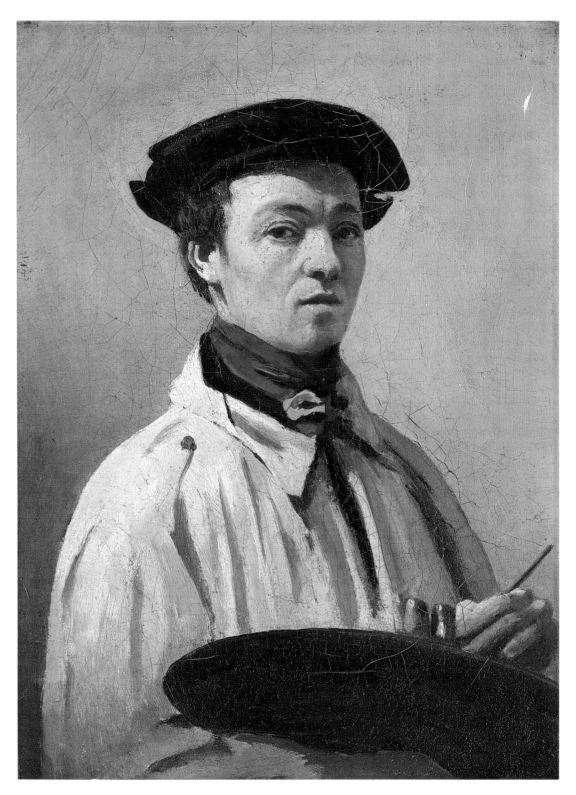

802
JEAN-BAPTISTE-CAMILLE COROT
Self-portrait
Oil on canvas, 13⅜ × 9¹³⁄₁₆ in. (34 × 25 cm)
Uffizi, Vasari Corridor; inv. 1890: no. 2063

The gallery director asked Corot for a self-portrait in 1872, and the artist's family donated it immediately after his death. It is thought to have been painted on Corot's second journey to Italy, in 1834, during which he spent a long time in Pisa, Volterra, and Florence. It is the only self-portrait he produced after one earlier one in the Louvre.

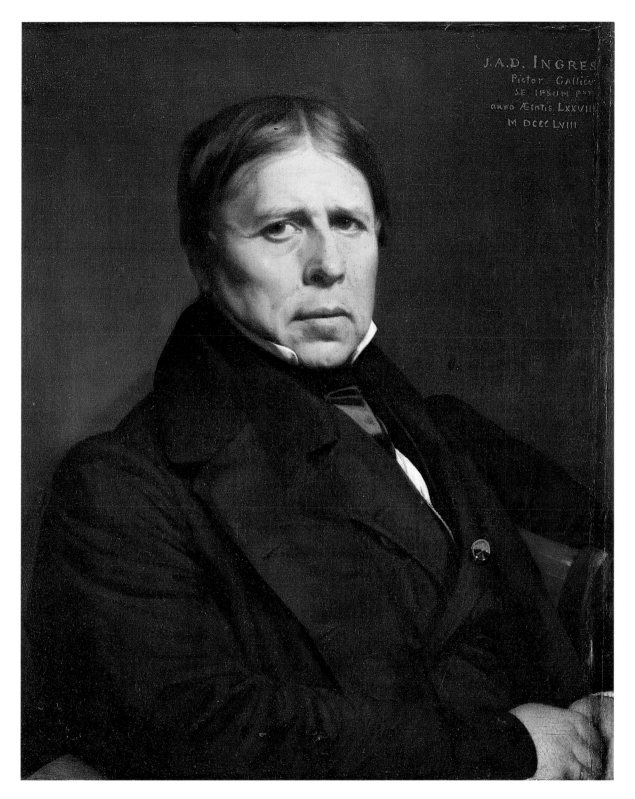

803

JEAN-AUGUSTE-DOMINIQUE INGRES

Self-portrait

Oil on canvas, 24⅜ × 20¹⁄₁₆ in. (62 × 51 cm)

Signed and dated in the top right-hand corner: J.A.D. INGRES / PICTOR GALLICUS / SE
IPSUM PXT / ANNO AETATIS LXXVIII / MDCCCCLVIII

Uffizi, Vasari Corridor; inv. 1890: no. 1948

The director of the Uffizi requested a self-portrait from Ingres in 1839, when the artist was
president of the Académie Française in Rome; though Ingres willingly agreed, he exe-
cuted the portrait and sent it only in 1858. It won him the Order of St. Joseph, bestowed by
the grand duke, which he is shown wearing in the Antwerp self-portrait of seven years
later. Here he is depicted with the Legion of Honor, which he received in 1855. This was
the last self-portrait to enter the gallery prior to the unification of Italy.

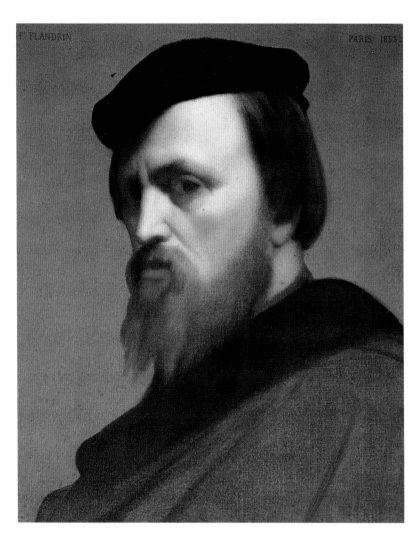

804

HIPPOLYTE FLANDRIN
Self-portrait

Oil on canvas, 17⁵⁄₁₆ × 14³⁄₁₆ in. (44 × 36 cm)

Signed and dated at the top: H.TE FLANDRIN (on the left)/ PARIS 1853 (on the right)

Uffizi, Vasari Corridor; inv. 1890: no. 1961

On the request of Luigi Mussini, this work was chosen to be sent to the gallery in 1865 by the painter's widow (who kept the oil sketch of it). This self-portrait has a clear Florentine stamp—the green background, the three-quarter-length pose—inspired by Andrea del Sarto.

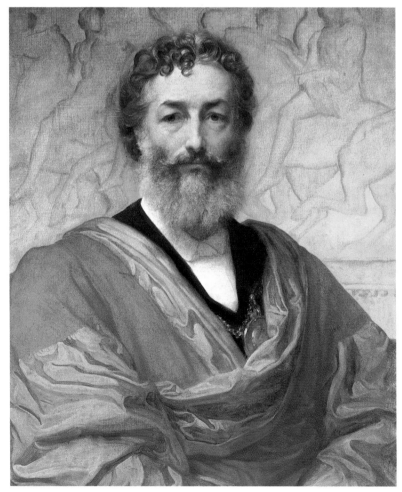

805

FREDERICK LEIGHTON
Self-portrait

Oil on canvas, 30⅛ × 25³⁄₁₆ in. (76.5 × 64 cm)

Labeled on the back: SIR F. LEIGHTON ESQ. P.R.A. HOLLAND PARK ROAD.

Uffizi, Vasari Corridor; inv. 1890: no. 1974

A frequenter of Florence from his infancy, Leighton was requested by the director of the Uffizi to "update" the English presence in the Uffizi. He successfully petitioned Millais and Watts and sent his own Titianesque likeness in 1880. In the background is a tracing of the Parthenon frieze that he kept in his studio; he wears the Oxford doctor's gown and the medal of the president of the Royal Academy.

806

LAWRENCE ALMA-TADEMA

Self-portrait

Oil on canvas, 26³⁄₁₆ × 21¹⁄₁₆ in. (66.5 × 53.5 cm)

Signed in the top left-hand corner: L. ALMA TADEMA /
OP. CCCXLI

Uffizi, Vasari Corridor; inv. 1890: no. 3132

Requested by the gallery in 1895, this portrait was exe-
cuted and sent the following year, as is confirmed by the
progressive number it bears and by a stamp behind the
frame, which is itself represented within the painting.

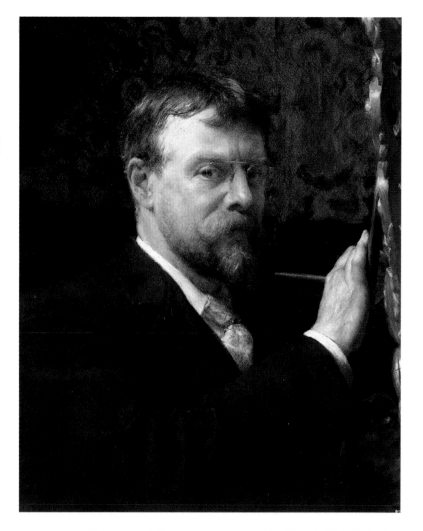

807

HENRI FANTIN-LATOUR

Self-portrait

Oil on canvas, 21¼ × 17⁵⁄₁₆ in. (54 × 44 cm)

Signed and dated in the bottom left-hand corner:
FANTIN.83

Uffizi, Vasari Corridor; inv. 1890: no. 3124

This was the last of many self-portraits produced by the
artist. Requested by the director of the Uffizi, Enrico
Ridolfi, in 1895 it was sent to the gallery immediately
after being exhibited in the salon.

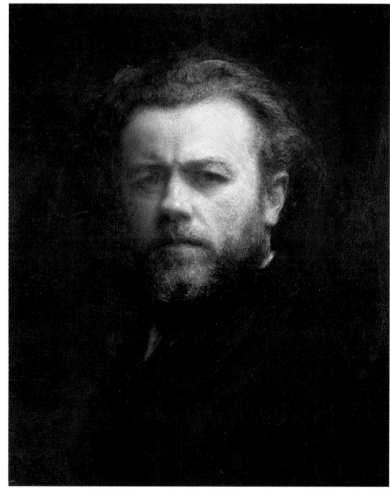

623

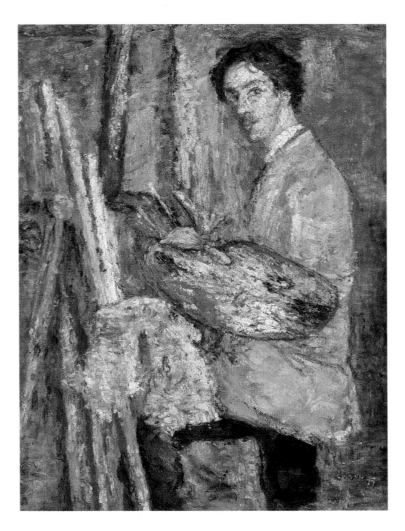

808

JAMES ENSOR

Self-portrait

Oil on canvas, 16½ × 13⅜ in. (42 × 34 cm)

Signed in the bottom right-hand corner: JAMES ENSOR

Uffizi, Vasari Corridor; inv. 1890: no. 8472

Painted in 1922 and given to the gallery a year later, this is, among the numerous self-portraits by the artist, one of the last and least symbolic. A second (or perhaps first) version is in a private collection in Ghent.

809

MAURICE DENIS

Self-portrait with His Family in Front of Their House

Oil on canvas, 26¾ × 31½ in. (68 × 80 cm)

Signed and dated on the left-hand side of the frame:
MAURICE DENIS 1916

Uffizi, Vasari Corridor; inv. 1890: no. 8451

This work was acquired by the gallery in 1916. In 1922 the artist exchanged it for a slightly smaller replica, which he then replaced with the lively original in 1930. The picture shows Denis working in front of Le Prieure at Saint-Germain-en Laye (today his museum) with his wife and five children.

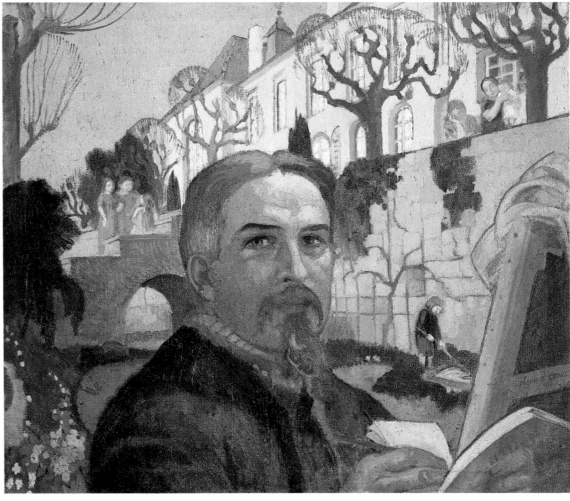

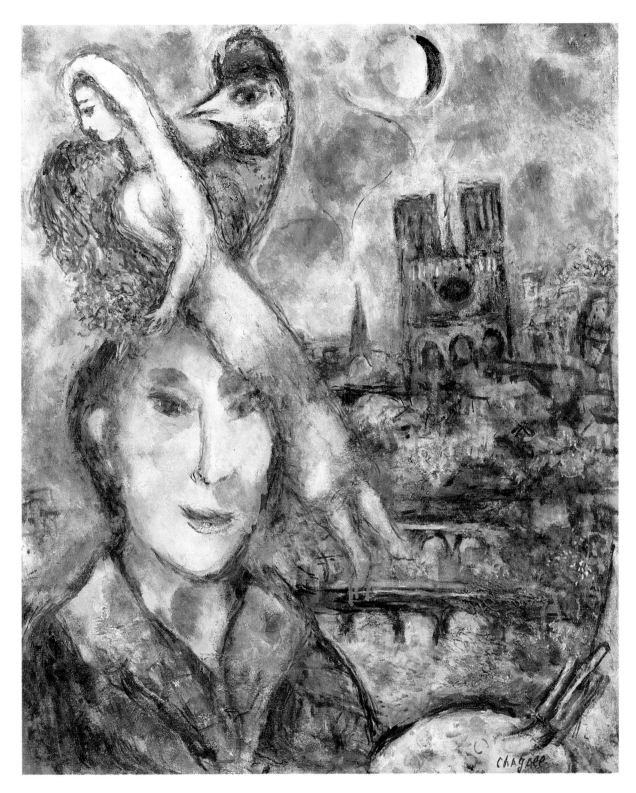

810

MARC CHAGALL
Self-portrait
Oil on canvas, 24³⁄₁₆ × 20¹⁄₁₆ in. (61.5 × 51 cm)
Uffizi, Vasari Corridor; inv. 1890: no. 9496

In 1976 the artist, then in his ninety-first year, brought this portrait personally to the Vasari
Corridor. Painted between 1959 and 1968, it is rich in all the recurrent symbols of Chagall's
art: his brushes, the bride, the cock (emblem of the Russian nation), Notre-Dame, the
Eiffel Tower, and the bridges of Paris.

The Collection of Miniatures and Small Portraits

The collection of miniatures in the Uffizi, which numbers around 250 paintings on parchment and more than a thousand portraits, was assembled by various members of the Medici family between the middle of the sixteenth century and the middle of the eighteenth. There was a conscious plan behind this collecting, and the works acquired, with the exception of a few later additions, were all from that period. The collection has thus become an absolutely indispensable tool for reconstructing the history of miniatures in the first centuries after the invention of printing, when the "scene," whether sacred or profane, accurately painted in gouache on vellum, left the confines of the book to become a little devotional or decorative painting in a precious frame, destined generally for a study or some other small room. Manuscripts on historical subjects incorporated medallions with portraits of heroes, creating portable images that were easier to execute than struck medals. These were quickly used as political documents, making familiar the visages of far-off rulers or possible consorts, or putting a face to those people with whom many had had only a literary correspondence. The courts that were finally established in the second half of the sixteenth century employed artists of various specialties who could provide sumptuous gifts and keepsakes: goldsmiths, masters of inlay and tapestry, armorors, and, in particular, miniaturists. Giulio Clovio, for example, was present for a brief time at the court of Cosimo I de' Medici; he was followed by Daniel Froeschl, Jacopo and other members of the Ligozzi family, the Servite brother Giovan Battista Stefaneschi, Giovanna Garzoni from the Marches, the Capuchin Ippolito Galantini, the portraitist Giovanna Fratellini, and others who also supplied scientific illustrations (both botanical and zoological), still-lifes, views, miniature copies of famous paintings, and large and small portraits. Many of these works still survive.

Shortly after the middle of the seventeenth century, Cardinal Leopoldo de' Medici's refined curiosity, which until then had for the most part been focused on the collections of self-portraits and drawings, turned to small-format portraits. Beginning with a nucleus of about forty, his agent in Venice, the Florentine merchant Paolo del Sera, was able to help Leopoldo build a collection of almost six hundred miniature works.

Miniatures were uncommon in Italy, which, unlike France and England, could boast of no specialist in the genre. However, many artists, whether through whim or by necessity, did experiment in this smallest of formats, using their techniques as painters on a variety of supports including metal, wood, and slate. Leopoldo's precocious notion contributed to the great quality of the collection, which today comprises autograph works by Bronzino, Barocci, Lavinia Fontana and Sofonisba Anguissola, Guercino, and almost all of the Bolognese painters of the seventeenth century, as well as the best of the sixteenth-

and seventeenth-century Venetians (including two pieces by Rosalba Carriera), Cristofano Allori, Orazio Fidani, Carlo Dolci, and other Florentines. Also represented are foreigners such as Hans Holbein the Younger, the Germans Koenig and Johann Strauch, Samuel and Alexander Cooper, Jean-Marc Nattier, and many Dutch artists. Leopoldo and his nephew Cosimo III also added works done in pen and ink—simulated engravings minutely delineated in pen on parchment (a genre born in France and the low countries at the end of the sixteenth century)—by Scottish artists (the little portraits by David Paton) and Dutch ones (the naval battles by Willem van de Velde and the Roman views by Lieven Cruyl). The Medici women were also great collectors of miniatures, especially Violante of Bavaria.

A more recent addition to the Uffizi's miniatures is a group of eighty excellent English silhouettes, dating from the eighteenth to the twentieth centuries. Done in lampblack on gesso, they enrich the collection without distorting the physiognomy of a unique nucleus.

Silvia Meloni

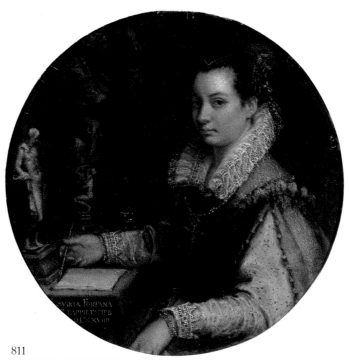

811

LAVINIA FONTANA
Self-portrait
Oil on copper, 6⁵⁄₁₆ in. (15.7 cm) in diameter
Signed and dated: . . . AVINIA FONTANA TAPPII FACIEB [M]DLXXVIIII
Uffizi, Vasari Corridor; inv. 1890: no. 4013
Executed for the Modenese scholar Alfonso Ceconio, this portrait subsequently entered Grand Prince Ferdinand de' Medici's collection at Poggio a Caiano, from which it came to the Uffizi in 1773.

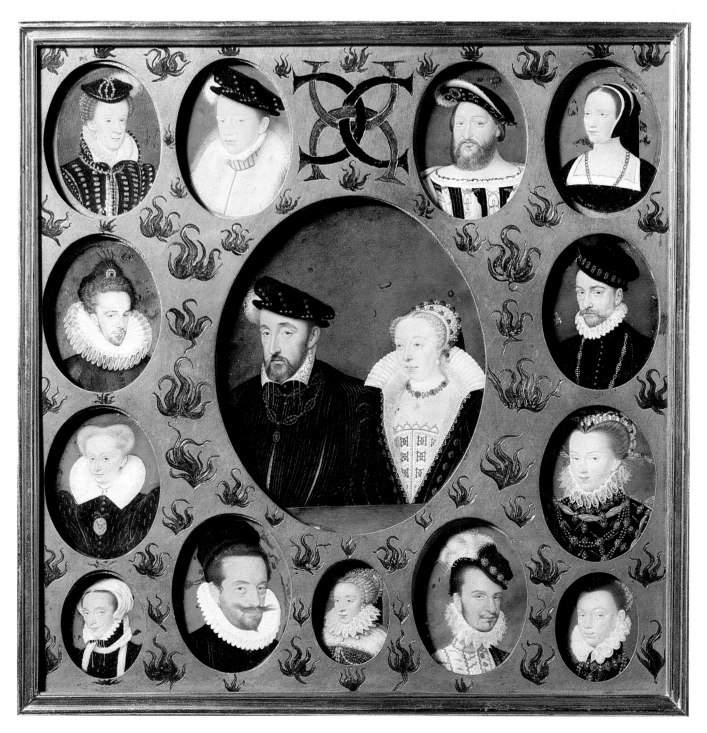

The collection of miniatures and small portraits is kept in the so-called Jewel Room, which housed the objects from the Tribune when that gallery was used only for masterpieces of painting and sculpture. On the walls of the room, shown on the following page, numerous panels like this one each display a series of miniatures.

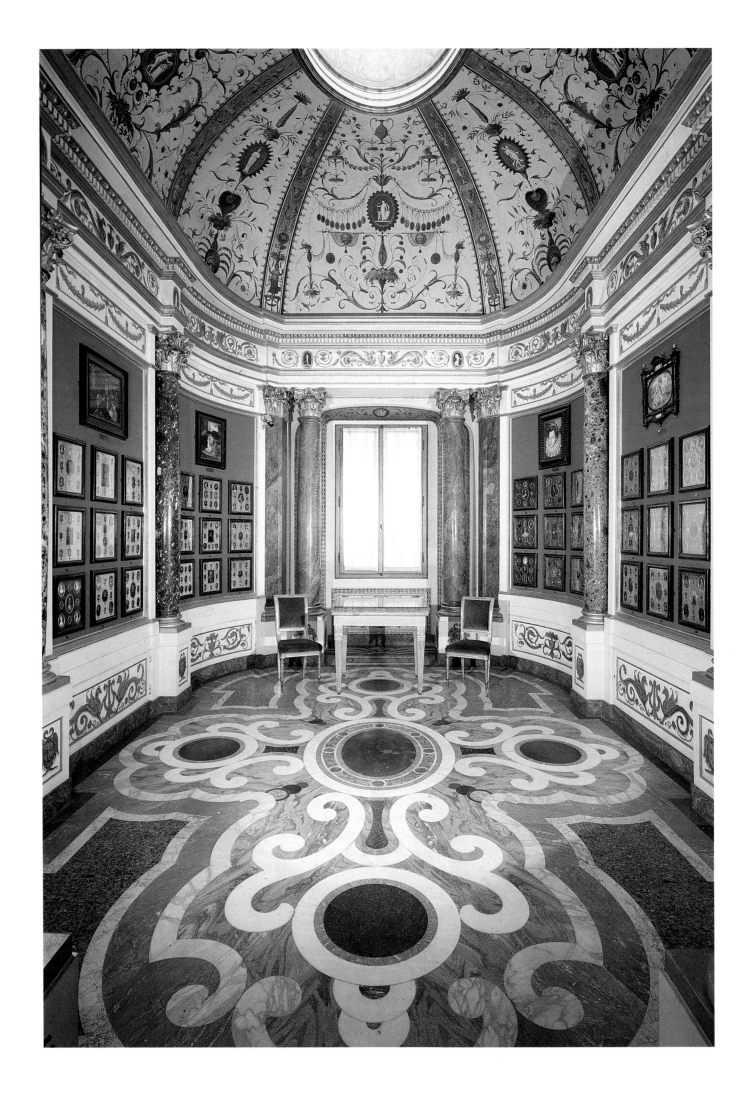

Bibliography

F. PIGAFETTA: *Canzone del Signor Gio. Battista Elicona nelle sponsalitie della Serenissima Madonna Maria de' Medici et del Christianissimo Henrico Quarto re di Francia.* Rome, 1600.

A. F. GORI: *Musaeum Florentinum exhibens in Signoria vetustatis monumenta, quae Florentiae sunt Johanni Gastoni Aetruriae Magno Duci dicatum* (10 vols.). Florence, 1731–1762.

Quadreria Medicea, ou Tableaux de la Galerie des Medicis, gravés d'après les dessins de Fr. Petrucci, par Mogalli, Picchianti, Lorenzini, Gregori. Florence, 1733–1771.

I. ORSINI, D. M. MANNI: *Azioni gloriose degli Uomini illustri fiorentini, espresse coi loro ritratti nelle volte della R. Galleria di Firenze.* Florence, 1745.

F. MOÜCKE: *Serie di ritratti degli eccellenti pittori dipinti di propria mano che esistono nella I. R. Galleria di Firenze con le vite in compendio dei medisimi* (4 vols.). Florence, 1752–1762.

G. BIANCHI: *Ragguaglio delle antichità e rarità che si conservano nella Galleria mediceo-imperiale di Firenze.* Florence, 1759.

O. MARRINI: *Serie di ritratti di celebri pittori dipinti di propria mano in seguito a quelli già pubblicati nel Museo fiorentino esistenti appresso l'Abate Antonio Pazzicon brevi notizie intorno al medesimi* (2 vols.). Florence, 1764–1766.

G. BENCIVENNI PELLI: *Saggio istorico della R. Galleria di Firenze* (2 vols.). Florence, 1779.

A. FABBRONI: *Dissertazione sulle statue appartenenti alla favola di Niobe.* Florence, 1779.

Raccolta degli Imperatori romani incisi in rame fino a Costantino Magno, cavati dai busti originali della R. Galleria di Firenze, con un estratto il più interessante delle loro vite. Florence, 1780.

L. LANZI: *La R. Galleria di Firenze accresciuta e riordinata per comando di S. A. R.* Florence, 1782.

F. ZACCHIROLI: *Description de la Galerie Royale de Florence.* Florence, 1783.

G. CAMBIAGI: *Descrizione della R. Galleria di Firenze secondo lo stato attuale.* Florence, 1792.

R. MULOT, S. MARÉCHAL: *Les Musées de Florence.* Paris, 1797–1801.

Reale Galleria di Firenze illustratra. Serie I: *Quadri di storia* (vols. I–III); Serie II: *Quadri di vario genere* (vol. I); Serie III: *Ritratti di pittori* (vols. I–IV); Serie IV: *Statue, Bassirilievi, Busti e Bronzi* (vols. I–III); Serie V: *Cammel ed Intagli* (vols. I–II). Florence, 1817–1831.

MONGEZ: *Tableaux, Statues, Camées de la Galerie de Florence* (4 vols.). Paris, 1819.

F. RANALLI: *Imperiale e Reale Galleria di Firenze. Storia della pittura dal suo risorgimento in Italia dimostrata coi monumenti della Reale Galleria di Firenze* (6 vols.). Florence, 1841–1867.

Nuovo Catalogo dell'I.e R.Galleria di Firenze, con l'indice dei ritratti degli uomini illustri. Florence, 1851.

G. CONESTABILE: *Delle iscrizioni etrusche e etrusche-latine in monumenti che si conservano nella I. e R. Galleria degli Uffizi* (2 vols.). Florence, 1858.

E. BURCI, G. CAMPANI: *Catalogue de la R. Galerie de Florence* (2 vols.). Florence, 1860.

A. GOTTI: *Le Gallerie di Firenze, relazione al Ministero della Pubblica Istruzione.* Florence, 1872.

A. GOTTI: *Le Gallerie e i musei di Firenze, discorso storico.* Florence, 1875.

C. DONATI: *Le Gallerie e i Musei di Firenze negli anni 1881, '82, '83.* Relazione al Ministero della Pubblica Istruzione. Rome, 1885.

C. RIGONI: *Catalogue of the R. Uffizi Gallery, Florence.* Florence, 1888.

Catalogo delle Pitture nella R. Galleria degli Uffizi a Firenze riprodotte col sistema isocromatico, con l'aggiunta degli affreschi e sculture. Florence, 1891.

Catalogo della Galleria Feroni. Florence, s.a., 1895.

E. PIERACCINI: *Catalogue de la Galerie Royale des Uffizi à Florence.* Florence, 1897.

C. RICCI, G. FRIZZONI: *La Galleria degli Uffizi in Firenze.* Bergamo, 1901.

A. VATTI: *Le Meraviglie dell'Arte nelle RR. Gallerie Fiorentine. Galleria Uffizi. Volume I: Pittura.* Florence, 1903.

E. RIDOLFI: *Il mio direttorato delle Regie Gallerie fiorentine.* Florence, 1906.

P. SCHUBRING: *Moderner Cicerone, Florenz I. Die Gemälde-Galerien der Uffizien und des Palazzo Pitti.* Stuttgart-Berlin-Leipzig, 1907.

M. CRUTTWELL: *A Guide to the Paintings in the Florentine Galleries, the Uffizi, the Pitti, the Academia.* London, 1908.

R. Galleria degli Uffizi. Elenco dei dipinti. Florence, 1920.

R. Galleria degli Uffizi. Elenco dei scultore. Florence, 1921.

G. POGGI: *R. Galleria degli Uffizi. Catalogo dei dipinti.* Florence, 1923.

B. VIALLET: *Gli autoritratti femminili della R. Galleria degli Uffizi in Firenze.* Rome, 1923.

M. MARANGONI: *Come si guarda un quadro. Soggio di educazione dei gusto su capolavori degli Uffizi.* Florence, 1927.

E. GRIFI: *Catalogo delle Galleria degli Uffizi e Pitti in Firenze.* Florence, 1928.

N. TARCHIANI: *La Galleria degli Uffizi in Firenze.* Milan, 1928.

Catalogo topografico illustrato con note fotografiche. R. Galleria degli Uffizi. Florence, 1929–1931 (ending with room XX).

Masterpieces of Art in the Uffizi–Pitti Galleries. Florence, 1930.

O. H. GIGLIGLI: *La Regia Galleria degli Uffizi.* Rome, 1932.

C. FASOLA: *Le gallerie di Firenze e la guerra. Storia e cronaca con l'elenco delle opere d'arte asportate.* Florence, 1945.

F. ROSSI: *Soprintendenza alle Gallerie di Firenze. Galleria degli Uffizi. Catalogo dei dipinti.* Florence, 1948.

M. Bernardi, A. Della Corte: *Gli strumenti musicali nei dipinti della Galleria degli Uffizi.* Turin, 1951.

L. Berti: *La casa del Vasari in Arezzo e il suo museo.* Florence, 1951.

U. Baldini, L. Becherucci, A. M. Francini Ciaranfi, I. Collori Ragghianti: *Bozzetti delle Gallerie di Firenze.* Exhibition catalogue. Florence, 1952.

R. Salvini: *La Galleria degli Uffizi, guida per il visitatore e catalogo dei dipinti con notizie e commenti.* Florence, 1952.

G. Pacchioni: *La Galleria degli Uffizi.* Rome, 1954.

H. Tietze: *I tesori delle grandi Gallerie Nazionali.* Florence, 1954.

A. M. Francini Ciaranfi: *La Galleria Palatina (Pitti), guida per il visitatore e catalogo delle opere esposte.* Florence, 1956.

L. Becherucci: *Tesori della Galleria degli Uffizi.* Milan, 1957.

F. Rossi: *Le Gallerie Uffizi e Pitti.* Milan, 1957.

R. Abbondanza: *Mostra documentaria e iconografica della fabbrica degli Uffizi.* Exhibition catalogue. Florence, 1958.

A. M. Francini Ciaranfi: *Alcune opere di Salvator Rosa.* Florence, 1958.

G. A. Mansuelli: *Galleria degli Uffizi. Le Sculture.* Rome, 1958 (I), 1961 (II).

L. Marcucci: *Gallerie Nazionali di Firenze. I dipinti toscani del secolo XIII. Scuole Bizantine e Russe dal secolo XII al secolo XVIII.* Rome, 1958.

E. Micheletti: *Dipinti del Seicento fiammingo e olandese.* Florence, 1958.

L. Becherucci, E. Micheletti: *Dipinti italiani del Sei e Settecento.* Florence, 1959.

R. Chiarelli, L. Becherucci, E. Micheletti: *Nuovi acquisti delle gallerie fiorentine.* Florence, 1960.

N. Martellucci: *Galleria Uffizi.* Florence, 1961.

C. Fasola: *La Galleria degli Uffizi in Firenze. Album Itinerario.* Florence, 1963.

L. Becherucci, S. Meloni: *Dipinti del Seicento genovese.* Florence, 1964.

C. Piacenti: *Mostra temporanea di alcune pitture straniere.* Florence, 1964.

G. A. Mansuelli, M. Moriondo, E. Micheletti: *La Galleria degli Uffizi.* Milan, 1965.

L. Marcucci: *Gallerie Nazionali di Firenze. Dipinti toscani del secolo XIV.* Rome, 1965.

L. Becherucci: *Gli Uffizi.* Florence, 1966.

A. M. Crinò: *Mostra di ritratti inglesi per la settimana britannica a Firenze.* Verona, 1966.

M. Lenzini, E. Micheletti: *I grandi maestri della pittura nella Galleria degli Uffizi. Selezione di 50 capolavori.* Florence, 1966.

O. Millar: *Zoffany and His Tribuna. Studies in British Art.* London, 1966.

M. Chiarini: *Paesisti bamboccianti e vedutisti nella Roma Seicentesca.* Exhibition catalogue. Florence, 1967.

E. Micheletti: *The Uffizi and Pitti.* Florence, 1968.

M. Chiarini, K. Aschengreen Piacenti: *Artisti alla corte granducale.* Exhibition catalogue. Florence, 1969.

A. M. Maetzke, M. Chiarini: *Dipinti restaurati delle Gallerie fiorentine.* Exhibition catalogue. Florence, 1969.

L. Berti: *Mostra storica della tribuna degli Uffizi. Premessa alla mostra.* Florence, 1970.

E. Borea: *Caravaggio e Caravaggeschi nelle Gallerie di Firenze.* Exhibition catalogue. Florence, 1970.

M. Chiarini, A. Martelli Pampaloni, A. M. Maetzke: *Pittura su pietra.* Exhibition catalogue. Florence, 1970.

S. Rudolph, A. Biancalani: *Mostra storica della tribuna degli Uffizi.* Exhibition catalogue. Florence, 1970.

R. Salvini: *Uffizi, Firenze.* Novara, 1970.

L. Berti: *Gli Uffizi. Tutti i dipinti esposti in 659 illustrazioni.* Florence, 1971.

R. Fremantle: *Florentine Paintings in the Uffizi and Introduction to the Historical Background.* Florence, 1971.

W. Prinz: *Die Sammlung der Selbstbildnisse in der Uffizien: Band I. Geschichte der Sammlung.* Berlin, 1971.

M. Webster, A. M. Crinò, M. M. Mosco: *Firenze e l'Inghilterra, rapporti artistici e culturali dal XVI al XX secolo.* Exhibition catalogue. Florence, 1971.

R. Rambelli: *Galleria degli Uffizi.* Padua, 1972.

N. Bemporad, L. Berti: *Inaugurazione del Corridoio Vasariano, Galleria degli Uffizi.* Florence, 1973.

L. Berti: *Inaugurazione della donazione Contini Bonacossi, Itinerario.* Florence, 1974.

S. Negrini: *Galleria degli Uffizi.* Milan, 1974.

L. Berti: *Gli Uffizi. Tutte le pitture esposte in 698 illustrazioni. Il Corrodoio Vasariano.* Florence, 1975.

F. Borea: *Pittori bolognese del Seicento nelle Gallerie di Firenze.* Exhibition catalogue. Florence, 1975.

P. Dal Poggetto: *Capolavori degli Uffizi restaurati nel 1975.* Exhibition catalogue. Florence, 1975.

S. Meloni Trkulja: *Omaggio a Leopoldo de' Medici: II, I ritrattini.* Exhibition catalogue. Florence, 1976.

Uffizi. Guida alla galleria. La guida completa con un grande manifesto a colori. Turin, 1976.

D. Bodart: *Rubens e la pittura fiamminga del Seicento nelle collezioni pubbliche fiorentine.* Exhibition catalogue. Florence, 1977.

E. Borea, A. M. Petrioli Tofani, K. Langedijk: *La Quadreria di Don Lorenzo de' Medici.* Exhibition catalogue a Poggio a Caiano. Florence, 1977.

P. Rosenberg, S. Meloni Trkulja, I. Juija, N. Reynaud: *Pittura francese nelle collezioni pubbliche fiorentine.* Exhibition catalogue. Florence, 1977.

C. Caneva, D. Mignani: *Inaugurazione della sala del Botticelli.* Florence, 1978.

Tiziano nelle Gallerie fiorentine. Exhibition catalogue. Florence, 1978.

Gli Uffizi. Catalogo Generale. Florence, 1979.

C. CANEVA: *Inaugurazione della sala di Leonardo.* Florence, 1980.

C. CANEVA, A. GODOLI, A. NATALI: *Inaugurazione della sala archeologica e delle sale dei Sei e Settecento.* Florence, 1981.

A. NATALI: *Autoritratti del Novecento per gli Uffizi.* Florence, 1981 (I), 1983 (II).

Gli Uffizi: quattro secoli di una galleria. Convegno internazionale di studi. Fonti e documenti. Florence, 1982.

S. MELONI TRKULJA: *Al servizio del Granduca.* Exhibition catalogue. Florence, 1982.

S. MELONI TRKULJA, S. PADOVANI: *Il cenacolo di Andrea del Sarto a San Salvi, guida del Museo.* Florence, 1982.

L. BERTI, C. CANEVA, M. G. CIARDI DURPE DAL POGGETTO, M. GREGORI: *Gli Uffizi* (2 vols.). Florence, 1982–1983.

Gli Uffizi. Storia e collezioni. Florence, 1983.

Gli Uffizi quattro secoli di una galleria (2 vols.)(Atti del Convegno Internazionale di Studi a cura di P. Barocchi e G. Ragionieri). Florence, 1983.

V. SALADINO: *Musei e Gallerie. Firenze Gli Uffizi. Sculture Antiche.* Florence, 1983.

Sustermans. Sessant'anni alla corte dei Medici. Exhibition catalogue. Florence, 1983.

I pittori della Brancacci agli Uffizi. Florence, 1984.

L'opera ritrovata. Omaggio a Rodolfo Siviero. Exhibition catalogue. Florence, 1984.

Raffaello a Firenze. Exhibition catalogue. Florence, 1984.

Restauri: La Pietà del Perugino e la Madonna delle Arpie di Andrea del Sarto. Florence, 1984.

A. CECCHI, A. NATALI: *L'Adorazione dei Magi di Filippino restaurata.* Florence, 1985.

Il Tondo Doni di Michelangelo e il suo restauro. Florence, 1985.

Natura viva in casa Medici. Exhibition catalogue. Florence, 1985.

F. PULCINI, R. ORSI LANDINI, G. BUTAZZI, S. MELONI TRKULJA: *I principi bambini. Abbigliamento e infanzia nel Seicento.* Exhibition catalogue. Florence, 1985.

Andrea del Sarto 1486–1530. Dipinti e disegni a Firenze. Catalogue of an exhibition at Florence. Milan, 1986.

C. CANEVA, A. CECCHI, A. NATALI: *Gli Uffizi. Guida alle collezioni e catalogo completo dei dipinti.* Florence, 1986.

A. CECCHI, A. NATALI: *La Presentazione al Tempio di Ambrogio Lorenzetti restaurata.* Florence, 1986.

A. CECCHI, C. CANEVA, A. NATALI: *Tre opere restaurate.* Florence, 1987.

M. CHIARINI: *Il secolo di Rembrandt. Pittura olandese del Seicento nelle Gallerie fiorentine / Dutch Painting of the Seventeenth Century in the Florentine Galleries.* Exhibition catalogue. Florence, 1987.

Kunstschätze der Medici. Gemälde und Plastiken aus den Uffizien dem Palazzo Pitti une welteren Flörentiner Sammlungen. Catalogue of an exhibition at Dresden and Berlin. Rostock, 1987.

La Nascita di Venere e l'Annunciazione del Botticelli restaurate. Florence, 1987.

L. BERTI, A. GODOLI: *Gli Uffizi. La sala delle "Reali Poste."* Florence, 1988.

C. CANEVA ET AL. *Painters by Painters.* Catalogue of the exhibition at New York and Houston. Wisbech, 1988.

M. CHIARINI: *Il paesaggio nelle gallerie fiorentine.* Rome, 1988.

U. FORTIS: *Gli Uffizi e un modo di visitarli.* Venice, 1988.

M. MOSCO, M. RIZZOTTO: *Floralia florilegio delle collezioni fiorentine del Sei–Settecento.* Exhibition catalogue. Florence, 1988.

M. CHIARINI: *Battaglie. Dipinti dal XVII al XIX secolo delle Gallerie fiorentine.* Catalogue of the exhibition at Florence, Toledo, Oviedo. Florence, 1989.

A. DEL SERRA: *Gli Uffizi. La Maestà di Duccio restaurata.* Florence, 1989.

I pittori della Brancacci agli Uffizi. Florence, 1989.

Gli Uffizi. Restauri 1989. Florence, 1989.

Autoritratti degli Uffizi da Andrea del Sarto a Chagall. Catalogue of the exhibition at Rome and Florence. Wisbech, 1990.

M. BACCI: *Discover the Flowers of the Uffizi Gallery.* Florence, 1990.

M. CHIARINI: *Gallerie e Musei statali di Firenze. I dipinti olandesi dei Seicento e del Settecento.* Rome, 1990.

M. CHIARINI, L. MEDRI: *Horticulture as Art. Paintings from the Medici Collections.* Catalogue of the exhibition at Poggio a Caiano. Florence, 1990.

A. NATALI, C. DEL BRAVO: *Gli Uffizi. Viatico longhiano.* Florence, s.d. 1990.

A. PETRIOLI TOPANI, G. MICHELUCCI: *Gli Uffizi. Progetti per il nuovo museo.* Florence, 1990.

A. GODOLI, A. NATALI: *Gli Uffizi. La sala di Leonardo.* Florence, 1991.

Letture in San Pier Scheraggio. Florence, 1991.

P. BESCHI: *La statua del guerriero ferito. Storia, prospettive esegetiche, restauri di un originale greco.* Florence, 1992.

Itinerario laurenziano. Florence, 1992.

K. LANGEDIJK: *Die Selbstbildnisse der Holländischen und Flämischen Künstler in der Galleria degli Autoritratti der Uffizien in Florenz.* Florence, 1992.

La Madonna d'Ognissanti di Giotto restaurata. Florence, 1992.

A. NATALI: *Gli Uffizi. La donazione Balla.* Florence, 1992.

Giuseppe Maria Crespi nei Musei fiorentini. Exhibition catalogue. Florence, 1993.

List of Artists

AELST, Willem van (Delft, 1626–Amsterdam, 1683)

ALBANI, Francesco (Bologna, 1578–1660)

ALBERTINELLI, Mariotto (Florence, 1474–1515)

ALLORI, Alessandro (Florence, 1535–1607)

ALLORI, Cristofano (Florence, 1577–1621)

ALMA-TADEMA, Lawrence (Dronrijp, 1836–Wiesbaden, 1912)

ALTDORFER, Albrecht (Regensburg, c. 1480–1538)

AMBERGER, Christoph (Schwaren, c. 1500–Augsburg, 1561/1562)

AMICO FRIULANO DEL DOSSO ["Friulan friend of Dosso"] (active in the Veneto and Emilia between c. 1505–1525)

ANDREA DEL CASTAGNO. Andrea di Bartolomeo di Simone, called Andrea del Castagno (San Martino in Corella, c. 1417/1419–Florence, 1457)

ANDREA DEL SARTO (Florence, 1486–1530)

ANDREA DI GIUSTO. Andrea Manzini, called Andrea di Giusto (documented in Florence, 1424–Prato, 1450)

ANGELICO, Fra. Guido di Pietro, called Fra Angelico (Vicchio di Mugello, c. 1395–Rome, 1455)

ARALDI, Alessandro (Parma, c. 1460–1528/1529)

ARETINO, Spinello (see Spinello Aretino)

ASPERTINI, Amico (Bologna, c. 1475–1522)

ASSELIJN, Jan (Diemen or Dieppe, c. 1625/1626–Amsterdam, 1652)

BACCIARELLI, Marcello (Rome, 1731–Warsaw, 1818)

BACHIACCA. Francesco Ubertini, called Bachiacca (Borgo San Lorenzo, 1494–Florence, 1557)

BACICCIO. Giovan Battista Gaulli, called Baciccio (Genoa, 1639–Rome, 1709)

BACKHUYSEN, Ludolf (Emden, 1631–Amsterdam, 1708)

BALDOVINETTI, Alesso (Florence, 1425–1499)

BAMBOCCIO (see Laer, Pieter van)

BAROCCI, Federico (Urbino, 1535–1612)

BARTOLOMEO DI GIOVANNI (active from 1488–Florence, 1501)

BARTOLOMEO, Fra. Bartolomeo di Paolo del Fattorino, called Fra Bartolomeo; also called Baccio della Porta (Savignano di Prato, 1472–Florence, 1517)

BASSANO, Francesco the Younger. Francesco Da Ponte, called Francesco Bassano (Bassano, 1549–Venice, 1592)

BASSANO, Jacopo. Jacopo Da Ponte, called Jacopo Bassano (Bassano, c. 1515–1592)

BASSANO, Leandro. Leandro Da Ponte, called Leandro Bassano (Bassano, 1557–Venice, 1622)

BATONI, Pompeo Girolamo (Lucca, 1708–Rome, 1787)

BAZZANI, Giuseppe (Mantua, 1690–1769)

BECCAFUMI, Domenico. Domenico di Giacomo di Pace, called Beccafumi (Montaperti, by 1400–Siena, 1551)

BEGA, Cornelis (Haarlem, 1631/1632–1664)

BELLA, Stefano della (Florence, 1610–1655)

BELLINI, Giovanni (Venice, c. 1435/1440–1516)

BELLINI, Jacopo (Venice, c. 1400–1470/1471)

BELVEDERE, Andrea (Naples, 1646–1732)

BERCKHEYDE, Gerrit (Haarlem, 1638–1698)

BERNINI, Gianlorenzo (Naples, 1598–Rome, 1680)

BERRUGUETE, Alonso (Paredes de Nava, c. 1488–Toledo, 1561)

BILIVERT, Giovanni (Florence, 1585–1644)

BIMBI, Bartolomeo (Florence, 1648–1730)

BOCCACCINO, Boccaccio (Ferrara?, before 1466–Cremona, 1525)

BOLTRAFFIO, Giovanni Antonio (Milan, 1467–1516)

BONAIUTI, Andrea (Florence, documented between 1346–1377)

BONIFACIO VERONESE (Verona, 1487–Venice, 1553)

BONZI, Pietro Paolo (Cortona, c. 1576–Rome, 1636)

BORDONE, Paris (Treviso, 1500–Venice, 1571)

BORGOGNONE. Jacques Courtois, called Borgognone (St. Hyppolite, 1621–Rome, 1676)

BOSCOLI, Andrea (Florence, c. 1560–1607)

BOTTANI, Giuseppe (Cremona, 1717–Mantua, 1784)

BOTTICELLI, Sandro (Florence, 1445–1510)

BOTTICINI, Francesco (Florence, 1446–1497)

BOUCHER, François (Paris, 1703–1770)

BOURDON, Sébastien (Montpellier, 1616–Paris, 1671)

BRAMANTINO. Bartolomeo Suardi, called Bramantino (Milan?, c. 1465–Milan, 1530)

BRAMER, Leonard (Delft, 1596–1674)

BRILL, Paul (Antwerp, 1554–Rome, 1626)

BRONZINO, Agnolo (Florence, 1503–1527)

BRUEGHEL, Jan (Brussels, 1568–Antwerp, 1625)

BRUSASORCI. Domenico Riccio, called Brusasorci (Verona, c. 1515–1567)

BUGIARDINI, Giuliano (Florence, 1475–1554)

BURGKMAIR, Hans (Augsburg, 1473–1531)

CAGNACCI, Guido (Santarcangelo di Romagna, 1601–Vienna, 1663)

CAIRO, Francesco (Milan, 1607–1665)

CAMBIASO, Luca (Moneglia, 1527–El Escorial, 1585)

CAMPI, Giulio (Cremona, 1507–1572)

CANALETTO. Giovanni Antonio Canal, called Canaletto (Venice, 1696–1768)

CANTARINI, Simone (Pesaro, 1612–Verona, 1648)

CAPORALI, Bartolomeo (Perugia, c. 1420–before October 1505)

CARACCIOLO, Giovanni Battista (Naples, 1578–1635)

CARAVAGGIO. Michelangelo Merisi, called Caravaggio (Milan, 1571–Porto Ercole, 1610)

CAROTO, Giovanni Francesco (Verona, c. 1480–1555)

CARPACCIO, Vittore (Venice, c. 1465–c. 1526)

CARPIONI, Giulio (Venice, c. 1613–Vicenza, 1679)

CARRACCI, Annibale (Bologna, 1560–Rome, 1609)

CARRIERA, Rosalba (Venice, 1675–1757)

CASSANA, Niccolò (Venice, 1659–London, 1713)

CASTAGNO, Andrea del (see Andrea del Castagno)

CASTELLO, Valerio (Genoa, 1624–1659)

CASTIGLIONE, Giovanni Benedetto (see Grechetto)

CATENA, Vincenzo (Venice, c. 1480–1531)

CAVALLINO, Bernardo (Naples, 1616–1656?)

CAVAROZZI, Bartolomeo (Viterbo, 1588?–Rome, 1625)

CERANO (see Crespi, Giovanni Battista)

CERQUOZZI, Michelangelo (Rome, 1602–1660)

CERUTI, Giacomo (Milan, 1698–1767)

CHAGALL, Marc (Vitebsk, 1887–Saint-Paul-de-Vence, 1985)

CHARDIN, Jean-Baptiste-Siméon (Paris, 1699–1779)

CIGOLI, Ludovico. Ludovico Cardi, called Il Cigoli (Cigoli, 1559–Rome, 1613)

CIMA DA CONEGLIANO, Giovanni Battista (Conegliano, 1459/1460–1517/1518)

CIMABUE. Cenni di Peppo, called Cimabue (Florence, documented 1240/50–1302)

CIOCI, Antonio (Florence?, 1732–Florence, 1792)

CIVETTA. Herry met de Bles, called Il Civetta (Bouvignes, c. 1510–Ferrara?)

CLAUDE LORRAINE. Claude Gellée, also called Claude Lorraine (Chamagne, 1600–Rome, 1682)

CLEVE, Joos van (Antwerp, c. 1480–c. 1550)

CLOUET, François (Tours, c. 1510–Paris, c. 1572)

CLOUET, Jean (Southern Netherlands, c. 1485–Paris, c. 1540)

CODAZZI, Viviano (Bergamo, c. 1640–Rome, 1670)

COMMODI, Andrea (Florence, 1560–1638)

CONCA, Sebastiano (Gaeta, 1680–Naples, 1764)

CORNEILLE DE LYON (The Hague, active 1533–Lyon, 1574)

COROT, Jean-Baptiste-Camille (Paris, 1796–Ville d'Avray, 1875)

CORREGGIO. Antonio Allegri, called Correggio (Correggio, 1489–1534)

CORTONA, Pietro da. Pietro Berrettini, called Pietro da Cortona (Cortona, 1596–Rome, 1669)

COSTA, Lorenzo (Ferrara, c. 1460–Mantua, 1535)

CRANACH, Lucas the Elder (Kronach, 1472–Weimar, 1553)

CRANACH, Lucas the Younger (Wittenberg, 1515–Weimar, 1586)

CREDI, Lorenzo di (Florence, c. 1460–1537)

CRESPI, Giovanni Battista, also called Il Cerano (unknown, 1565/1570–Milan, 1632)

CRESPI, Giuseppe Maria (Bologna, 1665–1747)

CURRADI, Francesco (Florence, 1570–1661)

DADDI, Bernardo (Florence, documented 1320–1348)

DANDINI, Cesare (Florence, 1596–1657)

DANDINI, Vincenzo (Florence, 1609–1675)

DANIELE DA VOLTERRA. Daniele Ricciarelli,

called Daniele da Volterra (Volterra, c. 1509–Rome, 1566)

DAVID, Gerard (Oudewater, c. 1460–Bruges, 1523)

DENIS, Maurice (Granville, 1870–Paris, 1943)

DESUBLEO, Michele (Maubege, 1602–Parma, 1676)

DIANA, Benedetto. Benedetto Rusconi, called Benedetto Diana (Venice, c. 1460–1525)

DOLCI, Carlo (Florence, 1616–1687)

DOMENICHINO. Domenico Zampieri, called Domenichino (Bologna, 1581–Naples, 1641)

DOMENICO DI MICHELINO. Domenico di Francesco, called Domenico di Michelino (Florence, 1417–1491)

DOMENICO VENEZIANO. Domenico di Bartolomeo di Venezia, called Domenico Veneziano (Venice, c. 1410–Florence, 1461)

DOSSI, Dosso. Giovanni de Luteri, called Dosso Dossi (unknown, c. 1479–Ferrara, 1542)

DOU, Gerard (Leiden, 1613–1675)

DUCCIO DI BUONINSEGNA (Siena, documented 1278–1318)

DUGHET, Gaspard (Rome, 1615–1675)

DÜRER, Albrecht (Nuremberg, 1471–1528)

DYCK, Anthony van (Antwerp, 1599–London, 1641)

ENSOR, James (Ostend, 1860–1949)

FALCONI, Bernardo (Pisa, second half of the fifteenth century)

FANTIN-LATOUR, Henri (Grenoble, 1836–Bure, 1904)

FERRARI, Defendente (documented in the Piedmont between 1509 and 1535)

FERRETTI, Giovan Domenico (Florence, 1692–1768)

FERRI, Ciro (Rome, 1634–1689)

FETTI, Domenico (Rome, 1589–Venice, 1624)

FICHERELLI, Felice (San Gimignano, 1603–Florence, 1660)

FIDANI, Orazio (Florence, 1606–1656)

FLANDRIN, Hippolyte (Lyon, 1809–Rome, 1864)

FLORIGERIO, Sebastiano (Conegliano, c. 1500–post 1543)

FLORIS DE VRIENDT, Frans (Antwerp, 1516/1520–1570)

FONTANA, Lavinia (Bologna, 1552–Rome, 1614)

FONTEBUONI, Anastagio (Florence, 1571–1626)

FOPPA, Vincenzo (Brescia, 1427/1430–1515/1516)

FORABOSCO, Girolamo (Venice, 1605–Padua, 1679)

FOSCHI, Pierfrancesco (Florence, 1502–1567)

FRANCESCO DI GIORGIO MARTINI (Siena, 1439–1501)

FRANCIA, Francesco. Francesco Raibolini, called Francesco Francia (Bologna, c. 1450–1517)

FRANCIABIGIO. Francesco di Cristofano, called Franciabigio (Florence, c. 1482–1525)

FRANCKEN, Frans II (Antwerp, 1581–1642)

FROMENT, Nicolas (Avignon, active c. 1450–c. 1490)

FURINI, Francesco (Florence, 1603–1646)

GABBIANI, Anton Domenico (Florence, 1653–1726)

GADDI, Agnolo (Florence, documented 1369–1396)

GADDI, Taddeo (Florence, documented c. 1330–1366)

GANDOLFI, Ubaldo (San Matteo della Decima, 1728–Bologna, 1781)

GARBO, Raffaellino del (see Raffaellino del Garbo)

GAROFALO. Benvenuto Tisi, called Garofalo (Garofalo, 1476–Ferrara, 1559)

GARZI, Luigi (Pistoia, 1638–Rome, 1721)

GARZONI, Giovanna (Ascoli Piceno, 1600–Rome, 1670)

GELLÉE, Claude (see Claude Lorraine)

GENGA, Girolamo (Urbino, c. 1476–1551)

GENTILE DA FABRIANO (Fabriano, c. 1370–Rome, 1427)

GENTILESCHI, Artemisia (Rome, 1593–Naples, 1652/1653)

GHERARDINI, Stefano (Bologna, 1696–1756)

GHIRLANDAIO. Domenico Bigordi, called Ghirlandaio (Florence, 1449–1494)

GHIRLANDAIO, Ridolfo. Ridolfo Bigordi, called Ridolfo del Ghirlandaio (Florence, 1483–1561)

GHISOLFI, Giovanni (Milan, 1623–1683)

GIAQUINTO, Corrado (Molfetta, 1703–Naples, 1766)

GIMIGNANI, Giacinto (Pistoia, 1606–Rome, 1681)

GIORDANO, Luca (Naples, 1634–1705)

GIORGIONE (Castelfranco Veneto, 1477/1478–Venice, 1510)

GIOTTINO. Giotto di Stefano, called Giottino (Florence, documented 1368–1369)

GIOTTO. Giotto di Bondone, called Giotto (Colle di Vespignano, 1267–Florence, 1337)

GIOVANNI DA MILANO (documented in Florence and Rome from 1346–1369)

GIOVANNI DA SAN GIOVANNI. Giovanni Mannozzi, called Giovanni da San Giovanni (San Giovanni Valdarno, 1592–Florence, 1636)

GIOVANNI DAL PONTE, also called Giovanni di Marco (Florence, 1385–1437)

GIOVANNI DEL BIONDO (Florence, documented 1356–1398)

GIROLAMO DA CARPI. Girolamo Sellari, called Girolamo da Carpi (Ferrara, 1501–1556)

GIROLAMO DEL PACCHIA (Siena, 1477–after 1533)

GIULIO ROMANO (Rome, end of fifteenth century–Mantua, 1546)

GOES, Hugo van der (Ghent, 1440/1450–Andergen, 1482)

GOYA, Francisco (Fuendetodas, 1746–Bordeaux, 1828)

GRAMATICA, Antiveduto (Siena, 1571–Rome, 1626)

GRANACCI, Francesco (Villamagna, 1469–Florence, 1543)

GRECHETTO. Giovanni Benedetto Castiglione, called Grechetto (Genoa, 1609–Mantua, 1664)

GRECO, El. Doménikos Theotokópoulos, called El Greco (Crete, 1541–Toledo, 1614)

GUARDI, Francesco (Venice, 1712–1793)

GUERCINO. Giovan Francesco Barbieri, called Guercino (Cento, 1591–Bologna, 1666)

GUIDO DA SIENA (Siena, second half of the thirteenth century)

HEEM, Jan Davidsz de (Utrecht, 1606–Antwerp, 1683/1684)

HOECKE, Jan van de (Antwerp, 1611–Brussels, ?/1651)

HOLBEIN, Hans the Younger (Augsburg, 1497–London, 1543)

HONTHORST, Gerrit van (Utrecht, 1590–1666)

HULSDONCK, Jacob van (Antwerp, 1582-1647)

INGRES, Jean-Auguste-Dominique (Montauban, 1780–Paris, 1867)

JACOPO DA EMPOLI (Florence, 1551–1640)

JACOPO DEL CASENTINO (Florence, c. 1295–1349)

JACOPO DI CIONE (Florence, documented 1365–1398)

JORDAENS, Jacob (Antwerp, 1592–1678)

JOUVENET, Jean (Rouen, 1644–Paris, 1717)

KAUFFMANN, Angelica (Coira, 1741–Rome, 1807)

KEIHLAU, Eberhard (see Monsú Bernardo)

KESSEL, Jan van (Amsterdam, 1626–Antwerp, 1679)

KULMBACH, Hans Suess von (Kulmbach, c. 1480–Nuremberg, 1522)

LAER, Pieter van, also called Il Bamboccio (Haarlem, c. 1599–c. 1642)

LANFRANCO, Giovanni (Parma, 1582–Rome, 1647)

LARGILLIÈRE, Nicolas de (Paris, 1656–1746)

LE BRUN, Charles (Paris, 1619–1690)

LEIGHTON, Frederick (Scarborough, 1830–London, 1896)

LEONARDO DA VINCI (Vinci, 1452–Cloux, 1519)

LICINIO, Bernardino (Venice, 1485–post 1549)

LIGOZZI, Bartolomeo (Florence, c. 1620–1695)

LIOTARD, Jean-Étienne (Geneva, 1702–1789)

LIPPI, Filippino (Prato, c. 1457–Florence, 1504)

LIPPI, Fra Filippo (Florence, 1406/1407–Spoleto, 1469)

LIPPI, Lorenzo (Florence, 1606–1665)

LISS, Johann (Oldenburg, 1595/1597–Verona, 1631)

LONGHI, Alessandro (Venice, 1733–1813)

LONGHI, Pietro (Venice, 1702–1785)

LOO, Carle van (Nice, 1705–1765)

LORENZETTI, Ambrogio (Siena, documented 1321–1348)

LORENZETTI, Pietro (Siena, documented 1306–1345)

LORENZO DI CREDI (see Credi, Lorenzo di)

LORENZO MONACO (Siena, c. 1365–Florence, before 1426)

LORRAINE, Claude (see Claude Lorraine)

LOTH, Johann Carl (Munich, 1632–Venice, 1698)

LOTTO, Lorenzo (Venice, c. 1480–Loreto, 1556/1557)

LUTI, Benedetto (Florence, 1666–1724)

MACCHIETTI, Girolamo (Florence, 1535–1592)

MAGNASCO, Alessandro (Genoa, 1667–1749)

MAINERI, Giovan Francesco (Parma, documented 1489–1506)

MANETTI, Rutilio (Siena, 1571–1639)

MANFREDI, Bartolomeo (Ostiano Cremona, 1582–Rome, 1622)

MANNOZZI, Vincenzo (Florence, 1600–1658)

MANTEGNA, Andrea (Isola di Carturo, 1431–Mantua, 1506)

MARATTA, Carlo (Camerano, 1625–Rome, 1713)

MARIO DEI FIORI. Mario Nuzzi, called Mario dei Fiori (Rome, 1603–1673)

MARIOTTO DI CRISTOFANO (San Giovanni Valdarno, 1393–Florence, 1457)

MARTINELLI, Giovanni (Montevarchi, 1600 or 1604–Florence, 1659)

MASACCIO. Tommaso di Giovanni, called Masaccio (San Giovanni Valdarno, 1401–Rome, 1428)

MASOLINO DA PANICALE (Panicale in Valdarno, 1383–c. 1440)

MASSARI, Lucio (Bologna, 1569–1633)

MASTER OF HOOGSTRATEN (Flemish, fifteenth century)

MASTER OF ST. CECILIA (Florence, active c. 1290–1325)

MASTER OF ST. FRANCIS BARDI (Florence, second quarter of the thirteenth century)

MASTER OF SAN GAGGIO (Florence, active c. 1280–1310)

MASTER OF THE CASTELLO NATIVITY (active in Florence and Prato in the third quarter of the fifteenth century)

MASTER OF THE CODICE OF SAN GIORGIO (Florence, active c. 1310–1335)

MASTER OF THE CRUCIFIX NO. 434 IN THE UFFIZI (Florence, second quarter of the fourteenth century)

MASTER OF THE DOMINICAN IMAGES (Florence, fourteenth century)

MASTER OF THE MAGDALEN (Florence, active c. 1265–1290)

MASTER OF THE MISERICORDIA (Florence, active from 1365–c. 1400)

MASTER OF THE STRAUS MADONNA (Florence, active from c. 1385–1415)

MASTER OF THE VIRGO INTER VIRGINES (Delft, second half of the fifteenth century)

MATTEO DI GIOVANNI (Sansepolcro, c. 1430–Siena, 1495)

MATTEO DI PACINO (Florence, documented 1359–1394)

MAZZOLINO, Ludovico (Ferrara, c. 1480–c. 1528)

MECARINO (see Beccafumi, Domenico)

MEHUS, Livio (Ondenaarde, c. 1630–Florence, 1691)

MELIORE (Florence, documented 1260–1271)

MELOZZO DA FORLI (Forli, 1438–1494)

MEMLING, Hans (Selingenstadt, 1435/1440–Bruges, 1494)

MEMMI, Lippo (Siena, documented from 1317 to 1347)

MENGS, Anton Raphael (Aussig, 1728–Rome, 1779)

METSU, Gabriel (Leiden, 1629–Amsterdam, 1667)

MICHELANGELO BUONARROTI (Caprese, 1475–Rome, 1564)

MIERIS, Frans van the Elder (Leiden, 1635–1681)

MOLA, Pier Francesco (Coldrerio, 1612–Rome, 1666)

MOLENAER, Jan Miense (Haarlem, 1609/1610–1668)

MONSÚ BERNARDO. Eberhard Keihlau, known as Monsú Bernardo (Helsingor, 1624–Rome, 1687)

MOR, Antonis. Anthonis Moor van Dashorts, called Antonis Mor (Utrecht, 1517–Antwerp, 1576)

MORANDINI, Francesco (see Poppi)

MORAZZONE. Pier Francesco Mazzucchelli, called Morazzone (Morazzone Varese, 1573–Piacenza?, 1626)

MORE, Jacob (Edinburgh, 1740–Rome, 1793)

MORONE, Francesco (Verona, 1471–1529)

MORONI, Giovan Battista (Albino?, 1520/1524–Albino, 1578)

MUNARI, Cristoforo (Reggio Emilia, 1667–Pisa, 1720)

MURILLO, Bartolomé Esteban (Seville, 1618–1682)

NANTEUIL, Robert (Reims, 1623–Paris, 1678)

NAPOLETANO, Filippo. Filippo Napoletano Angeli, called Filippo Napoletano (Rome or Naples, 1587/1591–Rome, 1629)

NARDO DI CIONE (Florence, documented 1346/1348–1365)

NATTIER, Jean-Marc (Paris, 1685–1766)

NEEFS, Pieter the Elder (Antwerp, c. 1578–1656/1661)

NEROCCIO DI BARTOLOMEO LANDI (Siena, 1447–1500)

NICCOLO DI SER SOZZO. Niccolo Tegliacci, called Niccolo di Ser Sozzo (Siena, documented 1348–1363)

ORCAGNA, Andrea (Florence, documented 1343–1368)

ORLEY, Bernard van (Brussels, c. 1488–1542)

PACINO DI BUONAGUIDA (documented 1303)

PAGANI, Gregorio (Florence, 1558–1605)

PAGGI, Giovanni Battista (Genoa, 1554–1627)

PALMA VECCHIO. Jacopo Palma the Elder, called Palma Vecchio (Serina/Bergamo, c. 1480–Venice, 1528)

PALMEZZANO, Marco (Forli, 1459/1463–1539)

PAOLO VENEZIANO. Paolo di Martino, called Paolo Veneziano (Venice, documented 1339–1358)

PARMIGIANINO. Francesco Mazzola, called Parmigianino (Parma, 1503–Casalmaggiore, 1540)

PARROCEL, Joseph (Brignoles, 1646–Paris, 1704)

PASSAROTTI, Bartolomeo (Bologna, 1529–1592)

PENCZ, Georg (Nuremberg, c. 1500–Lipsia, 1550)

PEREDA, Antonio de (Valladolid, 1611–Madrid, 1678)

PERINO DEL VAGA. Pietro Buonaccorsi, called Perino del Vaga (Florence, 1501–Rome, 1547)

PERUGINO. Pietro di Cristoforo Vannucci, called Perugino (Città della Pieve, c. 1450–Fontignano, 1524)

PESELLINO. Francesco di Stefano, called Pesellino (Florence, 1422–1457)

PIAZZETTA, Giovanni Battista (Venice, 1638–1754)

PIERI, Stefano (Florence, 1542–1629)

PIERO DELLA FRANCESCA (Sansepolcro, c. 1415–1492)

PIERO DI COSIMO (Florence, 1462–1521)

PIETRO DA CORTONA (see Cortona, Pietro da)

PILLEMENT, Jean (Lyons, 1728–1808)

PINI, Giovanni (Florence, notices, 1633–1635)

POELENBURGH, Cornelis van (Utrecht, 1595–1667)

POLLAIOLO, Antonio (Florence, 1431/1432–Rome, 1498)

POLLAIOLO, Piero (Florence, 1441–Rome, 1496)

PONTORMO. Jacopo Carrucci, called Pontormo (Pontormo, 1494–Florence, 1557)

POPPI. Francesco Morandini, called Poppi (Poppi, c. 1544–Florence, 1597)

PORTELLI, Carlo (Loro Ciuffenna, before 1510–Florence, 1574)

POURBUS, Frans the Younger (Antwerp, 1569–Paris, 1622)

POUSSIN, Nicolas (Les Andelys, 1594–Rome, 1665)

PRETI, Mattia (Taverna, 1613–La Valletta, 1669)

PULIGO, Domenico. Domenico di Bartolomeo degli Ubaldini, called Puligo (Florence, 1492–1527)

RAFFAELLINO DEL GARBO (Florence, c. 1466–1524)

RAPHAEL. Raphael Sanzio, called Raphael (Urbino, 1483–Rome, 1520)

RECCO, Giacomo (Naples, 1603–before 1653)

RECCO, Giuseppe (Naples, 1634–Alicante, 1695)

RÉGNIER, Nicolas (Maubege, 1591–Venice, 1667)

REMBRANDT HARMENSZOON VAN RIJN (Leiden, 1606–Amsterdam, 1669)

RENI, Guido (Bologna, 1575–1642)

RESANI, Arcangelo (Rome, 1670–Ravenna, 1742)

RESCHI, Pandolfo (Danzig, c. 1640–Florence, 1686)

REYNOLDS, Joshua (Plympton, 1723–London, 1792)

RIBERA, Jusepe de (Jativa, Valencia, 1591–Naples, 1652)

RICCI, Sebastiano (Belluno, 1659–Venice, 1734)

RIGAUD, Hyacinthe (Perpignano, 1659–Paris, 1743)

RIMINALDI, Orazio (Pisa, 1593–1630)

ROOS, Johann Heinrich (Reipoltskirchen/Pfalz, 1631–Frankfurt am Main, 1685)

ROSA, Salvator (Naples, 1615–Rome, 1673)

ROSSELLI, Cosimo (Florence, 1439–1507)

ROSSELLI, Matteo (Florence, 1578–1650)

ROSSO FIORENTINO. Romolo, Giovan Battista, called Rosso Fiorentino (Florence, 1495–Fontainebleau, 1540)

RUBENS, Pieter Paul (Slegen, 1577–Antwerp, 1640)

RUISDAEL, Jacob van (Haarlem, 1628/1629–Amsterdam, 1682)

RUSTICI, Francesco (Siena, 1592–1626)

RUTHART, Carl Andreas (Danzig, c. 1630–L'Aquila, 1703)

RUYSCH, Rachel (Amsterdam, 1664–1750)

RYCKAERT, David III (Antwerp, 1612–1661)

SACCHI, Andrea (Nettuno?, c. 1599/1600–Rome, 1661)

SALIMBENI, Ventura (Siena, c. 1568–1613)

SALVIATI, Francesco. Francesco de' Rossi, called Salviati (Florence, 1510–Rome, 1563)

SANDRART, Joachim von (Frankfurt am Main, 1606–Nuremberg, 1688)

SANTI DI TITO (Sansepolcro, 1536–Florence, 1603)

SASSETTA. Stefano di Giovanni, called Sassetta (Cortona, beginning of the fifteenth century–Siena, 1450)

SAVOLDO, Giovanni Gerolamo (Brescia, 1480/1485–post 1548)

SCACCIATI, Andrea (Florence, 1642–1710)

SCACCIATI, Pietro Neri (Florence, 1684–1749)

SCHEGGIA. Giovanni di Ser Giovanni, called Lo Scheggia (San Giovanni Valdarno, 1406–Florence, 1486)

Index to Paintings

Numbers in *italics* refer to pages with reproductions of paintings.

639

641

Index to Artists

Numbers in *italics* refer to pages with reproductions of paintings.

Photographic Credits

The photographs for this publication were supplied by:

Serge Domingie and Marco Rabatti, Florence
Nicola Grifoni, Antella (FI)
Antonio Quattrone, Florence
Paolo Tosi, Florence
Marcello Bertoni/Archivio Magnus
Paolo Marton/Archivio Magnus
Archivio Scala, Antella (FI)
Paolo Tosi/Archivio Magnus

Printing completed by Grafiche LEMA of Maniago/Pordenone
in September 1994

DATE DUE	
OCT 04 1995	
OCT 17 1995	
JUN 15 99	